D1451789

BUILDINGS OF LOUISIANA

Buildings of the United States is a series of books on American architecture compiled and written on a state-by-state basis. The primary objective of the series is to identify and celebrate the rich cultural, economic, and geographical diversity of the United States as it is reflected in the architecture of each state. The series has been commissioned by the Society of Architectural Historians, an organization dedicated to the study, interpretation, and preservation of the built environment throughout the world.

Buildings of Alaska
Alison K. Hoagland (1993)

Buildings of Colorado
Thomas J. Noel (1997)

Buildings of the District of Columbia
Pamela Scott and Antoinette J. Lee (1993)

Buildings of Iowa
David Gebhard and Gerald Mansheim (1993)

Buildings of Louisiana
Karen Kingsley (2003)

Buildings of Michigan
Kathryn Bishop Eckert (1993)

Buildings of Nevada
Julie Nicoletta, with photographs by Bret Morgan (2000)

Buildings of Virginia: Tidewater and Piedmont
Richard Guy Wilson and contributors (2002)

Buildings of
LOUISIANA

KAREN KINGSLEY

OXFORD

UNIVERSITY PRESS

2003

OXFORD
UNIVERSITY PRESS

Oxford New York
Auckland Bangkok Buenos Aires Cape Town Chennai
Dar es Salaam Delhi Hong Kong Istanbul Karachi Kolkata
Kuala Lumpur Madrid Melbourne Mexico City Mumbai Nairobi
Sao Paulo Shanghai Taipei Tokyo Toronto

Copyright © 2003 by the Society of Architectural Historians

Published by Oxford University Press, Inc.
198 Madison Avenue, New York, New York 10016

www.oup.com

Oxford is a registered trademark of Oxford University Press

LIBRARY OF CONGRESS CATALOGING-IN-PUBLICATION DATA
Kingsley, Karen.
Buildings of Louisiana / Karen Kingsley.
p. cm. — (Buildings of the United States)
Includes bibliographical references and index.
ISBN 0-19-515999-3
1. Architecture—Louisiana—Guidebooks. I. Title. II. Series.
NA730.L8 K55 2003
720´.9763—dc21 2002155947

1 3 5 7 9 8 6 4 2

Printed in the United States of America
on acid-free paper

The Society of Architectural Historians gratefully acknowledges the support of the following, whose generosity helped bring *Buildings of Louisiana* to publication:

National Endowment for the Humanities, an independent federal agency

The Ella West Freeman Foundation

The Booth-Bricker Fund

Louisiana Department of Culture, Recreation and Tourism,
Division of Historic Preservation

Louisiana Endowment for the Humanities

The Samuel I. Newhouse Foundation

The Azby Fund

Governor and Mrs. Mike Foster

Mr. Peter Reed

Southeast Chapter, Society of Architectural Historians

Many individual members of the SAH

Initial and ongoing support for the
Buildings of the United States series has come from

National Endowment for the Humanities

Graham Foundation for Advanced Studies in the Fine Arts

Pew Charitable Trusts

University of Delaware

College of Fellows of the American Institute of Architects

Contents

List of Maps

Guide for Users of This Volume

Buildings of Louisiana begins with an introduction that provides a historical and environmental context for understanding the state's buildings and landscape. The introduction is followed by twelve regional sections. Within each of these, cities, towns, and rural vicinities are grouped by parish (Louisiana is unique in having parishes rather than counties), and entries for buildings and sites are each numbered with an alphabetic prefix that abbreviates the name of the parish. The first entry in each parish is the parish seat or the largest town. Subsequent entries spiral out, in most cases moving first northerly, then clockwise. One notable exception to this arrangement is the Lower River region, where five of the seven parishes are divided by the Mississippi River. The sequence follows a route upriver on the Mississippi's east bank to Baton Rouge (East Baton Rouge Parish), across the bridge in that city to Port Allen in West Baton Rouge Parish, and then downriver on the west bank.

For each place, numbered guidebook entries for buildings and sites follow walking or driving tour order. Heading information includes the current name (sometimes followed in parentheses by an earlier name) of the building or site; the date of construction; the architect, if known; the dates of major additions or alterations and their architects, if known; and the address. Entries are keyed by site number to maps of the twelve regions and to selected cities and towns.

Useful complements to this volume are guidebooks containing information on accommodations and hours of operation for museums and historic sites and the highway map produced annually by the Louisiana Department of Transportation. Many local historical societies and visitor information centers throughout the state offer additional information on historic buildings and sites in their towns.

Almost all the sites described in this book are visible from public roads or public property. A few properties that are not visible are included, however, because of their importance in understanding Louisiana's architectural history. If the property is not visible, that is noted with the location information for its entry. We know that readers will respect the property rights and privacy of others as they view the buildings.

Buildings of Louisiana is intended to present an overview of the state's architecture. Buildings and sites included here were chosen either as exceptional examples of the state's architectural heritage or as representative of the varieties of architectural styles, building types, and physical settings and their geographic distribution. Although the guidebook entries are intended to include only extant buildings, a few structures may have been destroyed while the editing and production of this book have been in progress. The uses of others may have changed.

Deciding what to include in a book such as this requires making tough choices. *Buildings of Louisiana* is meant to serve as an introduction and as a springboard for further exploration of the state's diverse built environment.

Foreword

Buildings of Louisiana is the eighth of a projected fifty-eight volumes in the series Buildings of the United States, which is sponsored by the Society of Architectural Historians (SAH). When the series is completed, it will provide a detailed survey and history of the architecture of the whole country, including both vernacular and high-style structures for a complete range of building types from skyscrapers to barns and everything in between.

The idea for such a series was in the minds of the founders of the SAH in the early 1940s, but it was not brought to fruition until Nikolaus Pevsner, the eminent British architectural historian who had conceived and carried out Buildings of England, originally published between 1951 and 1974, challenged the SAH to do for this country what he had done for his. That was in 1976, and it was another ten years before we were able to organize the effort, commission authors for the initial group of volumes, and secure the first funding, a grant from the National Endowment for the Humanities. Matched by grants from the Pew Charitable Trusts, the Graham Foundation, and the Michigan Bicentennial Commission, this enabled us to produce the first four volumes, *Buildings of Michigan, Buildings of Iowa, Buildings of Alaska,* and *Buildings of the District of Columbia,* all of which were published in 1993. *Buildings of Colorado* appeared in 1997, followed by *Buildings of Nevada* in 2000 and *Buildings of Virginia: Tidewater and Piedmont* in 2002. Another ten volumes are expected in the next five years, with many more to follow.

Although Buildings of England provided the model, in both method and approach Buildings of the United States was to be as different as American architecture is from English. Pevsner was confronted by a coherent culture on a relatively small island, with an architectural history that spans more than two thousand years. Here we are dealing with a vast land of immense regional, geographic, climatic, and ethnic diversity, with most of its buildings—wide-ranging, exciting, and sometimes dramatic—essentially concentrated into the last four hundred years, although with significant Native American remains stretching back well beyond that. In contrast to the national integrity of English architecture, therefore, American architecture is marked by a dynamic heterogeneity, a heterogeneity woven of a thousand strands of originality, or, actually, a unity woven of a thousand strands of heterogeneity. It is this quality that Buildings of the United States reflects and records.

Unity born of heterogeneity was a condition of American architecture from the first European settlements of the sixteenth and seventeenth centuries. Not only did the buildings of the Russian, Spanish, French, Dutch, Swedish, and English colonies differ according to national origin (to say nothing of their differences from Native American structures), but in the translation to North America they also assumed a special scale and character, qualities that were largely determined by the

aspirations and traditions of a people struggling to fashion a new world in an abundant but demanding land. Diversity marked even the English colonies of the eastern seaboard, though they shared a common architectural heritage. The brick mutations of English prototypes in the Virginia Colony were very different, for example, from the wooden architecture of the Massachusetts Bay Colony. They were different because Virginia was a farm and plantation society dominated by the Anglican church, whereas Massachusetts was a communal society nurtured entirely by Puritanism. But they were different also because of natural resources and the traditions of the parts of England from which the settlers had come. This is even more true for the present volume, for the architecture of the French settlers in Louisiana is very different, indeed, from that of the English in either Virginia or Massachusetts. As the colonies became a nation and developed westward, similar radical contrasts became the way of America's growth. The infinite variety of physical environment, together with the complex origins and motivations of the settlers, made it inevitable that each new state would have a character uniquely its own.

The primary objective of each volume, therefore, is to record, analyze, and evaluate the architecture of the state. The authors are trained architectural historians who are thoroughly informed in the local aspects of their subjects. In each volume, special conditions that shaped the state or part of the state, together with the building types necessary to meet those conditions, are identified and discussed; barns, silos, mining buildings, factories, warehouses, bridges, and transportation buildings take their places alongside the familiar building types conventional to the nation as a whole—churches, courthouses, city halls, commercial structures, and the infinite variety of domestic architecture. Although the great national and international masters of American architecture receive proper attention, especially in the volumes for the states in which they did their greatest work, outstanding local architects, as well as the buildings of skilled but often anonymous carpenter-builders, are also brought prominently into the picture. Each volume is thus a detailed and precise portrait of the architecture of the state that it represents. At the same time, however, all of these local issues are examined as they relate to architectural developments in the country at large. Volumes will continue to appear state by state until every state is represented. When the overview and inventory are completed, the series will form a comprehensive history of the architecture of the United States.

These volumes deal with more than the highlights and the high points of architecture in this country. They deal with the very fabric of American architecture, with the context in time and in place of each specific building, with the entirety of urban and rural America, with the whole architectural patrimony. This fabric includes modern architecture, as, on the other end of the scale, it includes pre-Columbian and Native American remains. But it must be said, regretfully, that the series cannot cover every building of merit; practical considerations have dictated some difficult choices in the buildings that are represented in this as in other volumes. There are, unavoidably, omissions from the abundance of structures built across the land, the thousands of modest but lovely edifices and the vernacular attempts that merit a

second look but which by their very multitude cannot be included in even the thickest volume.

Thus it must be stated in the strongest possible terms that omission of a building from this or any volume of the series does not constitute an invitation to the bulldozers and the wrecking ball. In every community there will be structures not included in Buildings of the United States that are clearly deserving of being preserved. Indeed, it is hoped that the publication of this series will help to stop at least the worst destruction of architecture across the land by fostering a deeper appreciation of its beauty and richness and of its historic and associative importance.

The volumes of Buildings of the United States are meant to be tools of serious research in the study of American architecture. But they are also intended as guidebooks for everyone interested in the buildings of this country and are designed to facilitate such use; they can and should be used on the spot, indeed, should lead the user to the spot. It is our earnest hope that they will not only be on the shelves of every library from major research centers to neighborhood public libraries but that they will also be in a great many raincoat pockets, glove compartments, and backpacks.

During the long gestation process of the series, many have come forward with generous assistance. We are especially grateful, both for financial support for the series as a whole and for confidence in our efforts, to the National Endowment for the Humanities, the Graham Foundation for Advanced Studies in the Fine Arts, the University of Delaware, and the College of Fellows of the American Institute of Architects. For this volume, we are also enormously indebted to the Ella West Freeman Foundation, the Booth-Bricker Fund, the Louisiana Department of Culture, Recreation and Tourism, Division of Historic Preservation, the Louisiana Endowment for the Humanities, the Samuel I. Newhouse Foundation, the Azby Fund, Governor and Mrs. Mike Foster, Mr. Peter Reed, the Southeast Chapter of the Society of Architectural Historians, and many individual members of the SAH. A reception launching the volume was hosted by Governor and Mrs. Mike Foster at their home in Franklin, and we are deeply grateful to them for this. We would also like to express our appreciation to Debbie Broussard, assistant to First Lady Alice Foster; Dr. Thomas and Mrs. Glenna Kramer of Franklin; and Suzanne Haik Terrell, former councilmember of New Orleans, for their aid in organizing this reception. We are thankful, too, to the members of the Buildings of the United States series Leadership Development Committee: Madelyn Bell Ewing, Frances Fergusson, Elizabeth Harris, Ada Louise Huxtable, Philip Johnson, Keith Morgan, Victoria Newhouse, Robert Venturi, and the late J. Carter Brown.

For providing institutional support for two successive editors in chief of the series, we are very grateful to Dean Larry Clark of the University of Missouri and to the following at the University of Delaware: Provosts Mel Schiavelli and Dan Rich; Deans Mary Richards, Margaret Andersen, Thomas DiLorenzo, and Mark Huddleston of the College of Arts and Science; and Professor Ann Gibson, chair of the Department of Art History.

Our gratitude extends to many other individuals. These include a large number of presidents, executive committees, and boards of directors of the SAH, going back at least to the adoption of the project by the Society in 1979, and a series of executive directors covering that same span. All of these individuals have supported the series in words and deeds, and without them it would not have seen the light of day.

We would also like to express our appreciation to the current members of our editorial board, listed earlier in this volume, and the following former members: Adolf K. Placzek, Richard Betts, Catherine Bishir, J. A. Chewning, S. Allen Chambers, Jr., Alex Cochran, Kathleen Curran, John Freeman, David Gebhard, Alan Gowans, Alison K. Hoagland, William H. Jordy, Robert Kapsch, Henry Magaziner, Tom Martinson, Sally Kress Tompkins, and Robert J. Winter. Of this group, we would like especially to single out Dolf Placzek, founding editor in chief, who served in that capacity from the early 1980s to 1989 and continued to play a major role in the project until his death in the spring of 2000.

We have tried to establish as far as possible a consistent terminology of architectural history, and we are especially appreciative of the efforts of J. A. Chewning in the creation of the series glossary included in every volume. The *Art and Architecture Thesaurus,* a comprehensive publication and database compiled by The Getty Art History Information Program and published by Oxford University Press, has also become an invaluable resource.

In our fund-raising efforts we have benefited enormously from the dedicated services of our directors of development, first Anita Nowery Durel and then Barbara Reed, as well as associate director of development William Cosper, and of our administrative staff: first fiscal coordinator Hillary Stone and then comptroller William Tyre; and the current executive director of the SAH, Pauline Saliga.

Editorial work for this volume was overseen by our excellent managing editor for the series, Cynthia Ware; thanks to Janet Wilson for copy editing and proofreading, and to Jennifer Rushing-Schutt for compiling the index. Maps were prepared by the Geographic Resources Center in the Department of Geography at the University of Missouri–Columbia, by project manager Andrew Dolan, Jeff Thomas, and Jackie Shoemaker. Research assistants at the University of Delaware were Jhennifer Amundson, Anna Andrzewjewski, Heather Campbell, Martha Hagood, Nancy Holst, Amy Johnson, Sarah Killinger, Ellen Menefee, Louis Nelson, and Karen Sherry.

Finally, there are our present and former colleagues in this enterprise at Oxford University Press in New York and Cary, North Carolina, especially Karen Day, Timothy DeWerff, Nancy Hoagland, Mark Mones, Leslie Phillips, Rebecca Seger, and John Sollami.

To all of these we are enormously grateful.

DAMIE STILLMAN

OSMUND OVERBY

WILLIAM H. PIERSON, JR.

Acknowledgments

This book would not have been possible without the help of many people. For financial support of all phases of manuscript development I am indebted to the Society of Architectural Historians and to the organizations and individuals whose contributions are acknowledged in the front of this volume. Thanks to Jessie Poesch and Damie Stillman, who reviewed the manuscript on behalf of the Buildings of the United States Editorial Board, and to Cynthia Ware, whose editing and suggestions greatly improved this volume. Jonathan Fricker, Donna Fricker, John Geiser III, and Gary Van Zante read sections of the manuscript and made helpful comments. I thank Andrew Dolan for drawing the maps, Janet Wilson for her careful copy editing of the text, and the staff of the Society of Architectural Historians for administrative support and encouragement.

I am grateful to the many individuals I met in my travels around the state who generously shared their knowledge and insights into Louisiana's architecture, especially Eric J. Brock, Joe Cash, Arthur Q. Davis, Ron Downing, Ron Filson, Stephen Fox, John Desmond, Michael Desmond, Jack and Pat Holden, Thomas and Glenna Kramer, James Lamantia, Robert Leighninger, F. Lestar Martin, Kim Mitchell, Lydia Schmalz, and Bill Wiener, Jr. Students from Tulane University who assisted with research are Melissa Devnich, Kathy Falwell, Heather Fielding, Silvia Fernandez, Lelia Goehring, Nora Gordon, Sara Jensen, Andrew McKernan, Lora Lefevre, Tracy Nelson, and Mark Reynolds. Thanks also to William Drummer, Mary Mouton, Susan Saward, and Ellen Weiss, and to the property owners and architects who kindly provided information about their buildings, designs, renovations, and restorations.

Resources essential to the realization of this volume include the files of the Division of Historic Preservation, Louisiana Department of Culture, Recreation and Tourism, and their National Register nominations, which represent the work of many people over the years. The Division of Archaeology also provided information. Critical to a number of entries was the research conducted by the numerous authors who wrote the series of books on New Orleans architecture published by the Friends of the Cabildo. Libraries, museums, historical societies, and other organizations whose resources were invaluable include the New Orleans Public Library, the Historic New Orleans Collection, Ouachita Parish Public Library, Howard–Tilton Memorial Library of Tulane University, and the Caddo–Pine Island Oil and Historical Society.

Photographs are an essential part of this book, and Louisiana's buildings have been recorded by many eminent photographers, past and present. Among those whose work is represented in this volume are Frances Benjamin Johnston, Richard Koch, Clarence John Laughlin, and Frank Lotz Miller. New photographs were taken mostly by Robert and Jan White Brantley, R. West Freeman III, Betsy Swanson,

and Jim Zietz. In locating and obtaining other photographs (as well as for research help), I gratefully acknowledge Judy Bolton (Special Collections, Louisiana State University Libraries, Baton Rouge), Kathie Bordelon (McNeese State University, Lake Charles), John Burns (Historic American Buildings Survey), William Meneray (Special Collections, Tulane University), Sally Stassi (The Historic New Orleans Collection), Laura Conery and Glenda Sharbono (Louisiana State University at Shreveport), Francine Judd (School of Architecture, Tulane University) and Kevin Williams (Southeastern Architectural Archive, Tulane University). A full list of illustration credits follows the bibliography at the end of the book.

KAREN KINGSLEY

BUILDINGS OF LOUISIANA

Introduction

OUISIANA'S SPINE IS THE MISSISSIPPI RIVER. AS THE LINK FROM America's interior to the Gulf of Mexico and the Atlantic Ocean, the river has drawn to the state people from Europe, Africa, and Asia. The imprint and interaction of such diverse cultures, along with contributions from the Caribbean, laid the foundation for Louisiana's distinctive architecture.

From the state's northern hills to the southern swamps, Louisiana's architecture is also inseparable from its geography and semitropical climate. Forests of ever-green and deciduous trees originally covered the entire state except the coastal marshes and southwestern prairies. Cypress, oak, magnolia, and other hardwoods filled the alluvial valleys, and oak, gum, cottonwood, tupelo, and longleaf and short-leaf pine covered the uplands. The pines reach a height of more than 100 feet. The landscape is arrayed in shades of green: the sharp light greens of the cypresses' spring foliage and the rice plants on the prairies, the banks of brilliant green grass carpeting the levees of the Mississippi, the vivid green of sugarcane, the subdued shade of pines and pecan orchards, the gray-green of Spanish moss lacing the dark glossy leaves of the live oak trees, and the shimmering, almost black greens of swamp waters. In the summer, when the air is dense and tangible with moisture, the greens seem bluer, heavier, and opaque. Colors other than green make an appearance primarily in those all-too-brief respites, hardly proper seasons, that bridge the bland, wet winters and close, hot summers: the gaudy pinks and reds of camellias and azaleas, the lavender water hyacinth blanketing the bayous, and the yellow butterwort that gave the town of Golden Meadow its name.

Geologically, Louisiana is relatively young. Low hills and the floodplains of the Red River characterize northwestern Louisiana; the land along the west bank of the Mississippi consists of river deposits and ancient natural levees made by the river; the southwest is prairie and coastal marsh; east of the Mississippi from Baton Rouge are hills and terraces known as the Loess Bluffs; and the southeast is a series of old

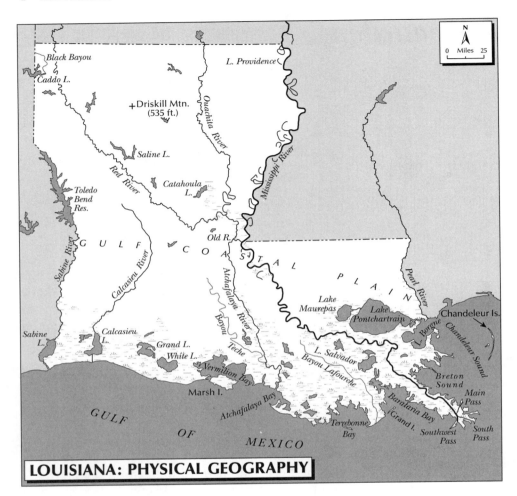

LOUISIANA: PHYSICAL GEOGRAPHY

river channels, swamps, and marshes. In southern Louisiana there are more wet-land marshes than in any other state in the nation.

Elevations in the state range from approximately 5 feet below mean sea level in New Orleans to 535 feet in the northwest at what is generously called Mountain Driskill in Bienville Parish. The Louisiana State Capitol in Baton Rouge, at a height of 450 feet, is almost as tall. Water towers and the few surviving nineteenth-century sugar-mill chimneys are the primary vertical markers of town and place; many church steeples blown away during hurricanes were not replaced. Horizontally, the landscape is traced with the parallel lines of river, levee, road, and railroad track.

From the state's northern border with Arkansas, the Mississippi River travels about 569 miles to the Gulf, but its average gradient is less than 3 inches per mile. Over the centuries, alluvial deposits settled on the river's floodplain, constantly modifying the landscape and providing the rich soil that was the magnet for plantation owners. At least six times since the end of the last Ice Age—the past 9,000 years—the Mississippi

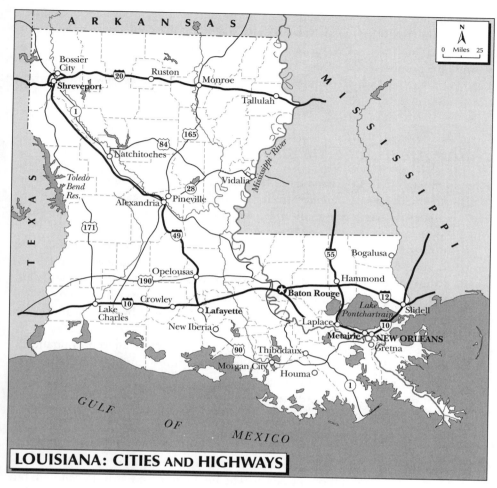

A R K A N S A S

Bossier
City
Ruston
Monroe
Shreveport
Tallulah

Natchitoches

Toledo
Bend
Res.
Vidalia
Alexandria
Pineville

Opelousas
Bogalusa
Hammond
Crowley
Baton Rouge
Lake
Charles
Lafayette
Lake
Pontchartrain
Slidell
New Iberia
Laplace
Metairie
NEW ORLEANS
Gretna
Thibodaux
Morgan City
Houma

GULF
OF
MEXICO

LOUISIANA: CITIES AND HIGHWAYS

has changed its course, seeking a quicker and more direct route to the Gulf of Mexico. Abandoning earlier deltas—Bayous Teche, Lafourche, and Plaquemines all were former channels of the Mississippi—the river has built new ones, forming and altering the coastline. The present-day delta was only about 300 years old when René Robert Cavelier, Sieur de La Salle, sailed down the Mississippi. Since around 1870, the Mississippi has sought to change its course again and this time flow along the Atchafalaya River channel, thereby shortening its route to the Gulf by approximately 140 miles. Only the river-control structures built by the Army Corps of Engineers where the Mississippi and the Atchafalaya meet have persuaded it otherwise.

Other major navigable rivers in Louisiana are the Ouachita-Black, from the north, which joins the Red River, from the northwest, before they flow together into the Mississippi; the Sabine, which forms the Louisiana-Texas border for almost 300 miles; and the Calcasieu, emptying into the Gulf in the state's southwestern corner. In southern Louisiana, Bayou Teche and Bayou Lafourche once bustled with traffic

until railroads and highways made them redundant. Modern navigation channels feed into the Mississippi near New Orleans, including the Gulf Intracoastal Waterway, one segment of the west-east water route from Texas to Florida. Along the Mississippi are numerous cutoff and oxbow lakes, formed as the river shifted course. Lake Pontchartrain, which empties into the Gulf, almost isolates New Orleans from the rest of the state.

Native American Settlement

Human habitation in Louisiana dates back approximately 12,000 years. Over time, Native American culture changed from the nomadic hunter-gatherer bands of the early years to the settled agricultural tribes that European settlers encountered when they arrived in the early eighteenth century.

Very little is known about these tribal cultures before c. 6000 B.C., although they were widespread in Louisiana. Isolated tribal groups lived by gathering indigenous plants within the existing ecosystem of broad grasslands and hunting the large animals, such as long-horned bison and mammoths, that are now extinct. The migration pattern of these ancient societies has been determined by the distribution of distinctive spear and arrow points.

As the Ice Age ended, the landscape throughout the state altered dramatically. The grasslands were replaced by pine and hardwood forests and the large-mammal populations by white-tailed deer, bear, and waterfowl. Impermanent tribal villages hunted these new animals, gathered woodland plants, and cultivated others. A more abundant supply of food led to increased population. Recent excavations show that mound building began as early as c. 3000 B.C. in south central and northeastern Louisiana and that it was practiced by more than one culture. At Watson Brake (c. 3000 B.C.) in northeastern Louisiana, eleven conical mounds are connected by ridges in an oval organization. The enclosed area was not occupied, but artifacts, including fired clay blocks measuring 3 inches by 1 inch, and 1 inch in depth, were found in the mounds and ridges.

Burial and temple mounds in Louisiana date from at least c. 1500 B.C. The Poverty Point site beside Bayou Macon in West Carroll Parish (WC2) belongs to the Poverty Point Culture, which ranged from Florida to Missouri. The site, the second-largest mound complex in the eastern woodlands, consists of six concentric earth ridges in the form of a half circle enclosing a plaza over 1,800 feet across. Excavations at this site reveal artifacts that indicate widespread trade throughout the Mississippi River valley to the Appalachian Mountains and the Great Lakes.

A series of cultures define the next few hundred years in Louisiana. The Tchefuncte Culture (c. 600 B.C.–A.D. 200) was concentrated around coastal streams, the oak-covered ridges in water known as cheniers, and Lake Pontchartrain. The Tchefuncte site (now in Fontainebleau State Park) included shell middens used for burials. Pottery used for food storage was introduced during this period.

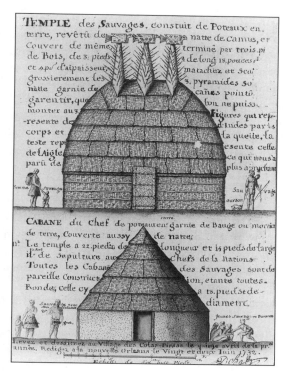

"Temple des Sauvages," drawing by Alexandre de Batz of a structure in a Native American settlement in Louisiana, 1732

The Marksville Culture lasted from A.D. 100 to 550 and left behind the Marksville mounds in Avoyelles Parish (AV5). The site consists of a semicircular ridge of earth along the edge of a bluff, which partially encloses five mounds. Other sites exist along the Red River and Bayou Teche, and there were at least eleven mounds near Bayou LaLoutre in St. Bernard Parish. The Troyville-Coles Creek Culture (c. A.D. 400 to 1100) developed ceremonial mounds in east-central Louisiana and along Bayou Lafourche, as well as a greater level of tribal organization and intertribal trade. The trails established by these people were used by the first Europeans who arrived in the area and are still, in many cases, the basis of modern transportation routes. Louisiana 66, between Angola and Bains, and Louisiana 8, from Sicily Island to Burr Ferry, are constructed over two of the most important tribal routes, as is U.S. 90, the east-west route in southern Louisiana, built on the route known as the Old Spanish Trail, which itself lay over a Native American and buffalo trail.

Written accounts by early explorers as well as archaeological finds give some idea of the nature of tribal societies and the structures they built at settlement sites located along streams and lakes. Some settlement sites may have been occupied for long periods of time, while others, it seems especially after the arrival of the Europeans, were occupied only briefly, or intermittently, by one or more tribes. Most

tribal villages were organized around the nucleus of temple and chief's house, facing each other across a plaza. French military architect-engineer Alexandre de Batz's drawing (1732) and written description of a temple and cabin north of Lake Pontchartrain correspond with other contemporary accounts of Native American structures in Louisiana: "Temple of the savages, constructed of posts in the ground sheathed with cane mats and roofed with the same. Terminated by three wooden stakes. . . . The three pyramids are of straw matting, trimmed with pointed canes to prevent anyone from being able to climb up to the 3 figures which represent turkeys in their body and whose head represents that of the eagle."[1] The other building illustrated is described as "Chief's cabin of posts in the ground, plastered with mud or earth mortar, roofed also with straw mats."[2]

The plaza may have served as a gathering place for ceremonies or game playing and may have contained houses of important tribe members and some other minor structures. Dwellings were scattered in clusters at a distance from this nucleus and closer to the fields, connected to the center by footpaths. The most common structure was the family dwelling, but granaries, storage places, mortuaries, ritual sweathouses, and temples were also built.

In the northwest, peoples of the Caddoan cultures reportedly built grass houses in the shape of beehives, but little is known about these forms, as repeated flooding of the Red River valley has obliterated the evidence. More common were the winter and summer houses of the northern tribes. Similar in construction techniques to the buildings described by de Batz but square in shape, the winter house measured from 10 feet to 30 feet on each side. A single entryway pierced the wall, which contained neither windows nor smoke hole. Around the walls on the interior were raised platforms that served as beds and storage areas. The summer house included a small smoke hole at the top of each gable. After the Louisiana Purchase, Caddoan tribes were forced in 1835 to cede a million acres of their homelands to the United States government and moved west to Texas.

Contact with European explorers and settlers profoundly changed Native American life, causing tribal migrations within Louisiana, into the state from other areas, and out of the state. The Choctaw, who lived north of Lake Pontchartrain and were the first major tribe to form an alliance with the French, were forced to give up their land in 1830 and were moved to Oklahoma. One tribe belonging to the Tunican group migrated from northeastern Louisiana in 1706, settling at a Houma village near the present-day Angola Prison in West Feliciana Parish, where they remained until 1731. Now known as the Bloodhound site, it contains Tunican burials and artifacts that indicate widespread patterns of trade with both Europeans and other tribes. The now-displaced Houma, who had greeted La Salle when he descended the Mississippi in 1682, moved south, some ultimately settling in Terrebonne Parish, where the town of Houma is named for them. The Houma is the largest state-recognized tribe, with a current membership of approximately 11,000.

Farther south in the state and west of the Mississippi were the Atakapa and Chiti-

macha tribes. The Atakapa, mostly located from Bayou Teche to the Sabine River, lived along the coast during the summer months but moved inland to the forests bordering the prairies during the fall and winter. Their houses were built of poles and mat coverings that could be disassembled and moved to another site. They had little contact with French settlers until the colonists drove them westward out of the state. The Chitimacha tribes lived along the Atchafalaya River and Bayou Lafourche in rectangular, palmetto-thatched houses with small entryways and smoke holes in the roof. Although their numbers are now considerably reduced, approximately 250 Chitimacha live near Charenton (St. Mary Parish).

A major period of migration followed the Treaty of Paris of 1763. Originally from Alabama, the Coushatta (Koasati) tribe settled in Allen Parish. The Coushatta are one of the federally recognized tribes in Louisiana, along with the Jena Band of Choctaw, the Chitimacha, and the Tunica-Biloxi.

European Exploration and Early Settlement

Louisiana has one of the most diverse and colorful histories in the United States. As an early focus of European exploration, the state, or a portion of it, was the property of three monarchies—France, Spain, and Britain—before the United States purchased it from France in 1803.

In 1541, Hernando de Soto and Luis de Moscoso de Alvarado became the first Europeans to see the lower Mississippi River in their unsuccessful search for gold and silver. French exploration was stimulated by hunters and fur traders from Canada, the *coureurs de bois* (runners in the forest) who traveled downriver to trade with the Indians. In 1682, La Salle and his party descended the Mississippi River, reached its mouth, claimed the entire drainage basin for Louis XIV of France, and named the territory La Louisiane in honor of the king. In 1699, Pierre Le Moyne, Sieur d'Iberville, and his brother, Jean-Baptiste Le Moyne, Sieur de Bienville, navigated upriver from the Gulf of Mexico to explore Louisiana.

The French had three ambitions for their American possession: to acquire the vast mineral riches thought to exist, to control the lucrative fur trade with the Indians, and to prevent Spanish expansion into their territory. Although the French did build a lucrative trade network with the Indians, the search for minerals proved fruitless. When Philippe, duc d'Orléans, came to power following Louis XIV's death in 1715, his Scottish financial adviser, John Law, persuaded Philippe that he could restore France's ruined economy by establishing a trading post in the Louisiana colony. Law's Company of the West, formed in 1717 and in 1719 renamed the Company of the Indies, caused a flurry of land speculation that brought French, German, and Swiss settlers and African slaves. The company named Bienville governor of the colony and directed him to establish a city, to be named Nouvelle Orléans (New Orleans), on the banks of the Mississippi. In 1718, Bienville selected a site near where Bayou St. John, a Native American portage, joined the Mississippi.

Louis-Pierre Leblond de La Tour and his assistant Adrien de Pauger laid out the city in 1721.

Unfortunately, the Louisiana colony proved a constant drain on France's purse, so following the Treaty of Fontainebleau in 1762, France ceded to Spain all of Louisiana except for the area east of the Mississippi and north of Lake Pontchartrain (the Florida panhandle). This area, now known as the Florida parishes, was handed to Britain in 1763 in the Treaty of Paris. The change of government had little impact on Louisiana; the region remained essentially French in character, and the Spanish continued the practice of giving land grants to French settlers. In fact, the French presence increased in the 1760s with the arrival of French-speaking Acadians expelled from Canada by the British.

In 1800, Spain returned the Louisiana colony to France in a deal involving European concessions from Napoleon, and the French promptly sold Louisiana to the United States. The Americans divided the newly acquired land in two, naming the southern section the Territory of Orleans. In 1812, with approximately the same boundaries, it entered the Union as Louisiana, the eighteenth state. The term parish rather than county was adopted for Louisiana's internal divisions; in shape and size, the early parishes were roughly similar to those the Catholic Church had established in the state. At the time of the Louisiana Purchase of 1803, Louisiana had an estimated population of 50,000, of which approximately 12,000 inhabited New Orleans. The American acquisition of Louisiana opened the doors to a flood of new English-speaking immigrants, and by 1860, the state's population totaled approximately 708,000 and that of New Orleans 168,675, making it the largest city in the South.

Louisiana's earliest communities were established along the banks of the Mississippi or on the numerous bayous or rivers. Thus settlement patterns tended to be linear, allowing property owners access to the water, the principal means of transportation. Land was apportioned by the French "long-lot" system, with the narrow side of the lot bordering the waterway—a system the French had used along the St. Lawrence River. The French measured land in arpents, and, although an arpent was approximately 180 feet on each side, it was freely used in Louisiana as a linear measure equivalent to 192 English feet. An average land grant along the Mississippi was 8 arpents bordering the river and 40 arpents deep. The Spanish continued to use the long-lot system in many of their land grants and, for a time, the United States government carried on the tradition. However, in the areas of Louisiana that the French ceded to the British in 1763, the Florida parishes, British and Anglo-American settlers used a measuring system of metes and bounds that produced irregularly shaped lots between natural landscape features and artificial lines. Ultimately, the American land survey system of 1785, with its compass-oriented grid of townships, ranges, and sections, was imposed on the landscape, but its impact was primarily in the areas settled after 1803—the uplands of northern Louisiana and the southwestern prairies.

Most towns and communities were laid out on a simple square or rectangular

Plantations on the Mississippi River from Natchez to New Orleans, detail from a map by Marie Adrien Persac, 1858, showing the long-lot system of land division

grid, with streets leading away from the river. A plan of New Orleans dating from 1723 illustrates the relationship of its public square (the Place d'Armes, now Jackson Square) within the grid and to the river, as well as its planned, but unbuilt, fortification wall. Louisiana's most ambitious urban plan was drawn up in 1806 by a French engineer for Captain Elias Beauregard's town, in what is now Baton Rouge (EB19–EB24). The squares, diagonal boulevards, formal gardens, and monumental

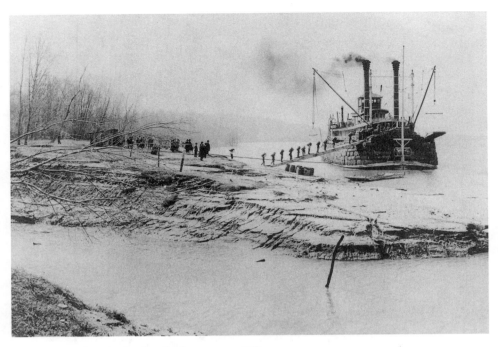

Steamboat at a plantation landing, loading cotton, c. 1910

civic buildings satisfied Beauregard's desire for a town in the "Grand European Manner," but only portions of it were ever built. In 1807, William Donaldson engaged French engineer Barthélemy Lafon to devise a plan for his town of Donaldsonville (Ascension Parish) at the junction of Bayou Lafourche and the Mississippi. The town was oriented toward the Mississippi, with a riverfront boulevard, a curved street facing the river, and a large public square for the courthouse behind it. The arrival of the railroad in the late nineteenth century shifted the commercial center away from the river corridor, a pattern repeated in many Louisiana towns. But until the coming of the railroad, almost everyone and everything in Louisiana traveled by water, arriving and departing via the levee.

Although Louisiana's extensive watercourses presented considerable obstacles to cross-country travel, they were the thread that bound the early communities and isolated settlements to one another. Flatboats, rafts, and barges, all suited to the shallow waters of river and bayou, carried both goods and people. The steamboat revolutionized river transport, providing superior cargo facilities for the upstate cotton plantations and opening Louisiana and the Port of New Orleans to the midwestern states upriver. A steamboat's wide flat bottom, shallow draft, and enormous paddle wheels were ideally suited to shallow-water navigation, and the engines could achieve speeds of anywhere from fifteen to twenty miles per hour. In 1812, the *New Orleans*, the first of the Mississippi steamboats, made the trip from Natchez, Mississippi, to New Orleans. By the early 1820s, at least seventy steamboats linked

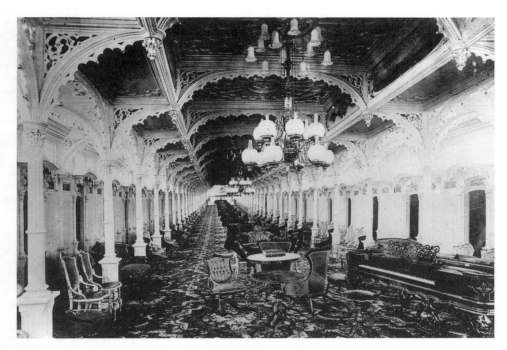

The main salon of the steamboat *Grand Republic* in 1890

New Orleans with St. Louis, Louisville, Cincinnati, and Pittsburgh, and by 1840, more than 500 steamboats were in operation. Steamboats—riverboats, coast packets, and oceangoing ships—transported the products of Louisiana's plantations, as well as passengers and immigrants, turning New Orleans into a major port with more than 1,000 arrivals annually. Inland ports functioning as regional centers for trade and communication, such as Washington (St. Landry) and Cottonport (Avoyelles), developed along the bayous. Because steamboats carried their own gangplanks and did not need special docking facilities, they were able to stop at any plantation on their route, making plantation life less isolated and the culture of the city more accessible. By the 1870s, steamboats could accommodate 600 or more passengers, and some achieved such a level of decorative splendor in staterooms, public spaces, and dining facilities that they were known as floating palaces. The *Grand Republic* possessed one of the most palatial main cabins, 300 feet long, with elaborate Gothic arches supporting its ceiling, painted scenes on the upper side walls, and thickly carpeted floors. But by 1900, the steamboat trade had been eclipsed by the railroads and the newly developed system of towboats and barges.

Louisiana's waterways could be treacherous. Flooding along the Mississippi was a constant danger, and as early as 1727, New Orleans was protected by a levee one mile long and about 3 feet high. Property owners along the riverfront were required to maintain the natural levees to control flooding. In 1820, Congress commissioned studies on the best way to maintain an open channel for navigation along

the Mississippi and how to limit the magnitude of floods. A scheme proposed in 1850 by A. A. Humphreys of the Army Corps of Engineers was adopted, which employed high levees and dredging to control the river system from Cairo, Illinois, southward. Once the commitment to levees was made, irreversible changes in the landscape were inevitable; sediment formerly deposited over the Mississippi floodplain during the frequent floods was now carried to the Gulf of Mexico, extending the delta. In 1879, engineer James B. Eads finished construction of parallel jetties in the South Pass at the Mississippi's mouth to pinch the current and prevent the buildup of silt deposits. The river level continued to rise; with swamps and bayous severed from the river by levees, more water flowed down the Mississippi. Although the levees were raised regularly, crevasses and floods occurred frequently. After the devastating flood of 1927, new schemes for controlling the river had to be found. Consequently, in 1928, Congress passed the Flood Control Act and adopted a plan for the Mississippi River, calling for the creation of floodways, spillways, and basins, as well as levees.

The Bonnet Carré Spillway (CH4) diverts water from the Mississippi River into Lake Pontchartrain and thence to the Gulf of Mexico, and the Morganza Spillway (PC13) forces water into the Atchafalaya Basin Floodway. The latter protects the industries along the lower Mississippi, and both protect New Orleans. However, the town of Morgan City in the Atchafalaya Basin would be vulnerable despite its 21-foot-high protective flood wall. In the 1950s, the Army Corps of Engineers began construction of a system to control the flow of the Mississippi at its confluence with the Atchafalaya–Red River systems in order to prevent it from changing course and flowing down the Atchafalaya (CO3). The system was supplemented in the 1980s by an auxiliary structure (CO4). Whether these structures can keep the Mississippi on its present course is uncertain. If the Mississippi deviates, the present river channel would turn into a saltwater estuary, with devastating effects on southern Louisiana's economy of refineries, petrochemical and nuclear power plants.

With its dense forests, cypress swamps, razor-sharp palmettos, and waterlogged soils, Louisiana was a difficult and treacherous place in which to settle. The subtropical climate, with grueling summer heat, humidity to match, and heavy rainfalls that could precipitate sudden and disastrous floods, imposed additional hardships. Mosquitoes and contaminated water supplies spread diseases that decimated families and communities. A sense of the inhospitable climate and landscape that the colonists confronted can still be experienced by spending more than a few minutes outdoors in July or August.

However, Louisiana's climate and landscape had also shaped flora and fauna that intrigued some European explorers and travelers and offered tantalizing curiosities to naturalists and ornithologists. As early as 1721, Diron d'Artaguette reported on the quantities of medicinal plants he had found.[3] Dr. Louis Prat maintained a botanical garden in New Orleans during his ten-year sojourn beginning in 1724, and it is believed that his brother, Dr. Jean Prat, came to New Orleans in 1735 at the behest of Bernard de Jussieu, the creator of a system of plant classification.[4] The

first garden guide for the lower Mississippi Valley, *Nouveau jardinier de la Louisiane*, was published in New Orleans in 1838.[5] Among the ornithologists who studied Louisiana's birds, the best known is John James Audubon, who made drawings of the area's birds during his stint as a tutor at Oakley Plantation in West Feliciana Parish (WF12) in 1821.

Others acquired a familiarity with Louisiana's topography, flora, and fauna for more nefarious purposes. The maze of passages through the delta marshes and along the Gulf bayous provided an ideal covert environment for piracy and smuggling. The most famous, or infamous, of these entrepreneurs was Jean Lafitte, who controlled privateering in the Mississippi's Barataria region with its inland waterways and thick vegetation. His name survives today in the Jean Lafitte National Park system, which preserves Louisiana's wetlands and its culture.

Ethnic Groups

Louisianians like to use the language of food to describe things; thus the mixture of ethnic groups in the state is frequently referred to as a gumbo, analogous to the different ingredients that are combined to make a delicious stew. It has not always been a harmonious blend, however, as evidenced by slavery, racial and ethnic conflict, and discrimination. The resolution of inequities has been a constant challenge in Louisiana's history.

The European settlers who established the colony in 1682 were French. However, very few French citizens were interested in settling in their new colony, and a brief policy of transporting vagrants and criminals proved unsuccessful. After Bienville founded New Orleans in 1718, French immigrants increased in number, some coming directly from France and others from French possessions in the Caribbean. French-speaking refugees, white and black, arrived following the late-eighteenth-century slave revolutions in St.-Domingue (present-day Haiti), including 10,000 in 1809. At the same time, groups of royalist refugees fleeing the French Revolution of 1789 brought a new wave of French immigrants to southern Louisiana. Both New Orleans and the Natchitoches area became centers of French and Creole culture. The term Creole is often used to identify or label the first French immigrants, but in the eighteenth century, it almost always referred to black slaves born in Louisiana.[6] Today the term generally refers to Louisianans descended from French and Spanish settlers, as well as those associated with them and people who spoke French or a Creole patois, including whites, blacks, and people of mixed race. *Creole* also is used to identify things native to southeastern Louisiana, especially cuisine and architecture.

Another French-speaking group in Louisiana were the Acadians, known today as Cajuns. In the early seventeenth century their ancestors founded a French colony called Acadie in what is now the Canadian province of Nova Scotia. In 1713, Britain won sovereignty over this territory and, in 1755, after the start of the French and In-

dian War, expelled the Acadians. Beginning in 1763, Acadians began to settle in Louisiana, some in St. James and Ascension parishes and others along Bayou Teche and the eastern edges of the southwestern prairies—areas not yet claimed by other colonists. Approximately 1,600 refugees arrived in 1785. Acadians became the dominant group in rural southern Louisiana, forming a culture distinct from that of the older French families of the state. They were mostly small farmers who grew a variety of crops and also raised cattle.

French contributions to Louisiana's culture and architecture are profound, for the first architects, surveyors, and engineers were French. Although French was no longer the dominant language by the late twentieth century, French culture and Cajun festivities are actively encouraged in the Acadian areas of Louisiana, including the annual spring festival in the town of Lafayette. Many French words have enriched the Louisiana vocabulary; of particular interest are those for historic building techniques and materials. Additionally, French civil law strongly influenced Louisiana's legal system, distinguishing it from the common-law systems in the other states of the Union.

African Americans have been in Louisiana since the earliest days of European colonization, brought to work on the plantations along the Mississippi River. The first two slave ships from Africa to Louisiana arrived in 1719.[7] Until 1808, when the United States ended the importation of slaves, slave traders transported most Africans directly from Africa; others were conveyed from St.-Domingue or from the Atlantic seaboard. The 1726 census recorded 300 slaves living in New Orleans, and, by 1732, there were nearly 1,000 slaves in the city. Free people of color were recorded in New Orleans in the 1720s, and a considerable number arrived from the Caribbean, escaping the Haitian slave revolution of 1791–1808. Haitian refugees who fled to Cuba after the revolution were then expelled by the Spanish government following Napoleon's invasion of Spain. Between 1806 and 1810, they poured into New Orleans, doubling its population; by 1810, 5,727 free blacks, 10,824 slaves, and 8,000 whites were living in the city. Between 1803 and the outbreak of the Civil War, migrating white farmers and slave traders brought tens of thousands of Protestant and English-speaking slaves into Louisiana from the eastern seaboard slave states. In addition to working on the plantations, slaves built levees, maintained streets, and engaged in skilled trades and crafts, such as blacksmithing, brickmaking, carpentry, and sewing. Free people of color, some of whom were economically well off and owned property, worked in a variety of occupations and were especially significant in wrought iron design and fabrication. However, the Code Noir (Black Code), first legislated by Bienville in 1724 to regulate the activities and punishment of slaves, also incorporated restrictions on free people of color, as well as on Jews by prohibiting the practice of any religion other than Roman Catholicism. The code was renewed, with revisions, during the Spanish period, and again in 1806.

Although Spain possessed the Louisiana Territory from 1762 to 1800, Spanish immigration during this period was negligible, consisting primarily of colonial administrators who settled in and around New Orleans. Canary Islanders (Isleños)were a

specific group sent by Charles III of Spain during the 1770s to protect his territory, especially New Orleans. They mostly settled south of New Orleans in present-day St. Bernard and Plaquemines parishes. Beginning in the 1950s, people whose first language was Spanish came mostly from Cuba, Honduras, Nicaragua, and Mexico, often because of political upheaval or for economic reasons. New Orleans became the favored location in Louisiana for these recent Spanish-speaking immigrants. Spanish influence on Louisiana's architecture can be seen in the Vieux Carré's flat roofs, internal courtyards, and balconies with wrought or cast iron ornament—contributions made following the fires of 1788 and 1794.

Germans began to arrive in 1720, attracted by the offer of farmland from John Law's Company of the Indies. They settled upriver from New Orleans on what became known as the Côte des Allemands (German Coast), present-day St. Charles and St. John the Baptist parishes. A majority of these immigrants came from the Rhine River region. A second wave of Germans came after the 1817 famine, and others emigrated beginning in 1840, fleeing political unrest. From 1860 to 1900, Germany provided more immigrants to Louisiana than did any other European country; nevertheless, other than the work of individual architects, little is known about the German impact on southern Louisiana architecture. The Germans apparently adopted Creole building forms, and many in the first wave of immigrants Gallicized their names, rendering them indistinguishable from the dominant group.

A significant number of German immigrants were Jews, but the Jewish community grew slowly because of the prohibition under the Code Noir of religions other than Roman Catholicism. A small community of Jews lived in New Orleans when the philanthropist Judah Touro arrived in 1802. Restrictions on Jews were not removed until Governor William C. C. Claiborne's proclamation of religious freedom in 1804. German Jews organized a congregation in New Orleans in 1828, followed by one founded by Sephardic Jews in 1846. Jews settled throughout Louisiana, principally in towns where they engaged in trade and business. By 1860, New Orleans had the largest Jewish population in the South, numbering approximately 8,000.

Anglos in Louisiana's delta region were mostly of Scots-Irish or English descent, and had migrated from New York, Pennsylvania, Massachusetts, Maryland, Virginia, the Carolinas, and the upland South in general. In the northern sector of Louisiana, tens of thousands of yeoman farmers from eastern and south-central states settled along small streams in scattered hamlets or widely dispersed farms and dwellings. A considerable number of these farmers owned at least a few slaves. Substantial numbers of Anglo-Americans settled in the Florida parishes while that area was under British control (1763–1783), and some established large plantations. Midwestern farmers came to Louisiana's southwestern prairies beginning in the 1880s after the railroads opened up this area for settlement. The Anglo impact on Louisiana's architectural forms included log dwellings in the north and in the Florida parishes, eastern seaboard house types, central-hall plans, and Federal details and ornamentation.

Immigration from Ireland expanded in the 1830s and underwent a huge increase between 1846 and 1859 as a result of the potato famine. The Irish immigrants arrived on ships returning from delivering cotton to England's factories. Most of the Irish who came to Louisiana settled in New Orleans, both upriver and downriver from the Vieux Carré. An upriver neighborhood known as the Irish Channel received its name from the high concentration of Irish residents. The majority of these immigrants arrived in dire poverty and found work digging canals and building levees, physically shaping New Orleans's early infrastructure. But many artisans and professionals were among the Irish-born immigrants, including two of the state's most important architects: James Gallier, Sr., and Henry Howard.

A small number of Italians arrived before the Civil War, but it was not until the late nineteenth century that they came in substantial numbers. Most were from Sicily, escaping economic depression and political oppression. Some of the Italian immigrants worked as seasonal laborers on sugar plantations in the southern part of the state, and others engaged in truck farming. Many who settled in Tangipahoa Parish north of Lake Pontchartrain, in the communities that did not exclude them, were instrumental in the development of Louisiana's strawberry industry.

Immigrants from Asia began to settle in Louisiana by the late eighteenth century. Filipino sailors jumped ship from Spanish galleons plying the Gulf of Mexico. Others came throughout the nineteenth century, most of them working in the fishing industry and settling in St. Bernard Parish. Filipinos made Manila Village in Plaquemines Parish a center of the region's shrimp-drying industry in the 1890s, until the community was destroyed by a hurricane in 1965. By 1920, the New Orleans area had the largest Filipino community in the United States.

In the 1840s, the first Chinese arrived. They worked as agricultural laborers on sugar plantations, but most left this work for urban occupations. In the 1870s, New Orleans had a distinct Chinatown in what is now part of the Central Business District; new building in that area subsequently led the Chinese to reside throughout the city. They also settled and found work in Baton Rouge and Lake Providence. Vietnamese, mostly refugees, began to arrive in 1975; many of them settled along the bayous and coast of Louisiana, bringing their experience in the shrimp-fishing industry. The Vietnamese also established communities in New Orleans, notably in the eastern sectors of the city. Immigrants from other parts of Asia, such as Japan, Korea, Cambodia, India, and Pakistan, are still few in number.

Other ethnic groups in Louisiana with small populations include Greeks and Lebanese, who mostly worked in trade and commerce in southern Louisiana; Dalmatians from Croatia in the former Yugoslavia, who engaged first in oyster harvesting and later in citrus farming; and Hungarian farmers, who settled near Hammond (Tangipahoa) between 1900 and 1910, worked for the lumber companies. Two Czech communities, Libuse and Kolin, still exist in central Louisiana.

Building (in) Louisiana

Louisiana's landscape and semitropical climate, more than anything else, determined the shape of its architecture. By raising buildings off the ground, early settlers met the challenges of flood control, improving air circulation, and combating insects. Deep galleries (the term gallery, from the French word *galerie*, refers to what are called porches or verandas elsewhere in the United States) could shade a building's walls and provide an outdoor living space that might capture a breeze. The alignment of windows and doors could provide for cross ventilation, and high ceilings and steep roofs could draw off the heat.

The seemingly endless supply of primeval cypress and pine provided Louisiana with its principal construction material. Because wooden buildings require constant attention and renewal, they often seem to reflect the transience of land and climate. Consequently, structures of brick and stone, or the more recent ones, of concrete and steel—the courthouses, schools, and banks—acquire a substantiality and sense of permanence that make them seem all the more impressive because they appear able to resist the vagaries of the natural habitat and environment.

Fortifications were among the first structures that the colonists built. Fort de la Boulaye, begun in 1700 on the east bank of the Mississippi below the present site of New Orleans, was roughly square in plan, with four bastions at the corners for the placement of artillery, and was constructed of wood and banked with earth. A French fort, St. Jean Baptiste (NA13), was built in 1716 at the site of present-day Natchitoches; Spain responded in 1721 with Los Adaes (NA29), just fifteen miles away. Historical accounts and maps record several early forts, although no trace of them remains.

Other than forts, the earliest documented European buildings in Louisiana were designed for the Company of the Indies. A plan, elevation, and section of a company directors' house were signed by Louis-Pierre Leblond de La Tour in 1723.[8] Drawings made over the next ten years for numerous buildings, all in New Orleans, including a barracks, a warehouse, a hospital, and the parish church of St. Louis, show construction of the types known as *colombage* (heavy timber frame) and *poteaux-en-terre* (vertical posts inserted into the ground), steeply pitched roofs pierced by dormer windows, symmetrical facades, segmental-arched casement windows, and doors facing each other to aid ventilation. Virtually all of Louisiana's earliest civic and institutional buildings were laid out by military engineers, who sent to France records of their plans, which are now in the Archives Nationales in Paris.

Timber-frame construction had a long history in France. In Louisiana, the spaces between the timbers were filled with *bousillage*, a mixture of mud and Spanish moss or animal hair, which the French copied from Indian dwellings. Brick, employed by a technique known as *briquette-entre-poteaux* (brick between posts), proved a more substantial and durable infill for the timber frame. Both methods continued in use through much of the nineteenth century, and whether the infill was brick or *bousillage*, the material required a surface covering to prevent its deterioration from rain

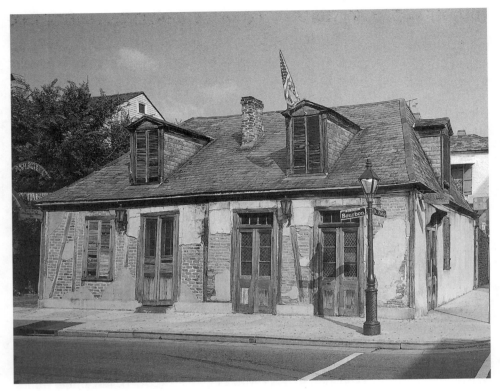

Lafitte's Blacksmith Shop, New Orleans, 1795, showing brick-between-posts construction

and humidity. The exteriors of the directors' house and its accompanying buildings were covered with wide boards; later in the century, stucco became a popular alternative. Because draftsman-architect Alexandre de Batz omitted a covering for the timber frame and *bousillage* walls of the first convent for the Ursuline nuns in New Orleans, which he designed in 1727, the building had disintegrated by 1734. By contrast, Adrien de Pauger covered the *briquette-entre-poteaux* walls of St. Louis Church (later, Cathedral) with stucco, and the building survived from 1724 until 1788, when it was destroyed by fire. The bricks for St. Louis—the first Louisiana building on record as using bricks between the timber frame and for its foundations—were fabricated in a brickyard established for that purpose on Bayou St. John in New Orleans. The second building for the Ursuline Convent, designed by Ignace François Broutin in 1745, has solid brick walls and is the earliest surviving documented building in New Orleans (OR30).[9]

Cypress was the preferred timber for construction because it was the most resistant to rot, and the surrounding swamps could provide what must have seemed at the time to be limitless stands of virgin wood. Cut and shaped cypress was mortised, tenoned, and pegged to construct the Norman truss roofs that covered the early buildings, a method used in northern France. The roofs, sheathed with wood shin-

gles, planks, or strips of bark, were invariably steeply pitched—essential for adequate rain runoff from these absorbent materials and also providing better insulation from the heat.

At first, buildings were constructed on a base of timbers laid directly on the ground, a system known as *poteaux-sur-sol,* or with their upright posts inserted into the ground (*poteaux-en-terre*). The French traveler C. C. Robin described the structures he saw in 1803:

> Cypress posts about three inches square and about ten to fourteen feet long are driven into the ground a depth of about two feet, to form the shape of the house. . . . The vertical posts are slatted and the chinks filled with earth mixed with the plant called Spanish beard. . . . The roofs are covered with bark, with planks or with shingles. . . . Bolts, locks, even the keys, are made out of wood. The chimney is made of four posts . . . with slats nailed across the posts, the whole covered with a wide coat of mud."[10]

The last surviving example of *poteaux-en-terre* in Louisiana is the Badin-Roque House (c. 1800), near Natchitoches (NA24). Since wood sills and posts quickly decomposed in the wet Louisiana soils, it soon became customary to raise buildings above the ground, either on cypress blocks or brick piers or on brick walls of sufficient height to provide a ground-level basement. The building in New Orleans known as Madame John's Legacy (OR22), rebuilt in 1788, is an early surviving example of a ground-level brick basement, raised about 8 feet from the ground; the principal living spaces are on the upper floor. Thus, early in colonial Louisiana, wood's vulnerability to destructive forces made it imperative to establish brickyards to supply a more durable building material.

Galleries on one or more sides of a building are one of the distinguishing features of Louisiana's architecture. As early as 1728, plans of the Vieux Carré in New Orleans show several houses with full-length or peripteral galleries, and a drawing of the unbuilt Intendance, signed by I. Broutin in 1749, shows a two-story galleried building.[11] Visibly demonstrating that galleries had become an integral spatial element of the Louisiana house is the pitch of a roof, which, whether gable or hipped, encompasses the gallery within its embrace. Galleries not only substituted for interior hallways by serving as a circulation path, but also provided outdoor living and sleeping space, while offering protection from sun and rain; curtains hung from iron rods between the columns provided privacy. Galleries were frequently decorated with cornices, moldings, and wall treatments that echoed interior features, thus blurring the distinction between exterior and interior space. Galleries on Louisiana's earliest buildings were supported on heavy piers on the ground floor and by slender wooden colonnettes on the second level; in the early nineteenth century, galleries supported on columns the full height of a building came into vogue. Whether single- or double-story in height, galleries raise interesting questions about the primacy of the exterior design of a building, for their very existence draws attention to the facade. In the majority of Creole houses, where symmetry was

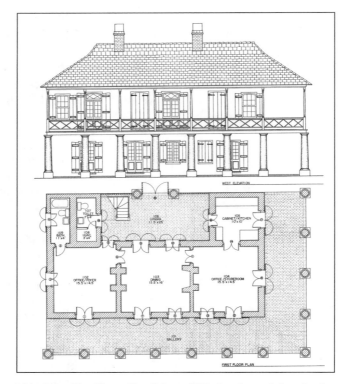

Major James Pitot House, New Orleans, 1799, elevation and plan, showing
a variation on the basic two-room Creole house

not of great importance, gallery posts or colonnettes were not balanced with doors
and windows. That changed in the nineteenth century with the introduction of the
American central-hall plan and passion for symmetry. Builders had to devise a rela-
tionship between the gallery columns and the windows and doors and relate their
proportions to the aesthetic qualities of the entire building. The varied solutions to
gallery and facade design enrich the narrative of Louisiana's architecture.

The term Creole architecture describes the building traditions associated with
early residents, specifically the Creoles, in Louisiana and along the Gulf Coast. Its
sources, therefore, are many and varied, including Native American and Caribbean
buildings and the ideas and traditions of the different peoples who inhabited early-
eighteenth-century Louisiana. Creole architecture is usually identified as a vernacu-
lar, and the term is primarily applied to residential buildings of any size, in either a
rural or urban setting, that share certain characteristics.

Many of the building elements, materials, and techniques of Louisiana's first
early-eighteenth-century structures were identical to those used in the Creole
house. It is in the plan that the distinguishing features are most apparent. A Creole
house consists of a rectangular core of two rooms: a nearly square *salle* (parlor) and
a narrower *chambre* (bedroom). This core could be expanded to three rooms or

more, as in the James Pitot House in New Orleans (OR62) or doubled to four rooms, but these rooms are always arranged en suite, that is, without a hall; movement was from the gallery through the French doors or through one room to the next. Except for the smallest houses, a rear cabinet-loggia range was common, that is, an open loggia framed at each end with enclosed small rooms called cabinets, which frequently served as extra bedrooms. If the house had two stories, the stairs usually were located in the loggia or sometimes in one of the cabinets. Creole houses were raised above the ground either on piers or a full basement. The ground floor was reserved for storage, slave quarters, and occasionally an office or a dining room. Roofs were hipped or double-pitched and some had a slight tilt at the edge. Dormer windows to ventilate the attic were common. Fireplaces were on inside walls and might have a French wraparound mantel. The essential principles were to provide as much ventilation and as much shelter from heat and rain as possible. (However, the raised house, which is designed to combat heat by encouraging air circulation underneath, has miserably cold floors in Louisiana's damp, chilly winters.)

Although scholars agree for the most part on the basic form of the Creole house, its origins and first appearance are the subject of much debate.[12] The core of two rooms is found before 1655 in houses in St.-Domingue and Jamaica as well as in Haiti, where it may have been brought by immigrants from northern Spain or the Guinea coast of West Africa. Galleries were already common in the Caribbean houses of the sugar planters, and the open loggia in the Spanish colonies dates from the late sixteenth century. However, the Creole house bears remarkable similarities to a drawing of c. 1540 by Italian architect Sebastiano Serlio in his *On Domestic Architecture*.[13] He depicts farmhouses with plans consisting of three rooms en suite, galleries, and a gallery or loggia with flanking cabinets, all with steeply pitched roofs. These drawings suggest that fundamental elements of the Creole house have a long Mediterranean history and came to Louisiana both directly and indirectly by way of the Caribbean. The existence of numerous theories highlights the many forces that have played a part in the formation of Louisiana architecture.

American innovations to the Creole plan were the central hall, an emphasis on bilateral symmetry in plan and exterior expression, and architectural details fashionable in the eastern United States. These differences in the organization of interior space raise some intriguing questions about the nature of Anglo versus French attitudes to privacy and family relationships. Anglo-Americans, of course, also introduced to Louisiana some completely different house types, such as the two-story, box-shaped house, with a gallery only at ground level, and the urban two-story, side-hall house. But in terms of the Creole house, the American imprint on the basic plan resulted in some creative variants, and many plantation houses dating from the 1820s to the 1840s combine Creole and American planning principles. In any of these combinations, except for the more modest houses, service and servant quarters were separate or attached to the rear of the dwelling.

When the Acadians (Cajuns) settled in Louisiana beginning in the late eigh-

teenth century, they adopted the essentials of the Creole house, as had the German immigrants before them. But unlike the Germans, who imposed no apparent change on the Creole house, the Acadians did make some conversions to suit their particular social needs. A basic Acadian house was two rooms wide, with a steep gable roof without dormers and a front gallery. A principal difference between a Creole and an Acadian house is that in the latter, the attic was used as a sleeping space and was accessed by a stair or ladder from the front gallery. Placing the stairs within the gallery was a logical extension of the concept of a gallery as a place of circulation. By the mid-nineteenth century, however, these simple distinctions between Acadian and Creole and American were blurred, so that many houses from that time defy classification. Acadian houses are widespread in Lafayette and surrounding parishes.

In northern Louisiana and in parts of the Florida parishes, the Scots-Irish from the Appalachians, Virginia, and North Carolina began to arrive in the 1790s and built houses of logs or of heavy squared timbers. Using the available pine, they constructed single-pen (room) or double-pen dwellings, using either half-round or round logs. The most common notching method in Louisiana was the square notch, but the more complex V-notch and the full- or half-dovetail notch were also employed. In Louisiana, a log single-pen house tended to be about 16 feet square. One variant of log structures was the dogtrot house, composed of two pens separated by a passageway that is open at front and back and through which "a dog could trot." The enclosed rooms were entered from the passage. The entire structure was covered by a single continuous roof, and Louisiana dogtrots had front galleries and massive outside end chimneys. The origins of dogtrot houses are uncertain. It has been suggested that the dogtrot was conceived to allow breezes to flow through the passage in order to cool the house, but cultural geographers prefer to see the passage as an attempt to create a formal central-hall house.[14] Some dogtrots probably originated as a means of enlarging a single-pen log house by avoiding the problems of physically joining new construction to a preexisting notched corner. Few historic dogtrots survive. Noteworthy examples are the Autrey House, near Dubach (LI8), of 1849 and the King House (1830s), now at the Mile Branch Settlement in Franklinton (WA4).

In contrast to rural Louisiana, streets of shotgun houses are a distinctive characteristic of the state's towns and cities. The simplest shotgun house is one room in width and anywhere from two to five rooms in depth, in an enfilade (lined up), without a corridor, and all under a single gable or hipped roof. Doors are aligned from front to back, which means, so it is said, that a shot fired through the front door would exit the house at the rear without interruption. The basic form, however, might have a side gallery or, with American influence, a side hall, both of which give the house a three-bay facade, or an ell at the rear. Two shotguns joined on their long sides and sharing one roof are called a double; when a second-floor room is added onto the rear room, it is known as a camelback shotgun. Decorative details followed the styles of the time. The oldest shotguns are recorded in New Or-

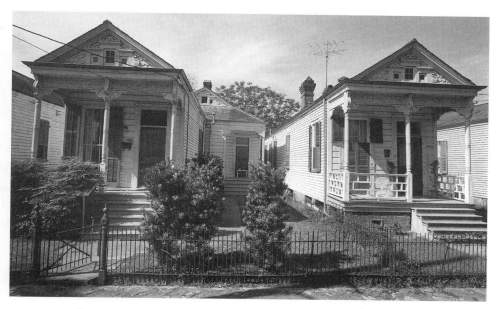

Shotgun houses in New Orleans: single type with ell (above) and double type with camelback (below)

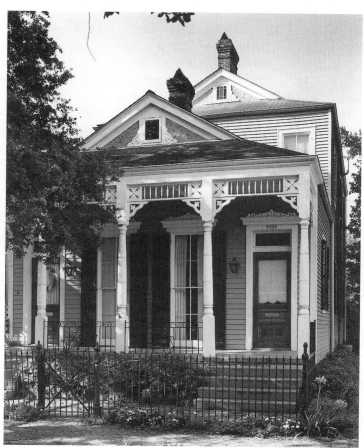

leans by 1840, and they continued to be built into the early twentieth century. The origins of the form are unclear. Arguments have been made for a source in West Africa transmitted by Haitian Creoles who came to New Orleans in the 1820s, or that the shotgun is essentially a Creole cottage turned sideways to fit a narrow lot.[15] Such *enfilade* plans are also found in Serlio, as illustrations of houses for poor urban artisans.[16] Visitors to Louisiana from New York compare the shotgun house plan to "railroad" apartments, and the plan certainly fits New Orleans's long, narrow lots. Although in Louisiana shotgun houses are primarily an urban form, they are also encountered in rural areas.

Almost all the eighteenth-century architects, engineers, and surveyors in Louisiana were French born, and they gave a distinct French flavor to New Orleans's civic and institutional buildings. The most important among the first group were Louis-Pierre Leblond de La Tour, Adrien de Pauger, Ignace François Broutin, and Alexandre de Batz. The military engineer Gilberto Guillemard, a native of France working under the Spanish regime, drew up proposed fortifications for New Orleans in 1792, in addition to a warehouse, market, and powder magazine and the second St. Louis Cathedral in 1789 (OR2); however, his most important surviving contributions to the city were his designs for the Presbytère (1789; built 1791–1813) and the Cabildo (1795–1799; OR3 and OR4). Barthélemy Lafon drew up plans for the areas now known as the Lower Garden District and Lee Circle in the American sector of New Orleans and designed several large houses. Jacques Nicholas Bussière de Pouilly, who came to New Orleans from France in 1833, designed the St. Louis Exchange Hotel in 1835–1838, now demolished. In 1850, his design for a new and larger St. Louis Cathedral was under construction when the new tower collapsed. His architectural practice slumped after this debacle, but he had already established a fine and stable reputation for his designs of monumental above-ground tombs, and, with these, de Pouilly made a lasting contribution to the city (see OR36). In southern Louisiana, because of the waterlogged soil and tendency to flood, the Mediterranean tradition of above-ground tombs was adopted, except that, in Louisiana, the body or bodies were placed in the tomb, not below it. De Pouilly introduced to Louisiana the latest fashions in tomb design, which he had seen in the new Père Lachaise Cemetery in Paris.[17]

Following the Louisiana Purchase, American architects began to arrive. Benjamin Henry Latrobe, the English-born architect who had made his name with his designs for the Bank of Pennsylvania, the Roman Catholic cathedral in Baltimore, and the Philadelphia waterworks, lived and worked in New Orleans for the last two years of his life. Latrobe came to the city to complete his waterworks project (now demolished) and engine station after the death of his oldest son, Henry Latrobe, who had been supervising the project. The younger Latrobe designed the first Charity Hospital of 1815. Benjamin Latrobe stayed on in New Orleans to design the Louisiana State Bank of 1819 (OR17), a two-story Neoclassical design with a domed and vaulted interior, and a central tower for St. Louis Cathedral. Like his son, Benjamin Latrobe died of yellow fever in New Orleans.

By the mid-nineteenth century, increasing prosperity and growth had made Louisiana and New Orleans a magnet for some of the nation's most accomplished architects. William Strickland sent plans for the U.S. Mint (OR52), completed in 1838, as did Robert Mills, in 1837, for the U.S. Marine Hospital in McDonoghville, across the river from New Orleans. This four-story hospital, the first castellated building in the state, was destroyed in 1861 in an explosion caused by stored gunpowder. Other architects arrived in person. James Harrison Dakin, who had been a partner in the New York office of Town and Davis (later Town, Davis and Dakin) and then established his own practice in 1833, moved to New Orleans in 1835 to join his brother, architect Charles B. Dakin. Charles soon left for Mobile, Alabama, to run that branch of the firm. James designed numerous buildings in Louisiana, including residences, the Arsenal in 1839 (OR9), the now demolished Medical College of Louisiana (in New Orleans), and, most important, the castle-like Louisiana State Capitol in Baton Rouge (1847–1850; EB19). Dakin reputedly had a difficult personality. Architect James Gallier, Sr., in his autobiography, describes him as a genius—high praise indeed from a person who tended to be rather critical.[18] Dakin introduced to Louisiana beautifully austere forms of the Classical Revival and Gothic styles.

Irish-born James Gallier, Sr. (originally Gallagher, having changed his name in London), had worked for William Wilkins in London before immigrating to New York. He was briefly employed as a draftsman for Town, Davis and Dakin in 1832, then partnered with Minard Lafever from 1833 to 1834. Gallier went to New Orleans in 1834, collaborated at first with Charles Dakin and then established his own practice in 1835. Gallier and Charles Dakin won the 1835 commission for the 350-room St. Charles Hotel in New Orleans, but their partnership was dissolved soon after the building was begun; Gallier completed the hotel. Occupying an entire city block, six stories high, with a colossal Corinthian portico and a dome raised on a tall colonnaded drum, the hotel was visible from miles away and was renowned for its luxurious interiors. A fire destroyed the hotel in 1851, and its replacement, similar in design but without a dome, was built by George Purves; in 1894 this building was also destroyed by fire.[19]

The first St. Charles Hotel established Gallier's reputation, and he received the commission for the City Hall (1850–1851), now known as Gallier Hall (OR92), built in the Classical Revival style in New Orleans's American sector. Gallier's autobiography provides an illuminating picture of architectural practice in the mid-nineteenth century.[20] His son, James Gallier, Jr., who formed a partnership with Richard Esterbrook in 1858, designed New Orleans's French Opera House in 1859, basing his design on the eighteenth-century La Scala Opera House in Milan. The French Opera House was a mecca for opera, plays, and cultural events until it was destroyed by fire in 1919. Gallier's own house (1857), in the Vieux Carré, is now a historic landmark (OR28).

The biggest mid-nineteenth-century project in the United States after the Capitol in Washington, D.C., was the U.S. Customhouse in New Orleans. Alexander T.

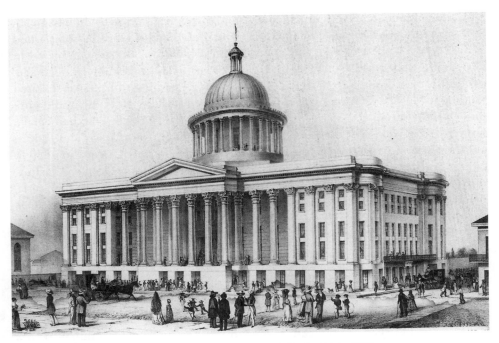

St. Charles Hotel, New Orleans, designed by James Gallier and Charles Dakin, 1835

Wood was appointed architect in 1848, as a result of winning the design competition, but this immense granite structure saw the involvement of several architects, including James Dakin and Thomas K. Wharton, before it was completed in 1881 (OR66).

Henry Howard emigrated from Ireland in 1836 and reached New Orleans in 1837, where he worked briefly with James Dakin before opening his own office in 1848. He completed the Pontalba Buildings in Jackson Square (OR5) and designed Madewood Plantation near Napoleonville in 1846 (AM3); the Carrollton Courthouse in 1854 (OR148); and churches, houses, and commercial structures. Howard introduced variations on traditional plans and brought to New Orleans and its environs an inventive expression of grandeur, most notably in his design (1852) for Belle Grove Plantation in Iberville Parish. This vast plantation house, irregular in plan, with two double-height porticoes and more than forty rooms, had a Beaux-Arts scale and splendor only equaled later in the century by the mansions in Newport, Rhode Island, and along the Hudson River. Abandoned in the early twentieth century, Belle Grove slowly decayed and finally burned down in 1952. Fortunately, the Italianate Nottoway plantation house (IB10), designed in collaboration with Albert Diettel, Sr., in 1846–1848, survives to give some idea of Howard's more ostentatious manner.

Iron decorative elements are seen as a quintessential element of New Orleans architecture. Free people of color dominated the ironwork industry at first, making

delicate wrought iron balconies and fences, but beginning in the 1830s, they were supplanted by German and Irish immigrants who brought skills in casting iron. The development of the iron industry in Louisiana, however, had a greater incentive than the manufacture of Vieux Carré balconies. Iron was needed for the machines that fueled the booming sugar industry of the first half of the nineteenth century. The Leeds Iron Company (OR96) was founded as early as 1825, but the 1850s marked the real rise of local foundries. In addition to machinery and tools, cast iron was used for tombs, window moldings, and building facades. Of the several structures with cast iron facades designed for the business district by New Orleans architect William Alfred Freret, only one, an insurance company (OR67), survives. In 1859, with his cousin James Freret, he designed the Moresque Building, entirely of cast iron, on Lafayette Square. Not completed until after the Civil War, the building was destroyed in a spectacular fire in 1897. William Freret served as Supervising Architect of the U.S. Department of the Treasury from July 1887 to March 1889; his post office and customhouse designs were mostly in the Romanesque Revival style.[21] James Freret was the first Louisiana architect to study at the Ecole des Beaux-Arts in Paris.

From the mid-nineteenth century on, Louisiana's architecture, both domestic and public, increasingly reflected national ideas and fashions. Beginning in the late

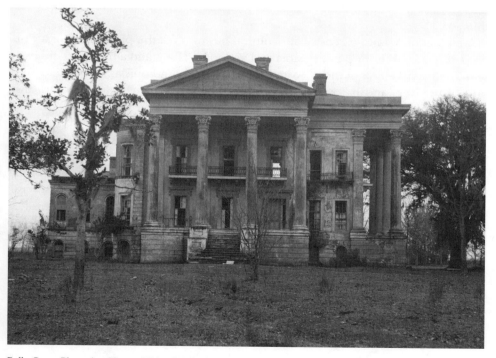

Belle Grove Plantation House, White Castle vicinity (Iberville Parish), designed by Henry Howard, mid-1850s; photo fby Thomas T. Waterman, 1936

twentieth century, a renewed interest in Louisiana's early domestic architecture, especially the Creole house, led to the construction of Creole-style residences in many new suburbs and subdivisions. Inevitably, however, the Creole elements are primarily aesthetic, for the houses are air conditioned, and the front galleries are merely decorative features or nostalgic reminders of the past.

Plantation Culture

An enduring and popular image of Louisiana is the white-columned plantation house set at the end of an allée of live oak trees draped with Spanish moss. The plantation house represents many aspects of life in the state: it is a symbol of romance, an emblem of the cotton-boom South and of indefensible wealth and privilege, and a reminder of the exploitation of slaves. All of these images have appeared in novels and films, and all have some basis in fact. Yet the "big house" was just one component of a plantation, though it is the one that has survived in the greatest numbers. Very little remains of other plantation buildings, such as slave quarters, kitchens, and sugar mills. The perishable nature of the materials used to build these structures, political and economic changes, and the disregard for these buildings hastened their destruction. But to understand a plantation, attention must be given to all of its buildings, as well as crops and its trade in goods and humans.

A plantation was an extensive agricultural business for the production of a cash crop. It required fertile land, reliable and abundant labor, and a transportation system to the market. All of these existed or were created in Louisiana: rich delta soil; numerous rivers and bayous for water transport; towns, especially New Orleans, where the products were marketed and distributed; and the slaves who provided the labor.

The institution of slavery enabled plantations to flourish. Slaves from Africa were brought to Louisiana beginning in 1719. By 1860, the state had 1,640 plantations whose landholders owned fifty or more slaves, and there were innumerable other plantations with fewer than fifty.[22] A few slave owners, especially those with several landholdings, possessed enormous numbers of slaves. For example, John Burnside, who owned 22,000 acres—of which 7,600 were considered "improved"—in Ascension and St. James parishes, is recorded as having owned 940 slaves, probably on four plantations, and Duncan Kenner of Ascension Parish owned 473 slaves on his three plantations.[23] The populations of some rural parishes were almost entirely made up of slaves; Concordia Parish's population was 90.9 percent slaves, and that of Tensas Parish was 90.8 percent.[24]

Plantations were first developed along the lower Mississippi River around 1718 on the land concessions granted by the Company of the Indies. In Louisiana, a plantation was usually laid out in one of three basic patterns: linear, lateral, or

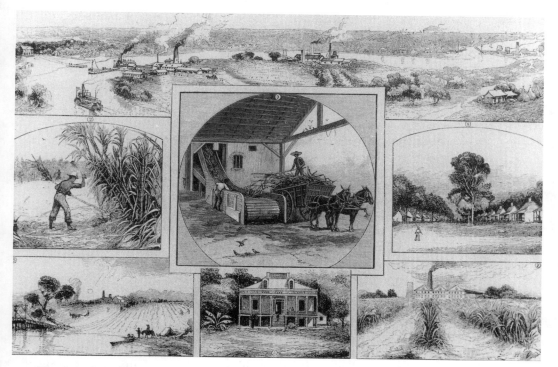

"The Sugar Industry of Louisiana," illustration depicting aspects of the plantation economy, from *Harper's Weekly*, July 21, 1883. Below the general view at the top are "Stripping and Cutting" (left), "Bringing in the Cane" (center), "Plantation Quarters" (right), "Planting" (bottom left), "Sugar Planter's Residence" (bottom center), "Young Sugar-Cane" (bottom right).

block. Along the Mississippi River, where a linear plan fit the pattern of long, narrow lots, the planter's house was located near the levee. Behind it, although at some distance, were slave houses in single or double rows perpendicular to the river, and beyond them stood the sugar mill. Evergreen Plantation (JO7) is a typical example. When a lot was wide rather than deep, as was common along the bayous, buildings paralleled the watercourse, as at Magnolia (NA27) and Oakland (NA23) plantations on the Cane River in Natchitoches Parish. The block arrangement, said to have been introduced by Anglo-Americans, clustered the buildings informally either near the planter's residence or at some distance from it and was employed when all the structures were set well back from the bayou, as at Laurel Valley Plantation (LF10) on Bayou Lafourche near Thibodaux.

Among the many buildings on the plantation were the planter's house, *garçonnière* (which housed the young men of the family from age fourteen), cistern, kitchen, *pigeonnier* (dovecote), office for the planter, doctor's house, dairy, icehouse, smokehouse, privy, blacksmith shop, overseer's house, slave quarters, storage buildings, barns, and, of course, the sugar mill or cotton gin. From the landing

stage at the river to the cypress swamp at the rear of the property, the buildings and the crops in the fields were protected from too much water by ditches and drainage channels. The entire complex was surrounded by a fence, and it was the planter's responsibility to maintain the stretch of levee protecting the plantation from the river. John H. B. Latrobe described the sugar plantations he saw during his travels in 1834:

> The farm houses, or plantation houses rather, in this part of the world appear to have been built, all of them, after the same model. . . . The climate requires all the shade that can be procured, and to obtain it the body of the building is surrounded with galleries. . . . About a hundred yards from the dwelling are the quarters of the ne- groes, small huts, generally comfortable in their appearance and ranged in parallel rows. . . . Above all the buildings and exhibiting by far the most imposing appearance is the sugarhouse surrounded with sheds. In the neighborhood of it the plantation bell is elevated upon a tall post, and shielded from the weather by a conical cap. Among the many plantations that I have passed and we are now within ten miles of New Orleans, I have not seen one which did not exhibit the appearance of thriving industry.[25]

The plantation house, the residence of the owner, was always the largest building and was located on the highest and best-drained ground. But not all of these houses were grand or huge; some were quite modest, and early plantation houses were often the same size as the urban Creole house. By the mid-nineteenth century, the American central-hall plan had been widely adopted and was a feature of the popu- lar raised one-and-one-half-story house with galleries. Most plantation houses were planned by the owner and constructed without the aid of an architect, although sometimes a builder was used. Construction, from felling the trees for lumber and making bricks to erecting the house and carrying out the carpentry work, was usu- ally undertaken by the planter's slaves. It is not known to what extent slave crafts- people added their imprint to the design, or the exact nature of the collaboration between slaves and their owners in creating the final form of a house. Since this method of design and building worked for most people, employing an architect was presumably a demonstration of cultural pretensions and perhaps a desire for the aesthetic sophistication an architect could bring to a design. Whatever the case, the highest priority was a house designed to provide maximum air circulation; the ex- tent of embellishment, such as articulated gallery supports, pediments, or architec- tural dressings, depended on the taste and purse of the owner.

Classical styling proved a particularly felicitous solution for the plantation house's simple rectangular plan and galleries. Gallery supports could be inter- preted as Greek columns, whether stacked on top of each other or of double height. Piers or Tuscan columns—the least complicated to construct and appropri- ately rural in appearance—were common for the lower floor, and slender wooden colonnettes for the upper. The roof, which at Destrehan (1790; CH2) was steep and double-pitched, and at Oak Alley (1839; JM6) was hipped, had acquired, by the

mid-nineteenth century, Greek Revival elements. At Ashland–Belle Helene (1841; AN4), for example, the roof was reduced and hidden behind a tall entablature to convey the image of a classical temple, and at Bocage (c. 1840; AN2) the entablature was shaped to suggest a pediment. This temple-like image was reinforced by the white paint applied to the exterior. By the late nineteenth century, however, pastel colors such as rose and lavender, combined with olive or dark green trim, became a popular exterior finish. Many Creoles favored an exuberant color scheme for their houses, as is evident at Laura Plantation (1805; JM7).

Some scholars have argued that adherence to Greek forms after the style had peaked in fashion elsewhere in the nation reveals the southern planter's deep conservative streak, combined with a resistance to change.[26] This explanation ignores the extent to which internal space and environmental considerations governed exterior appearance. Written accounts and architectural evidence reveal that style was important to plantation owners and that, highly conscious of shifts in fashion and taste, many of them added or altered architectural or decorative elements as styles changed. But these changes were invariably within the given theme of classicism, on which the planters achieved an infinite number of variations. The persistence of classical forms should not be read as resistance to originality, but as evidence of a different goal and aesthetic. More intriguing, a number of these plantation houses attain such a reduction of form that they seem to represent something other than mere building, perhaps some kind of arcadian abstraction. Certainly Ashland–Belle Helene and Bocage achieve an austere purity of form that places them among the best and, in the case of Bocage, the most original interpretations of the American Greek Revival style in the nation.

The Gothic Revival style, on the other hand, proved an awkward dress for the plan and environmental requirements of the typical galleried plantation house, and this may be one of the reasons it did not prove popular. Very few plantation houses were designed in this style. The most spectacular was Afton Villa, 1848, destroyed by fire in 1963, although its foundations and gardens survive (WF20). The villa was a delightful concoction of slender colonnettes, pendant arches, decorated bargeboards, and lancet windows. Orange Grove in Plaquemines Parish (1847–1853), designed according to plans by Philadelphia architect William Johnston, was another Gothic experiment. It, too, burned to the ground, in 1984. Just before the Civil War, Italianate forms sparked interest. Nottoway, in Iberville Parish (IB10), designed by Howard and Diettel in 1849, combines the crispness of these forms in a building with vertical emphasis that makes it more urban than rural in character.

Although the majority of Louisiana's plantation houses have disintegrated or been destroyed, they are plentiful compared with the other types of plantation buildings; more than 200 are currently listed in Louisiana's National Register of Historic Places. Several subsidiary buildings were located close to the big house. Frederick Law Olmsted described some of these structures in 1856 after visiting a plantation house:

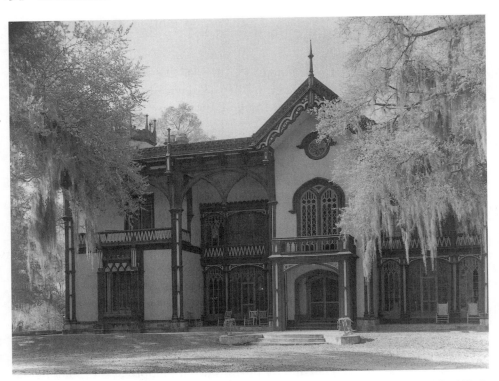

Afton Villa Plantation House, St. Francisville vicinity (West Feliciana Parish), 1848; photo by Richard Koch, 1930s

> Between the house and the street was a yard, planted formally with orange-trees and other evergreens. A little on one side of the house stood a large two-story, square dove-cot, which is a universal appendage of a sugar-planter's house. In the rear of the house was another large yard, in which, irregularly placed, were houses for the family servants, a kitchen, stable, carriage-house, smoke-house, etc. Behind this rear-yard there was a vegetable garden, of an acre or more.[27]

Making the kitchen a detached structure protected the big house from fires, as well as from additional heat, odors, and flies. A *pigeonnier* could be square, hexagonal, or octagonal in shape and was constructed of either brick or wood or a combination of both. Pigeons and their eggs were a delicacy, and pigeon droppings made good garden manure. Plantations in the delta region collected and stored water either in underground cisterns or, more commonly beginning in the mid-nineteenth century, in huge barrel-shaped cisterns made of cypress, placed to catch the rain runoff from the roof. It wasn't until the Spanish-American War that Walter Reed discovered that stagnant water provides a breeding ground for mosquitoes, the carriers of yellow fever, one of the diseases that regularly plagued Louisiana. Other buildings in the vicinity of the planter's house that Olmsted included in his "etc." might include a dairy, a privy, a schoolhouse, and the planter's office. The plantation house

Parlange, New Roads vicinity (Pointe Coupée Parish), *pigeonnier* and house

was often fronted by an allée of trees, usually live oaks, to provide shade as well as a formal walk to the landing stage at the levee, where the steamboat would dock.

Farther from the big house were the cabins of the slave quarters, which were arranged in a single or double row, rather like a village street, or occasionally in a courtyard-like formation. Olmsted also described the slave cabins he saw:

> [T]he negro quarters . . . were apparently intended for the accommodation of about
> one hundred slaves. . . . They were generally creoles, and spoke English, French, and
> Spanish, among themselves. The cabins were small, built mostly of hewn plank, set
> upright, and chinked with rags and mud, roofed with split clapboards, and provided
> with stick and mud chimney. There was but one room, and no loft to each cabin; or,
> where there were two rooms, they were occupied by two families.[28]

A gallery usually fronted the cabin, and a small rear room was sometimes added. Typically a slave dwelling in Louisiana was constructed of wood; masonry construction, as at Magnolia Plantation, was rare. In northern and eastern Louisiana, both slaves and planters lived in log cabins. Following the Civil War, slave cabins became tenant houses, and plantations added a commissary or plantation store for the rural wage earners.

Planters who owned more than thirty slaves invariably employed an overseer to supervise their work routines. The overseer's house was larger than the slaves' cabins and was entirely separated from them or at the end of the quarters' row. Since slaves constituted a considerable investment for their owner, larger plantations often included an office for a visiting doctor and, in some cases, a hospital, which might consist of just one room. Occasionally, a separate chapel was provided for the slaves; only one survives, a masonry structure of c. 1840 at Live Oak Plantation (IB3). More often, a section inside the church or on the balcony was reserved for slaves.

Indigo, processed for blue dye, was the principal crop during the eighteenth century. Planters also grew tobacco, corn, and wax myrtle. Following the failure of indigo crops later in the century, planters turned to sugarcane. The rich alluvial soils of the delta and bayou areas in southern and south central Louisiana, as well as the unlikelihood of early frosts, provided an ideal environment for sugarcane cultivation. Sugarcane was probably introduced to Louisiana from the West Indies in the 1740s. However, it did not become the crop of choice until Jean-Etienne de Boré succeeded in granulating sugar on a commercial scale in 1795 at his plantation, located on what is now Audubon Park in New Orleans. Growth of the sugar industry was rapid and was stimulated by Norbert Rillieux's development of the vacuum pan method of crystallizing sugar from cane juice, which surpassed the open pan method in quantity and quality of production as well as in fuel economy. In 1832, there were more than 700 sugar plantations in Louisiana, and by 1850, the state's 1,495 sugarhouses supplied half the sugar consumed in the United States.

Sugar grinding—the term used to describe the harvesting, crushing, and crystallization of raw sugar—lasts from October to January, with mills working twenty-four hours a day. John Latrobe gives an evocative description of a sugar plantation he observed during his 1834 trip to Louisiana:

> On either side of us the sugar plantations were now seen extending from the river
> to the marsh or swamp in the rear and presenting the most beautiful appearance
> that I ever saw in any species of cultivation. The green was so vivid, the foliage so
> dense, and the light wind waving it to and from marked it with the varying shadows
> that rolled after one another like waves upon a sea. It was the season for gathering

in the crop, and grinding it, and Sunday as it was every man woman and child that we saw was at the sugarhouse, the unsteady puffings of which vapour from a narrow chimney with a funnel shaped aperture shewed where the steam engine was at work.[29]

Solomon Northup's account (1853) of his illegal enslavement in Louisiana gives an illuminating portrait of working in the sugarcane fields and mill and an equally vivid description of cotton-picking.[30]

Early sugar-grinding mills were animal-powered—horses and oxen in the eighteenth century and mules in the nineteenth. Beginning around 1822, steam-powered mills made the domed, circular mills obsolete, and regrettably none survive. The new steam-powered mills, with their tall, often square brick chimneys, were usually two stories high and about 300 feet long, although some were much bigger, and housed the engines to power the enormous iron rollers that extracted juice from the cane, as well as the boilers and cooling vats that completed granulation. The sugar was then scooped into a hogshead, a cask that held approximately 1,150 pounds of raw sugar, ready for shipment. In 1862, John Burnside of Houmas Plantation (AN2) turned out 5,150 hogsheads of sugar. The dried, rejected cane pulp, called bagasse, was initially used as fuel for the mill but is now primarily recycled for building materials and horticultural mulch.

Devastated during the Civil War, the sugar industry rebounded in the late 1880s. But the high cost of building and maintaining a mill led planters to form processing cooperatives and send their sugarcane to central factories on larger plantations. Improved roads and an expanding railroad system encouraged the separation of cane growing from processing, and vast manufacturing plants were constructed. Colonial Sugars in Gramercy (JM2) is one example; the plant has the distinction of possessing a powerhouse designed in 1929 by New York's renowned architecture firm of McKim, Mead and White. Today, Louisiana produces about 14 percent of all the sugar grown in the United States, including that from sugar beets.

Northern Louisiana is cotton country. The alluvial valleys of the Red and Mississippi rivers and the bluff land along the ancient terraces provide the ideal soil and climate conditions. Cotton became a commercially viable crop only after Eli Whitney's invention of the cotton gin (1793), which mechanically separates the fiber from the seeds. Tempted by the potential profits in cotton, tobacco planters from the eastern seaboard migrated with their slaves to the lower Mississippi River valley. Cotton processing took place in a single structure, built of wood or, more recently, of metal. Cotton was picked, ginned, and compressed into bales on the plantation (a mule-driven cotton press of c. 1840 survives at Magnolia Plantation in Natchitoches Parish). The bales were transported to warehouses in New Orleans, where they were compressed into even smaller bales on massive steam-powered cotton presses and then shipped to mills in Britain and the northeastern United States. Although the cotton industry quickly recovered after the Civil War, the boll weevil's invasion of Louisiana beginning in 1908 retarded production until effective insecti-

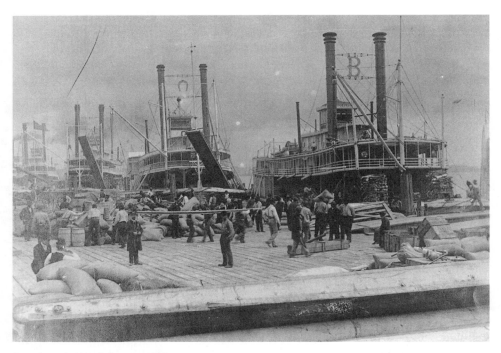

Steamboats in New Orleans, c. 1890

cides and herbicides were developed. During cotton's growing season, the tiny bright yellow crop duster airplanes (which now spray rather than dust) punctuating the endless horizon of cotton fields are a picturesque sight, but they may soon be a thing of the past because of recent developments in disease-resistant cotton. Louisiana currently ranks fifth in the nation in cotton production.

Rice was mostly grown on small farms. It was introduced to Louisiana from Africa in 1719, brought with slaves who knew how to cultivate it However, rice did not become a major crop until the 1880s, when the railroads provided access to the prairie lands of southwestern Louisiana. For a certain period of its growth, rice must be kept constantly under water, and fields in this area have the essential impervious layer of soil that can hold water pumped from the bayous. Towns such as Crowley, Jennings, and Kaplan owe their existence to the railroads and to rice, and their rail tracks are lined with rice silos. By 1900, Louisiana supplied rice to over half of the nation; today it produces one-third of the crop. In recent years a two-crop rotation system, of rice and crawfish, has been developed. After the rice is harvested, water levels in the field are brought up, and the crawfish emerge from their burrows, eat the rice stubble, hatch, and are gathered until rice is planted again in the spring.

New Orleans was the principal marketing center for rice, as it was for sugar and cotton. Photographs and popular illustrations of the nineteenth century depict the

city's wharves piled high with bales of cotton and hogsheads of sugar, and steamboats crowded together. Sugar and cotton factors transacted their business in handsome, elaborately decorated buildings constructed for these purposes. New Orleans also was a major center for the sale and purchase of slaves. Although federal law had ended the importation of slaves from Africa in 1808, the trade flourished because of the growth of the slave population and the transfer of slaves from other states where slavery was legal. The huge labor force required by the sugar and cotton plantations made slave auctions a regular occurrence. The rotunda of J.N.B. de Pouilly's St. Louis Exchange Hotel provided one of these auction spaces.

After the Civil War

The Civil War and Reconstruction changed Louisiana in many ways. Although Louisiana seceded from the Union in January 1861, the war did not come to the state until March 1862, when a Union fleet began an ascent of the Mississippi River in order to capture New Orleans. After the city surrendered on April 30, the Union fleet continued upriver to Baton Rouge and occupied it on May 9; the governor and legislators had already moved on to Opelousas. By the time the war ended, in April 1865, many of Louisiana's buildings, railroads, bridges, and towns, including Baton Rouge and Alexandria, had been destroyed or suffered extensive damage. Surviving evidence of the war in Louisiana includes the sites of earthen forts and of dams constructed to manipulate the Mississippi's water levels for troop movements, in addition to battlefields and cemeteries for both Confederate and Union soldiers. In the years following the war, commemorative statues and tomb markers were placed in town squares, in front of courthouses, and in cemeteries.

The war also left destitute orphans and widows. Although Louisiana was already well endowed with orphanages and homes—fifty-one were established in New Orleans alone between 1801 and 1851—existing buildings were enlarged and new ones built. Most of these facilities were funded by religious or philanthropic groups and individuals to benefit people of prescribed religious or ethnic backgrounds. Occasionally professional architects were hired to design the buildings, attesting to the desire not only for well-planned accommodations but also to indicate the organization's status. In New Orleans, Henry Howard made additions to the now-demolished Jewish Widows' and Orphans' Home on Jackson Avenue in 1869, and Thomas Sully designed several facilities, including the Protestant Orphans' Home in 1887 (OR121). Frequent epidemics of cholera and yellow fever contributed to the need for more orphanages and made New Orleans an important medical center. Charity Hospital (now the Medical Center of Louisiana) was founded in 1736 with funds donated by a French sailor.

The Reconstruction period lasted until 1877. New Orleans had the largest African American population in the nation (50,456) and became a leading center for black progress during these years. The city integrated its police force and deseg-

Illinois Central Railroad Station, New Orleans, designed by Adler and Sullivan, 1891

regated its schools, and an African American, P. B. S. Pinchback, served briefly as governor. But a reaction set in among many white Louisianians who were experiencing economic hardship. Although much of this was the inevitable result of war-caused devastation, they organized to overthrow Reconstruction policies and to pass segregation laws. The passage of a law in 1890 to racially segregate passengers in railroad cars led, in 1896, to the U.S. Supreme Court's decision in *Plessy v. Ferguson*, which upheld Louisiana's right to enact the law on the condition that "separate but equal" facilities were provided. In 1898, Louisiana's white lawmakers rewrote the state constitution, adding requirements for literacy or property ownership that effectively barred nearly all African Americans from voting. Segregation was also reflected in Louisiana's buildings. In places such as schools, colleges, and churches, there were completely separate buildings for blacks and whites; in other types of buildings, such as railroad stations, hospitals, and recreation facilities, entrances and interior spaces were separate. These restrictions determined the planning principles of Louisiana architecture until 1954, when the U.S. Supreme Court, in *Brown v. Board of Education*, signaled the beginning of desegregation.

In the countryside after the Civil War, most surviving plantations adopted a share-cropping or tenant-farming system; slave cabins became tenant houses, and a plantation store was added. But in other sectors of the economy, the late nineteenth century was a period of renewal for Louisiana. From the eve of the Civil War to the turn of the century, Louisiana's population expanded from 708,002 to 1,381,625. Increased immigration brought fresh energy and modern industries, and the rail-

Southern Railway Station, New Orleans, designed by Daniel Burnham, 1908

roads transformed communications within Louisiana and changed its relationship with the rest of the country. New times required new buildings.

One of the more important factors in Louisiana's economic recovery after the Civil War was the rapid expansion of the railroad system—from 652 miles of track in 1880 to 5,554 miles in 1910. Many of the rail lines competed with and then supplanted river traffic or, as in the case of the deepwater ports of New Orleans and Baton Rouge, expanded commerce by connecting with oceangoing vessels. Communities hustled to attract a railway line, and towns were established, flourished, or declined, depending on their success. Ruston, Gibsland, and Arcadia in northern Louisiana grew because of the east-west railroad across that section of the state. But the railroad bypassed Sparta, Mount Lebanon, and Vienna, leaving them economic backwaters. In western Louisiana, Zwolle, Leesville, and DeQuincy and, in the south, Crowley, Eunice, and Jennings were all railroad towns. The railroads opened up new areas for settlement and agriculture. In the 1880s, the sparsely settled southwestern prairies saw an influx of midwestern farmers who developed an economy based on rice cultivation. The railroads enabled other cities to challenge New Orleans as the commercial center of the state. With seven lines converging on Shreveport, this city became a major hub for the products of northern Louisiana.

The railroad companies built handsome stations. In 1891, Adler and Sullivan designed Union Station in New Orleans for the Illinois Central Railroad, a two-story building with Sullivan's trademark broad, low arches defining the entrances. Frank Lloyd Wright was an assistant in Sullivan's office at this time and may have worked on the drawings for the station. The station was razed in 1954. Another splendid

terminal demolished in the 1950s was Chicago architect Daniel Burnham's Southern Railway Station at Canal and Basin streets in New Orleans, which was completed in 1908. The facade of this rusticated masonry Beaux-Arts building was in the form of a gigantic triumphal arch.

The railroads opened up the state's vast timber reserves for exploitation. Before European settlers came, forests had covered more than 85 percent of Louisiana. Commerce in cypress began almost immediately after the arrival of the Europeans, and by 1716, two sawmills were operating in southern Louisiana. By 1722, cypress was being exported from New Orleans to France and the French West Indies. The first steam-driven sawmill in the United States was established in New Orleans in 1811. However, the lumber industry was limited because of its dependence on river transportation for moving and marketing the logs. Railroads changed that. Northern lumber barons, having depleted resources in their own states, descended on Louisiana and consolidated and expanded the industry. Longleaf pine, 150 to 200 years old and with an average height of 110 feet, covered seventeen parishes across central Louisiana; the northwestern uplands offered shortleaf pine; hardwoods grew along the Mississippi River; cypress filled the delta swamps. Systematic cutting began. The steam-powered overhead skidder, invented in 1883, was adapted in 1889 to pull logs from the swamps. From 1900 to 1920, Louisiana was one of the nation's top three lumber-producing states, along with Washington and Michigan.

Sawmills dotted the landscape: seventy-five mills existed within a fifty-mile radius of Alexandria alone. By 1900, there were ten mills in the Lake Charles area, and the city became a major center for shipment from its port. Lumbermen and their families often were accommodated in "skidder towns," near the forests that were being cut down. These temporary settlements, consisting of dwellings, a schoolhouse, and a commissary, were relocated when the nearby lumber was exhausted. More permanent company towns were established around a sawmill; almost everything in these towns—housing, commissary, school, and churches, theater or movie house, sometimes a library, and recreational facilities—was built and owned by the company. When the lumber was exhausted and the mill closed, the towns were abandoned, and many have all but disappeared. Some of Louisiana's lumber history has been saved. The Crowell Sawmill Company, which established the town of Longleaf in 1892, closed in 1969, but its surviving buildings now form the Southern Forest Heritage Museum (RA27). In Garyville, the former headquarters of the Lyon Cypress Lumber Company has been converted into a museum (JO5). Some lumber towns remain active; among them are Fisher (Sabine Parish), founded in 1899 for the Louisiana Longleaf Lumber Company, whose mill was taken over by Boise Cascade in 1966, and Bogalusa (Washington Parish), laid out for the Great Southern Lumber Company in 1906. Bogalusa benefited from the decision of Colonel W. H. Sullivan, the mill's first manager, to reforest while cutting.

The lumber industry generated a vigorous economy and new construction. In the railroad towns and in the expanding suburbs of New Orleans, Lake Charles, and Shreveport, the nationally popular Queen Anne style was adopted with enthusiasm.

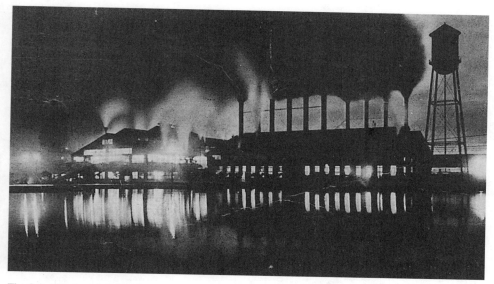

The Great Southern Lumber Company sawmill in Bogalusa, postcard view, 1936

Irregular in plan and outline, these houses celebrated virtuosity in use of wood with angled bay windows, turrets, dormers, gallery railings, and multiple gables that could be faced with differently shaped shingles and decorated with bargeboards, spindles, and brackets.

Louisiana celebrated its economic recovery at the World's Industrial and Cotton Centennial Exposition of 1884, held in New Orleans. As was typical of such events, the buildings were dismantled after the exposition closed, but in this case the site was transformed for another use, as Audubon Park.

Significant architects of the late nineteenth century include the cousins James Freret and William Freret. Both designed a wide variety of buildings, among which are the former's Ascension Parish Courthouse in Donaldsonville (AN8), 1889, and William added the bold iron spiral staircase in his 1882 renovation of the state capitol in Baton Rouge (EB19). Thomas Sully pioneered metal-frame skeleton construction in New Orleans, notably for the steel-frame Hennen Building (now Latter and Blum Building; OR81), designed in 1893 in partnership with Albert Toledano. Sully, who trained in Austin, Texas, and New York, opened an office in New Orleans in 1882 and introduced fashionable late-nineteenth-century styles in his designs for orphanages, commercial buildings, and residences. Although the renowned Henry Hobson Richardson was born in St. James Parish in 1838 and grew up in New Orleans, only one building in Louisiana bears traces of his hand. Howard Library (now the Ogden Museum of Southern Art; OR99) in New Orleans was built in 1886, the year of Richardson's death, under the supervision of his successor firm, Shepley, Rutan and Coolidge, following drawings (1886) for the unbuilt Hoyt Library in East Saginaw, Michigan.[31] Richardson was attending the Ecole des Beaux-

Arts in Paris when the Civil War erupted; when he returned to the United States after the war, he settled in Boston and never visited Louisiana.

In New Orleans, the business district grew dense with banks, offices, and trading companies, several of them high-rise buildings. In order to contend with the city's soggy, unstable soil, wooden piles were driven deep into the ground to support these larger and weightier structures. Concrete pilings were introduced to New Orleans in 1908 for the now-demolished Public Library, a Beaux-Arts design by Diboll, Owen and Goldstein. An alternative system involved the removal of an amount of soil that weighed more than the building that would replace it to form a basement on which the building would "float." New Orleans also began to expand outward, as new pumping systems drained marsh and swamp areas; by 1900, the city accommodated 21 percent of the state's population. Although New Orleans remained the state's principal commercial center, Shreveport was set to embark on an impressive era of growth following the discovery of oil in the early twentieth century.

The Twentieth Century

By 1920, Louisiana's lumber boom was over. After reducing much of central and western Louisiana to stump-covered wasteland, most lumber companies left the state for forests in the western United States, and much of the cutover land reverted to the state for nonpayment of taxes. Some areas were replanted and converted into national and state forests, such as the 600,000-acre Kisatchie National Forest in central Louisiana. Conservation work in Louisiana was pioneered by Henry E. Hardtner of the Urania Lumber Company (La Salle). Hardtner participated in a conference convened by President Theodore Roosevelt to persuade all of the states to organize their own departments of conservation. Louisiana did so in 1908, and a forestry act to support reforestation was passed in 1910. Hardtner began reforestation of his land in 1913. In 1916, the Louisiana Division of Forestry was founded, and, in 1923, the Alexander State Forest near Woodworth organized a nursery to demonstrate proper timber management. The Civilian Conservation Corps (CCC), established in 1933 as one of President Franklin Roosevelt's New Deal programs, participated in these projects. Kisatchie National Forest housed Louisiana's first CCC camp, and by the end of 1934, the state had twenty-seven camps. The CCC work included tree planting, clearing firebreaks, and the construction of lookout towers, bridges, and truck trails.

Forests now cover about 48 percent of Louisiana's land area, and lumber and its products are reinvigorated industries. Today half of the forests have softwoods, mostly shortleaf pine, and the lumber mill products are mostly paper, plywood, veneer, and pulpwood rather than whole timbers. Often seen in central Louisiana are mountain-shaped heaps of tree trunks, hose-sprayed with arching jets of water to keep them moist and pliable for the sawmill.

Lumber was replaced by another natural resource that created wealth—oil. Al-

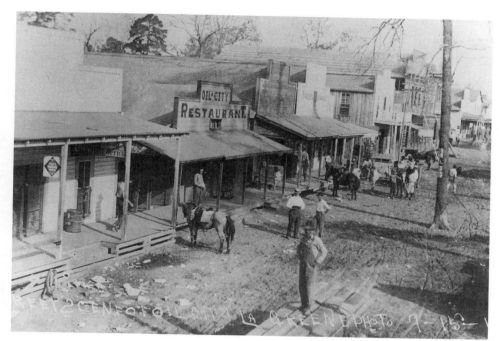

Oil City, 1912

though some drilling had taken place toward the end of the nineteenth century, there was little serious interest until the discovery of the huge Spindletop oil field near Beaumont, Texas, in 1901. This sparked an oil fever in Louisiana, and prospectors invaded the areas where signs of petroleum had been seen. In 1901, W. Scott Heywood drilled successfully near the town of Jennings in southwestern Louisiana, unleashing a boom that made Louisiana one of the nation's leading oil producers (JD4).

Standard Oil Company (now ExxonMobil) established a refinery in 1909 on a former cotton plantation just north of Baton Rouge, and by 1922 the company employed more than 10,000 people. Standard Oil also became a major political player in the state, making it a target for Governor Huey Long as well as the focus of journalist Ida Tarbell's exposés. Oil fields were developed in Caddo Parish in northwestern Louisiana and in the southwest, where Lake Charles was eager for new business for its deepwater port following the lumber industry's decline. New towns sprang up around the oil fields and related industries, proudly showcasing their valuable resources in names such as Oil City and Sulphur. Other oil and refining companies acquired and built on former plantation lands along the Mississippi River between Baton Rouge and New Orleans, where they had access to an unlimited supply of the fresh water necessary for their processing plants and transportation systems. This stretch of river forms one of the greatest concentrations of such companies in the nation. By the 1930s, oil refineries and petrochemical and fertilizer plants had

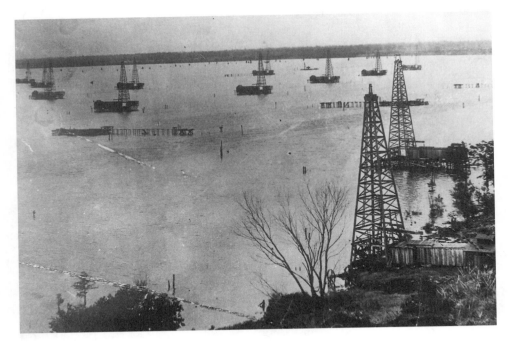

Oil wells in Caddo Lake, c. 1912

rudely swept away the notion of an arcadian landscape that the plantations represented in the popular imagination. Today oil and chemical plants, grain elevators, and plantation houses jostle for space along both banks of the Mississippi.

By 1910, the first well ever drilled over water was completed in Caddo Lake near Shreveport. The first successful offshore well in the Gulf of Mexico was drilled in 1937, just 6,000 feet off the Cameron Parish coastline. The Gulf is now the most intensively developed offshore oil and gas field in the world. More than 22,000 wells have been drilled in its floor; as of 2001, these are as deep as 3,800 feet. Some 4,000 operating structures remain in place, 90 percent of which are off the Louisiana coast. Despite their structural stability, these steel platforms, when viewed from the air, seem infinitely precarious and as transitory as the shrimp boats that navigate between them in search of a different harvest from the Gulf.

An industry to service these offshore oil rigs, providing for construction and repair of equipment and other needs, has transformed many of the formerly peaceful seafood-industry communities in the delta and along the coast. Some serve as hubs for land and helicopter transportation, such as Venice, the final community on the Mississippi River delta. Others, such as Morgan City and Houma, centers for fabrication, repair, and supplies, have expanded along U.S. 90 to shape an extraordinary horizon of giant oil-rig limbs under construction and platforms, drills, and cranes. The oil and chemical industry also spawned new company towns near their often rural plants. Lion Oil (Monsanto) built a subdivision at Luling, and Shell Oil built a

company town when it moved to Norco (the town's name derives from the previous company, the New Orleans Refining Company) in the 1920s.

The shift from a rural to a more urban state that had begun in the late nineteenth century accelerated between 1900 and 1940. After Huey Pierce Long (1893–1935) was inaugurated as governor in 1928, Louisiana underwent far-reaching economic, political, and social restructuring. Born in Winnfield in rural Winn Parish, Long practiced law in Shreveport before running for governor on a platform advocating progressive change and promising to build roads, bridges, highways, schools, and hospitals. He used ruthless methods to achieve his ends, but the results were impressive: from 296 miles of concrete roads in the state highway system in 1928 to 2,446 in 1935; from three major bridges in 1928 to over forty by 1935; and the construction of many schools, colleges, and hospitals. In 1931, Long ordered a new state capitol building for Baton Rouge, a high-rise tower in the latest fashion, sheathed with sparkling limestone (EB1). The architectural firm of Weiss, Dreyfous and Seiferth designed the building as well as Long's new official mansion in Baton Rouge in 1930 (EB21), new structures for Charity Hospital in New Orleans beginning in 1937 (OR155), and numerous buildings for the expanded and improved state university system (EB30), of which Long was so proud.

After Long was assassinated in 1935, succeeding governors won for the state millions of dollars in Works Progress Administration (WPA) contracts to build city halls, schools, post offices, and recreational facilities. WPA and Public Works Administration (PWA) funds also provided fifteen new courthouses in Louisiana, the majority constructed of light-colored masonry in the fashionable Art Deco or Moderne styles. Their design precedent was perhaps Long's state capitol building, an acknowledged symbol of progressivism. These courthouses are typically set toward the rear of the town's central square and are fronted by lawns, live oak trees, and a broad flight of stairs. In the small rural towns, these courthouses have a substantial presence, providing a civic focus that is especially poignant in communities where the commercial center that once surrounded the courthouse has been largely abandoned.

A PWA project of particular architectural merit was the municipal incinerator (now demolished) in Shreveport, designed in 1935 by Samuel Wiener of the Shreveport firm of Jones, Roessle, Olschner and Wiener. Photographs of this monumental Bauhaus-influenced incinerator were exhibited in the United States Pavilion at the 1937 Paris International Exposition as a superior example of modern American architecture. Architect Sam Wiener and his brother William Wiener designed a number of extraordinarily avant-garde structures in Shreveport during the 1930s, which place the architects among the first and best American modernists.

The federal programs particularly favored landscape projects, as they could engage a large labor force at a minimal expense. In 1933, the City Park in New Orleans was embellished with lagoons, bridges, pavilions, fountains, sculpture, flower gardens, a stadium, and a golf course, following a plan by the Chicago firm of Bennett, Parsons and Frost (OR64). Audubon Park in New Orleans, begun in 1898 to a

Municipal Incinerator, Shreveport, designed by Jones, Roessle, Olschner and Wiener, 1935

design by Olmsted Brothers, expanded its zoo with WPA funds (OR146). These public parks, along with many tree-lined boulevards, make New Orleans one of the greenest cities in the United States.

Improved transportation systems were one of the hallmarks of Huey Long's platform. Louisiana's first bridge across the Mississippi, the 4.35-mile-long combined highway-railroad Huey P. Long Bridge in Jefferson Parish, was the world's longest steel trestle railroad bridge when built in 1935 (JE16). In 1940, Baton Rouge's combination highway-railroad bridge made U.S. 190 a continuous route across the southern sector of the state. Louisiana's multitude of smaller rivers and bayous also were spanned, with either swing-span bridges or, more commonly, vertical-lift bridges on the busier or smaller waterways to avoid a central support obstructing river traffic. Two other water crossings that improved transportation out of New Orleans came in the 1950s: a 1958 bridge joining downtown to the west bank at Algiers (a second span opened in 1988), and the Causeway, a 24-mile-long bridge across Lake Pontchartrain. When opened to traffic in 1956, the precast, prestressed concrete structure, built at a cost of $51 million, was the world's longest continuous over-water highway bridge. Its effect on urban New Orleans was profound: by affording easy access to the north shore, it opened up the reforested Florida parishes to suburban sprawl, especially after a second two-lane span was inaugurated in

1969. The completion of north-south Interstate 49 in the 1990s further unified the state. The differences in religion, ethnicity, and cultural or social mores that had distinguished northern and southern Louisiana had been exacerbated by the inadequate road system linking the two regions. Shreveporters had tended to turn to the more accessible Dallas, rather than to New Orleans, when searching for big-city amenities.

New mechanized, labor-saving farming methods introduced in the late nineteenth century led to the depopulation of Louisiana's rural areas and a consequent growth in urban centers as displaced farm workers migrated to cities. In 1900, 26 percent of the population lived in urban areas; the proportion grew to 55 percent by 1950 and, by 1990, to nearly 70 percent. At the beginning of the twentieth century, the economic and political situation of African Americans was dire. The loss of voting rights in the 1890s, increased segregation, and poverty and discrimination in jobs and housing forced many to leave the state for northern cities. Racial segregation was gradually ended following integration of the transit systems in 1958 and of the public schools beginning in 1960. As elsewhere in the United States, one consequence of school integration was white flight from the cities to the suburbs; people moved from New Orleans to Jefferson Parish and to the other side of Lake Pontchartrain. The large shopping malls and commercial buildings that began to proliferate in the suburbs in the 1950s hastened decentralization.

The temporary collapse of the oil industry in the early 1980s was devastating for the entire state, but particularly for the oil-dependent communities along the Gulf Coast. New Orleans was particularly affected, and the lack of maintenance in its neighborhoods of nineteenth-century wooden houses resulted in deterioration and demolition of too many properties. Beginning in the 1990s, an improved economy and a growing tourist and convention industry encouraged urban renewal, and tourism was a spark to historic preservation.

In New Orleans, the traditional focus on celebrations, fun, and tourism received a considerable boost with the completion in 1975 of the Superdome, a sport and convention facility (OR75). The Louisiana World Exposition, commemorating the 1884 Cotton Exposition, was held in 1984 in an area of redundant warehouses between the business district and the river; for all its architectural and financial failings, the exposition did draw attention to the potential for renewal and adaptive reuse of this downtown area. Tourism, both cultural and frivolous, was seen as a key to Louisiana's economic woes. Beginning in the late 1980s, the convention center launched the first of several expansions; an aquarium (OR64) was built on the edge of the Vieux Carré, and a riverfront park was created along the Mississippi levee (OR25). After the Louisiana legislature legalized offshore gambling in 1991, riverboat casinos blossomed in Louisiana's westernmost cities, Lake Charles and Shreveport, attracting gamblers from Texas, where gambling is illegal. A land-based casino was approved for New Orleans in 1992 and was built at the base of Canal Street on the site of the hastily demolished Rivergate, an award-winning exhibit facility designed in 1968 by Curtis and Davis with Edward B. Silverstein and Associates and

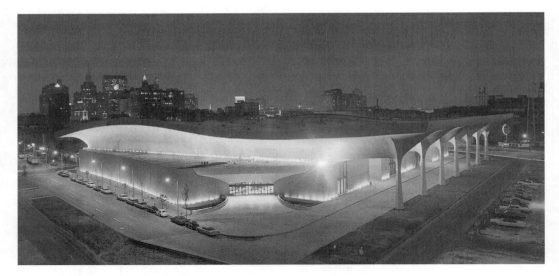

Rivergate, New Orleans, designed by Curtis and Davis with Edward B. Silverstein and Associates and Mathes, Bergman and Associates, 1968

Mathes, Bergman and Associates. This structurally innovative concrete building, with a huge undulating roof, was among the most aesthetically satisfying examples of expressionist architecture anywhere in the nation.

New Orleans's Canal Street, the wide commercial thoroughfare that separates the Vieux Carré from the business district, is one of the few vibrant historic downtown commercial streets in the nation. Increased tourism led to the conversion of several of Canal Street's commercial establishments into hotels in the 1990s, along with a similar transformation of underused high-rise office towers in the neighboring business district. Reinstallation of Canal Street's streetcars, which had been replaced by buses in 1964, guarantees the area's popularity and indicates that Louisiana is learning how to draw from the past to build the future.

Historic Preservation

More than twenty million people visited Louisiana in the year 2000, and around eleven million were drawn to New Orleans, three-quarters of them for pleasure. With a resident population of approximately 500,000, it is no wonder that the city relies heavily on revenues from cultural tourism. The concern now is that commercial tourism will stamp out the historic authenticity it seeks.

The Vieux Carré was an early testing ground for preservation measures, and it continues to be one. In the early twentieth century, politicians and real estate interests saw the Vieux Carré's aging structures as candidates for demolition. For others—writers, artists, and a few influential socialites—the decay was picturesque and

romantic. It was this mix of people who decided to seek legal mechanisms to protect the Vieux Carré and its residential character. The Vieux Carré Association, formed in 1926, evolved in 1936 into the Vieux Carré Commission (VCC), whose charge is to preserve the neighborhood's traditional architecture and its living, diverse character by setting guidelines for design and renovation.

The Vieux Carré's residents and the commission have achieved some notable successes, particularly in helping defeat a proposal in 1958 for an elevated expressway bordering the river in front of Jackson Square. Although the VCC initially approved the scheme, citizens' pressure and the local chapter of the American Institute of Architects forced the commission to reverse its decision in 1963, a decision that convinced the federal Department of Transportation to cancel the project in 1969. Among the challenges facing the VCC is maintaining the residential qualities of the area despite increasing numbers of tourists, conventioneers, and time-share rentals, which foster a "theme-park" atmosphere. The banning of large tourist buses in the quarter was a victory for the VCC. Vibrations from the weight and engines of these buses were destabilizing the very buildings the tourists want to see.

At the state level, Louisiana's Department of Culture, Recreation and Tourism in Baton Rouge is the umbrella office for a variety of divisions concerned with historic preservation. These include the Division of Archaeology and the Division of Historic Preservation. The latter administers such programs as listing on the National Register of Historic Places, to which it has added approximately 1,000 properties since 1971, and the Main Street program of the National Trust for Historic Preservation, which helps downtown areas capitalize on their historic buildings. As of 2000, twenty-eight Louisiana communities have benefited from this program. The division also administers the Federal Historic Preservation Tax Credit program, which was introduced in 1976 to nurture preservation and discourage demolition. In Louisiana, these tax breaks have been instrumental in saving such areas as New Orleans's historic warehouse district, which was converted from an abandoned downtown section of the city into a vital residential neighborhood.

The Division of Historic Preservation manages the state's division of the Historic American Buildings Survey (HABS), begun in 1933 under the Works Progress Administration. HABS continues to record historically significant buildings with measured drawings, photographs, and written documentation, which are preserved at the Library of Congress in Washington, D.C. Fortunately for Louisiana, in 1933 HABS hired architect Richard Koch as the state's first district officer. As a partner in the architecture firm of Armstrong and Koch, he was involved in the restorations of Shadows-on-the-Teche and Oak Alley plantations (1922 and 1926, respectively), as well as projects within the Vieux Carré. The buildings Koch photographed during this period form an invaluable record of the state's high-style and vernacular architecture. Koch's passion for Louisiana's architecture was inherited by his associate, Samuel Wilson, Jr., whose research in the notarial archives in New Orleans and in archives in France uncovered the history of many of Louisiana's earliest buildings. Louisiana's HABS drawings are now undertaken by architecture

students under the supervision of university faculty from Louisiana's architecture schools.

One consequence of the Vieux Carré expressway controversy was a new public awareness of the state's historic treasures. In the 1970s, Louisiana's citizens began to form organizations and to initiate programs dedicated to preservation. The Louisiana Landmarks Society, founded in 1950, primarily focuses on individual buildings and lobbies for the preservation of threatened structures. The society also maintains the Pitot House (OR62), one of New Orleans's oldest houses. Another statewide organization is the Louisiana Preservation Alliance, formed in 1979, which in the 1990s prepared a comprehensive preservation plan for the Mississippi River Road corridor. Other groups are devising programs specific to their communities. In Lake Charles, preservationists began Heritage Awareness tours of the city's historic downtown residential areas, which have successfully attracted a younger generation to purchase homes there. Save our Cemeteries, founded in New Orleans in 1974 to prevent demolition of wall vaults in St. Louis Cemetery 2, is now involved in protecting all of the city's unique above-ground tombs as well as those in historic cemeteries beyond the city. A city agency, the Historic District Landmarks Commission, was set up in 1976 to oversee the visual quality of buildings and regulate restoration and demolition.

New Orleans's Preservation Resource Center (PRC), a nonprofit organization incorporated in 1974, can count many significant achievements. It purchased, renovated, and in 1981 established its offices in a row house built in 1832 on then-decaying Julia Street, thus taking what proved to be the first step in a revitalization of the Central Business District. And in response to Louisiana's economic recession of the 1980s, which accelerated depopulation and blight, the PRC initiated several programs, among them enlisting the services of volunteers every October to repair and paint houses for homeowners in need of assistance. As almost all New Orleans houses are constructed of wood, continual maintenance is an essential tool of preservation. The PRC also selected the Lower Garden District for special attention. By the late 1980s, this twenty-four-block area of formerly upscale historic houses had more than one hundred severely blighted buildings; owner occupancy in the area was less than 28 percent, and sixty properties were vacant. A program to provide interim funding for the acquisition and renovation of vacant houses to prequalified home buyers has had considerable success and motivated resident involvement in the community.

Historic plantations are among Louisiana's most popular tourist attractions. In recent years, they have received preservation money from an unexpected source—the oil and chemical companies along the Mississippi River that would once have simply demolished them. Dow Chemical moved the Aillet House from land it acquired in West Baton Rouge Parish and restored it in a new location at the West Baton Rouge Museum. Marathon Oil gave financial assistance for the restoration of San Francisco Plantation, and Shell Oil has undertaken the restoration of Ash-

land–Belle Helene. Other industrial companies are following suit in lending some of their economic clout to the preservation effort.

The preservation of Louisiana's unique natural landscape and wildlife is also urgent. The state loses between twenty-five and thirty-five square miles of coastal wetlands each year.[32] The causes include storm damage, rising sea level, subsidence, floods, and such human alterations as oil and gas exploration, navigation canals, flood control levees, and urban expansion.[33] The Coastal Wetlands Planning, Protection and Restoration Act of 1990 has been an important step in addressing the problem.

In the late twentieth century, preservation efforts in Louisiana began to broaden their scope. For example, the focus on the plantation house and its elite society has expanded to an understanding of the entire built complex of the plantation and its community. A challenge still to be taken up is the preservation of buildings from the second half of the twentieth century, not yet a high priority in a state with such a rich and revered more distant past.

Notes

1. Samuel Wilson, Jr., "Louisiana Drawings by Alexandre de Batz," in *The Architecture of Colonial Louisiana, Collected Essays of Samuel Wilson, Jr., FAIA*, ed. Jean M. Farnsworth and Ann M. Masson (Lafayette: The Center for Louisiana Studies, University of Southwestern Louisiana, 1987), 266.
2. Ibid., 266.
3. Joseph Ewan, "French Naturalists in the Mississippi Valley," in *The French in the Mississippi Valley*, ed. John Francis McDermott (Urbana: University of Illinois Press, 1965), 165.
4. Ibid., 165–166.
5. J. F. Lelièvre, *Nouveau jardinier de la Louisiane, contenant les instructions aux personnes qui s'occupent de jardinage* (Nouvelle-Orléans: J. F. Lelièvre, 1838).
6. Gwendolyn Midlo Hall, *Africans in Colonial Louisiana: The Development of Afro-Creole Culture in the Eighteenth Century* (Baton Rouge: Louisiana State University Press, 1992), 157–159.
7. Henry P. Dart, "The First Cargo of African Slaves for Louisiana, 1718," *Louisiana Historical Quarterly* 14:2(April 1931):168.
8. Samuel Wilson, Jr., "The Directors' House—La Direction—1722," in *Architecture of Colonial Louisiana*, 387.
9. Samuel Wilson, Jr., "An Architectural History of the Royal Hospital and the Ursuline Convent of New Orleans," in *Architecture of Colonial Louisiana*, 182.
10. C. C. Robin, *Voyage to Louisiana, 1803–1805*, abridged and translated by Stuart O. Landry, Jr. (New Orleans: Pelican Publishing, 1966), 123.
11. Samuel Wilson, Jr., "Ignace François Broutin," in *Architecture of Colonial Louisiana*, 249.
12. Jay D. Edwards, "The Origins of Creole Architecture," *Winterthur Portfolio* 29:2/3 (1994): 156.
13. Sebastiano Serlio, *On Domestic Architecture: Different Dwellings from the Meanest Hovel to the Most Ornate Palace: The Sixteenth-Century Manuscript of Book VI in the Avery Library of Columbia University*, ed. Myra Nan Rosenfeld (New York: Architectural History Foundation, 1978), Plate I.
14. Jonathan Fricker, "The Folk Architecture of the Appalachian Uplanders," in *Louisiana Buildings, 1720–1940*, ed. Jessie Poesch and Barbara SoRelle Bacot (Baton Rouge: Louisiana State University Press, 1997), 78.

15. Ellen Weiss, "City and Country, 1880–1915: New Impulses and New Tastes," in *Louisiana Buildings, 1720–1940*, ed. Jessie Poesch and Barbara SoRelle Bacot (Baton Rouge: Louisiana State University Press, 1997), 281.
16. Sebastiano Serlio, *On Domestic Architecture*, Plate XLVIII.
17. Ann M. Masson, *Mortuary Architecture of Jacques Nicolas Bussière de Pouilly* (master's thesis, Tulane University, 1992).
18. *Autobiography of James Gallier, Architect*, ed. Samuel Wilson, Jr. (New York: Da Capo Press, 1973), 19.
19. Although frequently attributed to Isaiah Rogers, the second St. Charles Hotel was not designed by him. See Denys Peter Myers, "Isaiah Rogers," *Macmillan Encyclopedia of Architects*, vol. 3, ed. Adolf K. Placzek (New York: Free Press, 1982), 601. However, according to documentation in the Southeastern Architectural Archive at Tulane University, Isaiah Rogers and James Gallier, Jr., did play a role in the project.
20. *Autobiography of James Gallier.*
21. Antoinette J. Lee, *Architects to the Nation: The Rise and Decline of the Supervising Architect's Office* (New York: Oxford University Press, 2000), 142–147.
22. Joseph Karl Menn, *The Large Slaveholders of Louisiana–1860* (New Orleans: Pelican Publishing, 1964), 1.
23. Ibid., 105, 121–122, 353–354.
24. Ibid., 2.
25. *Southern Travels: Journal of John H. B. Latrobe, 1834*, ed. Samuel Wilson, Jr. (New Orleans: Historic New Orleans Collection, 1986), 38.
26. Kenneth Severens, *Southern Architecture: 350 Years of Distinctive American Buildings* (New York: E. P. Dutton, 1981), 59–60; Vincent Scully, *American Architecture and Urbanism* (New York: Frederick A. Praeger, 1969), 71.
27. Frederick Law Olmsted, *A Journey in the Seaboard Slave States, with Remarks on Their Economy* (New York: Dix and Edwards, 1856), 659.
28. Ibid., 629.
29. *Southern Travels*, 38.
30. Solomon Northup, *Twelve Years a Slave*, ed. Sue Eakin and Joseph Logsdon (Baton Rouge: Louisiana State University Press, 1968), 124–127; 159–162.
31. James F. O'Gorman, *H. H. Richardson and His Office, a Centennial of His Move to Boston, 1874: Selected Drawings* (Cambridge, Mass: Harvard College Library, 1974), 174.
32. Beth Vairin, "Restoring Coastal Louisiana: A Resource for the Nation," *WaterMarks* (winter 2000, Special Issue): 1.
33. Ibid., 2.

New Orleans
Orleans Parish (OR)

CRADLED IN A CURVE OF THE MISSISSIPPI RIVER AND CONTAINED on the north by Lake Pontchartrain, New Orleans has fluid boundaries; like an island, the city can be approached only over water. Its elevation is ten feet above sea level next to the river and lower in the center. With its saucerlike shape and with an average yearly rainfall of sixty inches, New Orleans must depend for its survival on an extensive and sophisticated system of pumps, flood walls, and levees. The city's physical growth paralleled the natural levee formed by the Mississippi's deposits, spreading into the center and toward Lake Pontchartrain only when these low-lying areas were drained beginning in the early twentieth century. This growth pattern can be tracked in the types and styles of the city's residential architecture: from neighborhoods of Creole cottages to urban town houses, shotgun houses, bungalows, and the low-ceilinged, ranch-style houses built after air conditioning became standard. Although New Orleans neighborhoods contain some of the oldest buildings in the nation, most of the city's fabric dates from the twentieth century.

Jean-Baptiste Le Moyne, Sieur de Bienville, selected the site for New Orleans in 1718, naming it for the French regent, Philippe, duc d'Orléans. Intended as a trading post for the Company of the West, the site offered a shorter route to the Gulf of Mexico via Bayou St. John and Lake Pontchartrain than that provided by the Mississippi River. The core of New Orleans is the Vieux Carré, laid out in 1721 on a grid plan by the engineer in chief of Louisiana, Louis-Pierre Leblond de La Tour (d. 1723), and his assistant, Adrien de Pauger (d. 1726). The surrounding cypress forests provided building materials for the new city, but disastrous fires in 1788 and 1794 led the Spanish governor to issue regulations that buildings of more than one story must be constructed of brick and, if the bricks were set between wood posts in the type of construction known as *briquette-entre-poteaux*, that they be covered with stucco or lime to help fireproof them.

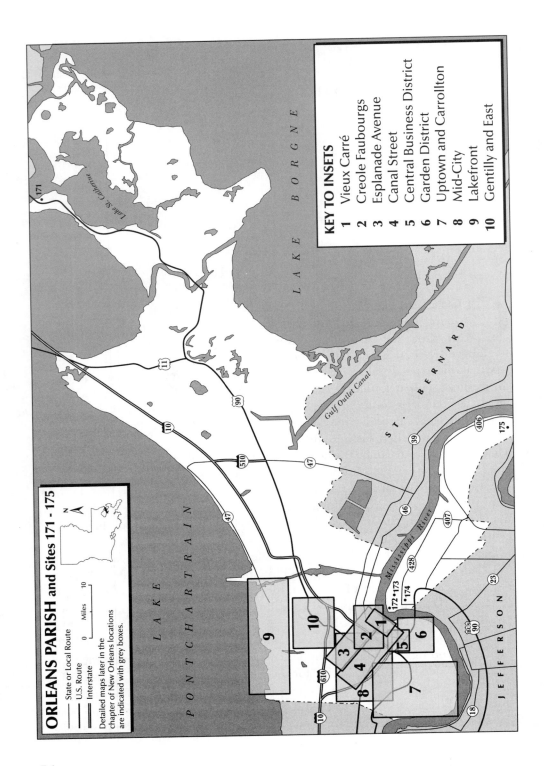

ORLEANS PARISH and Sites 171 - 175

N

0 Miles 10

— State or Local Route
— U.S. Route
— Interstate

Detailed maps later in the chapter of New Orleans locations are indicated with grey boxes.

KEY TO INSETS

1 Vieux Carré
2 Creole Faubourgs
3 Esplanade Avenue
4 Canal Street
5 Central Business District
6 Garden District
7 Uptown and Carrollton
8 Mid-City
9 Lakefront
10 Gentilly and East

LAKE PONTCHARTRAIN

LAKE BORGNE

Lake St. Catherine

ST. BERNARD

Gulf Outlet Canal

Mississippi River

JEFFERSON

By the end of the eighteenth century, new suburbs were laid out downriver and upriver from the Vieux Carré, and New Orleans grew rapidly in the first half of the nineteenth century, especially after the Louisiana Purchase (1803). This growth accelerated after the first steamboat navigated the Mississippi to New Orleans in 1812, for cargo could then be transported upriver as easily as down. By 1840, only New York had more business than the Port of New Orleans, and with a population of approximately 102,000, the city was the nation's fourth largest.

A construction boom in the Central Business District (CBD), lasting from the 1890s to the Depression of the 1930s, was accompanied by residential development. Shotgun houses predominated in the newly drained sections and, ornamented with varied and fancy overhangs, brackets, and cornices, offered individuality within uniformity. In New Orleans today, the less affluent nudge the wealthy in a multiplicity of small and distinct neighborhoods, often separated by no more than a street.

Although the railroads ended New Orleans's monopoly of the Mississippi River valley trade, the port's significance was maintained by the completion of the Industrial Canal in 1923, linking the river with Lake Pontchartrain and, later, the Gulf Intracoastal Waterway. And following World War II, the city benefited from the oil and gas industries. Between 1959 and 1970, the built-up area of New Orleans approximately doubled in size; suburban expansion in the 1970s, east across the Industrial Canal and west into neighboring Jefferson Parish, left much of the inner city to decay. The late 1990s began to see a reversal of this trend.

French and Spanish influences defined New Orleans architecture until 1803, when the Anglo-Americans who flocked to the city introduced eastern seaboard fashions. Architects were attracted by the opportunities this booming city offered. Among those who settled here in the nineteenth century were some of the nation's premier architects: James Dakin (1806–1852); James Gallier, Sr. (1798–1866); James Gallier, Jr. (1827–1868); and Henry Howard (1818–1884); and, from France, Jacques Nicholas Bussière de Pouilly (1804–1875). They crafted a unique architecture from the city's diverse heritage, one that was also sympathetic to the difficult climate and site. In the twentieth century, architects and firms have made major contributions to the city's extraordinary built landscape: Emile Weil (1878–1945); Charles A. Favrot (1866–1939) and Louis A. Livaudais (1871–1932), who formed Favrot and Livaudais in 1895; Leon C. Weiss (1882–1953) and F. Julius Dreyfous, who established a firm in 1919, expanded as Weiss, Dreyfous and Seiferth when Solis Seiferth (1895–1984) was made partner in 1927; and Nathaniel C. Curtis (1917–1997) and Arthur Q. Davis (b. 1920), who formed Curtis and Davis. Koch and Wilson, Architects, the partnership of Richard Koch (1889–1971) and Samuel Wilson, Jr. (1911–1993), did its most important work in historic preservation in southern Louisiana.

New Orleans has an unmatched culture of public display. In the days before air conditioning, the heat dictated outdoor living on galleries, porches, or stoops. In modest neighborhoods, this tradition lingers. Streets are also the setting for Mardi Gras and other ritual activities and parades, many generated by religious festivals.

New Orleans, 1969

The city's high water table has affected death as well as life: the deceased are often placed in elaborate above-ground tombs.

Most of the buildings in New Orleans are constructed of wood, and because of the high annual rainfall, the heat and humidity, and termites, they need constant repair. Plants grow out of control. Depending on one's point of view, the city can be characterized as looking either dilapidated or picturesquely decayed and antique. In many older sections, overhead electricity and telephone wires tangle with the branches of oak, magnolia, and crepe myrtle trees to form a sheltering canopy that perhaps contributes to New Orleanians' often parochial inclinations.

Since New Orleans is built in a crescent of the Mississippi River—thus its nickname, the Crescent City—the street grid merges in the center, which often makes finding one's way a challenge. For New Orleanians, locations and directions are identified not by compass points but rather on the basis of their relationship to the Vieux Carré, that is, upriver or downriver, and to the lake (lakeside) and the Mississippi River (riverside).

Vieux Carré

The Vieux Carré (old square), also known as the French Quarter, was designed in an eleven-by-six-block gridiron plan. A public square, the Place d'Armes (now Jackson Square), faced the river. Although surrounding fortifications were planned, they never amounted to much more than a ditch and palisade. Of the four planned corner forts, it was only in 1792, under Spanish rule, that one, Fort St. Charles (San Carlos), was built, and it was demolished in 1821. The old U.S. Mint (OR52) now stands on that site at the foot of present-day Esplanade Avenue. Eighteenth-century city plans show large free-standing houses set in formal gardens, but by the early nineteenth century, as the population increased, buildings fronted directly on the street and were provided with interior courtyards to shelter their occupants from noise and odors. The earliest extant structure is the Ursuline Convent, 1749–1753, and approximately seven-eighths of the Vieux Carré's buildings date from the nineteenth century. This unique mix of institutional, commercial, and residential structures forms the most complete historic neighborhood in the nation.

In addition to Creole cottages, two- and three-story brick row houses similar to those of eastern cities became popular in the early nineteenth century, as exemplified by the eleven brick houses on the 1100 block of Royal Street. Many structures combined commercial functions at ground level and residential space above, sometimes with an entresol—a shallow story between the ground floor and principal floor—to provide storage for the shops, although it was sometimes used as living quarters for the store owner. Beginning in the mid-nineteenth century, two-story wrought and cast iron galleries were added to many existing buildings, such as on the Gardette–Le Prêtre House of 1836

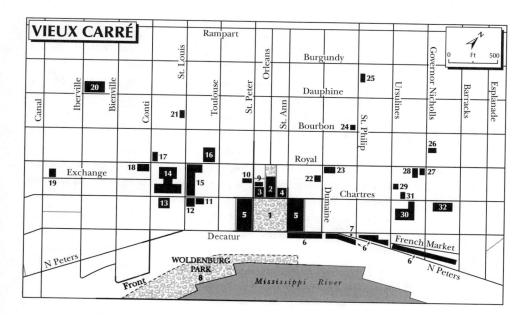

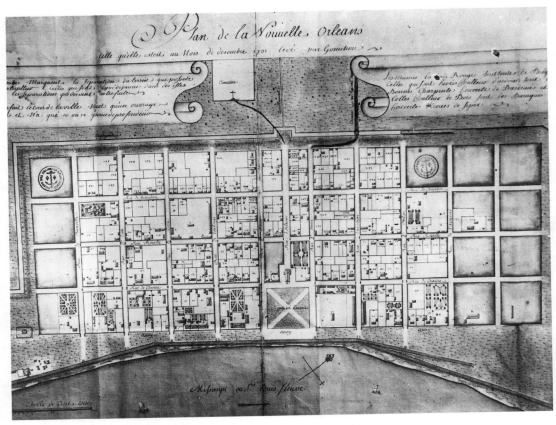

The Gonichon plan of New Orleans (1731), showing the Vieux Carré

(716 Dauphine Street), which give the Vieux Carré its filigreed aspect. Greek Revival details also became fashionable, especially for door and window frames.

By the early twentieth century, the Vieux Carré had become shabby, disreputable, and a cheap place to live. Among the many artists attracted to the area were Enrique Alferez, Alberta Kinsey, and Ellsworth and William Woodward, who gathered and exhibited at the Arts and Crafts Club (active from 1922 to 1951). Writers, too, notably William Faulkner, Frances Parkinson Keyes, and Tennessee Williams, gave an aura of glamour and a mystique to the Vieux Carré. In the 1930s, this renewed interest in the historic quarter was instrumental in the formation of a preservation movement, led by local preservation activist Elizabeth Werlein. In the 1950s, the Vieux Carré faced a major challenge from the proposal to construct an elevated expressway along the riverfront that would have severed Jackson Square from the Mississippi River. Citizens' objections were crucial in the long battle to defeat this proposal, and in the 1980s, the riverfront was developed for public use. Today, the Vieux Carré faces the danger of losing its identity because of too many tourist attractions and overrestoration that could make it a caricature of itself. Also, a recent dramatic decline in owner occupancy and permanent residency

(from 10,000 permanent residents in 1980 to 3,000 in 2000) has become a serious threat to the survival of the Vieux Carré as a viable neighborhood.

Although each of the Vieux Carré's streets has a distinctive character, the area closest to the river and toward Canal Street, including upscale commercial Royal Street and tawdry, raucous Bourbon Street, is largely the business, commercial, and tourist sector; the area downriver from Jackson Square is more residential. The buildings described here are unique or represent particularly fine examples of architectural types belonging to this extraordinarily rich built landscape. To appreciate fully the character and individual buildings of the Vieux Carré, one needs to walk the area street by street. The architectural survey housed in the Williams Research Center of the Historic New Orleans Collection can be consulted.

OR1 Jackson Square

1721, Adrien de Pauger. Bounded by Chartres, Decatur, St. Ann, and St. Peter sts.

Framed by St. Louis Cathedral, the Cabildo, the Presbytère, and the Pontalba Buildings, and facing the river, Jackson Square is the heart of the Vieux Carré, even of New Orleans. It was laid out by Adrien de Pauger as a parade ground called the Place d'Armes. Dominated by the cathedral, the square presented a formal gateway to the city in the era when arrival was principally by boat. Architect Benjamin Henry Latrobe (1764–1820) described the square in his journal entry for January 1819: "The public square which is open to the river has an admirable general effect, and is infinitely superior to any thing in our atlantic cities as a Water view of the city." In 1851, after the Baroness Micaela Almonester de Pontalba, who owned the land around the square, had buildings constructed along two sides, the city improved the square with plantings in parterres and a cast iron fence, added under the direction of surveyor Louis Pilié (1820–1884). Renamed Jackson Square in 1851, it is the site of a bronze

OR1 Jackson Square, showing St. Louis Cathedral, the Cabildo, the Presbytère, and the Pontalba Buildings

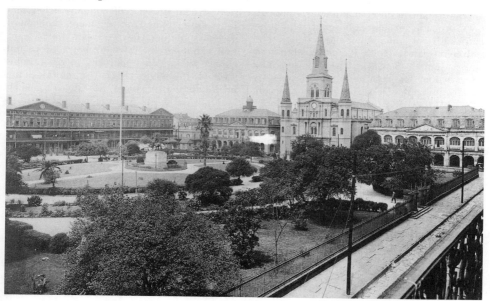

equestrian statue of General Andrew Jackson by sculptor Clark Mills, a replica of his earlier bronze statue in Washington, D.C., dedicated in 1853. The Jackson statue, unveiled in 1856, stands on a pedestal by Newton Richards.

OR2 St. Louis Cathedral

1849–1851, J. N. B. de Pouilly. Jackson Sq. on Chartres St.

Completed in 1851, the present cathedral replaced two earlier structures on the site: Adrien de Pauger's church of 1724–1727, which burned down in 1788, and that of 1789–1794 by Gilberto Guillemard, the architect for the Cabildo and the Presbytère. Benjamin Henry Latrobe designed a clock tower for the church in 1819. After the Cabildo and the Presbytère were heightened with mansard roofs in 1847, the cathedral was rebuilt, in part to keep it in scale with the new development, but also because the structure was in need of repair and too small for the congregation. J. N. B. de Pouilly's design was similar to that of Guillemard and also called for brick stuccoed on the exterior, but for a columned three-story rather than a two-story facade. The new design included a longer and wider nave, an open central steeple of cypress and iron, and, at each end of the facade, a three-story octagonal tower with a spire. Unfortunately, during construction in 1850, the central tower collapsed, bringing down some of the roof and walls. Although it was probably the fault of the contractor, John Patrick Kirwan, who did not allow enough time for the mortar to dry, de Pouilly was dismissed and Alexander Sampson hired to supervise construction. The final result was a three-story facade with paired Doric columns flanking central, round-arched openings on the two lower levels and paired pilasters on the third, balanced by horizontal moldings to create a harmonious design. All these elements project only slightly from the wall's surface, resulting in a lack of depth that conveys the impression that the facade is an elevation drawing rather than a three-dimensional structure. De Pouilly's open wrought iron spire was covered with slate tiles in 1859. The interior has galleries over each aisle and frescoes painted by Erasmus Humbrecht in 1872. Stained glass side windows made by the Oidtmann workshop of Linnich, Germany, in 1929 depict the life of Louis IX, king of France, patron saint of the cathedral. In 1793, this former parish church was made the

seat of a diocese, giving it the status of a cathedral.

St. Anthony's Garden behind the cathedral is laid out on the site of the original cemetery. The 15-foot-high marble obelisk topped by a burial urn was moved here in 1914 from its original site at the Quarantine Station, seventy miles below New Orleans, along with the remains of nineteen sailors who died of yellow fever during the epidemic of 1857.

OR3 The Cabildo

1795–1799, Gilberto Guillemard. Jackson Sq. (Chartres and St. Peter sts.)

The Cabildo and the Presbytère, designed by the French-born military architect-engineer Guillemard (1746–1808) as a pair flanking St. Louis Cathedral, housed the administrative units of the Spanish government. Almost identical in design, the two buildings are also similar to those in other Spanish colonies of the time, such as in Havana and Mexico (e.g., the Casa Reale, 1781, Antequera, Mexico). Built on the site of the early-eighteenth-century courthouse, barracks, and prison, all destroyed in the fire of 1788, the Cabildo was intended to be the city hall. Classical in design, it has an arcade supported on piers at the ground level and a second story featuring pilasters between the arched windows. The center of the facade is marked by a slightly projecting three-bay, two-story order, Tuscan half columns below and Ionic above, topped by a pediment. Guillemard gave the building a flat tiled roof; the mansard roof with its large voluted dormer windows and cupola was added under city surveyor Louis Surgi (1815–1869) in 1847. The exterior of the brick building is covered with stucco to match St. Louis Cathedral, and the wrought iron balcony railings were made in New Orleans by Marcellino Hernandez, who emigrated from the Canary Islands. The Cabildo, along with the earlier St. Louis Church (later Cathedral) of 1789–1794 and the Presbytère, introduced to New Orleans such classical elements as engaged columns, pilasters, and a central pediment.

The Cabildo served as New Orleans's city hall from 1803 (the Louisiana Purchase transfer took place here) to 1836. The American emblems on the pediment were added in 1821 by Italian sculptor Pietro Cardelli. When New Orleans was divided into three municipalities in 1836, the Cabildo served as the municipal

hall for the Creole population. Following the city's reunification in 1852 and until 1910, the Supreme Court of Louisiana occupied the building. In 1911, the Cabildo opened as the Louisiana State Museum. Following a fire in 1988 that destroyed the third floor, the Cabildo was restored by Koch and Wilson, Architects, of New Orleans, at which time the buff-tan exterior color used in 1847 was replicated.

OR4 The Presbytère

1791–1813, Gilberto Guillemard; Gurlie and Guillot. Jackson Sq. (Chartres and St. Ann sts.)

Begun in 1791 according to Guillemard's 1789 plans, and originally intended as the rectory for St. Louis Cathedral, the Presbytère was used as the courthouse. It was financed, as were the Cabildo and the St. Louis Cathedral, by the entrepreneur and merchant Don Andrés de Almonester y Roxas (1725–1798). Designed to match the Cabildo, the Presbytère is, in fact, a few feet wider and has broader arches than that structure. Only one story of the Presbytère had been constructed when Don Andrés died in 1798. The French-born architect-builders Claude Gurlie (1770–1858) and Joseph Guillot (1771–1838) completed the building in 1813. Rear wings designed by French immigrant Benjamin Buisson (1793–1874) were added in 1840, and the mansard roof in 1847; the cupola was removed after damage in a storm. Along with the Cabildo, the Presbytère was transferred to the Louisiana State Museum in 1911, itself becoming a museum piece.

OR5 The Pontalba Buildings

1849–1851, James Gallier, Sr.; Henry Howard. Jackson Sq. (Upper Pontalba on St. Peter St. and Lower Pontalba on St. Ann St.)

The Baroness Micaela Almonester de Pontalba (1795–1874), daughter of Don Andrés, commissioned James Gallier to design two rows of houses, each row having sixteen houses with ground-floor stores, for the downriver and upriver sides of Jackson Square. The buildings were financed as well as supervised by the baroness, who, after disputes with Gallier, replaced him with Henry Howard in 1849. Exactly who designed the Pontalba Buildings remains a matter of debate. Architect and historian Samuel Wilson believed Gallier was responsible for the plans, and certainly they are

acceptable as Gallier's work at that time. But Gallier never claimed credit for the elevations, and Howard did. The builder was Samuel Stewart (1832–1890). The houses in each row have three stories and are constructed of pressed red brick from Baltimore; New England granite was used for the square piers on the first story, and the slate roof tiles came from England. Pediments mark the ends and the center of each row. Each house has an attic space, with horizontal windows just below the narrow cornice, which accommodated the residents' slaves. The three-story cast iron galleries, designed by Gallier and made in New York, are possibly the first in New Orleans to be an integral part of the design rather than a later attachment. These galleries, embellished with the monogram AP for their patron, continue to shade pedestrians below and provide outdoor space for the apartments upstairs. When the Louisiana State Museum acquired the Lower Pontalba in 1927 and the city of New Orleans the upper building in 1930, these were shabby tenements. Both buildings were remodeled into apartments in 1935–1936 with Works Progress Administration (WPA) funds. A restoration in the 1950s by Koch and Wilson, Architects, returned the buildings to residential use. Among the American writers who lived in the Pontalba Buildings were Sherwood Anderson, William Faulkner, and Katherine Anne Porter.

OR6 The French Market

1813 to present. Bounded by Decatur, N. Peters, St. Ann, and Barracks sts.

For most of the eighteenth century, a public market was held out-of-doors on the levee near the Place d'Armes (Jackson Square). According to a May 21, 1779, ordinance, the city decided that "in view of the great abuses committed in the sales of provisions which are exposed to the elements," a covered market was essential for reasons of health. Consequently, the Spanish built a market of wood that was roofed but open along the sides. In 1813, the first of a series of more permanent structures was built on this waterfront site. The oldest section, formerly the meat market (Halle des Boucheries), is the 302-foot-long arcaded structure of plastered brick on Decatur between St. Ann and Dumaine streets, designed by city surveyor Jacques Tanesse (c. 1775–1824) and built by Gurlie and Guillot. Its Doric colonnade was added in the 1930s to unify the structure with

the similarly colonnaded vegetable market (Marché aux Legumes), on Decatur from St. Philip to Ursuline streets, designed by city surveyor Joseph Pilié (c. 1789–1846) in 1823. From 1936 to 1938, the market was extensively remodeled by Samuel Stone, Jr., and his son Frank M. Stone with PWA funding. Extensions to the market toward Barracks Street, dating from 1938, the 1970s, and 1991, essentially follow the earlier design.

OR7 Joan of Arc Monument

1880, Emmanuel Fremiet. Corner of Decatur, N. Peters, and St. Philip sts.

The dazzling gilded 13-foot-high equestrian statue of Joan of Arc, clad in armor and holding a lance, was a gift to the city from France in 1964, during the presidency of Charles de Gaulle. Originally installed in front of the World Trade Center (OR65), *Joan* was forced to move when a casino was constructed at that site in the 1990s. This new location in the heart of the Vieux Carré in a pocket park gives the work the greater visibility it deserves.

OR8 The Moonwalk and Woldenberg Riverfront Park

1976, Cashio-Cochran and Associates. 1990, Design Consortium. The levee (between St. Ann and Canal sts.)

For the city's early settlers, the levee provided a scenic setting for public promenades, with the added advantage of cool breezes from the river. The English traveler Francis Bailey, who visited New Orleans in 1797, described it as "a handsome raised gravel walk, planted with orange trees," which "in the summer time served for a mall, and in an evening was always a fashionable resort for beaux and belles of the place." "I have enjoyed many an evening's promenade here," he continued, "admiring the serenity of the climate and the majestic appearance of this noble river." In the nineteenth century, this land was increasingly occupied by wharves, industrial buildings, sugar sheds, warehouses, and railroad tracks. Esplanade and Canal streets replaced the levee as the site for casual perambulation. In the last quarter of the twentieth century, much of the levee fronting the Vieux Carré was returned to public use. The section opposite Jackson Square was the first. Improved in 1976 with a wooden walkway and shade trees by landscape architects Cashio-

Cochran, it was named the Moonwalk in honor of Moon Landrieu, mayor of New Orleans from 1970 to 1978. The twelve-acre Woldenberg Riverfront Park was built outward from the old levee with lightweight soil on the concrete foundations that formerly had supported the warehouses. Opened in 1990, the park is landscaped with lawns and trees and paved promenades affording views to the river.

OR9 The Arsenal

1839, James Dakin. 615 St. Peter St.

Built on the site of the 1769 Spanish Arsenal, this Greek Revival structure is one of Dakin's earliest works in the city. Designed to house the state armory, the narrow, vertical building of brick covered in plaster has a severe facade consisting essentially of four giant Tuscan pilasters raised on huge granite blocks. Adding to the image of strength and security, iron grilles cover the narrow windows; the massive iron door is studded with enormous rivets, and the heavy entablature presses down on the supports. Ornament is minimal, but the low relief sculpture of exploding cannonballs on the parapet and cannons and flags in the cast iron panels above the entablature emphasize the arsenal's military purpose.

OR10 Le Petit Salon (Victor David House)

1838. 620 St. Peter St.

French immigrant and hardware merchant Victor David and his Creole wife, Anne Carmelite Rabassa, hired builders Samuel Stewart and David Sidle to construct their four-story, side-hall house. Built of brick and raised on a full basement, the house has an exterior staircase (a rare feature in the Vieux Carré) that leads to the principal entrance on the second floor. The handsome Greek Revival entrance is framed by pilasters set between foliate ornamented jambs and supporting an anthemion-decorated lintel—details copied from Minard Lefever's pattern book, *Beauties of Modern Architecture* (1833). Each floor is marked by a narrow balcony with a wrought iron railing, each in a different pattern; the one on the fourth floor is of crossed arrows. Horizontal windows covered with foliate-patterned cast iron grilles provide light for the attic. Crowning the house is a strongly projecting cornice. In 1925, the house was purchased by Le Petit Salon, a women's lit-

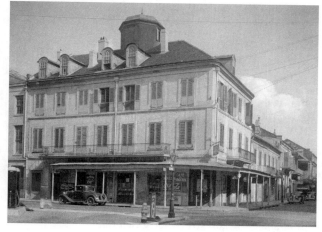

OR9 The Arsenal (above, left)

OR10 Le Petit Salon (Victor David House) (above, right)

OR12 Napoleon House (Girod House) (right)

erary and arts organization, whose first president and vice president were, respectively, author Grace King and journalist Dorothy Dix. The group hired Armstrong and Koch to restore the house, one of the first steps in the rejuvenation of the Vieux Carré.

OR11 **Pharmacy Museum** (Dufilho's Pharmacy)

1837, J. N. B. de Pouilly. 514–516 Chartres St.

Louis J. Dufilho, Jr., one of the first licensed pharmacists (1816) in the nation, built his apothecary shop and residence in the style of a typical Creole-American town house. The three-story building is brick covered with plas-ter. Three large round-arched openings in the lower facade are matched by a similarly shaped carriage entrance at one side. An entresol between the first and second stories is lighted by the upper portion of the window arches. A botanical garden in the rear courtyard supplied Dufilho's medicinal herbs. The pharmacy was restored as a museum in the 1930s.

OR12 **Napoleon House** (Girod House)

1814, attributed to Jean-Hyacinthe Laclotte. 500–506 Chartres St.

J.-H. Laclotte (1766–c. 1829), from Bordeaux, studied at the Ecole des Beaux-Arts in Paris before arriving in New Orleans in 1806. He built

this three-story residence for Nicholas Girod, mayor of New Orleans from 1812 to 1815. The ground story of the plastered brick building was used for business purposes and, in typical French fashion, opened directly onto the street by means of casement doors; the principal living spaces, with higher ceilings, occupied the second floor. The house was innovative in New Orleans, however, in its use of taller proportions. Curved-arched dormers and an octagonal cupola mark the hipped roof. A carriageway led from St. Louis Street into a two-story wing, dating from 1795. It is believed that Girod, one of the leaders in the plot to rescue Napoleon, wanted his house to serve as a refuge for the emperor after his escape from Elba, but Napoleon was subsequently sent to St. Helena, where he died in 1821, thus dashing Girod's hopes. However, it is claimed that Napoleon's physician, Dr. Francesco Antommarchi, maintained an office here about 1838, where he treated the poor without charge. By 1860, the building was an auction house, and in 1914 it became a bar. Today it is a popular bar and restaurant.

OR13 Williams Research Center, Historic New Orleans Collection (Second City Criminal Court and Third District Police Station)

1915, Edgar A. Christy. 410–414 Chartres St.

E. A. Christy (1880–1959), architect for the city of New Orleans from 1904 to 1923 and for the Orleans School Board from 1911 to 1940, gave this building's Beaux-Arts facade a rich variety of textures and decorative details. Each of the two stories features three large round-arched windows in the center of the facade. The distribution of weight is effectively realized with a terra-cotta-faced first level set into exaggerated stone joints. The second story, of brick, repeats the round arches over the three central openings, but window crowns, decorative garlands, and a roofline balustrade make the overall treatment much lighter. In a 1993 renovation by Jahncke Architects, Inc., to provide a research center for the building's new owner, the Historic New Orleans Collection (HNOC), the 24-foot-high former courtroom on the second floor was converted into a public reading room. The building's restrained classicism makes a nice foil for the grandeur of the nearby Supreme Court building (OR14).

OR14 Louisiana Supreme Court and Orleans Parish Civil District Court (Louisiana Supreme Court and Fourth Circuit Court of Appeals)

1907–1909, Frederick W. Brown and A. Ten Eyck Brown in association with P. Thornton Marye. 400 Royal St.

After a variety of tenants, among them the Department of Wildlife and Fisheries, and then unoccupied for several years, this former court building has been renovated to serve a similar purpose. The Atlanta-based architects who won

OR14 Louisiana Supreme Court and Orleans Parish Civil District Court

OR17 Commercial Building (Louisiana State Bank)

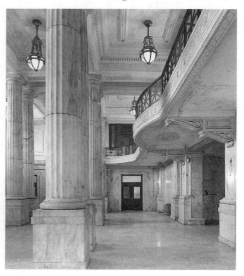

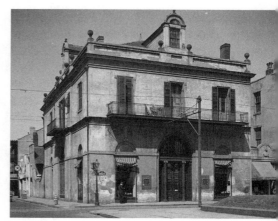

the design competition produced a Beaux-Arts showpiece inspired by late-nineteenth-century City Beautiful ideals. The symmetrical exterior has semicircular end walls that enclose courtrooms. White Georgia marble sheathes the first two floors; the upper two floors and the entablature are faced with glazed white terra-cotta. Ornamentation is rich and abundant, including marble brackets, terra-cotta pilasters, garlanded cartouches, upper-floor windows separated by two-story-high Ionic columns, and an ornate terra-cotta balustrade that surrounds the low-pitched roof. A grand staircase leads to the Royal Street entrance lobby, surrounded by twelve columns supporting the 30-foot-high ceiling. The single-height Chartres Street lobby features a magnificent curving double staircase. The courthouse was controversial when built and remains so today. It has been denounced not only for causing the demolition of an entire block of historic buildings but also for being too large and out of scale with the Vieux Carré. Its dazzling marble and glazed terra-cotta exterior has been criticized as flashy and thus incompatible with the muted tones and soft textures of the quarter's brick and stucco buildings. In the 1950s, at the suggestion of architect Richard Koch, magnolia trees were planted in an effort to hide the building. Despite all the objections, the courthouse reinforces the Vieux Carré as a living urban organism, able to encompass buildings that reflect all eras of its existence rather than being preserved in (nineteenth-century) aspic. Lyons and Hudson, Architects, undertook a renovation in the 1990s.

OR15 Omni Royal Orleans Hotel (Royal Orleans Hotel)

1956–1960, Curtis and Davis, Architects, and Koch and Wilson, Architects. 621 St. Louis St.

Although the Royal Orleans Hotel's developers initially selected a design by the firm of Curtis and Davis, the Vieux Carré Commission considered it too contemporary in appearance and thus incompatible with the quarter's historic character. Consequently, Koch and Wilson, a firm known for its restoration work, was hired to design the hotel's exterior, limiting Curtis and Davis to fashioning the interiors. In its general outline, height, and cornice line, the six-story hotel was modeled on J. N. B. de Pouilly's St. Louis Exchange Hotel, which previously stood on this site. Piers from that building's

granite arcade are incorporated into the Chartres Street elevation. The design features pedimented dormers, cast iron galleries, and fenestration that suggests rooms with high ceilings, although the seemingly tall windows of the second floor in fact extend over two low-ceilinged stories. The hotel has almost twice as many rooms as the St. Louis had. A mansard roof with dormer windows for additional rooms was added in 1963. Although the Royal Orleans is as tall as the courthouse opposite (OR14), its unobtrusive design, timid details, and historicized appearance enabled the hotel to avoid the controversies of that building. Additionally, nothing had been torn down to accommodate it because the site had been vacant for many years. However, the hotel raises crucial questions about issues of historical reproduction and deceptive period appearance.

OR16 Historic New Orleans Collection (Merieult House, Williams House)

1792. 533 Royal St.

This complex of brick buildings, all restored, includes the combination town house and ground-level commercial space on Royal Street that was built by Jacob Copperwaite for Jean-François Merieult; it was extensively remodeled in 1832 by Manuel J. De Lizardi, who substituted a granite front for the original ground-floor openings. Behind the main building at the rear of the courtyard is the house purchased in 1938 by General and Mrs. L. Kemper Williams, which was restored as their home by Richard Koch. The Historic New Orleans Collection now owns these properties, which are open to the public. The former Merieult House accommodates galleries and museum spaces; the Williams House, furnished in various period styles, includes Kemper Williams's former study, which is paneled with first-growth cypress from the family's lumber business in Patterson, St. Mary Parish.

OR17 Commercial Building (Louisiana State Bank)

1820–1822, Benjamin Henry Latrobe. 401 Royal St.

Latrobe was asked to design this bank shortly after arriving in New Orleans in January 1819 to complete the waterworks he had designed in 1811, which his recently deceased son, Henry, had been supervising. The bank would be La-

trobe's last project, for he died in 1820 from yellow fever, the same disease that had killed his son. Benjamin Fox completed the building. Exterior walls are finished with an ochre-colored stucco, lightly scored to resemble masonry, and the entry is flanked by two Ionic columns painted to resemble a veined green marble. The hipped roof and dormers were added after 1822. The discreet facade blends well with the urban streetscape, giving no hint of the wonderful space within. A shallow brick dome tops a central circular banking room, which is flanked by smaller vaulted spaces. The only ornament is a rosette in the center of the dome; the curved, uninterrupted plastered surfaces of walls and vaults provide a fluid, voluptuous series of spaces. The plan is similar to Latrobe's demolished Bank of Pennsylvania of 1799 in Philadelphia. A semicircular bay housing the director's office projects into what was once the rear yard, in which were located the slave quarters and the carriage house, entered through gates on Conti Street. The cashier's living quarters were on the second floor. The building housed many different tenants in its long history, including the Royal Turkish Bath Company for Ladies and, for many years, an antiques shop.

Several financial institutions were located near this corner of the Vieux Carré, including the former Bank of Louisiana diagonally opposite (OR18). The former Banque de la Louisiane (1805) at 417 Royal Street has been converted into a restaurant. A building (339 Royal Street) of c. 1800 attributed to Barthélemy Lafon was occupied by the Planters' Bank from 1811 to 1820 and by the Bank of the United States from 1820 to 1836; it is now an antiques shop with modern plate-glass windows on the ground floor.

OR18 New Orleans 8th District Police Station (Bank of Louisiana)

1826, Bickel, Hamblet and Fox. c. 1863, entrance portico, James Gallier, Jr. 334 Royal St.

After this massive rectangular two-story building of stucco-covered brick was damaged by fire in 1863, Gallier added a Tuscan entrance portico. He also gave the bank a much more imposing appearance by replacing the Ionic capitals with weightier Tuscan capitals on the two-story half columns of the bank's exterior. A prominent cornice and balustrade adorned with urns on rectangular pedestals complete

the ornamentation of the building. The fence and gates, based on Robert Adam's gates to Lansdowne House, London, were produced by a New York company in 1827. After the bank's assets were liquidated in 1867, the building served as the state capitol from 1869 to 1870, after which it housed an auction exchange, a concert hall, a saloon, a criminal court, and a tourist office.

OR19 Commercial Building

1866, Gallier and Esterbrook. 111 Exchange Pl.

Built by the Bank of America as a commercial rental venture, this is one of only two surviving cast iron facades in New Orleans (see OR67). Cast iron facades, as one advocate stated, had "strength, durability, and economy, and unequaled advantages in ornament . . . and [were] absolutely secure against danger from fire and lightning." They gained instant credibility in mid-nineteenth-century America's rapidly expanding commercial districts, although it was shortly discovered that cast iron melted in fires. Prefabricated and bolted together on site, window frame to window frame, the cast iron facade provided a prestigious appearance at a fraction of the cost and time of masonry construction. The building contract described the five-story facade as Venetian Renaissance, a popular mid-century style for commercial buildings. Designed by James Gallier, Jr., and Richard Esterbrook (1813–1906) and cast by the New Orleans firm of Bennett and Lurges, the facade exploits the decorative potential of cast iron with an arcade of fluted Corinthian columns at ground level and four progressively smaller rows of arched windows with projecting cornices above. Spandrels are embellished with foliate designs and acanthus leaf brackets pinned at the first and fifth levels. Charles Cavaroc and Company, wine merchant, was a long-term occupant of the building.

OR20 Dixie Parking Garage

1962, Seiferth and Gibert. Dauphine and Iberville sts.

Planned to serve shoppers at the Canal Street stores one block away, this witty building had to conform to the Vieux Carré Commission's requirement for architectural compatibility with existing buildings. Taking their cue from the decorative cast iron galleries throughout the quarter, the architects screened each floor of

parked vehicles with elaborate cast iron grilles. The garage and its identical addition of 1965 give a nod to modern times in the smooth horizontal expanse of wall separating each floor. The ground-level shops also follow Vieux Carré prototypes.

OR21 Hermann-Grima House

1831, William Brand. 820 St. Louis St.

Samuel Hermann, a German-Jewish immigrant merchant and commission banker, chose architect-builder William Brand (1778–1849) in 1831 to design his house. Brand, who arrived in New Orleans from Virginia about 1805, produced a subtle blend of American and Creole features in this freestanding two-and-one-half story, end-gabled house. Built to the front property line, the house has a typical American en-

OR21 Hermann-Grima House

OR22 Madame John's Legacy

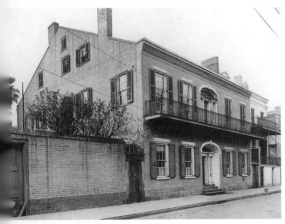

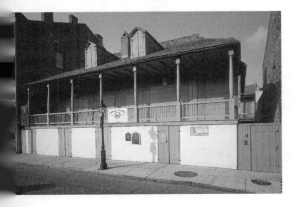

trance raised four steps above the sidewalk to a Federal doorway, set between slender Ionic columns with glass side panels and topped by an entablature and fanlight. On the second floor, an almost identical door opens onto a balcony. Windows are the double-hung American type on the first floor and triple-hung on the second, and the roofline is defined by a sawtooth-band cornice. Exterior symmetry reflects the American-style central-hall plan with flanking front rooms; the parlor features a hand-carved frieze. However, the rear second floor embraces the Creole loggia (now enclosed) between cabinets. The house is constructed of Philadelphia red brick laid in Flemish bond and painted pink with white mortar joints.

At the rear, a galleried, three-story brick service wing, which includes an open-hearth kitchen, extends along one side of the large courtyard. Paved with flagstones that came from England as ship ballast, the courtyard has planting beds that were raised to provide drainage; also there is a replica of the original cast iron cistern. In 1844, Judge Felix Grima acquired the house and in 1850 built the adjacent stables. It is recorded that he owned fifteen slaves and employed one free woman of color. His descendants sold the house in 1924 to the Christian Women's Exchange, an organization active in charity work, which was responsible for its restoration in 1965. The house was opened to the public in 1971.

OR22 Madame John's Legacy

c. 1730. 1789, rebuilt. 632 Dumaine St.

This complex, including a house, kitchen, and *garçonnière* organized around an L-shaped courtyard, is an important example of Creole architecture. Originally freestanding and set farther back on the lot, the house was reconstructed by the Anglo-American builder Robert James from materials salvaged after the city-wide fire of 1788. In this residence for the Spanish officer Don Manuel de Lanzos, Jones followed the prefire design, incorporating the original foundations, walls, and iron hardware. The house is raised on a brick basement with heavy batten doors that lead to service rooms and a loggia at the rear, framed at each end by cabinets. The upper floor, of brick-between-posts construction and covered on the outside with wide beaded horizontal boards, is shaded by a six-bay gallery supported on turned,

OR22 Madame John's Legacy, ground-floor and first-floor plans

shaped colonnettes. The double-pitched roof, which is over Norman trusses, has two dormer windows. Rooms are arranged en suite without hallways, in the Creole fashion. A restoration in the 1990s returned the house to the original paint colors: white at first level, moss green doors, and oxblood red sides. Believed to have been built by sea captain Jean Pascal, the house was occupied by his widow until 1771. Its name is said to derive from George Washington Cable's short story *Tite Poulette*, which is about a quadroon called Madame John. Artist Morris Henry Hobbs lived here in the early 1940s. The last owner, Stella H. Lemann, bequeathed the residence to the Louisiana State Museum in 1947, which maintains it as a house museum.

OR23　Miltenberger Houses

1838. 1858, cast iron galleries. 900–910 Royal St.

The cast iron galleries added to this group of brick three-story buildings illustrate the transformation undergone by many quite plain buildings in the Vieux Carré in the mid-nineteenth century. Ornamental cast iron was manufactured by several companies in New Orleans, reaching its peak of popularity in the 1850s. Complex and naturalistic patterns were preferred, such as these representing oak leaves and acorns. The houses, acquired by the Miltenberger family in 1854, were occupied by the Miltenberger brothers, who were engaged in the ironwork industry. The raised tomb for the Miltenberger family in Greenwood Cemetery is made entirely of cast iron.

Opposite (915 Royal Street) is one of New Orleans's two cast iron fences with a cornstalk pattern; the other surrounds the Short House in the Garden District (OR117). The design of c. 1850 represents cornstalks entwined with morning-glory vines. From this spot on Royal Street looking toward the Central Business District, a view of the 51-story One Shell Square building makes abundantly clear the sharp contrast between the low-rise, highly textured surfaces of the Vieux Carré and the crisp verticality of the business district just a few blocks away.

OR24　Lafitte's Blacksmith Shop and Bar

c. 1795. 941 Bourbon St.

Although often touted as a typical Creole or Vieux Carré structure, the Blacksmith Shop, unlike the Dolliole-Masson House (OR25), is inauthentic on many counts. Partial removal of the exterior stucco reveals the brick-between-posts construction. Although removal allows us to see this old construction method, it is not historically correct, for without this protective barrier, the wood frame and soft bricks would have rapidly deteriorated in the New Orleans climate. Additionally, the building has lost the roof extension that shaded the walls and has acquired dormers, and the original four-room interior has been totally altered. The building's purported history is also false; there is no evidence that the pirates Jean and Pierre Lafitte had anything to do with the building or even used it as a cover for their smuggling activities. But these tales and the building's overly quaint appearance continue to make it a highly popular tourist attraction, representing, perhaps in microcosm, the Vieux Carré's mystique.

OR25 Dolliole-Masson House

1805, Jean-Louis Dolliole. 933 St. Philip St.

Entrepreneur Jean-Louis Dolliole (1779–1861), a free man of color, constructed this fine example of a four-bay, hip-roofed Creole cottage with brick-between-posts construction: two rooms wide and two deep, with small cabinets at the rear, and a central chimney. A roof extension (*abat-vent*) shades the facade, and shutters cover the doors and windows. The house resembles Benjamin Henry Latrobe's description of a typical Creole cottage, written in his journal in 1819: "The roofs are high, covered with tiles or shingles, and project five feet over the footway, which is also five feet wide. The eaves therefore discharge the water into the Gutters. . . . These one stories houses are very simple in their plan. The two front rooms open into the street with french Glass doors. Those on one side are the dining and drawing rooms, the others chambers. . . . The french and continental Europaeans [*sic*] . . . employ the room they have, to more advantage, because they do not require so much space for passages. . . . The french stucco the fronts of their buildings and often color them." In 1981, architect Frank Masson restored the house with as much historical accuracy as possible, including colors, such as the mango yellow exterior. Dolliole built a number of houses in the Creole sections of New Orleans and contributed financially to the construction of St. Augustine Church (OR39).

OR23 Miltenberger Houses

OR25 Dolliole-Masson House

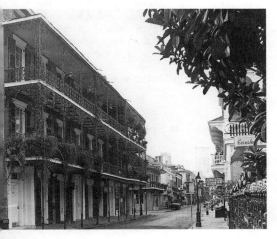

OR26 Thierry House

1814, Arsène Lacarrière Latour and Henry B. Latrobe. 721 Governor Nicholls St.

This one-story house of plastered brick was built for Jean Baptiste Thierry, editor of the newspaper *Le Courrier de la Louisiane*. According to restoration architect Samuel Wilson, Latour (c. 1770–1839) was responsible for the rear with its loggia and cabinets, and Latrobe (1792–1817) designed the Doric portico with segmental arches at the front. Wilson regarded the portico as the oldest residential use of the Greek Revival style in New Orleans. The facade's severity and planar undecorated surfaces are reminiscent of the contemporary work of John Soane in England. The house is set back rather than flush with the sidewalk, as are most Vieux Carré buildings. Latour and J.-H. Laclotte (see OR12) formed an architecture and engineering firm c. 1810 and operated a school for drawing, architecture, and decoration.

OR27 Lalaurie House

1831. 1140 Royal St.

Although the house was built for Edmond Soniat Dufossat, it is known as the "Haunted House" because of its second owner, the thrice-married Delphine Macarty de Lopez Blanque Lalaurie, then wed to the physician Louis Lalaurie. Rumors abounded that she tortured her slaves, and in 1834, during a house fire, shackled and starving slaves were discovered, prompting an enraged mob to sack the building. The Lalauries fled to France. Legends arose that the house was haunted by the spirits

of the tortured slaves. In 1837, Pierre Trastour acquired the two-story stuccoed brick house and added a third floor with arched windows and a cupola. A long, narrow vestibule, its barrel vault adorned with plaster rosettes, leads to an entrance door elaborately carved with garlands, flowers, birds, and Apollo in his chariot. Inside, a curved staircase rises to the principal living quarters on the second floor, where double parlors are decorated with Corinthian pilasters and plaster floral motifs drawn from the designs of French architects Charles Percier and Pierre Fontaine. Surviving drawings by Gallier and Esterbrook suggest that they may have renovated the house in 1865. The house later served as a girls' school, a gambling house, and, in the 1930s, as a home for indigent men. After Dr. Russell Albright purchased the house, Koch and Wilson undertook renovations in 1976 and 1980. The house is now subdivided into apartments.

OR28 James Gallier House

1857–1860, James Gallier, Jr. 1132 Royal St.

The younger James Gallier designed this two-story residence for his wife, Josephine Aglae Villavaso, and four daughters. Constructed of stuccoed brick, rusticated and painted to resemble granite on the ground floor, the mildly Greek Revival facade is softened by a two-story,

rosette-patterned cast iron gallery. In his plan, Gallier combined the Creole carriageway leading back to a courtyard with the American preference for a staircase in the side hall rather than on the rear gallery. A double parlor divided by a screen of decorative pilasters and square columns is situated on the ground floor; four bedrooms occupy the second floor, and the dining room is in the service wing. Gallier's home possessed all the architectural amenities and fashions of the upper-middle-class lifestyle at that time, including a ventilation system, plumbing, hot and cold running water on the second floor, a copper bathtub, a cast iron cooking range, and closets. The present exterior cistern (c. 1850) was moved here from a St. James Parish plantation. A wing for four servants, including a kitchen, is attached to the rear of the house. Gallier maintained an office in the upstairs hall, illuminated by a skylight. Architectural drawings and house records made possible an accurate restoration of the building in 1971 by Henry Krotzer of Koch and Wilson, with interiors by Samuel Dornsife. It is now a house museum open to the public.

OR29 Croissant d'Or Patisserie

c. 1870. 617 Ursulines St.

In the late nineteenth century, a large number of immigrants from Sicily settled in the Vieux

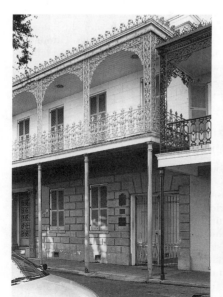

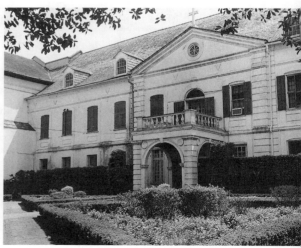

OR28 James Gallier House

OR30 Ursuline Convent

Carré. Angelo Brocato opened a confectionery and ice cream parlor in this stuccoed brick building in 1907 and tiled its interior in the style of those in his hometown of Palermo. Recreating the archways of traditional ice cream parlors, he then divided the space into two salons to separate the sexes. The walls are entirely covered with glazed tiles, including, just below the ceiling, a charming low-relief border of pastel-colored garlands. The exterior of the first floor has been altered. Another early-twentieth-century tiled building is Casamento's Restaurant (1919; 4330 Magazine Street), whose shiny white tiles include decorative bouquets.

OR30 Ursuline Convent

1749–1753, Ignace François Broutin. 1845, church, J. N. B. de Pouilly. 1100 Chartres St.

French-born engineer-in-chief Ignace François Broutin (1690–1751) designed this second convent for the Ursuline nuns in 1745, but construction did not begin until 1749, after the disintegration of their first building, completed in 1734. This convent, constructed of *colombage* and brick with a white stucco finish, was built by plantation owner Claude Joseph Villars Dubreuil, who was also responsible for the first levees in the city. The convent is the only building surviving in New Orleans from the era of French colonial rule. The facade is quite simple, articulated by a slightly projecting central pavilion with a pediment and segmental-arched casement windows and a steep hipped roof, which curves at its edges and is pierced by small dormers. The small entrance portico was added in the 1890s; the original front entrance faced the river. Inside is a cypress staircase with wrought iron railings, both from the earlier convent.

Nine Ursuline nuns, one novice, and two postulants arrived in New Orleans in 1727 to operate a new hospital. The nuns also opened a school and orphanage for girls. In the 1820s, the nuns relocated downriver, and the convent served until 1899 as the archbishop's residence, for which, in 1845, Bishop Antoine Blanc commissioned a new chapel. It features a gabled front facade, given a classical effect by the addition of four pilasters and moldings around the gable. Following the hurricane of 1915, the chapel's French glass was replaced with stained glass by the Emil Frei Art Glass Company of St. Louis, and a sanctuary was added. Renamed several times over the years, for a time as Our Lady of Victory Church, it is now known once again as St. Mary's Church. In 1973, the convent was restored and now houses the Historical Archdiocesan Archives. The parterre garden, replanted in 1954, follows the design of the botanical garden of 1731.

OR31 Beauregard-Keyes House

1826, François E. Correjolles. 1113 Chartres St.

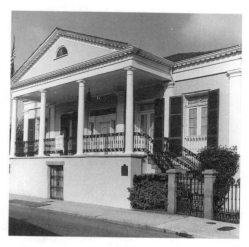

Auctioneer Joseph Le Carpentier purchased this lot from the Ursuline nuns and hired Baltimore-born Correjolles (1795–1864) to design his house. James Lambert was the builder. After 1833, the house had a succession of owners and residents, among them Confederate General P. G. T. Beauregard (1818–1893), who rented rooms here for eighteen months in 1866–1868. From 1944 to 1955, novelist Frances Parkinson Keyes leased the house, where she wrote a book about Beauregard, *Madame Castel's Lodger* (1961). She began restoration of the house with Richard Koch in 1945 and in 1955 created the Keyes Foundation, which acquired ownership at her death in 1970. Constructed of plastered brick, the raised house combines the American central-hall plan with the Creole open gallery, or loggia (now enclosed), flanked by cabinets at the rear. At the front, curved granite twin staircases rise on either side of a pedimented, four-columned Tuscan portico to double doors that open to the principal living area. For its time, this is an unusual and sophisticated design within the Vieux Carré; the newly fashionable classical elements were perhaps influenced by Correjolles's East Coast background. The side

walled garden is laid out in parterres, based on an 1865 drawing in the city's Notarial Archive that shows its design. The Garden Study Club of New Orleans maintains the garden, which can be viewed from Chartres Street. The house is open to the public.

OR32 **Richelieu Motor Hotel** (Lanata Houses)

1845, J. N. B. de Pouilly. 1206–1234 Chartres St.

These five Greek Revival houses are a type more commonly found in the Lower Garden District. Two stories high, with two-story galleries on slender piers, the houses are distinguished by an austere simplicity of form, Greek Revival shoulder molding around the windows and doors, and the height of the interior rooms, unusual within the scale of the Vieux Carré. The exteriors are brick stuccoed and scored to resemble stone. Their setback from the property line with small gardens in front makes their elegant severity easier to view. The wooden fence extending along the front of the houses is new. Despite the conversion of one house to a hotel and the others to condominiums, the row has retained its character.

Creole Faubourgs

New Orleans's rapid expansion in the late eighteenth century led to growth beyond the Vieux Carré, across Rampart Street to Faubourg Tremé and downriver to Faubourg Marigny, Bywater, and Holy Cross. Tremé, bounded roughly by North Rampart and Canal streets and North Broad and Esplanade avenues, was platted in 1812 by city surveyor Jacques Tanesse on former plantations, including that of Claude Tremé. Marigny, bounded by Esplanade and St. Claude avenues, Press Street, and the river, was laid out by Barthélemy Lafon for Bernard de Marigny in 1806 in accordance with a plan drawn up earlier that year by engineer Nicolas de Finiels, which called for twelve houses to a block and a public square, Washington Square. Both Tremé and Marigny were populated mainly by free people of color, many of whom came to New Orleans from St.-Domingue (Haiti) and Cuba.

Bywater and Holy Cross were new names for their neighborhoods; the former was the name of the telephone exchange, and the latter was the name of a schoool. Bywater, between Franklin and St. Claude avenues, the Industrial Canal, and the river, housed primarily German, Irish, and Italian immigrants, who arrived in great numbers beginning in the 1840s. The Beaux-Arts classical memorial arch (1919) in Macarty Square commemorates local war veterans. Press Street, originally Cotton Press Street, was the city's first thoroughfare paved with concrete, built to support the weight of the huge cotton presses. Holy Cross, once an area that housed truck farmers, dairies, and commercial gardeners, lies downriver from Bywater across the Industrial Canal. Jackson Barracks (OR51) forms the downriver boundary of the neighborhood and of New Orleans.

All these neighborhoods have retained the intimacy and small-scale character of their nineteenth-century origins. The houses in Tremé and Marigny are mostly Creole cottages and shotgun houses, whereas the latter are characteristic of Bywater and the less dense Holy Cross. Front yards are infrequent in Tremé and Marigny; for the most part, houses front directly on the street, with steps (or stoops) for sitting outside. Gardens are more common in Bywater and Holy Cross. In all these neighborhoods, some street corners are still occupied by commercial property that combines a store at ground level

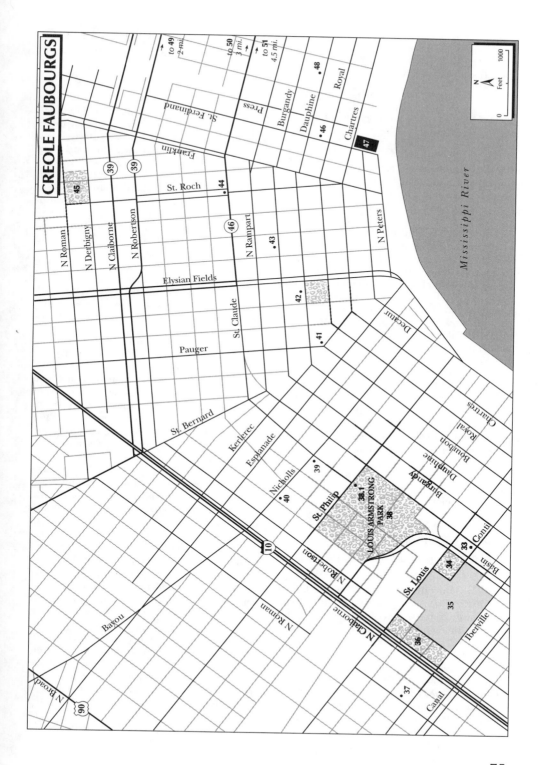

CREOLE FAUBOURGS

to 49
2 mi.
to 50
3 mi.
to 51
4.5 mi.

St. Ferdinand
Press
Burgandy
•48
Dauphine
•46
Royal
Chartres

Franklin
39
39
St. Roch •44

N Roman
N Derbigny
N Claiborne
N Robertson
N Rampart
46
•43
N Peters

Elysian Fields

St. Claude
42•

Pauger
•41

Decatur

Mississippi River

St. Bernard

Kerlerec
Esplanade
Nicholls
39•
•40

St. Philip
38.1•
38•

LOUIS ARMSTRONG PARK

Burgandy
Dauphine
Bourbon
Royal
Chartres

33
•Conti

St. Louis
34
35

36
Iberville

N Robertson
N Roman
N Claiborne

10

Bayou

N Broad

90

•37

Canal

N

Feet
0 1000

75

and a residence above, with deep canopies to shelter pedestrians. The river edge maintains its industrial nature, although the surviving rice, sugar, and cotton-press sheds have been converted for other uses.

OR33 Our Lady of Guadalupe Chapel
(Mortuary Chapel)

1826–1827, Gurlie and Guillot. 411 N. Rampart St.

Because it was believed that corpses laid out for burial were a source of contagion for yellow fever, the wardens of St. Louis Cathedral established a mortuary chapel outside the original city limits. Burial took place in St. Louis Cemetery 1 (OR34) behind the chapel. The triple-arched facade of this stuccoed brick chapel rises to a curved parapet and square belfry tower. Over time, the chapel assumed the duties of a parish church, celebrating Mass and providing baptisms and weddings. By 1873, the chapel served the Italian immigrants settling in this area and was dedicated to St. Anthony of Padua. In 1903, the Dominicans took over the chapel and replaced the tower's dome with a steeple and clock. Subsequently, the Oblates of Mary Immaculate, from San Antonio, took charge of the chapel in 1918. With the expectation of a large Mexican congregation (which never materialized), they renamed it Our Lady of Guadalupe in honor of Mexico's patron saint. In the 1920s, Diboll and Owen refurbished the chapel, and the Emil Frei Art Glass Company of St. Louis made the stained glass windows. A replica of the grotto at Lourdes was added in 1924. A shrine to St. Jude, the patron saint of hopeless causes, was installed in 1935.

OR34 St. Louis Cemetery 1

1789. Basin St. (bounded by Conti, St. Louis, and Tremé sts.)

Travel writer Edward Henry Durell (Henry Didimus), who visited New Orleans in the mid-nineteenth century, described the local practice of burial in his book *New Orleans As I Found It* (1845): "This method of above ground tomb is adopted from necessity; and burial under ground is never attempted, except . . . for the stranger without friends or the poor without money, and they find an uncertain rest, for the water, with which the soil is always saturated, often forces the coffin and its contents out of its narrow and shallow cell, to rot with no other covering than the arch of heaven." Established

in 1789 just beyond the Vieux Carré's boundary, St. Louis Cemetery 1 is crowded with above-ground tombs, separated only by narrow and tortuous paths. Although in-ground burial was common in New Orleans's early years, above-ground tombs reflect the city's French and Spanish heritage, and their continued use is probably a result of periodic flooding. Most of the tombs are simple rectangles in shape, taller than they are wide, with flat, curved, or gable roofs. Constructed of brick, the tombs were covered with plaster and then whitewashed, sometimes tinted with color ranging from yellow ochre to red. The tombs usually contained space for more than one body, being intended for use by generations of a family. When a new burial was necessary, the bones of the current occupant were swept to the rear of the tomb or placed in an ossuary in order to provide room for the new interment. The cemetery, like the others in New Orleans, contains a few multi-story tombs that accommodate several burial vaults. Called society tombs, they belonged to fraternal or benevolent societies and were intended to ensure the decent burial of their members. The high brick walls enclosing the cemetery contain wall vaults (or *fours*) on their inner surfaces, with openings covered by brick or marble slabs. These vaults were a less expensive alternative to the freestanding tomb. Sale of the vaults was a source of revenue for the city. Benjamin Henry Latrobe designed the tomb for Governor William C. C. Claiborne (1811), who later was reburied in Metairie Cemetery. Benjamin Latrobe and his son Henry are buried in the ground in the cemetery's rear in an area, originally outside the cemetery, designated for those who were not Roman Catholic. Etienne Boré (1741–1820), sugar refiner and first mayor of New Orleans, and Marie Laveau (c. 1804–1881), a voodoo practitioner, are both buried here. On every All Saints' Day (November 1), families visit their ancestors' tombs, rewhitewash them if they are stucco-finished, and decorate them with flowers. The nonprofit preservation organization Save Our Cemeteries conducts guided tours here, using the fees to restore the ancient tombs in this and other historic cemeteries in New Orleans.

OR35 Iberville Housing Project

1939–1941, Herbert A. Benson, George H. Christy, and William Spink. Iberville St. (between Basin and N. Robertson sts.)

Iberville is one of three low-income housing projects built in New Orleans shortly after passage of the U.S. Housing Act of 1937 and the subsequent formation of the Housing Authority of New Orleans, which would supervise all low-income housing in the city. Iberville and the St. Thomas project (the latter was demolished in 1999) were planned for white residents, and the C. J. Peete Housing (Magnolia Street; now partially demolished) for African American residents, although all three now accommodate mostly African American families. Built on a twenty-two-acre site, Iberville was planned for a population of approximately 2,000, to be housed in 858 apartments in seventy-five brick buildings. Construction was federally funded, requiring the use of durable materials. These substantial, nicely proportioned brick buildings were designed to be in scale with the city's row houses, and each unit was provided with a front stoop or balcony, essential during the hot summers. However, the buildings' uniformity of design and detail in a city that consists primarily of diverse styles of wooden houses has made the three projects stand out like a sore thumb. Also a drawback was the elimination of through roads, and, in common with many housing projects across the nation, the landscaped grounds are not adequately maintained.

Iberville is located on the site of Storyville, New Orleans's notorious redlight district, where prostitution was legal until 1917. When the United States entered World War I, the military authorities, fearful of the spread of venereal disease, pressured cities with large numbers of military personnel, including San Francisco, Boston, Kansas City, and New Orleans, to ban prostitution. Nevertheless, Storyville continued to operate illegally, although the area became increasingly blighted and, beginning in 1939, was razed for the Iberville housing project.

OR36 St. Louis Cemetery 2

1823, attributed to Antoine St.-Philippe Le Riche. N. Robertson St. (bounded by Iberville, N. Claiborne, and St. Louis sts.)

Originally laid out as one continuous strip with a broad central avenue and narrower parallel

OR36 St. Louis Cemetery 2, Caballero tomb (middle)

side aisles, St. Louis Cemetery 2 was divided into three almost square units when Bienville and Conti streets were cut through. Although this partition diminished the monumental aspect of the central avenue, the arrangement of straight aisles lined with tombs still gave each of the cemetery's squares a formal order. In the early nineteenth century, cemetery design in the United States was profoundly influenced by the new Père Lachaise Cemetery in Paris, which combined formal avenues and winding paths, all lined by handsome marble tombs. In New Orleans, where space was limited, cemetery planners adopted the tightly packed straight avenues of Père Lachaise rather than its spacious gardenlike aspects. Although not strictly enforced, the social distinctions that existed in life were carried into death in the designation of sections for different religious faiths and ethnic groups. Many of the most sought-after tomb designers in nineteenth-century New Orleans were French immigrants, among them Paul H. Monsseaux and Prosper Foy, whose son Florville Foy followed in his father's footsteps. Some of this cemetery's most striking tombs were designed by J. N. B. de Pouilly, who probably introduced temple-fronted tombs to New Orleans, in the style of those at Père Lachaise. De Pouilly's Peniston tomb (1842) is a good example. De Pouilly's sketchbook (now in the Historic New Orleans Collection) reveals his interest in tomb design. Particularly noteworthy is his Gothic Revival tomb for the Caballero family (1860), with a trefoil arch in each gable, crockets, and finials. With tombs neatly aligned along straight avenues and many surrounded by low cast iron fences, St. Louis Cemetery 2 conveys the appearance of a city in miniature. Each of the

cemetery's squares is surrounded by a high brick wall lined with wall vaults, in one of which de Pouilly's simple tomb is located.

OR37 St. James African Methodist Episcopal Church

1848–1851. 222 N. Roman St.

This attractive small church, established by free people of color, was built in the mid-nineteenth century, but its present Gothic appearance dates mostly from the early twentieth. In a renovation of 1903, Diboll and Owen replaced the pediment with a parapet ornamented with a blind arcade, added an openwork bell tower with a steeple in the center of the facade and pinnacles at its corners, and resurfaced the brick facade with stucco textured and scored to resemble rusticated masonry. The ornamental pressed metal ceiling was also added at this time. New Orleans police closed the church from 1858 to 1862 after the Reverend John M. Brown allowed slaves to attend—an act prohibited in the state charter issued to the church—and church members advocated an end to slavery. During the Civil War, the church was used as the headquarters for a company of African American Union soldiers under the command of Colonel James Lewis. In 1865, the first annual A.M.E. Louisiana conference was held in the church. From the late 1950s to the 1960s, St. James was a center for civil rights activities.

OR38 Louis Armstrong Park

1974–1979, Robin Riley; Cashio-Cochran and Associates; Mathes, Bergman and Associates. N. Rampart St. (bounded by Basin, N. Villere, and St. Philip sts.)

Louis Armstrong Park, planned as an urban renewal project, was established on a thirty-two-acre site covering fourteen blocks, nine of which were cleared of houses. This necessitated closing a section of St. Claude Avenue, a main thoroughfare in the area. Named for the famous New Orleans musician, the park includes a statue of Armstrong by the African American artist Elizabeth Catlett. The park, modeled on the Tivoli Gardens in Copenhagen, Denmark, was picturesquely laid out with a lagoon, hillocks, and three hundred trees. From the start, the project was controversial because it ruthlessly swept away a historic neighborhood, including the bars where jazz musicians had played. When the park was completed, it was perceived as unsafe and therefore was little used, making it even less safe. Armstrong Park also incorporates the site of the former Congo Square, where, as early as the 1740s, slaves sold their homemade wares and gathered socially. Among the significant structures within the park are one of the red and white Mediterranean Revival pumping stations of the Sewerage and Water Board of New Orleans (see OR152), Favrot and Livaudais's Municipal Auditorium of 1929, and the Mahalia Jackson Center for the Performing Arts (1973), designed by Mathes, Bergman and Associates with Harry Baker Smith. The park will gain new life when the National Park Service completes the New Orleans Jazz National Historical Park within its boundaries.

OR38.1 Perseverance Hall No. 4 (Loge La Perseverance)

1819–1820, Bernard Thibaud. Louis Armstrong Park (enter on St. Philip St.)

Refugees from St.-Domingue and Cuba made up most of the original membership of this Masonic lodge, chartered in 1810, which is the oldest lodge in Louisiana. The tall rectangular building of stuccoed brick is articulated with shallow pilasters on both stories of its narrow facade. Alterations in 1850 removed much of the interior millwork, but the main staircase, musicians' gallery, and entrance doors are original. The hall will become an educational and performance venue for the national park. Moved

OR38.1 Perseverance Hall No. 4 (Loge La Perseverance)

to this site and located behind and to the right of the lodge is the Rabassa–De Pouilly House (c. 1825), a four-room cottage with raised galleries and rear cabinets, formerly the residence of J. N. B. de Pouilly, which will house the national park's office. Other adjacent structures will accommodate research and multimedia centers.

OR39 St. Augustine Church

1841–1842, J. N. B. de Pouilly. 1141 St. Claude Ave.

Built by Ernest Godchaux and Pierre Vidal to designs of de Pouilly, the church occupies land donated by the Ursuline nuns for a church to honor their patron saint, St. Augustine of Hippo. Bishop Antoine Blanc contributed most of the funds for construction. The facade is quite spare, articulated only by shallow pilasters and, above the central door, a row of narrow rectangular wrought iron grilles, over which is a semicircular window, and a circular opening in the pediment. These elements, combined with the flat, two-dimensional look of the facade, give the church an austere, abstract appearance that makes it seem almost modern. The asymmetry resulting from the bell tower on one side, added in 1858, reinforces that impression. In a restoration of 1926, Weil and Bendernagel gave the brick church a plastered and scored exterior finish. They also installed

stained glass windows depicting saints of special significance to the French, which were manufactured in the Munich studio of the Emil Frei Art Glass Company of St. Louis. When built, the church served a population of about equal numbers of free people of color and French-speaking whites; seating along the walls was provided for slaves. In 1842, Henriette Delille (1813–1862), a free woman of color, founded the Sisters of the Holy Family here as the first exclusively African American order of nuns in New Orleans and one of the first in the nation. The nuns devoted their lives to helping the elderly and the sick and to educating African American children.

OR40 New Orleans African American Museum of Art, Culture, and History
(Simon Meilleur House)

1828–1829, perhaps William Brand or Joseph Correjolles. 1418 Governor Nicholls St.

Located on the old road to Bayou St. John and the site of the first brickyard in New Orleans, the raised house of stuccoed brick with a six-columned wooden gallery was built for the keeper of the city jail, Simon Meilleur, and his Philadelphia-born wife, Catherine Flack. The house was restored in the 1990s by Williams and Associates with Eugene D. Cizek, who preserved the original central-hall layout and exterior appearance. They reconstructed the slate roof and the two roof dormers, destroyed in a fire in 1911, and re-created the decorative cast iron gallery railing. A central entrance door is framed by delicate Ionic columns and side lights and crowned by a fanlight. The house is surrounded by a large garden.

OR41 Flettrich House

c. 1830. 1445 Pauger St.

Integrating Creole and American forms, this house represents southern Louisiana's unique and creative solution to local traditions and new fashions and influences. One and one-half stories in height, the stucco-covered house, of brick-between-posts construction, is shaded by an *abat-vent* on iron brackets, and a small single dormer with pilasters and arched top pierces the gable roof. However, the slightly recessed central entrance with fanlight and the Ionic pilasters marking the ends of the facade reveal the builder's taste for stylistic innovation. The

house was built for commission merchant Antoine Boutin, but financial problems forced him to sell it to W. C. C. Claiborne II in 1845. On the opposite side of the street (1436 Pauger Street) is a fine example of earlier traditions, a stucco-covered Creole cottage of brick-between-posts construction built by Jean-Louis Dolliole for his family in 1820. Its charm also lies in its unusual outline, which exactly fits the configuration of the wide-angled corner site.

OR42 Claiborne House

1855. 2111 Dauphine St.

Splendidly located facing Washington Square, this two-story Greek Revival house was built by James Stewart for W. C. C. Claiborne II, son of Louisiana's first American governor, and his Creole wife, Louise de Balathier. This block of Dauphine Street, with its varied residential types ranging from this American-influenced house to the slightly earlier Creole cottages, demonstrates the shifts in fashion occurring at the time New Orleans was beginning to expand beyond the boundaries of the Vieux Carré. Stuccoed on the exterior, the brick house has a central entrance recessed between Ionic pilasters, a narrow iron balcony across the second floor, a cornice outlined by a continuous row of dentils, and a parapet disguising the gently sloped roof. A two-story brick kitchen wing extends to the rear. Inside, the staircase was located in a separate small hall at the rear and to one side of the central hall.

OR43 Sts. Peter and Paul Church

1860, Howard and Diettel. 2317 Burgundy St.

The Redemptorists commissioned Henry Howard, then in partnership with Dresden-born Albert Diettel (1824–1896), who had arrived in New Orleans in 1849, to build this church for a mainly Irish Catholic congregation. Exploiting fully the sculptural potential of brick construction, the architects employed brick hood moldings with curved profiles to outline the round-arched windows and manipulated brick into elaborate corbels and moldings and a shaped parapet. Two substantial towers, one square and the other octagonal, squeeze the facade between them. The towers are of different heights; the taller was originally even higher than at present. A fire in 1911 caused the loss of its spire, and it was then lowered 25 feet in

1934, when its weight caused the tower to sag. The sloping courses of brick at the tower's outer corner reveal the problem, and the tower leans slightly to the left front. Inside the church, a flattened barrel vault and attached columns between the arches of the nave arcade establish a smooth rhythm toward the altar. The stained glass windows featuring religious figures were made in 1908 by Flanagan and Biedenweg of Chicago. The adjacent school, designed in 1899 by New Orleans architect Allison Owen (1869–1951) of Diboll and Owen (Collins C. Diboll, 1868–1936), repeats the narrow vertical forms of the church. The Archdiocese of New Orleans closed the church in 2001.

OR44 St. Roch Market

1837, Joseph Pilié. 2381 St. Claude Ave.

Located on the neutral ground of St. Roch Avenue, the market, constructed by William Bell, offered fruits, vegetables, fish, and meat sold by individual vendors from open stalls. The building's original materials—iron frame and brick lower walls—have been somewhat modified over the years. Iron columns with inverted bell capitals support the roof, which carries a ridge ventilator with louvered windows. The market was enclosed when modernized by the WPA in 1937. Although now privately owned, the market continues to sell groceries to neighborhood residents, whereas a majority of the other surviving markets in the city have been adapted for other uses (see OR132).

OR45 St. Roch Cemetery and Chapel

1876. 1725 St. Roch Ave.

The cemetery and its chapel are the only ones in the United States dedicated to St. Roch, the fourteenth-century French saint who ministered to plague sufferers. Father Peter Thevis of Holy Trinity Church purchased the land to build the cemetery and chapel in thanks to St. Roch for saving his congregation from the devastating yellow fever epidemic of 1867. The interior of the diminutive stuccoed brick Gothic Revival chapel is dimly lit by tall narrow windows, and its lower walls are faced with metal panels painted in imitation of wood. The cemetery, laid out like the Campo Santo dei Tedeschi, the German cemetery in Rome, is surrounded by a brick outer wall containing

vaults and chapel-like niches for almost life-size sculptures of the Stations of the Cross that were installed in 1948. Two sturdy castellated Gothic towers guard the entrance. An extension to the cemetery and St. Michael's Mausoleum were added soon afterward.

OR46 Holy Trinity Church

1853, Theodore E. Giraud. 721 St. Ferdinand St.

In the 1840s, the growing number of Irish and German immigrants tended to settle in neighborhoods by ethnic group and establish their own churches, where services were conducted in their native languages. Holy Trinity was one of the churches established for German Catholic immigrants in this part of Marigny, once popularly known as Little Saxony. Twin bell towers with small segmental, onion-shaped domes mark the corners of the plain plastered brick facade, which is scored to imitate stone. Entrances and windows are round-arched, and elliptical clerestory windows line the upper side walls. Inside the church, slender box columns support the barrel vault. Closed in 1997 because of dwindling attendance, the church was purchased by an individual intending to convert it into a private residence. The sixteen rare French stained glass windows dating from the 1880s were removed by the archdiocese and will be placed in Assumption of Our Lord Church in LaPlace (St. John the Baptist Parish).

OR47 New Orleans Center for the Creative Arts

1999, The Mathes Group and Billes/Manning Architects. 2800 Chartres St. (bounded by Chartres, Press, and St. Ferdinand sts.)

This high school for the creative arts, known as NOCCA, incorporates recently built structures and nineteenth-century brick warehouses. The new structures were designed to relate to the neighboring industrial buildings, as seen in the use of corrugated metal siding. However, the intricate layout of the complex, the over-restoration of the brickwork on the original warehouses, and the reuse of some original material frequently make it difficult to distinguish between old and new construction. Clearly old is the large brick warehouse with segmental-arched windows and corbeled gable, as is a row of granite post-and-lintel openings retained

from a building by Alexander T. Wood along the St. Ferdinand Street side of the Center. The new three-story, curved metal structure that defines NOCCA's boundary along the railroad tracks of Press Street includes a second-floor terrace that provides a view of the river over the adjacent 10-foot-high flood wall. The Center houses a 300-seat theater, a black-box theater, recording studios, art and dance studios, art gallery, photography lab, and performance rooms. NOCCA is a professional training center in the visual and performing arts, serving students from more than fifty schools in a seven-parish area.

OR48 St. Vincent de Paul Catholic Church

1866, Daniel Mulligan. 3051 Dauphine St.

This bright red brick church, with a tall, massive square tower marking the center of the facade, is a major landmark in a neighborhood of small one- and two-story wooden houses. The mostly French-speaking congregation was formed in 1838 and worshiped in a wooden structure until the new church was built. The entrance portal at the base of the tower is an immensely tall arched opening, vigorously outlined by multiple rounded moldings. Although the bell tower's upper stage was probably intended from the beginning, it was not added until 1924. Inside the church, Corinthian columns, which were added in 1923 to reinforce the superstructure, reach to the colorful scenes depicting events in the life of St. Vincent de Paul, painted across the shallow-arched barrel vault c. 1907 by Italian-born New Orleans artist Achille Peretti (c. 1857–1923). French- and American-made stained glass fills the tall paired round-arched side windows. Carpenter and builder Daniel Mulligan (1821–1874) emigrated with his brother, builder Thomas Mulligan (1823–1877), from Ireland.

OR49 Inner Harbor Navigation Canal

1918–1923. From the Mississippi River to Lake Pontchartrain

Built at a cost of $19 million, the five-and-one-half-mile-long deepwater canal permits navigation between the Mississippi River and Lake Pontchartrain and provides a connection to the inland route of the Gulf Intracoastal Waterway and the Mississippi River–Gulf Outlet (completed in 1966). The latter, a deep-draft route

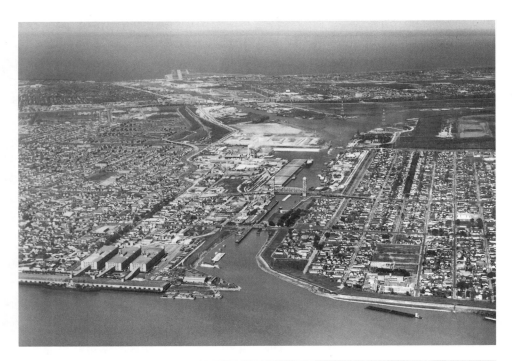

OR49 Inner Harbor Navigation Canal (above)

OR50 Doullut Steamboat House (right)

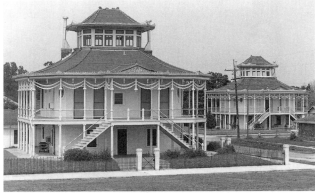

OR51 Jackson Barracks, with General John J. Pershing reviewing troops, 1920 (below)

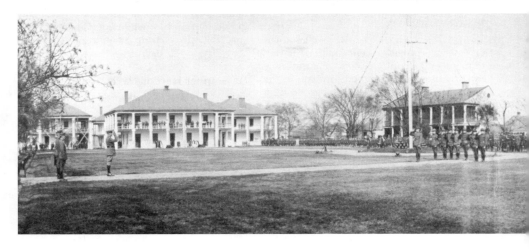

through the marshes of St. Bernard Parish, shortens the distance between the Port of New Orleans and the Gulf of Mexico from the 110 miles of the river route to 76 miles. Work on the canal began in 1918 under the direction of engineer Colonel George G. Goethals (1858–1928), who was also the chief engineer for the Panama Canal locks and, in Louisiana, for the Plaquemine Lock in Iberville Parish (IB5), built 1895–1909. The canal (usually called the Industrial Canal) gives approximately eleven additional miles of waterfront to the Port of New Orleans; its banks are lined with wharves, shipyards, and industries. Midway along the canal's eastern side, a 150-acre railroad yard provides the land-based component of this transportation complex. A 640-foot-long lock to mediate the difference in water levels between the Mississippi River and the lake is located at the river entrance to the canal; a project to widen it was initiated in 1999.

OR50 Doullut Steamboat Houses

1905 and 1913, Milton P. Doullut. 400 and 503 Egania St.

These two almost identical houses were built by the river pilot, civil engineer, and shipbuilder Captain Milton P. Doullut and his wife, Mary—one house for themselves (number 400) and the other for their son, Paul, who helped construct them. Doullut's profession explains the nautical details of these octagonal buildings, which include porthole-type openings; broad galleries reminiscent of riverboat decks, draped with double strands of wooden balls strung on steel wires; an enclosed belvedere resembling a pilothouse; and twin metal smokestack chim-

neys. Oriental influences are also pronounced, in the tiered effect of the three stories, the concave roof, and deep eaves. The houses are remarkably similar to the Kinkaku, or Golden Pavilion, shown in the Japanese Village at the Louisiana Purchase Exhibition of 1904 in St. Louis, and are also reminiscent of Longwood, erected in 1860 in Natchez, Mississippi, which Doullut had probably seen. Equally delightful is Doullut's smorgasbord of building materials, including white glazed brick for the lower exterior walls, pressed tin anthemion cresting along the roof overhang, green roof tiles at number 503, stained glass windows, and, inside the houses, glazed brick walls on the ground floor and pressed metal walls and ceilings upstairs. Each house has a central-hall plan with two rooms on each side.

OR51 Jackson Barracks

1834–1835, Frederick Wilkinson. Bounded by the Mississippi River and Delery, Orin, and Government sts.

Now the headquarters for Louisiana's National Guard, Jackson Barracks was begun during Andrew Jackson's presidency to house a federal garrison. Then known as the New Orleans Barracks, the complex was renamed in 1866 to honor the hero of the Battle of New Orleans. The barracks, which now extends one mile inland from its original site on the Mississippi River, includes sixty-two buildings, a museum, and an air park featuring several restored aircraft. Captain Frederick Wilkinson (1812–1841), then only twenty-one years old, designed the original scheme: a rectangular parade ground facing the river, measuring 300 feet by 900 feet, flanked on each of its long sides by

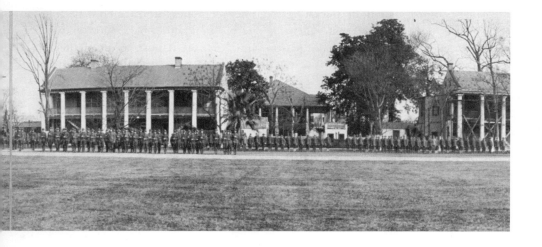

three buildings and, at its head, by a group of four buildings arranged in a square formation. All of these red brick structures, designed to house officers and commandants, have two stories, with wooden Doric columns painted white and extending from the ground level to the galleries above, in imitation of a plantation house. The simplicity and proportions of these buildings, their symmetrical layout and scale in relation to the parade ground (now a lawn) combine to form one of Louisiana's most serene and magnificent spaces. Although many new buildings were added to the barracks in suc-

ceeding years, fortunately they were placed farther inland and did not disrupt Wilkinson's scheme.

Shortly after completing the barracks, Wilkinson designed New Orleans's Cypress Grove Cemetery Gate and Lodge (OR159); he was later appointed deputy U.S. surveyor. The barracks have seen constant use: as a debarkation point for both U.S. troops and Indians during the second Seminole War, during the Mexican War, during the Civil War for both Confederate and Union forces, and during World Wars I and II.

Esplanade Avenue to City Park

Esplanade Avenue's closely spaced houses, tall and narrow with side halls, often front directly onto the street, giving it a distinctive and sophisticated urban character. By the 1850s, when the Vieux Carré was becoming shabby, the Creoles, many of them free people of color, began to build houses along Esplanade Avenue. Many adopted the American town house plan: three bays wide to incorporate a side hall, a service wing to the rear, a rear or side garden, and Greek Revival embellishments, most notably around the entrance portals. Houses on the blocks from the river to North Rampart Street display these features best. By the early twentieth century, Esplanade Avenue was built all the way to Bayou St. John, beyond which lay City Park. Midway along Esplanade, in the 2200 block, is a small triangular park, Gayarré Place, marking the point where Bayou Road crosses the avenue. A statue of the Goddess of History stands on a tall square pedestal of red terra-cotta decorated with arches, cherubs, and various leafy ornaments. Now dedicated to New Orleans historian Charles Gayarré (1805–1895), the pedestal was originally displayed at the Cotton Centennial Exposition of 1884 in Audubon Park. Esplanade's architectural integrity was compromised by construction of the Claiborne Avenue elevated expressway, built in 1966–1968, which cut across the avenue and caused several blocks of houses to be demolished or become derelict.

Bayou St. John is about four miles long and, since it empties into Lake Pontchartrain, was a Native American trade route. Bienville referred to it as the "back door" entrance to New Orleans and named it for his patron saint, John the Baptist. In the eighteenth and early nineteenth centuries it became an important transportation route linking New Orleans to the Gulf of Mexico via Lake Pontchartrain, but it is no longer used for commercial traffic. It is now a placid waterway picturesquely lined with houses on both banks.

OR52 **Louisiana State Museum** (U.S. Mint)

1835–1838, William Strickland. 400 Esplanade Ave.

As a center for foreign trade and for gold, especially after gold deposits were discovered in

nearby Alabama, New Orleans was selected as the site for a mint during the presidency of Andrew Jackson. This structure is one of the two oldest surviving buildings used as mints in the United States; the other is in Dahlonega, Geor-

OR52 Louisiana State Museum (U.S. Mint)

gia. Benjamin F. Fox and John Mitchell constructed the three-story, E-plan brick building in the Greek Revival style, according to plans sent by the noted Philadelphia architect William Strickland. Although not an inspiring design, the building looks secure and functional. Its most architecturally developed feature is the projecting portico with four Ionic columns flanked by Doric piers. Each angle of the building is defined by a gray granite pilaster. The exterior surface of red-tinted stucco scored to resemble granite blocks follows the original finish. Although the walls are 3 feet thick at ground level, structural reinforcements were necessary within a year of its completion. James Gallier, Sr., inserted iron rods to stabilize the groin vaults, and in the 1850s, General P. G. T. Beauregard improved the building's fireproofing, replaced the slate roof with one of corrugated galvanized iron (then a new building material), and added iron balconies. Approximately $300 million in coins were manufactured here before the mint closed in 1909. The building then served various functions, including use as a federal prison from 1932 to 1943. Following renovations by E. Eean McNaughton, Architects, the building reopened as a museum and archive in 1981. It is located on the site of what was once Jackson Square and, before that, Fort San Carlos of 1792.

OR53 Lucy Cheatam Houses

1861–1862. 529–533 Esplanade Ave.

Cotton factor John Hagan built these two houses for Lucy Cheatam, a free woman of

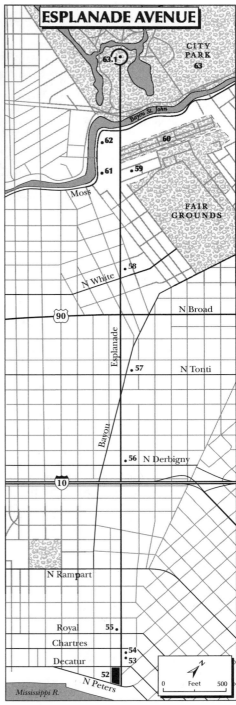

color, and bequeathed them to her two sons. In many ways a typical example of the Esplanade Avenue two-story, side-hall house, these are smaller and have a more human scale than most of the others on this street. They also differ in being set back behind front gardens. Constructed of brick, plastered and scored, the houses have facades shaded by two-story cast iron galleries, one ornamented with a pattern of grapes and the other of flowers; number 529 has anthemion cresting. Entrance doors are surrounded by Greek key architraves, and the square-headed windows are finished with molded lintels. The building contract specified marble mantels and wallpaper, the latter very modish at the time, for the parlors. Two-story brick service wings extend from the rear of the houses.

OR54 Johnston House

1879, William Fitzner. 547 Esplanade Ave.

Designed by the German-born architect William Fitzner (1845–1914), this two-story town house with an attic is an impressive example of the side-hall residences in these blocks of Esplanade next to the Vieux Carré. Edging its property line, the front-plastered brick house with a hexagonal bay on the right side is entered by way of six steps that rise to the recessed entrance vestibule, framed by pilasters, which has a coved ceiling decorated with rosettes. The windows are round arched and surrounded by heavy moldings. The second story opens onto a small balcony, and a large bracketed cornice defines the roofline. A lower two-story service wing at the rear is visible on the Chartres Street side of this corner house, as is the row of ground-level ventilation openings covered with cast iron grilles. Peter Middlemiss (1826–1887) was the builder for Fitzner's design.

OR55 Gauche-Stream House

1856. 704 Esplanade Ave.

Crockery merchant John Gauche supervised the construction of his large, square house, which cost $20,000. Exceptionally fine cast ironwork adds a light and delicate touch to the massive weight of the stuccoed brick house. Putti (or miniature figures possibly representing Bacchus) cavort among the grapevines adorning the second-story cast iron balcony; at

eaves level, a projecting cornice supported on paired iron brackets is edged with a cast iron frieze with anthemion cresting. The building's finest feature, and one unusual for New Orleans, is the light gray granite pedimented Doric portico, whose weight and severity of design make it a splendid foil for the lacy cast iron decoration. The house is set back slightly from the property line and enclosed by a cast iron fence and granite gateposts. To the rear of the house, a lower two-story service wing faces the carriage entrance on Royal Street. The house has a central-hall plan, with a stairway located in a side opening to the rear, and full-length casement windows. Richard Koch restored the house for Matilda Geddings Gray after she purchased it in 1937. Koch and Wilson undertook further restoration in 1969 for Martha Stream when she inherited the house from her aunt.

OR56 Dufour-Baldwin House

1859, Howard and Diettel. 1707 Esplanade Ave.

Designed for lawyer and state senator Cyprien Dufour and his wife, Louise Donnet, the house cost $40,000—an extraordinary amount for the time—and the price of the lot was $12,000. Howard and Diettel designed this house and the Robert Short House (OR117) at the same time, and the two have many features in common: a three-bay facade, stucco-covered brick construction, side bays, and Italianate details. However, this house exhibits more exciting and dramatic effects than the Short House. The facade is shaded by a two-story wooden gallery supported on paired columns; paired brackets and dentils mark the cornice; and a parapet adds additional height. Two large side bays have triple-arched doorways with multiple prominent moldings. At the rear of the house, a two-story galleried round bay outlines the staircase at the end of the wide interior hall; to its left on the upper story only is an elaborate Italianate bay window whose panels are extremely tall and narrow. Extending from the right side of the rear facade, the lower two-story service wing also has a bowed gallery. This magnificent combination of galleries, bays, and curves evokes an opera set. The builders were Wing and Muir. The house is named for its first two owners, the second being hardware merchant and bank director Albert Baldwin, who purchased it in 1870.

OR54 Johnston House

OR55 Gauche-Stream House

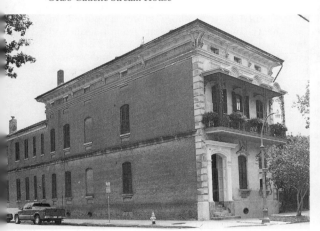

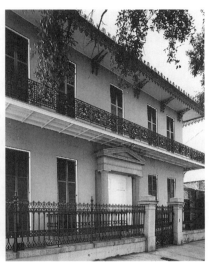

OR57 **Benachi-Torre House**

1859. 2257 Bayou Rd.

In 1853, one year after Nicholas Benachi purchased an existing house on this enormous lot, his wife and two of his children died of yellow fever. A few years later, Benachi married Anna Marie Bidault and replaced the old house with this tall, handsome Greek Revival residence built of wood. The house features a two-story gallery supported on slender paired piers, a plain entablature, two dormers, and a central-hall plan. A detached two-story service building has a two-story gallery. The large garden, originally even bigger but reduced when Laharpe Street was cut through it on one side, is enclosed by a cast iron fence with beautiful gateposts paneled and decorated in the Gothic Revival style and a wide entrance gate in the shape of an ogee arch. Peter Torre bought the house in 1886. The raised galleried house next door (2275 Esplanade Avenue) was probably built in 1802, then moved to this site and remodeled in 1836; further modifications were made in the twentieth century.

OR58 **Hannon House**

c. 1902. 2809 Esplanade Ave.

Irish real estate speculator W. James Hannon built this exuberant Queen Anne raised wooden house, which appears to incorporate every variety of wood trim available at the time:

turned columns, spindlework, brackets, bargeboard, and quoins. A double flight of stairs (added in 1946 when the house was raised) rises to a richly decorated central gabled portico and a deep, shady gallery. One side of the gallery ends in an angled corner; the other side, sweeping in a wide curve around that end of the house, is topped by a squat octagonal spire with a multicolored roof. The owners boasted that the 12-foot-by-86-foot central hall was the largest and longest in town. The gazebo in the side garden is a modern addition.

OR59 **Luling Mansion**

1865–1866, Gallier and Esterbrook. 1438 Leda Ct.

Luling Mansion originally faced Esplanade Avenue behind a deep front garden, which was sold and subdivided for houses after 1950. This Italianate house, the largest and most elaborate of James Gallier, Jr.'s, residential designs, was built for German immigrant and cotton merchant Florence A. Luling. Raised on a terrace, the three-story mansion of plastered brick is surrounded by a dry moat and, on the second and third levels, by galleries with low balustrades. The hipped roof extends well beyond the walls to shade the upper balcony and is finished with a parapet cornice and a square belvedere. All the windows are round arched, which contributes to the impression that the mansion belongs in Renaissance Italy. A granite

staircase rises from the rusticated first floor to the second-level entrance. Each of the upper two floors has six rooms. The house was originally flanked by pavilions (destroyed by 1924), which accommodated a conservatory and a bowling alley and were linked to the house by bridges across the moat. After Luling's two young sons drowned in nearby Bayou St. John and he suffered financial setbacks in the Reconstruction economy, he sold his mansion and thirty acres in 1871 to the Louisiana Jockey Club for use as a clubhouse and moved to England. The house is now a private residence subdivided into apartments.

OR60 St. Louis Cemetery 3

1854. 3421 Esplanade Ave.

The cemetery was laid out following the yellow fever epidemic of 1853, which killed 10 percent of the city's population. First laid out with three main avenues and four narrower parallel aisles, the cemetery was enlarged and improved in 1865 by French-born surveyor Jules A. D'Hémécourt (1819–1880). By widening the central aisle and adding cross aisles, he provided grand vistas along the continuous rows of above-ground tombs. The uniform size and gable roofs of the tombs give this cemetery, more than any other in New Orleans, the appearance of city streets in miniature. Near the entrance is the tomb James Gallier, Jr., designed in 1866 for his father, James Gallier, Sr., who died at sea along with his wife, Catherine. It is a vertical composition of stacked pedestals surmounted by a large urn. Among the society tombs, those for the Slavonian Benevolent Society (1876) and the Hellenic Orthodox Community (1928) are particularly impressive; much simpler is the multivault tomb of the Little Sisters of the Poor, which was donated by philanthropist Margaret Haughery (OR104). Francis Lurges fabricated the elaborate iron entrance gates.

OR61 Holy Rosary Rectory (Evariste Blanc House)

c. 1834. 1342 Moss St.

As the water link between New Orleans and Lake Pontchartrain, Bayou St. John saw some of the city's earliest habitations along its banks. Although this structure was built later than some, such as the Pitot House (OR62), it has much in common with earlier examples. However, its emphasis on height, its Greek Revival elements, and its central-hall plan clearly reveal the impact of American ideas on Creole forms. Fronted by a two-story gallery supported on heavy Tuscan columns at ground level and turned wood columns above, the stuccoed brick house has a hipped roof and widow's walk. The central front door is set between Ionic columns and side lights and is topped by a fanlight; the same design is repeated on the floor above. The house was donated to the Catholic church in 1905 by Evariste Blanc's descendants, the Denegre family.

OR62 Major James Pitot House

1799. 1805, Hilaire Boutté. 1440 Moss St.

Merchant and shipowner Don Bartholemé Bosque, from Palma, Majorca, began construction of this beautiful house and sold it unfinished in 1800. In 1805, Marie Tronquet, the widow of Vincent Rillieux and great-grandmother of Edgar Degas, purchased the residence and completed it. The ground floor is constructed of brick and the upper of brick between posts covered with stucco. A front and a side gallery are supported on brick Tuscan columns at ground level and slender wooden colonnettes above. The house has a double-pitched hipped roof. The plan consists of three rooms across the front, without corridors, and at the rear of the second level is a loggia between two smaller cabinets. Stairs in the loggia link the two floors. An original set of stairs within the side gallery was intended for guests. Some scholars describe this house type as

OR62 Major James Pitot House

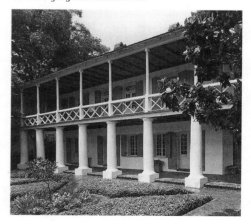

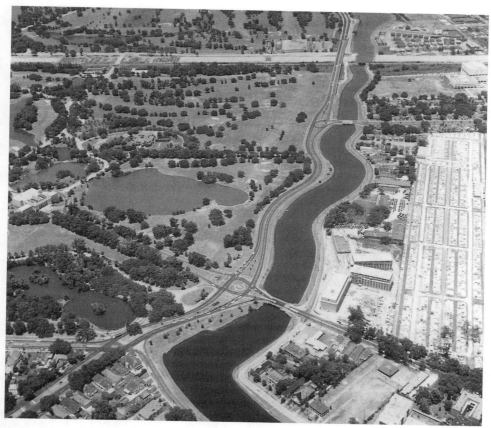

OR63 City Park, Bayou St. John, and St. Louis Cemetery 3 (OR60)

French West Indies because it is similar to contemporary houses on the Caribbean islands; however, others believe that French Canadians brought the type and style with them before 1700. In 1810, commission merchant James (Jacques) Pitot (1761–1831), who came to New Orleans from St.-Domingue in 1796 after the slave uprisings, purchased the house for his family. He later became New Orleans's first elected mayor. Behind the house Pitot had two cabins for his six slaves, a kitchen, a barn, stables, privies, a vegetable garden, and farm animals. In 1904, Mother Francis Cabrini purchased the house and used it as a convent, then rented it out. In 1964, when the sisters planned to demolish the house in order to build a school on the property, the Louisiana Landmarks Society acquired the building and moved it 200 feet from its original location, now occupied by the neighboring school. Koch and Wilson, Architects, were hired to restore it

to the Pitot time period, and it was opened as a house museum in 1972. Although none of the dependency buildings survive, the gardens have also been restored to Pitot's era, with flowers and herbs in the front garden and vegetables in the rear. Nearby at 1300 Moss Street is a similar house, known as the Spanish Custom House, built after 1807 by Robert Alexander for Captain Elie Beauregard. That residence probably acquired its nickname during the Spanish era, when it was the home of Spanish custom officer Luis Blanc.

OR63 City Park

From 1850. 1933, Bennett, Parsons and Frost. Bounded by City Park and Orleans aves. and Wisner and Robert E. Lee blvds.

City Park got its start in 1850 on eighty-five acres of swampy land adjacent to Bayou St.

John, donated by John McDonogh to settle his tax debts with the city. Known as the "wild park," it saw few improvements until the 1890s, when the area was properly drained and additional land acquired. At that time, civil engineer George Grandjean, a member of the City Park Board, devised a master plan, and a local firm of surveyors, Daney and Wadill, was hired to work out the scheme of lagoons, footpaths, and bridges, with the help of architect Paul Andry (1868–1946). Based on City Beautiful concepts, the plan inspired several donors to fund various pavilions and conveniences. These included the Peristyle, a rectangular dance pavilion with rounded ends surrounded by an Ionic colonnade, designed in 1907 by Paul Andry and Albert Bendernagel (1876–1952); Emile Weil's circular Popp Bandstand (1917), a replica of the Temple of Love at the Trianon, Versailles, funded by lumberman John F. Popp; a refreshment pavilion known as the Casino, with triangular arches, designed in 1913 by Nolan and Torre; a Beaux-Arts classical bridge (1923), given by Felix Dreyfous; a brick pigeon house (1928), perhaps designed by Dreyfous's son, architect F. Julius Dreyfous; and a mechanical carousel (1910) in a pavilion of 1906.

In 1929, the Chicago firm of Bennett, Parsons and Frost was hired to draw up a new plan for the park, which by then had increased to 1,300 acres. Work could proceed only after the receipt of federal funding, first from the PWA and then the WPA. The park underwent a spectacular transformation that cost $13 million, of which the City Park Board paid only 5 percent. From 1934 to 1940, 14,000 men, using mostly hand tools, landscaped the golf course on the east side of the park, dug more than sixty acres of lagoons, and built eight new bridges, a stadium, fountains, and cast concrete benches. Mexican-born sculptor Enrique Alferez (1901–1999), assisted by a team of sculptors, created both freestanding and architectural sculpture in a stylized Art Deco manner that suited the architectural forms. Particularly noteworthy is the Popp Fountain (corner of Marconi Boulevard and Zachary Taylor Drive), with waterspouts in the shape of leaping dolphins (recast in bronze in 1998), surrounded by a circle of twenty-six columns. The firm of Weiss, Dreyfous and Seiferth directed these federal projects.

After 1965, the park acquired land on the lake side of Harrison Avenue in compensation for the intrusion of Interstate 610. Now encompassing 1,500 acres, it is the fifth largest municipal park in the nation. The carefully contrived irregular landscape and plantings, the more than eighty species of trees, and the sensitively placed pavilions and sculptures give the park, despite its flat terrain, the romantic ambience favored by nineteenth-century urban landscapists. Architect Richard Koch and landscape designer William S. Wiedorn laid out the Botanical Garden and its structures in the 1930s; Wiedorn (1896–1988) had worked in Boston, Cleveland, and Florida before settling in New Orleans. The garden was restored in the 1980s, and a multi-activity pavilion by Trapolin Architects was added in 1994. In front of the entrance to the park from City Park Avenue is Alexander Doyle's bronze equestrian statue of Confederate General P. G. T. Beauregard, unveiled in 1915. The entrance is marked by a pair of pylons with engaged Ionic columns, built in 1913.

OR63.1 New Orleans Museum of Art
(Isaac Delgado Museum of Art)

1911, Samuel A. Marx for Lebenbaum and Marx. 1971, addition, August Perez and Associates with Arthur Feitel. 1993, addition, Eskew Filson Architects and Billes/Manning Architects. Lelong Ave. (at its conclusion)

In 1910, sugar broker and philanthropist Isaac Delgado (1839–1912) gave $150,000 and his art collection for a museum of art. He chose a site on a circle at the end of tree-lined Lelong Avenue. Samuel Marx of Chicago won the design competition in 1910, and the building was constructed by Richard Koch. According to

Marx, the design was "inspired by the Greek, sufficiently modified to give a subtropical appearance." The cream-colored Bedford limestone facade features a recessed Ionic portico with six columns set between pavilion-like wings, which are covered by pyramidal roofs of green tile and surrounded by a low parapet of stylized anthemia. Panels inset high on the wings replicate scenes from a Parthenon frieze. The building has the typical Beaux-Arts museum plan of gallery rooms set around a central two-story skylit sculpture hall, surrounded on three sides by a balcony supported on Ionic columns. In 1971, three wings were added to the museum, followed in the early 1990s by a more sympathetic extension to the rear Adapted from a design by Clark and Menefee of Charleston, South Carolina, this later addition made it possible to view the original exterior walls and their classical decoration from inside the building. The Sydney and Walda Besthoff Sculpture Garden, designed by Lee Ledbetter Architects of New Orleans and Brian Sawyer Design of New York, opened in 2003 in an area next to one of the lagoons adjacent to the museum.

Canal Street

Canal Street, 170 feet wide, extends three and one-half miles from the Mississippi River to the cemeteries on Metairie Ridge. As the city's premier commercial boulevard, lower Canal—the blocks that separate the Vieux Carré from the Central Business District (originally the Faubourg St. Mary)—flourished when other main streets in the nation withered. Its commercial and popular success can be attributed in part to its location, adjacent to both business and entertainment destinations. In the early nineteenth century, the street had become a boundary between the French-speaking Creoles in the Vieux Carré and the English-speaking Anglo-Americans in Faubourg St. Mary and is commonly believed to be the origin of the term "neutral ground" to describe all the landscaped strips that run down the center of New Orleans's broad boulevards. A nineteenth-century plan to construct a canal along the street to connect the Mississippi River with the New Basin Canal was not implemented but did give the street its name. Although most of lower Canal's first buildings were residences, by the 1840s, they were being replaced by handsome commercial buildings that would make the street a showplace of nineteenth- and twentieth-century commercial facades. The introduction of streetcars along Canal in 1861 encouraged the thoroughfare's outward growth from Basin Street; this stretch, known as upper Canal, developed with a mix of residential, institutional, and commercial structures.

In his book *God's Own Junkyard* (1964), architect and critic Peter Blake decried what he saw as the crass commercialism and shopfront signage of lower Canal. In response, architect Robert Venturi, author of *Complexity and Contradiction in Architecture* (1966), reprinted Blake's photograph of Canal Street and declared that "the seemingly chaotic juxtapositions of the honkytonk elements express an intriguing kind of vitality and validity." For Venturi, the attributes Blake deplored were precisely what made the street successful. Some of the "honkytonk" is gone (though the casino at the foot of Canal, completed in 1999, possibly qualifies), and department stores have been converted to sedate hotels, but Canal Street remains one of the city's busiest and most vibrant public spaces. The reinstatement of streetcars, which had been replaced by buses in 1964, guarantees the boulevard's continued appeal.

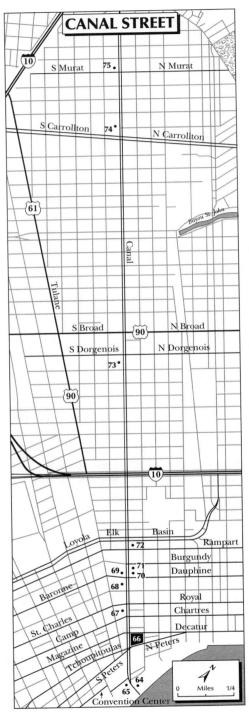

CANAL STREET

S Murat 75 N Murat

S Carrollton 74 N Carrollton

Bayou St. John

Canal

Tulane

S Broad 90 N Broad

S Dorgenois N Dorgenois

73

Loyola Elk Basin

72 Rampart

Burgundy

69 71 Dauphine
70

Baronne 68

Royal

St. Charles 67 Chartres

Camp Decatur

Magazine 66 N Peters

Tchoupitoulas

S Peters

64

65 0 Miles 1/4

Convention Center

OR64 Aquarium of the Americas

1987–1990, Bienville Group (Billes/Manning; Concordia Architects; Eskew, Vogt, Salvato and Filson; Hewett-Washington and Associates; and The Mathes Group). Canal St. at the river

The centerpiece of the aquarium complex is a 145-foot-high turquoise glass drum with a diagonally cut roofline, which is set amid lower wings faced with white and pastel-colored tiles. Around the aquarium are brick-paved plazas that extend to the river and to Woldenberg Riverfront Park (OR8). In the aquarium's dimly lit interior, visitors proceed past the exhibits, the most engaging of which is a clear acrylic barrel-vaulted tunnel that surrounds the visitor with 132,000 gallons of water inhabited by fish. The glass drum houses a tropical rainforest. A second-phase expansion included an IMAX film theater and exhibition gallery. The aquarium's location was controversial. Critics rightly saw that by attracting more tourists to an already overcrowded Vieux Carré, the aquarium would dilute the quarter's residential and business character and encourage the tendency to view it as a playground. It is unfortunate that the developers succeeded in locating the aquarium on the edge of the Vieux Carré, a part of downtown that does not need additional tourist venues, rather than in an area that would benefit from the revitalization this popular attraction could create.

OR65 World Trade Center (International Trade Mart)

1963–1967, Edward Durrell Stone with Robert Lee Hall and Associates, associate architects. 2 Canal St.

The World Trade Center was commissioned by a New Orleans nonprofit organization, the International Trade Mart (ITM), founded in 1945 to promote foreign trade through the Port of New Orleans. The ITM wanted a building that looked modern, thus its selection of Stone as architect. Stone conceived the building, sited by the river at the foot of Canal Street, as a gateway to the city and designed its cruciform shape to symbolize a compass pointing to all corners of the world. The exterior of the thirty-three-story reinforced concrete tower has alternating vertical strips of precast concrete panels and louver-shaded windows. The metal louvers give texture to the building's surface. A deep canopy surrounding the building's base is echoed in the horizontal extension of the

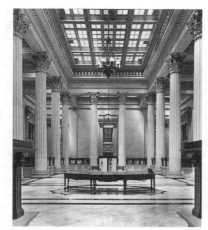

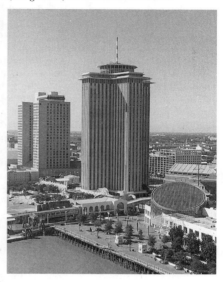

OR64, OR65 Aquarium of the Americas (foreground) and World Trade Center

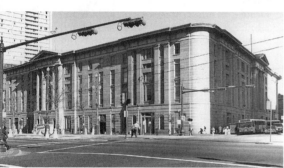

OR66 U.S. Customhouse, exterior (left) and interior (left, above)

rooftop observation deck and revolving bar. Robert Lee Hall and Associates of Memphis designed the deck with an exterior elevator a few years after the building was opened. Remnants of an ambitious plan for urban plazas and landscaping around the trade center survive in the Spanish Plaza and the 15-foot-high bronze statue by Spanish sculptor Juan de Avalos of Bernardo de Galvez, governor of Louisiana during the American Revolution. Both were gifts from the Spanish government in 1976 on the occasion of the American Bicentennial.

OR66 U.S. Customhouse

1848–1881, Alexander Thompson Wood and others.
423 Canal St.

The size and splendor of this customhouse testify to the importance of New Orleans as a port in the nineteenth century. Occupying an entire block, 300 feet on each side, the customhouse was then the second largest building in the United States, after the U.S. Capitol. James Gal-lier, Sr., James Dakin, and J. N. B. de Pouilly all submitted designs in a competition of 1845, but Alexander Wood (1806–1854) received the commission in 1848. According to Gallier's autobiography, Wood was in Washington during the design competition and "attended assiduously upon the secretary, having free access to all the plans and models that had been sent in, and from them concocted a design in accordance with the taste and ideas of the secretary, who . . . appointed Wood to be the architect . . . to the astonishment of all who knew anything of Wood's previous history." It is impossible to know if Gallier's reference to Wood's "history" alluded to his design skills or to the fact that he had recently been released from prison for the manslaughter in 1835 of his builder-foreman, George Clarkson.

The customhouse sits on a foundation of cypress planking, 7 feet in depth, surmounted by a grillage of logs and topped with cement. The building is faced with Quincy granite; its upper three stories are raised over a massive rusticated base articulated with arched niches. At

the center of each facade are engaged porticoes with lotus-blossom capitals on fluted columns supporting a pediment. The building's intimidating scale, the powerful and complex relationship between walls and windows, the stylized rustication, sense of enclosure, and Egyptian Revival detailing inspired Dakin to describe it as fit only for a "Mausoleum or Tomb for an Egyptian king." Mark Twain thought it looked like "a state prison." Stairs from the groin-vaulted ground floor lead to the grand hall (known as the Marble Hall), 125 feet by 95 feet, which is three stories (54 feet) high and surrounded by fourteen Italian white marble Corinthian columns. Column capitals display the heads of Mercury, the Roman god of commerce, and Luna, the moon goddess, representing the Crescent City. Because the customhouse lacked a roof for many years during its long building campaign, columns and capitals are somewhat weathered from exposure. Although a dome had been planned, it was later omitted because of a 3-foot settlement of the building; the hall was finally covered and illuminated by a skylight.

Problems with subsidence, political infighting, and the Civil War delayed completion. In 1850, Wood was removed as architect, and a series of supervising architects took over, among them James Dakin, from 1850 to 1851, who came up with all sorts of changes that were rejected. He was followed by Lewis E. Reynolds, then General P. G. T. Beauregard (from 1853 to 1860) and Thomas K. Wharton (from 1861 to 1862). English-born Wharton (1814–1862), who immigrated with his parents to America in 1829 and trained as an architect in New York, worked on the customhouse as a draftsman in 1848, recording his experiences in his journal. The building was still incomplete by the time of the Civil War, during which it served as a prison for Confederate soldiers while the city was under Union control. The customhouse was finally finished under Alfred B. Mullett, supervising architect of the U.S. Treasury Department. It was restored in the 1990s by Waggoner and Ball Architects. An insectarium is planned for the ground floor.

OR67 Commercial Building (Merchants' Mutual Insurance Co.)

1859, William A. Freret, Jr. 622 Canal St.

Freret's design for this cast iron facade, fabricated by the New Orleans foundry of Bennett and Lurges, is a splendid example of the flamboyant effects this new material made possible. The individual elements—the round-arched openings, curved bands of foliate ornament, spiral columns between the windows on the second story, fluted columns above, and, at the third level, a row of bull's-eye windows separated by prominent scrolling, leaflike brackets—offer a dense and organic effect. The parapet is ornamented with designs relevant to an insurance company in New Orleans: fireplug, hose, pipe, anchor, cotton bales, barrels, prow of a vessel, and furled sails. The entire facade can be understood as a sign, designed to attract attention to itself and clients to the business. An arcade on four fluted Corinthian columns, only two of which remain, defined the ground-level story. Mid-nineteenth-century commercial facades, of which this is a particularly fine example, combined historical forms with showy details to compete for attention. Some evidence of this is also apparent in the adjacent buildings, 626, 630, and 634 Canal, which, with Freret's building, make a particularly harmonious group. William A. Freret, Jr. (1833–1911), was Supervising Architect of the U.S. Treasury Department from 1887 to 1888.

OR68 Boston Club (Dr. William Newton Mercer House)

1844, James Gallier, Sr. 824 Canal St.

When Dr. Mercer, an army surgeon in the War of 1812, had this stucco-covered brick house built, Canal Street was still a fashionable residential address. The three-story, side-hall house has an angled side bay and an attic ventilated by narrow horizontal windows covered with iron grilles. The importance of the second story as the main living area is emphasized by its extra height and is also expressed in the tall windows with pediments and the continuous iron balcony that fronts them. Marble was used for the entrance piers, sills, and entablature. Uneven subsidence has caused the door lintel to slant downward on one side. Dr. Mercer was a generous philanthropist who funded St. Anna's Orphan Asylum (OR108) and St. Elizabeth's Home of Industry (OR131). The Boston Club, named for a popular card game, not the city, has occupied the building since 1884.

OR69 Walgreen Drugstore

1938, Weiss, Dreyfous and Seiferth. 900 Canal St.

Pharmacist Charles Walgreen established his drugstore chain in Chicago in 1901. The smooth, streamlined exterior of this steel-frame store in New Orleans suits the corner site it occupies and conveys a fresh, healthy image. A low, round tower wrapped by blue and red neon signage (added c. 1949) marks the corner entrance. Inside, retail departments and a 100-foot-long lunch counter originally occupied the ground floor, the second floor housed a restaurant and kitchen, and the third floor was used for storage. In 1997, Walgreen's proposed to demolish the drugstore and build a larger structure, but local preservation organizations prevented this.

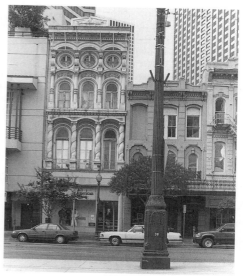

OR70 **Ritz-Carlton Hotel** (Maison Blanche Building)

1908–1909, Stone Brothers. 901–921 Canal St.

Originally planned as a complex combining a hotel, theater, and shopping arcade fronting on Canal Street, the Maison Blanche store located in the building was a favorite among New Orleanians. On the Dauphine Street side of the building, its U-shaped composition provided natural light for the offices on the upper floors, allowing a continuous facade on the Canal Street side. Striving to compete with all the other facades on this commercial street, the building features oversized columns and exuberantly interpreted classical detailing in glazed white terra-cotta. Appropriately, this commercial structure is far more floridly ornamented than the contemporaneous terra-cotta-faced Louisiana Supreme Court building (OR14). The terra-cotta was manufactured by the Atlantic Terra Cotta Company of New York. Samuel Stone, Jr. (1869–1933) collaborated with his architect brothers, Guy and Grover, on this large commission. Renovated by Robert Coleman and Partners of Baton Rouge and John Williams and Associates of New Orleans, the building was reopened as a hotel in 2000.

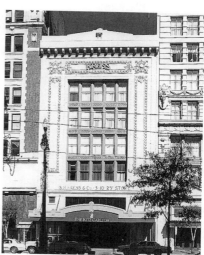

OR67 Commercial Building (Merchants' Mutual Insurance Co.)

OR71 Kress Building

OR71 **Kress Building**

1912–1913, Emile Weil. 923 Canal St.

The Kress Company rarely employed a noncompany architect to design its stores, but because of New Orleans's distance from New York and the particular circumstances of the site, Kress turned to local architect Emile Weil for its first store in New Orleans. The four upper floors of this five-level store have a continuous vertical screen of sash windows with cast iron mullions and spandrels set within a decorative terra-cotta frame. The Kress Company authorized the white terra-cotta facade, a material used only for its most important stores. The facade's composition and its ornamentation—stylized sunburst and geometric decorations, accented in blue, orange, and green—show the influence of Louis Sullivan. The Kress name is

inscribed at the top of the building. A curved metal canopy marks the entrance. Originally, the entrance was set deep within a long arcade lined with large plate glass display windows, a characteristic of Kress stores. Inside, a spacious center court was covered by coffered skylights and surrounded by a mezzanine supported on Corinthian columns. The satisfying proportions and ornamentation of the facade more than hold their own next door to the ostentatious former Maison Blanche Building. With the conversion of that building into a hotel, the Kress became its porte-cochere entrance.

OR72 Saenger Theater

1926–1927, Emile Weil. 1111 Canal St.

In 1911, the brothers Julian and A. D. Saenger formed the Saenger Amusement Company, which eventually operated 320 theaters in eleven southern states and the Caribbean. Emile Weil designed several theaters for the Saengers, including those in Cuba, Costa Rica, Texas, Arkansas, and the Saengers' home town of Shreveport (CA24). The New Orleans Saenger, which accommodated almost 4,000 people, was when built one of the largest theaters in the South. Although the brick exterior of the reinforced concrete structure is embellished with decorative niches, and the entrance marquee is framed by a triumphal arch motif, the glamorous interior still comes as a surprise. Weil designed a lobby embellished with black and gold marble, mirrors and crystal chandeliers, and a domed ceiling supported on elaborate Composite capitals. But the highlight is the auditorium, where, according to *Southern Architect and Building News*, Weil created the fantasy of "an Italian garden; a Persian court; in a Spanish patio." The auditorium walls were fashioned as building facades in plaster, wood, and marble, with architectural sculpture of towers and rooftops lined with classical statues in front of a painted backdrop of exotic plants and birds. To complete the illusion of an outdoor setting, images of slowly moving clouds were projected across a domed ceiling painted deep blue and perforated by hundreds of twinkling pinpoint lights. John Eberson pioneered the atmospheric setting at the Majestic Theater in Houston (1923); Weil, however, credited Chicago's Capitol Theater as his source. Since the Saenger was constructed for motion pictures as well as live theater, the auditorium had raked seating and a balcony. On the opening night,

moviegoers watched the silent film *Blonde or Brunette*, accompanied by an eighty-piece orchestra and the 778-pipe Wonder Organ. The theater is now a venue for Broadway shows and other theatrical events.

OR73 Pan-American Life Insurance Company (former)

1951, Skidmore, Owings and Merrill with Claude E. Hooton. 2400 Canal St.

This rectangular concrete and glass slab building marked Skidmore, Owings and Merrill's first use of wraparound sunscreening and was possibly the first large-scale use of that feature in the United States. Interior spaces are shielded from the sun on all four sides by tiers of 13-foot-high aluminum louvers set into the aluminum-edged, cantilevered concrete floor slabs. Because the main wing is oriented with the long sides facing northeast and southwest, the fins, 30 inches deep, are at right angles to the walls. The building was also engineered to be fully air conditioned. The aluminum-louvered facade was described at the time as "light and lacy" and a modern reinterpretation of New Orleans's balconies. The entry level is recessed, giving the impression that the upper four floors hover over their base. A cafeteria-auditorium and an executive dining room on the second floor face an interior courtyard, and a one-story service wing extends to the rear. SOM's associate architect for this project was Claude Hooton (1905–1993), who practiced in both New Orleans and Houston. During his relatively brief stay in his home state, Hooton also designed the Texaco Building (now Tulane University School of Public Health and Tropical Medicine) at 1501 Canal Street in 1955. It is sheathed in turquoise glass, green tile, and aluminum—materials and colors made fashionable by New York's Lever Building (1952).

OR74 Commercial Building (Automotive Life Insurance Building)

1963, Curtis and Davis. 4140 Canal St.

The insurance company's new headquarters was designed with a facade of gray solar glass and side walls of white marble, surrounded by a groin-vaulted arcade supported on precast concrete cross-shaped columns. Each vault defines a 12-foot-square bay, a module that underlies the entire plan. The vaults are not struc-

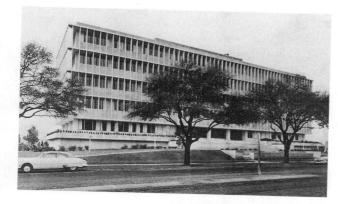

OR73 Pan-American Life
Insurance Company (former),
photo 1952

OR74 Commercial Building
(Automotive Life Insurance Build-
ing)

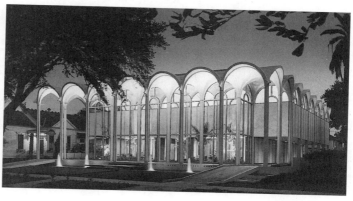

tural, instead consisting of plaster on a steel skeleton beneath a flat roof. The architects decided that local experience with new concrete construction methods was inadequate. The building's single pavilion masks rather than expresses the two-story interior. Entrance is across a shallow moatlike pool, through the portico to a center hall that leads past an enclosed garden to what was originally a two-story reception area at the center of the building. All the office spaces were laid out on two floors on both sides of this central corridor. When first opened, the building was a huge success, particularly because of its appearance at night, when it glowed like a lantern in its dark, semi-residential neighborhood. Nathaniel Curtis and Arthur Q. Davis established their firm in 1946 with the intention to design solely in a modern idiom; this building achieves that goal in its adherence to contemporary architectural forms, if not entirely in the materials used. The building received a First Honor Award from the Gulf States Region of the American Institute of Architects.

OR75 **William Cowley Residence**

1918, H. Jordan MacKenzie. 4506 Canal St.

H. Jordan MacKenzie, who arrived in New Orleans from California in 1904 and left in 1917, designed several houses in the city that were influenced by Arts and Crafts or Secessionist forms (see OR170). The bright blue tile roofs he introduced to New Orleans earned him the nickname "Blue Roof" MacKenzie. Among his houses with this feature was the one he built for himself in 1910 at 6339 West End Boulevard, where he lived for two years. Unfortunately, most of his houses have been altered. Although its roof is green, not blue, this low, broad house of red brick and white stone is a fine example of MacKenzie's work and displays his interest in textures and colors. The coffered entry porch, reached by a double set of stairs, is supported on overscaled columns with capitals that look as if they are oozing from their shafts. The house is sheltered by a sweeping tile roof with deep unsupported overhangs. It was built for William Cowley, a steamship agent and broker.

Central Business District

The abrupt and startling difference in scale between the low-rise Vieux Carré and the towering buildings of the business district on the opposite side of Canal Street highlights the contrasting histories of these two areas of New Orleans. What is now known as the Central Business District (CBD) began as Faubourg St. Mary, laid out by Carlos Trudeau in 1788 and inhabited by the Anglo-Americans who flocked to New Orleans after the Louisiana Purchase in 1803. The Anglo-Americans and the French-speaking Creoles soon found that they disagreed about almost everything. As a result, in 1836, New Orleans was divided into three municipalities; the Anglo-Americans dominated this section of the city and built their own city hall and public square. This division lasted until 1852, when the city was reunified.

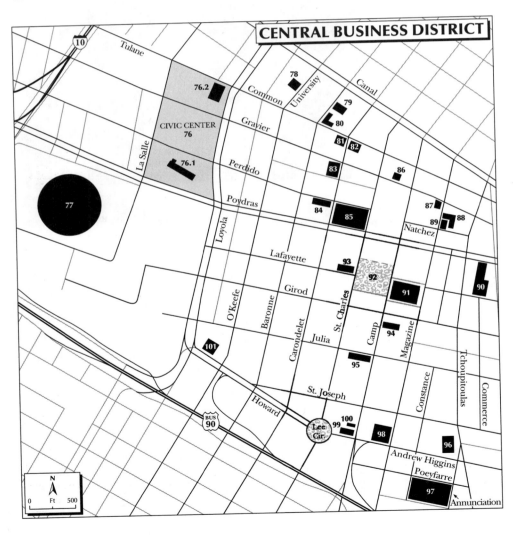

Warehouses and industrial structures were built along the streets closest to the wharves by the river; inland rose a mix of commercial and residential buildings. By the late nineteenth century, high-rise commercial structures had largely displaced residential property. In the mid-twentieth century, the remaining residential area was cleared for a new civic center. Following the early 1980s collapse of the oil boom that had fueled the New Orleans economy after World War II, the city increasingly turned to tourism as a source of revenue. A convention center, begun by Perez Associates in 1984, continues to expand upriver along the waterfront; high-rise commercial buildings are being converted into hotels and abandoned warehouses into apartments, all bringing a new vitality to this area.

OR76 Civic Center

1954–1961. Loyola Ave. (bounded by Poydras and La Salle sts. and Tulane Ave.)

Conceived as an urban revitalization plan by Brooke Duncan, a civil servant who became city planning director, the project centralized the city's government, which had been housed in several scattered buildings. The seven-square-block site on eleven acres, a blighted and crowded African American neighborhood, was selected because of several factors: the land could be acquired cheaply; the plan would clear a section of slums considered too close to an expanding downtown business sector; traffic circulation could be simplified with the construction of Loyola Avenue; and abandoned railroad tracks could be used for new expressways. Instant urban improvement was the goal. The state and city buildings, constructed mostly of glass and beige limestone, with the clean lines and smooth surfaces popular in the 1950s, are placed—also typically for the 1950s—around an asymmetrically shaped plaza and approached by diagonal pathways. The buildings include City Hall (1956; OR76.1), designed by Goldstein, Parham and Labouisse, with Favrot, Reed, Mathes and Bergman. The same firms, with the addition of August Perez and Associates, produced the State Supreme Court and the State Office Building, both dating from 1958, and the Civil Court (1959). The New Orleans Public Library of 1958 (OR76.2) anchors the downtown side of the complex.

Although most of these civic buildings are undistinguished, their symbolic value was great, demonstrating the city's desire to show a progressive face. However, the modern design provided the grounds for one of the critiques aimed at the complex, namely, that it made no effort to fit in with traditional New Orleans architecture—an unpopular move in this city. Others, including Mayor deLesseps "Chep" Morrison, described the project as a "dazzling complex" with "glistening" buildings. Indeed, in contrast to the dour, brown-colored high-rise retail mall and hotel (1970s) inserted between the city and federal buildings, the civic center looks positively cheerful and of human scale. Duncan Plaza has been relandscaped frequently, each time without aesthetic success or public approval, if measured by use. One block upriver from this complex and separated by a hotel and shopping mall are the fourteen-story Federal Office Building (1961, Freret and Wolf; August Perez and Associates; Mathes, Bergman and Associates) and the Union Passenger Terminal (1954) by Wogan and Bernard, with Jules K. De la Vergne and August Perez and Associates, which replaced the Louis Sullivan–designed station. The terminal's best feature is a series of brilliantly colored interior murals by Conrad Albrizio (1894–1973), a social commentary on the history of Louisiana, as depicted in four different time periods.

OR76.1 City Hall

1957, Goldstein, Parham and Labouisse, with Favrot, Reed, Mathes and Bergman. 1300 Perdido St.

Taking its cue from New York's Lever Building, the eleven-story rectangular City Hall has curtain walls of green-tinted glass between insulated spandrels. Corners, crown, and base are of limestone, and red granite surrounds the entry. Large neon letters across the top of the facade identify the building and serve to distinguish it from neighboring civic buildings of similar design. The modular structural system allowed flexible floor plans, and each floor is can-

tilevered a few feet beyond the wall, permitting the air conditioning pipes and ducts to run outside the main structural system. Metal-clad louvers block afternoon sun and control glare. The windows' green tint has faded, and although replacement panels seldom match the color exactly, they do have the unintended effect of enhancing the abstract qualities of the wall, making it appear even more like a modern painting. The green glass and aluminum glitter. Although the interior lacks any splendid spaces, it does feature some cheerful wall mosaics.

OR76.2 New Orleans Public Library

1956–1958, Curtis and Davis, Architects, with Goldstein, Parham and Labouisse, and Favrot, Reed, Mathes and Bergman. 219 Loyola Ave.

The three-story library is a steel-frame structure based on a 4-foot module, with two basement levels and foundations of reinforced concrete. With the exception of the west facade, the walls are entirely of glass, covered by an aluminum screen to shield the interior from glare but permitting light to enter. By day, the aluminum screen tends to dominate the building, but at night, as architect Arthur Q. Davis has stated, the library has "a transparency and a jewel-like quality" created by interior illumination shining through the screen. Librarians report that the screen has proved effective in eliminating glare while allowing vistas outside to the magnolia trees that now surround the building. The modular steel-frame structure makes it possible to open up interior spaces both horizontally and vertically, creating spatial drama. Open book stacks allow readers to browse; two glass-walled interior patios provide additional reading rooms. The transparency and indoor-outdoor qualities of this library are hallmarks of Curtis and Davis's work at the time. The library, which cost $2.5 million to construct, won awards from *Progressive Architecture* magazine (1957) and the American Institute of Architects (1963).

OR77 Louisiana Superdome

1971–1975, Curtis and Davis, Architects, with Nolan, Norman and Nolan, Architects, Edward B. Silverstein and Associates, Architects, and Sverdup and Parcel, consulting engineers. 1500 Poydras St.

Designed in 1967 and constructed between 1971 and 1975, this multipurpose sports and convention arena was built on the former Illinois Central Railroad yards. The building itself covers thirteen acres on a fifty-two-acre site and can accommodate approximately 95,000 people (72,600 for a football game) and provide parking for 5,100 cars. The structural steel frame is sheathed with precast concrete panels, and the dome has a six-ring, patented Lamella roof framing system. With a diameter of 680 feet and a height of 273 feet from the floor to the top (higher than Houston's Astrodome), the Superdome may be the largest enclosed steel-constructed building without supporting posts—a winning design that deserves a winning football team. A system of movable stands makes it possible to change the seating arrangement and capacity as needed for different events. The decision to locate the Superdome in the heart of New Orleans rather than in the suburbs, although controversial at the time, has given the city a new economic base. Viewed from the river end of Poydras Street, which was widened in the 1960s, the Superdome's concave walls and dome offer a seductive and enticing silhouette beyond Poydras's sharp-edged high-rise. Next to the Superdome, a multipurpose sports arena faced with shimmering green tile, designed by Arthur Q. Davis and Partners, opened in 1999.

OR78 Orpheum Theater

1918–1921, G. Albert Lansburgh, with Samuel Stone, Jr. 129 University Pl.

The Orpheum has New Orleans's finest example of a polychrome terra-cotta facade. G. Albert Lansburgh of New York, the architect for all the Orpheum theaters in the country, was known for his use of decorative terra-cotta, as was his local collaborator, Samuel Stone, Jr., whose firm designed the former Maison Blanche Building (OR70). Above the theater's marquee are three pedimented windows and a polychrome relief frieze depicting frolicking cherubs and fauns. The walls above the windows are faced with five vertical panels decorated with geometric and floral patterns, which are topped by a cornice punctuated with theatrical masks. The predominant colors are cream, with details highlighted in pink, yellow, and pastel shades of green and blue. Built for live entertainment, the auditorium was tiered, with two balconies. The theater also included an apartment where children could be taken care of during the show. In 1933, the Orpheum was converted into a movie palace, and in 1993

OR76.2 New Orleans Public Library, exterior detail

OR79 Immaculate Conception Church, with the Marriott Renaissance Pere Marquette Hotel (OR80) to the right

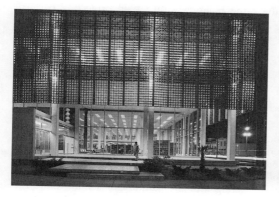

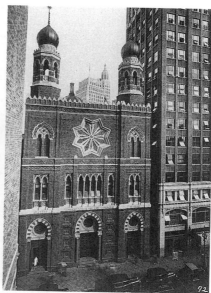

it became the home of the New Orleans Philharmonic Orchestra.

OR79 **Immaculate Conception Church**

1851–1857, Fr. John M. Cambiaso, with T. E. Giraud. 1928–1930, reconstruction, Wogan and Bernard. 132 Baronne St.

The present church is a reconstruction of the original, which was damaged first by pile driving for the Père Marquette Building next door and then by dynamite blasting for a nearby bank. Although the church was rebuilt on a framework of steel and reinforced concrete, much of the original material was reused, including the bricks (which were all numbered for accurate placement), the interior cast iron columns, and the cast iron pews. The only significant change was the addition of the two slender towers that were in Cambiaso's original design, which had not been built because of weight and soil problems. Exterior walls are of dark reddish-brown brick trimmed with white stone and red terra-cotta.

This Jesuit church is a highly original composition, blending Western and Eastern forms a decade before this idea caught on elsewhere in the United States, as at Cincinnati's Isaac Wise Temple of 1863. The twin towers, tripartite facade, and triple entrance are typical of Christian churches, but many of the elements and ornamentation are identified with Islamic architecture. These include horseshoe-shaped arches with polychrome voussoirs, interlaced arches, panels on both sides of the central door with patterns formed from Kufic script, and onion domes on the towers. The "rose" window in the upper facade is shaped like an eight-pointed Islamic star, although it symbolizes Mary as the morning star. Cambiaso, born in Lyons, France, taught in Africa and Spain before he arrived in New Orleans in the late 1840s, which explains the source of these Islamic features. Moreover, St. Ignatius Loyola, the founder of the Society of Jesus, was Spanish, and possibly Cambiaso wanted his design to reflect the order's origins. The blend of East and West may also be intended to evoke the Holy Land.

In a renovation in the 1870s, James Freret added the Islamic-inspired elements on the interior: the horseshoe-arched arcade, the carved column capitals, and the spectacular gilded bronze altarpiece with three onion domes. Most of the stained glass, made by the firm of Hucher Rathouis in Le Mans, France, depicts scenes and events in the early history of the Society of Jesus; the six apse windows have Marian themes. This church is said to be the first in the nation named Immaculate Conception, following the proclamation of the doctrine of the Immaculate Conception by Pope Pius IX in 1854. To the left of the church is the rectory, which

has been attributed to James Freret, even though he died in 1897 and the date 1899 is inscribed on the rectory's parapet. No documentary evidence confirms the 1899 date or Freret's authorship, but the building's polychrome masonry and Islamic features make the attribution plausible. James Freret (1838–1897) was a cousin of architect William A. Freret, Jr., and the first New Orleans architect to study at the Ecole des Beaux-Arts in Paris.

OR80 Marriott Renaissance Pere Marquette Hotel (Père Marquette Building)

1925, Scott Jay and William E. Spink. 817 Common St.

This former office building was designed soon after the Chicago Tribune Tower competition of 1922, for which the winning entry, along with the earlier Woolworth Tower in New York, made Gothic detailing for skyscrapers popular. Although the design follows a tripartite definition of base, shaft, and top, in the manner of Louis Sullivan's high rises, the continuous vertical piers, Tudor arches, and Gothic pinnacles and tracery emphasize the height of the eighteen-story building, as was intended. The ground floor is faced with polished red granite, and the two stories above it with off-white glazed tile. The middle section consists of pinkish-colored brick piers and green spandrels, which, in 1999, when the conversion of the structure into a hotel commenced, were painted to match the tile—a shameful desecration of the architects' intention to emphasize verticality and structure through subtle combinations of materials and color. The tower has a Gothic-patterned, glazed tile cornice. An entrance and a lobby for the hotel were designed by Lee Ledbetter Architects. Its marble floors and detailing in ceramic tile, wood, and chrome re-create a 1920s ambience.

OR81 Latter and Blum Building (Hennen Building)

1893–1895, Sully and Toledano. 203–211 Carondelet St.

When this ten-story commercial building, New Orleans's first skyscraper, was constructed, visitors paid ten cents to view the city from its roof. Commissioned by the controversial Louisiana State Lottery Company investor John Morris and named for his father-in-law, Supreme Court judge Alfred Hennen, the building is believed to be the first in the city with a steel frame. Its weight is supported on concrete and iron rafts set on spreading brick pyramids, which in turn rest on cypress pilings. Thomas Sully (1855–1939) employed Sullivan's tripartite system for organizing the facade, crowning the building with a bold projecting cornice. The yellow brick exterior walls, now painted a dark pinkish-gray, were originally painted deep russet and pale maroon; the decorative frieze beneath the eaves has Sullivan-inspired foliate ornamentation. Just a few years after the building was constructed, architectural tastes shifted to a preference for light colors and more classical ornament, as seen, for example, in the Maison Blanche Building (OR70) and a little later at the Hibernia National Bank (OR83). The Hennen Building's two-story base, with tall, round-arched openings, is among the alterations made by Emile Weil in the early 1920s, along with the addition of a floor above the cornice and an extension on the Carondelet Street side of the building, which omits the dramatic Chicago windows of Sully's design. Albert Toledano (1860–1923) was in partnership with Sully from 1888 to 1893. By the early twentieth century, a considerable number of architects, including Sully, maintained offices in the Hennen Building.

OR82 Bank One (National American Bank)

1928–1929, Moise Goldstein. 200 Carondelet St.

Erected for the Bankers Trust Company, the twenty-three-story, steel-frame building is constructed of concrete and hollow tile. A polished black granite base gives way to a cream-colored limestone skin, interrupted at four levels by shallow setbacks. At each setback, the parapets are emphasized by geometric sculptured panels of cast concrete. A six-story, off-center octagonal tower with fluted buttresses screens a water tower and is topped by an elaborate finned bronze lantern. Goldstein (1882–1972) described his design as an "American vertical style" with a "science fiction theme"; it is clearly influenced by contemporary Art Deco skyscrapers in New York. In a renovation of the 1980s, the double hung windows were replaced by smooth sheets of bronze-tinted reflective glass that upset the balance of solid and void. Interior finishes are sumptuous, mixing traditional with modern. A tall, rather severe en-

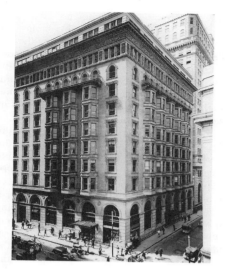

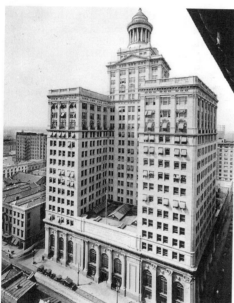

OR81 Latter and Blum Building (Hennen Building), photo late 1920s

OR83 Hibernia National Bank, photo late 1920s

trance leads to a marble-clad lobby, whose bronze elevator doors are decorated with stylized plant designs and a vast columned banking hall with walnut paneling and an elaborate plaster ceiling. Check-writing stations with bronze grilles cover the steam radiators. The original air conditioning system of 1929, per-

haps the earliest in the state, is still operable. The site and building cost $3.5 million.

OR83 Hibernia National Bank

1920–1921, Favrot and Livaudais, with Alfred C. Bossom. 313 Carondelet St.

Rising to a height of 355 feet, the twenty-three-story Hibernia Bank remained New Orleans's tallest building until the 1960s. Utilizing a U-shaped plan, with fourteen-story wings facing Union and Gravier streets, the steel-frame bank is sheathed in Indiana limestone. The design is obviously borrowed from McKim, Mead and White's Municipal Building (1907–1916) in New York, even to the tempietto at the top, although the Hibernia's tempietto also served as a beacon for ships on the Mississippi River. Corinthian pilasters enrich the exterior walls, and four engaged Corinthian columns mark the main entrance. New York architect Alfred C. Bossom, who specialized in the design of highrise banks, advised on the engineering aspects of the Hibernia. For the foundations, 3,153 wooden piles were sunk to a depth of 52 feet, reaching a layer of prehistoric oyster shells. Bossom also designed the marble banking room, giving it twenty-four fluted, 30-foot-high travertine Corinthian columns to support the coffered and gilded ceiling, and metal-grille tellers' cages decorated with replicas of ancient and modern coins. A brochure published by the bank in 1921 stated that the building was in the "Renaissance style" and noted that seven high-speed elevators made "the tower only a half-minute distance from the ground floor."

OR84 Factors Row

1858, Lewis E. Reynolds. 802–822 Perdido St.

A rare pre–Civil War survivor in the business district, this row of seven four-story Italianate structures was constructed by speculative builders Samuel Jamison and James McIntosh and designed by Lewis Reynolds (1816–1879), who moved to New Orleans from Norwich, New York, in 1843. The buildings housed cotton traders, including Michel Musson, uncle of the Impressionist artist Edgar Degas, who used the interior as the setting for his painting *A Cotton Office in New Orleans* (1873), now in the collection of the Musée des Beaux-Arts, Pau, France. All the exterior ornament for the brick buildings is cast iron, from the ground-level ar-

cade and the differently shaped moldings over each floor of windows to the scrolled brackets, cornice, and parapet. Originally the building was painted white with gilded trim and had a second-floor balcony. Next door (826–828 Perdido Street), the 1869 Santini-Providence Building was designed by Henry Thiberge (1837–1882) for the New Orleans Real Estate and Auction Exchange. This three-story, stucco-finished brick building has a facade animated by large arched windows surrounded by heavy moldings, paired windows on the third floor surmounted by smaller circular openings, an overhanging bracketed cornice, and a decorated parapet.

OR85 One Shell Square

1972, Skidmore, Owings and Merrill. Poydras St. at St. Charles Ave.

In 1972, at 51 stories and 697 feet, the Shell Company's office tower became the tallest building in Louisiana, a distinction it retains. Smoothly sheathed in off-white Italian travertine and bronze-tinted glass, the reinforced concrete and steel tower is supported on an 8-foot-thick concrete mat over 500 octagonal concrete piles, 18 inches in diameter and driven 210 feet into the ground. The reflective glass windows with dual panes eliminate the need for fins to shade the interior. Midway up a ziggurat-style stepped podium at the corner of St. Charles Avenue and Poydras Street is an orderly row of trees that provide shade and depth of color to counter the dazzling travertine. The podium, its steps, and the surrounding sidewalk are all covered with the same travertine to coordinate with the building. Thus the petroleum company's presence is forcefully asserted on the block as well as on the city's skyline. One Shell Square is similar but not identical to SOM's One Shell Plaza in Houston (1968–1971). Although it employs the same materials and the facade is similarly expressed, Houston's facade undulates and has a smaller podium.

OR86 Whitney National Bank Safe Deposit Vault

1888, Sully and Toledano. 619 Gravier St.

Dark-colored buildings were favored in the 1880s, when Thomas Sully designed this sturdy two-story, steel-frame bank. Fashioned from Missouri granite into immense rusticated blocks and grand-scale polished columns, the bank reveals Sully's flair for exploiting the tactile qualities of materials. Described when built as Egyptian in style, presumably because of its powerful forms, the bank, in fact, has no identifiable style. Sully has created something quite original with his use of outsize details, miniaturized turretlike forms at each end of the roofline, and column capitals that resemble upturned elephant feet. Bronze grilles over the windows and above the doors add to the impregnable appearance. The buildings of Philadelphia architect Frank Furness seem to have influenced those of Sully, who probably saw them before leaving the Northeast and arriving in New Orleans in 1881. The bank has an innovative 12-foot-deep underground vault, and an elliptical coffered dome originally covered the interior. George Q. Whitney established the bank in 1883 with his brother Charles and his mother, Marie Louise Morgan Whitney. This building became the safe deposit vault when the Whitney's new building at 228 St. Charles Avenue was completed in 1911.

OR87 Commercial Building (New Orleans Canal and Banking Company)

1843, James H. Dakin. 301–307 Magazine St.

This finely proportioned three-story corner building faced with light gray granite originally housed a bank and five stores. Archival drawings indicate that the superb granite Doric portico with fluted columns and a frieze of triglyphs and metopes, as well as the frame of the window directly above it, came from the previous structure on this site, a bank built in 1832 by architects J. Reynolds and J. M. Zacherie. Beginning in the 1830s, granite facings, a fashion said to have originated in Boston, became popular in New Orleans. In New Orleans, where subsidence problems usually confine the use of granite to piers at ground level, this building is unusual.

OR88 Board of Trade and Board of Trade Plaza (New Orleans Produce Exchange)

1883, Produce Exchange, James Freret. 1968, Board of Trade Plaza, Koch and Wilson. 316 Magazine St.

Formerly known as the Produce Exchange and located behind a section of Banks' Arcade, the Board of Trade was renamed in 1889 after its

merger with other associations. Freret designed a sumptuous facade for this one-story building of stuccoed brick, with full-height windows set between paired pilasters, a cornice encrusted with oversize dentils, and an entrance doorway surmounted by cresting that curls at its edges like a pie shell. At a later date, the shallow dome that covers the former trading room was painted with scenes of New Orleans's economic activities. The plaza in front of the building is a small park not much larger than a courtyard. It was developed in 1968 on the site of the hotel that occupied the center section of Banks' Arcade, which was acquired by the Board of Trade in 1889 for use as an annex and demolished in 1967. This allowed an unobstructed view of the Produce Exchange facade for the first time. In their scheme for the plaza, Koch and Wilson salvaged cast iron columns and arches from the hotel to form a loggia along one side and a blind arcade on the opposite wall. They enclosed the plaza with an iron fence, designed formal planting beds, and installed a Spanish fountain to create this little oasis in the heart of the business district.

OR89 St. James Hotel (Banks' Arcade)

1833, Charles F. Zimpel. 330 Magazine St.

Only about one-third of this former block-long row of three-story brick commercial and office structures survives today. The storefronts were separated by identical granite piers on the Magazine Street facade, but the shops were entered from the rear, where a three-story-high, glass-covered pedestrian arcade, extending from Gravier to Natchez streets, was attached to the building behind. Over the years, Banks' Arcade (so named because it was built for businessman Thomas Banks) housed a newspaper office, a hotel, an exchange, a restaurant, a barber shop, a bar, and a coffeehouse, where meetings were held in 1835 that led to the Texas Revolution; in the center section was a hotel. Bad investments and financial difficulties forced Banks to sell the arcade in 1843. A two-story, cast iron gallery was added to the corner unit after the Civil War and was extended across the rest of the facade in the twentieth century. This surviving section of the row of buildings was renovated for use as a hotel in 1999 by Trapolin Architects.

OR90 Piazza d'Italia

1978, August Perez and Associates, with Urban Innovations Group, designer Charles Moore. Bounded by Poydras, Tchoupitoulas, Lafayette, and Commerce sts.

Conceived as the centerpiece of a retail development and a site for festivals, especially for people of Italian heritage, the piazza originally included a temple-shaped pergola, a triumphal arch of painted stucco over a steel frame, a campanile, and St. Joseph's Fountain. Charles Moore designed the fountain in the form of six concentric half circles of pastel-colored column screens, each representing a different classical order. From the stainless steel capitals of the four colonnades in the front, water streamed down the columns and into a pool that flowed around an 80-foot-long contoured island in the shape of Italy. At night, neon lighting outlined the arches and columns. The historical allusions and playfulness of the ensemble were considered an ultimate expression of postmodernism. The piazza soon had problems. Because the surrounding area remained undeveloped, few people frequented it, and the absence of pedestrian traffic combined with the piazza's lack of shade and its rough cobblestone paving made the space uninviting. Moreover, the city neglected its responsibility for maintenance and operation of the water system. By the late 1980s, the piazza had disintegrated; the postmodern icon became another piece of neglected urban fabric and the first postmodern ruin. The campanile had been stripped to a rusting metal framework and the triumphal arch clumsily repainted in different colors, and the nooks and crannies formed by the arches and columns provided a refuge for the homeless. As of 2002, plans to incorporate

the plaza into a new hotel development were under consideration.

OR91 Fifth Circuit Court of Appeals (U.S. Post Office and Federal Courthouse)

1911–1913, James Gamble Rogers for Hale and Rogers. 600 Camp St.

In his use of Beaux-Arts classicism for this three-story courthouse, Rogers was following Supervising Architect of the Treasury James Knox Taylor's design guidelines for government architecture. Rogers won the courthouse competition of 1907 with a design that resembles an Italian Renaissance palazzo, producing two separate facades for the freestanding building. On the upriver long side, Rogers designed arched openings along a rusticated ground floor and borrowed from Antonio da Sangallo's Palazzo Farnese (1541) for the alternating triangular and segmental pediments over the second-floor windows. Third-floor windows are square-headed, and the building is finished with a balustrade. More dramatic are the structure's short sides, where two-story Ionic colonnades screen the second and third floors. Heavy, rusticated Doric portals are a feature of the corner pavilions; on the roof of each is a copper globe surrounded by four female figures, Daniel Chester French's allegorical sculptures representing History, Horticulture, Commerce, and Industry. The building, faced with Georgia marble, is organized around two interior courtyards, now roofed over, and includes three courtrooms on the second floor. Rogers's wide-ranging stylistic vocabulary is demonstrated in his more reticent design for the H. Sophie Newcomb Memorial College (OR143.1).

OR92 Lafayette Square

1788. Bounded by St. Charles Ave., Camp, S. Maestri, and N. Maestri sts.

Originally named Place Gravier, the square was renamed for the Marquis de Lafayette in 1824. The square served as the public open space for Anglo-Americans, their equivalent of the Creoles' Place d'Armes (now Jackson Square). It also became a focus for commemorative statues, among them Joel T. Hart's bronze statue of Henry Clay (1860), a bronze of Benjamin Franklin (1926), and Attilio Piccirilli's sentimental bronze (1898) of two children reaching up to a bust of John McDonogh (1780–1850), who in 1850 bequeathed $750,000 each to the public school systems of New Orleans and Baltimore. With Gallier Hall, the former city hall, on one side, the square became the site of many political demonstrations, especially during Reconstruction and, in 1934, between Mayor T. Semmes Walmsley and Governor (and Senator) Huey P. Long.

OR93 Gallier Hall (Old City Hall)

1845–1851, James Gallier, Sr. 545 St. Charles St.

In his autobiography, Gallier described his design: "[T]he style of architecture is Grecian Ionic, and the portico is considered as a very chaste and highly-finished example of that style." Although the portico was inspired by the north porch of the Erechtheum on the Acropolis in Athens, the building's axial orientation and dominant single portico give it a Roman presence. The building is raised on a dark gray granite podium, and the upper walls and columns are faced with white New York marble. Rather than rising from the podium, the portico's columns are placed midway from the base of the stairs, so that to reach the entrance, one has to pass between the columns while still climbing in the area of dark granite—a formidable experience. The principal floor is bisected by a wide central hall with pilasters along each wall and a ceiling of recessed panels. Rooms on either side have square-headed windows and are decorated with plaster cornices and ceiling medallions. New York artist Robert Launitz was responsible for the pediment sculpture of Justice flanked by Liberty and Commerce. Gallier Hall served as the civic center for the Anglo-American municipality until reunification of New Orleans in 1852, after which it functioned as the city hall until the new city hall opened in 1957 (OR76). The building is now city-owned and used for special events.

OR94 St. Patrick's Church

1838–1840, James and Charles Dakin. 1839–1840, James Gallier, Sr. 722 Camp St.

St. Patrick's was constructed for the English-speaking Catholics, primarily Irish, who lived in Faubourg St. Mary. The single tower in the center of the facade reveals the influence of British prototypes in contrast to the two towers of the French-inspired St. Louis Cathedral. Building specifications described the church as having been modeled on the English cathedrals of York Minster and Exeter, the latter for the ceil-

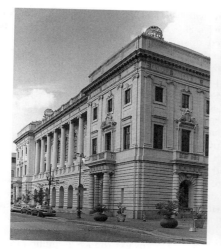

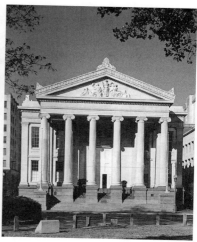

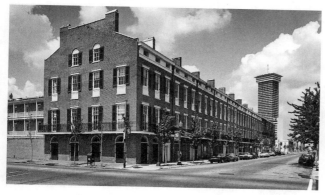

OR91 Fifth Circuit Court of Appeals (U.S. Post Office and Federal Courthouse) (above, left)

OR93 Gallier Hall (Old City Hall) (above, right)

OR95 Julia Row with Plaza Tower (OR101) in the background (left)

ing. Although the church was designed and begun by James Dakin and his brother Charles (1811–1839), Gallier replaced them in 1839, when it was found that the Dakinses had failed to install bond timbers, necessary for the structural support of the walls. Gallier eliminated the ornamentation that the Dakinses had planned for the tower and altered the 85-foot-high interior by introducing an arcade of clustered Gothic columns made of iron with wood casing. However, the lightweight fan vaults fabricated of wood and plaster retain the character of the original design. Despite the high ceiling, the church has an intimate feeling because of its considerable width, the low spring of its vaults, and an interior color scheme of cream and gold. After the hurricane of 1915, most of the original glass was replaced with new designs by the Emil Frei Art Glass Company of St. Louis, including the stained glass between the ribs of the semicircular apse vault. French-born artist Leon D. Pomarède (1807–1892), who worked in New Orleans from 1830 to 1869, painted the murals (1841) behind the altar, which include a copy of Raphael's *Transfiguration of Christ*. The exterior, covered with stucco several years after the church was built, is now finished with a cream-colored, rough-cast weatherproofing cement. Koch and Wilson undertook the restoration following Hurricane Betsy of 1965. To the right of the church is the two-story Italianate rectory (1874), designed by Henry Howard, which has suffered major alterations.

OR95 Julia Row

1832–1833, attributed to Alexander T. Wood. 600–644 Julia St.

Known as the "Thirteen Sisters," these three-and-one-half-story brick row houses were built

by the New Orleans Building Company, with Daniel H. Twogood, builder, as speculative real estate for Anglo-Americans, who favored this type of dwelling. These side-hall houses have entrance doors set between Ionic columns and a fanlight in the Federal style. Double parlors occupied the second floor, and service wings at the rear faced small courtyards. Built to accommodate the affluent, the houses had degenerated into boardinghouses and tenements by 1900, as the wealthy relocated to the uptown suburbs. The Preservation Resource Center (PRC) purchased 604 Julia in 1976 and renovated it in the 1980s, setting off a wave of renovation of the other houses on this block and the area in general. Architect Henry Hobson Richardson lived at 640 Julia Street as a child, from 1838 to 1841.

OR96　James Matthew Davis Memorial Building–Preservation Resource Center of New Orleans (Leeds Iron Foundry)

1852, Gallier and Turpin. 923 Tchoupitoulas St.

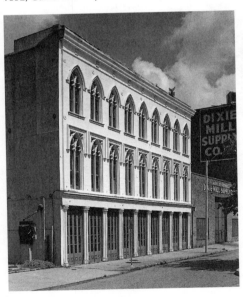

This three-story building was the warehouse and showroom for the Leeds Iron Foundry, one part of which was located on this block and another part upriver. Established in 1825, the foundry, the second largest in the South before the Civil War, manufactured steam engines, boilers, and machinery for sugar processing and sawmills and produced the first opera-

tional submarine in the United States, as well as cannons and other matériel for the Confederacy. The Neo-Gothic cast iron window tracery, hood moldings, and ground-floor clustered columns, all manufactured by the foundry, served to advertise its products. The Preservation Resource Center purchased this endangered building in 1998, restored it, and opened it in 2000 as a center for preservation activities and information.

OR97　Maginnis Cotton Mill

1882–1887. 1054 Constance St.

Built by Ambrose A. Maginnis and Sons, the textile manufacturing plant once employed 900 full-time workers who operated 12,000 looms to produce 21 million yards of cloth annually. It was the largest cotton mill in the South until it closed in 1944. The three-story, timber-frame brick building has 12-foot-high, double-hung cypress-frame windows. A magnificent square clock and stair tower, wider at the top than at the base, are surmounted by a steeply pitched mansard roof, supported on stepped brackets, which sheltered a water tank. The mill was enlarged in 1912 and again in 1922 by Emile Weil, but a changed economy and the increased popularity of synthetic fabrics forced it to close. In 1998, the mill was gutted and converted into apartments and commercial spaces by Historic Restoration, Inc., which retained an early-twentieth-century water tower, a separate 140-foot-high structure in the courtyard, to house antennae for local cellular telephone service companies. The smokestack had already been shortened from its former height of 115 feet. Despite unfortunate new additions to the exterior, such as the shedlike, two-story rooftop condominium structures and the ground-level metal roof canopies, the Maginnis remains the largest and handsomest of several factories and warehouses that, after standing desolate for years, have been converted into apartments or hotels since the 1980s. Two other examples are the Federal Fibre Mills building (1107 S. Peters Street) and the five-story Fulton Bag building (1200 S. Peters Street), which has a seven-story tower with a pyramidal roof supported on eaves brackets. The solidity and size of these structures and their fine brickwork remind us how important New Orleans's port and industrial enterprises were to the economy of the city. Archaeological excavations before the Maginnis

mill was renovated revealed that this site was formerly occupied by a late-nineteenth-century brewery, an early-nineteenth-century girls' school, and an eighteenth-century plantation house.

OR98 National D-Day Museum

1888, William Fitzner. 2000, Lyons and Hudson Architects Ltd. Magazine St. and Andrew Higgins Dr.

The D-Day Museum was established to honor American contributions to the D-Day invasion of June 1944 in World War II, and New Orleans was selected as the museum's site in recognition of the crucial role the city played in the event. Landing craft employed in the invasion of France were developed and constructed in New Orleans by Andrew Higgins (1886–1952) and were first tested on Lake Pontchartrain. Owner of a lumber export company, a fleet of ships, and a shipbuilding and repair operation, Higgins had developed before the war a highly maneuverable vessel with a shallow draft to move cypress logs out of the swamps. These boats also proved ideal for oystermen, fur trappers, and oil exploration crews in Louisiana who needed such shallow-draft boats. During World War II, Higgins adapted the vessel for amphibious landing operations. The D-Day Museum is housed in a structure that incorporates a restored former brewery and new construction. Built in 1888 to house the Weckerling Brewing Company, the historic five-story brick structure has segmental-arched windows and a corbeled cornice. For the addition, the architects repeated the structure's height and its industrial character by designing a facade of tinted glass outlined by an exposed truss, giving the impression of an airplane hangar. Set at an angle, the glass wall draws pedestrians to the entrance, showcases some of the exhibits, and gives the building a contemporary appearance. Two full-height columns at the sides frame the wall and, with the truss, hold the line of the street edge. The former brewery is an important building, a reminder of the industrial nature of this area in the late nineteenth century and of the brewing industry, the latter significant in the history of the city's large German-American population. The architect for the brewery, William Fitzner, designed several other breweries (demolished, with the exception of the remnants of one at Jackson Avenue and Tchoupitoulas Street) in the city. The D-Day Museum now includes exhibits on the Pacific campaigns of World War II and plans an expansion into three adjacent buildings to accommodate its growing collections.

OR99 Ogden Museum of Southern Art (Howard Memorial Library)

1886–1889, H. H. Richardson, with Shepley, Rutan and Coolidge. 601 Howard Ave.

After H. H. Richardson died in 1886, the Howard Library commission went to his successor firm, Shepley, Rutan and Coolidge. The firm's solution, a reworking of Richardson's unsuccessful entry for the Hoyt Library (Sagi-

OR99 Ogden Museum of Southern Art (Howard Memorial Library), exterior and interior

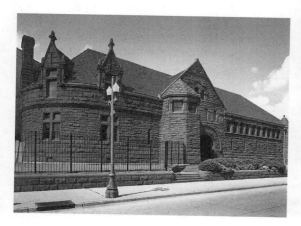
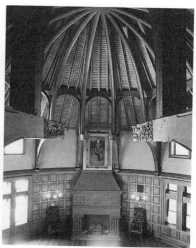

naw, Michigan) design competition, is recognizably Richardsonian in plan and appearance. Interior functions are separated: the stacks at one end of the building and the reading room, within the curved end, at the other. The off-center arched entrance, marked by a rudimentary tower, is hollowed out of the walls of roughly cut, dark red Massachusetts sandstone facing over brick, of which the library is constructed. And, characteristic of a Richardson building, intricately patterned sculpture marks transitions from wall to opening. Despite the beauty of Richardson's building, librarians complained about the poor interior lighting, owing to the 3-foot-thick walls and minimal fenestration. Nonetheless, the interiors are magnificent spaces, especially the reading room, with its oak hammer-beam ceiling, oak paneling, and vast gray sandstone fireplace, which creates the aura of a gentlemen's retreat. The stacks area also has a hammer-beam ceiling. The library was named for Charles T. Howard, president of the Louisiana State Lottery Company, who donated lottery funds to the library, as well as to several charities, to give his private company an air of respectability. In 1938, the library collection, having outgrown its space, was transferred to the Tulane University campus. After occupancy by several tenants, the Howard Library was renovated by Barron and Toups, Architects, and opened in 2003 as a museum to house Roger Ogden's vast collection of southern art. The same architects also designed the glass and brick addition (2003) to the museum, which incorporates a four-story atrium.

OR100 Confederate Museum (Confederate Memorial Hall)

1890, Sully and Toledano. 929 Camp St.

Lottery profits funded construction of the Memorial Hall as well as the Howard Library (OR99). Frank T. Howard, Charles Howard's son, donated $10,000 to the Confederate veterans for an archive building, described in the *Daily Picayune* as "an annex to the library a handsome iron fireproof building that is to be used as a library and a preservation room for all the historical records of the confederacy at present obtainable . . . the annex will be in keeping with the picturesque beauty of the library itself." Indeed, the hall's form, materials, color, and decorative details echo those of the Howard Library. It is thought that Sully and

Toledano developed their design from an 1889 drawing by Allison Owen, a drawing instructor at the Tulane Manual Training School. In 1896, Sully, Burton and Stone, the successor firm to Sully and Toledano, designed the small tower and the handsome Romanesque Revival porch for the building. The interior is paneled with red cypress.

OR101 Plaza Tower

1964–1969, Leonard R. Spangenberg, Jr., and Associates. 1001 Howard Ave. (See photo for OR95.)

Before construction began on this $18 million, forty-five-story tower, opponents of the project objected because it did not conform to the traditional architecture of New Orleans. Moreover, well before the structure was completed, it was mired in financial problems and scandal, including the architect's suit against the developer, Sam Recile, for nonpayment of $600,000 in fees. Recile and Mayor Victor Schiro similarly described the tower as a means to "revitalize" this area of downtown New Orleans, stimulate the economy, and "symbolize the progressive spirit of the city." However, they miscalculated. Financial difficulties halted construction in October 1966; the unfinished building was sold at auction in 1968 for $5.6 million, and the area was not revitalized. The tower, finally completed in 1969, has a latticed steel box frame, is wrapped on two sides by a lower curved section, and is finished with a broader three-story, flat-topped "hat." Early drawings of the tower reveal that its flat top was intended to accommodate a heliport (it is now littered with satellite dishes and aerials). The building is faced with white marble, and vertical steel columns finished with bronze-colored aluminum provide contrasting color and material. Indoor parking for 325 cars fits into eleven stories of the curved base. The tower is supported on 315 piles driven to a depth of 168 feet. In 1965, while the building was still under construction and only at the steel-frame stage, Hurricane Betsy, with wind forces in excess of 100 miles per hour, is said to have caused the elevator shaft to twist.

Certainly unique and one of the most visually complex buildings in the city, Plaza Tower blends elements from every significant architectural movement of the twentieth century: it is a homage to constructivism, futurism, expressionism, modernism, and the work of Frank Lloyd Wright, although a jumble rather than a

distillation. The curved wall, intended to echo the course of the Mississippi River, and the prowlike glass corner give it the semblance of a ship about to sail off into the future. The architect is also the designer of another unusual work in New Orleans, Unity Temple (OR127).

Garden District and Adjacent Neighborhoods

Most of this primarily residential area of New Orleans upriver from the Central Business District comprises what was once the independent city of Lafayette and the seat of Jefferson Parish. It was annexed to New Orleans in 1852. Today it consists of four distinct neighborhoods. The area now known as the Lower Garden District—bounded by Lee Circle, Erato and Annunciation streets, and Jackson and St. Charles avenues—was laid out beginning in 1807 by Barthélemy Lafon. His scheme included a circular park, the Place du Tivoli (now Lee Circle); wide, tree-lined boulevards; squares; canals; a college, which Lafon referred to as a prytaneum, for Prytania Street; and a coliseum at Coliseum

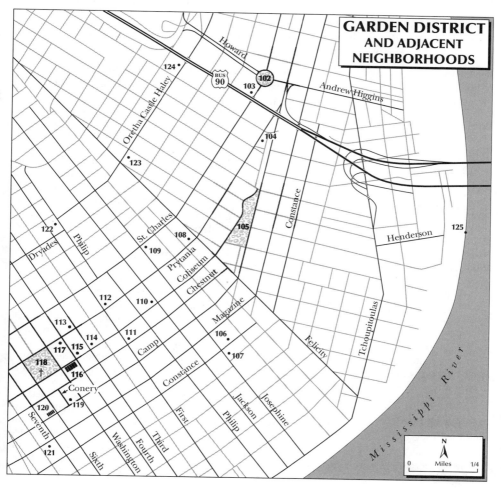

Square. The canals, school, and coliseum were never built, but many of Lafon's streets still retain the names of Greek gods, nymphs, and muses. Development of Central City, from Carondelet Street to the Claiborne Canal (now Claiborne Avenue), began in the 1830s, primarily with rental property for Irish, German, and Jewish immigrants.

In the nineteenth century, the Garden District referred to a much larger area of detached houses on tree-lined streets than today's more narrowly defined area, bounded by Magazine and Carondelet streets and Jackson and Louisiana avenues. Benjamin Buisson laid out these streets between 1st and Toledano in 1832 with four lots per square instead of twelve, as in the Vieux Carré; in the two prosperous decades before the Civil War, fashionable architects designed huge mansions set in landscaped gardens for wealthy Anglo-Americans. Magazine Street separates these houses from the far more modest shotgun houses and cottages of the Irish Channel, given its name in the nineteenth century when many Irish immigrants lived there and worked in Garden District mansions or in industries along the riverfront. Wharves, warehouses, railroad tracks, and oceangoing ships line the riverfront behind the concrete flood wall that protects the city from the Mississippi River.

Although the ethnic mix in these neighborhoods (with the exception of the Garden District) has changed over the years, they have to a surprisingly large extent retained their nineteenth-century architectural character. The houses and buildings described below represent the most exceptional examples of the area's rich architectural heritage. More detailed guidebooks and surveys are available for those who have the time to get to know these neighborhoods in greater depth.

OR102 Lee Circle

1807, Barthélemy Lafon. Lee Circle

In his urban plan for this area, Lafon envisioned a circular park, the Place du Tivoli, surrounded by a canal linked with the river and extending along what are now Howard and St. Charles avenues. Sadly, this imaginative scheme was never realized, and the planned park became a landscaped traffic circle. It was renamed for General Robert E. Lee in 1884, upon the dedication of New York sculptor Alexander Doyle's bronze statue of Lee atop a 60-foot-high Doric column of white Tennessee marble. John Roy designed the monument's Georgia granite base, which has four sets of stairs aligned with compass points. The four bronze urns were added in 1930.

OR103 K&B Plaza (John Hancock Mutual Life Insurance Building)

1960–1962, Gordon Bunshaft for Skidmore, Owings and Merrill, with Nolan, Norman and Nolan. 1055 St. Charles Ave.

Constructed on the site of the demolished public library, this seven-story office building of reinforced concrete sits on an elevated plaza, with parking space below. This was Gordon Bunshaft's first concrete-surfaced building. Vertical precast concrete louvers, 3 feet deep, shade the windows and balance the thick floor slabs; thin horizontal sun breaks, "eyebrow sunshades," provide additional shading and lateral bracing. Bunshaft described the wall as an "eggcrate wall supporting long-span beams." The precast frame eliminates support columns at the building's corners, leaving the cantilevered floor open. The central load-bearing core gives each floor uninterrupted, column-free space to permit partitioning as needed. The ground floor was originally occupied by the John Hancock Company, and the upper floors rented. On an axis with the steps to the plaza is Isamu Noguchi's rough-surfaced granite fountain, its top in the shape of a crescent to symbolize the curve of the Mississippi River. An elevated span of U.S. 90 highway, completed in the 1990s, passes next to the building, but Bunshaft's design more than hold its own. The

OR102, OR103 Lee Circle with K&B Plaza in the background

John Hancock Building received an AIA Award of Merit in 1963. It is now known as the K&B Building, after its former owners, the Katz and Besthoff drugstore chain.

OR104 The Margaret Monument

1884, Alexander Doyle. Margaret Pl. (bounded by Camp, Prytania, Clio, and Erato sts.)

The Margaret Haughery statue, one of the nation's first outdoor sculptures honoring a woman, was designed by Alexander Doyle (1857–1922), who had just completed his statue of General Lee (OR102). After Irish immigrant Margaret Gaffney (1813–1882) married Charles Haughery, they moved from Baltimore to New Orleans in the 1830s. Following the death of her daughter and husband, Margaret, penniless and illiterate, worked her way up from laundress to ownership of a dairy and bakery. She established and helped fund three asylums for the poor and, at her death, willed her fortune to eleven charitable institutions. In July 1884, thousands attended the unveiling of this white marble statue of Margaret seated on a chair with a small child at her knee.

OR105 Coliseum Square

1807, Barthélemy Lafon. Bounded by Camp, Coliseum, Melpomene, and Race sts.

This elongated, grassy public space, part of Lafon's ambitious urban plan for the area, flowered as a fashionable address in the 1840s and 1850s, and many fine mid-to-late-nineteenth-century houses still surround the square. Especially notable are the Rodewald-King House (1749 Coliseum Street), built in 1849 for banker Frederick Rodewald and purchased by novelist Grace King in 1904, which has a two-story Greek Revival gallery and an Italianate segmental-arched entrance door; the Greek Revival three-story house with a two-story gallery at 1228 Race Street, designed by Henry Howard and constructed by builder Frederick Wing in 1867 for John T. Moore; and the E. T. Robinson House (1456 Camp Street), a two-story, side-hall town house of stuccoed brick, perhaps built by Thomas K. Wharton in 1859.

OR106 St. Alphonsus Art and Cultural Center (St. Alphonsus Church)

1855–1857, Louis L. Long. 2045 Constance St.

One of three churches built within a two-block radius for Catholic immigrants, St. Alphonsus served an English-speaking, mostly Irish congregation. St. Mary's Assumption Church (see next entry) ministered to German immigrants, and the French worshiped at Notre Dame de Bon Secours, built in 1858 and demolished in 1926. All three churches were built by the Redemptorist fathers, who had arrived in New Orleans from Baltimore in 1847. St. Alphonsus, the first of the three churches constructed, is named for St. Alphonsus Liguori (1696–1787), founder of the Redemptorist order. Baltimore architect Louis Long designed the brick building, which is believed to have been built by the Irish immigrant brothers Thomas and Daniel Mulligan. In contrast to the undulating forms of St. Mary's, St. Alphonsus is crisp-edged and severely geometric, with large square twin towers and a facade animated by paired pilasters, a row of inset rectangular panels above the second-story arched windows, strongly bracketed cornices and moldings, and undecorated capitals. Spires planned for the twin towers were never built. An incongruously delicate triple-arched portico in the center of the facade was added in the 1890s. The interior is dazzling. Rear and side balconies that slope to slender column supports convey the impression of a theatrical space, an effect heightened by the splendid colorful ceiling, stained glass, and tall Neo-Baroque altar set in a stagelike columned

sanctuary. French-born Dominique Canova (1800–1868), who settled in New Orleans in 1840, was one of the artists who frescoed the coved plaster ceiling in 1866 with images of Mary, St. Alphonsus, and other figures suspended in fluffy clouds. F. X. Zettler, of Munich, Germany, manufactured the stained glass for the upper windows, depicting events from the lives of Mary and Jesus, which were installed in the 1880s. Services at St. Alphonsus ceased in 1979; the church reopened in 1990 as an art and cultural center focusing on the history of the Irish in New Orleans.

OR107 St. Mary's Assumption Church

1858–1860, attributed to Albert Diettel. 901 Josephine St.

It is said that St. Mary's German parishioners helped in the church's construction by wheeling carts of bricks from barges at the foot of Jackson Avenue. St. Mary's facade is distinguished by its beautiful brickwork and rounded forms. Tall arched openings are deeply set in the wall and outlined with prominent moldings, above which are a small rose window and a curving parapet with circular blind windows. A 142-foot-high tower, located next to the sanctuary, changes from square to variously shaped octagonal stages as it goes upward, each transition defined by curved arches or brackets, finally tapering to a series of miniature gilded segmental domes. Side walls are reinforced

with paired pilasters that continue above the roofline in the shape of miniature pedestals.

The equally florid interior has a ceiling with thick-ribbed vaults supported on fluted columns with overwrought floriated capitals. Foliate pendants are suspended from each of the arcade's arches. The multilayered, intricately hand-carved wooden high altar was made in Germany in 1874. After the parishioners saw the spectacular stained glass windows at St. Alphonsus (OR106), in the 1890s they, too, commissioned F. X. Zettler, who made representations of favorite German saints and of Mary as Queen of Heaven. Following hurricane damage in 1965, the church was restored by Nolan, Norman and Nolan, and Koch and Wilson. Along with the churches, the Redemptorists sponsored Catholic schools, convents, and orphanages to serve the neighborhood. The former girls' grammar school (1867; now Seelos Hall) for St. Mary and St. Alphonsus churches stands at 2118–2122 Constance Street.

OR108 St. Anna's (St. Ann's Orphan Asylum)

1853, Robert Little and Peter Middlemiss, builders. 1823 Prytania St.

St. Anna's was incorporated in 1853 by Christian women of several denominations as an institution for the "relief of destitute females and their helpless children of all religious denominations." The asylum is one of many that were

OR106 St. Alphonsus Art and Cultural Center (St. Alphonsus Church), interior

OR107 St. Mary's Assumption Church, 1930s photo

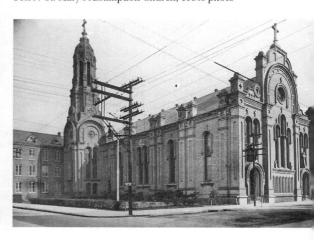

built in the nineteenth century to care for the survivors of deadly diseases such as yellow fever and cholera that regularly swept the city. Dr. William Newton Mercer, an army surgeon and philanthropist (see OR68), donated the site and funded the building in memory of his recently deceased daughter Anna. Additional donations came from the entrance fees charged by Garden District resident James Robb to see his famous marble statue, *The Greek Slave*, by Hiram Powers, which is now in the Corcoran Gallery of Art in Washington, D.C. The three-story brick building, positioned close to the property line, is fronted by an imposing and institutional-looking pedimented Doric portico raised on stuccoed brick piers scored to resemble stone. Although additions and alterations to the asylum were made between 1959 and 1965 by Freret and Wolf, Architects, the original facade has been retained. The building is now a home for the elderly.

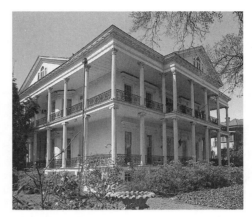

OR110 Buckner House

OR109 **The Red Room** (Eiffel Tower Restaurant)

1986, Concordia Architects. 2040 St. Charles Ave.

At the core of this peculiar steel-frame structure is the restaurant formerly located on the first level of the Eiffel Tower in Paris, 562 feet above the ground. Because the restaurant's weight was causing the tower to sag, it was sold to New Orleans investors and dismantled; the 11,000 pieces were then shipped to New Orleans and reassembled. The polygonal metal and glass restaurant is enshrined within an 88-foot-high superstructure that the architects hoped would recapture the feeling of the Parisian venue, yet not imitate it. Raised 12 feet above the ground, with parking underneath, the structure is entered by way of a 105-foot-long ramp. Despite its name, the restaurant was not a success in New Orleans and was subsequently reincarnated as a nightclub. Rust stains give the structure a precarious air, perhaps suitable for its nocturnal existence.

OR110 **Buckner House**

1856, Lewis E. Reynolds. 1410 Jackson Ave.

The building contract for this residence, of palatial scale with galleries on all sides, specified a "two-story brick house with observatory and four pediments." Slender gallery supports with Ionic columns on the lower level and Corin-

thian above give a lightness and airiness to this massive house, and the two-story portico that projects beyond the facade's deep gallery adds an equally delicate note. Detailing is Greek-inspired, from the lyre-patterned iron gallery railings to the moldings outlining the entrance door. The observatory-belvedere, which also vented hot air from the house, has been reduced in size. The house has a five-bay plan, including a ballroom and a formal dining room, both with 16-foot-high ceilings, flanking the 12-foot-wide central hall; stairs are at the end of the hall. Excluding the basement, the living area encompasses about 7,600 square feet, plus a three-story service wing at the rear. Kentucky-born cotton broker Henry S. Buckner hired Reynolds to design his house to rival that of his business partner, Frederick Stanton, for whom the architect was constructing a palatial home in Natchez, Mississippi. The house be-came the residence of Buckner's daughter and her husband, Cartwright Eustis, in 1884. In 1923, pioneer business educator Colonel George Soulé moved his business school, Soulé College, into the house. When the school closed in 1983, the house was sold and returned to residential use. Jackson Avenue was a fashionable street in the mid-nineteenth century, but only a few houses survive from this era.

OR111 **Carroll-Crawford House**

1869, Samuel Jamison. 1315 1st St.

Built shortly after the Civil War for cotton factor Joseph Carroll, from Virginia, this Italianate house of stuccoed brick combines many of the architectural features that were so popular in

New Orleans just before the war. The smooth, flat facade has segmental-arched windows and doors outlined by prominent moldings; crowning the roofline is a cornice with oversize dentils and a central tablet. A two-story cast iron gallery shades the entire facade, each of its bays arched to echo the shape of the windows behind. The contrast between the feathery ironwork and the building's solid weightiness gives each a sharper focus. To emphasize the central entrance, five bays wide, the gallery's center bay projects very slightly and is supported on slender paired columns. The house has a detached service building and carriage house. Samuel Jamison (1808–1880), who came to New Orleans from northern Ireland, had an active practice as a builder and architect both before and after the war.

OR112 **Louise S. McGehee School** (Bradish Johnson House)

1872, attributed to Lewis E. Reynolds. 2343 Prytania St.

Designed to present a showy, cosmopolitan facade for New Yorker and sugar planter Bradish Johnson, the house, of gray-painted brick with beige trim, rises in layers, from the tall flight of stairs to the balconied portico with Corinthian columns, the heavy cornice with paired brackets, the concave mansard roof with a prominent bull's-eye dormer window, the pedestal-shaped chimneys, and the iron cresting along the eaves of the roof. Formerly attributed to James Freret, in part because the Second Empire elements were thought to be a product of his studies at the Ecole des Beaux-Arts in Paris, the house was recently reattributed to Reynolds on stylistic grounds; the magnificent circular staircase has also lent support for crediting Reynolds, who wrote a handbook on stair design. However, such staircases were ubiquitous in grand mansions during this period, and designing a staircase was one of the first exercises that budding architects had to learn. This marble spiral staircase, beneath a glass dome, is reached from the entrance hall through a wide, decorated archway similar in form and effect to a theater's proscenium arch. If Reynolds did design the house, he did not take credit for it in his brief autobiography, which is included in Edwin L. Jewell's *Crescent City Illustrated* (1873). From 1873 to 1874, Reynolds was designing buildings in Galveston, one of several cities where he had worked earlier in his ca-

reer. After having several owners, the house was purchased in 1929 for use as a private girls' school.

OR113 **Charles Briggs House**

1849, James Gallier, Sr. 2605 Prytania St.

Houses in the Gothic Revival style are relatively rare in New Orleans, and this one adopts the mode as lightly as a dress on a classically symmetrical body. The exterior of brick painted a cream color and scored to resemble stone is adorned with a ground-level cast iron gallery with Tudor arches, pointed-arched windows on the second floor with shutters shaped to match and surmounted by hood moldings, paired octagonal chimneys, and doubled pointed-arched windows on the side elevations. The octagonal side bay was added a few years after the house was constructed. Inside, the traditional double parlors are separated by Gothic-inspired clustered columns and pendant brackets. The freestanding carriage house in the side yard, now converted for residential use, is also Gothic in style but constructed of wood. Charles Briggs emigrated from England, where houses in this style were quite popular. The Briggs House is also similar to Design II, "A Cottage in the English or Rural Gothic Style," in Andrew Jackson Downing's *Cottage Residences*, published in 1842. In 1854, a few years after the house was built, architect Thomas Wharton described the garden in his journal: "Lofty bananas fling open their rich purple pendants and reveal the fruit clusters in heavy branches. This plant groups charmingly with the more compact shrubbery, and fine examples of its introduction occur on the grounds of Mr. Briggs, whose place . . . is to my fancy the most tasteful in the entire suburb."

OR114 **Walter Robinson House**

c. 1859, attributed to James Gallier, Jr., and to Henry Howard. 1415 Third St.

Walter G. Robinson, from Lynchburg, Virginia, made one fortune as a cotton factor and another from perique tobacco, a curly black blending variety grown only in St. James Parish. He began construction of this five-bay brick house just before the Civil War. A two-story gallery across the front, supported on slender fluted columns, Doric below and Corinthian above, curves at each end to meet the facade. An arch-shaped parapet tablet at the center of

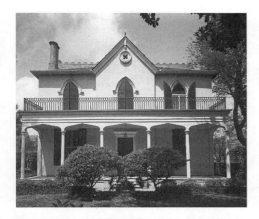

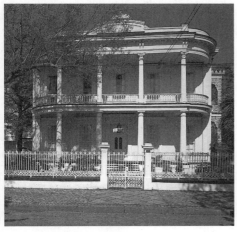

OR113 Charles Briggs House

OR114 Walter Robinson House

the roofline emphasizes the central entrance. Midway along the hall is a curved staircase in a similarly shaped alcove, and, just beyond, the hall opens onto the dining room, which projects as an octagonal bay from the side of the house. The painted ceilings are possibly the work of Dominique Canova, who adorned the ceilings of St. Alphonsus Church (OR106). In a renovation of the 1940s, the dining room was decorated with nineteenth-century hand-blocked French-style wallpaper depicting an Arcadian landscape.

The design of the house has been attributed to Henry Howard, in part because of similarities in plan to Howard's Nottoway Plantation House of 1857 (IB10), but these are not conclusive evidence. Moreover, Howard never took credit for designing this splendid house in his

autobiography, published in Edwin L. Jewell's *Crescent City Illustrated* (1873), whereas he did claim others in the Garden District. Architect and historian Samuel Wilson, Jr., believes that James Gallier, Jr., was the designer, and certainly the curved gallery can be compared to Gallier's modeling of the curved corners of his French Opera House and Mechanics Institute in New Orleans, both demolished. Another view is that Howard began the house before the Civil War and Gallier completed it after the war.

These huge Garden District homes required a large staff to keep them in proper shape. Not atypically, approximately 30 percent of the floor area in this house provided working and living space for servants. The two-story service wing extends from the left side of the house at the rear and has a two-story cast iron gallery. To its left is the carriage house. A wrought iron fence with anthemion ornament encloses the entire complex.

OR115 James Eustis House

1876, William A. Freret, Jr. 2627 Coliseum St.

James Eustis was elected to the U.S. Senate in the same year that his wife, Ellen, the daughter of Henry S. Buckner, purchased this lot, and they hired William Freret to design their house. The result, perhaps the most individualistic of the nineteenth-century houses in the Garden District, reflects the contemporary interest in exotic styles and in the three-dimensional play of forms, light and shade, textures and materials. The facade of the two-story building of painted brick is set back in three stages, each topped by an enormous projecting gable ornamented with bargeboards, pendants, and massive brackets. A single-story gallery covers only two of the stages, contributing to this theatrical composition. The side facade includes a balconied window set within a projecting gable. This extravagant exterior adorns a quite simple, conventional plan; each of the principal facade's projecting stages and its gable correspond to an interior unit of space. The central unit contains a central hall, flanked on one side by double parlors and, on the other, by the living and dining rooms. After 1884, when Eustis was appointed ambassador to France, the house was leased until purchased by architect Julius Koch in 1903. It was restored by Julius's son, architect Richard Koch, who lived there for many years.

OR116 Freret's Folly

1861, William A. Freret, Jr. 2700–2726 Coliseum St.

Not all Garden District houses were individually designed for wealthy patrons. Freret built this row of five once-identical houses as a speculative venture. Constructed at the advent of the Civil War, the two-story frame houses were financially unsuccessful, thereby acquiring their name. This kind of house—tall, three bays wide, with a side hall—was common in the mid-nineteenth century in many Lower Garden and Central City neighborhoods. Wooden galleries in a simplified Greek Revival style provided shade, and French windows at least 10 feet high allowed cooling breezes to enter the house. Such houses are often adorned below the parapet with paired Italianate brackets and cornices with dentils. When they are part of a row, as here, their harmonious proportions form a unified, urbane streetscape.

OR117 Colonel Robert Short House

1859, Howard and Diettel. 1448 Fourth St.

Although it is justifiably famous for its cast iron fence, the house itself is equally splendid. The fence, patterned in morning glory vines and cornstalks, was manufactured in New Orleans by Wood, Miltenberger and Company. Henry Howard designed the Italianate house for Kentuckian Robert Short, a cotton commission merchant, at the same time as the Dufour-Baldwin House (OR56), and it shows the ease with which Howard could turn out magnificent stucco-covered brick houses with just enough individuality to please his clients. The house was constructed by Robert Huyghe, a builder from Baltimore. Emphasizing width as much as height, the house has a suburban feel, in contrast to the Dufour-Baldwin's urbanity. Two-story galleries shade the front and the curved bay on the left side; a single-story gallery wraps around the larger side bay on the right. A heavy bracketed cornice and parapet conceal the flat roof. The entrance hall extends through the house to a cross hall at the rear of the double parlors, a feature Howard employed for other houses. The double parlors to the left of the hall are separated by two columns, forming a triple arch. Interior details for door casings, plaster cornices, and the entrance door are in the Greek Revival style. The curved staircase toward the rear of the hall was added in the early twentieth century, when some interior changes

were made; Koch and Wilson also did some work on the house in the 1960s, including remodeling the loggia. Before the house was completed, the Civil War began. Colonel Short and his wife fled New Orleans for Kentucky but returned after the war. General Nathaniel Banks of the Union Army occupied the house during the war, in 1864 and 1865. The original grounds were subdivided in 1950 for the construction of two houses.

OR118 Lafayette Cemetery 1

1833, Benjamin Buisson. Bounded by Washington Ave. and Coliseum, Prytania, and 6th sts.

Designed at the height of one of New Orleans's worst cholera epidemics, this cemetery was divided by two shell-paved avenues, carefully planned to accommodate a funeral procession, and intersecting at the center to form a cross. In 1857, the cemetery was enclosed by a high brick wall, and individual vaults were built into its inner face to help meet the need for additional burial space. By 1867, magnolia trees had been planted along the principal avenues. The formality of the plan and the landscaping reflect the idea of the cemetery as a garden of rest. Closely spaced above-ground tombs line the avenues and aisles in each of the four squares.

OR119 Steinberg-Fischbach House

1955–1957, Curtis and Davis. 1201 Conery St.

A steel structural frame provides the utmost freedom for interior spatial organization in this modern house. Organized around a central courtyard, the house is composed of two levels on the bedroom side and a single 13-foot-high living room on the other. Indirect light from the courtyard and the clerestory windows accentuates the modernist interpenetration of space. The exterior also incorporates all the elements of modernist form in the way the house is cantilevered over a concrete foundation, so that it appears to float above the ground; the horizontal, screenlike brick wall; the continuous band of clerestory windows; and, hovering over all, the flat roof. Circular concrete steps from sidewalk to front door are an essential part of the design. Walter Rooney, Jr., Curtis and Davis's project architect for this house, absorbed and manipulated the principles of modernism to accommodate the New Orleans con-

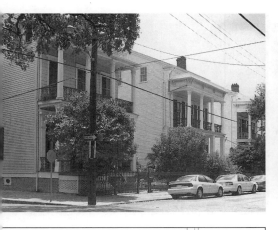

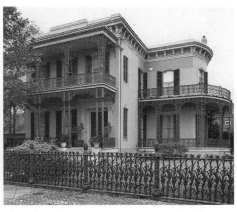

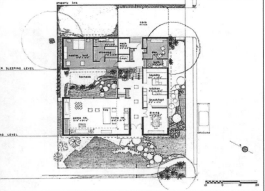

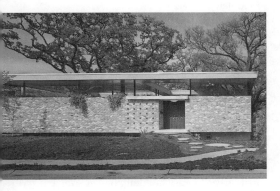

OR116 Freret's Folly (above, left)

OR117 Colonel Robert Short House (above, right)

OR119 Steinberg-Fischbach House, plan (left) and exterior (left, below)

houses. By the time the seminary was built, this city block already had a long and illustrious history. Immediately preceding the seminary, and before moving uptown in 1917, Newcomb College was located here, occupying the former mansion of James Robb, built by James Gallier, Jr., in 1854.

OR120 **Shotgun Houses**

c. 1890. 2901–2915 Camp St.

This row of camelback double shotgun houses exhibits exceptionally bold detailing. The overhanging roofs at the fronts of the wood-frame buildings are supported on elaborately ornamented prefabricated brackets that could be purchased from a catalogue. French windows with shutters open onto small porches, and small gardens in front are enclosed by low iron fences. Many of the uptown streets in New Orleans have similar rows of shotgun houses that display all manner of decorative details, from fancy gallery railings to elaborate window surrounds, brackets, spindles, and arches.

OR121 **Orphanage Apartments and Commercial Building** (Protestant Orphans Home)

1887–1888, Thomas Sully. 3000 Magazine St.

Founded by a group of Protestant women after the yellow fever epidemic of 1853, the orphan-

text and climate. The house received an Award of Excellence from *Architectural Record* in 1959.

This section of Conery Street, extending from Camp to Chestnut streets, was created in 1955, when the Baptist Theological Seminary, which occupied the entire block from Washington Avenue to 6th Street, divided its property into lots and sold them for the construction of

age was first housed in a smaller building on the same site. Deadly diseases continued to take their toll during the nineteenth century, so that the city's need for orphanages did not diminish. Sully designed this large three-story building to house a boys' dormitory, infirmary, and dining hall. A girls' wing was added at a later date. Sully blended elements of the Romanesque and Queen Anne styles to create a fairy-tale building, albeit a somewhat formidable one, with ornate brickwork, twin towers, turrets, and a huge, deep-balconied arch marking the entrance. However, he ornamented it prettily with a multicolored roof incorporating rose-colored, heart-shaped tiles. For several years, a high wall enclosed the orphanage to protect local residents from diseases that, it was thought, the children might spread. The orphanage closed in 1972 and, after standing empty for some years, the building was purchased and converted into apartments and commercial spaces by architect John Schackai III. At that time, the brick exterior walls were painted in shades of rose and terra-cotta, a treatment and color scheme not typical of Sully's work.

OR122 **Dryades YMCA** (Dryades Street Branch Library)

1914–1915, William R. Burk. 1924 Philip St.

An Andrew Carnegie grant in 1912 funded this library for African Americans on a site at the termination of Oretha Castle Haley Boulevard (formerly Dryades Street), a location proposed by black civic leaders and one that gave the building a highly visible presence. Constructed of red brick with decorative details of Bedford, Indiana, limestone, the facade imitates a triumphal arch, with three wide, round-arched bays framed by Ionic pilasters. An elaborate classically inspired portal is set in the center bay. Although the door has been altered and the huge windows that filled the side bays have been partially blocked, Burk's original design is still apparent, and the elaborate sculptural details—an open book, wreaths, and decorative capitals—are intact. When the library was built, a children's reading room was located to the left of the central entrance and an adult reading room to the right; an auditorium was in the basement. The library opened with 5,649 books, increasing to 13,000 by 1932. The Dryades Street Branch Library was the only public library in the city available for African

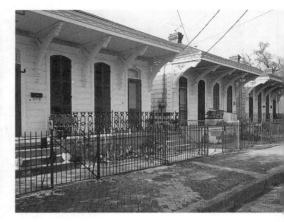

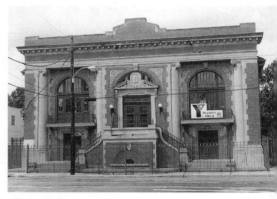

OR120 Shotgun houses

OR122 Dryades YMCA (Dryades Street Branch Library)

Americans until 1953, when the Nora Navra Branch, at 1902 St. Bernard Avenue, was constructed. Orleans Parish libraries were desegregated in 1955, although restrooms and water fountains remained segregated for several years. Of the six original Carnegie-financed libraries in New Orleans, three others survive: the Napoleon Avenue and Algiers Point branches still function as libraries, but the Canal Street Library building, by Lagarde and Burke (1910; 2940 Canal Street) is used as a beauty college. The Dryades Street Library, the handsomest of the surviving group, closed in 1965 following damage from Hurricane Betsy, and by then, the city's libraries were integrated. The YMCA now uses the building for its programs. William R. Burk (1888–1961) was the architect for many public buildings in southern Louisiana.

OR123 Venus Gardens Apartments
(Kaufman's Department Store)

1919, Samuel Stone, Jr. 1700–1724 Oretha Castle Haley Blvd.

This former department store prospered during the Jim Crow years, when black shoppers, who were not welcome in the Canal Street stores, made this street a center for commercial and social activities. Until the 1960s, it was the city's second most important retail district. A Kaufman's store occupied the corner of this block before 1895, but after purchasing the adjoining property, Kaufman commissioned Samuel Stone, Jr., to design a three-story building faced with fashionable white terra-cotta. Four bays wide, with huge windows on each floor, the facade is decorated with a row of terra-cotta lion heads along the cornice. The growth of suburban shopping malls dealt a death blow to shopping streets like this one. After standing empty for several years, the building was renovated in 1998 by Alecha Architects for retail use and apartments. On the next block, another former department store, Handelman's (1824 Oretha Castle Haley Boulevard), was designed on lines similar to Kaufman's by Weiss and Dreyfous in 1922.

OR124 St. John the Baptist Church

1869–1872, Albert Diettel. 1139 Oretha Castle Haley Blvd.

This handsome brick church, with a gilded onion dome that is an area landmark, was built for the Irish immigrants who settled in this area. The church, replacing a smaller, wooden structure of 1851, was built by Irish contractor Thomas Mulligan to designs of Albert Diettel, who took his inspiration from the onion-domed Hofkirche in Dresden, Germany. Diettel used paired pilasters on the facade to indicate internal space divisions and repeated the paired motif in Corinthian columns on the middle level of the tall, three-stage tower. A heavily molded and bracketed entablature wraps around the building, gently curving over the small rose window in the center of the facade. This entablature is repeated at each of the tower's setbacks in order to unify the design. The brickwork on this church is particularly fine. The cost of the building, $150,000,

exceeded the congregation's resources, so it was not until the 1880s, after the Reverend Thomas Kenny purchased the building, that the interior was completed and the enormous stained glass windows, made in the Munich studios of Franz Mayer and F. X. Zettler, were installed. The church was struck by lightning in 1909 and repaired with a steel and concrete roof. An adjoining school, built in the 1850s, was demolished in the 1950s for the raised expressway now next to the church.

OR125 *Delta Queen* Steamboat

1926–1928, Robin Street Wharf (river end of Henderson St.) (Visible only when docked)

The *Delta Queen* is one of the few overnight paddle-wheel steamboats that regularly travel the Mississippi River, primarily carrying tourists on cruises. Four decks high and 285 feet long, the boat has two 1,000-horsepower steam engines and reaches a speed of six miles per hour; its stern-wheel design is less vulnerable to damage than side-wheeler steamboats. The flat-bottomed design of river steamboats required housing engines and boilers on the main deck and adding upper decks for passenger accommodations. Once the type was developed, by 1850, little but size and elaboration of finish distinguished one boat from another. The golden age of steamboating lasted from 1820 to 1860, when these "floating palaces" offered lavish lounges, bars, barbershops, full dining service, and sometimes their own newspapers. Steamboat transportation waned as a result of the increased use of trains during the Civil War.

The *Delta Queen*'s steel hull was fabricated in Glasgow and the machinery in Dumbarton, both in Scotland; the wheel shafts and cranks were made at the Krupp plant in Germany. The interior, made in California to designs by Jim Burns, employs oak, teak, mahogany, and Oregon cedar, and features a splendid mahogany staircase leading to the main salon. After service first as a pleasure boat and then, during World War II, as a ferry transporting soldiers across San Francisco Bay, the *Delta Queen* was purchased in 1946 by Greene Line Steamers and restored in Pittsburgh for a new life cruising the Mississippi and several tributaries. With a crew of 75, the steamboat can carry up to 190 passengers.

Uptown and Carrollton

New Orleans's expansion upriver was encouraged, beginning in 1835, by the steam-powered New Orleans and Carrollton Railroad, laid out along St. Charles Avenue. The line was converted to mule power in 1867, then electrified in 1893, and the streetcars continue to carry passengers along this route. Four major streets, all running parallel to the river, define the character of Uptown. Closest to the river, Tchoupitoulas Street developed as the industrial and warehouse corridor serving the port, evidenced in the half-mile-long brick warehouse that extends from Louisiana Avenue to General Taylor Street. The former Lane Cotton Mills (closed in 1957), established in the 1850s in a building by George Purves (d. 1883) at Valence Street and the river, was enlarged in 1881 by William Fitzner, and again in 1903 by Favrot and Livaudais; this last section has been adapted for use as a supermarket. Between Napoleon and Nashville avenues and the river are the remaining silos of a once much larger grain elevator (now used for storing green coffee), two thirty-story-high cranes, and several 57-foot gantry cranes for handling the containers and cargo at the wharves. A few blocks inland, Magazine Street grew as an eclectic mix of commercial and residential buildings. St. Charles Avenue acquired grand mansions for the affluent and became the most prestigious address in the city. By 1900, almost the entire length of St. Charles had been built up. Claiborne Avenue was developed in the early twentieth century, when more efficient pumps became available to drain the swamps that lay inland from the river. Now a major traffic route, the avenue has a wide, landscaped neutral ground that conceals a drainage canal.

Carrollton was reputedly named for General William Carroll, a commander who aided Andrew Jackson in the battle to defend New Orleans in 1815 (and who later became governor of Tennessee). This former plantation land was acquired by the New Orleans Canal and Banking Company and subdivided by Charles Zimpel in 1833. Carrollton quickly became a popular resort, with a hotel and a public garden, both now buried under a levee setback. The town was incorporated in 1845 and annexed to New Orleans in 1874.

OR126 Cuthbert Bullitt House

1868–1869, Edward Gottheil. 3627 Carondelet St.

Described as a "Swiss villa" by the *Daily Picayune* in 1868, this prettily decorated frame house raised on 8-foot-high brick piers was built for Cuthbert Bullitt, from Kentucky, a customs collector, bon vivant, and gambler, who spent his winters in New Orleans as he got older (he lived to the age of ninety-seven). It is believed that Edward Gottheil (c. 1813–1877) brought the design from Europe. The symmetrical facade is animated with decorative cross timbers and the wide and deep gable roof adorned with jigsaw bargeboards, and this decoration is repeated on a smaller scale on the gables over the windows. The interior details, however, are in the Greek Revival style. Originally located on St. Charles Avenue, the house was moved here in 1883, after cigar manufacturer Simon Hernsheim purchased the St. Charles Avenue site to build his enormous mansion, now the Columns Hotel.

OR127 Unity Temple

1960–1961, Leonard R. Spangenberg, Jr. 3722 St. Charles Ave.

Spangenberg, a former student at Frank Lloyd Wright's Taliesin Fellowship, and Ruth Murphy, a Unitarian minister, determined the plan of this church, choosing a circular design as a

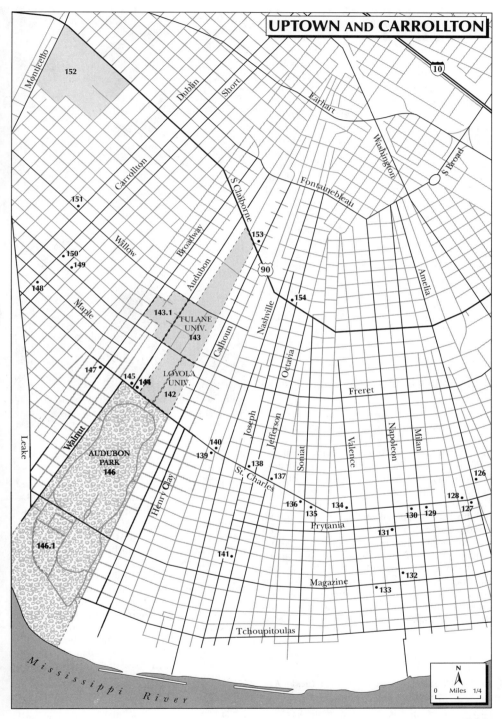

152

Monticello

Dublin

Short

Earhart

Washington

S Broad

10

Carrollton

Fontainebleau

151

S Claiborne

Willow

Broadway

153

Audubon

90

154

Nashville

Amelia

148

150

149

Maple

143.1

FULANE
UNIV.
143

Calhoun

Octavia

Freret

147

145 144

LOYOLA
UNIV.
142

Joseph

Jefferson

Soniat

Valence

Napoleon

Milan

Leake

Walnut

AUDUBON
PARK
146

Henry Clay

140

139

138

137

St. Charles

126

128

127

136

135

134

130 129

146.1

Prytania

131

Magazine

141

132

133

Tchoupitoulas

Mississippi River

N
0 Miles 1/4

symbol of unity and eternity. Everything in the design is based on the circle, from the two low, intersecting domed structures to the entrance plaza, outdoor planters (one originally was a pool), catch basins, benches, lighting fixtures, staircase, pulpit, and decorative trim.The building, including its two saucerlike domes, is constructed of poured concrete. The larger dome shelters a sanctuary seating 300 people, and the smaller covers the narthex and offices. Interiors are illuminated by continuous bands of Plexiglas clerestory windows and circular skylights in the domes. A rectangular extension was attached to the sanctuary in 1987 but fortunately is not visible from St. Charles Avenue. Although the building is quite at odds with all the others on this conservative street, Spangenberg justified his design by claiming that new buildings were replacing old ones so quickly that any attempt at conformity was doomed. He was wrong with regard to St. Charles Avenue, but he nevertheless gave it a genuinely twentieth-century design and not another nineteenth-century replica. Spangenberg also designed another of the city's unusual buildings, Plaza Tower (OR101)

OR128 Emlah Court Apartments

1912, Diboll, Owen and Goldstein. 3823 St. Charles Ave.

One of the first of the grand early-twentieth-century apartment buildings in New Orleans and the city's first cooperative apartment building, Emlah Court broke the tradition of single-family houses on the avenue. The structure reflects contemporary ideas about the design of tall apartment buildings, more common in New York than in New Orleans. The five-story building is constructed of reinforced concrete, wood, and brick, and the first story is stuccoed with horizontal divisions to imitate rustication. Emlah Court offered three-bedroom apartments on each floor, with the luxury of three bathrooms and an elevator with brass doors. A curved metal marquee over the entrance and curved frames on some windows suggest the influence of Art Nouveau, a rare feature for New Orleans.

OR129 John S. Wallis House

1885–1889, Sully and Toledano. 4114 St. Charles Ave.

The Shingle Style was at the height of its popularity in the United States when Sully designed

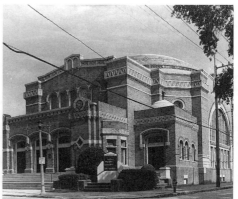

OR127 Unity Temple

OR130 Touro Synagogue

this house for John S. Wallis, the president of the Louisiana Sugar Refining Company, probably as a wedding gift for his daughter, Louise. In his use of shingles, Sully once again introduced to the city the latest fashions in building materials and forms, and he did not do it in a halfhearted way. This house is smothered in differently shaped cypress shingles, including the front gallery piers; all the shingles are now painted white, as is typical of Louisiana's shingled houses, although originally they were stained a dark natural color. Providing a striking touch of color are the checkerboard bands of blue glazed tiles and white-painted cement squares beneath the eaves of the second story. A Sully innovation is the use of lattices between each bay of the gallery, which are cut in the shape of stilted arches and impart an Islamic touch. The house originally had a widow's walk

above the oversize gabled dormer, which blew off during Hurricane Betsy in 1965. The entrance leads into a large hall that has wood paneling on its lower walls and is flanked by a library and a parlor. The former carriage house (4115 Pitt Street), also shingled, is now a private residence. Sully and Toledano built an almost identical house for the Wallis family in Pass Christian, Mississippi.

OR130 Touro Synagogue

1907–1908, Emile Weil. 1928, Sabbath school, Nathan Kohlman. 1989, addition, Lyons and Hudson Architects. 4238 St. Charles Ave.

Touro Synagogue was named for Judah Touro (1775–1854), a descendant of the Touro family of Newport, Rhode Island. A significant figure in New Orleans, he bequeathed his fortune to a wide variety of charitable institutions and to Touro Hospital, formerly the Hebrew Hospital. Touro Synagogue's congregation was formed by the merger in 1881 of German and Spanish-Portuguese congregations. Emile Weil won the synagogue's design competition in 1907 with his scheme for a low-domed, Byzantine-influenced structure, a solution adopted by many synagogues because of its Middle Eastern origins. The synagogue is constructed of beige pressed brick and ornamented with polychrome glazed terra-cotta bands and cornices; the dome is tiled in pale green interspersed with yellow and blue. The main auditorium, covered by a shallow dome, 71 feet in diameter, has two walls of stained glass windows in varied shades of gold and green.

Nathan Kohlman (1883–1957) designed the

OR131 St. Elizabeth's (Home of Industry)

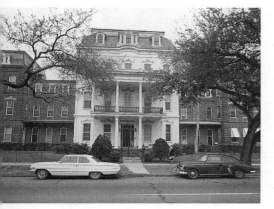

Sabbath school at the rear of the temple (corner of General Pershing Street), which shows Islamic influences in its colorful entrance composed of three arches framed by a larger arch. The multipurpose addition (1989), next to the synagogue on St. Charles Avenue and linked to it by an arcade, echoes, in a simplified and more angular composition, the forms and decoration of the original building. It includes classrooms, a 120-seat chapel, and stained glass windows designed by New Orleans artists Ida Kohlmeyer and Gene Koss.

OR131 St. Elizabeth's (St. Elizabeth's Home of Industry)

c. 1864, Thomas Mulligan. 1883–1884, Albert Diettel. 1314 Napoleon Ave.

St. Elizabeth's Home of Industry was founded by the Daughters of Charity of St. Vincent de Paul in 1855 to teach vocational skills, such as sewing, to orphaned girls between the ages of fourteen and eighteen. First occupying a Henry Howard–designed building at a different site, the home was relocated here in 1871. The building had formerly housed St. Joseph's Academy, and at that time consisted of just the three-story central section, constructed by builder Thomas Mulligan. The brick building is shaded by a two-story gallery supported on cast iron Corinthian columns. In 1883, a wing is added to the Prytania Street side of the building. Designed by Albert Diettel and built by Albert Thiesen, it had a two-story-high chapel with stained glass windows on the upper floor. The wing has rusticated brickwork at ground level and on its quoined corners and is covered by a mansard roof. The following year, an identical wing was built on the Perrier Street side of the central building. In 1888, the earlier central section was given a mansard roof, an addition that gave the complex the unified appearance it has today. Although by that time mansards were no longer the cutting edge of fashion, the addition here may have been influenced by the popular mansard-roofed main building at the Cotton Centennial Exposition of 1884 in Audubon Park. St. Elizabeth's was funded in part by Dr. William Newton Mercer, in memory of his daughter Elizabeth; his other daughter, Anna, was commemorated at St. Anna's Asylum (OR108). In 1993, after standing empty for several years, St. Elizabeth's was purchased by novelist Anne Rice, who renovated it to use for charitable events and parties.

OR132　St. George's Episcopal School
(McDonogh School No. 6)

1875, William A. Freret, Jr. 923 Napoleon Ave.

This brick building, one of the schools funded by John McDonogh's bequest, was among the first public schools "for colored children" in New Orleans. The classical entrance, added in the twentieth century, and exterior symmetry disguise the fact that Freret's design is basically in the Gothic Revival style, apparent in the brick hood moldings and gable-end blind arcade. A feature of several of Freret's school designs was a ground-floor open play area, which in this case has been enclosed for additional classroom space. When the school board reassigned the McDonogh School to white children in 1888, protests from the African American community, whose members then still had voting rights, caused this decision to be temporarily revoked. However, in 1926, because the school was located in a primarily white neighborhood, the board succeeded in transferring it to white students, remodeling the building for commercial and secretarial classes for girls. After the school closed in 1960, it was purchased by the Tikvat Shalom congregation and then, in 1977, by St. George's Episcopal School. A few years later, St. George's acquired the nearby former Jefferson Market (4301 Magazine Street), an E. A. Christy design of 1917, which was converted into a gymnasium in 1990.

The architect for St. George's, William Freret, designed several handsome schools for the New Orleans public school system in the late nineteenth century. One example nearby (1111 Milan Street) is McDonogh School No. 7, built in 1877, which has retained its Gothic Revival exterior. Near St. George's are two other noteworthy buildings: the Carnegie-funded Neo-Renaissance Napoleon Avenue Branch Library (913 Napoleon Avenue), designed in 1905 by Favrot and Livaudais, and, in the next block, St. Stephen's Church, 1868–1887 (1025 Napoleon Avenue), designed in the Gothic Revival style by Thomas W. Carter, with a spire added in 1908.

OR133　Valence Street Baptist Church
(Mission Baptist Church)

1885–1886, Thomas Sully. 4636 Magazine St.

Sully's versatile use of all the popular trends of his time is revealed in his admirable handling of the Stick Style for this wooden church. The frame is outlined and emphasized, giving it the skeletal attributes that are the hallmark of the style; the diagonal and horizontal arrangement of the boards on the gable further emphasizes the angular, sticklike qualities of the design. A large square tower, with small dormers set in a pyramid-shaped steeple, anchors the church to its corner site. Diamond-shaped multicolored glass fills the pointed-arched windows. In the 1930s, the church was raised to its present two-story height in order to provide more space for the growing congregation. Although this modification gave the church a much more commanding presence than was originally intended, the building retains an unpretentious character and a clarity of construction that reflect the congregation's origins. It grew from a mission opened in 1880 in a house on Valence Street by Emma Gardner, from Mississippi, following the Mississippi Baptist Convention's decision to establish more churches in New Orleans. At that time, the only Baptist church in New Orleans was the Coliseum Place Baptist Church (1376 Camp Street), designed in 1855 by John Barnett, with a tower, also of 1855, by Thomas Wharton in consultation with Richard Esterbrook and Lewis Reynolds.

OR134　William Perry Brown House

1902–1907, Favrot and Livaudais. 4717 St. Charles Ave.

Cotton merchant William Brown promised his new wife the best house on the avenue. Elevated on an earthen terrace, this huge two-and-one-half-story house in the Richardsonian Romanesque style is constructed of warm-hued beige limestone and has a red tile roof. The walls themselves are striking, with stones that are coursed but vary in size and surface treatment across the principal facade, whereas the gables, chimneys, and subsidiary walls are laid out in random patterns. Across the front, the one-story porch, with a row of wide arches outlined by huge voussoirs and supported on squat columns, provides a deep, shadowy transition from the dazzling marble steps to the interior. The central hall led to a breakfast room at the rear, and this principal floor included a parlor, dining room, library, and billiard room. The largely classical interior decor was fashionable, and Brown must have pleased his wife with the hot-air heating in every room, a bath for each bedroom, electric lighting, and electric call signals for summoning servants.

OR135 Joseph Vaccaro House

1912–1913, Edward F. Sporl. 5010 St. Charles Ave.

Medieval English styles were popular when this house was built by Joseph Vaccaro, founder of the Standard Fruit and Steamship Company and an importer of bananas from Central America. Edward Sporl (1881–1956) chose the Tudor Revival style, as evidenced in the picturesque silhouette, gable roofs, half timbering on the second floor and on the gables, prominent brick chimneys, stone trim, and diamond-pane mullioned windows. The porte-cochere is more Jacobean than Tudor in its detailing. The reception and living rooms are wood-paneled and have carved stone fireplaces.

OR136 Milton H. Latter Memorial Library
(Marks Isaacs House)

1906–1907, Favrot and Livaudais. 5120 St. Charles Ave.

Occupying an entire block and raised on an embankment, this stone house was constructed for Canal Street merchant Marks Isaacs. After his death, the house was sold in 1912 to lumber baron Frank B. Williams and was occupied by his son, pioneer aviator Harry Williams, who was married to silent-movie star Marguerite Clark. After Harry Williams died in a plane crash in 1936, Clark sold the house to racetrack entrepreneur Robert Eddy, who sold it to Mr. and Mrs. Harry Latter in 1947. They donated it to the city for use as a public library in memory of their son, Milton, who was killed in World War II. Although interior changes were made for library needs, the homelike atmosphere and materials were retained, including the mahogany paneling, staircase, and dining-room mantel and the ceiling murals. When built, the house possessed one of the city's first home elevators, and a ballroom occupied the third floor. A separate carriage house is at the rear of the property.

OR137 Farnsworth Apartments

1932, Weiss, Dreyfous and Seiferth. 5355 St. Charles Ave.

This small brick apartment complex, constructed for R. P. Farnsworth and Company as an investment property, was a unique addition to St. Charles Avenue in its frank expression of modernist principles. The streamlined horizontal emphasis, wraparound metal-frame windows, and flat roof were ideas new to New Orleans, let alone this street. Organized in the typical U-shaped format around an entrance courtyard, the building accommodates eight two-bedroom apartments, each provided with service stairs leading from the kitchen to the basement garage and servants' entrance.

OR138 Emanuel V. Benjamin House

1916, Emile Weil. 5531 St. Charles Ave.

Emile Weil sited this large house well back from the street in order to fully display its fashionable Beaux-Arts facade to passersby. At the time Weil received the commission from Emanuel V. Benjamin, who in 1914 had purchased the Maginnis Cotton Mill (OR97), he was, along with the firm of Favrot and Livaudais, the architect of choice for clients seeking to assert their social standing and wealth in a stylish house on an Uptown avenue. Both Weil and the Favrot and Livaudais firm became masters of Beaux-Arts designs derived from those of McKim, Mead and White of New York. Benjamin also hired Weil to design the extensions to his mill. For this house, Weil provided a well-proportioned symmetrical facade faced in beige stone, with a wide but shallow single-story central pseudo-portico supported on paired Ionic columns in front of the slightly recessed central section. Iron railings define the portico's upper edge; this horizontal movement is repeated, in stone, in the balustrade along the roofline and in front of the house, where a low balustrade outlines a shallow front terrace. The low hipped roof has three dormers with round-headed pediments. Because there is little depth to the facade's architectural elements and thus no significant play of light and shade, the house lacks any sense of three-dimensionality. The exterior appearance is also misleading in its relationship to the interior organization; behind what would seem to be the central entrance was a wood-paneled living room, and the reception hall was located at the side of the house by the porte-cochere.

OR139 Antonio Palacios House

1867, Henry Howard. 5824 St. Charles Ave.

Cotton factor Antonio Palacios built this five-bay raised house of white-painted wood early in the development of this section of New Orleans, and at first glance, Howard's design

seems to reflect an earlier era. The single central pedimented dormer and the gallery on slender Ionic columns are traditional features; only the segmental-arched windows indicate contemporary taste. The interior has a central-hall plan, with detailing in a simplified Greek Revival style. Set far back on its lot, the house is romantically veiled by the trees and foliage of its large front garden. Diagonally opposite (5705 St. Charles Avenue) is a house exemplifying the Antebellum Revival: a white-painted brick replica of Tara, from the movie *Gone with the Wind*, built in 1941 for George Palmer by Andrew W. Lockett.

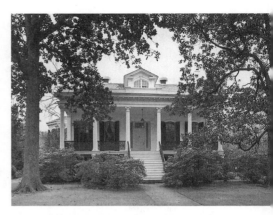

OR140 Nicholas Burke House

c. 1896 or 1907, Toledano and Wogan. 5809 St. Charles Ave.

Known as the "wedding cake" house because of its tiered appearance, profuse decoration, and all-white exterior, the residence was described as "colonial" by the architects, though rarely has this style been so festive. The single-story gallery of the wooden house is supported on clusters of columns with Ionic capitals draped with garlands, and garlanded friezes decorate the gallery entablature. Gallery balustrades are punctuated by finials in the shape of classical urns; window surrounds are adorned with scrolled brackets, moldings, and gooseneck gables; the roof has elaborate dormers. The gallery is curved on the right side, which gives the symmetrical facade the deceptive appearance of asymmetry. A porte-cochere on the left side of the house and a gallery have identical decoration. Toledano was in partnership with Ferdinand Reusch (1826–1901) when this house was built; however, the surviving detailed drawing of the elevation, signed but undated, identifies Toledano and Wogan (Victor Wogan, 1870–1953) as the architects. Their partnership was formed in 1901 and lasted until 1914. The house was renovated in 1907 following an electrical fire, but since the signed drawing suggests more than a renovation, the precise date of Burke's house may remain unknown. William F. Krone was the builder. The liveliness of the design was probably influenced by buildings at the World's Columbian Exposition of 1893 in Chicago, particularly the New York State Pavilion, by McKim, Mead and White. Born in Ireland, Nicholas Burke arrived in New Orleans in 1850, made a fortune in the retail grocery business, was one of the founders of Hibernia Na-

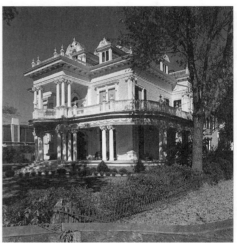

OR139 Antonio Palacios House

OR140 Nicholas Burke House

tional Bank, and was financial adviser to Irish-born Margaret Haughery (see OR104). The flamboyant exterior of his house is all the more surprising, given that Burke was a reserved and religious man.

OR141 Dr. and Mrs. Henry G. Simon House

1960–1961, Charles Colbert for Colbert-Lowrey-Hess-Boudreaux Architects. 922 Octavia St.

Built for a young pediatrician and his family, the house is composed of four pavilions identical in size and form, connected by glazed passageways that define two interior courtyards, one for meditation and the other for recre-

ation. Each of the pavilions serves a specific use, as specified by the clients: living, dining and food preparation, children's space, and parents' space. Each pavilion has a pyramidal roof of wood and steel. Windows on the exterior brick walls are small and high to ensure privacy, and all large glassed areas face inward to the courtyards. New Orleanian Charles Colbert (b. 1921), dean of Columbia University School of Architecture from 1960 to 1963, said of his modern design, "I have attempted to recall the earlier forms of architecture in Louisiana, maintain a reasonably constant residential scale, and repeat some of the roof forms of the immediate environs." The house received a *Progressive Architecture* Residential Design Citation in 1960 and was widely published in architecture journals.

OR142 Loyola University

1909 to present. Rathbone DeBuys for DeBuys, Churchill, and Labouisse. 6363 St. Charles Ave.

In 1909, the Jesuits held a design competition for the new college they planned to build on this site, acquired in 1889. The competition attracted all the top architecture firms in the city, including Favrot and Livaudais and Toledano and Wogan, but Rathbone DeBuys's Tudor Gothic design won the Jesuits' favor. Although the first building completed on the new campus was the Burke Seismographic Observatory in 1909, Marquette Hall is the centerpiece of the design. A red brick structure with limestone details, reminiscent of Hampton Court (1514) in England, Marquette Hall faces St. Charles Avenue across an open-ended court. It is linked to the buildings along the sides of the court by a covered arcade that has a convincing medieval atmosphere. In 1913, Rathbone DeBuys (1874–1960) designed the Holy Name of Jesus Church (completed in 1918), which is located on the upriver side of the academic court. The church is said to be modeled after Canterbury Cathedral, but its enormous square, pinnacled tower in the center of the facade is a feature of many English churches. Viewed from Audubon Park across the avenue, the tower rising above the treetops presents a scene quite evocative of an English landscape.

Subsequent buildings on the campus were arranged around courtyards in a typical collegiate manner, including those of the 1960s and 1970s, in styles fashionable during those decades. Particularly noteworthy is the Science Center (1968, J. Buchanan Blitch and Associates; Mary Mykolyk, project architect), a bold design with removable concrete infill panels set within the exposed concrete frame structure. For the new library (1998), the Mathes Group revived the medieval theme in red brick.

OR143 Tulane University

1893 to present. 6823 St. Charles Ave.

Tulane University had its origins in the Medical College of Louisiana, founded in 1834, and became the University of Louisiana in 1847. The university began to prosper only after merchant Paul Tulane (1801–1887) endowed it for white youths; it was named for him in 1884. With the purchase in 1891 of a long, narrow strip of land across St. Charles Avenue from Audubon Park, construction on the new campus began in 1893. The architects for the first buildings were Harrod and Andry and the successor firm of Andry and Bendernagel, whose winning entry in a design competition featured time-defying rusticated stone buildings clearly influenced by H. H. Richardson, America's most admired architect in the 1890s. Gibson Hall, the administration and classroom block facing St. Charles Avenue, was the first building completed on Tulane's Uptown campus. Gibson Hall physically defines both the outer edge of the campus and the Gibson quadrangle behind it. Four of the quad's buildings are similar in materials and style; the most notable is the former library, Tilton Memorial Hall (1901, with a 1906 extension), by Andry and Bendernagel, which has a richly decorated triple-arched entrance, carved portraits of its benefactors on the facade, and Tiffany windows illuminating the stairs in the entrance lobby. Andry and Bendernagel's Richardson Memorial Building (1908), constructed for the School of Medicine, now houses the School of Architecture.

On the far side of the quad in the direction of Freret Street, and part of the initial scheme, are two orange brick structures, dating from 1894, and the brick former refectory (now Robert C. Cudd Hall) of 1901, notable for its curving front gable in the Dutch Colonial Revival style. The campus then expanded toward the lake, with brick buildings lightly influenced by either the Richardsonian Romanesque or the Dutch Colonial Revival style. In the 1920s, further expansion and construction of new buildings took the campus across Freret Street.

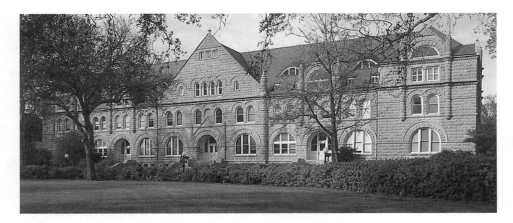

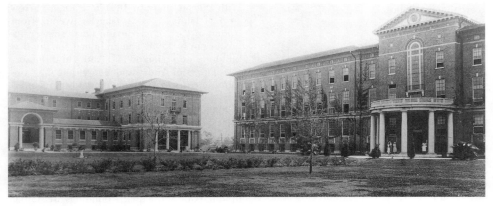

OR143 Tulane University, Gibson Hall

OR143.1 Newcomb College of Tulane University (H. Sophie Newcomb Memorial College), photo c. 1920

Before Freret is crossed, however, a cluster of more recent buildings, dedicated to engineering and the sciences, interrupts the historical chronology of expansion. The latest arrival is the Merryl and Sam Israel, Jr., Environmental Sciences Building (1999), designed by William Wilson Associate Architects and Payette Associates, both of Boston.

Across Freret Street, the campus discards unity for modernity; buildings dating from the 1920s to the 1940s are interspersed with others from the 1950s onward in a variety of styles. Among the most architecturally interesting buildings is Favrot and Reed's 1,900-seat MacAlister Auditorium (1940), a severe Moderne version of the Roman Pantheon, with a saucer-shaped, self-supporting dome of reinforced concrete, 110 feet in diameter, and inscribed pilasters framing the triple-door entrance, representing a kind of classical portico rendered

in shallow relief in the Art Deco style. Beyond these structures are the red brick buildings that make up the H. Sophie Newcomb Memorial College, the women's college affiliated with Tulane (see OR143.1). Academically, the two colleges are now fully integrated, but Newcomb was established as a separate institution for women students.

OR143.1 Newcomb College of Tulane University (H. Sophie Newcomb Memorial College)

1917, James Gamble Rogers. 1229 Broadway

In 1886, Josephine Louise Newcomb (1816–1901) donated $100,000 to establish a women's college in memory of her deceased daughter, Harriet Sophie Newcomb. The college was designated a coordinate college of Tulane Univer-

sity with its own president and administrative structure—the first degree-granting coordinate college for females established within the framework of a university for males. It opened in 1887 with thirty students in a former mansion downtown but soon outgrew this space and transferred its 174 students to a larger Garden District mansion. It was at this second location that the college earned national attention for the Newcomb Pottery, a quasi-commercial venture fostered by the art program. In 1918, Newcomb moved uptown to a site adjacent to Tulane, a new campus designed by James Gamble Rogers, who had won the design competition in 1911. The competition program specified that the buildings be architecturally distinct from Tulane's and constructed of brick. According to the Board of Administrators' minutes of January 1912, Rogers's proposal pleased the judges because the design displayed "great dignity, memorial character, a style both American and Southern, and had the refinement, simplicity and charm fitting for a college for women in the South."

Newcomb's buildings form two open-ended courts, with Newcomb Hall, the academic and administrative building in the center, linking the quadrangles. Twelve buildings were envisioned, but only four were erected initially because of a lack of funds. All are built of a domestic-looking red brick with white trim and have small balconies and diffident classical details; for example, the shallow, four-columned Ionic pedimented portico of Newcomb Hall, although tall, is disproportionately small in relation to the size of the building. Although there is nothing bold or assertive about these structures (presumably the reason the judges thought the design sufficiently feminine), the ensemble is unified and harmonious. Emile Weil completed the buildings around the quadrangle in 1928. Subsequent buildings have followed Rogers's concept in scale and materials, while achieving a more contemporary appearance. The Elleonora P. McWilliams Hall (1996), designed by Waggoner and Ball, is particularly successful, blending with the other buildings through its use of red brick and the clarity of its form. The Arts and Crafts imagery apparent in the emphasis on textures, the deep eaves, and the red tile roof suits its function as a center for theater and dance. On the third story, a continuous band of windows under spreading eaves makes the building appear less weighty while giving it a contemporary look.

OR144 Audubon Place Entrance Lodge and Gates

1894, Thomas Sully. 6900 St. Charles Ave.

A rusticated lodge and gates in the Richardsonian Romanesque style stand guard at the entrance to this private street, New Orleans's second residential park, or private landscaped street. Rosa Park, at the 5800 block of St. Charles Avenue, was the first, in 1891. The project was developed by a St. Louis syndicate and modeled on similar successful ventures there and in northern cities. Surveyor George H. Grandjean drew up a plan in 1894 for twenty-eight lots, each with a 100-foot frontage facing a landscaped neutral ground. The lots sold for about $5,000 each, and the minimum construction cost of a house was set at $7,000. The most unusual of the enormous houses on Audubon Place is the Flonacher residence (1926), designed by Weiss, Dreyfous and Seiferth, which is sited at the far end of the park and partially visible from Freret Street. The house, in the Spanish Colonial Revival style, has a bright pink stucco exterior and is decorated with tiles from Spain. Audubon Place popularized exclusive landscaped residential streets in this area of Uptown and neighboring Carrollton, but it is the only residential park in the city that is still restrictive.

OR145 Tulane University President's House (William T. Jay House)

1907, Toledano and Wogan. 2 Audubon Pl. (6915 St. Charles Ave.)

Although the developers of Audubon Place stipulated that this house be oriented toward their street, owner William Jay, a cotton broker and vice president of the Union Lumber Company, preferred to face St. Charles Avenue. Thus this square house was given two major entrances, ostentatious two-story Ionic porticoes with weighty entablatures and continuous balustrades that almost overwhelm the house as well as the viewer. Both entrance doors have surrounds shaped like miniature temple fronts. To please the client, the St. Charles Avenue door led into the entrance vestibule, and behind the Audubon Place portico was a dining room. In 1917, Jay sold the house to Russian immigrant Samuel Zemurray of the United Fruit Company, who hired Edward F. Sporl to remodel the interior and enlarge the attic to accommodate a billiard room. The house is

built of wood with veneering of dark brown pressed brick, originally left unpainted to contrast with the white trim but now a dark cream color. In 1965, the Zemurray family donated the house to Tulane for use as the president's residence.

OR146 Audubon Park

1898, Olmsted Brothers. 6800 St. Charles Ave. (bounded by St. Charles Ave., Exposition Blvd., Walnut Street walkway, and the Mississippi River)

Established in 1886 on the site of the World's Industrial and Cotton Centennial Exposition of 1884, Audubon Park now encompasses more than three hundred acres and stretches to the Mississippi River. The exposition grounds were the former sugar plantation of Etienne Boré, who developed a method for granulating sugar that could be employed on a commercial scale. John Charles Olmsted, Frederick Law Olmsted's nephew and stepson, in an effort to give the flat site a luxuriant and southern picturesque effect, designed a scheme for the park that included lagoons, bridges, copses, and regional plants. The park's central section is now occupied by a golf course, which restricts most public activities to the perimeter, where tree-lined paths attract walkers and skaters. It took many years to complete the landscaping; the lagoon at the St. Charles Avenue end was not finished until 1918. Two pairs of monumental stone pylons, designed by Moise Goldstein in 1921, mark the park's entrances on St. Charles Avenue. Isidore Konti (1862–1938) sculpted the attractive bronze Gumbel Fountain (1918) just inside this entrance. Emile Weil designed the oval Newman Memorial Bandstand in 1921. In 1924, the park gained an additional fifty acres following the closing of the Louisiana Sugar Experiment Station, built in 1890, and the zoo (OR146.1) was located on this site. In 1969, the forty-acre riverfront park, part of the original Olmsted vision, was created from landfill. In 1886, the park was named in honor of naturalist and bird painter John James Audubon (1780–1851), who lived for a short time in New Orleans and in 1821 worked as a tutor at Oakley Plantation (WF12).

OR146.1 Audubon Zoo

1924 to present

John Charles Olmsted's emphasis on using indigenous plants in his design for Audubon Park heightened awareness of the beauty and unique qualities of southern Louisiana's plants and animals. Consequently, an exhibit on swamps was opened in 1913 and a flight cage for birds in 1916. These displays were followed, in 1924, by Favrot and Livaudais's Odenheimer Aquarium, a circular brick structure linked to rectangular brick wings by Tuscan-columned pergolas, and a sea lion pool partially surrounded by a classical colonnade, designed by Samuel Stone, Jr. The zoo officially opened in 1938, following the construction of several WPA-funded animal houses designed by Moise Goldstein beginning in 1934. These included a brick elephant house (1934) in the style of a French farmhouse, and a tropical-bird house (1936) decorated with a low-relief sculpture of Noah's Ark. Monkey Hill, New Orleans's only hill (28 feet high), is the by-product of a pile of mud left from a WPA lagoon-building project. After grass grew on the hill, it became a favorite play spot for children. In 1958, Curtis and Davis built a circular brick structure for giraffes, which now houses two camels. The zoo expanded from thirteen to fifty acres in 1978, and in 1980, the last cage was removed to provide the open spaces for animals now favored. The firm of Cashio-Cochran designed the Louisiana swamp exhibit which won honors from the American Society of Landscape Architects in 1983.

OR147 Greenville Hall of Loyola University (St. Mary's Dominican College)

1882, William Fitzner. 7214 St. Charles Ave.

St. Mary's, the first Catholic women's college in Louisiana, traces its roots to the arrival in 1860 of seven Dominican sisters from Cabra, Ireland, to run a girls' academy affiliated with St. John the Baptist Church (OR124). With increasing student enrollment and requests for boarding, the sisters purchased this site in 1865 and hired William Fitzner to design an academic building accommodating classrooms, an administrative office, and a chapel. Thomas Mulligan constructed the building, which the *Times-Democrat* described in August 1882 as in the "style of a dwelling house," as were many women's schools and colleges in the nineteenth century. Constructed of cypress, the building is shaded by colonnaded galleries at the front and rear. A narrow gallery surrounding the central cupola provided a place for students to make astronomical observations. In

OR145 Tulane University President's House (William T. Jay House)

OR147 Greenville Hall of Loyola University (St. Mary's Dominican College)

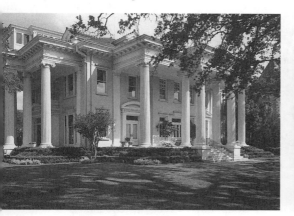

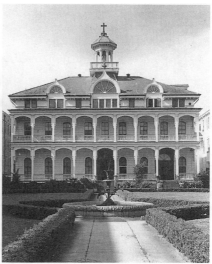

this and other ways, the curriculum was advanced for its time; rhetoric, rarely taught to girls, was part of the course of study in the humanities and science, and a student literary journal was published from 1888 to 1900. In 1911, three ogee-shaped dormers were added to the third story, giving the building a Venetian flavor. St. Mary's was absorbed by Loyola University in 1984. The building is now used for administrative purposes.

OR148 Lusher School (Jefferson Parish Courthouse)

1855, Henry Howard. 719 S. Carrollton Ave.

In 1855, when the town of Carrollton became the seat of Jefferson Parish, Henry Howard was hired to design the courthouse. Employing the classical temple formula then popular in America, he noted in his specifications for the building that the portico's four Ionic columns were to be based on those of the Erechtheum in Athens. However, the columns were made of brick and the bases and capitals of cast iron. The brick walls were plastered and scored to resemble masonry, and the joints were originally painted brown. A side entry is pedimented, matched originally by side windows with pediment-shaped moldings. Frederick Wing and Robert Crozier were the builders for the courthouse, which cost $59,000. After Carrollton was annexed to New Orleans in 1874, the structure was remodeled for use as a public school.

OR149 D'Antoni House

1918 Edward F. Sporl. 7929 Freret St.

The owner of this house is said to have sent architect Edward Sporl to Chicago to see Frank Lloyd Wright's Prairie Style buildings. Their influence is evident in the house, which emphasizes horizontality with its low, spreading forms, flat roof, projecting sun-breaker cornice, and light-colored bands of stone trim. Although the front facade is symmetrical, the house conveys a picturesque aspect due to the chiaroscuro effects of multiple recessions and projections and an entrance so deeply set and so heavily shaded within its porch that it seems to dissolve. The construction material—long, thin buff-colored bricks separated by wide, indented mortar bands—exaggerates the building's textural qualities and the relationship of its horizontal lines with the earth. Decorative motifs along the cornice were inspired by Louis Sullivan. The garage is a small-scale version of the main house.

OR150 Nathaniel Wilkinson House

1849–1850. 1995, addition, Trapolin Architects. 1015 S. Carrollton Ave.

English-born immigrant Nathaniel Newton Wilkinson was an exchange broker and commission merchant and an officer of the New Orleans Canal and Banking Company, which financed the Carrollton railroad and resort. He

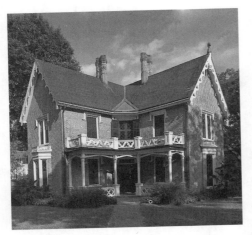

OR150 Nathaniel Wilkinson House

built this unusual Gothic Revival house, one of the earliest residences in Carrollton, as a holiday home when this area was still a resort community. The cross-shaped, two-story brick residence resembles an English manor house in its construction materials, steeply pitched gable roofs, and such details as the Tudor-style chimneys and diagonal-pane casement windows. These elements can be found in William Ranlett's Design III (plate 13), "The Entrance Front," in his book, *The Architect: A Series of Original Designs for Domestic and Ornamented Cottages and Villages* (1847), and it is likely that the unknown builder of Wilkinson's house, or Wilkinson himself, used this as a source. Among the other similarities are a gallery supported on flattened pointed arches, a balcony with trefoil designs, bargeboards, and finials. In the nineteenth century, the exterior brick walls were stuccoed and scored. The medieval theme is carried through to the interior, with its Gothic inspired moldings and medallions and a circular staircase in an octagonal hall. The wings of the house radiate from the hall to create rooms with windows on three sides, providing interior light and catching cool breezes. The house was originally surrounded by an eight-acre garden, now reduced to less than one acre, planted with exotic specimens that included imported tropical plants, giant bamboo, and palm trees. A 1995 wing, designed by Trapolin Associates for the new owners, Joseph and Stephanie Bruno, is constructed of wood to distinguish it from the original building.

OR151 Streetcar Barn

1893. 8200 Willow St.

In 1892, the St. Charles Avenue streetcar tracks were extended along the neutral ground of South Carrollton Avenue to a new carbarn, where the Carrollton route of the New Orleans and Carrollton Railroad would terminate with a loop through the barn. The Berlin Iron Bridge Company of Berlin, Connecticut, constructed the nine-track carbarn (265 feet by 128 feet), which has corrugated metal sides and a slate roof supported on steel trusses. Adjacent buildings for storage, oil, paint shops, and electric machinery were constructed of brick; a few years later, a repair shed with seven tracks was built next to the carbarn. In 1893, the railroad company converted to overhead electricity to power the streetcars, having the year before built an electric powerhouse, at Napoleon and Tchoupitoulas streets, to contain its boilers and three Corliss compound steam engines. This one-story brick powerhouse, designed by Thomas Sully, is now in poor condition and lacks its original chimneys. The new electric cars, made by the St. Louis Car Company, were described in 1893 by the *Daily Picayune* newspaper as "elegantly made, and . . . furnished inside with carved cherry wood with spring seats, and back of woven bamboo. . . . The ceilings are of papier-maché, decorated with conventional designs of brown and gold." The electrified line opened on February 1, 1893, to a performance of *The Trolley Polka*, a musical composition written for the occasion by Paul Tulane Wane. Soon dismissed were initial public fears that the electrical poles installed along the rail route would shock bystanders and that these much speedier streetcars would hit pedestrians. In 1923, the current streetcars, designed and built by the Perley A. Thomas Car Company of High Point, North Carolina, were introduced. The Arabella streetcar barn (5600 Magazine Street), constructed in 1893, was first converted into a barn for buses when they replaced the Magazine Street streetcars and in 2001 was acquired by a supermarket and renovated for its new use.

OR152 Sewerage and Water Board of New Orleans

1903 to present, James Wadsworth Armstrong. 8700–9300 S. Claiborne Ave.

In 1899, two years after the city was quarantined during a yellow fever epidemic, voters passed a bond issue to finance and build a sew-

erage and drainage system and waterworks. Construction began in 1903 to designs by James Armstrong (1868–1953), who had studied engineering and architecture at the University of Illinois. The system began operating in 1907 in several parts of the city. Armstrong designed nine pumping stations and two large water-purification plants and established the exterior appearance and style of the buildings that house the pumps, boilers, and administrative offices, which the Water Board has followed in all new construction. The Water Board wanted buildings with a distinctive look, which the design achieved: red tile roofs with wide overhanging eaves, brick walls stuccoed in a cream color, and red terra-cotta outlining the round-arched openings. According to the waterworks superintendent, projecting eaves were ideal for the New Orleans climate, shading walls and saving the expense of gutters and downspouts. The buildings convey a clean, crisp image for the Water Board and were economical to construct. Engine floors in the powerhouses were built well above ground level, which reduced the amount of excavation necessary for the foundations and kept the machinery above the water table. The old filter gallery, twenty-eight filters in an open water tank subdivided into 8-foot-by-8-foot-square units and surrounded by an arcade like a medieval cloister, reinforces the Mediterranean appearance of the buildings. By 1909, New Orleans had a water-purification system, and Armstrong completed his work the following year. The Mississippi River is the source of water for New Orleans, which uses approximately 120 million gallons each day. City water is treated at

OR153 Ted's Frostop

this plant for east bank residents and at another plant in Algiers, on Elmira Avenue, for west bank residents.

OR153 Ted's Frostop

c. 1955. 3100 Calhoun St.

A frothy, neon-lit, giant root-beer mug high atop a freestanding support quickly identifies a Frostop restaurant. Red, blue, green, and yellow letters spelling *Burgers*, spaced across the width of the facade, advertise the favorite item on the menu. Above them, a pediment-shaped metal and neon sign displays the restaurant's name at its center. The restaurant, small-scaled and inobtrusive compared with its signage, has a continuous window that wraps around the front and one side above the tile-covered lower wall. On the other side, a deep, cantilevered roof shelters what formerly was a drive-in area, where customers had to walk only a few steps to the service windows. Inside, a self-service counter (for Lot-a-burgers) and open grill are located in the center, and booths are arranged around the perimeter of the space. The counter is surfaced in black and white tiles in a checkerboard pattern. All these elements, with only slight variations, are found in other Frostops in southern Louisiana. In New Orleans, two other examples are at 3166 General Meyer Avenue in Algiers and at 2900 Canal Street (1961), although at the latter, the root-beer mug is at eye level and painted a non–root beer color. Frostops are rare surviving examples of the kind of fast-food outlets that proliferated along America's highways in the 1950s and 1960s in response to the surge in automobile ownership. The buildings, designed to be seen at a distance, joyfully utilize brightly colored, outsize signage, made possible by the availability and economy of such materials as aluminum, plastic, and neon. Frostop Products, headquartered in Rochester, New York, manufactured root beer and an orange drink, and its products and name were franchised.

OR154 Lone Star Cement Corporation House (Parlongue House)

1935, Weiss Dreyfous and Seiferth. 5521 S. Claiborne Ave.

The Lone Star Cement Corporation hired the architects to demonstrate that a well-designed, soundly constructed house could be built of

concrete at moderate cost. Lone Star maintained that a concrete house, safe from termites, moisture, and decay, stable in hurricanes, and fire resistant, was ideal for the New Orleans climate. The hollow-ribbed concrete walls provided air space for insulation against heat and cold and accommodated pipes and conduits. The construction cost of the demonstration house was $10,200. The firm of Weiss, Dreyfous and Seiferth, then famous as architects for Governor Huey Long, as well as for its contemporary designs, was selected by the cement company. August Perez, Jr. (1907–1998), an architect then recently hired by the firm, gave the house an appropriately modern look: a geometric composition with wraparound windows and no decoration other than polished black concrete panels between the windows. (The house is now painted completely white.) Lone Star insisted, for "aesthetic reasons," on a pitched roof rather than a modern flat one, but the hipped roof, with a small

chimney at the center, has a low profile, so that the modern appearance of the house is not diluted. An outdoor terrace was placed on the garage roof. The interior was organized traditionally; the combination of living and dining areas created the only integration of spaces. Three months after construction began, the house was completed, provided with Russel Wright furnishings from the Maison Blanche department store, and opened to sightseers at ten cents each. Despite all the publicity and interest in the project, concrete houses never caught on in New Orleans. The year after this one was constructed, the *Times-Picayune* commissioned Moise Goldstein to design a "New American Home" in celebration of the newspaper's one hundredth anniversary. Located at 1514 Henry Clay Avenue, the streamlined, white-painted brick house with modern wraparound windows had no more influence on residential design in New Orleans than did the concrete house.

Mid-City

Mid-City extends from Tremé and the Central Business District in a northwesterly direction toward the Metairie Ridge. Although the higher ground along the Metairie Ridge had been acquired for cemeteries as early as the mid-nineteenth century, the area's development came in the twentieth century after the New Orleans Drainage Commission's powerful new steam-powered pumps drained this below-sea-level swamp. Light industries and commercial companies chose to locate in Mid-City adjacent to the railroad corridor that runs through the area. Favrot and Livaudais designed the former American Can Company in 1906 (602 N. Cortez Street), which was expanded in 1922 and has now been converted into apartments and retail stores. The factory's concrete frame is clearly expressed on the exterior in the manner of Albert Kahn's industrial buildings for the automobile industry in Detroit. Mid-City also provided land for the new institutional, educational, and medical buildings needed for a growing city. Before Interstate Highway I-10 was brought through Mid-City, Tulane Avenue (U.S. 61) was the principal automobile route into New Orleans from the west, but only a few motels and other traveler-related buildings survive along this formerly bustling avenue. Residential buildings in Mid-City consist primarily of shotgun houses, bungalows, and modest two-story houses.

OR155　Medical Center of Louisiana at New Orleans (Charity Hospital)

1937–1939, Weiss, Dreyfous and Seiferth. 1532 Tulane Ave.

New Orleans's largest medical complex occupies several blocks along Tulane Avenue. It includes Louisiana State University School of Medicine (1931) and is adjacent to Tulane University School of Medicine. The architectural centerpiece is the Medical Center of Louisiana, formerly (and still popularly) known as Charity Hospital. Charity's origins date to 1736, when a French sailor donated

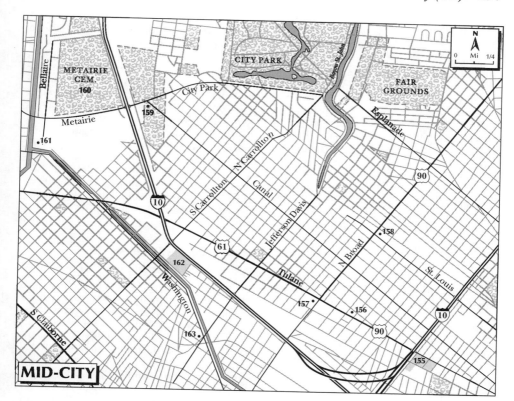

funds for a hospital for the indigent, L'Hôpital des Pauvres de la Charité. The hospital moved to this site in 1833, and a year later the Sisters of Charity arrived to nurse the sick. In 1893, they established a School for Nurses (now Delgado Community College Charity School of Nursing), one of the first in the nation. Beginning in 1928, Charity saw an infusion of money for a massive building program, first from spending promoted by Governor Huey P. Long and then $3.6 million in federal funds, totaling $13 million. New structures were built for the Louisiana State University Medical Center School (1932) and, in 1939, a fifteen-story School of Nursing, ambulance garage, laundry, power plant, and Charity Hospital.

Governor Long's favored architecture firm, Weiss, Dreyfous and Seiferth, designed the buildings, giving them all a similar external appearance. The twenty-story Charity Hospital, along with the nursing and medical schools, were designed like contemporary New York skyscrapers, emphasizing verticality, with setbacks at the upper floors and carved stone Art Deco relief sadorning the summits and en-

trance doors. At Charity, a decorative aluminum screen over the main entrance depicts Louisianans at work and play. The design incorporates two ducks—sculptor Enrique Al-ferez's satirical reference ("de ducks were flying") to Huey Long's government, in which "de-ducts" from workers' pay for Long's "charitable" activities were commonplace. Identical low buildings and a forecourt form the entrance to the hospital from the street. A steel-frame building sheathed with Alabama limestone, the hospital is roughly M-shaped, organized to create projecting wings and courtyards that provide ventilation and give the interior natural light. The hospital formerly had separate facilities for African American and white patients in the east and west wings, but services are now integrated. With a capacity of 2,680 beds, Charity was the second largest hospital in the nation when it opened. The medical center buildings had some of the most modern facilities of the time and were widely published in both architecture and medical journals.

OR156 Dixie Brewery

1907, Louis Lehle and Sons. 2401 Tulane Ave.

Of the ten breweries that produced beer for the city in the years before Prohibition, Dixie Brewery is the only one still in operation. The former Jackson (Jax) Brewery in the Vieux Carré was converted into a shopping and restaurant mall in the 1980s; the Weckerling Brewery now houses the D-Day Museum (OR98); and the six-story Falstaff Brewery (2600 Gravier Street) stands empty since it closed in 1978. Designed by a Chicago architecture firm, Dixie is housed in a six-story, steel-frame building of red brick trimmed with white stone. A diminutive corner turret and a tall, silver-painted mansard dome make it an area landmark. Two circular storage tanks on the roof hold the rice used in the brewing process, which utilizes a gravity flow system; both tanks are painted to resemble Dixie beer cans. Apart from the giant cans, Dixie has an institutional rather than an industrial appearance and fits in well with Tulane Avenue's other buildings. During Prohibition, the brewery manufactured ice and ice cream. Emile Weil designed the four-story extension in 1919.

OR157 Criminal Courts Building

1929, Diboll and Owen. 2700 Tulane Ave.

Architect Allison Owen stated that his design for the Criminal Courts Building represented two characteristics of the law: "elegance reflected in the classical colonnade and severity reflected in . . . modern buttresses." The result does suggest that two eras have collided: a massive twelve-columned classical temple book-ended between doubled pavilions (Owen's "buttresses") of Egyptian shape and proportions and with Art Deco ornament. The building is faced with limestone and adorned with bronzed cast iron panels between the windows that depict scenes from local history, stylized pelicans (Louisiana's state bird) in relief, and anthemia carved near the summit of the pavilions, all designed by New Orleans artist Angela Gregory (1903–1990). The courthouse entrance, at the center of the long side, is reached by way of a tall flight of granite steps passing through the colonnade. From a small marble lobby, stairs lead up to the great marble hall that extends the length of the building and gives access to seven two-story-high courtrooms. Architect Owen likened the great barrel-vaulted hall to the early-seventeenth-century Salle des Pas Perdus of the Palais de Justice in Paris; although the details differ, the overall appearance and effect are similar. Huge Art Deco chandeliers of bronze and opalescent glass illuminate the walls of veined black and cream-colored marble and the dusky pink marble floor. The hall's epic scale and luxuriant materials, as well as the noise that rebounds from the hard surfaces, are more than enough to awe both defendants and lawyers. District Attorney Jim Garrison's prosecution of Clay Shaw, who was accused and acquitted in connection with the assassination of President John F. Kennedy (a unanimous verdict of not guilty took just fifty-four minutes), took place here in 1969.

OR158 Pumping Station No. 2

1899, Benjamin Morgan Harrod. Broad Ave. and St. Louis St.

The problem of flooding after heavy rains, a common occurrence in New Orleans, was solved by Albert Baldwin Wood's invention of a heavy-duty pump that could raise great quantities of water and deposit it elsewhere. Today there are seventeen pumping stations in Greater New Orleans, with a network of pipes that could extend from New Orleans to beyond Seattle and more than 172 miles of canals to carry and release surplus water into Lake Pontchartrain and Lake Borgne. The system is capable of pumping 1.5 inches of rainwater in two hours. This pumping station, located on the neutral ground of Broad Avenue over the drainage canal, was the first in a series of brick stations whose rectangular shape and walls articulated with pilasters are evocative of classical temples. The station's tall, narrow windows with keystones are covered by dark green iron shutters; rosettes decorate the entablature, and a ventilator runs along the ridge of the hipped roof. On one side, huge drainage pipes painted green emerge from the station's lower wall and disappear underground.

Similarly designed pumping stations are located at the junction of Broad Avenue and Martin Luther King Boulevard (doubled in size in 2000) and at Marconi Boulevard near Zachary Taylor Drive. Albert Baldwin Wood (1879–1956) continued to develop more efficient and powerful pumps throughout his life, notably, in 1913, the Wood screw pump, 12 feet in diameter, which was later used to drain the Zuider Zee in the Netherlands. By 1929, he had de-

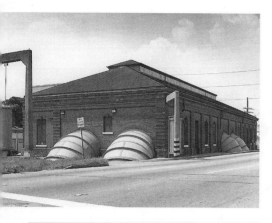

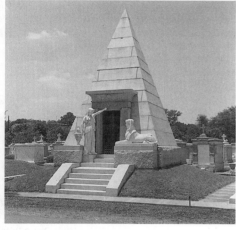

OR158 Pumping Station No. 2

OR160 Metairie Cemetery

ing water, the preference for above-ground tombs persisted. The cemetery, laid out with a 28-foot-wide central avenue flanked by narrower aisles, has a monumental entrance gate in the Egyptian Revival style, suggesting a triumphal passage from one world to the next. The stuccoed brick gate was originally topped by a lintel, making it similar in appearance to the Egyptian Revival gate at Mount Auburn Cemetery (1831) in Cambridge, Massachusetts. Frederick Wilkinson came to New Orleans from the northeastern United States, so it is likely that he was familiar with Mount Auburn. Two pavilions flank the gate, one a porter's lodge and the other the so-called dead house. On a practical level, gates and gatehouses were essential for cemetery security in that era, because grave robbery was a problem until the medical profession was able to obtain cadavers legally. One of the cemetery's finest tombs, adapted from a design in Père Lachaise Cemetery in Paris, is J. N. B. de Pouilly's monument for fireman Irad Ferry (1841), composed of a large broken column, symbolizing the extinction of life, rising from a sarcophagus-shaped marble tomb. Across the road, at 5242 Canal Boulevard, is Greenwood Cemetery, established in 1852 by the Firemen's Charitable Association, which has a cluster of magnificent tombs near its entrance. The tomb for the Benevolent Protective Order of Elks, Lodge No. 30, is a marble chamber covered by a grassy mound and surmounted by a bronze elk. The tomb is lopsided; its pedimented granite entrance with Doric columns tilts perilously forward, sinking into the soft ground because the engineer failed to build a pile foundation.

signed a pump 14 feet in diameter; four of these were installed in the Metairie Pumping Station (Jefferson Parish) in the Metairie Relief Outfall at 17th Street. Benjamin Harrod (1837–1912), the station's designer, also was the architect for many of New Orleans's fire stations and laid out Metairie Cemetery (see OR160).

OR159 Cypress Grove Cemetery Gate and Lodge

1840, Frederick Wilkinson. 120 City Park Ave.

Established by the Firemen's Charitable Association, Cypress Grove Cemetery is located on a ridge four miles from the city center. Although graves here could be sunk 6 feet without reaching

OR160 Metairie Cemetery

1872, Benjamin Morgan Harrod. Pontchartrain Blvd.

In 1872, the Metairie Cemetery Association purchased the former Metairie racetrack and converted it into a sixty-five-acre landscaped burial ground. The elliptical track formed the basis of the plan, and three smaller ellipses were laid out within it to serve as paths. Cross avenues and diagonals creating circles and triangles, live oak trees festooned with Spanish moss, and, originally, a series of lagoons created a picturesque garden of the dead in the manner of the influential Père Lachaise Cemetery in Paris. Tombs at Metairie are more spaciously laid out than in other New Orleans cemeteries and constitute some of the most spectacular and grandiose fu-

nerary architecture in the United States. They include Greek temples, Gothic extravaganzas, Islamic pavilions, a Celtic cross, and tombs embellished with stained glass windows, broken columns, and allegorical figures. The early-twentieth-century tomb of Lucien Brunswig, designed by the Weiblen Marble Company, features a pyramid, sphinx, and female figure gesturing toward the bronze door.

OR161 Longue Vue House and Gardens

1939–1942, house, William and Geoffrey Platt. 1935–1939, gardens, Ellen Biddle Shipman. 1966, gardens, William Platt. 7 Bamboo Rd.

Longue Vue is a re-creation of the past, a house in the classical style, built for cotton broker, banker, and philanthropist Edgar Bloom Stern and his wife, Edith Rosenwald Stern, an heir to the Sears, Roebuck fortune. It replaced a smaller house on the site after the Sterns purchased additional land and found that the eight acres of gardens designed for them by Ellen Biddle Shipman (1870–1950) had "left the house behind," as Edith Stern put it. On Shipman's recommendation, the Sterns hired the noted New York architects William and Geoffrey Platt to design a new house. The house, like Shipman's gardens, is a carefully conceived example of nostalgic revivalism that also embraced modern structural methods and such amenities as air conditioning. Longue Vue has a Portland cement exterior over a steel frame and brick walls. Its two principal facades are set at 90-degree angles to each other to allow for the best views to and from the gardens. One facade, similar to that of the Beauregard-Keyes House (OR31), has a second-story portico accessed from curving exterior stairs, and the other is based on Shadows-on-the-Teche (IA5). Flanking dependencies are linked by colonnades. Inside, the architects provided a circular staircase lit by a glass dome, a ubiquitous feature of New Orleans's grandest nineteenth-century houses. The Platts designed the rooms in eighteenth- and nineteenth-century styles, incorporating original pieces, such as mantels, purchased in Europe. In contrast, the bathrooms are modern, Edith Stern's in powder blue tile and glass block and Edgar Stern's a dramatic Art Deco composition of Vermont black marble, black ceramic fixtures, and black and white marbleized wallpaper. For Long Vue's eight acres of gardens, Shipman, landscape designer for such wealthy clients as the Du Ponts, Fords, and Astors, cre-

ated garden "rooms" and plantings based on different themes. These included the Wild Garden, with plants indigenous to the Gulf South and a brick *pigeonnier* modeled on nineteenth-century types; the rose-filled Walled Garden; and a garden planted with yellow blooming plants. William Platt redesigned some areas in 1966 after they were damaged by Hurricane Betsy, including the Spanish Court, inspired by the Generalife Garden at the Alhambra in Granada. In 1999, a half-acre children's Discovery Garden was added by Jack Cochran. The Sterns bequeathed Longue Vue for use as a museum of decorative arts and garden design, which opened to the public in 1968.

OR162 Xavier University of Louisiana

1932 to present. 2 Drexel Dr.

In 1891, Katharine Drexel (1858–1955), the daughter of Philadelphia multimillionaire financier-banker Francis Drexel, founded the Sisters of the Blessed Sacrament, an order dedicated to educational and charitable work among America's minorities. St. Katharine (she was canonized in 2000) established a high school in 1915, naming it for the Spanish Jesuit missionary St. Francis Xavier, and in 1917 added a two-year normal school for training black teachers. Xavier became a four-year liberal arts university in 1925 and opened a college of pharmacy in 1927. Xavier is the only historically black Catholic university in the United States. First located at 5100 Magazine Street, a site now occupied by Xavier Preparatory High School for girls, Xavier University moved to its new site in 1932. Wogan and Bernard designed the Indi-

OR163 Blue Plate Fine Foods, photo c. 1941

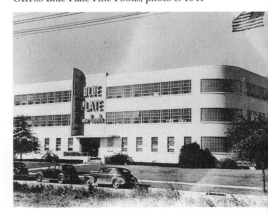

ana limestone administration building with its two wings, one a science building and the other a convent for the sisters, in the Neo-Gothic style of many collegiate structures. A library (now the music building) was added in 1937. Expansion in the 1960s added more buildings, and in the 1990s, the enormous success and growth of Xavier's pharmacy and premedical programs generated further growth. Xavier now comprises forty-one buildings in a multiblock area, serving approximately 4,000 students. On an unprepossessing site adjacent to a freeway overpass, the campus has also grown vertically, with buildings in expressive forms and colorful materials that challenge its difficult setting. The six-story Library and Resource Center of 1996, by Blitch/Knevel and Billes/Manning, was joined in 1998 by the Norman C. Francis Science Academic Complex, named for the university's current president and designed by Sizeler Architects. The latter structure, a sharp-angled composition with tower, bay windows, pinnacled piers, prowlike corner, and pointed-arched entrances, has a castlelike quality that fits in with the original Collegiate Gothic building. All the new buildings have green roofs, Xavier's modern signature.

OR163 **Blue Plate Fine Foods**

1941, August Perez, Jr. 1315 S. Jefferson Davis Pkwy.

The Blue Plate Fine Foods building was August Perez, Jr.'s, first major commission in New Orleans and one of the city's earliest modernist buildings. Blue Plate was named after Blue Willow chinaware, renowned for its quality, because the company liked the upscale image it conveyed, and a sign by the entrance door reproduces the Blue Willow pattern. The manufacturing process for the company's products, including mayonnaise and other sauces, determined the layout of the plant's three floors, although the ground floor is now used for warehouse space rather than the original corporate offices. Walls of poured concrete are reinforced with rail ties, a substitution due to a war-related scarcity of materials when the building was being constructed. The smooth white stucco-covered exterior, streamlined rounded corners, and horizontal bands of glass-block windows have a hygienic and wholesome look. An enormous blue neon sign on the roof, identifying the factory, was added later. The rear of the building was near the tracks to facilitate loading the company's products. The front was set back 75 feet from the street to allow for a lawn and landscaping—an early instance of preserving open space on an industrial building site. The factory is now used mostly for storage, not for making mayonnaise, as advertised on its rooftop neon sign, which was added a few years after the building was completed.

Lakefront

The ranch-style houses that characterize many of these twentieth-century suburbs on the Lake Pontchartrain side of New Orleans are typical of those in residential neighborhoods in much of the United States. The principal remnants of this area's history are the fragments of the walls of the Spanish Fort, built in 1779 on the left bank of Bayou St. John where it enters Lake Pontchartrain (now Beauregard Avenue and Jay Street); the Milneburg Lighthouse (1855) (OR166); and the two-story lighthouse (1890s) at the lake end of West End Boulevard. In 1831, the New Orleans and Lake Pontchartrain Railroad, the nation's first interurban line, began to transport pleasure-seekers from the city to the hotels and restaurants along the shores of the lake. In 1926, the Orleans Levee Board began an extensive landfill project, pumping sand from the lake to create over 2,000 new acres along its southern shore for residential subdivisions and other development. The entire area on the lakeside of Leon C. Simon Drive and Robert E. Lee Boulevard is landfill. Much of this land was given over to military installations during World War II. In 1956, the University of New Orleans (formerly Louisiana State University in

New Orleans) held its first classes in some of these buildings until its new campus was built, beginning in 1961. The names of the residential subdivisions were drawn from their location: Lake Vista (1936), West Lakeshore (1951), East Lakeshore (1955), Lake Terrace (1953), and Lake Oaks (1964). All the houses are individually designed; noteworthy interpretations of modern design in West Lakeshore are the Ricciuti House (7341 Beryl Street), designed in 1957 by Ricciuti Associates, and the Valle House (423 Topaz Street), designed in 1956 by John Rock. The Orleans Levee Board constructed a five-mile-long concrete seawall and beachfront public parks. Lakefront Airport (formerly Shushan Airport) was built in 1932–1934 on a separate landfill east of this development on the other side of the Industrial Canal (also known as the Inner Harbor Navigation Canal).

OR164 St. Francis Cabrini Church

1961–1964, Curtis and Davis. 5500 Paris Ave.

The design for St. Francis Cabrini Church was developed to conform with the liturgical changes established by Vatican Council II between 1962 and 1965, which recommended that church ceremonies (from Mass to baptism) be contained within a single space, one that would emphasize, physically and symbolically, the unity of the congregation. Thus, rather than the traditional rectangular basilica form, which creates a hierarchy of spaces, the architects designed a square-shaped church with an interior seating arrangement emphasizing community. Pews are arranged in three clusters, fanning out from the sanctuary, and all 1,500 seats are within 100 feet of the altar. The sanctuary is highlighted by an arched concrete canopy, which rises smoothly from four broadly spread legs through the roof to form, on the exterior, a slender, tapered spire, 135 feet in height. Beneath it is the altar, carved from a single block of golden-veined white Carrara marble. Three cantilevered barrel vaults radiate from the altar to cover the nave, each vault corresponding to one of the clusters of pews. The curved shape of these thin, pre-stressed concrete vaults was intended to recall the form of the Quonset hut in which the new congregation first held its services. The members of the congregation wanted the feeling of intimacy and warmth they experienced in the Quonset hut to be translated into their new church building. A circular baptismal font in the church's narthex is illuminated by a domed skylight. The church's exterior walls are of textured brick. The clarity and simplicity of the design give the church a monumental appearance while responding to the small-scale residential qualities of its post–World War II neighborhood. Sidney Folse, Jr., of the Curtis and Davis firm, was the project architect for the church. Adjacent to the building is St. Francis Cabrini Elementary School (1500 Prentiss Avenue), built in 1957 and also designed by Curtis and Davis. It consists of single-story, steel-frame linear units of brick and glass, each one room deep to allow for cross ventilation, arranged parallel to each other and linked by covered walkways.

OR165 Lake Vista Development

1936, Hampton Reynolds. Bounded by Robert E. Lee and Marconi blvds., Beauregard Ave., and Lakeshore Dr.

Planned and implemented by the Orleans Levee Board, the 404-acre Lake Vista was the first of the lakefront's residential neighborhoods to be built on the reclaimed land. The consulting engineer, Hampton Reynolds, a member of the New Orleans city planning board and father-in-law of Louisiana's then-governor, Richard W. Leche, based Lake Vista on such garden city schemes as Radburn, New Jersey (1928). Lake Vista was laid out with streets that terminate in cul-de-sacs and curving, landscaped pedestrian lanes, accommodating more than 800 individually designed dwelling units (including a few low-rise apartment buildings) on variably sized lots. The first residents moved in in 1939, but most of the houses were built after World War II. At the heart of the development, and within walking distance for all residents, was the Lake Vista Community Shopping Center, on Spanish Fort Boulevard. Built in 1946 by Wogan and Bernard and August Perez, Jr., Associate Architects, this smooth-curved building has horizontal lines that are empha-

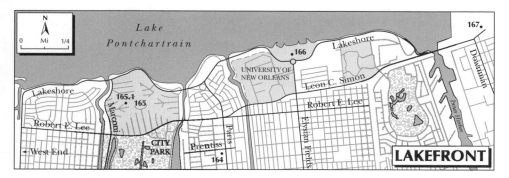

sized by a continuous canopy that shades the shopfronts. The stores did not prosper; by the time they were opened, shoppers favored larger retail centers. The spaces are now used by financial service offices and beauty and physical fitness centers. Behind the shopping center are a school and two churches. St. Pius X

OR164 St. Francis Cabrini Church

OR165.1 St. Pius X Church

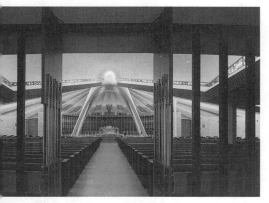

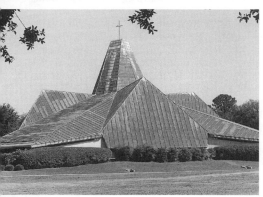

School (1953–1954), designed by Burk, Le Breton and Lamantia, initially served as both a school and a temporary church until the completion of St. Pius X Church (OR165.1). August Perez, Jr., and Associates designed the elliptical Lake Vista United Methodist Church (1961), which has lacelike, metal-screened glass walls and a folded-plate roof. Several houses are significant examples of modernist design, particularly Samuel Wiener's Cahn House at 20 Swan Street (1951); Lawrence and Saunders's Shalett House at 15 Tern Street (1955); Lawrence, Saunders and Calongne's widely published Mossy House at 28 Tern Street (1956); and the Higgins House, by Sparl and Maxwell, at 30 Tern Street (1949). The last is constructed of Thermo-Con, a cellular concrete building material developed by Andrew Higgins, the designer and manufacturer of landing craft used in World War II. Unfortunately, new residents in Lake Vista are buying and razing many of the houses dating from the 1950s and 1960s in order to build enormous homes in Antebellum Revival and other neohistoric styles that are profoundly insensitive to the scale and character of the community.

OR165.1 **St. Pius X Church**

1964–1966, James Lamantia, Jr., for Burk, Le Breton and Lamantia. 6666 Spanish Fort Blvd.

Sheltered by an enormous copper roof that sweeps down almost to ground level, the church is a powerful expression of the liturgical changes effected by Vatican II. The plan is octagonal in shape, with the altar at the center, reflecting the shift from the traditional axial organization to a nondirectional, unified space. Light fills the interior, from the bands of colored glass separating the roof from the low walls below it to the golden and green stained

glass window on the north face of the central tower, which focuses light directly onto the altar. The roof, supported on steel trusses, has a complex folded shape that is suggestive of an origami figure. New Orleans architect James Lamantia, Jr., created a bold design, but one whose size, scale, and concept fit harmoniously within Lake Vista.

OR166 Milneburg Lighthouse (Port Pontchartrain Lighthouse)

1855. Lakeshore Dr. (at the end of Elysian Fields Ave.)

One of a series of federal lighthouses erected around Lake Pontchartrain from the Rigolets to Madisonville (see ST5), this 56-foot-high, hourglass-shaped brick tower was stranded inland when the Orleans Levee Board completed the landfill project along the lakeshore. The lighthouse, which became redundant in 1929, belonged to a group built in Louisiana in the 1850s and modeled on New England brick lighthouses. It was named for Milneburg, the former lakefront resort at this location, which was developed by Scotsman Andrew Milne in 1831. Near the lighthouse are buildings housing the Navy Information Technology Center (1999) in the Research and Technology Park of the University of New Orleans, designed by Perez Ernst Farnet.

OR167 Lakefront Airport (Shushan Airport)

1932–1934, Weiss, Dreyfous and Seiferth. 1964, facade, Cimini and Meric

In order to accommodate seaplanes as well as land-based craft, Lakefront Airport was built on land dredged from Lake Pontchartrain to create a site that projects into the lake. The first plans for the airport were drawn up by William E. Arthur of Los Angeles, who was replaced in 1932 by Weiss, Dreyfous and Seiferth. Following Arthur's earlier concept, the airfield's buildings were laid out on the triangular-shaped site in a winged arrangement symbolizing flight; the central terminal building was given a similar outline. Both the exterior and interior were lavishly ornamented with relief sculptures that alluded to flight. Above the main entrance was a figure of man as a flying machine, flanked by window panels with similar representations; on the side walls were sculptures representing the four winds. Among the sculptors who created these works were Enrique Alferez, William Proctor, and John M. Lachin. This beautiful facade—Weiss, Dreyfous and Seiferth had reached their peak in the integration of sculpture and architecture by the early 1930s—was covered up in 1964 by a windowless wall. According to public announcements, this was done to save the expense of needed exterior repairs and to enable the airport to function as a radiation shelter. Fortunately, much of the interior has retained its 1930s appearance despite the division of the former double-height lobby into two floors, an alteration that conceals the balcony-level murals by Xavier Gonzalez. The rose-, cream-, and beige-colored marble paneling, streamlined aluminum stair railings and light fixtures, plaster friezes of mechanical tools and of cloud and sun motifs all convey the magical and modern aura of early flight.

Funded at a cost of $4 million and supervised by the Orleans Levee Board, the airport was named, despite considerable public protest, for the board's president, Abe Shushan (1894–1966), who had his initials inscribed throughout the terminal, reputedly in more than a thousand places, from doorknobs to roof. Shushan, a friend of Huey P. Long, was indicted for income-tax evasion. He was subsequently acquitted, but in 1939 the Orleans Levee Board nonetheless renamed the airport and ordered the removal of every trace of Shushan's name. Shushan was jailed for mail fraud the following year. On either side of the terminal are two of the original aircraft hangars, each with metal gable ends inscribed with the image of an airplane. Adjacent to the airport's entrance is Enrique Alferez's striking fountain, of 1938, which is composed of four 9-foot-high nude figures of cast stone representing the four winds, grouped around a hemisphere and surrounded by a pool. Three of the figures are female; the male figure, representing the north wind, was heavily criticized in its time by citizens who regarded its nudity as harmful to public morals. The airport is now used primarily by small private airplanes.

Gentilly and East to the Parish Line

The elevated strip of land, known as Gentilly Ridge, that runs through this area was occupied by Native Americans before Europeans began to settle here in the eighteenth century. The surrounding swamps and marshes, however, were not drained until the early twentieth century. In 1909, the real estate firm of Baccich and deMontluzin formed the Gentilly Terrace Land Company and laid out Gentilly Terrace (now called Old Gentilly). It is considered New Orleans's California-style suburb because of its tree-lined streets of stucco-covered, red pantile–roofed bungalows with Arts and Crafts details. Gentilly Woods was developed in 1951 by Hamilton Crawford, who hired architect J. W. Leake to design residences in thirteen different styles, including contemporary ranch-style homes.

In the 1960s and 1970s, residential subdivisions continued to creep eastward, crossing the Industrial Canal onto former swamplands. This area, known as New Orleans East, still experiences new growth, both industrial and residential. U.S. 90 (Chef Menteur Highway), eastward en route to the Orleans Parish line, passes the National Aeronautics and Space Administration's Michoud Space Center, on Old Gentilly Road, which assembles rockets in plants on the former site of the Michoud Shipbuilding Facility. Nearby on Alcée Fortier Boulevard, a double row of Vietnamese-owned shops and restaurants

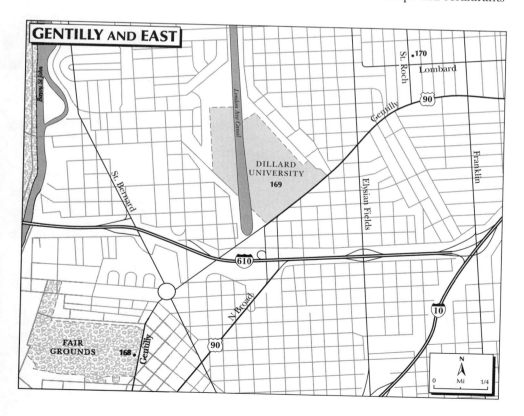

forms the center of a Vietnamese community, which has expanded since 1975, when, following the American withdrawal from Vietnam, the Catholic Church first provided housing in the neighborhood for approximately a thousand people. Heading east, U.S. 90 follows a ribbon of land between Lake Pontchartrain and Lake Borgne, forming a main street through a seven-mile-long string of "fishing camps." These flimsy, idiosyncratically decorated dwellings, raised precariously on stilts at the water's edge, constitute one of southern Louisiana's unique vernacular types. The waterway known as the Rigolets, which links Lake Pontchartrain with the Gulf of Mexico via Lake Borgne, divides Orleans Parish from St. Tammany Parish and is spanned by a narrow truss bridge built in 1930. Guarding the entrance to the Rigolets stand the remains of Fort Pike (OR171), part of Louisiana's early-nineteenth-century fortification system.

OR168 Fair Grounds Entrance Gates

1866, Gallier and Esterbrook. 1751 Gentilly Blvd.

Laid out in 1852, this racetrack was known as the Union Race Course until New Orleans renamed it the Creole Race Course and built these gates, resembling little cottages, in 1859. Each gate has a Carpenter's Gothic front porch, the upper section covered by panels with trefoil and quatrefoil cutouts; the gable roof has serrated-edged bargeboards. The New Orleans Fair Grounds purchased the track in 1872. Rathbone DeBuys's clubhouse and grandstand of 1919 burned to the ground in 1993 and was replaced by a similar design in 1997 by Eskew Filson Architects. Horse races are held at the fairgrounds during the winter months, and the annual New Orleans Jazz and Heritage Festival takes place here in late April.

OR169 Dillard University

1934 to present, Moise H. Goldstein. 2601 Gentilly Blvd.

Formed from the merger of two colleges for African Americans, Straight College and New Orleans University, Dillard University opened in 1935 on its new sixty-two-acre campus designed by Moise Goldstein. Named in honor of James Hardy Dillard, educator and administrator of funds for African American schools in the South, the university was funded in part by the American Missionary Association. According to the architect's son, Louis Goldstein, his father offered three different designs to Dillard's board of trustees—Gothic Revival, modern, and classical—and the last was selected. The master scheme for Kearny Hall, a structure with columns and a pediment dominating an open-ended court, followed the model of Thomas Jefferson's design for the University of Virginia. All the buildings are painted white, with classical details of the simplest kind, making them appear more Antebellum Revival than classical in style. This impression is heightened by the avenue of oak trees that extends the length of the court, from Gentilly Boulevard to Kearny Hall, establishing a major axis and formal entrance to the campus. The landscape architect for Dillard was William S. Wiedorn.

OR170 Henry Bihli House

1912, Morgan Hite. 4615 St. Roch Ave.

Built by the design department of the Gentilly Terrace Land Company, perhaps as a model house, this small residence in the Arts and Crafts style is one of the most attractive of the Gentilly Terrace bungalows. Henry W. Bihli purchased it in 1912. The deep entrance porch is covered with a wide, low-pitched roof, its gable end crafted from interlocking wood beams, brackets, and slats in the manner of California architects Greene and Greene. Indeed, one of Gentilly Terrace's developers, Colonel R. E. Edgar de Montluzin, traveled to California to study suburbs there before Gentilly Terrace was begun, and Los Angeles foremen, familiar with the building techniques and forms of the California bungalow, were brought in to oversee construction of the earliest houses. The stucco-covered, red pantile–roofed bungalow at 4486 St. Roch Avenue, with a capacious front porch supported on massive obelisk-shaped brick piers, is a fine example of the California type. More unusual in this neighborhood is H.

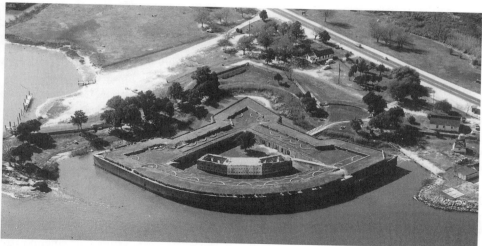

OR171 Fort Pike

Jordan MacKenzie's 1910 design for a two-story house in a Dutch gable style (4437 Painters Street), similar to designs by the early-twentieth-century Secession architects at the Darmstadt Colony. Gentilly Terrace developed slowly at first; then a building boom in the late 1930s generated the yellow-brick houses and Cape Cod cottages in this area.

OR171 Fort Pike

1819–1826. U.S. 90 (at the Rigolets Bridge)

Fort Pike, one of the first forts built under a national coastal fortification program that extended from the end of the War of 1812 to the Civil War, was designed to withstand attack from land or sea. Pointed, earth-filled brick bastions flank the land side of the structure, and a curved wall faces the waters of the Rigolets. Two moats originally surrounded the fort. Accommodations and storage areas, also constructed of brick, lined the inner walls, and groin vaults covered the ground-level spaces. A one-story citadel at the center was intended as a stronghold in case the walls were stormed. The fort could accommodate up to 400 men. It served as a stopover for soldiers bound for Texas during the Mexican War of the 1840s and in 1862, during the Civil War, was seized by Union Army soldiers, who used it as a base for raids along the Gulf Coast and the Lake Pontchartrain area. The Union Army also used Fort Pike as a training center, where former slaves were taught to use heavy artillery. The fort was abandoned in 1890 and is now a Louisiana State Commemorative Area open to the public. Fort Pike was named for General Zebulon Montgomery Pike, the explorer and soldier whose name was also given to Pikes Peak in the Rocky Mountains. Fort Macomb, similar in design, stands at the entrance to Chef Menteur Pass, another, but narrower, link between the lake and the Gulf. Constructed between 1820 and 1827 and garrisoned in 1828, it now lies in ruins.

Algiers

Algiers, located on the west bank of the Mississippi River opposite the Central Business District, was annexed to New Orleans in 1870. Algiers was the site of the Company of the Indies's first plantation, Louisiana's first slave-trading depot, and New Orleans's gunpowder magazines. In the nineteenth century, dry docks and shipbuilding brought prosperity to the town. After 1853, when the New Orleans, Opelousas and Great West-

ern Railroad (later the Southern Pacific) left Algiers, it became a center for freight transportation, via steamship and rail, from the eastern seaboard to the West Coast until the 1960s. Pacific and Atlantic streets were named to commemorate that trade. The older section of Algiers, known as Algiers Point, was rebuilt after a fire in 1895. It consists primarily of streets of small cottages and shotgun houses, many elaborately decorated with Eastlake ornament, as seen in the 200 block of Olivier Street. Construction of the Mississippi River Bridge (now known as the Crescent City Connection) in 1958 made Algiers more accessible to east-bank New Orleanians and triggered new suburban development. Algiers has two small buildings in the Beaux-Arts classical style: a Carnegie-funded public library (725 Pelican Avenue), designed in 1907 by Rathbone DeBuys, and the former Canal Commercial Trust and Savings Bank (505 Patterson Road), designed in 1907 by Emile Weil. The small frame Mount Olivet Episcopal Church (526 Pelican Avenue) dates to 1856. The Rosetree (formerly the Algy) Theater (1930s; 446 Vallette Street), an Art Deco movie house, was a social center for Algerines. A ferry, operating since 1827, continues to link Algiers Point with Canal Street and provides spectacular views of both banks of the river and of downtown New Orleans. (For locations of Algiers sites OR172–OR175, see the Orleans Parish map on p. 56.)

OR172 Algiers Courthouse and Community Center

1896, Linus Brown and Alonzo Bell. 225 Morgan St.

This brick, twin-towered courthouse was constructed after the fire of 1895, which destroyed several blocks of downtown Algiers, including the former Duverje plantation house, which had served as the courthouse since 1869. City engineer Linus Brown and Alonzo Bell designed this awkwardly proportioned but picturesque courthouse in a round-arched Italianate style; the builder was John McNally. The two-story building's facade, rather too wide for its height, features square towers at each end, one three stories tall and the other with an additional story and a clock. The facade and towers have paired, round-arched windows set between shallow pilasters and emphasized by prominent hood moldings. Small-scale brick dentil bands adorn the cornice, and a pediment-shaped parapet tablet marks the facade's center. The small central portico is supported on doubled Doric columns. Renovated in the 1980s by Lyons and Hudson, the courthouse also serves as a community center.

OR173 Trinity Evangelical Lutheran Church

1911. 620 Eliza St.

Built for a congregation formed in 1875, this pretty white frame church has steeply pitched gables inset with small rose windows on its two principal facades. Two square towers have pyramid-shaped steeples supported on brackets; the larger tower anchors the church to its corner site.

OR174 Old Algiers Main Street Fire Station (Fire Engine No. 17)

1925, Andrew S. Montz. 425 Opelousas Ave.

The new main fire station for Algiers was designed to blend in with the residential character of the neighborhood. It is one of several that draw on the English Tudor style, which city architect E. A Christy introduced to New Orleans in his design of 1909 for the fire station at 436 S. Jefferson Davis Parkway on the east bank of New Orleans. This Algiers station by Andrew Montz (c. 1882–1963) is a particularly fine example of the style. The two-story building of red brick trimmed with white stone has a wide, Tudor-arched entrance for the fire trucks, a row of square-topped windows on the second story, and a crenellated parapet. Fire stations are extremely important in New Orleans,

where most buildings are constructed of wood and closely spaced, making fires a constant hazard.

OR175 Audubon Institute Center for the Research of Endangered Species

1996, Design Consortium and Eskew Filson Architects. 14001 Patterson Rd. (Not visible from the road)

This 36,000-square-foot center houses a complex of laboratories, veterinary clinics, library, and conference spaces as well as wildlife from around the world, including lions, antelope, and wildcats, on an isolated 1,200-acre hardwood forest site. At the request of the client, each function was given its own building. However, uniformity and a recognition of the natural environment are achieved through color and a consistent use of similar materials, principally wood and brick. The design of these buildings, with their low-pitched roofs and deep eaves, large windows with horizontal mullions, and wood detailing, clearly derives from the work of Frank Lloyd Wright. The center is not open to the public.

Delta Parishes

WATER FORMS MOST OF THIS REGION'S BOUNDARIES (LAKE Pontchartrain, Lake Borgne, and the Gulf of Mexico), threads its land with bayous and passes, and saturates its swamps, marshes, and cypress forests. Coastal erosion is a major concern, as salt water from the Gulf of Mexico continues to invade the fragile freshwater marshes. Between 1932 and 1990, the delta lost more than 1,000 square miles of land. River control projects to improve navigation along the Mississippi and to protect New Orleans from floods have also created problems, preventing the river from carrying silt to rebuild the low, unstable barrier islands that help protect the coastline from hurricanes and tidal surges. Individual buildings and entire communities have disappeared. The Balize, a small fort built in 1734 on a little island at the mouth of the Mississippi River, is now submerged, and Manila Village, a Filipino fishing settlement that became a hub of the shrimp-drying industry beginning in the 1890s, was destroyed by Hurricane Betsy in 1965.

The region comprises three parishes. Plaquemines Parish (1807) derived its name from *piakemines*, the Indian word for the persimmon, which once grew abundantly here; St. Bernard Parish (1807) was named in honor of St. Bernard of Clairvaux; and Jefferson Parish (1825) recognizes Thomas Jefferson. Jefferson Parish's eastern boundary originally stood at Felicity Street in New Orleans but was slowly pushed westward as that city expanded.

Earth and shell mounds and middens, which Native Americans first began to build about 1,500 years ago along the waterways and bayous of this area, are the earliest surviving structures. Reaching as high as 25 feet, some are burial mounds, while others are thought to be bases for temples and houses. European, mostly French, settlement of the delta began in the early eighteenth century. Between 1779 and 1783, when Louisiana was under Spanish control, King Charles III of

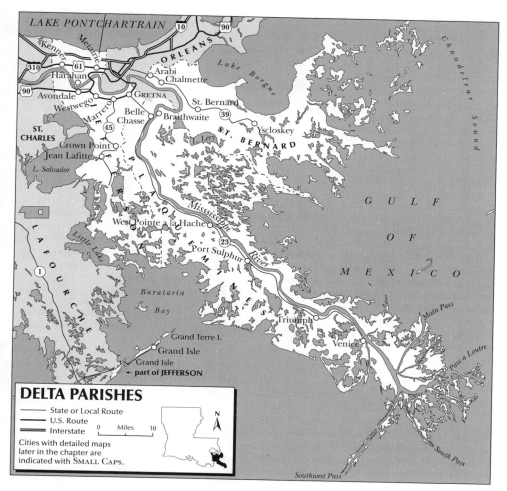

Spain relocated 2,000 people from the Canary Islands to this region. His aim was to establish loyal and strategically located Spanish-speaking communities within the French-speaking colony. Descendants of the Isleños (Islanders) celebrate a distinct culture in St. Bernard Parish today.

Few structures survive from the many sugar plantations that once existed in the area or from the cypress logging industry. Citrus fruit is now the major crop in Plaquemines Parish. After James B. Eads constructed jetties at the South Pass of the Mississippi River in 1879, the region's importance as a route and a port for ocean-going ships was assured. The U.S. Army Corps of Engineers now controls the navigation channels. Beginning in the 1850s, the railroad also contributed to the region's industrial growth, spurring shipbuilding and the development of sugar and oil refineries. The seafood industries and their related structures remain important in this region.

Initially, people built houses along the natural levees, but as effective drainage

schemes were introduced during the course of the twentieth century, suburban and industrial development accelerated, most significantly in Jefferson Parish. Conservationists and government agencies are beginning to address the impact of this growth in the more environmentally fragile areas of the delta. Along with the oceangoing ships and the fishing boats along the bayous, the most compelling and characteristic structures of this region are the shipbuilding facilities, warehouses, and industrial plants along the river's edges.

Jefferson Parish (JE)

Gretna

Modern-day Gretna was formed from three nineteenth-century communities: Mechanikham, Gretna, and McDonoghville. Mechanikham was laid out in 1836 by Nicolas Destrehan according to a plan by Benjamin Buisson. It consisted of a common (now Huey P. Long Avenue) stretching southward from the river, with two streets on each side. In 1838, the St. Mary's Market Steam Ferry Company developed a four-block-wide community immediately downriver from Mechanikham, which became known as Gretna, although from the mid-nineteenth century, the two villages were often together referred to as Gretna. Gretna is said to have been named for Gretna Green in Scotland because of its reputation during the 1840s as a mecca for quick marriages and elopements, performed by a justice of the peace at any hour. In 1913, the adjoining downriver community of McDonoghville, laid out by John McDonogh on his land in 1815, was

incorporated into Gretna. McDonoghville was famous as the site of the U.S. Marine Hospital, designed by Robert Mills. This large Gothic Revival structure, completed in 1850, was destroyed by an explosion in 1861, when it was being used as a powder magazine.

Gretna's early industries included shipbuilding and sawmills, both stimulated by the arrival of the New Orleans, Opelousas and Great Western Railroad (purchased by the Southern Pacific in 1883), which ran westward from Algiers beginning in 1853. In 1884, Gretna became the parish seat. Although commercial establishments now favor U.S. 90 rather than Huey P. Long Avenue, the latter retains several significant early-twentieth-century structures. In addition to the old courthouse (JE1), these include the First National Bank of Jefferson Parish, a brick and limestone Beaux-Arts structure (c. 1925; 203 Huey P. Long Avenue) and, at number 519, a three-story brick building, designed by Stevens and Nelson in 1910, which was formerly the Gretna Elementary School and now serves as the German-American Cultural Center. (Many of Gretna's early settlers were Germans.) A ferry still crosses the Mississippi River, linking Gretna with New Orleans at the foot of Jackson Avenue.

JE1 Gretna City Hall (Jefferson Parish Courthouse)

1907, Robert S. Soulé and Francis J. MacDonnell. 2nd St. and Huey P. Long Ave.

Parish boundary changes and inadequate facilities have given the Jefferson Parish seat of justice a peripatetic history. Its earlier homes included two in what is now New Orleans: an Egyptian Revival structure (2251 Rousseau Street, much altered and used as a storage facility) and the Greek Revival courthouse designed

JE1 Gretna City Hall (Jefferson Parish Courthouse)

by Henry Howard in Carrollton (OR148). In Gretna, the former William Tell Fire Hall, a two-story wooden structure (c. 1875; Newton and 3rd streets), served as the courthouse from 1884 to 1907. The site for this three-story brick structure, a narrow site in the center of Huey P. Long Avenue, was selected in 1905. The courthouse is conventional in its Beaux-Arts forms, but, squeezed onto its narrow site, it is a compact composition with a vertical emphasis. Its central projecting portico has a triple-arched entrance on the first floor, four Corinthian columns in front of the second and third stories, and a pediment. The end and side walls are marked by Corinthian pilasters between closely spaced rectangular windows. The building is finished with a projecting cornice lined with modillions and dentils and a parapet. At the center of each of the side elevations, the second and third stories together form a single projecting curved bay, which correspond to the concave-curved walls of the courtroom's interior. A columned loggia fronting the second story of the bay further articulates the exterior. The courthouse is painted in a lively color scheme: beige walls, white columns, gray windowsills, and a burnt-orange cornice. In 1929, a plain three-story boxlike annex was added to the rear of the building. When a new and larger courthouse was constructed in 1958, the interior was remodeled to meet the needs of a city hall, but, fortunately, the round arches dividing rooms and areas on the principal floor were retained. The building reopened as Gretna's city hall in 1964. The courthouse of 1958, a nine-story glass skyscraper (Dolhonde and 3rd streets) designed by Claude Hooton, is now slated for demolition, to be replaced by a

new parish government complex at 1st, 3rd, Dolhonde, and Derbigny streets.

JE2 Jefferson Memorial Arch

1923. 100 Huey P. Long Ave.

Dedicated to the soldiers of Jefferson in all wars and inscribed with the dates 1812, 1861, 1898, and 1917, the memorial stands in the center of a small public square, originally the town common of Mechanikham. The memorial's form, a single round arch topped by an entablature, was inspired by Roman triumphal arches. Constructed of red brick with white trim, it has little decoration other than shallow niches on each side of the central opening and a tall, plain entablature. Aligned with and located between the former courthouse and the ferry landing, the arch gives presence to Gretna's historic heart. Funds to erect the arch were raised by local citizens organized in 1918 by Jacob Huber, engineer of the Gretna ferry.

JE3 Louisiana Railroad Museum (Texas-Pacific Railroad Depot)

c. 1905. 739 3rd St.

Two surviving depots in Gretna's center affirm the importance of the railroad to the town's growth. This brick one-story former passenger and freight railroad depot has a gabled parapet and deep overhangs along three sides carried on battered brick piers and iron brackets. One block away is the former Southern Pacific Railroad Depot (now the City of Gretna Visitor Center; 4th St. and Huey P. Long Avenue), a small wooden structure built in 1906, which has a pitched roof and gable in the center of its long side. It was used primarily as a relay station for railroad employees. A caboose is on display beside the building.

JE4 David Crockett Firehouse

1859. 205 Lafayette St.

In 1841, a group of local citizens formed a volunteer fire-fighting company, incorporating as the Gretna Fire Company No.1 in 1844. The company's name was changed in 1874 to honor Davy Crockett, who fell at the Alamo. Built on land purchased from Claudius Strehle (see next entry), one of the founders of the fire company, the station is a two-story wooden

JE4 David Crockett Firehouse

structure with a wide-arched opening on the ground floor to allow passage of the fire engine. On the upper floor is a meeting hall with round-arched windows. The front gable is finished to resemble a pediment; at its peak is a large openwork hexagonal bell tower surmounted by a small cupola. The firehouse shelters a steel, copper, and brass fire engine, known as the Gould No. 31 Pumper, manufactured in 1876 by the R. Gould Company of Newark, New Jersey. Weighing 3,000 pounds, it was first propelled by teams of firemen; later, when it was horse-drawn, a driver's seat was installed at the front. The fire engine's water pump was powered by a steam engine resting upon four wooden wagon wheels and could propel a constant stream of water to the height of a five-story building.

JE5 Gretna Historical Society Museum Complex (Kittie Strehle House)

c. 1845. 201 Lafayette St.

This single-story, four-room wooden house with a front gallery supported on wooden posts and gabled ends is typical of the area's early residential stock. It was built by German immigrant Claudius Strehle shortly after he purchased the land in 1840. His family occupied the house until 1935, the last member being schoolteacher Catherine (Kittie) Strehle, the youngest of his nine children. The furnishings and Depression-era appliances remain much as

they were at her death. The house is now part of a museum complex that includes the David Crockett Firehouse and, to the right of the firehouse, the White House (209 Lafayette Street), a mid-nineteenth-century galleried cottage with four bays that serves as a working blacksmith's shop.

JE6 St. Joseph's Catholic Church

1926, William R. Burk. 600 6th St.

St. Joseph's serves a parish founded in 1857 whose earliest members were mostly of German origin. Replacing a Gothic Revival structure, this Spanish Colonial Revival church was built during the pastorate of Father (later Monsignor) Peter M. H. Wynhoven, who founded the Hope Haven and Madonna Manor homes for children in Marrero (JE9), also designed in the Spanish Colonial Revival style. The church's stuccoed-brick facade and bell tower are almost identical to Bertram Grosvenor Goodhue's design for the California Building at the Panama-California Exposition in San Diego (1915–1916). Ornamentation covers the center of the facade in a dense, high-relief composition incorporating scalloped-arched openings, twisted columns, foliate vines, cartouches, angels, a sculpted head of Christ, and a continuous band of shell-shaped motifs surrounding the round-arched entrance; above the upper window, shallow niches hold a row of saints. The outer sections of the facade are unadorned, intensifying the impact of the ornament. The entire facade is framed by a scalloped parapet, which climbs from the outer edges to the taller center in a series of reverse curves and is decorated along the top with ball-shaped urns. A round-arched open arcade extends along each side of the church. The square tower is at the rear of the church rather than beside the facade, as in Goodhue's scheme, and its upper section rises to a pair of setbacks (one less than Goodhue's tower), with a small cupola above. The church's nave has a barrel vault with transverse arches, and a half-dome defines the apse; the interior is modest in its decoration.

JE7 St. Joseph Luxury Apartments and Senior Citizen Center (Perpetual Adoration Convent and Infant Jesus College)

1899, 1907. 614 7th St.

This large L-shaped, three-story brick structure accommodated the Perpetual Adoration Convent of the Sisters of the Most Holy Sacrament and a boarding school for young boys, the Infant Jesus College. It replaced an earlier structure damaged in the crevasse of 1891, when the levee broke and the area was flooded, and was built in two campaigns. The first section, constructed in 1899 by builder John McNally, has three stories, segmental-arched windows, a gabled facade, and a small entrance portico in front of the principal (second) floor; at the building's rear, facing 8th Street, is a three-story wooden gallery. In 1907, a three-story wing was added to the left of the building, incorporating a chapel on the second story, which is indicated on the exterior by a semicircular apse and pointed-arched windows. All other windows have segmental-arched tops, matching those of the earlier section. The exterior walls are decorated with corbels along the top, and at the rear is a three-story cast iron gallery. After the school closed in 1975, the buildings were restored in the 1990s for use as apartments and a center for senior citizens.

Harvey

Harvey's origins date back to 1839, when Nicolas Destrehan laid out a town on an eight-by-thirteen-block grid, which he named Cosmopolite City. Destrehan also constructed a drainage canal along his lower property line to provide a direct route from the Mississippi River to Bayou Barataria. Destrehan's eldest daughter, Louise, and her husband, Joseph H. Harvey, for whom the canal and the town are now named, had the waterway widened and deepened. Sold in 1898 to the Harvey Canal Land and Improvement Company, and then in 1924 to the U.S. government, the canal was incorporated into the new Gulf Intracoastal Waterway system, at which time it was again widened, to 75 feet, and given new locks. Another contribution to Harvey's growth was the New Orleans, Opelousas and Great Western Railroad, which by 1857 included Harvey on its line from Algiers to Morgan City. The town of Harvey served as the seat of Jefferson Parish from 1874 to 1884. The courthouse was located in Joseph and Louise Harvey's three-story castlelike mansion, built in 1844 and occupied until 1870. It was demolished in 1924 to accommodate the new locks.

Marrero

In 1904, when Louis "Leo" H. Marrero organized the Marrero Land and Improvement Association to develop the town, it was known as Amesville. In 1914, the town was renamed to honor Marrero, who at one time served concurrently as president of the Jefferson Parish Police Jury and as state senator, and later (1896–1919) as sheriff of Jefferson Parish. The former Jefferson Water District Building No. 2 (4512 7th Street; now Mary's Helpers Inc.) is a two-story red brick building with cast concrete trim, decorated in each end gable with a relief bust of Thomas Jefferson.

JE8 Immaculate Conception Church

1957, Curtis and Davis with Harrison B. Schouest. 4401 7th St. (corner Ave. C)

The most noticeable feature of this rectangular church, built of reinforced concrete, is its sweeping folded-plate gable roof. The pie-shaped panels of structural steel form a rhythmic zigzag pattern on both the exterior and interior. At the front, the roof extends to form a sheltering portico, and, along the sides, it rests on triangular-shaped reinforced concrete piers that act as buttresses against its outward thrust. The textured brick walls are laid in Flemish bond, with projecting and recessed headers in alternate courses; the bricks have the pink-hued beige color favored by this architecture firm in the 1950s. The church seats 900 people. Walter J. Rooney, who was in charge of this project for the firm, stated that he sought to create "an emotional impact . . . by using dim illumination in the low ceiling peripheral areas to lend great emphasis to the vaulted nave. The undulating ceiling hovers lightly over the congregation and focuses all attention on the sanctuary and main altar." Decorative elements inside include a narthex screen of perforated precast concrete panels, designed by sculptor Jack B. Hastings.

JE9 Hope Haven Center (Hope Haven and Madonna Manor Homes)

1925–1940, various architects. 1100 block of Barataria Blvd.

These homes for dependent children are set in spacious grounds on both sides of Barataria Boulevard: Hope Haven on the west and

Madonna Manor on the east. The largest ensemble of Spanish Colonial Revival buildings in Louisiana, they are especially fine, offering a splendid panorama of white stuccoed walls, red tile roofs, round-arched arcades, curved parapets, towers, elaborate sculptural decoration, and ornamental ironwork. The earliest structures were Hope Haven, founded in 1925 by Peter M. H. Wynhoven, pastor of St. Joseph's Church in Gretna (JE6), as a home for teenage boys of all religions. Madonna Manor was established in 1932 for boys and girls under the age of twelve (although later restricted to boys) and was administered by the Sisters of Notre Dame. Today the Hope Haven structures are used in part for homeless families, and Madonna Manor is a residence for troubled adolescents, administered by Associated Catholic Charities.

JE9.3, 9.4 Hope Haven Center (Hope Haven and Madonna Manor Homes), chapel and school

JE9.1 Hope Haven

1925, William R. Burk

This former administration building, in the center of the group of structures on the west side of the boulevard, was the first to be built and has the least ornamentation of them all. Inspired by the mission churches of California, the three-story structure has a projecting single-story, round-arched arcade that wraps around the front and sides; a square off-center tower is topped by a small, red-tiled dome. Ornamentation consists primarily of slender spiral columns between the windows of the third story and applied to the surface of the arcade's piers. The two-story structure to the far left on this side of the street served as the vocational school (1931) for the approximately 125 boys housed at Hope Haven. The tools of their future trades—axes, pliers, planes, and hammers—are indicated in relief sculpture in a frame around the school's central entrance. The Hope Haven complex originally also included a dairy to provide instruction in this trade. To the rear of this group of buildings (not visible from the street) is the former Julian Saenger Gymnasium (1930), which, from the front, is shaped like a church, with an arcaded portico and flanking square tower

JE9.2 Madonna Manor

1932, Jack J. H. Kessels for Diboll and Owen Architects

On the east side of the boulevard, this is the largest structure in the complex. By 1940, it housed approximately one hundred boys and forty girls (girls were more commonly adopted). The three-story structure has a five-part composition, with a central section outlined by a curved parapet and lower, slightly recessed sections between it and the end wings. Second-story windows across the entire facade are fronted by iron balconies; the third-story windows of the end wings are fronted by wooden galleries with turned posts and balustrades, and iron grilles cover other windows. A circular stained glass window on the upper facade of the central section features a Star of David to recognize the contributions of the Jewish community to this Catholic-founded home. The rich mix of forms, materials, colors, and textures, along with the play of light and shade over the facade, is essential to the building's drama. Contributing to the effect is the square tower on the right side of the building, which has small semicircular balconies around its openwork top and a red-tiled pyramid roof.

JE9.3 Chapel

1941, Diboll-Kessels and Associates

The chapel has the most ornate facade in this group of buildings. Rendered in light gray stone, vertically organized across the center of the facade in various shapes and sizes, are columns, niches holding statues of saints,

moldings, arches, rams' heads, shields, obelisks, and crosses. Floral scrolls and shells embroider bands around the arched frame of the entrance door. Along each side of the chapel is an open round-arched arcade. To the right of the facade is the square bell tower, which has two setbacks at the top and a miniature red-tiled dome.

JE9.4 **School Building** (Hope Haven School)

1932, Jack J. H. Kessels for Andrew S. Montz

Completing the row of buildings on the eastern side of the road is this two-story school, whose complex, asymmetrical composition and lack of applied ornamentation make it different from the other buildings in this group. A squat round tower is inserted into the reentrant angle on one corner of the building, and a projecting single-story, round-arched arcade stretches across the front. The building's ornamental restraint speaks to the serious nature of its scholarly function and, at the same time, offers a further interpretation of the Spanish-inspired theme that unifies the entire complex.

Westwego

First known as Salaville in honor of Spanish immigrant Pablo Sala, who is considered the town's founder, Westwego acquired its present name in the 1870s. Westwego is said to be the only town in America whose name forms a complete sentence. Among the several claims for the name's origin, the most plausible is that it derives from the town's position as the departure point for travelers heading west after crossing the Mississippi River. After the Texas and Pacific Railroad located a railroad yard here in 1870, the town flourished as a hub for freight shipments, stimulating the construction of warehouses, grain elevators, and, in the twentieth century, refineries.

Westwego was also a center for the processing and canning of seafood, brought in by fishermen who used the canal, opened in 1841, that connected the Mississippi River to Bayou Segnette, Lake Salvador, and the Barataria estuary. In the 1950s, this industry suffered a death blow after the Corps of Engineers closed and filled the canal as part of a flood-protection plan for New Orleans. A surviving structure from this industry is the two-story brick shrimp-

canning plant (1943; 300 Sala Avenue). The former Bernard Hardware Store, now the Westwego Museum (1907; 275 Sala Avenue), also represents this part of Westwego's history. The two-story wooden corner store, which closed in 1997, has a gallery along the front and side; the first-floor interior has beaded-board walls and ceilings and the original shelves and counters. Emile Weil designed the three-story brick Westwego High School, now the Joshua Butler Elementary School (1923; 300 4th Street), which features a monumental Palladian central entrance portico. Westwego's most monumental structure is the grain elevator, now owned by Cargill Incorporated (933 Louisiana 541), erected by the Texas and Pacific Railroad in 1892 and given a second set of concrete silos in 1901. At 2141 Louisiana 541, Magnolia Lane Plantation House (c. 1830) stands as a reminder of the many that once lined the west bank of what is now Jefferson Parish. The house, shrouded by trees, has a brick ground story, an upper and principal floor of *bousillage* between posts, a gallery on all sides, and a central hall.

Avondale

Avondale is home to one of the nation's biggest shipbuilding facilities. Established in 1938 as Avondale Marine Ways, it is currently a unit of Northrop Grumman Corporation. In its early years, the facility specialized in all-steel construction and primarily built and repaired river barges. Just before the United States entered World War II, Avondale manufactured a self-propelled bulk-liquid cargo cruiser for service on the Atlantic, and during the war it constructed tenders. In the postwar period, the company expanded its range to include seagoing vessels for the U.S. Coast Guard and the U.S. Navy, tankers for oil companies, and container ships for commercial companies. Encompassing 268 acres along the bank of the Mississippi River, the shipyards present a formidable sight, with cranes, partially built ships, and structural equipment rising high above the levee, reiterating the centrality of the river to the area's culture.

Metairie

This suburb of New Orleans experienced phenomenal growth in the twentieth century, al-

though the area was rural throughout most of its history. Because of the swampy nature of the soil, the remnants of an alluvial ridge, known as Metairie Ridge, became the locus of the town's early development. Metairie Road now traverses this ridge, overlying what was once an Indian footpath. The name Metairie is believed to derive from the French word *métairie*, which designated a type of small farm operated on the basis of *métayage*, whereby the farm's products were split evenly between tenant and landowner. Beginning in the mid-nineteenth century, real estate speculation, driven by railroad construction, prompted property owners to subdivide their land. An electric streetcar line from downtown New Orleans to the suburb, established in 1915, encouraged a construction boom in the 1920s and 1930s. This included development of an exclusive residential area promoted as Metryclub Gardens, now known as Old Metairie. While many of the original homes remain (JE10 and JE11), numerous others began to be replaced in the 1990s by residents eager to outdo one another with houses of enormous proportions, designed in historically derived styles that look back to the Colonial and Antebellum revivals and Beaux-Arts eclecticism. Unlike the original houses, which were sufficiently set back from the street and far enough away from one another to ensure a rural ambience, the new dwellings are too big for the size of their lots. Crowded together, they dilute the neighborhood's gardenlike character.

In the second half of the twentieth century, expansion farther west and toward the lake became possible after the completion of effective drainage systems and the lakefront levee system, the latter in 1948. The construction of the Lake Pontchartrain Causeway (1956, and a second span in 1969) contributed to this growth, spawning an undistinguished row of boxlike high-rise office buildings on Causeway Boulevard near the lake. By the 1980s, Veterans Memorial Boulevard, a multilane divided thoroughfare, offered approximately four miles of strip commercial development with accompanying flat-top parking areas, catering to and fostering the appetite for shopping via automobile.

JE10 Feibleman House

1938, Weiss, Dreyfous and Seiferth. 12 Nassau Dr.

Inspired by photographs of houses designed by German architect Walter Gropius, James Feibleman requested the architects to provide a design that expressed the most modern architectural forms of the time. Constructed of brick covered with white-painted stucco, the house is an asymmetrical composition of angled and curved forms. The latter are most evident in the front bay and at the second story, executed with a pronounced horizontal emphasis. Some recent, seemingly minor alterations have minimized the design's modernist aesthetics. Larger window frames have replaced the original modest frames on some of the windows, interrupting the continuity of the building's smooth, streamlined image. Removal of window mullions on the front bay window has diminished the relationship of grid to curve that was fundamental to the design. Nevertheless, this house, handsomely set behind a large front garden, is the most original in Old Metairie.

JE11 House (Seiferth House)

1929–1930, Weiss, Dreyfous and Seiferth. 608 Iona St.

This large Colonial Revival house, the architectural antithesis of the Feibleman House (JE10), demonstrates its architects' skill in designing across the entire range of fashionable styles of the late 1920s and 1930s. The two-story wooden house was designed for Solis Seiferth, a partner at the time the firm was achieving artistic recognition and financial success. Familiar elements are awkwardly proportioned, as in the portico's four closely spaced, two-story columns with Egyptian capitals, which appear far too tall and narrow for the house and their small pediment, itself edged with overscaled dentils. Two elongated dormer windows dominate the pitched roof. Despite the distortions, the effect is quite satisfying. To the left of the Seiferth House is a Colonial Revival residence (620 Iona Street), designed in 1929 by Lockett and Chachere. To the right (600 Iona Street) is another fine Weiss, Dreyfous and Seiferth design, this one built c. 1933 in the style of a French château.

JE12 St. Catherine of Siena Roman Catholic Church

1956, James Lamantia for Burk, Le Breton and Lamantia. 105 Bonnabel Blvd.

Asked to design a large and important church for this congregation, James Lamantia produced a contemporary interpretation of the

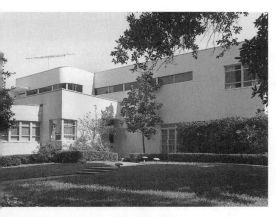

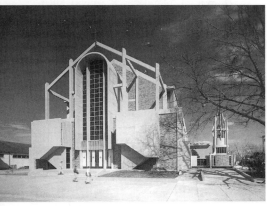

JE10 Feibleman House

JE12 St. Catherine of Siena Roman Catholic Church

traditional basilica form, one he describes as the most baroque of all his compositions. The reinforced concrete frame is pulled to the church's exterior, revealing and clarifying the logic of the structure while creating a dramatic play of vertical and diagonal lines. At the east and west ends, stained glass windows are recessed into vaultlike spaces to provide a contrasting dynamic to the angularity of the external frame and to give a hint of the space within. Placement of the choir stairs on the exterior, at each side of the entrance, adds another sculptural note and allows more interior space by reducing the size of the narthex. Vertical precast concrete louvers alternate with stained glass windows along the clerestory; the lower walls are of beige brick. The interior is impressively lofty. The rectangular concrete piers that separate the tall, wide nave from the narrow aisles echo the external frame, as do the laminated

wooden arches that form the ceiling. A freestanding circular baptistery (now occupied by offices) is crowned by a tall openwork bell tower that responds to the skeletonlike frame of the church, to which it is connected by a covered walk. The church's facade faces the street, whereas the baptistery was intended to be seen from Metairie Road.

JE13 The Galleria

1987, Ernest Hanchey. Causeway Blvd and I-10

This twenty-two-story glass tower exemplifies the suburban office park developments of the boom-and-bust economy of the 1980s. As envisioned by the Dallas developer Daniel P. Robinowitz in 1983 and designed by a Texas architect, the project was to consist of six glass towers, each nearly 400 feet high, to provide office space, a hotel, apartments, and a mall, along with numerous parking decks. The project drew vociferous opposition from nearby residents, who objected not only to the height, which exceeded zoning limits, but also to the potential impact on sewerage, drainage, and traffic systems. After a court ruling permitted construction, the first phase, consisting of the sumptuously detailed Galleria One tower and adjacent six-level parking garage, opened in 1987. The building unfortunately opened in the midst of an office glut resulting from a downturn in the oil economy, and the tower, which sought to draw businesses away from downtown New Orleans, was only 20 percent leased when it opened. Eventually the tower attracted tenants, but it was never popular enough to give investors the incentive to complete the complex.

JE14 Jefferson Baseball Park

1992–1997, Hellmuth, Obata and Kassabaum with Perez Ernst Farnet, Architects and Planners. 6000 Airline Dr.

In 1990, a 113-acre parcel of land was purchased from the Illinois Central Gulf Railroad, and during the next two years, then-Governor Edwin Edwards brokered a deal to finance the stadium, which included issuing a $52.2 million bond. The Denver Zephyrs, a Triple A–rated minor league team, was selected in 1992, the first professional baseball team to play in New Orleans since 1977. Construction finally began on the ballpark in 1995, two years behind schedule. The medium-sized stadium

seats 10,000 people on three levels: two levels of grandstands, along with air-conditioned press and luxury boxes on the third tier. The stands are of typical stepped concrete construction, supported by an exposed steel structure, painted green. The exposed structure allows visual access to the field from the circulation and concessions area and encourages the passage of cooling breezes. A canopy shades the top level. The design is dominated by an industrial aesthetic, evident in the clarity of structure, the materials, and the five circulation and service towers that ring the exterior. The principal facade overlooking the parking lot is, however, faced with brick—the requisite material of southern regionalism—red below the buff color on the second and third stories, with brown brick pilasters on the first level.

JE15 Camp Parapet Powder Magazine

1861, Benjamin Buisson. Arlington Street (east side of Causeway Boulevard)

This brick powder magazine is the only survivor from a line of Civil War fortifications built along Metairie Ridge to protect New Orleans and Jefferson Parish from Union assaults. Designed by Benjamin Buisson in July 1861, Camp Parapet was intended for a site one-half mile downstream but instead was located here because of the unobstructed view both up and down the river. The powder magazine was originally situated within an irregularly shaped 9-foot-high earthen redoubt (a temporary outlying fortification used for defense), which included an observatory, a hot shot furnace, officers' quarters, and a guardhouse. Only the magazine survives. It consists of a 20-foot-long, 4-foot-high tunnel that leads into an interior room, 8 feet by 15 feet, where the explosives were stored, all of which was originally covered with earth and had a chimneylike air vent. Confederate troops were stationed at Camp Parapet in 1861, but the fortification was seized by Union troops in May 1862. In the 1930s, this structure was used temporarily as a parish prison.

Harahan

In 1894, the Illinois Central Railroad established railroad yards and a roundhouse at what is now the town of Harahan, and residential subdivisions were laid out for railroad employ-

ees. The town was named for James T. Harahan, then president of the railroad. In 1915, Harahan was linked to New Orleans by the Orleans-Kenner Traction Company (the O-K Line), encouraging its growth as a commuter suburb. An early building of interest is the two-story stuccoed-brick Harahan Elementary School (1926; 6723 Jefferson Highway), designed by William R. Burk in the Spanish Colonial Revival style. Its central domed rotunda is covered by a red-tile conical roof, and the main entrance is decorated with scalloped arches, twisted columns, and volutes. St. Rita Catholic Church (1964; 7100 Jefferson Highway), designed by James Lamantia for Burk, Le Breton and Lamantia, is a small but monumental basilican church of blond brick with a steeply pitched roof and a tapered tower made from concave panels of precast concrete at each end.

JE16 Huey P. Long Bridge

1935. Clearview Pkwy. and the Mississippi River

This combined railroad and highway bridge, the first to cross the Mississippi River in Louisiana, replaced a train ferry and gave New Orleans a continuous highway to the west. It is 4.35 miles long, with a center span 790 feet long, and the roadway is 135 feet above the river. The steel cantilevered bridge has a series of truss spans carried on six Gothic-arched concrete supports, the deepest resting 170 feet below sea level. Spectacular views of the river can easily distract a driver and, combined with the narrow automobile lanes, make crossing the bridge a thrilling but nerve-wracking experience.

Kenner

Kenner (first known as Kennerville) extends across the former plantation lands of Minor Kenner and William Butler Kenner (brothers of Duncan F. Kenner of Ashland Plantation [AN4]). Much of the original town, laid out by surveyor W. T. Thompson in 1855, was absorbed into a new Mississippi River levee in the twentieth century. Thus few of Kenner's early historic structures have survived. Kenner remained a primarily rural community of truck farms until New Orleans's International Airport opened in 1945. Initially named for pioneer aviator John B. Moisant, who died in a plane crash in New Orleans in 1910, the airport

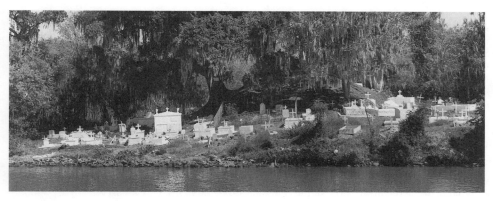

JE18 Fleming Family Cemetery

was renamed Louis Armstrong International Airport in 2000 to honor the New Orleans–born musician. The airport generated support industries and residential subdivisions in its vicinity. Airline Highway (now Drive), the original route to the airport from New Orleans, blossomed with motels and restaurants, sadly deteriorated or demolished after I-10 superseded the older highway. One of Kenner's earliest buildings is the two-story Felix and Block General Mercantile Store (1907; 303 Williams Boulevard); its brick facade is ornamented with pilasters, a cornice with dentils, and a sawtooth brick panel in the center of a small pediment.

Crown Point Vicinity

JE17 Education Center, Barataria Unit, Jean Lafitte National Historical Park

1993, Eskew Filson Architects. Pecan Grove Trails (at the 6700 block of Louisiana 45)

The Barataria unit of the multi-unit Jean Lafitte National Historical Park encompasses 8,600 acres of hardwood forest, cypress swamp, and freshwater marsh. The Education Center, a linear structure with a steel truss frame, an exterior of wood paneling and glass, and a corrugated metal roof, is raised on concrete piers above soggy soil that is sometimes inundated by spring floods. The steel truss frame is both a strong formal and a structural element of the design, piercing the wooden skin at the front to give the effect of a ship's prow, appropriate imagery for its setting. A raised translucent roof panel runs the length of the building, marking the circulation spine and linking the rangers'

offices, study rooms, and screened amphitheater overlooking the swampland. The different textures and colors of the structure's materials echo the tactile qualities of its swampy and wooded site.

Jean Lafitte

Named for the notorious Jean Lafitte (c. 1780–c. 1826), who used the bayous, shallow bays, and islands of this region for his smuggling operations, the town developed along the alluvial ridge of Bayou Barataria. It is typical of Louisiana's "line settlements," linear villages or towns where the waterway was (and sometimes still is) the main route of communication. Similar communities along the bayous of Louisiana's Gulf parishes, most notably Bayou Lafourche, share an unbroken line of houses, boat-repair facilities, marine supplies, commercial and leisure docks, and, on the water, fishing vessels. It is such vernacular structures, rather than any individual monument or building, that give this town its character.

JE18 Fleming Family Cemetery

c. 1200. Late nineteenth century, with additions. Beside 2184 Jean Lafitte Blvd. (Louisiana 45). (Not visible from the road)

This earth and shell Indian burial mound, at the confluence of Bayous Barataria and Villars, is one of the few surviving such mounds of the many, dating from c. A.D. 500 to approximately 1500, that once existed in this area. In the nineteenth century, new settlers reused it as a burial site; above-ground brick tombs painted white

crowd around the base and wedge into the sides of the mound. Situated next to Bayou Barataria and crowned with trees dripping with Spanish moss, the mound is extraordinarily picturesque. The cemetery is on private ground. Nearby (2234 Louisiana 45) is the rectangular-shaped brick smokestack from the demolished sugar mill of the former Fleming Plantation.

Grand Isle

Approximately eight miles long and one mile wide, Grand Isle is one of the largest of the barrier islands along the north shore of the Gulf of Mexico. Although now primarily a residential and vacation spot, the island once supported sugar plantations developed on land grants given by Spanish governors in the late eighteenth century. By the mid-nineteenth century, the island was becoming a favored summer resort for New Orleanians seeking cool sea breezes and healthy air. Hotels were built to accommodate the visitors, as the journey to the island took at least eight hours by steamboat along the Harvey Canal and Bayou Barataria. Novelist Lafcadio Hearn's *Chita, a Memory of Last Island* (1889) is said to portray Grand Isle's new industry after the Civil War. Kate Chopin also captured the island's architectural landscape and ambience in her novel *The Awakening* (1899). In 1893, a hurricane swept eight to ten feet of water over the island, destroying the hotels and most of the houses.

In 1931, Grand Isle was physically connected to the mainland by a highway (Louisiana 1) and a bridge over Caminada Pass. Shortly afterward, Humble Oil Company began drilling offshore, and ExxonMobil currently maintains an oil facility at the tip of the island. Offshore drilling platforms are visible from the island. In 1960, the Freeport Sulphur Company (now Freeport-McMoRan Sulphur, Inc.) built a one-and-one-half-mile-long steel rig for an offshore sulfur mine, its first offshore facility. The prefabricated elements of the rig, located approximately seven miles southeast of Grand Isle,

were floated to the site and assembled there. In operation until 1991, the rig was submerged in 1997 to form the state's first artificial reef made from a rig. As a haven for fish, the reef has made the island a favored destination of anglers as well as birdwatchers, for the island is a winter sanctuary for migratory waterfowl. This has created new challenges for those concerned with environmental issues. The island has a permanent population of approximately 1,500, but during the summer months it jumps to around 10,000 people. Subdivisions and beachfront houses have proliferated. Raised on stilts a full story above the ground to provide protection from sea surges, these wooden houses form an alien landscape. This over-building causes further erosion of the coastline and the salt marshes, already endangered by flood-protection schemes along the Mississippi River that have prevented river-borne silt from building up the barrier islands.

Grand Terre

This barrier island, smaller than Grand Isle and at its eastern tip, has been without permanent habitation since the hurricane of 1893. Today it supports only a Louisiana Wildlife and Fisheries research station and the ruins of Fort Livingston. The fort was one of a series that constituted the U.S. coastal defense program initiated after the War of 1812 (see OR171, PL2, and SB8). Begun in 1841, the four-sided trapezoidal fort was intended to guard the Barataria Pass, which provided a route to New Orleans. Constructed of cemented shells faced with brick and trimmed with granite, the fort was still incomplete when occupied by Confederate troops during the Civil War. The fort never saw action and remained unfinished. It is not open to the public but is visible from the easternmost tip of Grand Isle. In the early nineteenth century, Grand Terre was a rendezvous for the pirate brothers Jean and Pierre Lafitte and their smuggling activities.

Plaquemines Parish (PL)

Belle Chasse

Belle Chasse is home to a Naval Air Station Joint Reserve Base, which relocated here in 1957 from its smaller facility on the south shore of Lake Pontchartrain, now the site of the University of New Orleans. Alvin Callender Field, New Orleans's first airport, was incorporated into the base.

West Pointe à la Hache Vicinity

PL1 Woodland Plantation Inn (Woodland)
c. 1855. 21997 Louisiana 23 (2 miles north of West Pointe à la Hache)

From the road, only the rear facade is visible, as this house was oriented toward the river. Front and rear facades are alike; each has a single-story gallery with seven slender wooden piers and a row of five dormer windows in the pitched roof. The front of the house has been immortalized on the label of Southern Comfort, a whiskey created in New Orleans in the 1870s. In May 1871, a drawing of Woodland was published in *Every Saturday* magazine, and that same year, a similar picture, although reversed and with a few added details, was issued as a print by Currier and Ives, titled *A Home on the Mississippi*. This image has been used on the Southern Comfort label since 1934.

The one-and-one-half-story raised house, constructed of cypress, was built by retired river pilot William Bradish Johnson. It was managed by his son George until 1856, then taken over by his other son, Bradish Johnson of New Orleans, who owned it until 1894. Anglo-American features were added to the basically Creole design, but in an unorthodox fashion. For example, the hall extends without interruption from front to rear but is off center, and Greek Revival shoulder moldings ornament French doors. The house has a spiral mahogany staircase in the hall and six bedrooms upstairs. Only the foundations of the sugar mill survive; the brick slave quarters were destroyed by Hurricane Betsy in 1965. A two-story hip-roofed wooden house for the overseer (1855), a late-nineteenth-century tenant cabin, and a brick cistern are next to the house. Woodland was

purchased and restored in the late 1990s by Claire and Jacques Creppel and now serves as an inn. In 1998, the Creppels moved the deconsecrated and deteriorating Gothic Revival St. Patrick Church (1918, with additions) to the site from Port Sulphur, renovating it for use as a restaurant.

Port Sulphur

Port Sulphur was founded by the Freeport Sulphur Company in 1933 to house employees at the company's mine ten miles west at Grande Ecaille. A canal was dug from Grande Ecaille to Port Sulphur, the processing and shipping point, which is still the company's largest sulfur terminal. Approximately 200 houses were built in the new town, along with churches, a hospital, and a school. Following World War II, the company added mines in the Gulf of Mexico, such as the one near Grand Isle (Jefferson Parish). By this time, Port Sulphur had grown beyond its company-owned buildings, so that the town survived even after the Grande Ecaille mine was closed in 1978 and the company townsite dismantled. (Some houses were sold and moved elsewhere.)

Triumph Vicinity

PL2 Fort Jackson
1822–c. 1832. Louisiana 23 (2 miles north of Triumph)

Occupied in 1832 and named to honor Andrew Jackson, this fort, along with another on the east bank of the river (Fort St. Philip, whose few remains are inaccessible), was designed to safeguard the river approaches to New Orleans from the Gulf of Mexico. The forts were singularly ineffectual in this effort; after a five-day bombardment early in the Civil War, they failed to stop the Union fleet, under the command of Admiral David Farragut, from proceeding upriver to New Orleans, which surrendered on April 28, 1862. Fort Jackson was built on the site of Fort Bourbon, a Spanish redoubt of c. 1792 that was destroyed by a hurricane in 1795. Pentagonal, with a large bastion at each corner, the fort has 20-foot-thick brick walls and rises 25 feet above a surrounding moat. According

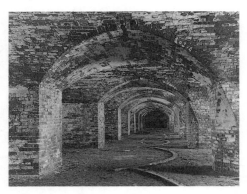

PL2 Fort Jackson

to historian Powell A Casey, several contractors, engineers, and construction superintendents participated in the fort's construction, which was hampered by difficulties in clearing the site, hurricanes and floods, wage disputes, and the unhealthy surroundings. At the time of the Civil War, a large citadel occupied the center of the parade area; it was destroyed during the bombardment, along with the wooden quarters outside the fort. Repairs were made to the fort after the war, and it received additional guns during the Spanish-American War in 1898. In World War I, several units based at Jackson Barracks in New Orleans (OR51) underwent training at Fort Jackson. In 1926, the fort was declared surplus property, and the following year it was purchased by Mr. and Mrs. J. H. Harvey, who donated it to Plaquemines Parish in 1960. The fort was designated a national historic monument and was restored and opened to the public in 1962.

Venice

Venice is the last habitable community on the Mississippi River before land dissolves into water. It cannot be said to resemble its more fa-

mous eponym, nor is it as picturesque, but it does have a distinctive character of its own. Like the Italian Venice, it is laced with and surrounded by water channels. As a base for helicopters transporting workers and supplies to the offshore oil rigs, Venice has that untidy but purposeful and fascinating industrial appearance that characterizes other Louisiana Gulf communities, such as Morgan City and Berwick. Venice is also a popular spot for sport fishing.

Braithwaite Vicinity

PL3 Promised Land

c. 1900, c. 1925. 5907 Louisiana 39 (7 miles south of Braithwaite)

Leander Perez (1891–1969), the political boss of Plaquemines Parish, purchased this two-and-one-half-story wooden house in 1925 and occupied it until the early 1960s. Surrounded by a gallery on two stories, the house has a rear ell kitchen and a central staircase that leads to the principal floor on the second story. The remodeling of the house probably took place when Perez first occupied it. A large dormer containing a sleeping porch was added, and the roof was given red tiles. The gallery's first-floor concrete block piers, which are cast to resemble stone, suggest that the house has been raised. Slender fluted square posts are on the gallery's upper level. Appointed a judge in 1920, Perez then served as district attorney for the judicial district of Plaquemines and St. Bernard parishes from 1924 to 1960, becoming a multimillionaire on a district attorney's salary that never exceeded $7,000. A short distance upriver from Promised Land is Mary Plantation House (c. 1820 and 1840; 5539 Louisiana 39), a two-story, hip-roofed house of brick-between-posts construction on the upper story and a two-story gallery.

St. Bernard Parish (SB)

Chalmette

In the neutral ground of Louisiana 46 (at Montesquieu Street) are several brick piers, the sole remains of Versailles, the sixteen-room plantation house built in 1805 by Pierre Denis de la

Ronde, which was destroyed by fire in 1876. Extending from the ruins toward the river is the allée of oaks planted c. 1821 by de la Ronde. The trees are known as both the de la Ronde Oaks and the Pakenham Oaks, named for British Major General Sir Edward Pakenham,

who was incorrectly said to have died beneath one of the trees after his defeat by Andrew Jackson at the Battle of New Orleans (SB4). De la Ronde had dreamed of creating two cities in this area that would overshadow and absorb New Orleans. The city focused around his plantation would be named Versailles, and the other, beside Lake Borgne, was to be called Paris. The modern highway Paris Road (Louisiana 47) gets its name from the Chemin de Paris, the road planned by De la Ronde to link the two cities. Today near the river end of Paris Road is Our Lady of Prompt Succor Church (2320 Paris Road), designed by James Lamantia for Burk, Le Breton and Lamantia in 1957. The church's gabled facade of colored glass is articulated with mullions, and a multifaceted roof encloses a column-free, amphitheater-like space.

SB1 St. Bernard Parish Courthouse

1939, Weiss, Dreyfous and Seiferth. W. St. Bernard Hwy. and Jackson St.

This PWA-funded courthouse, constructed when the parish seat was transferred from St. Bernard to Chalmette, is an austere Moderne structure, with a central section four stories in height and wider than the slightly recessed three-story wings. Faced with smooth limestone and sparely ornamented, the reinforced concrete structure projects an image of weight and serious purpose—characteristics of this architecture firm's designs. Narrow foliate-patterned carved bands placed to define architectural parts enhance the building's linear qualities. Occupying the full width of the interior central section is a two-story lobby with curved staircases at each end leading to a balcony, a geometrically patterned terrazzo floor, and walls sheathed in gray-veined marble. The principal courtroom has wood paneling and narrow vertical windows with metal mullions on the exterior that are decorated with stylized female representations of Justice, alternating with magnolia flowers.

SB2 Smokestack of the Kaiser Aluminum and Chemical Corporation

1951–1953. 9000 W. St. Bernard Hwy.

This 500-foot-high smokestack towering over Chalmette, visible from miles away, was built for the Kaiser Aluminum Corporation plant, which in its heyday employed up to 2,700 people. The smokestack, 80 feet in diameter at its base and said to be one of the tallest smokestacks in the world, was shut down in the late 1960s for environmental reasons. Kaiser opened this aluminum-producing plant a mere ten months after construction began at the 280-acre site. Completed in 1953, it was the nation's largest aluminum reduction plant (see JM1). Engineer Frank A. Backman, chief of construction for the Kaiser company, who had previously worked on the Hoover Dam, supervised construction of the plant's approximately eighty buildings. Kaiser closed the plant in 1983, and the site is now an industrial park.

SB3 Chalmette National Cemetery, Jean Lafitte National Historical Park

1864, with additions. 8606 W. St. Bernard Hwy.

Occupying a long, narrow site next to Chalmette Battlefield, this cemetery was established in 1864 for Union soldiers who died in Louisiana during the Civil War. It also contains the graves of veterans of the Spanish-American War, World Wars I and II, the Vietnam War, and four Americans who fought in the War of 1812. Many of the 15,000 graves are unidentified, and all are marked by small plain headstones. The cemetery is surrounded by a brick wall, completed in 1873. Chalmette cemetery and battlefield are named for Ignace de Lino de Chalmet (1755–1812), whose plantation lands they now occupy. His house was burned to the ground in 1818 by American troops under Andrew Jackson to prevent the invading British from using it as a base.

SB4 Chalmette Battlefield, Jean Lafitte National Historical Park

1812, with additions. 8600 W. St. Bernard Hwy.

The Battle of New Orleans, which took place here on January 8, 1815, sixteen days after the signing of the Treaty of Ghent on December 24, 1814, was the last engagement of the War of 1812. Under the command of Major General Andrew Jackson, American forces defeated British troops led by Major General Sir Edward Pakenham. The battle took place on a strip of land approximately one-half mile wide and

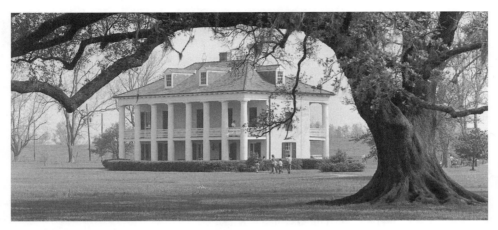

SB4.2 Malus-Beauregard House

lasted less than two hours. British casualties exceeded 2,000, and Pakenham was among those killed; the Americans reported only 71. The British retreat to Lake Borgne on January 18, 1815, marked the end of the Louisiana campaign and preserved America's claim to the territory acquired from France in the Louisiana Purchase. A section of the American earthworks has been restored, and battery positions are identified by artillery displays. Visitors can take a 1.5 mile tour by automobile or on foot that links important sites on the battlefield. A visitor center provides additional information.

SB4.1 Chalmette Monument

1855–1908, Newton Richards

Marking the site of Jackson's position during the battle on January 8, 1815, this 102-foot-high marble obelisk (originally planned to be 200 feet) is modeled after the Washington Monument. Its cornerstone was laid in January 1840, a few days after Andrew Jackson visited the field on the twenty-fifth anniversary of the battle. Construction began in 1855 but was halted at the outbreak of the Civil War, when the obelisk was only 55 feet high. It was completed to the shortened version of the original design in 1908 by the U.S. War Department, one year after the federal government acquired the monument from the state of Louisiana. The obelisk sits on a stepped podium and has Neo-Egyptian entrance porticoes on all four sides; three of them are blind, and one opens to the shaft's interior, where an iron spiral staircase surrounds a brick central support.

SB4.2 Malus-Beauregard House

c. 1833

This two-story house of stucco-covered brick was never part of a plantation. It served as a country residence for a succession of owners, one of whom was Judge René Beauregard, son of Confederate general P. G. T. Beauregard. The house has full-height Doric-columned galleries at front and rear, a hipped roof with six dormers, and three rooms on each floor. The principal entrance was from the river side. The Greek Revival exterior and interior moldings were probably added in the 1850s. The house was restored in 1957, and changes were made to the interior to accommodate exhibits on the Battle of New Orleans.

Arabi

Arabi was laid out on the site of three brickyards and a stockyard, which gave the town its early name, Stock Landing. Bungalows from the 1920s and 1930s predominate. Italian Romanesque architecture inspired William R. Burk's design for the two-story former Arabi Elementary School (1929; 701 Friscoville Avenue; now the Joseph Maumus Center). It has a triple round-arched entrance, and the geometrically patterned brick walls, ranging in color from yellow to brown, are embellished with blind arcades. François B. Le Beau built the magnificent two-story house at Le Beau Avenue and Bienvenue Street (1854), which is now in a deteriorated condition. Constructed of brick, with outer walls covered in wood, the house has

front and rear galleries on square columns, iron railings, and a hipped roof with a tall octagonal cupola.

SB5 Domino Sugar Corporation
(American Sugar Refinery)

1905, with additions. 7417 N. Peters St.

The American Sugar Refinery, which owned refineries in Brooklyn, Jersey City, Boston, and Philadelphia, purchased this tract of land in 1905 and commenced operations in the new plant in 1909. Constructed to plans prepared by the company, the refinery, which was described as one of the largest in the world at the time, included a wharf on the Mississippi River and vast warehouses. Of the many concrete-frame and brick-faced structures in this plant, the fourteen-story filter house is the tallest. Here the liquid sugar solution flows by gravity from storage tanks on the upper floor through filter tanks filled with bone char, which removes impurities and whitens the sugar. Other structures include the twelve-story pan house and nine-story granulator, where the sugar is dried, granulated, and pulverized. A pair of 225-foot-high cylindrical brick smokestacks flank the powerhouse, glorifying it as a twin-towered cathedral of industry. The powerhouse, which originally supplied all the plant's electrical needs, has a facade articulated by an enormous inverted V-shaped vent. Within the refinery's grounds is Cavaroc House (c. 1840), built by the Paul Darcantel family on its brickyard but named for businessman Pierre Charles

SB5 Domino Sugar Corporation (American Sugar Refinery)

Cavaroc, who owned the house from 1860 to 1880. The two-story, stucco-covered brick structure is surrounded by a two-story-gallery on square Doric piers and has a hipped roof with dormers on all four sides.

St. Bernard

SB6 P. G. T. Beauregard Middle School
(St. Bernard Parish Courthouse)

1914–1915, Toledano and Wogan. 1201 Bayou Rd. (Louisiana 300)

This three-story building served as the parish courthouse until completion of the present structure in Chalmette (SB1). The building was converted for use as Beauregard High School for girls and subsequently served as a middle school for both sexes. (St. Bernard Parish schools were sex-segregated until 1987.) It is a handsome Beaux-Arts structure with paired Corinthian columns outlining a loggia in front of the second and third stories. An entablature and balustrade complete the building.

SB7 Los Isleños Museum

19th century. 1357 Bayou Rd.

This museum is one of several buildings on a 22-acre site dedicated to the interpretation and preservation of the Spanish influence in Louisiana, particularly as it relates to the 2,000 or so Canary Islanders who were settled in St. Bernard Parish between 1779 and 1783. All the structures exemplify the parish's early building stock. The museum is a one-and-one-half-story front-galleried wooden building, originally a house, which was altered in the late nineteenth or early twentieth century by the addition of two dormers, a curved side gallery, and gingerbread trim for both new and original galleries. Next to the museum is the former Ducros House (c. 1820), now serving as a branch of the parish library and an exhibition space. This one-and-one-half-story structure has a front gallery with six columns, French doors, and, added at a later date, a shingled front gable with three windows.

Yscloskey

SB8 **Fort Proctor** (Fort Beauregard)

1856. Lake Borgne at the end of Louisiana 46 (visible in the distance)

Fort Proctor is another of the forts (see entries on Fort Pike [OR170] and Fort Jackson [PL2]) in the coastal fortification system authorized by Congress after the War of 1812. The fort was sited on the southern shore of Lake Borgne at a place formerly known as Proctor's Landing. Because it was at that time the terminus of the Mexican Gulf Railway, it was seen as a potential route for an enemy intent on reaching New Orleans. Coastal erosion has now marooned the fort in the lake. The fort was never completed; in 1858, a lack of funds halted construction after only one and one-half of the intended three stories had been built, and two years later, a storm destroyed the nearby town of Proctorville and damaged the fort. The fort's plan was designed by Lieutenant H. G. Wright, and construction is believed to have been supervised by Lieutenant Geoffrey Weitzel under the direction of P. G. T. Beauregard, then an army major. Rectangular in plan, the fort was constructed of brick, with iron girders and beams and granite lintels. The two lower floors were intended to serve principally as living quarters. The one entrance to the fort that was completed has a pediment over the arched doorway that gives it a monumental appearance. After the Civil War, during which the fort played no significant role, it was rendered obsolete by more advanced military technology and a lack of perceived external threats.

On the western shore of Lake Borgne, at the mouth of Bayou Dupre, is the six-sided brick Martello Tower (1841), also built to guard the approaches to New Orleans. Now surrounded by water, it is not visible from land.

Lower River Parishes

MARK TWAIN DESCRIBED HIS JOURNEY BY STEAMBOAT ALONG the lower Mississippi River in *Life on the Mississippi* (1883): "From Baton Rouge to New Orleans, the great sugar plantations border both sides of the river all the way, and stretch their league-wide levels back to the dim forest-walls of bearded cypress in the rear. Plenty of dwellings all the way, on both banks—standing so close together, for long distances, that the broad river lying between the two rows, becomes a sort of spacious street." Today the vista along the 132 miles of river from Baton Rouge to New Orleans is just as memorable as it was in the nineteenth century. Vast grain silos, fields of circular oil-storage tanks, and shiny petrochemical plants have displaced many of the plantations, but their products, transported by water for export throughout the world, make the Mississippi as much a corridor now as it was then. Twain's world still echoes in the surviving allées of ancient oaks that lead inland from the river, although often to no more than the memory of a former plantation house.

Native Americans first inhabited this area, and some of the mounds they built can still be seen, most notably on the Louisiana State University (LSU) campus. The first European settlers, who came in 1720 and 1721, were Germans, mostly from Alsace-Lorraine, who emigrated in response to enthusiastic descriptions of the new land given by John Law and his Company of the Indies. These settlers established small farms in what are present-day St. Charles and St. John the Baptist parishes, an area that became known as La Côte des Allemands (the German Coast). In the 1750s, Acadians expelled from Nova Scotia settled immediately upriver from the Germans in what are now St. James and Ascension parishes, then known as the Acadian coast. They reinforced southern Louisiana's French culture, and, over time, many Germans gallicized their names. After 1803, Anglo-Americans arrived in significant numbers, and some brought their slaves with them. In the early nineteenth

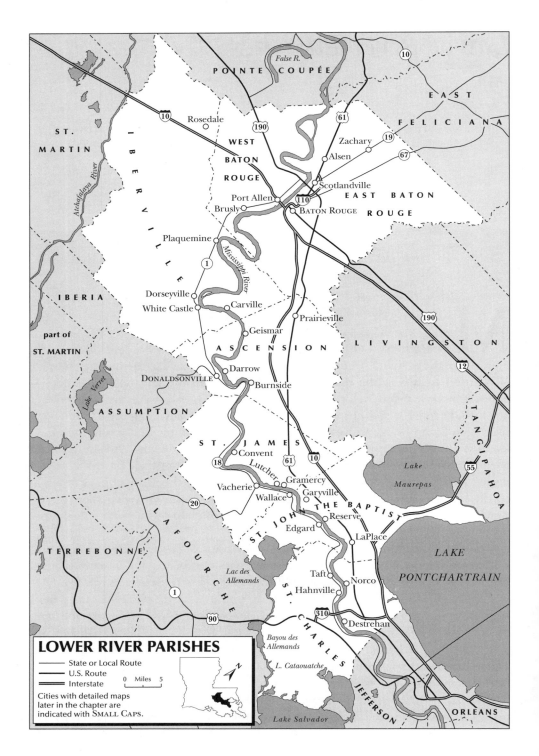

LOWER RIVER PARISHES

— State or Local Route
— U.S. Route
— Interstate

0 Miles 5

Cities with detailed maps
later in the chapter are
indicated with SMALL CAPS.

POINTE COUPÉE

False R.

ST. MARTIN

EAST FELICIANA

WEST BATON ROUGE

Rosedale

Zachary

Alsen

Scotlandville

Port Allen

Brusly

Baton Rouge

EAST BATON ROUGE

IBERVILLE

Mississippi River

Plaquemine

Archafalaya River

IBERIA

Dorseyville

White Castle

Carville

Geismar

Prairieville

LIVINGSTON

part of
ST. MARTIN

ASCENSION

Darrow

DONALDSONVILLE

Burnside

Lake Verret

ASSUMPTION

TANGIPAHOA

ST. JAMES

Convent

Lutcher

Vacherie

Wallace

Gramercy

Garyville

Lake Maurepas

TERREBONNE

LAFOURCHE

ST. JOHN THE BAPTIST

Reserve

Edgard

LaPlace

*Lac des
Allemands*

Taft

Norco

Hahnville

ST. CHARLES

LAKE PONTCHARTRAIN

*Bayou des
Allemands*

L. Cataouatche

Destrehan

JEFFERSON

ORLEANS

Lake Salvador

170

century, wealthy planters consolidated smaller farms into vast landholdings, transformed the hinterland of cypress swamp into fertile fields, and built elegant mansions and houses. The lower Mississippi River became known as the Gold Coast.

Early crops were indigo and perique tobacco, but by the early nineteenth century, sugarcane reigned supreme. A description of the Mississippi in 1803, by France's colonial prefect in Louisiana, Pierre Clément de Laussat, painted a far less idyllic picture than that offered by Twain some eighty years later: "We proceeded downstream from sugar mill to sugar mill. It was really interesting and picturesque to see so many furnaces, one after the other, belching clouds of curling black smoke that were ablaze at times. This spectacle entertained us as we came down the river and provided the milestones by which we gauged our progress" (*Memoirs of My Life*, 1831). Industrialization of the lower Mississippi is thus not just a twentieth-century phenomenon. Although reduced in number after the Civil War, these sugar mills grew substantially larger when the manufacturing process was consolidated into a few factories. In some cases, new towns developed around the mills, such as Reserve for the Godchaux Sugar Company and Gramercy for Colonial Sugars. Among surviving sugar mills are Cora Texas Manufacturing, Inc.(Iberville Parish, west bank), the Evan Hall Sugar Cooperative (Ascension, west bank), and Cinclare Sugar Mill (West Baton Rouge).

Although cypress was cut and exported to the Caribbean islands as early as the 1720s, the lumber industry did not become a major force until the late nineteenth century, and by the 1930s it had declined. Some mills were so large that new communities were built by the companies to house their labor force; among these were Lutcher (St. James Parish), built by the Lutcher and Moore Cypress Lumber Company, and Garyville (St. John the Baptist Parish), by the Lyon Cypress Lumber Company. The railroad accelerated industrial growth, as did maintenance of a deepwater channel that allowed oceangoing vessels to travel as far as Baton Rouge.

In the twentieth century, grain elevators were established on the river's east bank, where grain harvested in the Midwest was received and loaded onto ships. The Zen Noh Grain Corporation elevator (St. James Parish) is particularly striking. Finally, petroleum, chemical, and fertilizer plants arrived, using water from the Mississippi to make steam to drive turbine engines and cool products after processing. These industrial companies located first along the east bank: among them Dupont (St. John the Baptist Parish), with its golf-ball-shaped storage units, and Norco Refining/Motiva Enterprises (St. Charles Parish), bristling with pipes and tubes. Beginning in the 1950s, they built plants on the west bank, for example, IMC Agrico Faustina (St. James Parish), noisily making phosphates and fertilizers in huge sheds with ventilators, and Dow Chemical Company (Iberville Parish), which began production in 1958, the largest petrochemical complex in the state. Between 1945 and 1961, 150 new industrial plants were established along the river between Baton Rouge and Port Sulphur below New Orleans. Together these diverse industrial complexes create a spectacular skyline.

Other than the state capital of Baton Rouge, most of the communities and towns

Landscape beside the Mississippi River, St. Charles Parish, 1999

in these parishes are small and rural in ambience. House types range from nine-teenth-century Creole cottages and shotgun houses to early-twentieth-century company-town housing and modern pastiches of regional types in the new subdivisions spreading out from Baton Rouge. Buildings by some of the nation's best nine-teenth-century architects can be found here: James Dakin's Old State Capitol in Baton Rouge, plantation houses (Nottoway and Indian Camp at Carville) by Henry Howard, and Ascension Parish Courthouse by James Freret. The twentieth century produced some fine buildings, among them the Louisiana State University campus by Theodore Link and the new state capitol by Weiss, Dreyfous and Seiferth. Henry Hobson Richardson was born in St. James Parish in 1838, but his architectural career commenced when he relocated to Boston; the sole Louisiana building from his office is in New Orleans (OR99).

This region consists of seven parishes. East Baton Rouge and West Baton Rouge, on either side of the river, have the name of the state capital. Iberville was named for the explorer Pierre Le Moyne, Sieur d'Iberville. St. Charles, St. John the Baptist, St. James, and Ascension parishes were church parishes before becoming governmental units. Occupying almost half of the 250,000 acres of St. John the Baptist Parish are Lake Pontchartrain, named for Jérôme P. de Pontchartrain, minister of the navy and colonies for France, and Lake Maurepas, named for his son Jean Frédéric-Philippe, Comte de Maurepas.

Because most of the parishes in this region of Louisiana straddle the Mississippi and bridge crossings are few, the sequence for the following entries proceeds up-river on the east bank of the river to Baton Rouge and then downriver on the west bank.

St. Charles Parish, East Bank (going north)
(CH1–CH5)

Destrehan

CH1 Bunge Grain Elevator

Date unkown. 12442 River Rd. (Louisiana 48)

This grain elevator's rectangular tower is a landmark along the lower Mississippi. Grain from America's Midwest is first stored in the row of concrete silos behind the tower, then moved to the waiting ships via covered conveyer belts that span the highway and levee. The loading spouts, approximately 120 feet high, reach out 100 feet from the dock face. Bunge chose this site for its grain elevator, as did Archer Daniels Midland (ADM), located next to it at 12710 River Road, because of the availability of barge, rail, and truck transportation and the deepwater channel in the Mississippi that accommodates oceangoing ships. A spectacular geometry is created by the undulating forms of the tall concrete silos, the three cylindrical storage containers with conical roofs, and the angular elevator tower and conveyer shafts. Driving along the highway underneath the conveyer shafts is akin to passing through a series of triumphal arches. The elevator acquires a particularly magical aspect when ships are being loaded and a fine dust of grain permeates the air. The nearby Archer Daniels Midland elevator (1963) has a longer row of silos than Bunge's, but its composition is not quite as visually satisfying. ADM'S elevator is 247 feet high, and the concrete silos are 133 feet high.

CH2 Destrehan Plantation

1787–1790. c. 1820, side wings. 1840s, columns and gallery. 13034 River Rd. (Louisiana 48)

In January 1787, indigo planter Robert Antoine Robin de Logny signed a contract with free man of color Charles (whose last name may have been Paquet), a carpenter, woodworker, and mason, for the construction of his house. The contract specified a building 60 feet in length, 35 feet in width, raised 10 feet on brick piers, a surrounding gallery 12 feet in depth, and three dormers above the principal doors on the front and one dormer at the rear. For payment, Charles received a slave, a cow and her calf, fifty quarts each of rice on chaff and corn in husks, and 100 piastres. The house was

CH1 Bunge Grain Elevator

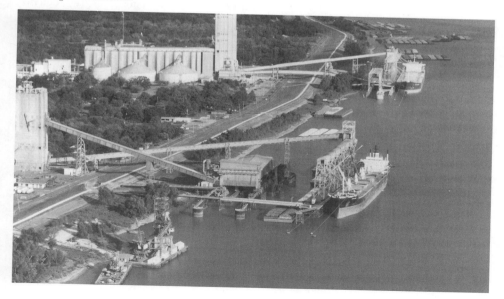

built with a pegged cypress frame and *bousillage* infill, a double-pitched roof with Norman trusses, and an upper gallery supported on slender wooden columns. In plan and exterior appearance, the structure was similar to Home Place (CH7).

At de Logny's death in 1792, an inventory of the estate recorded a house, a kitchen, a storehouse, two old hospitals, a *pigeonnier,* a coach house, nineteen slave cabins, nine pairs of vats for indigo processing, various sheds, and fences. In 1802, de Logny's daughter Marie-Claude Celeste Robin de Logny and her husband, Jean-Noël, acquired the plantation. Sometime before d'Estréhan's death in 1823, two-story wings were added to each side of the house. Along with other planters at this time, the d'Estréhans turned from indigo to sugarcane production. It was during the d'Estréhans' ownership that the plantation was involved in one of the largest slave revolts in American history. In 1811, about five hundred slaves, led by slave Charles Deslondes, marched from a plantation near present-day LaPlace (St. John the Baptist Parish) to Kenner (Jefferson Parish), and several slaves from Destrehan joined them. More than sixty slaves were killed during the uprising, and approximately seventy-five others faced tribunals, one of which took place at Destrehan. Jean-Noël d'Estréhan served as a member of the tribunal.

When the d'Eestréhans' daughter Louise and her husband, Pierre Rost, acquired the plantation in 1838, they refashioned the house in the latest Greek Revival style. They encased the gallery supports in double-height columns of plastered brick, remodeled the cornice, enclosed the rear gallery, moved the stairs from the outer corners of the rear gallery to its center, and added Greek Revival trim to the doors and windows. The plan of six rooms on the upper floor was left largely unaltered; the principal change was the conversion of the two center rooms into a double parlor with pocket doors instead of a wall. On the exterior of the house, light yellow stuccoed walls scored to resemble stone, dark green shutters, and red-painted gallery rails replicate the mid-nineteenth-century color scheme.

For two years during the Civil War, Destrehan served as a headquarters for the Freedmen's Bureau, where ex-slaves were housed and taught a trade. After the war, Destrehan passed through several ownerships, from the Rosts to Mexican Petroleum Company in 1914, to the American Oil Company (Amoco) in 1958, who

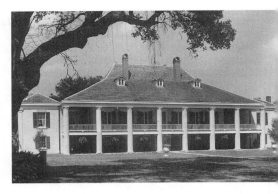

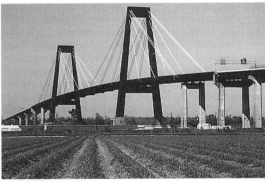

CH2 Destrehan Plantation

CH3 Hale Boggs Bridge (Luling Bridge)

donated it to the River Road Historical Society in 1971. The society restored the badly deteriorated house under the direction of architect Eugene Cizek. As part of the restoration two cisterns were reproduced, one to house an elevator that provides wheelchair access to the upper floor of the house. Of the plantation's dependency buildings, only one hip-roofed structure of unknown purpose survives. In 1997, an immense elevated mule barn, 162 feet by 35 feet, constructed in the 1830s of pegged timber, was moved from Glendale Plantation and rebuilt at Destrehan. Destrehan is open to the public.

CH3 **Hale Boggs Bridge** (Luling Bridge)

1975–1983. Modjeski and Masters and Frankland and Lienhard. I-310

The sleek form of this bridge derives from its cable-stayed design; the cables supporting the span are directly connected from the road to the pylons, eliminating the clutter of supports

found in most bridges. Cable-stayed bridges were developed in Europe following World War II to replace the many destroyed bridges. This was the third cable-stayed bridge built in the United States, and the structure works particularly well in soft soil conditions such as exist here. With a center span of 1,225 feet, the bridge soars over the river, conveying both lightness and strength through the two dark brown steel pylons, battered like Egyptian gateways, and the taut lines of the diagonal cables. A magnificent view of the bridge is provided to drivers approaching it from the north on I-310, where its deck appears to delineate a second horizon over the cypress swamps.

Norco

In 1916, the New Orleans Refining Company (Norco) purchased 366 acres of cane fields from Good Hope Plantation to build a crude-oil receiving dock and refinery. As the nearest railroad stop was at the adjacent small community of Sellars, the company posted a sign at the station indicating that this was the place to alight for Norco; inevitably, Sellars's name was changed to Norco. After Shell Petroleum Corporation (later Company) acquired the refinery in 1929, it built housing for workers, along with the amenities common to company towns.

CH4 Norco Refining/Motiva Enterprises
(Shell Petroleum Company)

1920–present. 15536 River Rd. (Louisiana 48)

The refinery began operations in 1920, and by the end of the decade, the site had two small cracking units and three stabilizers and was manufacturing such byproducts as asphalt and kerosene. Crude oil and supplies were received via the Mississippi River. In 1992, the company added a 240-foot-high catalytic cracker, a unit that helps produce gasoline by "cracking" large T crude-oil molecules into small ones by means of heat and zeolite. Like similar plants, this complex prohibits close public access. From a distance, it looks like a random collection of cylinders, tanks, and domes encased in a tangle of pipes and embellished by steam and flames erupting from tall narrow chimneys. All of this is accompanied by incessant humming and whirring sounds. In fact, within the complex all the units are rationally organized on a grid of streets to allow products of one unit to pass efficiently to another for additional processing, to facilitate maintenance, and to prevent the spread of fire or explosions. The complex stretches approximately two miles back from the river, crossing U.S. 61, at which point another panorama of glistening metal and geometric shapes is revealed. At the main entrance on River Road, the company has laid out a landscape of trees and flowers in Shell's colors—yellow, orange, and red—which reinforces the image of the machine in the garden.

A short distance beyond the entrance gates is a two-story Art Deco brick structure, built in 1929 by the New Orleans architecture firm of Weiss, Dreyfous and Seiferth, which accommodated Shell's administrative offices on the first floor and, on the second floor, a ballroom, billiard room, library, and soda counter for the workers who lived in company housing. The lamella truss roof of the upper floor provided a clear and flexible space. On the exterior, the fluted pilasters separating the windows are topped by cast concrete capitals decorated with stylized shells (for the Shell Company) adorned with tendrils, and the parapet has shell-shaped anthemia. The building, which is not visible from the road, is adjacent to the museum that Shell opened in 1998, containing displays on the history of the plant and the company's oil business in the South, and is also close to the gift shop opened in 2000. In 1998, Shell merged some of its refining assets with other companies and became part of Motiva Enterprises.

Norco Vicinity

CH5 Bonnet Carré Spillway

1929–1936. Army Corps of Engineers. River Rd. (Louisiana 48)

The Bonnet Carré Spillway protects New Orleans from Mississippi River floods by providing a passage for excess water from the river into Lake Pontchartrain. The spillway is one of the flood control structures along the lower Mississippi authorized by the Flood Control Act of 1928 and maintained by the Army Corps of Engineers. Other structures in Louisiana include the Morganza Spillway (PC12) and Old River Control (CO3). This site was chosen for the dam and spillway because four major crevasses developed here between 1849 and 1882, indicating that it was a weak point in the levee. The Bonnet Carré dam consists of 350 bays, each 20

feet wide, set between reinforced concrete piers and closed by vertical timbers that can be raised as necessary. The bays can be opened singly or in combination. Guide levees to contain the water within the spillway are spaced 7,700 feet apart at the river, gradually widening to 12,400 feet at the lake for a total length of 5.7 miles. The vast width of this spillway illustrates the force and power of the Mississippi River, dramatizing the fact that the river is higher than the spillway. The spillway has been utilized eight times between 1937 and 1997. A railroad and a highway (U.S. 61) on the lake side of the dam were completed in 1936. The spillway project cost just over $14 million.

On the downriver side of the spillway is the Shell Chemical Company (16122 River Road), which began operations in 1955, manufacturing chemicals and feedstock from the byproducts of gases produced at Norco (CH4). At sunset the vista is spectacular from the top of the levee that separates the spillway from the chemical plant. Downriver is the glistening industrial complex, with its twinkling lights and continuous low humming sound; across the river the towers and pipes of other chemical plants spike the sky; upriver the red sky blazes over the spillway's broad, flat expanse of grass, and the Mississippi River's gleaming sunset-tinted surface is broken only by huge silent ships at anchor.

St. John the Baptist Parish, East Bank (going north) (JO1–JO5)

LaPlace

LaPlace developed from a small community known as Bonnet Carré, which was named for the right-angle turn of the Mississippi River at this location. The name was changed to LaPlace in honor of French immigrant Basile La Place, who in 1879 built a station and granted a right-of-way across his land to the New Orleans and Baton Rouge Railroad. The railroad, soon taken over by the Yazoo and Mississippi and later by the Illinois Central, made commercial stops for local truck farms. By the 1930s, when the main highway from New Orleans to Baton Rouge and points farther west passed through LaPlace, various commercial establishments catering to motorists were established along the road.

JO1 Airline Motors Restaurant

1948. 221 E. Airline Dr. (U.S. 61)

In 1937, H. C. Cothan and Alvin Woods opened a car dealership on this site and two years later added a car repair shop, a filling station, and a small café. In 1948, the partners stopped selling cars and remodeled the restaurant to take advantage of increased traffic. A deep, metal-edged canopy extends across the width of the facade to shelter customers and to carry a tall vertical sign prominent enough to be seen by approaching motorists. The restaurant's heyday was in the 1950s and 1960s before I-10 re-

placed Airline Drive as the main route between New Orleans and Baton Rouge.

To the left of the restaurant (207 E. Airline Drive) was another favorite eatery, Roussel's (now a commercial building), built in 1935 and expanded in 1956. Its Art Deco facade has rounded corners filled with glass block, and although the vertical sign is new, its placement and size are sympathetic to the original. In the opposite direction is a Frostop drive-in restaurant (411 E. Airline Drive), which still has its original angled canopy over the drive-in spaces and a sign in the form of a giant rotating root-beer mug, the company logo.

Reserve Vicinity

JO2 Globalplex Intermodal Terminal

Date unknown. Louisiana 44

Owned by the Port of South Louisiana, the 205-acre maritime industrial park provides handling and storage for bulk and containerized cargoes from around the world and for materials to be used in manufacturing. The general cargo dock, 204 feet wide and 660 feet long, includes two Manitowoc rail-mounted gantry cranes, and the bulk cargo dock, 44 feet by 570 feet, has a Manitowoc swing crane. The terminal is served by the Illinois Central/Canadian National and the Kansas City Southern railroads. An extensive covered conveyer system al-

JO1 Airline Motors Restaurant

lows cargo to be moved to open or covered warehouses from ship or barge or to truck or rail. Cargo handled by the facility includes cement, mineral ores, and wood chips. Two cement-storage domes, with a capacity of 50,000 tons, are among the largest in the world; their smooth, mountainous forms are especially impressive. Because of the soft soil conditions at the site, these concrete domes rest on a 30-inch-thick reinforced concrete mat supported by prestressed concrete piles that are 110 feet deep.

The complex includes the site and surviving buildings of the former Godchaux-Hennessey Sugar Refinery, which closed in 1985 and was acquired by the port in 1992. Some of the former refinery structures can be seen at the rear of the complex adjacent to the rail lines. Within the Globalplex grounds and facing River Road is the two-story Colonial Revival house (c. 1911) formerly belonging to the Godchaux family, which has been renamed the Guesthouse and is used by Globalplex for business meetings and special events.

JO3 San Francisco Plantation

c. 1853–1860. River Rd. (Louisiana 44)

Edmond Bozonier Marmillion bought this plantation land from Elisée Rillieux, a free man of color, in 1830 and probably began construction of his house shortly after the crevasse of 1852, completing it in 1856, the year he died. One of his sons, Antoine Valsin Marmillion, took over management of the plantation and with his wife, German-born Louise von Seybold, gave the house its interior decoration. They named the plantation St. Frus-

quin—not a real saint but a play on *sans frus-cins*, meaning "without a cent" or "having lost everything," possibly alluding to the high cost of the house. When Achille D. Bougère purchased the plantation in 1879, he renamed it San Francisco.

The first floor is constructed of brick, and the second floor of brick between posts. A wide double flight of stairs leads to the principal living spaces on the second floor. The symmetrical placement of the stairs and the central entrance suggest that the house has an American central-hall plan, but that is not the case, for the entrance leads to rooms that connect en suite. Edmond Marmillion chose a room layout that was conventionally Creole, but which, by that time, was considered out of date for Creoles. Moreover, he followed Creole tradition by using the ground floor for dining and service rooms and the upper for the principal living spaces. In contrast to this conventional solution (but one that was practical, for it suited the climate), the exterior displayed the latest in American picturesque taste: a gallery with fluted Corinthian capitals and Tudor arches, a decorative balustrade screening the band of louvered windows that ventilate the attic, an overscaled projecting and bracketed cornice, ogee-arched dormer windows, and a widow's walk raised above a row of ogee-shaped windows. The exterior is gaudily painted in blue, peach, and pistachio. Creole families favored colorfully painted houses, in contrast to the Anglo-American preference for white or pastel colors. San Francisco's flamboyant silhouette, decoration, and color have caused it to be described as Steamboat Gothic. Cisterns with reconstructed onion-domed copper covers stand on each side of the house; water was pumped from them to a tank in the attic, which led to sinks through a system of lead pipes.

Antoine and Louise Marmillion, rather than Edmond, were probably responsible for the delicate renderings of flowers, garlands, birds, and putti painted on ceilings in five of the rooms; the striking Pompeiian decoration of some doors (attributed by some to Dominique Canova, although without documented evidence); the false wood patterns on doors and trim; and false marbling on the mantels. Some of this work is original to the house, and some has been repainted, based on the evidence of fragments discovered during the restoration in the 1970s under architect Henry W. Krotzer, Jr. No buildings survive from the plantation's wealthy years before the Civil War, but Antoine

Valsin Marmillion was known for severe treatment of his slaves.

Marathon Oil purchased the plantation in 1976 and funded the restoration project. San Francisco now sits incongruously next to oil-industry structures (Marathon's storage tanks downriver from the house are painted a pastel shade of green). It is also bereft of its former gardens, which were lost to several levee setbacks. The nineteenth-century sugar mill was dismantled in 1976 and sold to a corporation in Panama. The house is open for tours.

Garyville Vicinity

JO4 Emilie Plantation House

1882. 2858 River Rd. (Louisiana 44)

Cyprien Chauff commissioned this attractive raised five-bay house in 1882, naming it for his daughter. In both plan and structure, Emilie is an interesting mix of local and, for its time, old-fashioned forms. The brick-between-posts construction, a plan that is two rooms wide with rear cabinets and loggia, and a Greek Revival gallery were all familiar pre–Civil War elements in Louisiana. The decorative features, however, are of the late nineteenth century, among them the six corner fireplaces, square gallery supports with stepped capitals, and an Italianate balustrade. The architect showed a firm commitment to exterior symmetry with centrally placed stairs and entrance (although the entrance opens into a room, not a central hall) and a square cupola flanked by identical chimneys at the summit of the steep pyramidal roof. A board-and-batten structure behind the house was moved here from San Francisco Plantation in the 1980s.

Garyville

In 1903, the Lyon Lumber Company of Illinois purchased the former Glencoe sugar plantation and many acres of cypress swamp and established the Lyon Cypress Lumber Company in St. John the Baptist Parish. New Orleans architect Southron Duval (c. 1862–1916), of Favrot and Duval, was hired to design and lay out the mill town, which was named Garyville after one of the company's directors, John W. Gary. Organizing the buildings on a grid plan, Duval designed the mill, the company head-

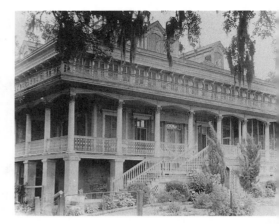

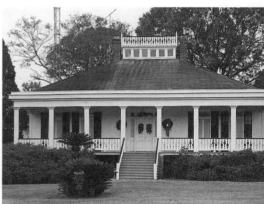

JO3 San Francisco Plantation, 1941 photo by Clarence John Laughlin

JO4 Emilie Plantation House

quarters, two rail depots, four hotels, a bank, a town hall, two churches (Catholic and Presbyterian), a general store, schools, a theater, and housing. As was typical of company towns at this time, the company owned all the housing, and Garyville was segregated; whites and blacks lived on separate sides of town, whites in the blocks focused on West and Main streets and blacks on East Street. The white areas were further subdivided into sectors for Chicago executives, local managers, and workers, with houses ranging in size and elaboration according to the rank of the employee. The commercial district ran along both sides of the railroad track; some of these wooden stores are still in operation along this corridor.

By 1915, the cypress was depleted, so the company purchased extensive pine lands far-

ther north, in Livingston and St. Helena parishes. With a new name, Lyon Lumber Company, it converted the mill to process pine and extended the logging rail line, the Garyville Northern Railroad, thirty-five miles across the swamp to serve the new logging areas. Between 1926 and 1928, two fires destroyed many of the company's storage sheds and millions of feet of dressed lumber. Although the Lyon Lumber Company ceased production here in 1931 and departed for the forests of Oregon, smaller companies continued logging in the area for another thirty years. The company houses were sold to private individuals in the 1940s. All that remain of the 230 original buildings are the Lyon office buildings and some sixty residences, which together have been designated a National Register Historic District.

JO5 Garyville Timbermill Museum (Lyon Cypress Lumber Company Headquarters)

1903, Southron Duval for Favrot and Duval. N. Railroad St. (corner of Main St.)

The large two-story frame building is one of the very few surviving lumber company headquarters from Louisiana's lumber boom of the early twentieth century. Business activities occupied the ground floor, and it is thought that the second floor accommodated visiting officials and managers. Duval gave the building the typical Louisiana double gallery and a hipped roof. The present upper gallery and widow's walk replicate the originals, which were blown away by Hurricane Betsy in 1965. The large sign across the front of the gallery imitates in size an original sign that identified the building as the Lyon Cypress Lumber Company.

St. James Parish, East Bank *(going north)* (JM1–JM5)

Gramercy Vicinity

JM1 Kaiser Aluminum Corporation

1958, with additions. Louisiana 44 (at the parish line)

This alumina refinery presents an extraordinary panorama of vast red-dusted processing and storage structures. The plant processes bauxite ore, a white powdery material, into red alumina, the key ingredient in the production of aluminum. The bauxite is shipped from mines in Jamaica and unloaded at Kaiser's riverside dock. It is stored in an enormous rectangular structure, 800 feet in length and 80 feet high, until conveyed to the digesters, where the bauxite is heated with steam under pressure to extract the alumina. Originally, Kaiser's alumina was transported to its aluminum plant in Chalmette (St. Bernard Parish), but since the closing of that plant, alumina extracted here has been sold to other companies. An explosion in 1999 severely damaged one quarter of the plant, including the digesters, and injured twenty-nine workers. Kaiser rebuilt the plant and reopened in 2001.

Formerly, Kaiser's operations at this site included an industrial chemical plant (Kaiser Aluminum and Chemicals), which the company built in 1958. When Kaiser withdrew from industrial chemical operations in 1988, La-Roche Industries Inc. (formed in 1986) purchased this complex. It is one of LaRoche's largest plants and manufactures chlorine and caustic soda (sodium hydroxide), which is used in the manufacture of pulp, paper, and textiles and in water treatment.

Gramercy

Gramercy was the company town for the Gramercy Sugar Company, founded in 1895 by New York investors associated with the Yazoo and Mississippi Valley Railroad. In an effort to increase profits by filling the railroad's boxcars for the journey north after carrying goods to Louisiana, the company took advantage of the changeover in the sugar industry from small local plants to large corporate refineries. The company's name came from Gramercy Park in New York, where two of its directors had homes. The company town included schools, a church, a store, recreation facilities, a jail, and housing, mostly built between 1895 and 1920. Although the surviving historic structures are enclosed within the fenced property of Colonial Sugars, some are visible from S. Millet Street. Among them is a row of early-twentieth-century two-story frame houses for high-ranking employees, which face a tree-lined company park. At S. Millet Street and the railroad

tracks is a brick chapel, which was purchased from the Woodmen of the World and remodeled for religious use c. 1920. Built c. 1910, the two-story Gothic Revival structure originally housed a space for worship on the ground floor and a meeting hall for the Knights of Columbus on the second. The chapel is now used for storage, only its exterior retaining any semblance of its former appearance.

JM2 Colonial Sugars Company (Gramercy Sugar Company)

1895–present. 1230 S. 5th Ave.

Laid out beside the Illinois Central rail line, the Gramercy Sugar Company began operations in 1895 with a mill converting sugarcane into raw brown sugar. In 1902, a refinery to make granulated sugar was added. Among the many historic buildings in this large complex, the most significant is a nine-story brick char house, built in 1902 by George Newhall, which contains twenty-seven char filtering chambers, each 20 feet high, to remove impurities and color from the brown liquid sugar. This structure has segmental and round-arched windows and cast iron interior columns. The boiler house (1909, with additions) is a three-story steel-frame structure sheathed in corrugated tin; its boilers date from 1950 or later. A tapering 211-foot-high reinforced concrete smokestack (1927) is decorated at its summit in imitation of an Egyptian column.

In 1902, a newly formed company, Colonial Sugars, acquired the factory and renamed it. Since then, it has been controlled or owned by several corporations, including, from 1908 to 1971, the Cuban-American Sugar Company. The company discontinued the milling operation in 1914 to concentrate on refining.

JM2.1 Colonial Sugars Company Powerhouse

1929, McKim, Mead and White

The most remarkable of the refinery's buildings is the powerhouse. The three-story Beaux-Arts brick structure has a rusticated base, Doric pilasters separating the large windows, and gable ends outlined to resemble a pediment. The sophisticated design by the well-known New York firm reflects the widespread desire at that time to celebrate the benefits of industrialization through architect-designed monumen-

JM2.1 Colonial Sugars Company (Gramercy Sugar Company) powerhouse, elevation

tal structures. Three steam turbine generators, the oldest dating from 1930, provided the refinery's electric power. A fourth generator and addition date from 1968. The powerhouse is visible from the company's entrance on E. Main Street.

Lutcher

Lutcher grew after Henry J. Lutcher and G. Bedell Moore established the Lutcher and Moore Cypress Lumber Company in 1891. When the company's landholdings expanded to 60,000 acres, Lutcher and Moore claimed they had the second largest cypress mill in the world. After the company closed in 1930, the sawmill was dismantled. Very little survives other than the company's former headquarters, a single-story frame structure with a gable roof and gallery (2049 Railroad Street). The St. James Historical Society Culture and Heritage Center is located in an old pharmacy (1988 E. Jefferson Highway, at the corner of Louisiana 44 and Louisiana 3193), and adjacent to it are several small historic vernacular structures brought to the site.

Convent Vicinity

JM3 Manresa House of Retreats (College of Jefferson)

1836, with many additions. 5858 River Rd. (Louisiana 44)

The Manresa House of Retreats, a Jesuit retreat house for laymen, occupies the buildings and

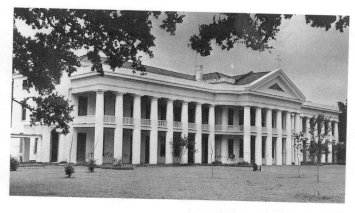

JM3 Manresa House of Retreats (College of Jefferson), main building (above) and chapel (right)

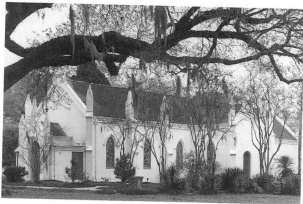

grounds of the former College of Jefferson, founded in 1831 by a group of wealthy Louisianians of French ancestry for the education of their children. When Governor André Roman signed legislation incorporating the college, he described it as "an institution . . . where our children will find the means of completing their course of studies without leaving their native land" to study in schools from which they were likely to "return completely strangers to our manners, to our customs, and above all to our climate." Construction of the school was financed by private subscription, although the state legislature later provided some subsidies. The first buildings were completed in 1833, classes began in 1834, and a year later sixty-two students were enrolled. Classes were given in French and English on alternate days. In 1842, a fire destroyed almost all the buildings, and although they were rebuilt immediately, the college never fully recovered and was sold in 1848. Professor Louis Dufau purchased the college in 1853, reorganizing it as the Louisiana College.

After it failed, planter Valcour Aimé purchased the site in 1859, perhaps building the Gothic Revival chapel in memory of his children at that time, or possibly in 1865, the year after he donated the college to the Marists (Society of Mary). They renamed it St. Mary's Jefferson College and operated it until 1927; in 1931, they sold to the Jesuits (Society of Jesus), who opened the retreat house.

Two small templelike gatehouses with Doric porticoes mark the entrance to the complex. Built in 1836, they are two of the three structures that survived the fire of 1842; the two-story Greek Revival president's house is the other. According to architect and historian Samuel Wilson, it is possible that Joseph Pilié, a New Orleans architect and surveyor, designed these buildings, given that he probably was responsible for Oak Alley (JM6), then under construction on the other side of the river. Jefferson College's main building, the great colonnaded structure that faces the road, was erected after the fire and probably completed in 1843. The

facade is composed of twenty-two giant columns, a projecting pedimented portico-like center section, and a second-floor gallery. Although the building appears to have only two stories, a third story is concealed behind the massive entablature and parapet. No record has been found of the architect who designed it, but Samuel Wilson noted that the curved connections between the central portico and the flanking colonnades are similar to those in the work of James Gallier, Sr. Wilson also suggested that James Gallier, Jr., may have designed the Gothic Revival chapel, which he dated to 1865, based on its similarities with some Gallier drawings for an unidentified chapel. This picturesque little structure has tall pinnacles on its portico and side buttresses. Both the Marists and the Jesuits added buildings to the complex during the twentieth century.

Convent

Convent took its name from the Convent of the Sacred Heart, a girls' school established in 1825 by the Sisters of the Sacred Heart and which functioned until 1926. The town of Convent replaced the west bank town of St. James as parish seat in 1868 after residents of the more populated east bank objected to crossing the river to conduct legal business.

JM4 St. Michael's Church

c. 1875. 6480 River Rd. (Louisiana 44)

When members of the Society of Mary (the Marists), a Roman Catholic missionary order founded in France in the early nineteenth century, assumed ownership of the church of St. Michael in 1863, they established the first Marist parish in the United States. The Marists altered and enlarged the church, originally built in 1833, constructing the aisled cruciform basilica it is today. At first glance the church appears to be Gothic Revival in style, with a tall, square pinnacled tower in the center of the facade (an octagonal spire was lost to Hurricane Betsy in 1965) and stepped buttresses. However, all the openings are finished with Romanesque round arches, as are the elongated blind decorative arches of the gable and the many buttresses. Statues of St. Michael and Joan of Arc are set within niches on the upper part of the facade. Inside the church, the nave arcades are carried on clustered columns with

elongated capitals in various foliate designs, and foliate pendants are suspended from the center of each of the arcade's arches. Ceiling fans are now attached to the ends of these pendants. An open truss roof and stained glass windows from Germany add to the interior's animated appearance. The organ, built by Henry Erben of New York in 1857, was installed in the church in 1858 and enclosed in a pine case in the Greek Revival style. A carved wooden altar imported from the Paris World's Fair of 1889 is set within a semicircular arched screen, behind which is the Grotto of Our Lady of Lourdes. Florian Dicharry and Christophe Colomb, Jr., constructed this grotto in 1876 from bagasse clinkers (rocklike chunks of dried and charred waste from the sugarcane) and thousands of seashells.

To the left of the church is a two-story brick Greek Revival rectory (c. 1875). A late-nineteenth-century cottage next to the church housed the nuns who taught in the two schools. For many years, St. Michael's sponsored two schools for boys. St. Joseph's School for African American students, founded in 1867 at the Convent of the Sacred Heart in Convent, moved here in 1932. It closed in 1967 after schools were integrated; the school building, a five-bay galleried cottage (1892), was relocated to the rear of The Cabin Restaurant at the intersection of Louisiana 22 and Louisiana 44. The school for white pupils, St. Michael's, was established in 1940 and closed in 1971. In the cemetery behind the church is a cast iron raised tomb (undated), manufactured by Wood, Miltenberger and Co. of New Orleans for W. P. F. Welham. The tomb is enclosed by a cast iron fence.

JM5 Judge Poché Plantation House

c. 1870. 6554 River Rd. (Louisiana 44)

Judge Felix Pierre Poché, Civil War diarist and one of the founders of the American Bar Association, built this one-and-one-half-story raised house of cypress wood in the Renaissance Revival style shortly after the war ended, when he resumed his law practice. The gallery's chamfered posts and flattened arches, paired piers indicating the central entrance and corners of the house, double-pitched roof, oversized central dormer with paired round-arched windows and bull's-eye motifs, and smaller flanking dormers (added in 1927) combine to form a lively exterior. The house has a central-hall

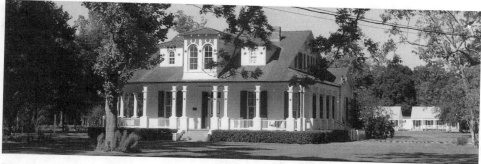

JM5 Judge Poché Plantation House

plan, with a rear staircase set in a side alcove. All but eight panes of glass are original to the house, as are eight mantels, five of cypress, two of marble, and one of cast iron. A servants' quarters adjacent to the house predates it, probably built in either 1839 or 1840; used as the judge's law office, it is now a bed-and-breakfast cottage. Cisterns were placed on each side of the house. In the late twentieth century, two servants' quarters at the back of the house were moved and attached to the main house for use as a kitchen and garage.

Ascension Parish, East Bank (going north) (AN1–AN5)

Burnside Vicinty

AN1 Houmas House

c. 1809, c. 1840. 40136 River Rd. (Louisiana 942)

Despite extensive investigation, the exact chronology and early building history of Houmas remain unknown. What is documented is that Houmas stands on land purchased in 1774 from the Houma Indians; that by 1809 a house existed on the site, perhaps built by William Donaldson and John W. Scott, who then owned the land; and that General Wade Hampton (1752–1835), from South Carolina, acquired the plantation in 1811. It has been generally accepted that the two-story, four-room brick house now attached to the rear of the main house was constructed by Donaldson and Scott, and that John Smith Preston and Caroline Hampton Preston (Wade Hampton's daughter) built the big house when they moved to the plantation in 1840. Since records show that Wade Hampton II (Wade Hampton's son) purchased building supplies in 1830, it has been suggested that the front section of the house and the columns that surround it on three sides should be dated 1830 rather than 1840. However, John Preston's authorship of the design can be argued on the basis of his well-known patronage of the arts and commitment to classical aesthetics, as evidenced in his sponsorship of sculptor Hiram Powers's trip to Italy.

This two-and-one-half-story Greek Revival mansion is constructed of stucco-covered brick and shaded by a monumental Tuscan columned gallery along the front and sides. The hipped roof has Federal arched dormers and a belvedere. The house has a wide central hall and is is three rooms deep, with a spiral staircase set in a rear vestibule. Wide doors connect the dining room and parlor, which have black marble mantels. On each side of the house is a hexagonal two-story brick *garçonnière* (c. 1840) with an ogee-shaped roof, but these are more ornamental than functional, as they measure only 10 feet on each side. A short allée of four live oaks leads to the house; the other trees were destroyed for a setback of the Mississippi River levee.

In 1857, the Prestons sold the house, 12,000 acres, and 550 slaves to John Burnside, an Irish immigrant and New Orleans merchant, for $1 million. Burnside expanded the plantation's acreage, built four sugar mills, and acquired other plantations in Ascension and St. James parishes. By 1862, Burnside was the nation's foremost sugar producer, turning out 5,150 hogsheads of sugar (approximately five million pounds). In 1860, he was recorded as owning

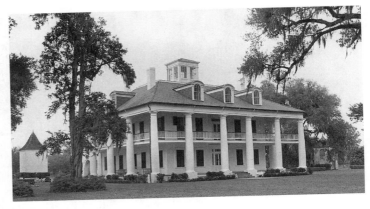

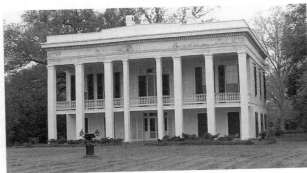

AN1 Houmas House
AN2 Bocage

753 slaves who lived in 192 cabins, although Joseph Menn, in his study of Louisiana's large slaveholders, believes this was the total number of slaves on Burnside's four holdings in Ascension Parish. Burnside was also known for the lavish balls he held at Houmas. During the Civil War, General Benjamin Butler attempted to occupy the plantation house, but the Irish-born Burnside claimed immunity by convincing Butler he was a British subject.

Burnside never married, and at his death in 1881, Houmas passed first to his business associate Oliver Beirne and then through the Beirne family to Colonel William Porcher Miles of South Carolina. Before he acquired the plantation in 1889, Miles had represented that state in the U.S. Congress and served as mayor of Charleston. When his son Dr. William Miles, Jr., inherited the plantation in the early twentieth century, the collapse in sugar prices convinced him to discontinue production. By the time Dr. George Crozat acquired the house in 1940, it had badly deteriorated. With architect Douglass Freret, Crozat restored the main house to its 1840s appearance, demolished two rooms connecting it to the older section, and

replaced it with a breezeway with an arch at each end. He also established a formal garden based on the recently restored garden of the Governors' Palace in Colonial Williamsburg and added or restored the square *pigeonniers* flanking the house. The plantation was featured in the movie *Hush, Hush, Sweet Charlotte,* starring Bette Davis. It is open for tours.

Darrow Vicinity

AN2 **Bocage**

c. 1801. 1840, remodeling, attributed to James Dakin. Louisiana 942

Although Bocage's early history is hazy and there is no architectural evidence to support the claim, local tradition has maintained that the house was built by Emanuel Marius Pons Bringier of L'Hermitage Plantation as a wedding gift for his fourteen-year-old daughter, Françoise (Fanny), and her husband, French-born Christophe Colomb, in 1801, and that the house was remodeled in the Greek Revival style

around 1840 by James Dakin after a fire in 1837. Dakin did work for the Bringier family, receiving payments in 1839 and 1840, but no documentation exists to prove that he designed this house. Nevertheless, Bocage is such a sophisticated and unique interpretation of the Greek Revival style that it argues for the hand of an architect with a refined aesthetic sensibility such as Dakin.

The two-story mansion has a front gallery on double-height plastered brick Tuscan piers that rise to a tall wooden entablature hiding the hipped roof, as at Ashland–Belle Helene (AN4). Two thinner piers, approximately half the width of the others, mark the center of the facade, a distinctive variation on the Greek Revival facade. The upper-floor rear loggia is defined by two piers in antis, a feature used by James Dakin for the Arsenal (OR9). Because of the house's narrow width, the upper story, much taller (16 feet) than the lower, appears to be pushing the building into the ground, but this curious imbalance of proportions achieves a most satisfying aesthetic. Among Bocage's other visual delights are the full entablature with banded architrave and denticulated cornice and the shallow central pediment of the parapet on each of the four elevations. The floor plan includes such traditional French Creole elements as the main living spaces on the second floor, cabinet rooms flanking the rear loggia, French doors, and a rear exterior staircase. Old photographs of the house show a double set of stairs in the center of the facade, but these were removed in a restoration of 1941 and an interior curved stair added. Dakin's remodeling included pocket doors between the center rooms to create a double parlor, and the door frame is decorated with anthemia and paterae, similar to examples shown in Plate 26 of Minard Lafever's pattern book for builders, *Beauties of Modern Architecture* (1835), for which Dakin drew several plates. Other details integrate exterior and interior, as seen in the use of pedimented shoulder moldings over the main entrance, most of the interior doors, and even some fireplaces.

AN3 L'Hermitage Plantation
(The Hermitage)

c. 1816. Louisiana 942

Shortly after his marriage in 1812 to fourteen-year old Louise Aglaé du Bourg from Baltimore, Michel Doradou Bringier built L'Hermitage on land given as a wedding gift by his father, Marius Pons Bringier. Documentary evidence suggests that the house was completed by 1819, when the Bringiers' second child was baptized. Michel Bringier, who had fought with General Andrew Jackson at the Battle of New Orleans in 1815, named his plantation house in honor of Jackson's property in Tennessee.

The twenty-four monumental stuccoed brick Tuscan columns that surround this two-story plantation house give it an impressive exterior, belying its actual size and relatively modest interior. Rooms on the upper, principal floor reach a height of only 10 feet. The first floor is constructed of brick, and the second of brick between posts. Although the house has a symmetrical plan and a central hall, it is typical of Louisiana's early mansions in that the windows and doors on the first floor do not align with those on the second nor with the spacing of the columns. One of the rear rooms on the first floor was used as the plantation's office. It is not known when the columns were added to the house. A date of c. 1840, when owners of similar plantation houses along the river added monumental colonnades, has traditionally been accepted, but an inventory of Bringier's property in 1833 records the house as a "two-story master house with columns all around with a surrounding gallery." If this was an accurate description of the exterior at that time, then L'Hermitage may be one of the earliest of the great columnar mansions. During a renovation undertaken by Robert and Susan Judice after they purchased the house in 1959, it was revealed that the columns are tied into the structural body of the house, thus supporting the earlier date. Although all the plantation's original dependencies and support structures have disappeared, Bringier recorded his possessions at L'Hermitage in 1832 as including two *pigeonniers*, a kitchen, a hospital, ten slave cabins each 30 feet square, a sugarhouse, a smokehouse, four barns, and livestock.

At Michel's death in 1847, his second son, Louis Amédée, became owner of the plantation. In 1881, Duncan Kenner of Ashland–Belle Helene (see next entry), who was married to Bringier's daughter Nanine, purchased a part share of the plantation, acquiring full control from 1884 until his death in 1887. By 1911, the plantation was in the hands of a developer who planned to subdivide the land and build a small town, a project that was never realized. A plan of this project is displayed in the house. After the Judices purchased and restored the house, they

planted an allée of thirty-six oak trees in 1990 to replace the original trees that were removed in 1919 and laid out the formal garden on the downriver side of the house. The house is open to the public.

Geismar Vicinity

AN4 Ashland–Belle Helene

1839–1841. Louisiana 75 (corner of Louisiana 3521)

Perhaps more than any other plantation house, Ashland–Belle Helene epitomizes the popular image of the grand Greek Revival southern mansion. And indeed it has been used to reinforce that myth in numerous movies, including *A Band of Angels* (1957), *The Autobiography of Miss Jane Pittman* (1974), and *The Long, Hot Summer* (1985). Ashland was built for planter, lawyer, and politician Duncan Farrar Kenner and his bride, Anne (Nanine) Bringier, daughter of Michel Doradou Bringier of L'Hermitage Plantation (AN3). Kenner named Ashland after the Kentucky estate of Henry Clay. Although attribution is purely speculative, four different architects have been credited for the design of Ashland: James Gallier, Sr., as was incorrectly stated in early-twentieth-century publications; Henry Howard, on the basis of the staircase; Charles Dakin, who was in the area when he died in 1839, the same year that Kenner married Nanine (according to Bringier family tradition, Michel Doradou Bringier gave each of his daughters a new house when they married); and (the most credible attribution), James Dakin, on the basis of the gallery's square columns and overall austere appearance. Moreover, Bringier's accounts show several payments made to James Dakin between 1839 and 1840, although their purpose is not itemized.

Kenner's Ashland is really a quite simple design: a square box surrounded by twenty-eight 30-foot-high piers supporting a two-story gallery and a simple but massive wooden entablature that hides the pyramid roof. Yet the effect is magnificent in size, scale, proportions, and overall clarity of the design. Exterior brick walls, scored to resemble masonry, are painted their original pastel yellow color, and the brick piers, each 3 feet square, are stuccoed and painted white. Shutters and gallery rails are green. A narrow, continuous row of dentils or-

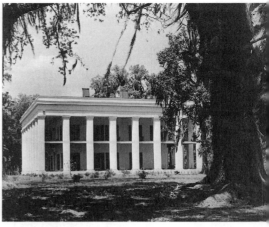

AN4 Ashland–Belle Helene

naments the entablature, and identical bands of dentils are repeated at ceiling height in the interior rooms. This repetition gives the building a unified appearance and dilutes the distinction between exterior and interior space; this effect is most apparent in the first-floor central hall, 12 feet wide, which feels like a boulevard between two buildings. Both floors are bisected by a central hall, with three rooms on each side; in an unusual reversal of height for a Louisiana plantation house, the first-floor rooms, at 14 feet, are taller than those of the second story, which reach 13 ½ feet. Two rooms on the first floor were parlors, and on the opposite side of the hall were a library and a dining room. All second-floor rooms were bedrooms, the walls of which were finished with white plaster and left unpainted. A freestanding spiral staircase is set in a large curved alcove at the rear of the hall.

Not one of the plantation's dependency buildings survives. The 1840 census lists 117 slaves at Ashland; that number had increased to 169 in 1850. By 1860, Kenner owned a total of 473 slaves on three plantations, making him the eighth largest slaveholder in the state. Recent excavations at the house, sponsored by the current owner, Shell Chemical Company, have established that the slaves lived in wooden cabins laid out in two parallel rows located between the big house and the brick sugarhouse. The cabins were placed 32 feet apart; measuring approximately 40 feet by 20 feet, each consisted of two equal-sized rooms separated by a double brick fireplace. The two-room cabin

with front gallery that currently stands to one side of Ashland was built as a prop by a film company in 1974. Foundations of Kenner's brick sugarhouse, an overseer's house, and a blacksmith shop have been unearthed. Kenner bred horses and on his plantation had a course for training his racehorses.

In 1862, Union troops raided Ashland in hopes of capturing Kenner, who was prominent in the Confederate Congress. He escaped on horseback, but troops detained his wife and three children. In early 1865, Confederate President Jefferson Davis sent Kenner to Europe as his ambassador. After the war, Kenner successfully reestablished his plantation, growing both sugarcane and rice until his death in 1887. Sugar planter George B. Reuss, son of Mulberry Grove's John Reuss (AN6), purchased Ashland in 1889 and renamed it Belle Helene for his daughter. In 1911, Reuss began a subdivision and sale of the land, and from that date there was no sustained habitation of the house. The Reuss heirs sold the house in 1992 to Shell Chemical Company, which already owned a petrochemical plant on land behind the house; the company then began the restoration of Ashland–Belle Helene.

Prairieville

AN5 **Robert Penn Warren House**

c. 1905. 16381 Old Jefferson Hwy. (Louisiana 73)

Author Robert Penn Warren purchased this house in 1941 while teaching at Louisiana State University (LSU) in Baton Rouge, although he lived here only until June 1942, when he left to teach at the University of Minnesota. The one-and-one-half-story frame Colonial Revival house is set in a grove of live oaks—one of the features that attracted Warren to the house. It is quite simple, the main feature a Palladian window set in the front gable. Originally the gallery extended only partway along the facade, but after Warren's residency it was extended to continue around one side.

While at LSU, Warren cofounded the *Southern Review*, one of the most distinguished literary publications of the time, and published two novels and two volumes of poetry. His Pulitzer Prize–winning novel, *All the King's Men*, inspired by the career of Louisiana's Governor Huey Long, was published in 1946. Warren was named the nation's poet laureate in 1986.

Iberville Parish, East Bank (going north) (IB1)

Carville Vicinity

IB1 **Gillis W. Long Center, Louisiana National Guard** (Gillis W. Long Hansen's Disease Center; Carville Leprosarium)

1920s, Neill P. Thompson; many additions. 5445 Point Clair Rd. (Louisiana 141)

The nation's first state-operated leprosarium, the Louisiana Leper Home (popularly known as Carville), opened in 1894 at an isolated and abandoned former sugar plantation named Indian Camp. The first seven patients were housed in the former slave cabins. In 1896, four nuns of the Sisters of Charity of St. Vincent de Paul arrived to provide nursing care, establishing themselves in the dilapidated former plantation house (IB1.1). Twelve cottages were completed in 1906 to house the patients, and the plantation house was slowly repaired. In 1921, the U.S. Public Health Service took over

the facility, designated it the national leprosarium, and began an extensive building campaign, adding support buildings, a recreation center, cafeteria, and, in 1934, an infirmary funded by the Public Works Administration (PWA). New buildings to accommodate approximately three hundred patients were organized around two quadrangles in 1939, one on each side of the infirmary. In keeping with the image of the Greek Revival plantation house, the hospital was given a gallery and pedimented portico. Only the Gothic Revival Catholic chapel of 1924 and the Mission Revival Protestant chapel of 1934 deviated from classical forms.

Carville was a research center as well as a hospital and made medical history in 1941 with the introduction of a sulfone drug (Promin) that proved successful in treating Hansen's disease. Another landmark of 1941 was *The Star*, a newspaper started by a patient, which was to become the most widely distributed periodical on Han-

sen's disease. Since leprosy is now extremely rare in the United States and can be treated on an outpatient basis, the government closed the facility in 1999, although a few patients continue to live there. A majority of the buildings are now occupied by the Louisiana National Guard. A museum on the history of Hansen's disease is being planned at the facility.

IB1.1 Indian Camp Plantation House

1858–1859, Howard and Diettel

This former plantation house, now adjacent to the entrance to the complex, was designed for Virginia-born General Robert C. Camp by New Orleans architects Henry Howard and Albert Diettel at the same time Nottoway (IB10) was under construction. Although Indian Camp, like Nottoway, exhibits many unusual decorative features, it does not share Nottoway's innovative plan or three-dimensional qualities. The architects provided the familiar balanced rectangular composition, a second story that is taller than the first, a two-story gallery, and smaller recessed two-story wings that flank the center section, reinforcing the building's symmetry. But Howard and Diettel put all the emphasis on the facade, creating something that has the appearance of a theater backdrop. The gallery has rusticated stucco brick piers at the

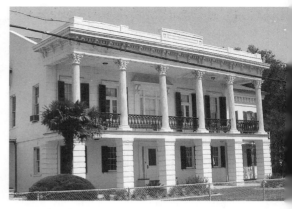

IB1.1 Indian Camp Plantation House

first story, topped by fluted Corinthian columns on the second level carrying abundantly leafed capitals and iron railings. A top-heavy entablature is busily dotted with dentils, modillions that are paired over the columns, a projecting cornice, and a tall parapet that hides the double-pitched roof, all of which give the house a distinct urban character. The walls of the upper story are scored to resemble stone, and the French windows have segmental arches. Located across the river from Nottoway, Indian Camp was adorned by Howard and Diettel with different though equally joyful finery.

East Baton Rouge Parish (EB)

Baton Rouge

Louisiana's capital, Baton Rouge, occupies a bluff on the east bank of the Mississippi River. The site was named by French explorers for the red (blood-stained) stick they saw marking the land between the Houma and Bayagoula nations. The city's origins date back to 1779, when the British built a small star-shaped earthen fort as a defense against the Spanish, naming it Fort New Richmond (or Baton Rouge Redoubt). After the Spanish seized the fort, they renamed it Fort San Carlos. From 1803 to 1810, Baton Rouge was the capital of the Spanish province of West Florida, and as early as 1805, sufficient numbers of Europeans were settling near the fort for a subdivision to be laid out, now known as Spanish Town (EB4). A year later a far more ambitious urban scheme was drawn up for Cap-

tain Elias Beauregard, to develop a new center for Baton Rouge on land he owned. Part of the plan was carried out and is now a neighborhood of Baton Rouge known as Beauregard Town (EB19–EB24). In 1845, Baton Rouge was designated Louisiana's capital. The city thrived in the nineteenth century as a major port and center of commerce, a position enhanced by the arrival of the railroad in the 1880s. The tracks were laid next to and parallel with the river to facilitate the transfer of goods.

In 1909, when the Standard Oil Company (now ExxonMobil) purchased a vast tract of land immediately upriver from the city, Baton Rouge became a center for Louisiana's oil industry. Within ten years the city's population more than doubled. New residential subdivisions were laid out, among them Roseland Terrace (1911); Drehr Place (1921), developed by

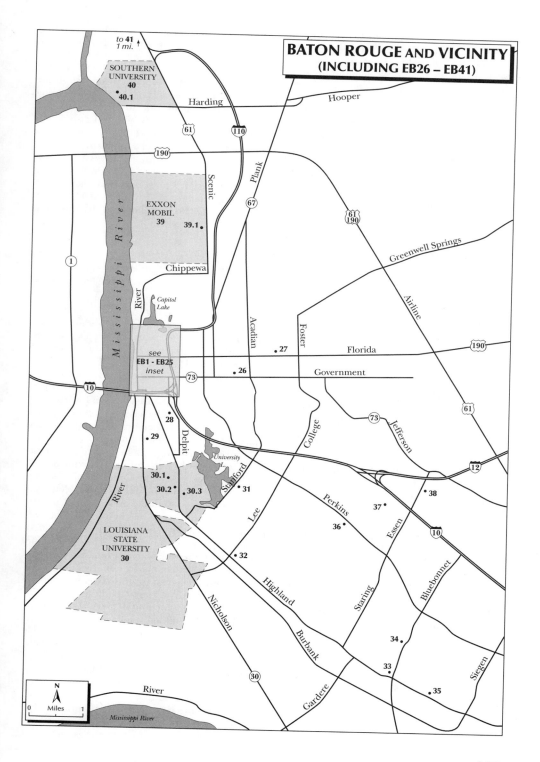

BATON ROUGE AND VICINITY
(INCLUDING EB26 – EB41)

to 41
1 mi.

SOUTHERN
UNIVERSITY
40
• 40.1

Harding

Hooper

61

110

190

Scenic

Plank

67

61
190

EXXON
MOBIL
39
• 39.1

Greenwell Springs

1

Chippewa

Mississippi River

River

Capitol
Lake

Acadian

Foster

Florida

190

see
EB1 - EB25
inset

• 27

• 26

Government

73

73

Jefferson

61

10

• 28

12

• 29

Delpit

University
L.

Stanford

• 31

Perkins

• 38

• 37

30.1 •
30.2 • • 30.3

College

Lee

• 36

Essen

10

LOUISIANA
STATE
UNIVERSITY
30

River

• 32

Highland

Staring

Bluebonnet

Nicholson

Burbank

• 34

Siegen

30

• 33

• 35

Gardere

N
0 1
Miles

River

Mississippi River

189

Alvin Drehr on a forty-acre site; and Kleinert Terrace (1927), with houses of various sizes, some occupying two lots. Now known locally as the Garden District, these neighborhoods of tree-lined streets include residences of diverse styles and shapes, from shotguns to Craftsman bungalows, Colonial Revival houses, and English cottages.

State government also expanded, especially in the 1920s and 1930s under Governor Huey P. Long, as did two universities, Louisiana State University and Southern University. The first bridge to cross the Mississippi at Baton Rouge (1940) was a combined rail and highway structure (U.S. 190), designed by Norman E. Lant with construction engineer E. L. Ericson at a cost of over $9 million. A second bridge, for Interstate 10, opened in 1968. Built at a cost of $46 million, it is supported on caissons driven 100 feet below the river bed.

Today Baton Rouge is one of the largest deepwater ports in the United States and, although 245 miles inland, is the head of navigation for oceangoing ships on the Mississippi by virtue of a 40-foot-deep channel dredged and maintained by the Army Corps of Engineers. The city continues to expand, especially to the south and southeast, with the creation of new subdivisions and shopping malls. The downtown is also being revitalized under the auspices of the Downtown Development District, established in 1987. In 1998, the Miami-based firm of Duany Plater-Zyberk and Company was hired to prepare a master plan for the city. One of its components entailed the demolition of several post–World War II glass-curtain-wall buildings owned by the state government and the construction of a new twelve-story office building and two multistory garages, which the architects (Eskew+) describe as a "contemporary response to the Art Deco vocabulary of the State Capitol." While these new structures display the weight and mass of Art Deco, they lack its sense of optimism, invention, and delightful ornamentation. Among the other buildings scheduled for completion early in the twenty-first century in the vicinity of the state capitol is a new branch of the Louisiana State Museum, also designed by Eskew+.

Several of Louisiana's most prestigious nineteenth- and twentieth-century architects have designed buildings for Baton Rouge, such as James Dakin; Weiss, Dreyfous and Seiferth; and Curtis and Davis, but the city has fostered architects it can claim as its own. A. Hays Town (1903–) was born in Crowley and began his ca-

reer in 1926 as a modernist with N. W. Overstreet in Jackson, Mississippi. He established his own practice in Baton Rouge in 1939. At first Town continued to design buildings that expressed the tenets of modernism, but in the 1960s, he made an abrupt switch to designing homes based on historic southern vernacular styles, which were highly admired and widely imitated. John Desmond (1922–) opened his first office in Hammond (Tangipahoa Parish) in 1952, but beginning in the early 1970s worked almost exclusively in Baton Rouge. He designed the city's most impressive late-twentieth-century buildings, paying particular attention to the relationship between structure and contemporary aesthetics.

EB1　Louisiana State Capitol

1931–1932, Weiss, Dreyfous and Seiferth. State Capitol Dr.

Governor Huey P. Long commissioned this new state capitol to symbolize the modern Louisiana he intended to create, calling a special session of the legislature to vote on an amendment to fund construction. The first vote failed, so Long made sure he was present in the chamber for the second vote in order to persuade reluctant legislators to see it his way. Governor Long also selected the architects, who were told they could design the capitol as they pleased, so long as it was a tower.

The new building was completed in a mere fourteen months at a cost of approximately $5 million. George A. Fuller Company of Washington, D.C., which built the Lincoln Memorial and the Flatiron Building in New York City, was the contractor. At a height of 450 feet and thirty-four stories, the building is the tallest state capitol in the nation. The steel-frame tower is clothed in Alabama limestone on the exterior and Italian marbles on the interior. An important precedent for this skyscraper capitol was Bertram Grosvenor Goodhue's Nebraska State Capitol in Lincoln (1922–1932), although the Louisiana building's setbacks and repetitive fenestration make it comparable to New York's commercial skyscrapers of the 1920s and 1930s. The central tower, flanked by two sets of lower wings, has four colossal winged figures and eagles marking its setbacks and is surmounted by an aluminum lantern.

The capitol's rich decorative program makes it a showpiece of Art Deco sculpture. The symbolic content of the program was as important

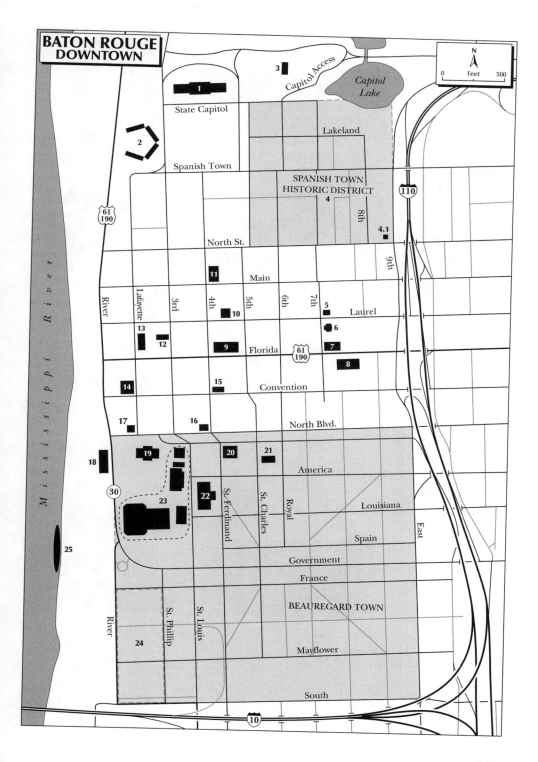

BATON ROUGE DOWNTOWN

N

0 Feet 500

Capitol Access

Capitol Lake

State Capitol

3

1

2

Lakeland

Spanish Town

SPANISH TOWN HISTORIC DISTRICT

4

8th

110

North St.

4.1

9th

61 190

River

Mississippi River

11 Main

Lafayette

3rd

4th

5th

6th

7th

10

5 Laurel

6

13

12

9 Florida

61 190

7

8

14

15 Convention

17

16 North Blvd.

18

19

20

21

America

30

23

22

St. Ferdinand

St. Charles

Royal

Louisiana

Spain

East

25

Government

France

BEAUREGARD TOWN

River

St. Phillip

St. Louis

24

Mayflower

South

10

EB1 Louisiana State Capitol (right), and details (below, left and right)

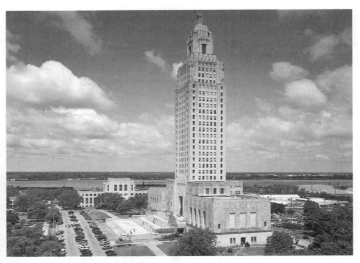

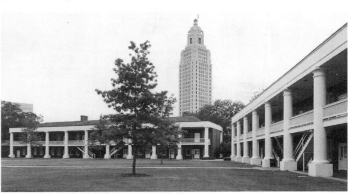

EB2 Pentagon Barracks

as its design aesthetics. Letters and documents in the Southeastern Architectural Archive at Tulane University reveal that the architects consulted historians and other experts for help in accurately depicting Louisiana's history and culture in the sculptural friezes. Major artists were invited to create the freestanding groups and bas-relief friezes on the exterior and frescoes for the interior. Flanking the entry stair-

case are groups entitled *Pioneer* and *Patriot*, by Lorado Taft (1860–1936). Ulric Ellerhusen (1879–1957) designed the intricately detailed frieze depicting Louisiana history along the upper walls of the side wings immediately flanking the tower—their distance from the ground makes them difficult to read—and the giant figures near the top of the tower that represent Law, Science, Philosophy, and Art. Particularly

noteworthy are the bas-relief panels by Lee Laurie (1877–1963) that frame the entry, depicting the resources and industries of Louisiana. Figures of heroic proportions and different ethnic groups are rendered in a highly stylized manner. More naturalistic in form are the scenes representing good government and the benefits of liberty and peace, carved on the relief panels on both sides of the entry, sculpted by Adolph A. Weinman (1870–1952). Along the top of the outer wings are twenty-two portrait busts, sculpted in stone, of people who played a significant role in Louisiana's history, including W. C. C. Claiborne, Andrew Jackson, Judah Touro, Louis Moreau Gottschalk, and John J. Audubon. These were carved by Juanita Gonzalez, Angela Gregory, John Lachlin, Rudolph Parducci, and Albert Rieker. Other artists who contributed to the sculptural program were Lewis Borgo, Andrew Mackey, and the Piccirilli brothers.

The principal public spaces inside remain much as they were when designed. The grand two-story entrance hall, measuring 35 by 120 feet and 37 feet in height, is a harmony of gold and bronze colors, from the marble wall facings to bronze grilles and massive chandeliers, a ceiling stenciled with oak-leaf patterns, and allegorical murals at each end of the hall by Jules Guerin (1866–1973), muralist for the Lincoln Memorial in Washington, D.C. The theme of Guerin's murals is the abundance of the earth. Limited illumination gives the space a mysterious and shadowy aura, an effect dramatically heightened in contrast to the glaring light outside.

The Senate and House chambers repeat the materials and rich, warm colors of the entrance hall, although the two chambers differ in design. The Senate chamber is divided into thirds by two rows of piers with engaged fluted Ionic columns, and the ceiling is finished with hexagonal coffers of acoustical Celotex. The House is one large space and has a wide cornice depicting Louisiana's flora and fauna, bronze heating grilles patterned with stylized sugarcane, and elaborate bronze light fixtures. Both chambers have rear balconies with seating for the public and large windows that provide abundant light. The walnut desks and rostrums were designed by Weiss, Dreyfous and Seiferth.

Governor Huey Long's office was located at the rear of the tower behind the lobby elevators, whose bronze doors are cast with portraits of Louisiana governors. The corridor in front of this office was the place where, in 1935,

Huey Long met an early death from an assassin's bullet (or a stray bullet from one of his bodyguards). Bullet holes in the marble walls mark the spot.

The capitol faces a formal garden and avenue of trees that lead to a 12-foot-high bronze statue of Huey Long, placed over his grave. Designed in 1940 by sculptor Charles Keck of New York, the figure of Long faces the capitol building, his left hand resting on a model of the capitol and the other hand gesturing toward the building. The statue stands on a marble plinth, the sides of which are carved with scenes depicting Long promoting education and, with a group of planners, pointing to the capitol; on the front of the plinth is a rearing winged horse accompanied by Long's motto, "Share Our Wealth." Senator Russell Long, Huey's son, posed for the statue. To the left of the capitol is the six-story Capitol Annex, built in 1938, which was designed by Neild, Somdal, and Neild to complement the capitol. Frescoes by Conrad Albrizio depicting the accomplishments of the state under Governor Richard W. Leche decorate its lobby.

Occupying a higher elevation than the rest of the city, the capitol tower can be seen miles away. Up close, the building is even more imposing, conveying a stark image of power that is achieved through several means: the vast staircase at the front of the building, blindingly white in the hot sun, each of the forty-nine granite steps engraved with the name of a state and the year of its admission to the Union; the entrance portal, which reaches a height of almost 50 feet; the decorative program, with its didactic scenes and stylized oversized figures; and the glistening, hard surfaces of the halls and corridors, in which every voice and footstep echo loudly. The architects, who stated their wish "to create a dramatic image of modernity and progress within an architectural tradition that was respectably conservative," achieved their goal. The capitol also reflects the powerful hierarchical government that Huey Long created.

EB2 Pentagon Barracks

1819–1824, James Gadsden. 3rd St. and State Capitol Dr.

The barracks are located just north of the site of the dirt fort the British built in 1779. In September 1810, West Florida revolutionaries seized the fort and flew the flag of their repub-

lic over it, but they surrendered peacefully to the United States in December 1810. As the westernmost fort in the United States at that time, it theoretically provided protection against the Spanish from the direction of the Sabine River, as well as from slave insurrections. (A major insurrection had taken place in 1811 along the river parishes.) A dirt fort was obviously inadequate, and a major expansion was initiated under the direction of army engineer James Gadsden, a negotiator of the Gadsden Purchase of land from Mexico in 1853.

The four two-story buildings enclose a pentagonal courtyard that is now open on the river side. Originally this fifth side accommodated a commissary-quartermaster structure and adjacent ordnance warehouse, but these were demolished by the 1830s because of their shoddy construction. Monumental Tuscan columns and two-story galleries were built across the fronts of the four buildings facing the courtyard, and identical columns and galleries were added in 1834 to the outer facades, where windows had been installed in 1826. All four buildings are covered by hipped roofs. Lieutenant Colonel Zachary Taylor, who had been posted to the barracks more than once, was in residence there when elected president in 1848. During the Civil War, both Union and Confederate armies occupied the barracks. The Baton Rouge post was deactivated in 1879, then leased by Louisiana State University (LSU) and used as dormitories until the university moved to its new campus in 1925. Today the buildings house a museum, the lieutenant governor's office, and apartments for legislators.

EB3 Old Arsenal Museum

1838. State Capitol Dr.

Although known as the Old Arsenal, this brick structure is a powder magazine, the last remaining of four that were constructed for the Baton Rouge military post, the main ordnance depot for the southwestern United States. For safety reasons, powder magazines were built at a distance from the barracks. The courtyard and high, thick brick walls surrounding the building were designed to send the force of any accidental explosion upward rather than outward. The arsenal itself, 135 feet in length and 35 feet wide, has walls that are 12 feet high and 4.5 feet thick, resting on brick foundations, with brick piers supporting a groin vaulted ceiling covered on the exterior with a long gable roof. The mag-

azine could hold up to 3,000 barrels of powder. Along with the Pentagon Barracks, the arsenal became redundant in 1879. LSU acquired the building in 1886, using it for different functions until the university moved to its new campus. In 1956, the Daughters of the American Revolution initiated the transformation of the magazine into a museum, achieved in 1962. The one remaining Indian mound west of the arsenal (another was removed around 1850) indicates that the capitol area was the site of a large Indian village around A.D. 1200.

EB4 Spanish Town Historic District

1805, with many additions. Bounded by State Capitol Dr. and N. 9th (I-10), N. 5th, and North sts.

Spanish Town, the oldest subdivision in Baton Rouge, was laid out in 1805 according to a scheme drawn up by surveyor V. S. Pintado for the Spanish governor of West Florida. It consisted of long and narrow but large lots, so that each family could have a house, a stable, and a garden. These lots have since been irregularly subdivided. Before the intrusion of the interstate highway, the area extended on the east to 12th Street. The *camino*, or public road, through the center was soon referred to as Spanish Town Road. This pleasant residential neighborhood now consists mostly of buildings constructed between 1885 and 1925 in a variety of styles and sizes.

EB4.1 Potts House

c. 1850, Nelson Potts. 831 North St.

Master brickmason Nelson Potts moved to Baton Rouge from New Jersey in 1846 and established a brickyard, advertising his wares in the local newspaper. Soon afterward, he constructed his house, a brick two-story building similar to those of the northeastern United States in the crisp simplicity of its design. A deep, two-story front gallery (a Louisiana influence), supported on paneled brick piers, overwhelms the facade, making it appear attached rather than integral to the design. Potts's house also served to display his construction skills and fine-quality bricks. In association with carpenter Richard Burke, he built many public and private buildings in Baton Rouge in the years up to the Civil War. One of his commissions stands nearby at 741 North Street, a two-story brick townhouse with front gallery, built c. 1850

for business promoter and developer Nathan King Knox. Potts also built the Florence Coffee House (130 Main Street) in 1850; its ground-floor level was remodeled in 1971.

EB5 **Office Building** (Warden's House)

1838–1839. 701–703 Laurel St.

This two-story brick building is the only structure surviving from what was once the Louisiana State Penitentiary. A prison store occupied the ground floor, and the upper floor housed the office of the prison clerk. At a later date the structure became the prison warden's residence. A lower two-story galleried kitchen and servants' wing are attached to one side of the house, and brick foundations of the original cistern remain in the yard. The building is constructed of soft mud brick made by the prisoners. The large transom windows of the south and west elevations of the first floor were necessary for light because of the high-walled prison across the street. Along the top of the facade is a row of corbeling, and decorative brick parapets enclose the gable ends of the structure. The original iron-studded wooden doors were retained in the 1960s conversion of the building into office space.

EB6 **United Way** (Baton Rouge Public Library)

1939, Lewis A Grosz. 700 Laurel St.

This PWA-funded Art Deco building has two stories, with the principal space on the second floor. The structure has two entrances, both recessed in the corners, and each is preceded by a broad, fan-shaped flight of stairs, which give a sense of occasion to the entrance sequence. Aluminum grilles over the doors and at the sides of the windows are patterned with foliate scrolls, and small carved panels with depictions of open books and the lamp of wisdom ornament the upper walls. Although the interior has been altered for its current use (it became offices for United Way in 1976), the two large piers that subdivided the space and the beige marble dadoes retain some of the original handsome finishes.

EB7 **Federal Building and U.S. Courthouse**

1932, Moise Goldstein. 707 Florida St.

This post office and courthouse is one of the few federal buildings of its era designed by a local rather than a government architect. New Orleans architect Goldstein provided a well-proportioned and subtly decorated three-story structure of Indiana limestone. All the ornamentation is geometric and highly stylized, from the fluted Ionic pilasters between the windows and the eagles with triangular bodies in panels on the top frieze to the impost blocks of stars and stripes on the corner pilasters. Since the building is no longer an active post office, the interior has been altered, although it retains such architectural details as the terrazzo floors and light fixtures. The courtroom is on the second floor. A new courthouse and federal building, the Russell B. Long Building, erected next door in 1994, is a postmodern version of Goldstein's. The design, by a consortium of four architecture firms, Newman and Grace Architects, Holly and Smith Architects, Raymond Post Architects, and E. Eean McNaughton Architects, repeats the floor levels and lines of Goldstein's building. However, with its two free-standing torchère columns of nickel-silver and bronze in front of a reflective glass wall, it lacks the sophistication restraint of the earlier structure.

EB8 **Federal Building and U.S. Post Office**

1966–1968, Miller, Smith and Champagne, and Wilson and Coleman. 750 Florida St.

Although the colonnade that envelops this three-story building and matches it in height has echoes of the galleries that surround Louisiana plantation houses, its simplified forms and round arches are typical of 1960s classicism, when perimeter columns were used to give dignity to institutional buildings and shade their glass walls. Behind the beige-colored stone colonnade is a steel and glass box, with a ground floor faced in dark gray polished stone. The second- and third-story windows, tinted dark gray, are modulated by closely spaced vertical metal fins that are decorative rather than functional, as they are too shallow to serve as a sunscreen.

EB9 **Bank One** (Louisiana National Bank)

1965–1968, Curtis and Davis. 451 Florida St.

This steel-frame bank and office building rises twenty-four stories above a below-ground banking floor and two levels of underground park-

ing sitting on a mat foundation without pilings. On the exterior, eight tapered, reinforced concrete piers carry the weight of the structure, visually expressing their function like massive buttresses. The walls are composed of a light brown concrete, sand-blasted to expose the pebbly aggregate; horizontal striations on the tapered piers reinforce the impression of mass and strength. A landscaped moat separates the tower from the street and provides a view down into the double-height, glass-fronted banking floor. Access to the building is across a bridge. To either side of the tower is a tree-lined plaza; in the center of each of these spaces are curved, funnel-shaped skylights faced with brick and angled to illuminate the banking floor underneath. Interior surfaces are richly textured, from the glazed brick paving of the banking floor, identical to that of the plazas, to sand-blasted and grooved light gray concrete elevator shafts and vertically grooved concrete walls that, from a distance, appear to be enormously heavy curtains behind the bank tellers. The bank's design received honor awards from the AIA's Gulf States Region and the Louisiana Architects Association. Since the building was completed, the exterior drive-in teller units have been replaced by a fountain in a gaudy pavilion and a parking garage has been added, neither feature designed by Curtis and Davis.

EB10 Arts and Humanities Council of Greater Baton Rouge (Old Bogan Central Fire Station)

1924, William T. Nolan. 427 Laurel St.

This former fire station was one of four authorized in 1922 to update the city's fire-fighting equipment under the leadership of Robert A. Bogan, chief of the fire department from 1918 until his death in 1959. The station was named in his honor in 1959. Paired, attenuated brick pilasters separate the two-story facade into five equally sized bays that are wide enough to accommodate the fire engines. In the 1978 conversion of the building into a small museum and offices, the wooden doors to these openings were replaced by glass windows. A tall frieze of cream-colored glazed tiles extends the width of the facade, separating the first floor from what was originally the second-floor living area. It is decorated with a pattern of blind arches enclosing chevron-patterned shields that are highlighted in green, yellow, and red. Terminating each end of the facade and fram-

ing it is a narrow projecting pavilion ornamented with bas-relief polychrome tile torches; similar torches adorn the parapet. The original hose-drying tower is behind the fire station. Architect William T. Nolan (1878–1969) maintained his office in New Orleans, but he designed civic, educational, and commercial buildings throughout southern Louisiana.

EB11 St. Joseph Cathedral

1853, John Cambiaso. 1891, bell tower and spire, F. B. Dicharry. Main and 4th sts.

Construction of this brick Gothic Revival church began in 1853 to a design by Father John Cambiaso, the Jesuit priest responsible for designing the Church of the Immaculate Conception in New Orleans (OR79). St. Joseph's also reveals Cambiaso's interest in decorative brickwork, evident in the blind arcade and quatrefoils that outline the gables and the hood moldings over the pointed-arched openings. Along the side walls, the buttresses are finished with tall pinnacles that extend well above the roofline, emphasizing the verticality of the design. However, it was not until 1891 that the church could afford a bell tower and steeple for Cambiaso's facade. These were added by T. B. Dicharry in a style compatible with the building; the existing spire is a replica of 1966 that replaced the original, which was damaged by Hurricane Betsy in 1965. The church's red brick walls were covered with plaster in 1895, and stained glass windows by the Emil Frei Art Glass Company were installed between 1911 and 1918. During a remodeling in 1924, the iron columns and entablature were removed, short transepts were added to the church, and a timber-frame hammer-beam roof was substituted for the coved ceiling. Following the formation of the Diocese of Baton Rouge in 1961, the church was elevated to the status of a cathedral. In 1966, the Baton Rouge firm of Desmond-Miremont Architects renovated the interior to comply with the liturgical requirements of Vatican II. They opened up the space by widening the apse and bringing the altar forward into the nave.

EB12 Roumain Building

1913, Favrot and Livaudais. 343 3rd St.

In 1888, Joseph K. Roumain founded the first wholesale jewelry business in Louisiana, and

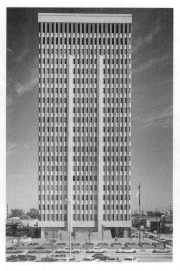
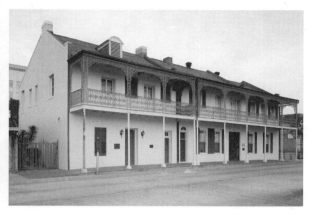

EB9 Bank One (Louisiana National Bank) EB13 Lafayette Buildings (Tessier Buildings)

this building, the city's first skyscraper, served to demonstrate his success. It is said that Roumain wanted the biggest, costliest, and most modern building in the city, so he chose the fashionable New Orleans firm of Favrot and Livaudais to provide the image he desired. The reinforced concrete frame building reflects the influence of Chicago high-rise design and the changing tastes of the time. The tripartite division of the facade, with a darker lower story, gridlike middle section, and prominent cornice, owes much to the work of Louis Sullivan. But the off-white terra-cotta facing on the four upper stories reflects newer ideas, and the ornamental motifs also show a hesitant step into modern design. Although the shields, acanthus, cartouches, and leaf drops are traditional motifs, they are rendered in a reduced abstract manner rather than naturalistically. This combination of elements gives the Roumain Building an appearance of modernity while staying safely within respectable Beaux-Arts formulas. The small lobby, placed centrally between the shop areas, has a marble floor and dado; a marble staircase leads to the office spaces above. A freestanding sidewalk clock is mounted on a fluted column. Across the road, at 344–350 3rd Street, is the Belisle Building, constructed in 1912 for Charles Belisle's dry-cleaning business and featuring four angled bay windows on the second floor and a prominent pressed metal cornice supported on paired brackets.

EB13 **Lafayette Buildings** (Tessier Buildings)

1820–1850s. 342–348 Lafayette St.

The three former town houses of this row are the only surviving examples of a type that at one time prevailed in much of the city. Two stories in height, with two-story ornamental cast iron galleries and end gable parapets, this row includes number 342 of c. 1820, number 346 (probably from the 1850s), and number 348 (from the 1830s or 1840s). The first two buildings, and possibly the third, were constructed for Charles R. Tessier, the first probate judge in the city.

EB14 **Capitol House Hotel** (Heidelberg Hotel)

1927, Edward F. Neild. 201 Lafayette St.

Shreveport architect Edward Neild designed the ten-story luxury hotel that became famous in its time as the unofficial headquarters of Huey Long. The hotel's bar, then called the Hunt Room, was a hotbed of political activity during the governorships of Huey and Earl Long. According to Huey's son, former Louisiana Senator Russell Long, votes taken in the Louisiana Senate or House merely confirmed decisions that had already been made in the bar. Most of Huey's autobiography-manifesto, *Everyman a King*, was written in the suite he

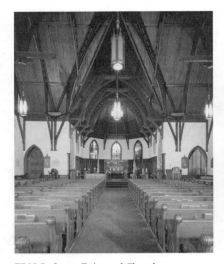

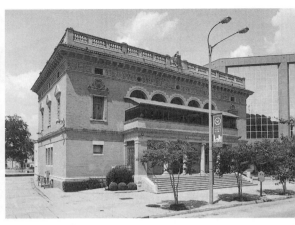

EB15 St. James Episcopal Church EB16 City Club (City Hall; U.S. Post Office and Courthouse)

maintained in the hotel. The steel-frame structure is sheathed in brick; its ornamentation, some of it in terra-cotta, is concentrated in the penthouse, which is decorated with spiral columns and a blind arcade below the cornice, in the then-popular style of a Mediterranean resort. The hotel closed in the 1980s and awaits a new use.

EB15 St. James Episcopal Church

1889–1895, William L. Stevens. 208 N. 4th St.

In contrast to the mid-nineteenth-century Gothic Revival style of St. Joseph's, this church exhibits late-nineteenth-century taste in its sharply angular forms. Stevens anchored the church to its corner site with a tall, narrow square tower surmounted by a pyramid-shaped steeple. Having a fine sense of the decorative potential of brick, Stevens articulated the planar wall surfaces with stepped buttresses, hood moldings around the windows, and an entrance that is doubly framed by an ogee-shaped hood molding beneath a blind-arcaded gable. Verticality is emphasized by the steeply pitched gables, typical of Episcopal churches, as well as three tall, narrow windows on the tower's lower floor and equally attenuated inset panels in the middle section. In all his work, Stevens (1872–1924) looked to his peers or to immediate predecessors for inspiration. He seems to have been intent on creating buildings that were thoroughly American in concept; this is also evident in his Commercial Building in Alexandria (RA8), where he draws on Louis Sul-livan's designs. The pink-colored mortar between the bricks gives the church a rich, rosy glow in the sun. An arcade along the N. 4th Street side is a later addition. The interior space is simple and harmonious, and, characteristic of Episcopal churches, the light is subdued. The stained glass side windows, made by the Jacoby studio of St. Louis, are richly colored. In 1910, the clear glass windows in the apse were replaced by three stained glass Tiffany windows. Above the wide, single nave is an Arts and Crafts version of a dark-colored wooden hammer-beam ceiling.

EB16 City Club of Baton Rouge (City Hall; U.S. Post Office and Courthouse)

1895–1897. 355 North Blvd.

This handsome former post office and courthouse was converted for use as a city hall in 1935 and then became a private club in 1957. The Renaissance Revival building is constructed of golden-colored Baltimore brick rather than the local red brick. A five-bay, one-story Ionic portico fronts the central entrance. Its roof provides a second-floor balcony in front of five arched openings separated by Corinthian columns, which, unfortunately, are now mostly obscured by a modern metal and glass extension. The third story, with rectangular and circular windows, is set behind a massive

terra-cotta frieze ornamented with rinceaux. A bracketed projecting cornice topped by an openwork balustrade, originally interspersed with urns, and a central cartouche complete the roofline. Facade windows are highlighted with relief sculptures of eagles encircled by wreaths, and the side windows have decorated triangular tops. The only interior space that retains its original appearance is the old courtroom. By 1932, the building was considered too small for its functions and was replaced by a new structure (see EB7). A small museum on the third floor has an exhibit on the history of Baton Rouge. In its location on North Boulevard, the building is part of an interesting and diverse mix of nineteenth-and twentieth-century commercial, residential, and institutional buildings. A landscaped median strip adds to the boulevard's attractive appearance.

EB17 Baton Rouge Waterworks Company Standpipe

1888, Smedley and Wood. 131 Lafayette St.

In 1887, the Common Council of Baton Rouge contracted with Edwin Smedley, president of the Smedley Manufacturing Company, and John H. Wood of Dubuque, Iowa, to build, maintain, and operate a waterworks in the city, including six miles of cast iron mains, a water tower, and seventy-five fire hydrants. The standpipe, which adjoins the city's waterworks, was in use until 1963 and was the only elevated water storage for Baton Rouge until 1938. Water originally was drawn from the Mississippi River until replaced by water from an artesian well, which was drilled in 1889. The standpipe, constructed of riveted wrought iron plates, is 15 feet in diameter; its original height of 100 feet was extended to 110 feet in 1937, bringing its storage capacity to 145,750 gallons. The standpipe sits on a 10-foot-deep foundation and is stabilized by iron triangular fins at its base. An elaborate ornamental iron cresting adorns the top, and an access ladder is attached to the sides.

EB18 Riverside Museum (Yazoo and Mississippi Valley Railroad Company Depot)

1925. 1974–1976, Desmond-Miremont-Burks. Planetarium, 2002, Smith, Tipton, Bailey, Parker Architects. 100 S. River Rd.

Tracks for the Yazoo Railroad, which arrived in Baton Rouge in 1884, were located alongside the levee and the river to facilitate connections between rail and ship transportation. The former station is a large red brick and limestone structure with a row of ten two-story Tuscan columns across the facade. The station consisted of a central ticket office flanked by separate waiting rooms and lounge facilities for black and white travelers. The north wing contained segregated dining rooms; the south wing housed freight and railway express offices; and office spaces were on the second floor. Passenger service continued at this depot until 1971. Considerable changes were made to the interior when it was converted into a museum in the 1970s to a design by William Burks. Other than reglazing and converting some doors into windows, the facade retains its 1925 appearance. A steam locomotive (1918) and its four-car train are displayed on a siding next to the former terminal, but demolition of adjacent train sheds has divorced the building from its original context. The Irene W. Pennington Planetarium is a circular brick structure with a dome covered in fish-scale-shaped tiles.

EB19–EB24 Beauregard Town

1806, with many additions. Bounded by S. River Rd. and North, East, and South blvds.

Beauregard Town is now a predominantly residential district whose origins date back to 1806, when Captain Elias Beauregard sought to realize an ambitious Baroque-inspired plan for a new center for Baton Rouge, at that time the seat of government for the Spanish province of West Florida (annexed by the United States in 1810). He hired French engineer Arsène Lacarrière Latour to draw up his proposal in the "Grand European Manner." The general layout of Beauregard's ambitious scheme can still be discerned today in this neighborhood's street pattern.

The plan centered on a cathedral square, from which four diagonally radiating streets led to open spaces and public buildings, including a hospital and a college. In a bilingual (French and English) advertisement circulated in 1806 to announce the auction of residential lots, Beauregard described his scheme: "The Public Buildings will stand at a distance from private property and are to be so situated in different parts of the town as to afford a more uniform value to all the Lots, and to contribute at the

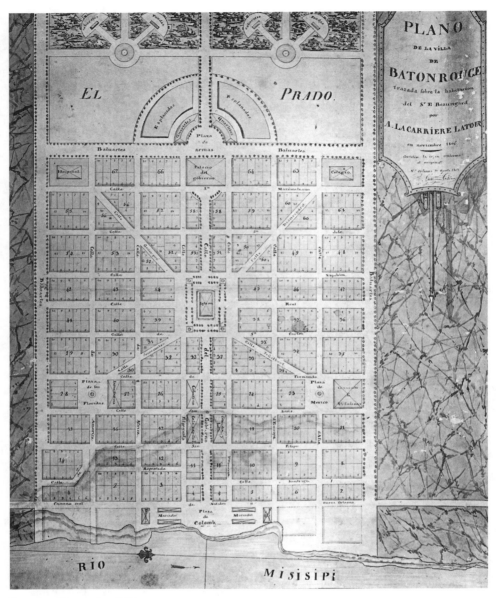

Beauregard Town, plan, 1806

same time to general convenience and ornament." A tree-lined boulevard named the Calle del Gobierno (now Government Street) bisected the area from west to east, crossing the cathedral square to the governor's residence and, beyond that, to the troop barracks and then the formal gardens, which were to contain a coliseum and a vauxhall (pleasure garden).

Markets, a customhouse, and the Plaza de Colomb were planned for the river's edge.

Many lots remained empty until the late nineteenth century, when a building boom swallowed the open spaces set aside for public plazas. Areas close to the river acquired warehouses for the railroad and port (see Catfish Town [EB24]). The four radiating streets

(Somerulos, Grandpré, Beauregard, and Penalvert) are still recognizable and retain their original names. In the 1960s, Government Street was redeveloped as a major traffic route and essentially split Beauregard Town in two.

Three houses illustrate the variety of residential types in the district. Among the oldest is the one-and-one-half-story Gesell House (c. 1866), galleried and five bays wide, located at 356 St. Charles Street, within the angle it forms with the diagonal Somerulos Street. The house is now occupied by lawyers' offices. The former Fuqua House (301 Napoleon Street), built in 1870, is five bays wide and one and one-half stories tall, with prominent gables on three sides. J. K. Roumain, whose Roumain Building (EB12) is a landmark in the city's business district, built a two-story, galleried cypress house, perhaps designed by Baton Rouge architect Ben Goodman, at 201 St. Charles Street. A recent addition that picks up on the pediments, gables, and columns of the neighborhood is an office building by Barron and Toups (320 Somerulos Street), a visually complicated structure intersecting volumes, stairs, courtyards, and bays, typical of its 1985 date.

EB19 **Old State Capitol**

1847–1852, James H. Dakin. 1880–1882, interior reconstruction and rotunda, William A. Freret, Jr. S. River Rd. and North Blvd.

In *Life on the Mississippi* (1883), Mark Twain described Baton Rouge's Gothic Revival state capitol as an "architectural falsehood" and accused novelist Sir Walter Scott of being "probably responsible . . . for it is not conceivable that this little sham castle would ever have been built if he had not run the people mad, a couple of generations ago, with his medieval romances." Local newspapers were no kinder, denouncing the building as an "unsightly mass" and "a castle of the dark ages—the age of tyranny, of Baronial oppression" and therefore thoroughly inappropriate for a democracy. In a letter to the building commissioners, architect James Dakin explained what prompted him to choose the style: "I have used the Castellated Gothic style of Architecture in the Design because it is quite as appropriate as any other Style or Mode of building and because no style or order of Architecture can be employed which would give suitable character to a Building with so little cost as the Castellated Gothic. Should a Design be adopted on the Grecian or

Roman Order of Architecture, we should accomplish only what would unavoidably appear to be a mere copy of some other Edifice already erected and often repeated in every city and town of our country. Those orders have been so much employed for many years that it is almost impossible to start an original conception with them." Dakin's originality is obvious, as this is one of only two former state capitols in the Gothic Revival style in the nation; the other, in Milledgeville, Georgia, was completed in 1841 (the present building there is a replica built after the original burned).

Construction began in 1847, and although the building officially opened in January 1850, the interiors were not completed until 1852. The capitol has four stories, with an additional story over the central stairwell. Round towers stand on each side of the entrance; all the windows, whether square-headed or pointed-arched, are surrounded by hood moldings; and the entire roofline is crenellated. The building's massing and proportions are similar to those of defensive castles built during the early Middle Ages in Europe.

In plan, Dakin adapted the traditional composition of American capitols—a central space flanked by legislative chambers—to a cruciform plan. The added (north-south) axis provided space for government offices. Dakin wanted the building's exterior to look as if it had been constructed of marble, so the off-white stucco finish over the brick is scored to imitate stone blocks. Both the House and Senate chambers feature Gothic details, carved wood moldings, and stained glass windows.

In December 1862, when it was occupied by Union Army troops, the building was gutted by a fire that started in a cooking stove. The ruined capitol stood empty for nearly twenty years. Mark Twain commented: "[L]et dynamite finish what a charitable fire began." Nevertheless, New Orleans architect William Freret began the restoration in 1880, enlarging the rotunda, adding an iron staircase that spirals around a central iron column, and replacing Dakin's elliptical skylight with a fan vault dome of harlequin-patterned colored glass. A short lantern tower protects the fan vault. Freret's dazzling interior is further enriched by salmon pink walls, green cast iron fretwork, and gold highlights, all recently restored in accordance with Freret's original color scheme. Also following Freret's specifications, interior cypress wood millwork and doors were grained to resemble oak. Freret added cast iron turrets to

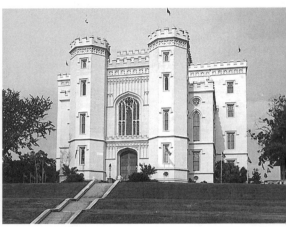

EB19 Old State Capitol, entrance facade (below) and interior (left)

EB20 East Baton Rouge Arts and Technology School (Baton Rouge Savings and Loan)

EB21 Old Governor's Mansion

the roofline, giving the capitol a truly fairy-tale aspect, but these were removed in the early twentieth century and not replaced in the recent restoration, which is faithful to Dakin's exterior and Freret's interior. Freret's lighting fixtures and hardware were replicated in bronze for the restoration.

Surrounding the capitol is a 6-foot-high iron fence with post finials in the form of the Louisiana emblems, the fleur-de-lis and magnolia pod, which was designed by James Dakin and cast at the John Hill Foundry in Baton Rouge in 1855. Botanical gardens were added. After completion of the new state capitol building in 1932, the Old State Capitol served as office space for various organizations until the 1980s. The superb restoration, completed in 1994 at a cost of $9.3 million, earned E. Eean McNaughton Architects an American Institute of Architects Honor Award in 1998. The Old State Capitol now serves as a museum of the state's political history.

EB20 East Baton Route Arts and Technology School (Baton Rouge Savings and Loan)

1955, Bodman and Murrell and Smith. 101 St. Ferdinand St.

In striking contrast to the former post office diagonally opposite, this asymmetrical modernist building emphasizes smooth horizontal lines and eschews ornament. The reinforced concrete frame system, partially revealed as an inset columned arcade along the St. Ferdinand Street side, allows the walls and windows to wrap as smoothly as skin around the two facades. A concrete canopy above both the first- and second-floor windows adds to the building's streamlined appearance. Applied ornament is as functional as the design; drawing attention at one corner is an oversized clock with rectangular bars in place of numerals, and at eye level a bas-relief panel depicting a woman and baby watching workers construct their house advertises the building's original purpose. The structure was converted for use as the East Baton Route Arts and Technology School (known as EBRATS) in 2002.

EB21 Old Governor's Mansion

1930, Weiss, Dreyfous and Seiferth. 502 North Blvd.

The mansion was commissioned by Huey Long, and its similarities with the White House in Washington have tempted many to speculate that the governor was getting in practice for the real thing. Indeed, Long's presidential ambitions, bolstered by the publication of his book *My First Days in the White House* (1935), were well known. In contrast to Long's modern state capitol, the two-story mansion, designed by the same architecture firm, draws on historic precedents and is constructed of brick, covered with plaster scored to resemble stone and painted white. Like many of this firm's designs, the composition takes a three-part form, with an emphasized center bay, in this case fronted by a portico of four 30-foot-high Corinthian columns. These support a pediment ornamented with the state's symbol, a pelican feeding her young. An encircling balustrade atop the building largely obscures the mansard roof and its dormer windows. The central entrance opens onto a large stair hall and curving staircase flanked by rooms of various sizes; among them is the East Room, a formal reception area, 33 by 55 feet, which has an elaborate gilded cornice. On the upper floor is the Oval Room, which was used as an informal sitting area.

Huey Long ordered convicts from the state penitentiary to demolish the existing governor's mansion, a white frame structure of 1857, before he received authorization to build the new house. Leon Weiss supervised construction at a cost of just under $150,000, which Long borrowed from the State Board of Liquidation. It is believed that Caroline Dreyfous Weiss, Leon Weiss's wife, helped select the mansion's furnishings, which cost $22,000. The residence was inhabited only until 1961, when Governor Jimmy Davis moved into a new but equally traditional-looking mansion, in the Antebellum Revival style, designed by William Gilmer (1001 Capitol Access Road). The Old Governor's Mansion was renovated and opened in the 1970s as a historic house museum, and in the 1990s it was restored through the efforts of Louisiana's first lady, Alice Foster, and the Baton Rouge–based Foundation for Historical Louisiana. Interior restoration included repairing the "Scenic America" wallpaper (a 1970s reproduction of the original paper) in the dining room and gilding on the elaborately ornamented cornices in the East Room. Landscape architect Lorrie Henslee brought back the mansion's former rose garden.

EB22 Old East Baton Rouge Parish Courthouse

1921–1922, Edward F. Neild and Clarence E. Olschner with Sanguinet and Staats. 1957, rear wing, Bodman, Murrell, and Smith. 215 St. Louis St.

This buff brick Beaux-Arts courthouse, occupying the site of Beauregard Town's Florida Square, is composed of a wide central section slightly recessed between two wings and screened by a row of twelve double-height Ionic columns at the second and third stories. Centered beneath the columns is a small pedimented entrance. The liberal use of limestone for columns, window and door surrounds, the entablature, a balustrade, and spandrel decoration in the form of eagles enclosed within wreaths gives the courthouse an aura of importance. The fourth floor, behind the balustrade, housed the jail. The three-story lobby, with its marble floor and staircase, metal stair banisters, and plaster moldings, is as splendid as the facade. The rear addition of 1957 is in the same style but without the decoration.

EB23 Centroplex

1974–1978, Desmond-Miremont and Associates. Bounded by S. River Rd., North Blvd, and Government and St. Louis sts.

This complex includes a government building, a 12,000-seat arena, a 2,000-seat theater, a 30,000-square-foot exhibition hall, and a library organized around a series of terraces that descend the bluff of the Mississippi River. Three levels of underground parking are built into the bluff. City planners conceived the complex as a means to revitalize and bring people back into the center of Baton Rouge, which had largely been abandoned, as was the case in many American cities by the early 1970s. Although the first concept was to design a low, attractive but conventional-looking government building, the architects decided that a bolder structure was needed to represent city-parish government. As the designer, John Desmond, wrote in 1993, "Justice should be somewhat more visible on the Baton Rouge skyline, taking its scale in the company of the State Capitol, the business center and the LSU complex." Thus the scale of the building is large, the forms are bold, and the construction materials are robust. The nine-story building's concrete frame is expressed visually on the exterior, and the infill panels are of striated concrete. Aggregate-faced concrete was used for the theater,

and the arena has a smooth finish. The library combines an exterior surface of smooth concrete with a first-floor glass curtain wall, and it has a freestanding stairway in its double-height lobby.

The several levels of the plaza are linked by stairs and variously landscaped with brick paving, lawns, pools, fountains, and plantings, and include several bronze sculptures by Yugoslav artist Ivan Mestrovic (1883–1962). Because the plaza is surrounded by the Centroplex buildings, it is not readily visible, but it is worth seeking out, if only for the splendid views it offers of the Mississippi River.

EB24 Catfish Town

c. 1900, 1980s. Bounded by River Rd. and France, St. Philip, and South sts.

The warehouses in this seven-block area once housed cotton, lumber, and other agricultural products brought here by the Yazoo and Mississippi Railroad to await shipment via the river. When trucks replaced rail and ship as the principal method of moving goods, many warehouses were left empty. In the late twentieth century, several of the buildings were converted to restaurants and other uses; when gambling was legalized in Louisiana, a casino gave the area a new economic base. The former Illinois Central Freight Depot (its end wall visible on France Street) was absorbed into a rambling complex that included a large glass atrium enclosing a multifunction retail and entertainment court and garden. Two-story brick warehouses on France Street between Front and St. Philip streets retain a semblance of their original appearance. The building on the corner of Front Street has an entresol. The area supposedly took its name from the large number of catfish found in the pools that were left after river floods receded.

EB25 USS *Kidd*

1943. 305 S. River Rd.

Now permanently berthed in Baton Rouge, the USS *Kidd*, a *Fletcher* Class destroyer, was decommissioned in 1964 and donated in 1982 to the Louisiana Naval War Memorial Commission. Built to the design of the USS *Fletcher*, these were the largest U.S. Navy destroyers built during World War II. Named for Rear Admiral Isaac C. Kidd, who was killed at Pearl Harbor,

EB27 Alamo Plaza Hotel Courts
EB29 Magnolia Mound (right)

the destroyer served in the Atlantic and the Pacific oceans during World War II and in the Korean War. The ship has been restored and retains its original diesel-power plants and two exhaust funnels. Five-inch gun turrets are mounted fore and aft. For the *Kidd*'s berth in Baton Rouge, a special mooring system was devised to cope with the waters of the Mississippi River, which can rise 45 feet. The *Kidd* is held in a cradle that keeps it dry when the river is low in the fall and allows it to float when the water rises. Adjacent to the destroyer is a historic center that houses a Warhawk fighter plane, model ships, and other nautical exhibits.

(Note: For locations of sites EB26–EB41, see the Baton Rouge overview map on p. 189.)

EB26 Baton Rouge Magnet High School

1926, William T. Nolan. 2825 Government St.

New Orleans architect William Nolan designed many schools in the southern parishes at a time when English medieval styles were fashionable. Set far back from the street, this building features an allée of trees leading to the central entrance, which is located within a pavilion that rises a full story above the three-story wings and is finished with a curved parapet set between crenellated towerlike forms. As in his design for the former fire station (EB10), Nolan lavishly applied cream-colored terra-cotta over the facade. The central pavilion features rows of foil panels, shields, rosettes, and lancets, motifs similar to those Nolan used at the fire station. The layout is a conventional early-twentieth-century design, with a large central entrance opening into a small lobby that crosses a hallway leading to the classrooms. Behind and on axis with the lobby is a large auditorium, decorated with plaster paneling in designs like those on the exterior of the building. Nolan also designed the smaller Nicholson School (1143 North Street) in 1922, noteworthy for its elaborate decoration on the central pavilion and Baroque parapet surmounted by urns.

EB27 Alamo Plaza Hotel Courts

1942. 4243 Florida Blvd.

This Baton Rouge outpost motel was the third built for a once-thriving chain of thirty-four franchises throughout the South and south central United States. The Alamo Plaza is con-

sidered an innovator in the motel business because of the many precedents it set in the areas of architecture, service, and cost. Founded in Waco, Texas, in 1929, the chain was established by Edgar Lee Torrance, who chose the Alamo theme for its historical associations. Rejecting the traditional U-shaped plan of motels, he opted for a distinctive long, white stuccoed facade along the road, which would unify the scheme and present an urban wall as well as a sort of Western false front to the busy highway. Flanking the central entrance and registration building were the automobile entrances under connecting archways that linked the smaller facades at the ends of the banks of rooms. The rooms were grouped in pairs and were entered from a grassy pathway between them, so that each offered windows on three walls and access to the central parking lot. Torrance's consistent use of these almost urban features distinguished the Alamo Plaza chain from other motels, as did his insistence on amenities such as porters. (Despite the emphasis on service, Alamo motels did exclude restaurants as a cost-cutting measure.) A tall, freestanding neon sign with a large star and arrow, placed perpendicular to and near the road, indicates this motel's entrance. Until the construction of the interstate highway, this road (U.S. 61/190) was the principal route into Baton Rouge from the east. The motel's exterior is now painted a peach color, and its curved cornice and details are aqua-colored.

EB28 Old McKinley High School

1926–1927, Jones, Roessle and Olschner. 1500 Thomas H. Delpit Blvd.

The first state-approved high school for African American students in East Baton Rouge Parish was part of a combined elementary and secondary school established in 1912 on Perkins Road. McKinley was the successor to that earlier institution and the first school in Baton Rouge constructed solely for high school students. The three-story building has a typical five-part plan, with a taller center section that is more elaborately decorated than the classroom wings and end pavilions. The design makes particularly attractive use of decorative brick, as in the gable-fronted central pavilion with a large, round polychrome arch encompassing three arched windows. Polychrome window arches are repeated across the facade. McKinley was converted into a junior high in 1949 when a

new high school was constructed. After it was phased out in 1972, the building was used by various community organizations. A fire in the 1990s badly damaged the building, but most of the facade was saved.

EB29 Magnolia Mound

c. 1815. 2161 Nicholson Dr.

The Magnolia Mound plantation house and the thirteen remaining acres of the former 900-acre plantation were purchased by the East Baton Rouge Recreation and Park Commission in the 1960s, restored by the Foundation for Historical Louisiana under the direction of architect George Leake, and opened to the public in 1981. The raised, galleried house was originally a four-room residence, constructed in the 1790s for John Joyce; it was enlarged after his widow, Constance Rochon Joyce, married French immigrant and widower Armand Duplantier in 1802. The Duplantiers added several rooms to the house, as well as a rear gallery and a tall hipped roof. The house is built of *bousillage* between posts, which in the late nineteenth or early twentieth century was covered inside and out with narrow beaded boards. They also gave the parlor a coved ceiling, made entirely of tongue-and-groove construction, which is thought to be the earliest of this type in the lower Mississippi Valley. The ceiling, painted a brilliant blue, and its elaborate cornice are made of wood. The wraparound mantel and overmantel are Creole forms, but the fluted pilasters are decorated in the Federal style. When the house was restored, the original paint colors and figured yellow wallpaper were reproduced.

After 1836, the house had a succession of owners, including Robert A. Hart, a businessman and former mayor of Baton Rouge, who purchased the house in 1904 but never occupied it. Instead, Hart built a one-and-one-half-story Queen Anne residence behind the plantation house and subdivided the land, selling most of it for Baton Rouge's southward expansion. Hart's home now accommodates administrative offices.

The Magnolia Mound site includes a kitchen, reproduced on its original site behind the house; an overseer's house (1880s), which was moved closer to the house from its original site; and several other buildings relocated here from elsewhere in southern Louisiana. These include a two-story cypress *pigeonnier* (c. 1820) and a

double slave cabin. Magnolia Mound's own slave cabins were demolished many years ago, but it is known that fifty-three slaves lived at the plantation in 1820 and that by 1860 there were seventy-nine.

EB30 Louisiana State University

1922, with many additions. Highland Rd.

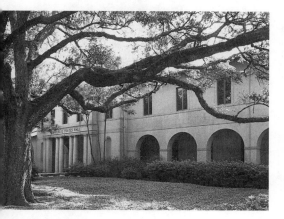

Louisiana State University (LSU) opened at this campus in the fall of 1925. Founded in January 1860 as the Louisiana State Seminary of Learning and Military Academy at Pineville, it relocated to Baton Rouge in 1869 and in 1970 was renamed Louisiana State University. The university's first home (1868–1887) was in the former Asylum for the Deaf, Dumb and Blind (now demolished); the Pentagon Barracks (EB2) also accommodated university needs. The site of the present campus, a former plantation, was purchased in 1918. Its first buildings were designed by St. Louis architect Theodore C. Link (1850–1923), who based his plan on one proposed by the Olmsted Brothers firm, which had been invited to submit a plan and landscape design in 1920. It is not known why Link rather than Olmsted Brothers was hired in 1922; possibly it was to reduce costs. Upon Link's death in 1923, the New Orleans firm of Wogan and Bernard completed most of Link's design.

In the 1930s, Governor Huey Long launched a major expansion of the university in order to give it national stature and provide a showpiece for his "Everyman a King" vision. At a cost of over $9 million, many new buildings were constructed, allowing enrollment to double and the faculty to expand from 180 to 400. The PWA funded seven of the new structures, several of which were designed by Weiss, Dreyfous and Seiferth. Some of the buildings, such as O. K. Allen Hall (1933), located on the quad, and the women's dormitory Pleasant Hall (1931), across the street from the quad, repeat Link's design. Other structures by Weiss, Dreyfous and Seiferth on the campus are in different styles, including the entrance gates (1936) on Highland Road, a Beaux-Arts classical design by Albert Bendernagel for the firm, and the law school (1938), which resembles the Supreme Court building in Washington, D.C. In order to provide housing for the increasing number of students, Weiss, Dreyfous and Seiferth inserted dormitory rooms for approximately fifteen hundred students in the space under the raked grandstand of the coliseum in 1932 and 1936. Shreveport architect Edward Neild designed the Agricultural Center Building (1938), whose rigid steel frame spans a length of almost 200 feet and reaches a height of almost 77 feet, giving the structure the appearance of an airship. During his tenure as LSU's part-time landscape architect, from 1932 to 1970, Steele Burden (1900–1995) was responsible for planning most of the campus grounds, including the oak-lined walks.

Since the 1950s, LSU has erected many new buildings, mostly unremarkable, with the notable exception of the Student Union (EB30.2). The campus now covers 1,700 acres and has a student body of approximately 31,000. In the northwest corner of the campus are two conical-shaped mounds, approximately 130 feet in diameter at the base and 17 feet high, which are believed to be approximately 5,000 years old. It is believed that they were once taller, erosion having reduced their size. They have not been excavated, so their original function cannot be certain. The residential neighborhoods adjacent to the university are notable for their varied and attractive houses, especially those on the boulevards around the lakes.

EB30.1 Central Quadrangle and Memorial Tower

1922, Theodore Link

Theodore Link, whose previous work included Union Station in St. Louis (1894) and the Mississippi State Capitol in Jackson (1903), planned sixteen buildings around an open quadrangle one-fifth of a mile long in the shape of a Latin cross, anchored at the east by

a 175-foot-high bell tower, known as Memorial Tower. The buildings have a unified Mediterranean appearance, with Tuscan columns, pediments, red tile roofs, a continuous round-arched arcade on the quad side, and an exterior finish of honey-colored stucco over an aggregate of tiny pebbles. When Weiss, Dreyfous and Seiferth added O.K. Allen Hall (1933) and Himes Hall (1938) to complete the quadrangle, they remained faithful to Link's design. In the 1970s, Henslee, Thompson and Cox landscaped the quad with regional plants. The misguided decision to place a library (1958) at the center of the quad has damaged its spatial qualities and vistas. Nevertheless, the quad's simple architectural features, soft color, and shady spaces within the arcades contribute to making this the most attractive campus in the state.

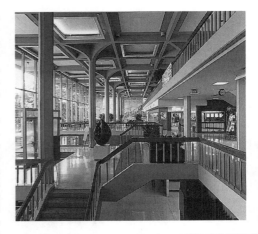

EB30.2 Union Building

1961–1965, Desmond-Miremont Architects; Mathes, Bergman and Associates; Wilson and Sandifer, Architects

More people are said to use the LSU Union than any other building in Louisiana, and it continues to receive accolades from many of those who frequent it. Design architect John Desmond wrote in *Louisiana Architect* (1964): "This was a very important commission, not only to LSU and to the architects but to the relationship of contemporary architecture to LSU. There were both contemporary and eclectic buildings still being built on campus. This building, because of its size and prominence, could weigh the balance one way or the other. . . . There should be no doubt that the building was frankly and honestly of the middle twentieth century." The building, which sits on a raised platform, is constructed of cast-in-place concrete, with glass walls shielded by a front gallery supported on concrete columns that flare out at the top to carry the grid of beams supporting the roof slab. The plan is based on a 24-foot-square structural bay, which provides a module for all the building's parts. Solar grilles shield the east and west facades. Inside, the two-story-high multipurpose lobby and sitting area extends the entire width of the building, its space modulated by flaring concrete columns like those of the gallery and broad open staircases. The impressive scale lends the space, as Desmond sought, "a feeling of exhilaration." The Union accommodates a book-

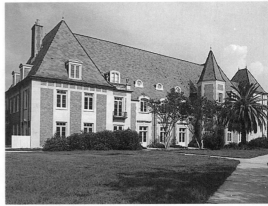

EB30.2 Louisiana State University, Union Building

EB30.3 Louisiana State University, Maison Française (French House)

store, a post office, an art gallery, a bowling alley, meeting rooms, a dining room, and a cafeteria. The theater, attached to the right side of the building, was cantilevered at its south end to prevent encroachment on the root systems of the ancient live oaks retained on the site. A ballroom projects to the rear of the Union. The Desmond-Miremont office was responsible for the building's design; Mathes, Bergman and Associates prepared the specifications; Wilson and Sandifer handled interior furnishings. The Union Building received an AIA Regional First Honor Award.

EB30.3 Maison Française (French House)

1935, Weiss, Dreyfous and Seiferth

This former study center and dormitory for students studying Romance languages was designed to resemble a French château or Norman manor house, with a formal French garden in front. The three-story brick building has quoins, window surrounds, and spandrels of cast stone and a dormered gray slate hipped roof that is steeply pitched and pierced by bull's-eye windows. A projecting two-bay pavilion on the left side is balanced by a hexagonal tower and spire on the right side of the facade. (The elevator tower attached to the right end wall is a recent addition.) Male students entered the building through glazed doors to the left, and women entered through an iron-studded wooden door at the base of the tower and climbed a spiral staircase to sleeping quarters on the upper story. As was customary for women's dormitories, the matron's suite was adjacent to this entrance. Although the dormitories had separate entrances, female and male students shared the dining room and living room. The central ground-floor living room was decorated in the French Empire style. The French House appears to have inspired Baton Rouge's residential builders, as an unusually large number of houses in the vicinity of LSU have features such as round towers and conical spires.

EB31 A. Hays Town House

1950, A. Hays Town. 1544 Stanford Ave.

Hays Town's own house is the first of many drawn from southern Louisiana prototypes that he designed in the latter part of his career. The single-story brick house with a front gallery and hipped roof appears long settled on its site. However, little touches, such as the single square brick chimney and plain wooden posts of the gallery, reveal that the house is modern Although Town incorporates such fundamental Louisiana features as roof overhangs, breezeways, and cross ventilation, the interior embraces all the modern conveniences, including air conditioning. Similarly, Town used a combination of old and new materials and techniques in building this house and others designed for his clients. In the 1970s, he added a large room to the house to use as his home office, which is decorated with white walls and dark woods in the style of a Spanish hall. To the rear of the house is a brick-paved courtyard; beyond it is a large garden that includes a *pigeonnier*, which usually served as storage space in the houses he

designed. Town's revival of the Louisiana vernacular proved highly popular in the last decades of the twentieth century, as evidenced by the new subdivisions that have proliferated around Baton Rouge and elsewhere. Unfortunately, these builder-contractor houses lack Town's exquisite sense of scale, proportion, and detail.

EB32 Baton Rouge Waterworks Water Storage Tank

1964. 5400 Highland Rd.

This elevated tank, known as a water spheroid, is one of the most dramatic modern designs for water-storage structures. In 1965, the Steel Plate Producers promoted innovative designs for steel water towers, proposing that they also serve as public sculptures. Built by the Chicago Bridge and Iron Company, this water tower resembles the type of space-age structures depicted in films and comics of the time and has also been described as a giant mushroom. The tank, which can hold 750,000 gallons of water, is elevated on a single slender column that rises from a flared base 45 feet in diameter. The tank is painted white, and the base and column are painted light blue. With an overall height of 105 feet, the tank served as a navigational landmark for small aircraft.

EB33 The Temple of Jesus Christ of Latter-day Saints

2000, Paul Teffier and Associates. 10335 Highland Rd.

This Mormon temple follows the plan that Joseph Smith, the religion's founder, said was transmitted to him through divine revelation. The lower level is used for general worship and the upper level for education and prayer; these include a foyer, separate dressing rooms for men and women, and richly decorated rooms for baptism, prayer, and marriage. The temple is rectangular in form, rising in a series of tiers to a central square spire surmounted by a golden statue of the angel Moroni, who points heavenward. White marble walls, entablatures, and narrow windows give the church a somewhat classical appearance. Mormon temples are not open to the public.

EB34　Bluebonnet Swamp Nature Center

2000, Marsha Cuddeback and Michael Desmond, Architects. 10503 N. Oak Hills Pkwy.

Set amid a 101-acre swamp and surrounding alluvial ridge, the center is a large, airy structure built with a variety of materials—wood, brick, glass, and metal shingles—that complement the lush textures and colors of the surrounding vegetation. In addition to administrative spaces, the center includes an open-plan exhibit and lecture area whose interior structural frame is composed of concrete columns, each with angled steel braces, so that they resemble trees with many branches.

EB35　John Gonce House

1966, MacKie and Kamrath. 11952 Pecan Grove Ct.

Houston architects MacKie and Kamrath interpreted Frank Lloyd Wright's Usonian designs for the southern climate in this single-story brick house. The floor plan radiates from the entry, separating the living and dining spaces from the bedroom wing. A flat roof extending beyond the wall line shades the horizontal window along one side; a flat-roofed carport on the opposite side of the house carries the horizontal lines outward to create the expansive composition typical of Wright's work. Construction materials of brick and wood are in the warm, earthy colors favored by this architecture firm.

EB36　Pennington Biomedical Research Center, Louisiana State University

1983–1993, Desmond and Associates; Coleman and Partners; Lasseigne and Leggett. 6400 Perkins Rd.

Opened in 1988, this research center, located three miles from LSU's main campus, was named for oilman C. B. Pennington, who helped fund it. In 1990, a conference center with a 470-seat auditorium was added to the original complex, which consists of an administrative building and laboratory, including patient treatment rooms and X-ray facilities. Reflecting the Desmond firm's commitment to structure as a generator of form, the two-story buildings have a smooth concrete frame that is clearly visible from the ribbed precast infill panels and horizontal "eyebrow" sun breaks. With their terraced landscape of fountains, lawns, and a lake, the complex conveys the impression of a corporate park rather than a university campus.

EB37　Louisiana State University Rural Life Museum

1810–present. 4560 Essen Lane (I-10 and Essen Lane)

This outdoor complex of southern rural vernacular buildings is located at LSU's 450-acre agricultural research experiment station on land donated by landscape designer Steele Burden and his sister Ione. The site was formerly a plantation that had been in the Burden family since the 1830s. More than twenty buildings from throughout the state were saved from demolition and resettled at this open-air "museum." Although the layout of the complex lacks historical accuracy, it effectively interprets plantation life through a collection of authentic rural structures and illustrates various early construction techniques. Some buildings were rescued from Welham Plantation (the house was bulldozed one night in 1979 after Marathon Oil Company purchased the plantation), including four slave cabins, an overseer's house, commissary, and smithy, all dating from the 1830s. Other structures at the site include a kitchen building (1855), a schoolhouse and a "sickhouse" (both 1830s), some privies, a small open-kettle sugarhouse and equipment, a log house (1810), a single-pen log cabin, a double-pen log barn (1847) from the Stoker homestead near Fort Jesup, and College Grove Baptist Church (1890s). Some of the transplanted buildings have been embellished, such as the small wooden church from the Welham area, which has acquired a fake cemetery with real iron crosses. Other structures, including the Cajun cabins, are modern replicas. The complex includes a building housing exhibits of Indian artifacts and crafts, as well as farming equipment, and serves as a research facility for LSU students of heritage conservation. Within the site is Windrush Gardens, consisting of twenty-five acres of gardens planted by Steele Burden beginning in 1921. The central section has a formal layout with parterres and is surrounded by pine woods and winding paths, along which are statues Burden brought back from his European travels. The gardens also include Windrush House (1850), a one-story galleried guest house, and a brick orangerie designed by A. Hays Town that features large round-headed windows and a gable roof.

EB38　State Archives Building

1985, John Desmond. 3851 Essen Lane

This repository for Louisiana's historical records includes exhibit spaces, storage, an auditorium, a public research room, administrative offices, a book restoration laboratory, and an art gallery. The design, in its simple geometry, piers, and sculpted friezes, gives modern expression to classical forms. A five-bay portico with slender piers shades the lower walls, which are composed of dark greenish-gray polished granite and glass. The second floor, of exposed precast concrete, is treated as a giant entablature, with windows omitted in order to create a secure archival environment. In their place, the facade is faced with five precast concrete panels of bas-reliefs (1987), designed by Al Lavergne, which depict Louisiana's history, especially as it pertains to state government. Both the design of the building and its iconographic program communicate its important cultural role.

Baton Rouge Vicinity

EB39 ExxonMobil (Standard Oil Company)

1909–present. 4045 Scenic Hwy. (U.S. 61)

ExxonMobil is the successor company to John D. Rockefeller's Standard Oil Company, formed in 1882. This refinery was established on the site of a former cotton plantation in 1909. Within a year, it had 700 employees and was processing 1,800 barrels of crude oil a day. Standard Oil officials chose this site because it was secure against flooding, had a deep-draft channel for oceangoing vessels, and was close to the oil fields of northern Louisiana and Oklahoma. Large "kerosene clippers" enabled shipment of products in bulk quantities. Today, crude oil arrives by pipeline from Louisiana and Texas and on oceangoing vessels from overseas. Rapid expansion and diversification added plants for producing paraffin in 1911, lubricating oil in 1913, and asphalt in 1914; cracking stills were built in 1917. Increased demand for petroleum made the refinery the largest in the world by the late 1920s, covering 1,600 acres and employing more than 5,000 people. In the 1930s, the company added a lubricant plant and in 1941 began manufacturing synthetic rubber, ethyl, and propylene, all serving vital needs during World War II. A plastics manufacturing plant, added in 1968 now also produces industrial chemicals. As with any refinery or chemical plant, the ExxonMobil complex is an efficient network of pipes and processors, columnar fractionating towers, and oil tanks laid out in a grid formation. These sleek metal structures present a startling, disturbing, and unintentionally sublime aesthetic.

EB39.1 ExxonMobil Building (Esso Standard Oil Company)

1949, Lathrop Douglass with Carson and Lundin

This five-story office building, designed to provide the abundant space, maximum flexibility, and easy circulation needed by company engineers, is similar to Lathrop Douglass's designs for engineering buildings in Bayway, New Jersey, and the Esso Building in Caracas, Venezuela. The design employs a 4-foot module to achieve complete standardization of facilities for each category of employee. The columns of the structural frame were placed deep within the outside wall to permit a clear span of interior space, so that movable partitions could be readily set against any of the mullions. The cellular steel floor incorporates continuous ducts, allowing wiring to be brought to any location. The light weight of this floor and column system was also desirable because of the soft soil of the site. Since the building's orientation was predetermined by the site and the long sides facing east and west, the horizontal bands of windows were provided with a 3-foot overhang to help control heat and glare. A butterfly-wing concrete canopy on a flared concrete support marks the entrance. The long, clean horizontal lines, white exterior, and rooftop cylindrical and rectangular shapes—inspired by Le Corbusier's design for the Villa Savoye (1931)—used to enclose the cooling tower and fan rooms make this building an icon of post-World War II modernism.

Scotlandville

EB40 Southern University (Southern University and Agricultural and Mechanical College)

1914, with many additions. Harding Blvd.

Founded in 1880, Southern University is the largest predominantly African American university system in the United States, with its parent campus in Baton Rouge and branch campuses in New Orleans (1956) and Shreveport (1964). In 1890, the university became eligible

to receive land-grant funds under the terms of the Morrill Act of 1862, making it the sole historically African American land-grant university system in the country. Southern, chartered by the Louisiana legislature in 1880, was founded in New Orleans as a liberal arts institution, with an enrollment of twelve students. It moved to this site north of Baton Rouge and reopened in 1914 with forty-seven students and seven teachers and today has approximately 9,000 students. In 1915, Favrot and Livaudais designed Southern's first new building, a two-story brick structure. In the 1920s, the Industrial Building for Girls and a larger equivalent for Boys (now the ROTC buildings) were added to the campus. Between 1938 and 1940, William Nolan designed the PWA-funded Art Deco gymnasium-auditorium, a women's dormitory (now Wallace L. Bradford Hall), and two dormitories for men. Since then, many new buildings have been added to the campus. Situated on a bend of the Mississippi River, the university offers spectacular vistas both upstream and down.

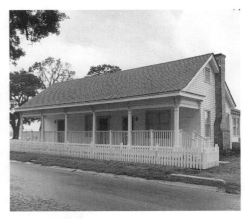

EB40.1 Southern University, Archives Building

EB40.1 **Southern University, Archives Building**

c. 1870. Netterville Dr.

This small raised cottage, three rooms wide and one deep, with a pitched roof and five-bay front gallery, was the only habitable building on the site when the university opened in 1914. In its early years it served many functions, from a home for the president to a women's dormitory and a dining hall. It has now been adapted to house the university's archives.

Alsen Vicinity

EB41 **Union Tank Car Repair Facility**

1958, Synergetics Inc., and Battey and Childs. Brooklawn Dr. (1.4 miles off U.S. 61)

Enclosing two and one-half acres, with a total clear span of 384 feet and a height of 128 feet at the center, this was, at the time of its construction, the largest geodesic dome ever built, as well as the first all-welded steel dome. So impressive was the structure that it was featured in a *Fortune* magazine cover story. Visionary architect R. Buckminster Fuller (1895–1983), the creator of geodesic domes as economical multi-

purpose structures, designed this dome with his firm, Synergetics, Inc. It was one of two built by the Union Tank Car Company for use as a repair facility. The other, smaller dome was in Wood River, Illinois (1959). The larger dome's shell consists of 321 identical hexagonal units, painted yellow, that form the skin, supported by an exoskeleton of tubes arranged in hexagons to which inward-folding metal panels were anchored. Only seven standardized parts were used in constructing the dome. Rail tracks brought the tank cars into the dome, where they were placed on a massive circular transfer table and rotated to one of thirty repair slots. Attached to the dome is a long, low tunnel constructed of identical materials and used for repainting the tank cars. From a distance, the dome and paint tunnel resemble a gigantic igloo. The facility was closed in the 1980s, when the company shifted the work to Houston, and the dome is now empty, awaiting a new owner and a new use.

Zachary

Although Zachary is now a commuter suburb for Baton Rouge, it was an important railroad town in the late nineteenth century. The wood-frame station has been restored. Nearby (at 4512 and 4524 Virginia Street), and dating from the same period, are two Queen Anne houses: a two-story galleried house, with patterned shingles and extensive Eastlake detailing, and the McHugh House (1903), with angled bays and gables, which now serves as a museum.

Zachary Vicinity

EB42 Port Hudson National Cemetery

1867, with additions. 20978 Port Hickey Rd.

Civil War General Nathaniel Banks selected this site as the burial place for Union soldiers who died at the siege of Port Hudson, which lasted for forty-eight days in 1863. To capture Port Hudson, the only site along the Mississippi River not in Union hands, approximately 30,000 Union troops were pitted against 6,800 Confederates. Originally encompassing eight acres, the cemetery has now grown to 19.9 acres. The older section is enclosed by a brick wall constructed c. 1875. A one-and-one-half-story brick lodge with a mansard roof was built in 1879 to a design by Quartermaster General Montgomery C. Meigs, according to a standard plan for Civil War–era national cemeteries. It was heavily restored in 1998. The Port Hudson State Historic Site, the 909-acre site of the battle, is on U.S. 61, thirteen miles north of Baton Rouge.

West Baton Rouge Parish (WB)

Port Allen

Port Allen, laid out in 1854, was named in 1878 for Henry Watkins Allen (1820–1866), Louisiana's last Confederate governor. Until 1940, when the combined railroad and highway bridge (Louisiana 190) was constructed, the ferry from Baton Rouge to Port Allen played a primary role in Louisiana's transportation system. Because the ferry offered easy access to Baton Rouge, Port Allen never developed a major commercial district.

WB1 West Baton Rouge Museum (Old Courthouse)

1882. 845 N. Jefferson Ave.

The West Baton Rouge Museum consists of a section of the parish's third courthouse and two structures, a former plantation house and a slave cabin, that were brought to the site. This surviving piece of the courthouse is believed to have been the records vault room. The Greek Revival columns and gallery across the front of the single-story building of stuccoed brick were added in the 1970s, as was a rear extension that houses a museum focusing on the local sugar industry. The courthouse was demolished in 1950 and replaced by a new structure to the rear of the museum.

WB2 Aillet House

c. 1830. 845 N. Jefferson Ave.

Planter Jean Dorville Landry built this one-and-one-half-story house, probably when he married Aureline Daigle. In 1990, under threat of demolition, the house was moved here from its original site facing the river five miles south of Port Allen. A small plantation house with a pegged timber frame and *bousillage* infill, it has two equal-sized front rooms, two rear cabinets, and, between them, an enclosed stair hall instead of the customary open loggia. Curtain hooks along the front gallery indicate that this space could be screened for use as sleeping quarters in the summer, as was customary in Creole houses. The front rooms have wraparound cypress mantels with paneled sides; Federal influence is evident in the corbeled mantel shelves, rectangular transoms, and molded door and window facings. The two original French doors were replaced with double-leaf screen doors at an unknown date. Paint analysis revealed that the house was originally white with black trim, as it is today. After several owners, Anatole Aillet purchased the house in 1880, and it remained in the Aillet family until Dow Chemical Company purchased the building and its land in 1990.

WB3 Plantation Worker's Cabin (Allendale Plantation Slave Cabin)

c. 1850. 845 N. Jefferson Ave.

This slave cabin, moved here in 1976 from the nearby Allendale Plantation, is believed to date from the period when Governor Henry Watkins Allen owned Allendale. His house was

burned in the Civil War. Two families occupied this four-room structure with board-and-batten siding; providing two rooms, with separate front doors, for each family, it was larger than most slave dwellings. An herb garden has been re-created at one side of the cabin.

WB4 **Port Allen Middle School** (Port Allen High School)

1938, Bodman and Murrell. 610 Rosedale Ave.

This striking Art Deco building was constructed with funds provided by the Public Works Administration (PWA) and designed by Baton Rouge architects Bodman and Murrell. Its principal feature is a central two-story pavilion topped by a large windowless tower, buttressed at each corner and decorated with stylized fleur-de-lis, pelicans, and magnolias and a tall, narrow panel with geometric patterning. Long, low, one-story classroom wings flank the central pavilion, and an auditorium is connected to the classroom wing on the east side. Horizontal parallel grooves above the windows extend across the entire building and combine with the white-painted finish on the concrete walls to give the school a streamlined, modern appearance. The school office and teachers' lounge occupy the central pavilion, whose lobby retains much of its original decoration, including gray marble facing. The upper part of the tower has no useful function but focuses attention on the central entrance.

WB5 **Port of Greater Baton Rouge**

1954–1956, U.S. Army Corps of Engineers. Louisiana 1 (1 mile south of Port Allen)

Located 230 miles from the Gulf of Mexico, this deepwater port is the farthest inland on the Mississippi River. It serves as a point of exchange between oceangoing vessels and river towboats coming down the Mississippi or from the Gulf Intracoastal Waterway via the Intracoastal Canal and the Port Allen Lock. Now ranked seventh in the nation in total tonnage, the port was constructed at this point on the west bank of the Mississippi because the location offered stable banks, a deepwater channel, rail facilities, and proximity to the then-proposed Intracoastal Canal and locks. The dock can accommodate three ships at the same time. The wharf and transit sheds, grain elevators, overhead conveyers, gantry cranes, a molasses

terminal, and a water tower form a monumental ensemble of geometric forms.

WB6 **Port Allen Lock**

1961, U.S. Army Corps of Engineers. 2101 Ernest Wilson Dr.

The Port Allen Lock, opened in 1961, gives access to the Mississippi River from the Intracoastal Canal, which runs south to join the Intracoastal Waterway at Morgan City. Replacing the Plaquemine Lock (IB5) downstream, it facilitated navigation for ships, which no longer had to negotiate the river's current on an upstream journey to Baton Rouge. And via the Port Allen Lock, the route from Morgan City to Baton Rouge was 160 miles shorter than that through the Harvey Lock in New Orleans. The Port Allen Lock was also designed to prevent flooding of low areas southwest of the structure during the Mississippi's high-water stages by allowing runoff through the Intracoastal Canal. The lock chamber's reinforced concrete walls are 68 feet high, 84 feet wide, and 1,202 feet long. Since the gates are designed for a maximum lift of 45 feet, vessels can pass regardless of the river's stage; the process of raising or lowering the water level in the lock takes fifteen minutes. The Port Allen Lock has a visitor center from which lock operations can be observed.

Port Allen Vicinity

WB7 **Poplar Grove Plantation**

1884, Thomas Sully. 3142 N. River Rd. (Louisiana 986) (Not visible from the road)

This house originated as the Banker's Pavilion for the World's Industrial and Cotton Centennial Exposition of 1884, held in New Orleans. In 1886, sugar planter Joseph L. Harris purchased the pavilion and had it transported by barge up the Mississippi River to his plantation, where it was converted into a home for his plantation manager, Horace Wilkinson, and his wife, Julia. The Wilkinsons purchased the property in 1903, and their descendants still occupy the house. Fortunately, the river was unusually high that year, making the task of getting the house over the levee much easier. The interior was given a central hall with two rooms on each side, four fireplaces were installed, and a rear

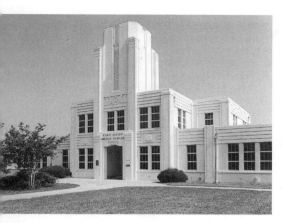

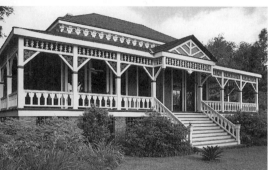

WB4 Port Allen Middle School (Port Allen High School)

WB7 Poplar Grove Plantation

wing was added. New Orleans architect Thomas Sully, who designed the pavilion for the exposition, had decorated the front and side galleries with fashionable machine-made wood trim that included gallery brackets shaped as Chinese dragons, grilles of Eastlake spindles, and an elaborate modillion cornice skirting a hipped roof that rises above the gallery roof. A cupola and spire were removed before the building was taken upriver. The windows have stained glass in checkered patterns. During an early-twentieth-century remodeling, a rear cottage (1850s) was extended and joined to the house. A levee setback of the mid-1920s

brought the river much closer to the house, and a grove of poplar trees was removed. Poplar Grove is open for tours by appointment. A short distance downriver on the west side of the road are a few disintegrating slave cabins, a mere handful of the approximately fifty that still had tenants in the mid-1960s.

Brusly Vicinity

WB8 Cinclare Sugar Mill

1855 to present. Louisiana 1 (at Terrill Dr. 1 mile north of Brusly)

Cinclare Plantation today consists of a working sugar mill and various support structures, including residences, that range in date from c. 1855 to the mid-twentieth century. The plantation was formed in 1855 by combining four tracts of land, each of which were producing sugarcane from at least the early nineteenth century, and was named Marengo. The census of 1860 records seventy slaves and twenty-five slave dwellings at Marengo. Cincinnati businessman James H. Laws acquired the plantation in 1878 and renamed it Cinclare, after his business partner, Lafayette Cinclare Keever. In 1897, Laws replaced the open-kettle mill with a large modern mill in order to process cane from other plantations as well as his own. The mill was expanded in 1906 and again in 1963 and 1984.

Cinclare's historic buildings date mostly from the first half of the twentieth century. They include houses for the mill workers, among which are four ordered from Sears, Roebuck and Co. (c. 1906); the former one-story Greek Revival plantation house (c. 1855); a larger Queen Anne main house (1906), designed by the Cincinnati architecture firm of Wener and Adkins for James Laws's son and successor, Harry; and smokestacks and a water tower. An uncommon structure is the late-nineteenth-century mule barn, particularly notable for its ventilation lantern covered by a rare ogee-shaped cupola in the center of the roof (not visible from the road).

Iberville Parish, West Bank (going south) (IB2–IB11)

Rosedale

IB2 The Church of the Nativity

1859. Laurel St. (off Louisiana 74)

This small frame Gothic Revival chapel with three bays, built for a congregation established in 1858 by the Reverend John Philson, exhibits the simplicity and honesty recommended for rural churches by New York architect Richard Upjohn. The exterior has a single door with a pointed arch on the facade and four windows along each side, and the warm brown wood of the board-and-batten siding has the natural qualities Upjohn considered appropriate. The siding and the steeply pitched roof emphasize the chapel's vertical qualities. The stained glass triple lancet windows behind the altar were made by D'Orsays of New York. The community of Rosedale, which this chapel serves, was named for the Cherokee roses that flourish in the area.

IB3 Live Oaks

1838. 15470 Louisiana 77

Charles H. Dickinson came to Louisiana from Tennessee in 1828 with his fourteen-year-old bride, Anna Turner. In 1838, he built this two-and-one-half-story house of pegged cypress beside Bayou Grosse Tete, perhaps incorporating an earlier structure of 1828. The house has a two-story gallery with square columns and a central entrance opening to a 20-foot-wide central hall. At the rear of this space, where it widens to 24 feet, is a spiral staircase suspended from the curved inner wall, without any support from the floor.

Of the two dependencies flanking the house at the rear, one originally was a combination smokehouse and servants' quarters (only one room of this brick structure survives); the other was a kitchen, although the present building is a reconstruction on the old foundations. A rectangular brick chapel to the left of the house, built around 1840 for the slaves, and the only surviving plantation chapel in Louisiana, has an entrance on the gable end and three windows along each side. It was later used as a schoolhouse and as an Episcopal chapel until the Church of the Nativity was built (IB2). Be-

hind the chapel, a brick tomb holds iron caskets cast in the form of the human body, with sliding metal doors that could be opened to view the deceased's face through a small glassed area. They were dated by the Smithsonian Institution to c. 1830 and said to have been shipped from Spain to Cuba and then to New Orleans.

Plaquemine

Plaquemine, like the similarly named parish, takes its name from the Indian word for persimmon, which early explorers had found growing along the banks of the bayou. Situated at the junction of the Mississippi River and Bayou Plaquemine, which provided a route from the river to the interior of Louisiana, Plaquemine thrived as a steamboat stop and trading center. But after numerous crevasses and floods, the two waterways were separated by a dam in the 1860s. The bayou was reopened to navigation in 1909 with construction of the Plaquemine Lock, which finally closed in 1961. Rail transportation came to Plaquemine in 1881, and trains continue to run along the center of Railroad Avenue. A brick railroad depot at the corner of Railroad Avenue and Main Street, now occupied by a market, dates from 1926. Although many of Plaquemine's earliest buildings were lost to floods and levee setbacks, numerous historic residences survive. Most notable are the Fremin Residence (23520 Church Street), a raised, galleried cottage with

IB5 Plaquemine Lock State Historic Site

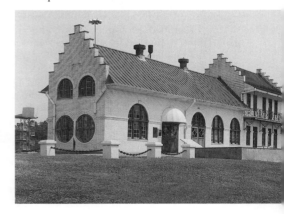

a central-hall plan, built c. 1842; the Joseph Wilbert-Durand House (23670 Church Street), constructed around 1905, featuring a curved gallery and decorative brackets; and the Frederick Wilbert-Hebert House (57725 Court Street), of c. 1885, an exuberant, angular house in the Queen Anne style, with a wraparound, two-story gallery, variously shaped dormers, a widow's walk, and Eastlake trim. Stevens and Nelson designed the former Plaquemine High School (600 Plaquemine Street) in 1911, giving it an enormous Ionic portico that overwhelms the Beaux-Arts facade.

IB4 Iberville Museum (Old City Hall, Iberville Parish Courthouse)

1848. Main St. (corner of Church St.)

Plaquemine was designated the parish seat in 1835, and this one-and-one-half-story courthouse of stuccoed brick replaced an earlier one destroyed by fire. The Greek Revival courthouse has a central portico with four Doric columns and a wood pediment, and the building's brick gable ends are outlined with brick moldings to resemble pediments. A central entrance door is set within a shallow porch and surrounded by an ear-molded frame, the only decorative feature on this simple rectangular structure. The firm of George and Thomas Weldon of Natchez constructed the building. A new, larger courthouse designed by Andrew J. Bryan, a prolific architect of courthouses for Louisiana and other states, was erected at the corner of Railroad Avenue and Meriam Street in 1906, after which the courthouse of 1848 was used as a city hall until 1985. Finally, a third courthouse (58050 Meriam Street) was built behind A. J. Bryan's courthouse, which then became the city hall. It became a museum of local history in 2000.

IB5 Plaquemine Lock State Historic Site

1895–1909, George W. Goethals. 57730 Main St. (at Bayou Plaquemine)

The Bayou Plaquemine Lock allowed ships to pass from the Mississippi River through the bayou to Louisiana's interior. The steel gates had a lift of 51 feet, the highest freshwater lift of any lock in the world at that time, and could withstand the pressure of a 33-foot water level. When completed in 1909, the lock used a gravity-flow system until hydraulic pumps were in-stalled in the late 1940s. The lock closed permanently in 1961, replaced by the larger Port Allen Lock (WB6). When construction on the lock began in 1895, the dynamite blasts were sufficiently powerful to cause structural damage to St. John the Evangelist Church.

The lock's pumphouse (the Gary J. Hebert Memorial Lockhouse) has an exterior facing of white glazed brick, a material chosen for its ability to reflect light, as there were no lighthouses along the river. The lock house has big, round-arched windows and a cast iron balcony; its prominent stepped gables are said to reflect the Dutch heritage of designer Colonel George Goethals (1858–1928) of the Army Corps of Engineers. Goethals later became the chief engineer for the Panama Canal and the first civil governor of the Canal Zone. The pumphouse now serves as a museum, with displays of early river traffic and a working scale model of the lock operation.

IB6 St. John the Evangelist Catholic Church

1926–1927, Emile Weil and Albert Bendernagel. Main St. (corner of Church St.)

The New Orleans architects' design for this brick church, the third on this site (the first was built in 1847), was modeled on Early Christian and Romanesque churches of Italy. A single-story portico with six Ionic columns and end piers extends across the facade in emulation of San Lorenzo fuori le Mura in Rome. Above it the wall is pierced by a rose window and outlined by a simple pediment, similar to that of San Giorgio in Velabro in Rome. This same source was used for the six-story campanile, a freestanding square structure articulated with blind arches on the second and third levels, an oculus on the fourth (filled with a clock in 1994), and triple-arched openings on the top two stages. A projecting cornice over a narrow blind arcade brings the tower to a firm conclusion. Statues of St. John and of St. Louis, king of France, were added to the niches on the upper facade in 1954.

The magnificent interior has the spatial qualities and atmosphere of an Early Christian basilica, such as Sant'Apollinare in Classe in Ravenna. A round-arched arcade with Ionic columns (twelve on each side) separates the nave from the aisles and rhythmically carries the eye to the triumphal arch marking the entrance to the semicircular apse. The architects

added a curved arcade behind the altar, so that it appears to be wrapped by an ambulatory, but this is merely an illusion, as two side chapels block passage beyond the triumphal arch. Again the architects drew on San Giorgio in his design for the hemispherical triumphal arch that is carried on an entablature and Corinthian columns, and also for the baldachino within the apse. The stained glass clerestory windows (1954), located high above the arcade, allow little light to enter, thus giving the interior the mysterious, shadowy qualities characteristic of Early Christian churches. The open-truss ceiling also is Early Christian in inspiration.

St. John's Church played an important role in Catholic education in the area, opening its first school in 1853. To the left of the church, the three-story brick structure began as a two-story building (1911) for the school (St. John School), acquiring its third floor in 1949. It is now used for church programs and administration. Behind it is the rectory, which dates to 1882.

IB7 **House** (St. Basil's Academy)

c. 1850. 23515 Church St. (corner of Court St.)

Dr. Edward Scratchley blended Creole and Anglo-American features for this two-story structure that began as a house and, in 1859, was sold and used for a school. Creole features are the brick lower floor and wood-frame upper level, French doors, and a second floor without a hall, the rooms arranged en suite. Anglo-American influence can be seen in the first floor's central hall, chimneys on the exterior walls rather than between rooms, the paneled square columns of the upper gallery, and the overall Greek Revival appearance. Scratchley sold the house for $7,500 to the Marianite Sisters of the Holy Cross in 1859. Six of the sisters had arrived in Plaquemine in 1857 to staff the girls' school, founded that year by Father August Chambost, and named it in honor of St. Basil, whose name was the same as that of their founder, Father Basil Anthony Moreau of Le Mans, France. The school merged with St. John School for Boys in 1937 and became St. John High School. Following the Civil War, the sisters also staffed St. Augustin's Colored High School, located a block away (now demolished), established in 1880 by Father M. Harnais of St. John Church. After the sisters vacated the building in 1976, it was sold, first

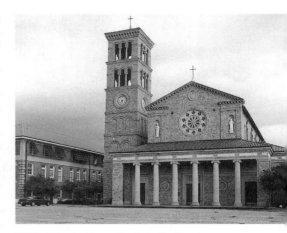

IB6 St. John the Evangelist Catholic Church

converted into a restaurant and, in 1985, into a residence.

IB8 **Brusle Building**

c. 1889. 23410 Eden St. (between Main and Plaquemine sts.)

This decorative two-story Italianate building, now used as a law office and residence, began as the Bank of Plaquemine. At the first-floor level, tall, narrow, paneled piers mark the four-bay facade. The second story is more elaborate, with four round-arched windows capped by prominent hood moldings and keystones and set between paneled pilasters. A projecting metal cornice punctuated with modillions decorated with acanthus leaves, brackets, and miniature piers is finished with a central pediment-shaped tablet topped by a pediment inscribed with the date of construction. This facade is painted in a medley of colors to emphasize its ornate character.

Plaquemine Vicinity

IB9 **St. Louis Plantation House**

1858. 57500 St. Louis Rd. (off Louisiana 405, 1 mile south of Plaquemine)

When coffee merchant Edward J. Gay came to Louisiana from St. Louis, he purchased this plantation, then named Home Plantation, and renamed it after his hometown, then built a house to replace an earlier one swept away by the Mississippi River in the 1850s. Gay became

one of the largest planters in the state and the first president of the Louisiana Sugar Exchange of New Orleans; he also served in the U.S. Congress from 1884 to 1889, the year he died. His two-story frame house, with galleries front and back (the rear gallery is now partially enclosed), rests on a brick below-ground basement, an unusual feature for southern Louisiana, which was probably used to keep foods cool. The building's vertical emphasis and delicate gallery, composed of Ionic columns on the ground floor and Corinthian above and cast iron railings in a grapevine pattern, combine to give it a distinctly urban appearance. As a departure from the rural tradition of isolating the kitchen as a separate structure, here a two-story kitchen wing is attached to the rear of the house—a common urban solution. A pediment-shaped parapet completes the facade, and a widow's walk crowns the center of the hipped roof. The interior of the house has a 16-foot-wide central hall, eleven bedrooms, and carved Italian marble mantels that were ordered by catalogue from Philadelphia. On the property are fourteen "slave cabins" of unknown date, possibly post–Civil War. It is known, however, that in 1856, forty-nine families lived on this plantation in twenty-five double cabins, a total of 167 slaves. The formal garden is being restored. Edward Gay's grandson, Edward J. Gay II, lived in the house while serving as U.S. senator for Louisiana from 1918 to 1921.

White Castle Vicinity

IB10 Nottoway Plantation

1857–1859, Howard and Diettel. 30970 Louisiana 405 (2 miles north of White Castle)

With sixty-four rooms in 53,000 square feet of space, Nottoway is one of the largest antebellum houses in the South and the largest surviving plantation house in Louisiana. John Hampden Randolph reviewed designs from several architects before he signed a contract in 1857 with the prominent New Orleans firm of Henry Howard and Albert Diettel for a fee of $1,250. Randolph chose well, for Howard and Diettel were designing mansions that had the size, grandeur, elaborate plans, and rich ornamentation that could satisfy a client wishing to display exquisite, up-to-the-minute taste as well as wealth.

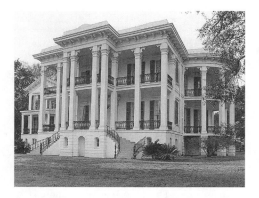

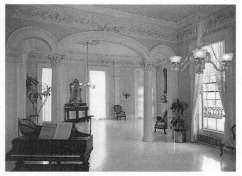

IB10 Nottoway Plantation, exterior and ballroom

In plan and composition, Howard and Diettel reiterated the decisive and imaginative break from the typical Louisiana plantation house that Howard had introduced at Belle Grove (mid-1850s), now destroyed. Nottoway features a separate bedroom wing that extends from one side of the main section of the house and a large curved bay with galleries on the other side, creating an asymmetry rarely seen in a plantation house. The structure emphasizes height rather than width by giving the first and second floors the same height (15 feet)and by raising the house on a brick basement. This allowed Howard and Diettel to include a double curved staircase in front, which rises to the first floor, so that the house extends two full floors above it to convey an impression of great height. Typically, such staircases rise to the second floor, as at Evergreen Plantation (JO7). The close spacing and angularity of the gallery's piers and their elongated capitals also emphasize the vertical qualities of the house. Above the capitals, small brackets branch out to carry a tall entablature decorated with modillions, supporting a dramatic projecting cor-

nice. Although Nottoway is built of wood, its crispness, visual solidity, and the rusticated stucco facing on the brick basement give a first impression of stone.

The house has a central hall (12 feet wide and 40 feet long), flanked by a library, stair hall, and dining room on one side and a ballroom on the other. The principal interior feature is the ballroom, which is all white (including the floor), with a freestanding Corinthian arch and an L-shaped extension into a curved bay. Molded plaster ornamentation in the house includes friezes and cornices, which in the central hall feature modillions interspersed with paterae. The rococo marble mantels are black in the dining room and library, gray in the bedrooms, and white in the ballroom. The house also incorporated luxuries of a more functional order—indoor plumbing, gas lighting, and coal fireplaces—all innovative features at the time. Seven interior staircases facilitated service while maintaining a strict separation of activities and hierarchies. Behind the house was an underground vault for storing the coal used in manufacturing gas for illumination. Originally an allée of oaks led from the house to the river.

The census of 1860 records that Randolph owned 155 slaves, who lived in forty-two cabins. Randolph and his wife, Emily Jane Liddell, raised ten children in the house, and all six of his daughters celebrated their weddings in the white ballroom. The Civil War began just two years after the house was completed. After Randolph died in 1889, his widow sold the plantation for $100,000, and Nottoway subsequently had a succession of owners. Nottoway is open for tours.

Dorseyville

IB11 St. John the Baptist Church

c. 1869. 31925 Lacroix Rd. (off Louisiana 1)

Former slaves founded Dorseyville (sometimes mapped as Dorcyville) after the Civil War, naming it in honor of the Reverend Bazile Dorsey, the first pastor of St. John the Baptist Church. The clapboarded structure has a gabled facade, a two-stage square tower over a projecting pedimented central bay, and a central doorway with a blind arch beneath a pediment. The basilican plan is five bays deep, with a second-story gallery on three sides of the interior. The windows are clear glass. Like other African American churches in Louisiana, St. John the Baptist played a crucial role in the education of African American youth. In the public-private arrangement in widespread use for African American schools in Louisiana at the time, the parish school board provided some financial support and the church provided the facilities.

Ascension Parish, West Bank (going south) (AN6–AN18)

Donaldsonville Vicinity

AN6 Mulberry Grove Plantation

c. 1836, with additions. 8579 Louisiana 405 (corner of Mulberry Grove Rd.)

Dr. Edward Duffel, from Virginia, had this two-story house constructed for his Acadian bride, Celeste Landry. A brick lower story and frame second story, French doors on the second floor, and an exterior staircase on the rear gallery show that the house was faithful to Louisiana's Creole traditions. However, its symmetrical central-hall plan and the Greek Revival front and rear galleries supported on piers reveal Anglo-American influences. The Greek Revival style is

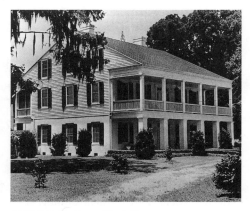

AN6 Mulberry Grove Plantation

also visible in the row of dentils along the entablature, pediment-shaped lintels, and shoulder molding over doors and windows. A few dependency buildings survive, among them a large barrel-shaped cypress cistern (c. 1836) raised on a circular brick base, a board-and-batten privy (c. 1890), and (to the left and facing the highway) a row of four two-room workers' cabins (also c. 1890), which have scroll-shaped bargeboard decoration on their end gables.

After the Civil War, John B. Reuss purchased the plantation to add to his other holdings in the parish; in the twentieth century, the house had several different owners. In the 1990s, an elevator tower was added to one side of the house. Mulberry Grove is still a working plantation.

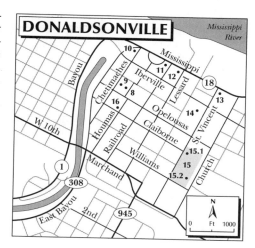

AN7 Evan Hall Slave Cabins

c. 1840. Louisiana 405 (near the junction with Louisiana 1)

Slave cabins constructed of brick rather than wood were rare in Louisiana. These buildings are unusual not only in employing that material but also in having such structural refinements as relieving arches over doors and windows and along the foundations. Of the two surviving cabins, one is four rooms wide and the other, two rooms. Chimneys are set between each pair of rooms, and wooden galleries run along the facades. The larger of the two cabins was converted into a private house in the 1980s and given a reconstructed pitched roof and gallery; the smaller cabin beside it was maintained as a picturesque ruin. Sugar cultivation at Evan Hall Plantation, owned by Evan Jones, began in 1807, and by the early twentieth century, Evan Hall's sugar mill was one of the largest central factories along the lower Mississippi River. The mill continues to operate, and its metal-sided buildings and towering chimney stack dominate the corner of Louisiana 1 and 405.

Donaldsonville

In 1806, William Donaldson hired architect and engineer Barthélemy Lafon to survey and prepare a town plan for land he owned at the junction of Bayou Lafourche and the Mississippi River. Lafon's scheme included a riverside boulevard and a crescent-shaped park (Crescent Place) facing the Mississippi River and the steamboat landing, from which an avenue ran inland to a large public square (Louisiana Square). Unfortunately, the clarity of Lafon's scheme has been diminished by twentieth-century buildings set back from their property lines and by surface-level parking lots along the outer edge of the Crescent. Donaldsonville prospered quickly as a riverboat stop, as the commercial and social center for the nearby plantations, and, from 1830 to 1831, as the capital of Louisiana. The Civil War brought this era to an abrupt close, for Admiral David Farragut's bombardment of Donaldsonville from the Mississippi River in 1862 caused extensive damage. To protect shipping lanes, Union soldiers and former slaves built the star-shaped earthen Fort Butler in 1862 to a design by Union soldier John Carver Palfrey. Recent excavations at the site have yielded numerous Civil War artifacts, and there are plans to reconstruct the fort.

Downtown Donaldsonville, rebuilt after the war, includes an Italianate Elks Building (1912; 115 Railroad Avenue) with a prominent bracketed cornice; a three-story Italianate brick structure (c. 1891; 122 Railroad Avenue), with third-story windows grouped in pairs, which accommodated a bank and a Masonic hall; the red brick U.S. Post Office (301 Iberville Street), a Colonial Revival structure with a tall cupola, designed by Louis Simon in 1937; an attractive row of late-nineteenth-century frame shotgun houses with Eastlake decoration (700 block of Lessard Street). A pre–Civil War survivor is the diminutive Carpenter's Gothic First

United Methodist Church (1844; 401 Railroad Avenue). On the other side of the railroad tracks is the block-long former Donaldsonville Rice Mill (now a commercial building), which local boosters claimed was the largest rice mill in the world when it was built in 1901. The brick structure combined both the mill (in the four-story central section) and warehouse space (in the two-story wings). In 1903, a dam was built to separate Bayou Lafourche from the Mississippi River in order to protect villages and plantations below Donaldsonville from spring floods.

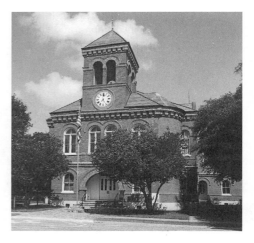

AN8 Ascension Parish Courthouse

1889, James Freret. 300 Houmas St.

This was Freret's second courthouse for Ascension Parish; his first, designed in 1887, was destroyed by fire in early 1889. Freret's drawing for the first scheme, in the Southeastern Architectural Archive at Tulane University, reveals that the two buildings were similar. Constructed of red brick, the two-story Romanesque Revival building, with its projecting square central tower, tall round-arched windows, and wide-arched entrance, has a solid, grounded appearance, similar to the work of H. H. Richardson. Freret attached a curved bay to the tower's right side to contain a circular staircase; this bay adds a subtle asymmetry to what at first glance appears to be a bilaterally symmetrical building. Surface articulation includes moldings over the round-arched windows and doors and corbeling along the eaves. Banded gray and red roof slates such as those incorporated here were a fashionable element in the 1870s and 1880s. A central hall crosses the interior space, which retains its wood door surrounds, beaded wood ceiling, and wood wainscoting. The courthouse faces the square that Lafon included in his urban plan of 1806.

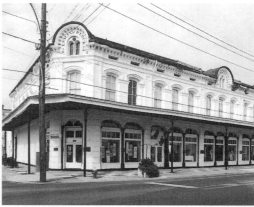

AN8 Ascension Parish Courthouse

AN11 Historic Donaldsonville Museum (B. Lemann and Bro. Store)

recorder's office, and jury room were squeezed into the second story. In 1889, the new courthouse (AN8) was completed.

AN9 Ascension Parish Sheriff's Office
(Ascension Parish Jail)

1867. 300 block of Chetimatches St.

This two-story brick structure was built by Thomas Supple as a temporary replacement for the courthouse and jail destroyed during the Union bombardment of Donaldsonville in 1862. Gable-end parapets are the building's only elaboration. A jail and sheriff's office occupied the ground floor, and the courtroom,

AN10 Commercial Building (Bel House)

c. 1881. 100 Chetimatches St.

Nemours Bel built this narrow two-story, stucco-covered building to serve as his drugstore and residence. A two-story cast iron gallery supported on slender columns curves around the building to shade its two principal facades. A narrow service wing extends from the back of the building. Greek Revival paneled piers outline the corner entrance, and the four dormer windows are topped by small pediments.

AN11 Historic Donaldsonville Museum
(B. Lemann and Bro. Store)

1877–1878, attributed to James Freret. 318 Mississippi St.

German-Jewish immigrant Jacob Lemann opened the first Lemann store in Donaldsonville in 1836, and his sons, Bernard and Meyer, built this handsome two-and-one-half-story structure of stuccoed brick after the Civil War. The design is attributed to James Freret on the basis of payments he received in 1877 and 1878 for work done at the Crescent (part of the store faces Crescent Place). Interior walls defined departments for dry goods and notions, hardware and groceries, and an all-purpose section, but these divisions were unified on the exterior by a continuous Italianate facade. It is the most ornate commercial building along the lower Mississippi, harmonizing such features as tall, attenuated cast iron pilasters between the ground-floor display windows; pronounced moldings over the segmental-arched windows; a modillion-ornamented cornice under a hipped roof; third-floor window arches and tiny rectangular windows; and a one-story gallery supported on thin, widely spaced cast iron columns. A two-story brick warehouse annex was constructed on the store's Crescent Place side in the 1890s. When the Lemann Store was converted into a history museum in the 1990s, the interior fluted cast iron supports were incorporated into the design.

AN12 Whitney National Bank (Bank of Ascension)

1911–1912. 420 Mississippi St.

The Bank of Ascension, organized in 1896, built this handsome Beaux-Arts structure after its first building was destroyed by fire. The surface of white glazed tile, cut into large squares, resembles marble when seen from a distance. Paired fluted Ionic columns flank the entrance portico and support a pediment heavily embellished with modillions and dentils. A semicircular fanlight over the door helps illuminate the interior. The two-story-high banking hall retains its elaborately corniced ceiling.

AN13 Church of the Ascension of Our Lord Jesus Christ

1876–1896. 716 Mississippi St.

Midway through the building campaign for this church, a shortage of funds brought the project to a halt, and the interior arcade's marble columns, imported from Austria in 1883, sat on the levee for three years. Although the columns were eventually moved into the church for protection, construction did not resume until 1895. Dominating the brick church is an immense square tower situated in the angle between nave and transept and topped by a tall steeple. The low-scale, triple-arched entry on the principal facade is proportionally overwhelmed by the tower and the enormous pointed-arched stained glass window above it. Tower-like buttresses anchor each corner of the facade, and nestled behind them are slender turrets crowned with hexagonal spires. The colorful interior has a pointed-arched arcade on marble columns with elaborate capitals and a pointed-arched wood barrel vault with transverse ribs.

AN14 Ascension Catholic Primary School
(St. Vincent's Institute)

c. 1850. Bounded by Iberville, St. Vincent, Opelousas, and St. Patrick sts.

The Sisters of Charity of St. Vincent de Paul established a hospital, orphanage, school, and convent in Donaldsonville in 1845. Only the rear of this two-story brick building is fully visible today (from Opelousas Street), since the facade, with its modest pedimented portico, four dormers, and central bell tower, is obscured by a twentieth-century structure in front of it. A two-story wooden gallery with angled brackets shades the rear wall and is accessed on the upper level through French doors. The extensive grounds were landscaped and used as a place for students to exercise, for the sisters believed a sound mind required a sound body. Around 1890, the hospital and orphanage were closed, and the school began to accept girls from all religious denominations. Now a Catholic primary school, it is associated with the Church of the Ascension.

AN15 Ascension of Our Lord Catholic Church Cemetery

c. 1772. Bounded by Opelousas, St. Vincent, Church, and Williams sts.

This Catholic cemetery was laid out on a grid plan shortly after the church parish was

founded in 1772. It contains several interesting raised tombs of stuccoed brick or stone with temple fronts of different styles, which date from the mid-nineteenth century.

AN15.1 Bringier Tomb

c. 1845, attributed to J. N. B. de Pouilly

The Bringier family tomb, at the Opelousas Street side of the cemetery, is four vaults high and four vaults wide. The tall marble tomb has acroteria at its corners and is surmounted by a marble cloth-draped urn. Two sides of the tomb are elaborated with giant arches flanked by inverted torches, although one of these sides has been damaged. The tomb's design is attributed to de Pouilly on the basis of its similarity to his design for the Iberia Society tomb (1843–1845) in St. Louis Cemetery 2 in New Orleans. Michel Doradou Bringier of L'Hermitage Plantation (AN3) was the first of the Bringier dynasty to be buried here (he died in 1847). The tomb also contains the remains of those who married into the family, such as Duncan Kenner of Ashland Plantation (AN4).

AN15.2 Landry Tomb

c. 1845, attributed to James Dakin

Dominating all the other above-ground tombs in this cemetery is the monumental burial vault of the Landry family. Arthur Scully, Jr., James Dakin's biographer, bases a convincing argument that the tomb is a Dakin design on Dakin's drawing for a similar tomb and on the Landry tomb's architectural features. Set on a heavy base, the tomb rises in two stages that are treated as separate templelike constructions but unified by similar architectural features. The lower stage is entered through an iron gate above a flight of four steps with elaborately scrolled sides. Like this side, the other three are articulated with Doric piers but are set in blind porticoes between four massive battered corner piers crowned with urns. The tomb's upper stage is composed of a tall pavilion top, again with paired piers set in antis in blind porticoes, but crowned with pediments. Piers in antis are an identifying feature of Dakin's work, as seen at the Arsenal in New Orleans (OR9). Dakin's design has echoes of English architect John Soane's early-nineteenth-century tombs in the reductive massing and decoration, the two stages, and the heavy chamfered corners

that emphasize the sense of weight. Nevertheless, Dakin's design is an imaginative and impressive creation. Members of the Landry family owned plantations in Ascension and St. James parishes.

AN16 St. Peter's United Methodist Church

1895. Corner of Houmas and Claiborne sts.

This Gothic Revival frame church was built for an African American congregation. Wooden decorations featuring a cross within a circle and trefoils are set in front of the apex of the gables on both front and side elevations, and paneled buttresses set up a rhythm along the side walls. At the corner of the building is a square bell tower that incorporates a narthex. Hand-carved arches cover the single nave, and the pointed-arched windows are filled with squares of colored glass.

Donaldsonville Vicinity

AN17 Palo Alto

c. 1852. Louisiana 1 (2.5 miles south of Donaldsonville at the junction with Louisiana 944)

Palo Alto plantation house was probably built by Pierre Oscar Ayraud and his wife, Rosalie, who inherited the plantation from her father, Mathias Rodriguez, in 1852. (The succession documents make no mention of a house among Mathias Rodriguez's improvements to the plantation.) Palo Alto is an excellent example of the type of smaller plantation residence that was prevalent throughout Louisiana. The one-and-one-half-story, central-hall house has a front gallery incorporated into the pitch of the gable roof and supported on six tapered and paneled box columns. Side and interior walls are of brick-between-posts construction, a late survival here of early techniques, as is the rear loggia (now enclosed) between cabinets. The double staircase at the front was reconstructed according to the original, as depicted in a watercolor painting by artist Marie Adrien Persac (1823–1873), made sometime between 1852 and 1860, when Persac made paintings of several southern Louisiana plantations for their owners. The octagonal panes of glass that fill the transom and side lights of the front door are original. In contrast to the simple exterior, the interior possesses an elabo-

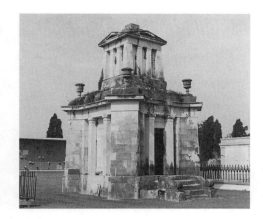

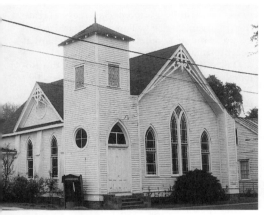

AN15.2 Landry Tomb

AN16 St. Peter's United Methodist Church

rate foliate cornice and ceiling plasterwork in the 14-foot-high rooms.

To the left of the house is the former kitchen, a two-room structure with a facade similar to that of the main house (not connected to the house by a recent addition). Persac's painting also shows that the property was surrounded by a white picket fence and included several outbuildings, a double row of slave cabins to the right of the house, and a sugarhouse. The *pigieonnier* is a reconstruction based on one shown in Persac's painting. A one-and-one-half-story, four-room frame dependency of c. 1880 was moved in 1979 to the rear of the house (34278 Louisiana 944) from a different location on the plantation. According to family tradition, the cottage was formerly an overseer's house, and the annex behind it served as a dining facility for workers. Approxi-

mately one-quarter of a mile farther along this road is a double row of two-room workers' cabins. Jacob Lemann, whose family owned the B. Lemann and Bro. store in Donaldsonville (AN11), acquired the plantation in 1867.

AN18 St. Emma Plantation House

c. 1850. 1283 Louisiana 1 (3 miles south of Donaldsonville)

Although it has been proposed that St. Emma was the work of New Orleans architect Henry Howard, his hand is not apparent in this well-proportioned but quite traditional design. Nor does Howard claim it as his work in his autobiographical sketch of 1872. German-born sugar planter Charles A. Kock purchased the plantation from Jean Baptiste Letorey in 1854. The census of 1860 records that Kock owned 124 slaves, who lived in thirty cabins. Kock also owned Belle Alliance Plantation in Assumption Parish (AM6). The two-and-one-half-story Greek Revival house has a ground floor of brick that is stuccoed and scored to resemble stone and an upper story of wood. Front and rear two-story galleries are supported on rectangular brick piers at ground level and square paneled wood supports above. The front gallery's iron railings were cast in Gothic Revival designs of pointed arches and quatrefoils. In the nineteenth century, a double staircase at the front of the house led to the second floor. Both staircases are now in the galleries, one at the front and the other at the rear. In the post–Civil War period, plantation workers probably used the rear staircase to reach a second-floor room at the back of the house that contained a cubicle where they received their pay. The relocation or addition of staircases in Louisiana plantation houses was a common occurrence, and it is interesting to speculate on whether such alterations resulted from changes in fashion, in family size and activities, or relationships between owners and slaves or servants, or from all of these. Following Creole tradition, St. Emma has no interior stairs, but it has an Anglo-American central-hall plan, with three rooms on each side; an angled bay was later added to one side. St. Emma and nearby Palo Alto Plantation were the scenes of a Civil War confrontation in 1862, during which 465 Union soldiers were killed. The sugarhouses of both plantations also quartered Confederate troops. Charles Kock sold the plantation in 1869, after which it had a succession of owners.

St. James Parish, West Bank (going south) (JM6–JM7)

Vacherie Vicinity

JM6 Oak Alley

1837–1839, attributed to Joseph Pilié. 3645 Louisiana 18

The 800-foot-long allée of twenty-eight massive, ancient live oak trees leading from the river to the columned house constitutes one of the most familiar and evocative images of Louisiana's grand plantation houses. The oaks were planted by an earlier settler almost a century before Jacques Télésphore Roman (brother of Governor André Roman) and his wife, Marie Thérèse Celina Pilié Roman, acquired the plantation. The Romans' new house, which they named Bon Séjour, was built by George Swainey, although Samuel Wilson attributed its design to architect Joseph Pilié, Marie Thérèse's father. Oak Alley is square in plan and constructed of brick, stuccoed and colored pale peach. Measuring 70 feet on each side, the house is surrounded by a gallery supported on twenty-eight colossal Tuscan columns, the same number as the oak trees. The hipped roof has three gabled dormers with round-headed windows on each side, which were added in the twentieth-century restoration undertaken by architect Richard Koch.

Compared with the grand exterior, the interior is surprisingly low-keyed. The rooms are large but not ostentatious, and the plan is quite simple, with a central hall on both floors. Doors at each end of the halls have elliptical fanlights and narrow side lights framed with delicate fluted colonnettes.

No buildings survive to tell about the life of the slaves who worked this 9,000-acre plantation, although records indicate that the slaves were housed in twenty-four cabins, each 40 feet square and divided into four rooms. Other buildings included a hospital, an overseer's house, stables with 100 stalls, a sugarhouse, and a sawmill. In 1846, field slave number 128, Antoine, successfully grafted pecan trees to create the first named variety, Paper Shell, which was grown in the first commercial pecan orchard at nearby Anita Plantation.

Oak Alley had several owners after the Romans and in 1925 was restored by architect Richard Koch. More recently it was featured in the films *The Long, Hot Summer* (1957) and *Interview with the Vampire* (1994). The house is open to the public.

Downriver from Oak Alley (approximately one-quarter of a mile) is St. Joseph Plantation, also known as Josephine House, built c. 1842, then enlarged and remodeled in 1858 by Alexis Ferry and his wife, Josephine Aimé. The galleried house is raised on brick piers and has a vast hipped roof with three dormers.

JM6 Oak Alley

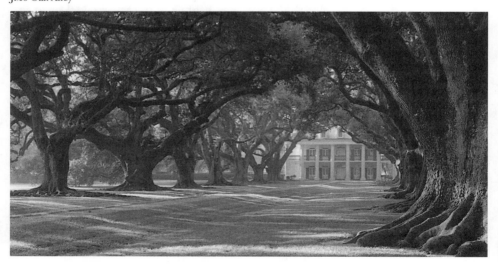

JM7 Laura Plantation

1805. 2247 Louisiana 18

French-born Guillaume DuParc, the former commandant of the Spanish post at Pointe Coupée, and his wife, Nanette Prudhomme, built this house in 1805 on a 13,000-acre federal land grant made under Thomas Jefferson's presidency. Raised on brick piers and constructed of brick between posts, the house was five rooms wide and two rooms deep, with front and rear galleries and covered by an umbrella roof on a Norman truss. Side galleries added in the 1820s were enclosed for use as bedrooms in 1822. By the early twentieth century, the house had a projecting gabled entrance porch with a sunburst motif and double stairs in front, and the gallery was adorned with Eastlake brackets and with sawtooth trim along the roof. The house is painted in the varied bright colors preferred by Creole families: yellow exterior walls, green shutters, white and red trim, and a red roof.

Laura's history is unique in that for nearly a century the plantation was managed by women, first by Guillaume's widow, Nanette, then by her daughter, Elizabeth, whom she chose rather than her two sons as heir to the property. Elizabeth's forty-seven-year tenure was infamous for her harsh treatment of her slaves. With her husband, French immigrant Raymond Locoul, who owned vineyards in France, Elizabeth operated a distribution center for Bordeaux wine; more than 10,000 bottles of wine were stored on the ground floor of the house. In 1876, Elizabeth divided the plantation equally between her daughter, Aimée, and her son, Emile; the house itself was also divided in half for the use of each family. When Laura Locoul Gore, Elizabeth's granddaughter, inherited the house, she had already decided to move north, so she sold it in 1891 to Florian Waguespack on the condition that the house carry her name. Her memoir, written in 1936, proved an important source for the restoration of the house, which its current owners, Norman and Sand Marmillion, began in 1992. The house opened for tours in 1994.

Outbuildings at Laura include a two-story dowager house, built in 1829 for Nanette DuParc. Constructed of brick with wood sheathing on the exterior, the house is five rooms wide and one room deep. In addition to two cottages and farm buildings, including a barn, six small slave cabins survive, but since the latter were extensively reworked in the late nineteenth century, they should be dated to that era. Laura and neighboring plantations are home to the Br'er Rabbit and Br'er Fox stories made famous by Joel Chandler Harris. The stories are based on tales brought from Africa by slaves and handed down to their descendants.

St. John the Baptist Parish, West Bank (going south) (JO6–JO9)

Wallace

JO6 Whitney Plantation

1803, with additions. Louisiana 18

Whitney Plantation was formed in the 1820s out of several tracts acquired beginning in the 1760s (and perhaps as early as the 1750s) by German immigrant Ambrose Haydel and his sons. Around 1790, one of Haydel's sons, Jean-Jacques, Sr., built a raised house with a first floor of plastered brick and an upper floor of brick between posts. Its Creole plan of three rooms across the front, a rear loggia and cabinets, and a front gallery was similar to that of his brother Christophe's house, Evergreen (JO7). In 1803, the house was expanded to five rooms in width and given a new and larger hipped roof. At Jean-Jacques's death in 1819, his sons, Jean-Jacques, Jr., and Marcelin, ran the plantation until c. 1830, when Marcelin took over. He remodeled the house between 1836 and 1839, adding dormers and ceiling, wall, and door murals depicting flowers and foliage and incorporating cartouches and crests with the initials *M.H.*, presumably for Marcelin. A putto atop an urn was painted on the loggia's wooden wall. On the basis of the painting style, Dominique Canova has been proposed as the artist, although there is no documentary evidence to support this attribution.

Numerous nineteenth-century dependency buildings survive at Whitney, among them an early-nineteenth-century barn raised on brick piers, which has a mortised, tenoned, and

pegged timber frame and a Norman truss supporting the hipped roof; an overseer's house; a square, two-story brick *pigeonnier*, one of two, probably built before 1820, that originally existed (the *pigeonnier* on the right is reconstructed on its original foundations); and, facing the road, a one-story plantation store of c. 1890 with a three-bay gabled porch. The census of 1860 records that Haydel owned ninety-seven slaves housed in twenty cabins.

In 1867, Bradish Johnson of New Orleans (see OR112) purchased the plantation, renaming it Whitney for one of his grandsons. Following a succession of owners, Formosa Plastics acquired the plantation in 1989, intending to build a plastics plant and restore the house. Strong opposition from preservationists, environmentalists, and local residents caused this plan to be abandoned. By this time, the plantation's structures were in deplorable condition, but it was subsequently sold to a private individual who is restoring the buildings.

Wallace Vicinity

JO7 Evergreen Plantation

1832. 4677 Louisiana 18

Evergreen is one of the largest and most intact plantations in the South. Its thirty-seven historic buildings include the big house, two *garçonnières*, kitchen, privy, and other dependency buildings, and a double row of twenty-two slave cabins on the original 22,000 acres. The present house is an expansion and remodeling of a two-story Creole house built in 1790 by planter Christophe Haydel, the brother of Jean-Jacques, who built Whitney Plantation. Haydel's grandson Pierre Clidament Becnel acquired Evergreen in 1830 and two years later hired John Carver, a builder and carpenter then living in St. Charles Parish, to transform the Creole house by remodeling it according to the latest taste in the Greek Revival style. Becnel had studied in Philadelphia, where his exposure to some of the nation's best examples of Greek Revival architecture presumably gave him a deep appreciation for the style. And, indeed, Evergreen's version is more urban and delicate than was typical of Greek Revival remodelings of other River Road plantation houses, such as Destrehan (CH2) and Houmas (AN1), with their thick, heavy columns.

The transformation began with the enclosure of the ground floor, raising its height by 2 feet and the upper floor by 2 1/2 feet. Tuscan columns two stories in height support a 10-foot-deep gallery that stretches across the front of the house and partway along each side. At the center of the facade is a pedimented portico that leads to an entrance door with an elliptical fanlight and side lights framed by fluted pilasters. As Becnel specified in the building contract, "In front of the venetian door a balcony or portico must be made to project out of the gallery eight feet by twelve." The house has a hipped roof and a widow's walk. On top of this, Becnel wanted an octagonal pavilion "shaped in the Chinese style," but it is not known if this was ever built. Becnel stipulated access to the principal entrance on the second floor: "Two winding stairs . . . must gracefully wind down with the proper slope so as to present the lower step fronting the river." A similar double staircase had been built in 1826 for the Greek Revival Beauregard-Keyes House in New Orleans (OR31). The central portico and staircases of Evergreen's exterior elevation imply that the house has a central hall, but Becnel retained the Creole plan of three rooms across the front, with a loggia flanked by cabinets behind and stairs leading to a parlor. As was typical of Creole houses, a dining room occupied the center of the ground floor.

Becnel replaced the old dependencies with new Greek Revival ones. A pair of square brick *pigeonniers* flanks the house, each two stories tall and with a circular window above the door. Beyond these are a matching pair of two-room *garçonnières* with front galleries, and behind the house are a kitchen and guest house with galleries also in the Greek Revival style. At the rear of the house is the fifth building, a Greek Revival brick privy designed to resemble a miniature temple. Its exterior, stuccoed and scored to resemble stone, is elaborated on two sides by four pilasters supporting pediments; the interior is divided into two compartments, each 6 feet square. These dependency buildings created an idealized and balanced setting for Becnel's elegant house. But it all proved too much for his budget, for by 1835 he was heavily in debt to his creditors, several of whom were in the building trades.

At some distance from the rear of the house is a double row of twenty-two slave cabins, the largest surviving group in Louisiana. Each row comprises ten two-room cabins, with a four-room unit located midway along each side. Built between 1830 and 1860 and placed 50

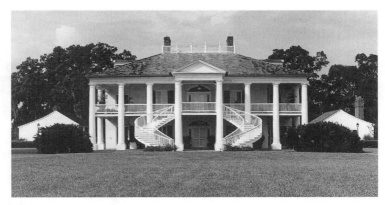

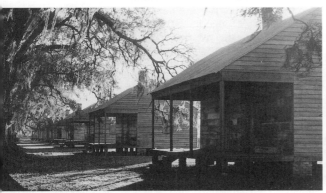

JO7 Evergreen Plantation (top), slave quarters (above, left), and privy (above, right)

feet apart, the frame cabins are raised on brick supports, with exposed beams on their front galleries and interiors. Although they lack any interior wall finish, they have wraparound chimneypieces. Archaeological investigations near the cabins have uncovered pottery fragments, beads, and bird traps that date from the 1830s. The sugar mill stood at the end of the row, and although this no longer exists, three late-nineteenth-century barns survive. Upriver from the main house and closer to the road is a seven-bay galleried and hip-roofed house, which has been tentatively identified as an overseer's house.

The plantation remained in the Becnel family until the 1890s, when the Songy family purchased it. But the great flood of 1927, sugarcane mosaic disease in the 1920s, and the Great Depression of the 1930s took their toll on the plantation's fortunes. By the time oil heiress Matilda Gray of Lake Charles purchased Evergreen in 1944, it was in a dilapidated state. Architect Richard Koch began the restoration for Gray, and Douglass V. Freret continued the work into the early 1950s. Freret redesigned the double staircase, as only one flight had survived the years. Although he followed Becnel's description in the contract of 1832, Freret gave the stairs a more dramatic curve and enclosed the rear loggias on both floors.

Evergreen's oak allée along the side drive is only fifty years old, but that of the slave quarters is much older. The French parterre garden at the front of the house is original, and the rear parterre was laid out in 1944 when Matilda Gray purchased the plantation.

As Louisiana's most intact plantation, Evergreen offers a remarkable picture of the social hierarchies and dynamics of slaves and masters in the years preceding the Civil War. Its layout and design also illuminate the image through which plantation owners sought to express their achievements, wealth, and aesthetic pretensions. Evergreen was designated a national historic landmark in 1992. It is open to the public.

Edgard

Edgard lies on the stretch of the Mississippi River formerly known as the German Coast (La Côte des Allemands), named for the German immigrants who settled here as early as 1721. Some came in response to John Law's promises of wealth, and others under the leadership of Karl Friedrich d'Arensbourg, a former Swedish army officer. Edgard became the parish seat in 1838. The present courthouse, a one-story, buff-colored brick building with narrow vertical windows, was designed by Thompson B. Burk and Associates in 1968. The town is allegedly named for its first postmaster.

JO8 E. J. Caire and Company Stores

c. 1855 and 1897. 2403 Louisiana 18

The earliest of these two stores was built by J. L. Aubert and purchased by French immigrant and peddler Jean Baptiste Caire by 1865. The store received goods from steamboats and merchants trading along the Mississippi. The two-story gable-fronted brick structure has a front portico on four square wood piers and a Greek Revival entablature. In 1897, Caire's son Etienne added a general merchandise store next to the brick structure. Constructed of wood and fronted by a seven-bay gallery supported on wood piers with decorative brackets, the store was said to be the largest in the area. Originally two octagonal cupolas were positioned on the roof ridge to facilitate ventilation.

At .6 mile upriver from the stores, a single tall chimney highlights the cluster of metal-sided structures that make up the Caire and Graugnard Columbia Sugar Factory (354 Columbia Factory Road). French immigrant Camille J.-B. Graugnard purchased the Columbia Plantation in 1876 and, with his relative Jean Caire, built the sugar mill a year later. The factory now produces specialty sugars.

JO9 St. John the Baptist Catholic Church

1922, Favrot and Livaudais. 2349 Louisiana 18

St. John's twin towers rising above the levee have long been a landmark along the Mississippi River and still indicate the landing for the ferry that links Edgard to the town of Reserve on the river's east bank. The first church on this site was built in 1772 for the German settlers, but the present church replaced a nineteenth-century structure destroyed by fire. The Italian Romanesque red brick church features a triple-arched entrance, a rose window, and a blind arcade outlining the gable front. Large stained glass windows and pastel-colored angels painted on the barrel-vaulted ceiling and half dome of the apse give the interior a bright, colorful aspect. A two-story rectory, dating from c. 1920, stands to the left of the church; to the right, the cemetery laid out in the 1770s contains some handsome raised tombs, some with Greek Revival decoration.

St. Charles Parish, West Bank (going south) (CH6–CH7)

Taft

CH6 Entergy, Waterford III Nuclear Power Plant (Louisiana Power and Light)

1979–1985. Louisiana 18

Louisiana Power and Light (LP&L) established Waterford I and II power plants in 1937 on this site, formerly occupied by Waterford Plantation. The nuclear power plant, planned in 1970, begun in 1974, and completed in 1985, was built to meet the ever-increasing needs of the chemical plants along the Mississippi River

for vast quantities of low-cost power. (The electricity used by just one plant, Norco Refining (CH4) to operate and illuminate its plant equals the needs of approximately 40,000 homes.) The plant, constructed at a cost of approximately $3 billion, is dominated by the tall cylinder-shaped, domed containment structure, a steel vessel encased in reinforced concrete. Modifications to the design of the plant were made during construction, delaying its completion by several years. These changes, which included improved safety equipment and additional fire protection, were in response to the incident in 1979 at Three Mile Island, Penn-

sylvania, where that nuclear plant's cooling system failed and caused a radiation leak.

Hahnville

CH7 Home Place Plantation House

c. 1800. Louisiana 18 (near corner of Louisiana 3160)

Home Place, built around 1800 for either Pierre Gaillard or his widow, was owned by Louis Edmond Fortier from 1806 until 1856, then changed hands several times until Pierre Anatole Keller purchased it in 1889. For many years, Home Place was known as the Keller Home. Because its physical form and date of construction parallel those of Destrehan Plantation (CH2) before the latter was altered, it has been suggested that Destrehan's builder, a free man of color named Charles (last name unknown), was also responsible for Home Place. In plan, construction, and exterior appearance, this raised house is typical of late-eighteenth- and early-nineteenth-century southern Louisi-

ana plantations. Its Creole plan is four rooms wide and two rooms deep, arranged en suite, and all open onto the 16-foot-deep gallery that surrounds the house. Ground-floor walls and columns are of brick, and the upper story's timber frame is filled with *bousillage*. Slender wood columns on the upper gallery rise to a high hipped roof that has a slight outward cant at the eaves and three front dormers. The front stairs were added in 1900. When built, the house had one set of stairs within the front gallery (since removed) and another (extant) in the rear gallery. Storage rooms and a dining room with a black and white marble floor occupied the ground floor; the upper floor consisted of eight variously sized living rooms and bedrooms. As is typical of early Louisiana plantation houses, the doors and windows respond to the interior spaces and are therefore neither regularly spaced nor aligned with gallery columns, creating asymmetries that add visual excitement to the composition of the house. A hybrid *pigeonnier*–carriage house (c. 1800) is located near the house.

CH7 Home Place Plantation House

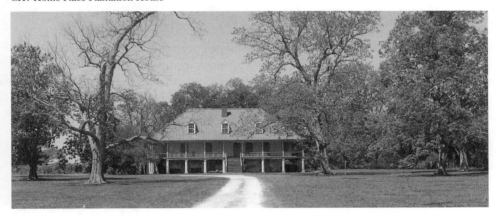

Bayou and Gulf Parishes

W RITER HENRY MILLER, WHO SPENT SOME TIME AT SHADOWS-on-the-Teche (IA5) in Iberia Parish, evoked the character of this flat, water-laden region bordering the Gulf of Mexico in his story "The Air-Conditioned Nightmare" (1945): "The Gulf is a great drama of light and vapor. The clouds are pregnant and always in bloom, like oneiric cauliflowers; sometimes they burst like cysts in the sky, shedding a precipitate of mercurium chromide; sometimes they stride across the horizon with thin, wispy legs of smoke." This region was shaped by the Gulf and four other major waterways: the Atchafalaya River (long river) and the Bayous Vermilion, Teche (snake), and Lafourche (fork or bend). The Teche, the Lafourche, and the Atchafalaya were outlet channels for the Mississippi River before it changed course a mere 500 years ago, and their deltas form a continuously shifting coastline of fresh- and saltwater marshes. With the exception of Iberia Parish's salt domes (Avery Island reaches an elevation of approximately 150 feet), the landscape is entirely flat; the sky forms a dramatic canopy over buildings and towns.

When Europeans began to explore the area, it was inhabited by the Atakapa. By the time the Europeans were building settlements, the Chitimacha had established themselves along the upper portions of Bayou Lafourche. Early documents record twenty-five Chitimacha villages. Today the Chitimacha have approximately 260 acres of land near Charenton (St. Mary Parish). European immigrants, mostly French and Spanish at first, established settlements on the ridges bordering the bayous. In 1869, Samuel H. Lockett, who was undertaking a topographical survey of Louisiana, described these linear communities: "The banks of the Lafourche present the appearance of a continuous village throughout its entire length." The region's earliest buildings are French-influenced, but Anglo-American immigration beginning in the nineteenth century soon made the Greek Revival style popular.

232

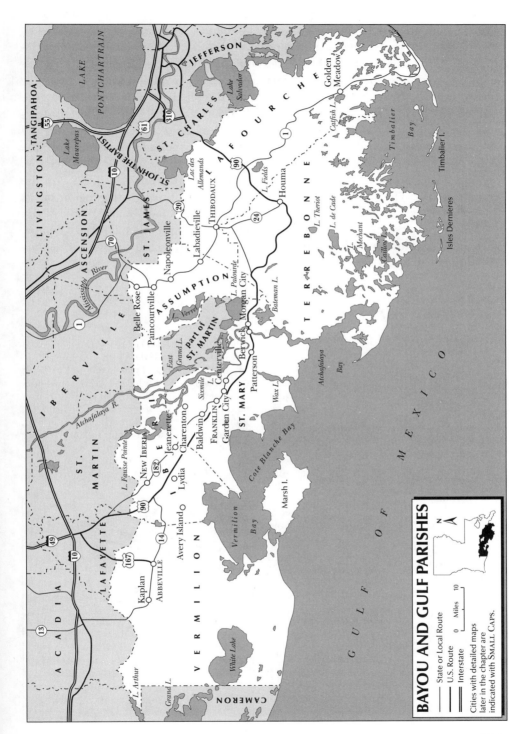

BAYOU AND GULF PARISHES

State or Local Route
U.S. Route
Interstate

Cities with detailed maps
later in the chapter are
indicated with SMALL CAPS.

0 Miles 10

233

The five parishes that make up this region are Lafourche (1807), Terrebonne (1822), Assumption (1807), St. Mary (1811), Iberia (1868), and Vermilion (1844). Production and processing of sugarcane, rice, seafood, and oil are the principal industries. Little survives today of the once-important cypress lumber industry. Immense sugar mills, the centralized factories that replaced the small individually owned mills in the early twentieth century, are the physical landmarks. During the fall harvest period, they operate twenty-four hours a day, the cluster of tall structures belching smoke and emitting the cloying odor of crushed cane. Rice mills and silos line the railroad tracks in the western parishes of Iberia and Vermilion. In the communities close to the Gulf, such as Delcambre, Galliano, and Golden Meadow, shrimp boats, processing plants, and boat building and repair facilities line the bayous' banks. The Intracoastal Waterway, which cuts through the region on its route from Texas to Florida, provides space for the manufacture and repair of rigs and machinery essential to the Gulf's oil wells. These, and oil-field service companies, have introduced an untidy but purposeful industrial landscape in the vicinity of Morgan City and Houma.

Lafourche Parish (LF)

Thibodaux

Thibodaux was founded by Henry Schuyler Thibodaux (1769–1827), a planter, legislator, and governor of Louisiana, on land he had purchased in 1818. Until 1838, the town was known as Thibodauxville. As was typical of Louisiana's bayou communities, Thibodaux grew in a linear fashion along the banks of Bayou Lafourche. In the residential district that grew around Canal Boulevard in the late nineteenth century are several attractive houses in the Queen Anne style, notably the two-story Robichaux House (1898; 322 E. 2nd Street), which balances the verticality of its steep gable and short square tower with a wide-spreading gallery. Similar, although with an octagonal turret, is the former McCulla House, built c. 1907 at 422 E. 1st Street (Louisiana 1), which was renovated for use as a bank by Morton-Verges, Architects, in 1982. The Roman Catholic St. Joseph Co-Cathedral (710 Canal Boulevard) of 1923, designed by the New Orleans firm of Burton and Bendernagel, has huge twin towers ornamented with Baroque details. Structures in Thibodaux's commercial district include the Riviere Building (1900; 405 W. 3rd Street), which has a second-story facade of pressed metal imprinted with urns and vines, paired engaged metal columns on tall plinths, and a metal-bracketed cornice. The ground story was remodeled at a later date with a facing of Carrara glass (a structural glass made of Vitrolite). The former E. N. Roth Drugstore, a two-story building of stuccoed brick with a two-story iron gallery (corner of Green and W. 3rd streets), built in 1910 by W. K. Ketteringham and Son, was remodeled as a restaurant in 2001. A more recent structure is the former Argent Bank, now the Lafourche Government Complex (c. 1950; 402 Green Street); its gold-colored mod-

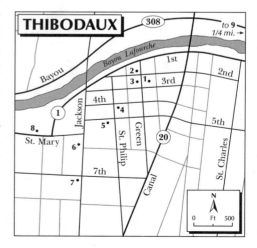

ular steel frame has an infill of gray marble and green-tinted glass. On Thibodaux's outskirts is Nicholls State University, which opened in 1948 as Francis T. Nicholls Junior College (906 Louisiana 1). Favrot and Reed of New Orleans were the architects for the college's first structure (C. C. Elkins Hall), a two-story red brick building with four full-height Corinthian pilasters and a pediment designed to monumentalize the entrance. Two miles south of Thibodaux on Louisiana 20 (actually in Terrebonne Parish) is Ducros plantation house, a large wooden Greek Revival house with a central-hall plan and colossal paneled piers, probably built c. 1860.

LF1 Lafourche Parish Courthouse

c. 1858. 1903, additions and remodeling, Favrot and Livaudais. 1959, renovations and addition, Fernand T. Picou. 201 Green St.

The present courthouse, the third on a site donated by Henry S. Thibodaux in 1818 in exchange for a tax exemption for his hotel and billiard hall, was extensively remodeled in 1903. New Orleans architects Favrot and Livaudais transformed a simple square brick structure into a Beaux-Arts monument by adding a classical portico with four Doric columns and a pediment, wings articulated with pilasters between the windows, and a low, copper-covered mansard dome flanked by four similarly styled miniature domes. Modest low-relief swags decorate the walls. Another addition made in 1959 has given the courthouse an irregular, cluttered silhouette; now that it completely fills its site on a narrow street, the building's Beaux-Arts presence is difficult to appreciate. Nearby, at the corner of Green and W. 3rd streets, is the severe Moderne two-story former jail designed by William R. Burk in 1939.

LF2 Office Building

c. 1900. 110 Green St.

This brick two-story commercial building is one of the few survivors of a type that once was numerous in Thibodaux's commercial district. The two-story gallery is formed of cast iron on the first floor, and the upper level has wooden columns adorned with decorative brackets; the metal balustrade is a recent addition. A tall pressed metal entablature decorated with shell designs and modillions gives a prominent finish to the building.

LF3 Commercial Building (Oil and Gas Building; Bank of Lafourche)

1897. 206 Green St.

Resembling a diminutive Renaissance palace, this former bank, three bays wide, is faced with light gray veined marble, rusticated on the base, with rusticated courses across the first story and smooth-surfaced on the upper story. The lower facade is treated as a single compositional unit in the form of a Palladian window. Square-headed windows flank the central entrance, which is outlined by Ionic columns and topped by a semicircular opening, within which is a decorative iron grille. Just above the side windows are small circular openings set within square frames in the classical style. The upper floor is illuminated by three round-arched windows with voussoirs of rusticated stone and topped by a balustrade and tablet. After 1929 the bank was sold to an oil and gas company, a transfer documented by the oil rig outlined in mosaic on the floor of the entrance vestibule.

LF4 Office Building (Citizens Bank of Lafourche)

1910. Favrot and Livaudais. 413 W. 4th St.

The handsome Beaux-Arts facade on this one-story building of beige brick is finished with a prominent cornice supported on paired, tightly scrolled modillions. Tall lunette windows flank the central entrance, which is crowned by two cornucopias in cast concrete

and a circular window. A rectangular stained glass skylight set in the low mansard roof illuminates the interior, which contains the original walk-in vault, encased in a pavilion that imitates the design of the facade. A second story has been added to one of the two lower curved wings that extend from each end of the building. Joseph Robichaux was the contractor for this building, as he was for many of Thibodaux's prominent early-twentieth-century structures.

LF5 Dansereau

1840s. 1870s, Henry Thiberge. 506 St. Philip St.

Originally one story in height, this stuccoed brick house with a central-hall plan was substantially enlarged in the 1870s for its new owner, Dr. Hercules Dansereau, who had recently married and would become the father of nine children. New Orleans architect Henry Thiberge added two floors; the upper was set within a mansard roof pierced by enormous dormers with paired, round-headed windows, which gave the house a fashionable Second Empire appearance. An octagonal cupola added height and prominence to what was already a tall structure. The ground-floor gallery has heavy rectangular brick piers to help carry the weight of the upper gallery and overhanging roof; the upper gallery is far more decorative, with slender piers topped by circular brackets. The house offers overnight accommodations and has a restaurant.

LF6 Auto Center

c. 1950. 600 Jackson St.

The steel frame of this long, two-story automobile showroom allows display windows along the entire front of the ground floor. A deep folded-plate canopy shading the windows has eye-catching vertical metal fins that mark each angle of its zigzag edge. The upper story is sheathed in metal, which serves as a backdrop for the building's sign, in huge letters across the front. The auto center represents the dynamic storefront designs of the post–World War II era, which enthusiastically celebrated new materials and consumerism.

LF7 St. John's Episcopal Church

1844–1845. 718 Jackson St.

Founded in 1844 by Bishop Leonidas Polk (1806–1864), St. John's is the oldest Episcopal church west of the Mississippi. Polk, who was Louisiana's first Episcopal bishop and rector of St. John's, lived in Thibodaux from 1843 to 1854. The church's building contract of 1843 suggests that Polk was responsible for the plan. The tall wooden bell tower was added in the 1850s. The present narthex, originally an open gallery, was enclosed in 1856 to create a classical facade with two tall, round-arched windows, applied pilasters, and central entrance door. A slave gallery was added at the same time. The triple-hung side windows are of clear glass and set between pilasters, and a row of dentils under the cornice is continued around the entire building. The brick walls are painted a light gray color. The brightly illuminated single-space interior concludes at the apse with a triumphal arch set on Corinthian pilasters. A window featuring the apostle John, made by Charles Connick of Boston and installed in the apse in 1933, is set within a round arch, echoing the shape of the triumphal arch. The original pews, with unusually high kneeling benches, were refinished in a 1971 restoration. A cemetery to the rear of the church contains raised tombs of various designs.

LF8 Acadian Wetlands Cultural Center (Percy-Lobdell Building)

1912. 1992, additions and remodeling, Tom Papazoglakis for Omega Synergistics. 314 St. Mary St. (Louisiana 1)

Peter Randolph Percy and John L. Lobdell opened a grocery and dry-goods store in 1901, and in 1912 they constructed this building for their wholesale business in such goods as rice, potatoes, flour, sugar, and, in the 1940s, wine bottling. The two-story brick structure, 200 feet long, faces St. Mary Street, the principal highway through Thibodaux. Its rear warehouse section opened onto Bayou Lafourche, and a spur line of the Morgan Railroad ran between the building and the bayou. Pent roofs supported by wooden brackets on the side and rear elevations protected the loading areas from rain and sun; these have been preserved in the current adaptive reuse. The St. Mary Street facade has a false front, with a narrow central pediment set in a bracketed cornice made of pressed metal, as are the molded cornices over each of the double sash windows. The building was remodeled and opened in 1992 as the Aca-

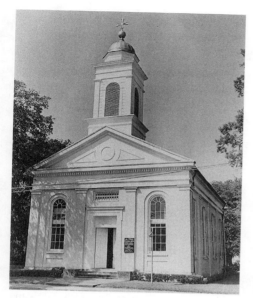

LF7 St. John's Episcopal Church

dian Wetlands Cultural Center, a branch of the Jean Lafitte National Historical Park. A branch library is housed on the upper floor, and a 200-seat theater was added to the building's west side as part of the remodeling. In its location and proportions, Percy and Lobdell's warehouse is typical of nineteenth- and early-twentieth-century commercial structures in the bayou towns.

LF9 Rienzi Plantation

c. 1800–1810, with additions. 215 Bayou Road (Louisiana 308)

Legend has it that Juan Ygnacia de Egana built Rienzi in 1796 as a refuge for Queen María Luisa of Spain should Napoleon conquer her country, and that de Egana lived at the house for some years. What is certain is that de Egana did build a house in the first decade of the nineteenth century, naming it perhaps after the fourteenth-century Italian military hero known as Cola di Rienzi. This house, with its brick first floor and wood upper story, forms the core of the present structure. It is believed, however, that the gallery on piers was added c. 1840, and other features of the house point to a similar date, most significantly the central-hall plan, with doors with side lights on both floors. Originally, carriages were housed on the first

floor, but this floor was enclosed in the 1850s and an inside staircase added. The double staircase at the front, based on that of Evergreen Plantation (JO7), dates from the 1930s. Although the exact chronology of the house is uncertain, it is an attractive example of the region's early architecture and the legends that surround it.

Thibodaux Vicinity

South from Thibodaux to Golden Meadow, a distance of approximately 50 miles, Bayou Lafourche is paralleled by the twin highways of Louisiana 1 and Louisiana 308. As is characteristic of Louisiana's bayous, Bayou Lafourche is bordered by a continuous settlement of houses interspersed with occasional commercial and industrial buildings. Between Thibodaux and Raceland, Louisiana 308 is the more interesting of the two routes today, passing several small, galleried former plantation houses; among the prettiest is Rosella (3515 Louisiana 308), a two-story house built c. 1814. South from Raceland, both banks offer a fascinating panorama of fishing and shrimping boats and boat repair and docking facilities.

LF10 Laurel Valley Plantation

1850–early twentieth century. Laurel Valley Rd. (off Louisiana 308 at 1.4 miles south of Thibodaux)

In 1832, Joseph W. Tucker from Tennessee established a sugar plantation on the land he purchased from Etienne Boudreaux, an Acadian exile who had settled here in 1790. Tucker brought twenty-two slaves with him from Tennessee. The house he built for his fifteen-year-old wife, Marceline Gaude, was burned at the Battle of Lafourche Crossing during the Civil War; the present house dates from c. 1880. Over the decades, the plantation increased in size, experiencing its greatest prosperity in the sugar-boom years, between 1890 and 1924. During that period fifteen miles of railroad track were built on the plantation to move cane from the fields to the mill. More than forty-three miles of canals and ditches drained excess water from the plantation, depositing it over a protective levee at the rear of the plantation into Bayou Lafourche. Today this 5,000-acre plantation retains approximately sixty buildings, now uninhabited, dating from the early twentieth century, when the plantation

was the largest sugar producer in the region. At that time Laurel Valley employed as many as 450 workers, mostly white Acadians, and more than 300 of them lived on the plantation. The tenant houses, arranged in neat rows, were constructed of cypress, raised on low brick piers, and originally roofed with wood shingles; they now have metal roofs. Most were built beginning in the 1880s, although a few may date from the 1850s. Several houses retain a free-standing wood-frame privy at the rear. Other structures include the ruins of a brick sugar mill (c. 1845) and a small schoolhouse (c. 1910) that was used until 1952. All these buildings stand along Laurel Valley Road, 1.7 miles off Louisiana 308. At the corner of Louisiana 308 and Laurel Valley Road is the plantation store (established 1905), which is also a small museum, along with a sharecropper's two-bay house (c. 1875) and a storekeeper's three-bay house (c. 1815). Laurel Valley has been the setting for several movies, including the slave-quarter scenes in *Interview with the Vampire*, based on New Orleans author Anne Rice's novel, and the film of Ernest J. Gaines's novel *A Lesson Before Dying*, in which the schoolhouse, with a cross added to its roof, featured as the church.

LF11 Edward Douglas White House

c. late 1830s. Louisiana 1 (5.5 miles north of Thibodaux)

This small one-and-one-half-story raised house with a central hall was built by planter Edward Douglas White, Sr., who served as governor of Louisiana and in the U.S. Congress. It was the birthplace in 1845 of his son Edward Douglas White, Jr. (1845–1921), chief justice of the U.S. Supreme Court from 1910 to 1921. Constructed of hand-hewn pegged cypress, the house has front and rear galleries integrated into the pitched roof in the Creole manner and three pedimented dormers. Although the house has been dated to c. 1790, the central hall suggest a later date. In 1936, the 1,600-acre plantation was purchased by the federal government and divided into small farms for needy Louisiana farmers. The house is now maintained as a memorial to both father and son and is open to the public.

Terrebonne Parish (TR)

Houma

Houma's location beside Bayous Terrebonne, Black, and Little Black and its accessibility to the Gulf of Mexico and the Intracoastal Waterway have made the town an important center for seafood processing and the offshore oil industry. Cranes and machinery for boat and oil-rig repair facilities physically define Houma's outskirts. Named for the tribe of Native Americans who inhabited south-central Louisiana, Houma was established as the parish seat on land donated by Hubert Madison Belanger and Richard H. Grinage in 1834. Houma's principal commercial street, which parallels Bayou Terrebonne, was rebuilt after the fire of 1887 with one- and two-story brick structures. Seafood processing (shrimp and oysters) supported the town's economy for the first third of the twentieth century, stimulating a wave of new construction. Favrot and Livaudais designed the two-story red brick former Methodist church (now the Terrebonne Parish Building) at 500 School Street in 1921, giving it a Palladian window on the front facade of the second (principal) floor. Other notable examples are the former Bank of Terrebonne and Trust Company, now used for parish services (1933; 7868 Main Street), a Moderne building with low-relief geometric ornament; the two-story former drugstore (7869 Main Street), with its streamlined turret-shaped parapet at the corner; and Terrebonne High School (7318 Main Street), constructed with Public Works Administration (PWA) funds in 1940 to a design by Wogan and Bernard. In the second half of the twentieth century, oil-related industries and services and boat building and repair became increasingly important, as can be seen in the structures along the Intracoastal Waterway, which threads through Houma.

TR1 Terrebonne Parish Courthouse

1937–1938, Wogan and Bernard. 7856 Main St.

This four-story courthouse is set at the rear of its site, behind a formal front garden shaded by

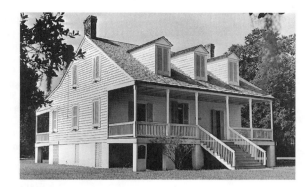

LF11 Edward Douglas White House

TR2, TR3 Office Building (Bank of Houma) (right) and Petit Theater (People's Bank of Houma) (left)

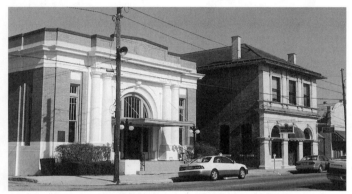

huge oak trees predating the Civil War. Built with PWA funds, the courthouse, concrete framed with stone facing, is a severe but handsome Moderne design with a row of six stylized Doric columns across the facade's second story. Ornamentation is minimal, consisting of zigzag bands and simplified geometric forms in shallow relief. The fourth floor, which is set back from the facade, accommodated the jail. The small lobby is faced with marble in shades of mottled brown and beige, the kind of muted colors popular in the 1930s. On the courtroom wall above the judge's bench is a mural painted by Robert Fuch entitled *Progress* (1938), depicting two men turning a huge wheel, with farmers and fishermen on one side and oil rigs on the other—a scene that accurately represents Houma's industries.

TR2 **Office Building** (Bank of Houma)

c. 1905. 7833 Main St. (between Church and Grinage sts.)

With its three round-arched openings on the first story and three square-headed windows

above, this two-story building resembles, on a diminutive scale, a Renaissance palace. Faced with white glazed bricks, the facade is richly embellished on its upper story. Window surrounds are shaped into pilasters, carried on scrolled brackets and ornamented with foliate patterns. Small panels under the eaves are decorated with lions' heads centered within garlands. An exterior stair on the building's right side provided access to the town's first telephone exchange, housed on the upper story. The bank failed in the sugar depression of the late 1920s.

TR3 **Petit Theater** (People's Bank of Houma)

1917, Favrot and Livaudais. 7829 Main St. (corner of Grinage St.)

The facade of this former bank is fashioned as a single-story triumphal arch flanked by paired Doric columns. It is topped by a tall entablature and a parapet. The building is constructed of beige brick, and the arch and columns are highlighted by a coating of white plaster. The

architects repeated this design with only minor variations (single rather than paired columns flanking the entrance, for example) for the Union Bank in Marksville of 1918 (AV1). After the bank failed in the Great Depression, Houma purchased it in 1933 to use as a city hall. It now serves as a theater and center for community events.

TR4 St. Matthew's Episcopal Church

1892, W. D. Southwell. 243 Barrow St. (corner of Belanger St.)

Constructed of local cypress, this Gothic Revival church has a prominent corner bell tower with a spire (replaced after the hurricane of 1926) flanked by four miniature spires. The entrance vestibule, located in the tower's base, opens onto a single nave covered by a hammerbeam ceiling. An ell was later added to the side of the church. Adjacent to the church is a raised one-and-one-half-story galleried house (c. 1892), which is used for church activities.

TR5 Standpipe

1902, George Cadogan Morgan. 600 Wood St. (corner of Roussel St.)

Hydraulic engineer George Morgan from Chicago designed this 68-foot-high circular brick towerlike foundation, which rises from a low octagonal base and originally was topped by a 40-foot high metal water storage tank with a capacity of 40,000 gallons, used for fire protection in the downtown area. The tower measures 11 feet in diameter and has an entrance doorway in the shape of a pointed arch. The tank was removed in the 1950s and the foundation capped with a conical roof. The interior of the foundation is open and was used to hang fire hoses to dry and and store.

TR6 Terrebonne Historical Museum
(Southdown Plantation House)

1859, ground story. 1893, second story. Museum Dr. (near the intersection of Little Bayou Black Dr. (Louisiana 311) and St. Charles St. (Louisiana 664)

This house in the Queen Anne style, with gaily painted pink walls and dark green shutters, was originally a one-story brick Greek Revival house built in 1859 by William J. Minor of Natchez, Mississippi, on his newly established sugar plantation. Minor constructed a sawmill in 1857 and a brick kiln in 1858 for use in building his house, which had a central hall flanked by two rooms. In 1893, Minor's son, Henry C. Minor, added a second floor covered by steeply pitched gable roofs and a circular tower. Servants were housed in a separate two-story brick building behind the house, now occupied by a gift shop.

In the 1920s, mosaic disease, identified in 1919, had caused sugar production in Louisiana to drop from 290,000 tons in 1922 to 47,000 tons in 1926. A variety of sugarcane resistant to mosaic disease was propagated on four acres of land at Southdown in 1924. In 1925, the American Sugar Cane League built a permanent laboratory on fifty acres of land rented from Southdown. In the meantime, however, Southdown's owners, unable to survive financially after the failure of sugar crops and the economic crash of 1929, sold the property in 1932. Under new owners, the mill operated until 1979. In 1975, the Terrebonne Historical and Cultural Society acquired the property, which was restored and opened to the public.

Houma Vicinity

TR7 Ardoyne

c. 1894, W. C. Williams and Bro. 2678 Louisiana 311 (5 miles north of Houma)

Described in a publication of 1894 as "a specimen of pure rural Gothic architecture and a fine type of the ideal country home," Ardoyne is the most elaborate and romantic-looking Gothic Revival residence surviving in Louisiana. Sugar planter John Dalton Shaffer hired the Williams brothers from New Orleans to design the house while his wife was in Europe for her health. According to family tradition, Ardoyne (little knoll) was designed after a Scottish castle that Shaffer had seen in a magazine. Pointed-arched bargeboards adorn the dramatically steep gables of the cypress-wood house, echoing the Spanish moss trailing from the surrounding oak trees. The window openings are pointed arches, and hood molds further emphasize their attenuated shape. A gallery encompasses the front and sides of the house, and a gabled tower rises from the octagonal first floor to a square-shaped second floor. Although the exterior conveys a strong impres-

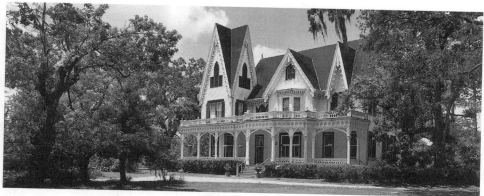

TR7 Ardoyne

sion of asymmetry, the house has a central-hall plan on both floors and is two rooms deep, with a two-story rear wing. The wooden stairs, balustrades, and mantels are quite elaborate, as was typical of late-nineteenth-century Arts and Crafts interiors.

Assumption Parish (AM)

Napoleonville

Napoleonville, first known simply as Courthouse when it became the parish seat in 1818, is said to have been named by one of its early settlers, a former soldier in Napoleon's army. Sited on the west bank of Bayou Lafourche, this small town is in the heart of sugarcane country. The twin-towered red brick St. Anne Church (417 St. Joseph Street) was built in 1909 in an Italian Romanesque style and acquired a white frame Colonial Revival addition on the right tower c. 1920.

AM1 Assumption Parish Courthouse

1896, Harrod and Andry. Louisiana 1 (at the junction of Louisiana 1008 East)

Two stories in height, with a square three-story tower in the center of the facade, the courthouse follows a popular formula for civic buildings in Louisiana around the end of the nineteenth century. One precedent is James Freret's Ascension Parish Courthouse in Donaldsonville (AN8) of 1889, and a later (1911), more elaborate version is Favrot and Livaudais's city hall in Lake Charles (CC2). Napoleonville's stuccoed brick courthouse has simple decoration, consisting of moldings around the entrance and a Palladian window on the tower's

top floor. A tall, obelisk-shaped World War I memorial (1920) stands in front of the courthouse.

AM2 Christ Episcopal Church

1853–1854, Frank K. Wills. Louisiana 1 (at the junction of Louisiana 1008 West)

New York architect Frank Wills (1822–1856), the official architect for the New York Ecclesiological Society, was paid $120 for the plan for this church, which cost $7,500 to construct. British-born Wills, who prepared drawings for three churches in Louisiana, derived his designs from the medieval churches of his birthplace. This small rectangular brick church has a square-ended chancel slightly lower than the nave, both covered by steeply pitched slate roofs; a small transept; and a side entrance. The entrance portico and brick belfry were added in 1896. The single-nave interior is narrow and tall under a pitched cypress ceiling, which is supported on collar-braced trusses. The stuccoed walls, painted a cream color, combine with the dark-stained wood ceiling and colorful figural stained glass to create a peaceful and harmonious space. During the Civil War, Union troops stabled their horses inside the church and are said to have used the windows for target practice. The church was re-

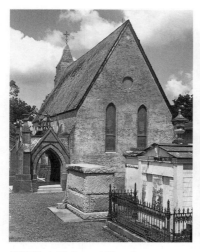

AM2 Christ Episcopal Church

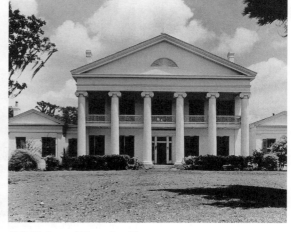

AM3 Madewood Plantation House

stored in 1869. The cemetery contains raised tombs of earlier dates than the church, which were perhaps moved there. Some are surrounded by cast iron fences.

Napoleonville Vicinity

AM3 Madewood Plantation House

1840–1848, Henry Howard. Louisiana 308 (2.2 miles south of Napoleonville)

This splendid Greek Revival house for sugarcane planter Colonel Thomas Pugh was one of Henry Howard's first commissions and helped launch his successful architectural practice. Madewood is one of the finest examples in Louisiana of a Greek Revival plantation house modeled on a temple. The facade has six double-height fluted Ionic columns, on a stylobate in the Greek manner, and a pediment with a small fanlight at its center. A rear gallery is supported on boxed piers. One-story pedimented wings flank the house. The proportions are so perfectly balanced that it is no wonder Howard was much sought after by clients with exacting taste. Constructed of bricks made on the plantation by Pugh's slaves, the house was painted white, as was then fashionable for Greek Revival designs. Interior woodwork also was milled on the plantation; this "made wood" is believed to have given the house its name. A central hall, its length and width gently interrupted by a triumphal arch on two Corinthian columns, concludes at a curved staircase. On each side of the central hall are two large rooms, a double parlor on one side and a library and bedroom on the other. The mantels in the double parlor are marble, and those in the other two rooms are of cypress painted to resemble marble. A ballroom occupied space in one of the wings. Artist Cornelius Hennessey painted the cypress doors to resemble oak.

In succeeding years, the house had several owners, including sugar magnate Leon Godchaux. In 1964, Naomi and Harold Marshall purchased the house and restored it. Madewood is now open to the public and offers bed-and-breakfast accommodations. The slave quarters, sugar mill, and lumber mill no longer exist. Adjacent buildings include a carriage house built in the 1840s and, relocated from nearby sites, a raised Greek Revival cottage (1822), a slave cabin, and a blacksmith's cottage.

Labadieville

AM4 St. Philomena Church

c. 1888. Louisiana 1 (corner of Brulee Labadie Rd.)

This Gothic Revival basilica with its tall square tower and octagonal spire is the landmark in this small community. Pinnacles around the spire and on top of the corner buttresses further emphasize the height of the building. The brick walls have a cream-colored stucco coat,

which is enlivened by corbeled and pointed-arched blind arcades along the eaves of the gable roof. The interior features compound piers between the nave and the side aisles, a pointed-arched vaulted wooden ceiling, and side windows filled with pastel-colored glass in figural and floral motifs. The rectory (c. 1850), believed to be on its original site, is a Greek Revival galleried plantation house with a central-hall plan.

Paincourtville

AM5 St. Elizabeth Catholic Church

1889–1903, F. B. Dicharry. Louisiana 403 and St. Elizabeth St. (one block from the corner of Louisiana 1)

This large twin-towered Gothic Revival church of red brick has an especially well-detailed facade. Square gable-topped towers, whose spires were blown down during a storm in 1909, outline a facade composed of a triple entrance, a triple-arched window above it, stepped buttresses with lancet panels, small rose windows over all the windows and in the central gable, and a blind arcade along the eaves of the facade and tower gables. The interior has a genuine sense of the spatial qualities of a Gothic church. Arcades carried on compound piers separate the center from the aisles. Slender columns on the inner faces of the piers rise uninterrupted to the rib vaults, emphasizing height and linearity and creating a rhythmic progression to the apse. The vaults, stenciled with foliate designs, appear to float like a canopy overhead. These designs and the figural representations of such heresies as Lutheranism and naturalism painted on the triforium were executed in 1916 under the supervision of a Father Grall, who was an artist.

Belle Rose

AM6 Belle Rose Middle School
(Elementary and High School)

1939, Bodman and Murrell. 7177 Louisiana 1

The school is laid out on a U-shaped plan around a court, with the administrative spaces and auditorium in the central block separating wings for the former high school and the elementary school. The building is stuccoed masonry scored horizontally along the lower sections of the walls to resemble rustication and give a streamlined effect. Baton Rouge architects Bodman and Murrell's design used the attic as a combined venting and lighting system. Originally, hot air was drawn up through ventilators on the roof ridge (now replaced by small dormer vents in the hipped roof), and classrooms received additional light through skylights. Relief sculptures of stylized figures representing the local economy and learning decorate the front walls of each wing. The school was built with PWA funds.

AM7 Belle Alliance

c. 1846. 1889, rear addition, Paul Andry. Louisiana 308 (.5 mile north of Belle Rose)

According to tradition, the 7,000-acre Belle Alliance plantation was formed out of three smaller plantations (thus its name) by German immigrant Charles Kock sometime before 1846, and the present house replaced one that burned down that same year. The house was built in two stages, the earliest section at the front. This consists of two stories, with a Greek Revival front gallery supported on six double-height Doric piers, an entablature, and a parapet that hides the hipped roof. The facade resembles, although on a smaller scale, that of Ash-land–Belle Helene (AN4), completed in 1841. A wide staircase leads to the central entrance and principal living area on the second floor. The house originally had a full-length rear gallery, but this was incorporated into the Greek Revival addition to the rear of the house, constructed in 1889 by Kock's son James. Along with several small rooms, the addition included a huge second-floor dining room that featured a coved ceiling, a high paneled wainscot, a wide polygonal bay that opened onto a rear loggia through French doors with decorative glazing bars, and an elaborate mantel. Doors and windows in the smaller rooms were given shoulder-molded surrounds similar to those in the earlier part of the house. The entire house is constructed of brick covered with stucco and scored to resemble stone. After James Kock's death in 1915, the house had several owners. Its sugar mill was dismantled in the 1930s, and none of the support buildings survive. In 2002 the house was restored by Barry Fox Associates with Frank Masson for new owners, Bryce Revely and Alan Caspi.

St. Mary Parish (MY)

Franklin

Franklin was founded on the west bank of Bayou Lafourche in 1808 by Alexander Guinea Lewis from Pennsylvania, who probably named it in honor of Benjamin Franklin. In 1814, Lewis donated land for a public square and courthouse. Franklin quickly established itself as an important interior port and social hub for the area's sugar planters. After the railroad reached Franklin in 1879, the town became a center for the cypress lumber industry. Wealthy planters and mill owners built showy Greek Revival residences along Main Street. Particularly notable are Shadowlawn (906 Main Street), built in 1833 on the front of a preexisting tavern, which has a central hall and a monumental six-columned Corinthian portico; the Hanson House (114 E. Main Street), built c. 1849, then enlarged in the 1880s by lumber magnate Albert Hanson, who added his custom mill-

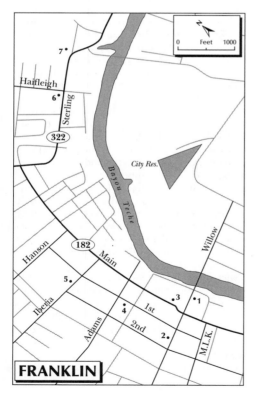

work; and the Gates House (205 E. Main Street), a raised galleried house built shortly after 1851, with pedimented doors and windows, a hipped roof, and a belvedere flanked by two chimneys. This residential stretch of Main Street, with its landscaped median, ancient trees, and early-twentieth-century lamp standards, is a splendid entrance to the town. At a short distance south of Franklin's city limits is Arlington, built in the 1850s (11532 Louisiana 182), with a pedimented portico of four double-height Composite columns, and 1.3 miles south of Arlington is Alice C Plantation House, also dating from the 1850s, with a two-story Greek Revival front gallery and central-hall plan.

Main Street's commercial sector dates mostly from the late nineteenth and early twentieth centuries. The two-story brick buildings are detailed with false parapets, stepped gables, and corbeled brickwork. The Franklin Lodge (709 Main Street), built in 1894 with a battlemented parapet, is a good example. By contrast, the post office (220 Willow Street), with six Doric columns across its facade, embraces Franklin's earlier Greek Revival mode. It was designed by Oscar Wenderoth in 1912. The Art Deco Teche Theater (501 Main Street), built as a movie house c. 1925, has sheathing of Carrara glass in shades of peach, red, and black on its lower facade and a V-shaped marquee above. Franklin's residential growth during the lumber boom is represented in a one-and-one-half-story house in the Queen Anne style built c. 1900 at 309 Adams Street, which displays the decorative properties of wood in its wraparound gallery, five gables, patterned shingles, and Eastlake trim.

MY1 St. Mary Parish Courthouse

1967–1968, Lloyd J. Guillory. Bounded by Main, Willow, Wilson, and Water sts.

Built soon after Hurricane Betsy caused great devastation in southern Louisiana in 1965, this courthouse was designed to withstand winds of up to 150 miles per hour. The seven-story courthouse has a reinforced concrete frame, a gridlike facade with small horizontal windows separated by concrete spandrel panels, and aluminum *brise-soleils*. The ground

story is sheathed in panels of a green aggregate, and a concrete canopy marks the unimposing central entrance. The building has been disliked not only for its rejection of historical precedent and regional traditions, but also because it is vociferously ugly and out of scale with its surroundings. Yet it has a certain presence, a requirement for a courthouse, and is a clear statement of its time. Unlike its predecessor, which occupied the center of the courthouse square, this building is situated at the rear of its site. In front of it is a flat-top parking lot, a familiar late-twentieth-century urban space. In all respects, the building belongs uncompromisingly to the Brutalist movement. A model of its Beaux-Arts predecessor and the Gothic Revival jail, both demolished, is displayed in the courthouse lobby, a bland but not intimidating space. The former courthouse was briefly seen in the movie *Easy Rider* (1969).

MY2 Old City Market

c. 1910. 314 Willow St. (between 1st and 2nd sts.)

Until it closed in the early 1960s, this nine-bay, open-sided market was the place where everyone shopped for food. It contained approximately ten individual buildings, without shared walls, which housed the various vendors. The market building, constructed by the Jeffries Machine Company of Franklin, has a steel frame supporting a cross-braced and trussed double-pitched wooden roof with a monitor along its entire length. Pent roofs on the short ends of the structure allow for cross ventilation. The market's fate was sealed after supermarkets were opened in the strip malls built on the edge of town.

MY3 St. Mary Bank and Trust Co.

1898. 612 Main St.

This two-story bank, three bays wide, is the most carefully detailed of Main Street's commercial buildings. It stands out because of its salmon-colored brick walls and beige stone voussoirs, oversized keystones, capitals, and egg-and-dart moldings between the floors. A row of lions' heads marks the cornice, and a prominent anthemion is centered on the parapet. Franklin's first telephone exchange occupied the bank's second floor.

MY4 St. Mary's Episcopal Church

1872, attributed to James Freret. 805 1st St. (between Adams and Jackson sts.)

This attractive small rectangular Carpenter's Gothic church with board-and-batten siding is similar in size and detailing to St. Andrew's Episcopal Church in Clinton (EF4) of 1871. Like that church, it achieves its effect through the repetition of a few simple elements. Gable roofs cover the nave, portico, and diminutive belfry; identically shaped bargeboards decorate the eaves of the porch, roof, and belfry; the side windows have pointed arches, and similar shapes are cut into the door jambs and at the corners of the building. The rose window over the entry is repeated in the wall above the porch. Inside the church, a flat ceiling is supported on curved brackets with exposed chamfered joists. Most of the windows have milk-white glass to softly illuminate the interior.

MY5 City Hall (Franklin High School)

1903. 300 Iberia St.

Converted for use as a city hall in the 1990s, this three-story building is constructed of honey-colored brick and trimmed with white stone. Its slightly projecting end pavilions are crowned by curved pediments filled with foliate relief sculpture, and similar decoration surrounds the bull's-eye windows on the upper floors. The school auditorium was located on the third floor in the area between the pavilions, a space illuminated by enormous round-arched windows that give the building a light, airy aspect. Windows in the classrooms are rectangular in shape. The hipped roof originally had a central rectangular cupola covered by a dome. To the left of the school is a two-story wooden structure (1930s) with tall and narrow closely spaced segmental-arched windows, which accommodated a gymnasium. The gymnasium was also used for community events, such as Mardi Gras balls.

MY6 Grevemberg House Museum (Grevemberg House)

c. 1851. 407 Sterling Rd. (Louisiana 322)

When plans were afoot in the 1960s to demolish this house and put a Little League ballpark on the site, the local branch of the Louisiana Landmarks Society stepped in to save it. Built

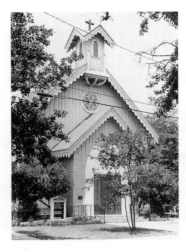

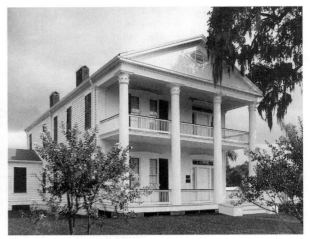

MY4 St. Mary's Episcopal Church
(above, left)

MY6 Grevemberg House Museum
(Grevemberg House) (above, right)

MY7 Sterling Sugar Mill (right)

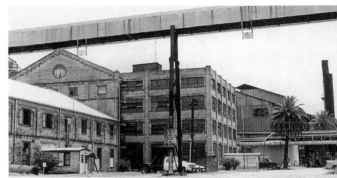

by lawyer Henry C. Wilson sometime between 1851 and 1857, the house was purchased in 1857 by Frances Wikoff Grevemberg, widow of Gabriel Grevemberg. Attesting to the continuing popularity of the Greek Revival style in Franklin, the cypress-wood house has a two-story temple front with four slender, double-height Corinthian columns and a pediment outlined by dentils. A second-floor balcony is inserted within the portico. The house was restored with furnishings of its period and is open to the public.

MY7 Sterling Sugar Mill

1890, Sully and Toledano; many later additions. Sterling and Irish Bend rds.

From the 1890s through the first decades of the twentieth century, St. Mary Parish was the leading sugar-producing parish in the state. This sugar mill, constructed as a centralized factory for independent farmers, contained the most up-to-date steam-process machinery. First known as the Caffery Central Sugar Refinery and Railroad Company, in honor of state senator Donelson Caffery, the mill was acquired in 1902 by the Sterling Sugar Railway Company. Its operations originally included refining, but it now produces only brown, or raw, sugar. This large complex includes the original steel-frame brick mill structures, designed by the New Orleans firm of Sully and Toledano. One is two stories in height and the other four stories. Pilasters are set between the windows, and one section of the four-story structure has a pedimented gable; the flat-roofed section was added at a later date. The numerous metal-sided additions that have enveloped these early structures accommodate the grinders, the machinery for clarifying and filtering cane juice, the machine shop, storage areas, and the boiler rooms and smokestacks. Separate smaller structures house offices and workers' quarters. In the fall, after

the cane is cut, the mill operates twenty-four hours a day.

Franklin Vicinity

MY8 Oaklawn Manor

1837. 3296 E. Oaklawn Dr. (off Irish Bend Rd. [Louisiana 322], 5 miles north of Franklin)

Irish-born lawyer Alexander Porter came to Louisiana from Nashville in 1809 and started buying land along Bayou Teche. It was Porter's Irish ancestry that gave this curved stretch of the Teche the name Irish Bend. After Porter had served on the Louisiana Supreme Court and represented the state in the U.S. Senate, he retired to his Bayou Teche property and built this Greek Revival house. The white-stuccoed brick house has identical porticoes front and back, with six full-height Tuscan columns and a pediment ventilated by a small window. Both floors of the house are identical in plan, with two rooms on each side of a central hall and a staircase set into a side hall. A ballroom was located on the third floor. An inventory of 1848 records that the plantation then possessed a sawmill, a sugar mill, 320 slaves, 80 workhorses and mules, and 160 head of sheep. After the Civil War and a succession of owners, the house was increasingly neglected, and an interior fire caused considerable damage. In 1925, paddleboat owner Clyde Barbour purchased and restored the house; it was renovated in the 1960s by owner George Thompson. In 1986, Murphy

MY8 Oaklawn Manor

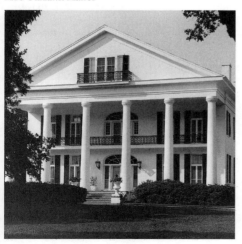

"Mike" Foster, who was elected governor of Louisiana in 1996, and his wife, Alice Foster, purchased the house and undertook another restoration. Of the plantation's original service buildings, only the separate kitchen and the brick butter house survive. The house is open for tours.

Baldwin

MY9 Darby House

c. 1820s. 606 Main St.

Once the center of a 1,386-acre sugar plantation (Rosebud), Darby House was built by Alfred Hennen but acquired its name from François Darby, who purchased it in 1856. The two-story raised house has a ground floor built of brick, a second story constructed of *bousillage* between posts, and a hipped roof pierced by two small dormers. The gallery's lower level is supported on thick brick columns and the upper on slender cypress colonnettes. The Creole plan consists of three front rooms, with a loggia behind that is set between cabinets; chimneys were placed against interior partition walls. From 1969 to 2001, the house was occupied by a bank, and about 1983, drive-up windows were added at one side. The town of Baldwin was founded by John Baldwin in 1867 and became a prosperous lumber and sugar community in the late nineteenth century.

Charenton Vicinity

MY10 Albert Heaton House

1853. 2194 Louisiana 326 (3 miles north of Baldwin)

Albert Heaton's house was copied from a design by Alexander Jackson Davis, published in A. J. Downing's *The Architecture of Country Houses* (1850; plates 125 and 126). This was one of a number of books published in the mid-nineteenth century that provided elevations and plans of houses in a variety of styles for potential homeowners to copy. Describing this design as a "small villa in the classical manner," Downing stated, "The exterior of the design is characterized in symmetry, good proportion, and a certain chasteness and simplicity which we like in a country house, while the whole mass obtains dignity from the height given to the central portion." The two-story-high central sec-

tion is flanked by one-story wings, and a gallery supported on simple posts extends almost the entire width of the house. The board-and-batten construction emphasizes the natural vertical qualities of wood, a feature Downing favored. Some rooms have paneled ceilings. The house had become quite dilapidated by 1966, at which time it was purchased and moved from Franklin to this location. It was restored in the 1960s for new owners by architect Samuel Wilson, Jr., of Koch and Wilson.

Garden City

Very little remains of Garden City, the lumber company town founded in 1900 by Albert Hanson as an expansion of his Franklin-based lumber business. Like other company towns, Garden City included a school, a church, a commissary, and the industrial component, in this case, lumber stacking and drying yards, adjacent to a railroad spur line. The lumber company closed in the 1950s. Among the few surviving buildings is the former Hanson Lumber Company Office (c. 1900; 10400 Louisiana 182), a two-story wooden structure with three doors set in a recessed entrance and a two-story gallery on fluted columns. Inside, an octagonal foyer surmounted by a cupola rotunda was flanked by offices on one side and dining facilities on the other; a spiral staircase led upstairs to sleeping quarters for temporary residents. The company owner's house, in the Queen Anne style, c. 1900 (10407 Louisiana 182), has polygonal bays, an Eastlake gallery that wraps around two sides of the building, a shingle gable, brackets, ball drops, and scrollwork, all designed to display the company's product. At 10320 Louisiana 182 is the former company store, a three-bay, galleried wooden structure. The residential section of Garden City, demolished in the 1990s, extended inland along two streets behind the company owner's house and consisted of three types and sizes of houses for the different ranks of workers.

Centerville

Centerville acquired its name because it was once the center for sugar shipment along Bayou Teche for the surrounding area; the town later became a center for the cypress lumber industry. Centerville's most interesting historic buildings are located on the main thoroughfare (Louisiana 182) near its intersection with Louisiana 317. These include the Joshua B. Cary House (9107 Louisiana 182), built in 1839, which has a pedimented portico supported on four square columns; the galleried Old Kennedy Hotel (9106 Louisiana 182), built c. 1854, described as a "hotel house" when William Cary sold it in 1855; and the Presbyterian church, 1878, which has a tall square front tower and octagonal spire in the center of the facade.

Patterson Vicinity

Named for a planter known as Captain Patterson, the village of Patterson is located on Louisiana 182, which follows the route of the Old Spanish Trail on the east side of Bayou Teche to Lafayette. Patterson was an important cypress lumber town. The F. B. Williams Cypress Company, Ltd. was the largest cypress lumber mill in southern Louisiana, in operation from 1892 to 1928. The company owned several steamboats for towing freshly cut timber to the mills.

MY11 Wedell-Williams Memorial Aviation Museum

1929, 1976. Louisiana 182 (3 miles west of Patterson)

The museum is situated at the airport established in 1929 by aviators James R. Wedell and Harry P. Williams, who founded the Wedell-Williams Air Service there. Harry Williams, son of Patterson lumber magnate Frank B. Williams (who also owned an enormous house on St. Charles Avenue in New Orleans [OR136]), cleared some sugarcane fields on his family's Calumet plantation to build the airport. Like other wealthy young flying enthusiasts in the 1920s, Williams and Wedell were inspired by Charles Lindbergh's successful solo flight across the Atlantic in 1927. In 1933, Wedell broke the world speed record by averaging 305.33 miles per hour. The aviators also built their airplanes here. After plane crashes that killed both Wedell (in 1934) and Williams (in 1936), Williams's wife, movie actress Marguerite Clark, sold the Wedell-Williams Air Service and its mail contracts to Eastern Airlines; she donated the airport to the state as a memorial to her husband. The museum displays artifacts related to Williams and Wedell and to aviation in general, along with some small airplanes. A cypress sawmill museum is being added to the site.

Berwick

MY12 Southwest Reef Lighthouse

1859. Front St. and the Atchafalaya River (between Lima and Canton sts.)

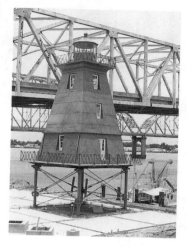

The three-story iron lighthouse, 37 feet high, was built to withstand hurricane winds. It has an unusual square form with sloping sides, similar to an Egyptian obelisk, even to a dramatic cavetto molding below the delicate iron of the upper balcony surrounding the cupola and light. The lighthouse is sheathed with iron panels fastened together with rivets, and each story has tall narrow openings to provide light. After damage from a hurricane in 1867, the lighthouse was given additional framework, including diagonal bracing. A pair of davit cranes, used for hoisting dinghies, were originally placed at the first level. Formerly located about fifteen nautical miles off the coast of St. Mary Parish in the Gulf of Mexico, the lighthouse stood on screw piles 49 feet above sea level and was visible for twelve miles. The lighthouse was decommissioned in 1916, moved to this site in 1987, and restored.

Morgan City

Morgan City is considered the birthplace of Louisiana's offshore oil and gas industry and is still an important port and manufacturing center for the Gulf of Mexico rigs. Boat and rig construction machinery dominates the horizon of Morgan City's outskirts. Incorporated in 1860 as Brashear City—named for the town's founder, sugar planter Dr. Walter Brashear—the town was renamed Morgan City in 1876 in honor of entrepreneur Charles Morgan (1795–1878). In 1869, Morgan had acquired the New Orleans, Opelousas and Great Western Railroad, the railroad's first link west from New Orleans, which reached Morgan City in 1857. In Morgan City, passengers and freight were transferred to steamboats for the journey west. Morgan, who already owned the steamship line, made the town a rail-steamship transportation hub between New Orleans and Texas. He also dredged the Atchafalaya Bay ship channel in 1872. Such coordinated transportation facilities made Morgan City a center for the cypress lumber industry when the trees in the Atchafalaya swamp were cut down at the end of the nineteenth century.

At Morgan City, the Atchafalaya River is one-half mile wide. Because it sits in the path of the Atchafalaya floodway, the town is protected behind a 22-foot-high concrete floodwall (seawall), which gives the community the appearance of a fortified town. A walkway along the top of the seawall offers splendid views of Berwick on the opposite bank of the Atchafalaya, the railway drop bridge (c. 1911), the Long-Allen Bridge with its 608-foot-long steel span, and the river traffic. Front Street, which now faces the floodwall, retains several of its one- and two-story brick commercial buildings dating from the turn of the century, when it was a bustling commercial street. Attractive wooden houses can be seen along 1st Street and adjacent streets, notably a house at 706 1st Street, with sweeping gable roofs with huge dormers, and a house at 716 1st Street, with a curved, two-story Ionic portico. To the east of Morgan City, the cypress swamp beside U.S. 90 served as a jungle in the first Tarzan movie, filmed here in 1917.

MY13 City Hall and Courthouse

1905, J. M. Parmelee. Everette and 1st sts.

This large two-story red brick structure incorporating a city hall, a courthouse, and a fire station stands on a foundation of "floating" wood mats above the soggy soil. A low, bracketed square tower is centered on the short side of the building, and a tower of similar shape but with open sides marks the long facade. Paired segmental-arched windows are set between shallow pilasters. The interior was substantially

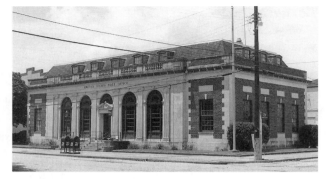

MY14 U.S. Post Office, Morgan City

MY15 Trinity Episcopal Church

altered in a 1985 renovation that included the removal of the original staircase. The city's water tower (c. 1912), behind the city hall, serves as a prominent marker for this civic center; its openwork steel-frame support structure echoes Morgan City's bridges and oil rigs.

MY14 U.S. Post Office

1932, James A. Wetmore, Acting Supervising Architect of the Treasury. 1st and Everette sts.

This Beaux-Arts post office of limestone-trimmed brick is the handsomest building in Morgan City. Fluted Ionic pilasters line the brick walls between the tall round-arched windows and the central entrance, which is topped by a broken pediment. The building has a mansard roof with a balustrade in front. The wood-paneled lobby, with terrazzo flooring and bronze fixtures, retains its original appearance.

MY15 Trinity Episcopal Church

1915. 716 Second St. (corner of Greenwood St.)

Founded as a mission chapel in 1874, Trinity was originally housed in a building that served as both schoolhouse and church. This was replaced in 1900 by a small rectangular structure, which was remodeled in 1915, giving it the Arts and Crafts appearance it has today. The low square shingle-covered tower and belfry were added, and the church's lower walls and gable were sheathed with wood shingles. Shingles are not common in Louisiana, and their use is almost always confined to houses. The church is dark green in color, with details highlighted in white, including the moldings around the doors and windows and the brackets under the church's pitched roof and the belfry's pyramidal roof.

MY16 International Petroleum Museum/Rig Museum

1952–1953. 1st St. and the Atchafalaya River

As the first transportable, submersible drilling rig used in offshore production, this rig, known as "Mr. Charlie," revolutionized the off-

shore oil industry worldwide. Its creator, Alden "Doc" Laborde, named the rig for Charles Murphy of Murphy Oil Corporation of Arkansas, an early supporter of his invention. From 1954 to 1968, Mr. Charlie drilled hundreds of wells in the Gulf of Mexico. This self-contained, self-sufficient industrial island had living accommodations for up to fifty-eight workers. The rig's platform is supported on massive legs that rise 60 feet above an attached barge, approximately 220 feet long and 85 feet wide. After being floated to a drilling location, the barge was flooded, which allowed the rig to sit on the floor of the Gulf of Mexico. Once it finished drilling one well, it could be moved clockwise to drill another one. The rig could be used only for shallow drilling in water up to 40 feet deep. Mr. Charlie was retired in 1986, when drilling activity headed into water deeper than its legs allowed. It was then brought ashore to serve as a museum and to train oilfield workers.

Iberia Parish (IA)

New Iberia

New Iberia, known as Nueva Iberia until 1847, was founded in 1779, when Louisiana was under Spanish rule. As the last inland port on Bayou Teche accessible to oceangoing steamers, New Iberia became an important shipping point for the region's sugarcane. Later in the nineteenth century, after the railroad was brought through in 1879, the town also became a center for the area's sawmills and rice mills. Rice processing is still an important industry. New Iberia's business district consists mostly of one- and two-story brick commercial buildings constructed after a fire in 1899; several of them were given new plate glass display windows in the 1930s. In 1932 Wormser's Department Store (112 E. Main Street) remodeled a c. 1900

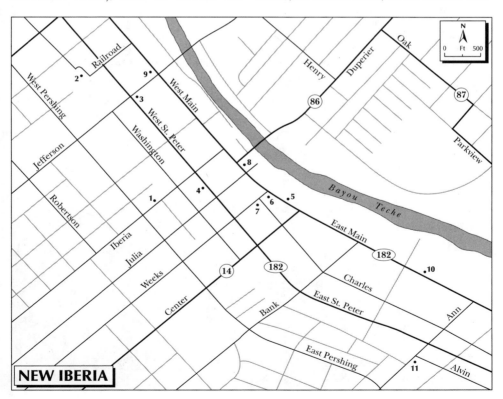

NEW IBERIA

commercial building, giving it windows set at an angle and Art Deco ornamentation on the surrounds and floor. Other stores acquired Carrara glass facades. Leading away from the commercial sector, Main Street has several grand mansions, notably Mintmere (c. 1845; 1400 E. Main Street), a Greek Revival central-hall house with two rear wings that form a three-sided galleried court overlooking the bayou. William T. Nolan designed the two-story New Iberia High School (1926) at 415 Center Street, giving it an entrance portico of Composite columns in antis; Favrot and Reed added the gymnasium in 1939.

IA1 Iberia Parish Court Building

1938–1940, A. Hays Town. S. Iberia St. (between W. Pershing and W. Washington sts.)

A. Hays Town designed this four-story, PWA-funded courthouse in the stark Moderne style he favored until the 1960s, when he turned to the vernacular revival styles with which he is most identified. The building has a dynamic facade, with fin-shaped piers between the windows, which have vertical, fin-shaped aluminum mullions. A uniform coating of white stucco over the brick walls exaggerates the building's austere angularity. Decoration is confined to stylized pelicans incorporated into the aluminum frames and aluminum doors modeled with representations of such indigenous wildlife as turtles and shrimp and also magnolia flowers. Leading up to the courthouse is a triple flight of

stairs, in the center of which is a sculpture of Justice in the form of a female figure standing on a prow-shaped plinth. The entrance lobby is a small rotunda with a shallow dome, supported on four large unadorned polished brown granite columns. The courtroom is on the second floor; the jail formerly occupied the top floor.

IA2 Southern Pacific Railroad Depot

1901. 402 W. Washington St.

This brick depot, modeled on H. H. Richardson's railroad stations in the northeastern United States, is a long, low building with round-arched openings surrounded by rock-faced concrete voussoirs. The voussoirs have foliate ornamentation influenced by Louis Sullivan's designs. The double-pitched hipped roof, which extends well beyond the walls to provide shade, originally had a turreted dormer and a small cupola. A central ticket office was located between two waiting rooms, which were segregated by race. The depot is one of the few stations that survive from the era of peak railroad development in Louisiana (1880–1910), upon which the rice and lumber booms were dependent.

IA3 First United Methodist Church

1891. 1907, remodeling. 119 S. Jefferson St.

After a fire in 1907, this church, originally in the Gothic Revival style, was repaired and trans-

IA1 Iberia Parish Court Building

IA4 St. Peter's Catholic Church

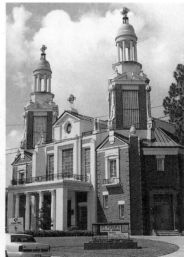

formed into a Mediterranean Revival structure. The fire-marked brick walls were stuccoed in a cream color, the gallery remade with broad round arches, and the roof covered with red tiles. A broad square tower anchors the church to its corner site, and each facade is marked by a steeply pitched gable. The sanctuary has a wooden scissors truss with hammer-beam supports and ornamental hanging pendants.

IA4 St. Peter's Catholic Church

1951–1953, Owen J. Southwell. 108 E. St. Peter St.

New Iberia architect Owen Southwell (1892–1961) adopted the traditional French two-towered basilica as the basis of his design, then refashioned the parts into a bold, imaginative composition. He described it as having "the light touch of French design." The facade, a contemporary interpretation of Georgian, Gothic, and Baroque forms, has a four-columned Corinthian portico surmounted by a balcony with an iron railing, large square-headed windows, and buttresses topped with sculpted kneeling angels. The twin towers rise from square bases, with huge scroll brackets supporting broken pediments and festooned with sculpted rosaries, to octagonal forms topped by miniature tempiettos, similar in design and size to the cupola on New Iberia's former post office (IA6). To heighten the drama, Southwell exploits the color and textural contrasts between the red brick walls and the white cast concrete ornamentation. The interior, shaped over a reinforced concrete frame, has a wide, spacious nave, as the arcade is pushed close to the side

IA5 Shadows-on-the-Teche

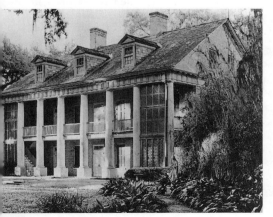

walls, allowing for only narrow aisles. A shallow barrel vault covering the nave was painted with symbols of the Evangelists to designs of the architect. George L. Payne designed the stained glass. Southwell's unique interpretation of traditional church architecture gave St. Peter's a postmodern appearance well before that style or even the term became popular.

IA5 Shadows-on-the-Teche

1831–1834. 317 E. Main St.

Sugar planters David and Mary Weeks built this Greek Revival house on the Spanish land grant given to David Weeks's father in 1792. The house was constructed by their slaves under the supervision of local carpenter James Bedell and mason Jeremiah Clark. Weeks chose to live in New Iberia because it was less isolated than his large holdings farther south, on what is now known as Weeks Island. The two-and-one-half-story, sixteen-room house was built of handmade red brick and is fronted by a gallery with eight full-height Tuscan columns of white-plastered brick standing on high square bases and topped by a Doric frieze. Three pedimented dormers pierce the gable roof. The house has a traditional Creole plan on both floors, with three rooms across the front and two rear rooms flanking an open loggia. A dining room occupied the center room of the ground floor, above which was a parlor. An exterior staircase is located on the left side of the front gallery, hidden behind louvered panels. Interior walls were covered with wallpaper; the cypress doors were painted to simulate oak and fireplaces were given a false-marble finish. Because the house is 20 feet above the bayou, it was provided with an underground brick cistern, 6 feet deep and 11 feet wide, with a 3-foot-high domed top and a capacity of over 4,000 gallons. The kitchen and slave dwellings were separate buildings on the Bayou Teche side of the house. On moving into her home, Mary Weeks wrote to her husband in June 1834: "I never saw a more delightful airy house, my room particularly. I have all the children in it and open the doors and windows every Night."

Under a later owner, William Weeks Hall, David Weeks's great-grandson, who had studied art in Paris, Shadows was restored by architect Richard Koch of the firm Armstrong and Koch. Weeks Hall also remade the two-acre garden. The house became famous for his soirees, attended by notable arts-related guests including

movie directors D. W. Griffith and Cecil B. De
Mille and writers Anaïs Nin and Henry Miller.
(The house and Weeks Hall are featured in
Miller's story "The Air-Conditioned Night-
mare.") At his death in 1958, Weeks Hall be-
queathed Shadows to the National Trust for
Historic Preservation, which commissioned
Koch and Wilson to restore the house before
opening it to the public. In the 1990s, Diana
Balmori and Associates with Jon Emerson and
Associates of Baton Rouge restored the garden,
on the basis of research by Suzanne L. Turner,
to its appearance when Weeks Hall lived there.
The restorers retained the paths that Hall had
made out of bricks from the slave cabins he de-
molished but marked in stone the corners
where the slave cabins and kitchen once stood.

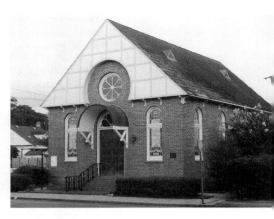

IA6 Schwing Insurance (U.S. Post Office)

1903, James Knox Taylor, Supervising Architect of the
Treasury. 300 E. Main St.

Raised on a high podium, this two-story former
post office has a tall, round-arched central en-
trance flanked by windows of equal size and
shape. Together, these three openings create
the effect of a triumphal arch and acquire fur-
ther prominence through the contrast between
their white stone surrounds and the building's
red brick walls. The post office has slightly re-
cessed wings, each with a rectangular window
set within a blind arch that is the same height as
the three center openings. A balustrade runs
along the top of the building, and a tempietto-
shaped cupola is centered on the hipped roof.

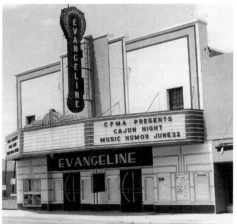

IA7 Congregation Gates of Prayer Synagogue

IA8 Evangeline Theater

IA7 Congregation Gates of Prayer Synagogue

1904. 109 S. Weeks St.

The congregation Gates of Prayer was formed
in 1897, and this synagogue, dedicated in Sep-
tember 1904, is one of the oldest in south cen-
tral Louisiana. Constructed of brick, it has a fa-
cade that features a central entrance with a
fanlight and round-arched windows on each
side. The upper half of the facade has a large
projecting gable supported on brackets and
pierced by a small circular window.

IA8 Evangeline Theater

c. 1900, 1929. 1940, William Bowen. 129 E. Main St.

This colorful building, a wholesale grocery
store built around 1900 and transformed in
1929 into a movie theater, was the inspiration
of Lebanese immigrant Kalil Sliman. To the
upper facade he added the vertical sign that an-
nounces the theater's name, Evangeline, in-
spired by Henry Wadsworth Longfellow's Aca-
dian heroine in the poem of the same name. It
is spelled out in white letters on a dark blue
background, and emblazoned above it is a red,
yellow, and green sunburst outlined with elec-
tric lights. In 1940, Sliman's son Theodore re-
fashioned the facade. He placed a glass ticket
booth in the center between the two entrance
doors and faced the lower half of the building
with red and peach-colored Carrara glass inter-
sected by bands of gold-colored glass. He also
added a yellow and red marquee with neon

light strips and painted the upper facade red, white, green, and yellow. When the movie house closed in the 1960s, the Sliman family donated the building to the city; it was renovated in the 1990s as a center for performing arts and community events. Although the auditorium has been altered for its new uses, the lobby retains such original details as the stairs and light fixtures.

IA9 Episcopal Church of the Epiphany

1857–1858. 303 W. Main St.

The small rectangular Gothic Revival church was constructed by slaves from locally made bricks and was consecrated by Bishop Leonidas Polk, as were many churches in southern Louisiana. The facade features a small portico with a pointed-arched entrance, above which are a diminutive rose window and belfry, the latter added in 1884. Angled pinnacled buttresses mark the facade's corners. The interior features a wooden gallery, originally reserved for slaves, which retains a few of the original pews. The pink, green, and gold stained glass windows behind the altar are from the Tiffany workshop. During the Civil War the Union Army used the church as a hospital, stable, and guardhouse.

IA10 Steamboat House

1896. 623 E. Main St.

When John Emmer built this house, using bricks from his brickyard, it consisted of a gal-

IA12 Joseph Jefferson House

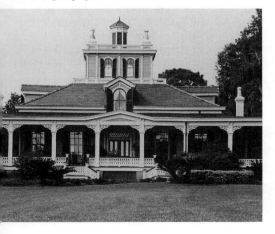

leried two-story section at the front, with towers at each end, and a single-story rear section. In 1948, the one-story portion was raised and given a hipped roof with dormers and a balustraded widow's walk, creating a picturesque if somewhat eclectic house. The original gallery was altered by the addition of slender, double-height round columns. One of the house's owners was Dr. Paul N. Cyr (1878–1946), who was elected lieutenant governor on Huey Long's ticket in 1928, but who soon fell out with Long when he opposed some of the governor's programs. Cyr was a major reason why Long chose to remain governor after winning election to the U.S. Senate in 1930; had he resigned, Cyr would have inherited the governorship.

IA11 Conrad (Konriko) Rice Mill

1914, with additions. 307 Ann St.

Phillip A. Conrad, Sr., founded the Conrad Rice Mill and Planting Company in 1914, milling rice from his land. As he began to buy and mill grain from other growers in the area, the mill was expanded twice to create a compact group of two- and three-story structures clustered together to facilitate the various processes, from warehousing and milling to packaging and shipping. All the buildings are constructed of heavy timber sheathed with galvanized iron corrugated siding. The delivery area for the first structure of 1914 includes a scale, hoist, and hopper. The mill has 10,000 square feet of interior space, tightly packed with much of the original milling equipment, although the older, belt-driven machines are now powered by electricity, not steam. Rice moves through the processing operation (hulking, grading, etc.) by means of gravity feed. The mill is located alongside the railroad track and incorporates its own truck loading dock.

New Iberia Vicinity

IA12 Joseph Jefferson House and Rip Van Winkle Gardens

1886. 5505 Rip Van Winkle Rd. (6 miles west of New Iberia off Louisiana 14)

Actor Joseph Jefferson (1829–1905) built this house as a retreat from his hectic theatrical career. He was most famous for his portrayal of

Washington Irving's Rip Van Winkle, a role he performed more than 4,500 times on stage and in one of the first movies ever made. The house was built on top of a salt dome that rises 90 feet above the surrounding marshes. Jefferson supervised the construction of his one-and-one-half-story wooden house, which was erected by master builder George Francis. The picturesque design, which is of no single style, is distinguished by broad airy spaces suitable for the climate. Deep galleries surround the house on three sides, and a tall belvedere in the center of the roof provides views across the watery landscape of this area. A 12-foot-wide central hall draws cooling breezes into the house, which has twenty-two rooms.

In 1966, when J. Lyle Bayless, Jr., owned the house, he hired horticulturalist Geoffrey Wakefield to design the planting schemes for the garden he had begun to develop. In 1980, oil-rig drilling in the lake (Lake Peigneur) bordering the property punctured one of the underground salt caverns, which caved in and swallowed the lake, nine barges, sixty-five acres of Bayless's garden, and a house built in the 1970s, but, fortunately, not Jefferson's house. The lake refilled (water from the Gulf of Mexico poured into it), and twenty-five acres of themed gardens were restored. An earlier incident also causing great excitement was the discovery, in 1923, of buried treasure: three pots of eighteenth-century Spanish and American coins. This area of secluded waterways and marshes had been a favorite haunt of Jean Lafitte and other pirates. Today, Joe Jefferson's house functions as a bed-and-breakfast, and its gardens are open to the public.

Avery Island

Avery Island is not a true island, but the 5,000-acre tip of a salt dome (or cone) that reaches eight miles down and is surrounded by Bayou Petite Anse (Little Bay). Roughly two miles in diameter, the salt dome is a curious sight, rising approximately 150 feet above the surrounding sea-level marshes. The land was granted by the Spanish government in 1791, and in 1812, John Marsh began extracting salt from springs. In 1862, rock salt was discovered 16 feet below the surface. This was such an important commodity for the Confederacy during the Civil War that Union General Nathaniel Banks captured the island and destroyed the saltworks in 1863. After the war, the Avery-McIlhenny fami-

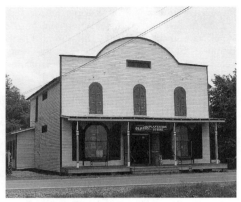

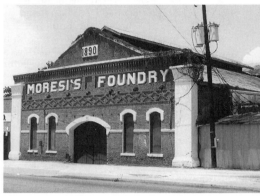

IA14 Olivier Plantation Store

IA16 Moresi's Foundry

lies, who then owned the island, returned there. To help in their financial recovery, Edmund McIlhenny (1815–1890) invented a hot sauce made from capsicum peppers, vinegar, and Avery Island salt, naming it Tabasco. In 1900, his son, naturalist Edward Avery McIlhenny (1872–1949), founded a bird colony to protect snowy egrets, which were being killed for their decorative feathers. Avery Island is now a principal breeding ground for 20,000 egrets, which nest every spring on specially built pierlike structures. He also developed the 250-acre Jungle Gardens, cultivating exotic plants from all over the world, including many varieties of bamboo. The gardens also contain a giant eleventh-century statue of Buddha from China, which is housed in a small pagoda. The gardens are open to the public. The salt mine (not open to the public) is the oldest in the United States and annually yields two million tons of salt.

IA13 Tabasco Pepper Sauce Factory

1910, with additions. Louisiana 329 (at its conclusion)

After the Civil War, Edmund McIlhenny began to grow capsicum peppers on the salt dome's topsoil from seeds he had been given. Blending and aging the peppers with vinegar and Avery Island salt, he produced a hot sauce that he named after the state in Mexico where the seeds came from. The original frame building in which he manufactured his sauce was replaced in the early twentieth century by a brick structure with stepped gables, and this building has been enlarged over the years. The factory, which is open for tours, houses the oak barrels in which the sauce ages and ferments, and the bottling areas. Approximately 500,000 bottles of sauce are now produced daily. Recent excavations on the site of McIlhenny's first manufacturing building, demolished in 1925, have unearthed its brick foundations and numerous early pepper-sauce bottles.

Lydia

IA14 Olivier Plantation Store

1898. 6811 Weeks Island Rd. (Louisiana 83)

Originally one of a group of plantation service buildings, this store, built by Jules Olivier, is constructed of cypress and has a three-bay porch, round-arched windows on both floors, and a false front that is also arched. The store is unusual among such buildings on plantations in having two floors. In the center of the interior, the two floors open to form a single vertical space from floor to ceiling. Fittings for the former post office and original shelving have been retained.

Jeanerette Vicinity

IA15 Alice Plantation (Agricole Fuselier House)

c. 1816. 9217 Old Jeanerette Rd. (Louisiana 87, .5 mile north of Louisiana 3182)

In 1961, the upper floor of this house was floated by barge along Bayou Teche from its original location in Baldwin (St. Mary Parish), which was being developed as a subdivision. The house had been built by planter Agricole Fuselier de la Claire. At the new location, the

ground floor of the house was reconstructed from the original salvaged bricks, and windows and doors were reset in their original frames and locations. The second story is constructed of *bousillage* between posts and sheathed in beaded cypress weatherboards and is sheltered under a steep hipped roof with two front dormers. A two-story front gallery is supported on six stucco-covered brick columns at ground level and eight small chamfered wooden columns above. In plan, the house follows early Louisiana models, with three rooms across the front and two deep, with a loggia between, where the stairs originally were located. Some later changes have been made to the house, including upper door and window frames. The house now accommodates bed-and-breakfast guests.

On the same road (9805 Old Jeanerette Road) is Bayside, a two-story Greek Revival plantation house built in 1850, which has a colossal six-column Doric gallery and, reflecting its later date, a central-hall plan.

Jeanerette

Jeanerette, named for sugar planter John W. Jeanerette, who came to the area in 1830, is a center for sugar-related industries. Dominating the town's center is the Jeanerette Sugar Company mill (2304 W. Main Street), an open-air spectacle with conveyer belts, grinders, and metal buildings noisily active from mid-September to early January. Inside the red brick U.S. Post Office (1614 Main Street), designed in 1939 by Louis Simon, Supervising Architect of the Treasury, is a mural depicting the sugarcane industry, painted by Hollis Holbrook in 1941. St. John the Evangelist Catholic Church (Church and St. Nicholas streets) is a large red brick Gothic Revival structure built in 1908, although it has recently been suggested that the church is a Nicholas J. Clayton design of 1881. One mile south of Jeanerette (in St. Mary Parish) is Albania (c. 1855; 1842 Loui-siana 182), a two-and-one-half-story Greek Revival plantation house built of wood with a central-hall plan and colossal boxed columns carrying a two-story front gallery.

IA16 Moresi's Foundry

1890. 506 Main St.

Swiss immigrant Antoine Moresi opened a blacksmith shop in 1852, then expanded into

manufacturing machinery and gears for the local sugar mills. The brick foundry constructed at the end of the century is a handsome building, 155 feet by 55 feet, with a pedimented front, dentils, decorative geometric bands, and huge piers at each corner of the facade. A wide central entrance is flanked by segmental-arched windows, and above is the Moresi name spelled out in brick. The foundry has more recent metal-sided structures at the rear and side. Today the foundry manufactures rollers for the sugar mills and iron sugar kettles.

Vermilion Parish (VM)

Abbeville

In 1843, French priest Father Antoine D. Megret (d. 1853), known locally as Père Megret, purchased the land now occupied by Abbeville in order to build a chapel. Four years later, he donated land for a courthouse and town square, and Abbeville was laid out in the 1850s beside the Vermilion River. The town is said to be named for Megret's native town of Abbeville in France. A statue of Père Megret can be seen in the town square, Magdalen Square. Abbeville grew slowly until the arrival of the Iberia and Vermilion Railroad (later the Southern Pacific) in 1892, after which it became a center for rice processing and trade. The one-story wooden former Iberia and Vermilion Railroad freight depot (c. 1894) was relocated from its original site closer to the river to the corner of W. Lafayette and S. Jefferson streets and renovated as a café. A fire in 1903 destroyed most of the commercial district's wooden buildings, but Concord, State, and Jefferson streets were quickly rebuilt with handsome new structures of brick. Primarily Italianate in style, these commercial buildings feature brick cornices, pan-

eled parapets, arched openings, and cast iron pilasters. An excellent example is the building now occupied by the Abbey Players Theater, c. 1905 (100 S. State Street), which features corbeling and a crenellated parapet. A WPA-funded mural depicting the sugarcane and cotton harvest, painted in 1939 by Louis Raynaud, decorates an interior wall of Louis Simon's Moderne post office of 1936 (200 N. State Street). Since much of Abbeville's growth occurred in the 1890s, many historic residences are in the Queen Anne or Colonial Revival styles, the majority painted white. Houses along Fairview Avenue and adjacent streets are prettily garnished with gables, turrets, and Eastlake brackets.

VM1 Vermilion Parish Courthouse

1953, A. Hays Town. Bounded by State, Peace, Tivole, and St. Charles sts.

This Antebellum Revival courthouse of white-painted brick is two stories tall and features a portico with six concrete Doric columns raised on plinths supporting an unadorned pediment. The rear facade is defined by eight Tuscan columns, a gallery, two small dormers in the hipped roof, and an exterior staircase in the gallery, similar in concept to the rear facades of many southern Louisiana plantation houses. A. Hays Town designed this courthouse after he had repudiated modernism, as exemplified by his Iberia Parish Courthouse in New Iberia (IA1), in favor of recreating Louisiana's historic vernacular architecture. A replacement for a courthouse that had become too small for its required functions, this one is altogether too big for its site.

VM2 Bank of Abbeville

1904, George Honold. 127 Concord St.

The bank of Abbeville's first building was destroyed in the fire of 1903. New Orleans archi-

ABBEVILLE

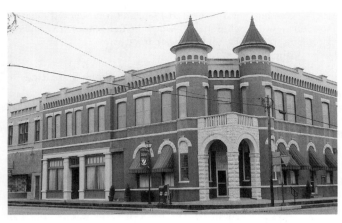

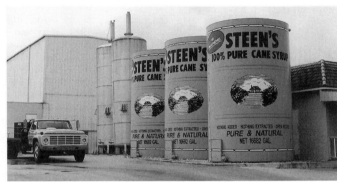

VM2 Bank of Abbeville

VM4 C. S. Steen Syrup Mill

tect George Honold (c. 1876–1941) designed this replacement, a two-story Romanesque Revival structure of red brick, to resemble a medieval castle. Its angled corner entrance portico of rusticated, rock-faced cast concrete is flanked by two conical-roofed circular towers. The first-floor window voussoirs and the second-story lintels are also rusticated, and a blind arcade outlines the eaves.

VM3 St. Mary Magdalen Church and Rectory

1910–1911, church, George Honold. 312 Père Megret St.

This church, the fourth to occupy the site of Père Megret's first church, is mostly in the Romanesque Revival style, but it has a tall square tower with an octagonal spire in the center of the facade. The triple-arched entrance, window surrounds, and cornice are of buff-colored stone to contrast with the red brick walls. In plan, the church is composed of a barrel-vaulted nave and aisles separated by an arcade with Composite capitals, a transept, and a semicircular apse covered by a half dome adorned with blue and gold mosaics representing rays of light across the heavens. The large stained glass windows are dominated by hues of green and amber. The interior, painted a cream color, was restored in 1981 following a fire. Next to the church is a two-story rectory (1921) with a round-arched gallery. To the rear of the church is the cemetery, established in 1844, which contains several graves with now-rare nineteenth-century iron crosses.

VM4 C. S. Steen Syrup Mill

Early 20th century, with additions. 119 N. Main St.

The six structures that make up this syrup mill include two cooking rooms, a warehouse, an office, a refrigerated storage building, and a canning room. The latter is housed in the former Abbeville Power Plant (1922), a one-story Beaux-Arts building of stuccoed brick that has

been adapted for its new purpose. The cooking rooms are large metal-sided structures with ridge ventilators. One is used for cooking syrup and the other for cooking molasses. At the entrance to the complex are three huge tanks labeled and painted bright yellow to resemble cans of Steen's syrup. While recalling Pop Art sculpture of the 1960s, these tanks are functional as well as decorative, for they are used to store pure cane syrup after it is cooked from the juice that is trucked from sugar mills in the area. When Charles S. Steen established the mill in 1910, sugarcane was crushed at the mill, which took place twenty-four hours a day in the fall. Now the juice is trucked in between late October and late December, and syrup is cooked from the filtered juice in the building originally used for crushing the cane.

VM5 Caldwell House

1907, 1920s. 105 E. Vermilion St.

This two-story brick house has matching hexagonal two-story, towerlike corner bays and a one-story Doric gallery that extends across the facade and along the sides of the building. In the 1920s, the exterior walls were covered with stucco, and the roof was resurfaced in tiles, which gave the house the then-fashionable Mediterranean Revival appearance. The house has a central hall and pressed metal ceilings in three of the first-floor rooms. Owner and builder Vernon Lee Caldwell was a partner in a brick manufacturing business that expanded to become Caldwell Brothers Construction Company. He was also a businessman and civic leader and served in both the Louisiana House and Senate. The house offers bed-and-breakfast accommodations.

VM6 St. Mary Congregational Church

1905. 213 S. Louisiana Ave.

A replacement for an earlier church building, this Gothic Revival church was funded by the American Missionary Association for the African American congregation. The antislavery association, founded in New York in 1846, purchased the site and provided funds for construction. The frame church has a gable front and a three-stage square corner tower, each level marked by projecting eaves ornamented with brackets. Brackets also decorate the steeply pitched gable roof. The congregation

was formed in 1885, and it is believed that the church established the first school in Vermilion Parish to educate freed slaves.

VM7 Riviana Mills (Louisiana State Rice Milling Co. and Planters Mill)

1902. 403–405 S. Washington St.

Riviana has its origins in the Abbeville Rice Mill, established in 1899 by Gus Godchaux, Abrom Kaplan, and other investors. Godchaux died in 1908; in 1911, his son Frank amalgamated thirty-three rice mills in southern Louisiana to form the Louisiana State Rice Milling Company, then the world's largest rice milling company. This brick structure was described as the most modern rice mill in the nation when Frank Godchaux constructed it in 1902; after 1911, it served Godchaux's newly organized company. A covered loading platform was built along the Railroad Avenue side of the building for the spur line brought from the nearby railroad tracks. Warehouse spaces occupied this two-story side of the structure, and the mill was located in the four-story section. The building is nicely detailed with pilasters, segmental-arched openings, and a decorative brick cornice. Additional buildings added to the site

VM6 St. Mary Congregational Church

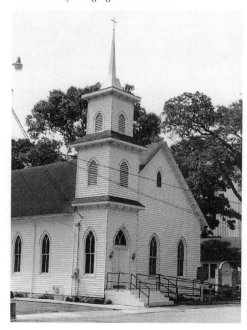

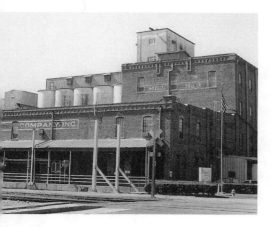

VM7 Riviana Mills (Louisiana State Rice Milling Co. and Planters Mill)

VM9 Kaplan Fire Station

Rice Milling Company, now houses the offices of the Riviana rice company. The streamlined building, of white-painted stucco over concrete block, has a two-story inset central portico outlined by stylized fluted quarter columns.

Kaplan

Incorporated in 1902, when it was not much more than a group of tents, Kaplan was founded the previous year by Abrom Kaplan (1872–1944) as a commercial and transportation center for rice processing and shipping. Kaplan, who emigrated from Poland, was one of the pioneers of the rice industry in southern Louisiana and owned several rice mills. Civil engineer F. T. Foote laid out the town, with wide streets leading away from the railroad tracks. By 1910, one- and two-story brick commercial buildings were being constructed along Cushing Boulevard. The Musée de la Ville de Kaplan (405 N. Cushing Boulevard) occupies the city's former water and light building, constructed in the 1920s. Favrot and Reed with Frederick J. Nehrbass designed the two-story Moderne house of white-stuccoed brick (1938) at 300 Lejeune Avenue, giving it one-story wings with roof terraces. The small town is dominated by monumental concrete silos, metal-sided rice dryers, mills, and warehouses located alongside the railroad tracks.

over the years included a two-story rice warehouse, a six-story metal-sided rice dryer, and a row of concrete silos.

On Railroad Avenue, a short distance from the mill, is the brick Abbeville Rice Mill, built by Gus Godchaux in 1899, which was incorporated by the Louisiana State Rice Milling Company as mill number 3. It was later used as a warehouse and for packaging.

VM8 Riviana Foods Inc. (Godchaux Building)

1941. 501 S. Main St.

The Moderne office building, which served as the headquarters for the Louisiana State

VM9 Kaplan Fire Station

1957. 501 N. Cushing Blvd. (corner E. 5th St.)

The two-bay fire station occupies the corner site in a group of small one-story brick civic buildings, including a city hall and a public library (now a senior citizen center), that were built in the 1950s. By far the most dynamic of the group, the steel-frame station has a butterfly roof that angles dramatically away from its center support. The station is illuminated by clerestory windows set between the side walls of blond rough-textured brick and the roof's upward slant. Unusual-shaped roofs became popular in the 1940s and 1950s after the renowned architect Marcel Breuer used them in many of his award-winning designs. Such innovative forms were also promoted by the steel industry in advertisements in architecture journals.

Acadian Parishes

FRENCH TRADERS HAD ESTABLISHED RELATIONS WITH THE NATIVE Americans in this region, the Opelousas and the Atakapa, decades before the first great influx of Acadians (Cajuns) following their expulsion from Canada in 1755. When the Spanish took possession of Louisiana in 1763, they converted the French trading posts into military posts and encouraged continued Acadian settlement through land grants. This mostly French-speaking area also proved attractive to members of the French aristocracy, who fled the French Revolution of 1789 and found refuge in St. Martinville. During those years, the waterways were crucial for trade and communication, and the region's oldest buildings are located along Bayous Teche and Courtableau and the Vermilion and Atchafalaya rivers. Sugar was the principal crop.

West of Lafayette, the region remained thinly settled until the railroads opened the prairie to cultivation in the 1880s. Attracted by advertisements extolling the fertile land and mild climate, midwesterners moved south to raise cattle and, more important, rice. Irrigation canals for the rice fields form a grid across the landscape. This geometry is repeated in the layout of the towns founded along the railroad, such as Crowley and Eunice. Laid out before they were settled, these towns feature the wide streets typical of the approach to town planning fostered by engineers and railroad surveyors. Rice mills and silos line the railroad tracks. Among other agricultural endeavors is frog farming. The town of Rayne, calling itself the "Frog Capital of the World," is bedecked with images of frogs painted on buildings and street advertisements.

Oil and gas discoveries of the 1930s and 1940s brought new workers, especially to Lafayette, which became a regional headquarters for these industries in the 1950s and 1960s. Lafayette also emerged as an important educational and medical center for southwestern Louisiana. In the last quarter of the twentieth century, tourism be-

ACADIAN PARISHES

——— State or Local Route
———— U.S. Route 0 Miles 10
═══ Interstate

Cities with detailed maps
later in the chapter are
indicated with SMALL CAPS.

came a major industry, focusing on Cajun music and food, along with French-influenced architecture. Travel to the region was made easier following construction in 1973 of the elevated four-lane, seventeen-and-one-half-mile stretch of Interstate 10 across the Atchafalaya River basin, which connects Baton Rouge and Lafayette. Under the direction of engineer in chief A. B. Ratcliff, Jr., concrete piles were driven into the water at intervals of 70 feet, and the precast concrete spans were shipped to the site by barge.

The region's parishes are St. Landry (1807), named for St. Landry Catholic Church; St. Martin (1807), named in honor of the fourth-century bishop of Tours; Lafayette (1829), in honor of the Marquis de Lafayette, the French hero of the American Revolution; and the two parishes created after the railroads brought increased population to the western sections, Acadia and Evangeline (named after the Acadian heroine of Henry Wadsworth Longfellow's poem), formed in 1888 and 1912 respectively.

St. Martin Parish (SM)

St. Martinville

St. Martinville is famous as the setting of Longfellow's romantic poem "Evangeline" (1847). Loosely based on the life of a real person, Emmeline Labiche, the poem describes her despair at being separated from her sweetheart, Louis Arceneaux (Gabriel in the poem), when the British expelled the French from Nova Scotia (Acadia). Local mythology, however, adds a heartrending coda to Longfellow's poem. Emmeline by chance encounters her beloved beneath an oak tree in St. Martinville and, discovering that he has wed someone else, soon expires of a broken heart. The Evangeline Oak is one of St. Martinville's landmarks and is among the trees in the state designated as members of the Live Oak Society on the basis of their antiquity, girth, or historical importance. Louisiana's Acadian legacy is commemorated at the Acadian Memorial Building (121 S. New Market Street) in a mural, *The Arrival of the Acadians in Louisiana*, by Robert Dafford, and a wall on which are inscribed in bronze the names of all 3,000 Acadians who came to Louisiana as refugees.

The town had its origins in the Poste des Attakapas, established by the French in the 1760s and named for the local Native American tribe. Acadians were the first sizable group of immigrants, followed by royalists who fled France during the Revolution of 1789. St. Martinville acquired the nickname "Le Petit Paris" because of the balls and galas organized by the French exiles. The Petit Paris Museum (103 S. Main Street), housed in the two-story Greek Revival wooden parish hall (1861) of St. Martin of Tours Catholic Church, displays costumes from that period.

St. Martinville is the only town in Louisiana whose main commercial district was developed on property belonging to the Roman Catholic Church, and which individual owners later acquired on a lease-purchase arrangement. Situated at the head of navigation on Bayou Teche, the town owed its commercial growth to the steamboat trade. One- and two-story nineteenth-century commercial buildings, some galleried, line Main Street opposite the church square. The one-story former bank, now the Thibodeaux Cafe (1893; 116 S. Main Street), designed by W. D. Southwell with mini-turrets on each side of its parapet, is one of a row of four formerly identical structures. The Teche Theater (c. 1940; 126 S. Main St.) has a yellow Carrara glass base and a rectangular canopy that displays *Teche* in large letters. At the corner of the square is the asymmetrical L. J. Gardemal House (c. 1895; 102 S. Main Street), a Queen Anne house with an onion-domed turret.

SM1 St. Martin Parish Courthouse

1854–c. 1859. 1937, Favrot and Reed; additions. 415 S. Main St. (between Claiborne and Bérard sts.)

Unlike the centers of most of Louisiana's small towns, St. Martinville's is dominated by the church rather than the courthouse. Located in a mixed residential-commercial neighborhood, the Greek Revival courthouse, of stuccoed brick, has a portico with four fluted Ionic columns two stories high, also of stuccoed brick but with bases and capitals of cast iron. In 1937, the architects Favrot and Reed enlarged the courthouse, adding lower two-story wings, recessed from the main body of the building, with pediments and pilasters in keeping with the original Greek Revival design. The result is a composition that resembles Madewood plantation house (AM3) and the Virginia State Capitol in Richmond (which received its wings in 1906). Favrot and Reed also renovated the interior of the older section, installing tile floors and marble wainscots and removing the iron staircase. In the 1950s and 1960s, the rear of the courthouse was enlarged, so that from the front the building retains its handsome mid-nineteenth-century classical appearance.

SM2 Maison Duchamp (U.S. Post Office; Eugène Duchamp House)

1876. 201 Main St. (corner of Evangeline Blvd.)

Sugar planter Eugène Duchamp, who settled in St. Martinville in 1853, is said to have modeled this large two-and-one-half-story brick house on his plantation home in Martinique in the West Indies. Both the front and rear facades are shaded by two-story pedimented galleries on extremely slender cypress posts treated as classical piers, and a tall square cupola is centered on the roof. After Duchamp sold the house in

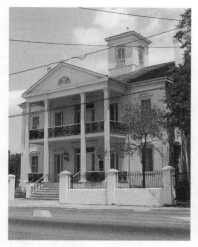 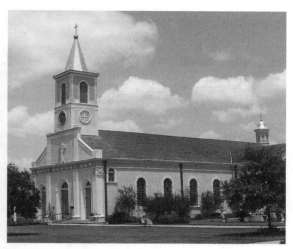

SM2 Maison Duchamp (U.S. Post Office; Eugène Duchamp House)

SM4 St. Martin of Tours Catholic Church

the early 1880s, successive occupants used it as a hotel, a restaurant, and a high school. In 1938, as a result of increased use of the mails in St. Martinville and the urging of local citizens, the federal government purchased the then-empty house for use as a post office. Federal architect Louis Simon remodeled the interior, removing walls on the ground floor to create one large space. The 15-foot-wide central hall on the second floor was retained. When a new post office was constructed in 1975, the building was renovated for use as a house museum and a venue for community events.

SM3 The Old Castillo Hotel

c. 1835. 220 Evangeline Blvd. (corner of New Market St.)

Located beside Bayou Teche and the Evangeline Oak, this former hotel is one of the few surviving examples of a once-common type built to serve the steamboat trade along Louisiana's bayous. It is thought that merchant Jean Pierre Vasseur built the two-and-one-half-story brick structure as a combination business and residence. The house has three dormers in the pitched roof, a central entrance with a fanlight, and a two-story front gallery on square wooden piers, rebuilt when the house was restored in the late twentieth century. From 1876 to 1899, under the management of Delia Greig Castillo, wife of steamboat captain Edmond Castillo, the

hotel became renowned for its gala balls and a subscription library. After Delia Castillo died in 1899, the Sisters of Mercy purchased the building for use as a girls' school. The school closed in 1986, and new owners restored the building, returning it to its original use as an inn and restaurant.

SM4 St. Martin of Tours Catholic Church

1844, Benjamin Buisson. 1870s, apse and transepts. 133 S. Main St. (between Bridge St. and Evangeline Blvd.)

This church, the spacious open square in front of it, and the historic commercial and residential buildings that surround the square combine to form one of the most harmonious and attractive town centers in the state. Although designed in 1836 by architect-surveyor Benjamin Buisson, the church was not completed until 1844. Construction was funded by $10,000 raised in a lottery. The rectangular church with three aisles was enlarged in the 1870s by the addition of transepts and a semicircular apse; the octagonal belfry over the apse was added in the 1880s. The simple, beautifully proportioned facade is articulated by shallow pilasters indicating the internal division of the nave and aisles. The piers at each end of the facade have capitals with a cross design rather than a traditional classical form. A square bell tower with an octagonal spire is centered over the facade. Pale

yellow stucco covers the brick walls, with details highlighted in white, and a cornice is decorated with Greek crosses in shallow relief. The interior has a spacious, hall-like quality, with aisles almost as tall as the nave. Massive Doric brick columns, painted to resemble a pinkish-beige marble, support a shallow barrel-vaulted wooden ceiling, and colored squares of glass fill the windows. The marble baptismal font is said to have been given by King Louis XVI of France to the earlier church sometime after the Acadians arrived in the area.

Behind the church is a bronze statue of Evangeline (1931), modeled on actress Dolores Del Rio, who played the role of Evangeline in the movie (1929) of the same name. To the right of the church is the Presbytère (rectory) of 1857, shaded by a two-story gallery carried on six fluted, double-height Doric columns that were added c. 1925. It has been attributed to builder Robert B. Benson, from Boston, who is credited with the construction of several buildings in St. Martinville.

SM5 Maison Olivier

c. 1815, with additions. 1200 N. Main St. (Louisiana 31, in Longfellow–Evangeline State Park)

Around 1815, sugar planter Charles DuClozel Olivier built a house on property beside Bayou Teche that he had inherited from his family. Improvements or enlargements were made in the 1840s, although it is not clear what these were. The two-and-one-half-story house has a brick ground floor and an upper structure of cypress and *bousillage*. The front two-story gallery, which has brick piers on the first floor and thinner square wooden piers above, is integrated into the pitch of the shingle-covered roof. A staircase within the rear gallery leads to an attic. The house has a typical Creole plan, without a hall, so that the four rooms are accessed from the galleries. In 1931, the house and its 157-acre site were donated to the state and became part of the Longfellow–Evangeline State Park, opening to the public in 1934. This park was the first in the Louisiana State Parks system and was developed by Civilian Conservation Corps (CCC) workers. Adjacent to the house are a kitchen, rebuilt on its original foundations, and a barn (1820s). The park also incorporates an eight-acre Acadian farmstead exhibit, including a one-room Acadian cabin, a working garden, and livestock.

Levert

SM6 Levert–St. John Bridge

1895–1900. St. John Bridge Rd. (2.5 miles north of St. Martinville, off Louisiana 31)

In 1900, Jean-Baptiste Levert, the owner of Levert–St. John Plantation (SM7), asked the Louisiana and Texas Railroad and Steamship Company to extend its tracks across Bayou Teche for his "convenience and benefit." Levert's plantation and sugar mill were situated on the opposite side of the bayou. He financed and erected the bridge, and the rail company laid the tracks. Although a metal plate on the bridge indicates a construction date of 1895, Levert's contract with the rail company indicates it was built in 1900. The bridge is made up of two Warren trusses, with diagonal and vertical bracing and a center section that could swing open to allow the passage of water traffic. The bridge, 264 feet long and 14.7 feet wide, is Louisiana's oldest known bridge and its only known Warren bridge. In the late 1950s, the sugar mill ceased using rail transportation, and in the 1960s the bridge's tracks were overlaid with asphalt. The bridge is now open only to pedestrian traffic. It is visible at a distance from Louisiana 347 just north of Levert–St. John Plantation (see next entry).

SM7 Levert–St. John Plantation

c. 1840. Louisiana 347 (3 miles north of St. Martinville)

Alexandre DeClouet built the two-story wooden house with a central-hall plan on his sugar plantation, named Lizima, but ill health and massive debts after the Civil War forced him to turn it over to broker Jean-Baptiste Lev-

ert, who renamed it St. John for his patron saint. A painting of the property (1861) by Louisiana artist Marie Adrien Persac, now in the Louisiana State University Museum of Art, shows the house as it looked in 1861. Little has changed in the appearance of this Greek Revival house. It still has four monumental Corinthian columns carrying a two-story gallery (the gallery's ground floor is now screened), pediments over the paired, narrow, full-length windows, and a pyramidal roof with a belvedere. The front of the house was plastered, marbleized, and scored to resemble marble blocks. Persac's painting shows a brick sugar mill near the house, which has since been replaced by a much larger structure located between the house and the bridge (SM6). In 1860, the year before Persac's painting was done, DeClouet owned 1,400 improved acres, 10,300 unimproved acres, and 226 slaves living in sixty cabins. The plantation's owner after the Civil War, J. B. Levert, served as president of the Louisiana Sugar Exchange in the 1880s.

Breaux Bridge

The name Breaux Bridge first appears in a document dated 1817, the town having previously been known as La Pointe (also La Grande Pointe). It is believed that the name comes from the wooden bridge (1799) constructed by Firmin Breaux to access his land on the opposite side of Bayou Teche. Replaced several times, the present steel and concrete bridge dates from 1950. An earlier turntable bridge (1855) was rebuilt as a fishing pier in the town's Parc des Ponts, a short distance away. The town of Breaux Bridge is located on a natural levee formed by the Mississippi when it flowed down Bayou Teche some three millennia ago. Breaux Bridge began to grow in the 1760s, when Acadians settled in the area. Incorporated in 1859, the town developed as a commercial center for the surrounding plantations, then experienced considerable growth following the arrival of the railroad in 1895. Many of the houses are in the then-fashionable Queen Anne or Colonial Revival styles. One notable example is Fourgeaud House (130 S. Main Street), built c. 1905, which has a pedimented portico with four columns. The principal commercial streets, Bridge and Main streets, contain a varied mix of buildings, both commercial and residential, of frame and brick; some are two-storied and some galleried, and a few are sheathed in metal designed to resemble cut stone. The red brick St. Bernard Catholic Church (1934; 204 N. Main Street) interprets such traditional elements as twin towers and a rose window in a crisp, angular, almost modernist fashion.

Lafayette Parish (LA)

Lafayette

Known as Vermilionville until 1884, Lafayette was established where the Old Spanish Trail crossed the Vermilion River. Of the several Native American groups that at one time had inhabited the area, the Atakapa were present when the first settlers of European origin, primarily Acadians, arrived. In 1821, Jean Mouton donated a section of his land for a church, secured the town charter for Vermilionville, and then, in 1823, when Lafayette Parish was created, donated additional land and a small frame building for a courthouse. In 1824, surveyor John Dinsmore, Jr., drew up a grid of streets centered on the courthouse. Because of limited navigation on the shallow Vermilion River, the town stagnated until the arrival of two railroads, the Morgan in 1880 and the Lou-isiana and Texas Railroad in 1883. Lafayette's emergence as a regional center was boosted in 1900 with the establishment of the Southwestern Louisiana Industrial Institute (now the University of Louisiana at Lafayette). Separate new street grids oriented around the railroad, the university, and residential subdivisions contribute to Lafayette's numerous and dispersed centers. City engineer Valdemar E. Smith laid out several subdivisions in the early twentieth century, including Arbolada, the Elmhurst Park Addition, and College Park. Commercial and light industrial structures lined Cameron Street (U.S. 90) by mid-century. A notable survivor is the modernist brick former Wolf Bakery (1948; 2000 Cameron Street), which was renovated and adapted for reuse by AAA Signs in 1995.

More than anything else, oil transformed La-fayette from a quiet university town to a vigor-

LAFAYETTE

← to 21
3/4 mi.

90

Cameron

Simcoe

167

Sterling

Moss

Mudd

13

14
Carmel

Eraste Landry

University

12

20.2
20.1

18

Souvenir

see inset
for sites
1 - 11

Louisiana

Congress

Evangeline

19

17

St. Mary

Cajundome

St. Landry

Johnston

167

Lewis

University

UNIV. OF LA.
LAFAYETTE
15

15.1

15.2

Girard Park

Taft

Oil Center

Pinhook

90

Bertrand

Versailles

St. John

3

Congress

7

Polk

OIL CENTER
16

16.1

College

Vermilion

4 5

6

10
11

W Main

Lafayette

1

2

8

9

Jefferson

Lee

E Main

Buchanan

University

0 Ft 500

N

0 Mi 1/4

ous city. Lafayette's proximity to the Gulf of Mexico enticed major oil companies to establish regional offices in the city in the 1950s. The most significant and extensive of the new developments is Oil Center (LA16). As was the case for many cities when the oil boom collapsed in the early 1980s, Lafayette's economy floundered. Despite a resurgence in the mid-1990s, the oil industry's presence in Lafayette has diminished. In its place, the city has drawn more energetically on its strengths in enterprises related to Lafayette's role as a regional medical center and on its historic and cultural heritage, attracting tourists to experience Cajun arts and cuisine. As a result, the old downtown has experienced something of a renaissance, with several buildings transformed into restaurants and galleries. The former Heymann's Department Store (1925–1928; 433 Jefferson Street), a three-story brick building designed by William T. Nolan, was renovated and opened in 2002 to serve as the Lafayette Natural History Museum and Planetarium. Behind it, Heymann's former grocery store (201 E. Congress Street) of c. 1935 was renovated in 1996 to house the Children's Museum of Acadiana. Downtown has also become the site for festivals focusing on Acadian music and culture. Indeed, Lafayette has developed a thriving industry in Acadiana, including Acadian Village (200 Greenleaf Road), an "authentic re-creation" of an Acadian society, and Vermilionville (LA21). Both sites include some historic buildings moved there from elsewhere in the region, along with several structures that are replicas of historic vernacular building types. The placement and

organization of all the buildings within these compounds are, of course, inauthentic.

LA1 Lafayette Parish Courthouse

1965, Don J. O'Rourke. 800 S. Buchanan St.

The exposed concrete frame of this seven-story courthouse sets up a basic form against which the stairway, elevator shafts, and facade setbacks produce a complex geometry of verticals and horizontals. The composition is rigidly symmetrical, with two sets of stairs, one on each side of the central elevator shaft. Thin vertical concrete louvers cover all the windows. Typical of 1960s designs, the architect emphasizes the tactile and contrasting qualities of textured concrete and brick, which adds to the bold, although rather static, design.

LA2 Council for the Development of French in Louisiana (CODOFIL) (Bank of Lafayette)

1898, George Knapp. 217 W. Main St.

George Knapp (d. 1949), who came to Lafayette from Indiana in 1887, created an eye-catching facade for this former bank. The two-story structure of dark red brick has three large round-arched openings on the first floor and segmental-arched openings on the second, highlighted with white trim and overscaled for the building. The central window on the sec-

ond floor is recessed behind a miniature curved balcony and crowned with a concave canopy. Remaining wall surfaces are busily patterned with cornices, moldings, and geometric shapes. Knapp seems to have favored the fiery-colored bricks used for this building, as evidenced in his design of 1917 for Hope Lodge (116 E. Vermillion Street). By 1905, the bank had outgrown this small building and moved to a new structure on Jefferson Street (LA7). The city of Lafayette purchased the bank to house the city hall, where it remained until 1939.

LA3 U.S. Courthouse and Federal Office Building

1998, The Lafayette Group (E. Eean McNaughton Architects, Guidry Beazley Ostteen Architects, Eskew Filson Architects). 800 Lafayette St.

The program for this courthouse, the largest building in downtown Lafayette, required a design that would embody and give a strong presence to the U.S. court system. It also specified that the building have columns. With that in mind, and seeking to produce a regionally responsive design, the consortium of architects drew inspiration from early-twentieth-century Louisiana courthouses for this four-story, stripped classical structure of precast concrete. A two-story gallery covers the central section of the facade's lower two floors; above it is a monumental two-story Doric colonnade, behind which is a curved glass window wall. Giant pilasters articulate the recessed flanking wings, and a diminutive cupola centered on the low hipped roof seems uncertain that it should be there. All these familiar elements are rendered in a spartan fashion, and the exterior color scheme of cream walls, green-tinted windows, and brown metal spandrels does nothing to enliven this postmodern building. The 200,000-square-foot interior includes seven courtrooms, judges' suites, and probation and federal marshals' offices.

LA4 Office Building (Lafayette Hardware Store)

c. 1890. 121 W. Vermilion St.

The ground floor of this two-story building has display windows set between cast iron pilasters and an entrance raised three steps above the sidewalk. Its second floor is faced with metal pressed to resemble rusticated stone and em-

bellished with columns between the paired windows, a projecting metal cornice pressed with a row of garlands, and a parapet with shells and fleurs-de-lis. The center of the parapet steps up to a miniature pediment. The former store was built shortly after the railroad was brought through Lafayette, making it the area's hub city. Several businesses have occupied the building, including a drugstore and a general merchandise store on the ground floor and a telephone exchange on the second floor, as well as its longest occupant, the hardware store. It is now the office of Meléton-Bacqué Group, the architecture firm that renovated the building in the 1990s.

LA5　Louisiana Buildings Association (LBA) Building (First National Bank)

1952, Freret and Wolf; Frederick Nehrbass, associate. 101 W. Vermilion St.

In the 1940s, the New Orleans firm of Freret and Wolf gained a reputation for modern designs that emphasized horizontal lines, crisp forms, and smooth surfaces. This bank, designed in association with Lafayette architect Frederick Nehrbass, typifies that style. The lower walls are faced with a highly polished pink-tinged brown marble and battered to convey an impression of weight and strength. A semicircular molding separates the marble from the beige stone of the upper walls. A row of vertically shaped windows set within projecting frames adds to the abstract geometries of the composition. Angela Gregory designed the relief sculpture, including a representation of the Marquis de Lafayette on the upper corner of the bank, as well as a miniature of a Native American and stylized scenes of Louisiana's cotton and sugar industries on the building's short side.

LA6　100 Gordon Square (Gordon Hotel)

1904, Favrot and Livaudais. 1928, William T. Nolan. 100 E. Vermilion St.

Lafayette's first hotel was financed by a stock company organized in 1899 by the Lafayette Improvement Association, a group of businessmen intent on bolstering the town's commercial potential. The choice of the fashionable New Orleans architecture firm of Favrot and Livaudais to design the hotel demonstrated their high ambitions. Lafayette architect-builder

George Knapp was the builder. As constructed in 1904, the hotel had three stories; its brick walls were unpainted (in contrast to today's pink and green trim finish); and it was fronted by a one-story, round-arched portico in the Renaissance Revival style that extended the full width of the facade, with a narrower gallery above. The hotel was named in honor of John Brown Gordon, a Confederate lieutenant general and former governor of Georgia, whose death coincided with the date the hotel was completed. In an expansion and remodeling of 1928, William Nolan added a fourth floor, a roof garden, and a curved parapet punctuated by miniature turrets. The corner quoins of the lower floors were continued vertically into shallow pilasters; the upper walls were ornamented with cast stone reliefs of rosettes between swag-draped shields; and the portico was replaced with a more fashionable glass and copper marquee decorated with anthemia. Nolan favored such decorative motifs as shields, garlands, and swags, which are featured on the numerous schools he designed across southern Louisiana, and, in Lafayette, on the Lafayette Elementary School (LA12). The Gordon Hotel was renovated for retail and office use by Perez and Associates in 1983.

The other early-twentieth-century downtown hotel in Lafayette is the six-story Evangeline (302 Jefferson Street). Built in 1928, it has been renovated and converted into apartments for the elderly. Its parapet is decorated with a blind arcade, a Mediterranean-inspired decorative feature popular at the time for hotels.

LA7　The Bank at 500 Jefferson (Guaranty Bank and Trust)

1905. 500 Jefferson St.

Converted in the 1990s for use as a restaurant and bar, with apartments on the second floor, this two-story brick building has a prominent corner entrance marked by a domed circular pavilion and Tuscan-columned portico. The windows, mostly with round-arched tops, are grouped and framed in sets of two or three. The old vault is now used for wine storage. Originally constructed for the Bank of Lafayette to replace the building it had outgrown (LA2), this building was taken over by the Guaranty Bank and Trust in 1937, when some banks were reorganized as a result of the economic depression. The exterior restoration is by James O. Ziler.

LA7 The Bank at 500 Jefferson (Guaranty Bank and Trust)
LA9 Lafayette Museum (Alexandre Mouton House)

LA8 **Centre International** (City Hall)

1939, Favrot and Reed; Frederick J. Nehrbass, associate. 735 Jefferson St.

This severe Moderne former city hall, funded by the Public Works Administration, is composed of a blocklike central section flanked by narrow setback wings. Ornamentation of the steel-frame, limestone-faced building consists of a frieze of scallops along the cornice and, flanking the windows, fluted capitals on plain shallow pilasters. The rigid geometry of the building's forms and its splendid site at the junction of three streets combine to give it considerable presence. Occupied by the city hall until 1980, the building was renovated in 1989 to house Lafayette's international trade offices and other city organizations.

LA9 **Lafayette Museum** (Alexandre Mouton House)

c. 1800–c. 1849. 1122 Lafayette St.

This two-and-one-half-story house was built in stages over many years by a succession of owners. It began as a one-room house with a separate kitchen, built by Jean Mouton (who donated land for St. John the Evangelist [next entry] and the courthouse) and his wife, Marie. The house was used only once a week when they came to town from their plantation in nearby Carencro. By 1820, the Moutons' son Alexandre (Jean and Marie Mouton had twelve children) had added three rooms to the house and moved his family and law practice into it. He sold the house in 1836. From 1843 to 1846, Alexandre Mouton (1804–1885) served as Louisiana's ninth governor, the first Democrat to hold the office. In 1849, Dr. W. G. Mills, who then owned the house, added the second and attic floors and the cupola. Built of brick between posts with exterior cypress siding, the house has a plastered front exterior wall, which is scored to resemble stone and is shaded by a two-story gallery supported on wooden piers. The house has a central hall, with two rooms on each side and end chimneys. A covered wooden porch now connects the rear kitchen to the main house; adjacent to it is a brick smokehouse. In 1954, the house was purchased by Les Vingt Quatre, a women's civic and cultural group, and converted into a house museum.

LA10 **St. John the Evangelist Cathedral**

1913–1916, design attributed to A. W. Cousin. 914 St. John St.

This splendid church attracts notice not only for its vivid red and white coloration but also for the enormous tower centered over the facade. According to Father William J. Teurlings,

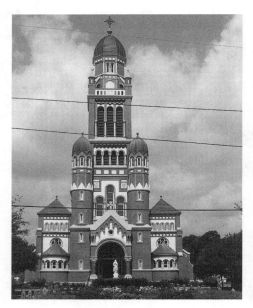

LA10 St. John the Evangelist Cathedral

who was responsible for the appearance of the church, its style is German Romanesque. However, there are clear indications of the Italian Romanesque and Byzantine styles in some of the architectural elements, which contribute to the church's appeal. A gabled portico with corbeled arches at the base of the tower shelters the entrance, which is set under a round arch springing from squat brown marble columns with oversized medieval capitals. The tower dramatically builds up in stages to a narrow domed octagon and is flanked by slender domed stair turrets. White mortar joints and white stone trim enliven the red brick walls.

After such a dazzling exterior, the interior does not disappoint. The three-aisle basilica plan finishes with a semicircular apse, and the nave is covered by plaster rib vaults hung from the steel roof trusses. In the 1920s, Rudi Compti painted the vaults with heads of saints set within medallions and the walls with foliate and geometric designs. The foliate arcade capitals are highlighted in gold. In his memoir, Father Teurlings, pastor from 1906 to 1929, recorded that the church's design was based on a description he gave to a Dutch architect, a Mr. Cousin, whom he met in 1910 while visiting his parents in Holland. Several months later, the architect mailed drawings of plans and elevations to Lafayette, and contractor Eugene Guillot of New Iberia was hired to execute the

scheme. To help cut the cost of this elaborate design, local farmers hauled construction materials to the site in the tradition of medieval building practice. St. John's was upgraded to cathedral status in 1918 shortly after the building was completed.

The bishop's residence (1921), to the left (south) of the cathedral, has an attractive gallery in the style of the early Renaissance. The extensive cemetery behind the cathedral contains many elaborate raised tombs. The live oak tree to the right of the cathedral, a charter member of the Live Oak Society, is estimated to be more than three hundred years old.

LA11 Chancery for the Diocese of Lafayette

1964, Neil Nehrbass. 914 St. John St.

Lafayette architect Neil Nehrbass (1931–1997), son of architect Frederick Nehrbass, established his practice in the belief that it was possible to design modern buildings that could respond to their historic surroundings. Accordingly, while his design for the chancery is forthrightly modern, it interacts effortlessly with its flamboyant neighbor, St. John the Evangelist Cathedral. A paved plaza with a fountain at its center links St. John to the chancery, which is located to the left of the cathedral and set back from it. The chancery's simple L-shaped plan, round-arched arcade across the facade, and warm red and gold coloration reflect the cathedral's character in contemporary terms. Its simplicity is carried to the interior, with beige stuccoed walls, light-colored wooden doors, and a raised ceiling over the central hall that allows lighting through clerestory windows.

LA12 Lafayette Middle School (Lafayette Elementary School)

1926, William T. Nolan. 1301 W. University Ave.

The wide facade of this red brick school building is composed of three pavilions linked by classroom blocks. The central pavilion accommodates administrative offices, and a 550-seat auditorium extends from the rear. Piers that extend from the ground to above the roofline mark the building's internal divisions, their regularity serving to unify the composition visually. Collegiate Gothic features popular at the time include Tudor arches over the windows on the pavilions and interlaced pointed arches on

the piers. But extension of the square-topped piers beyond the parapet hints at the more abstract Art Deco forms then coming into fashion. Delicate low-relief cast concrete decoration on the upper walls includes representations of open books set within wreaths, lions' heads, and garlands. The school's interior was modernized in 1982, with the exception of the auditorium, which has retained its pointed-arched proscenium.

New Orleans architect William Nolan designed several schools in Louisiana, and this is one of his most attractive designs. Nolan's taste for garlands, quatrefoil panels, and dainty details can be appreciated on other buildings in Lafayette, from the Gordon Hotel addition (LA6) to the N. P. Moss Middle School (800 block Mudd Avenue), which is embellished with urns and festoons and also features Tudor arches.

LA13 Charles H. Mouton Plantation House

c. 1848. 338 N. Sterling St.

Built by Charles H. Mouton, grandson of Jean Mouton and the state's lieutenant governor in 1856, the two-and-one-half-story house was part of a 3,000-acre sugar plantation that was later subdivided to become the Sterling Grove neighborhood. The house has a brick first floor and a timber-frame and *bousillage* second story and is shaded on the front by a two-story gallery carried on square piers at ground level and slender paneled piers above. The pitched roof is pierced by two dormers, and chimneys are placed at each end of the house. A central hall on the second and attic stories and front doors with transoms and side lights reveal Anglo-American influence. In 1988, the carriage house (c. 1890) was renovated for use as a bed-and-breakfast called Bois des Chênes. The Sterling Grove area includes several large and handsome nineteenth- and early-twentieth-century houses in various styles on large lots, notably along N. Sterling Street and Elizabeth Avenue.

LA14 Holy Rosary Institute

1913. 421 Carmel Ave.

The Holy Rosary Institute was founded in 1913 by the Reverend Philip Keller to provide vocational and technical training for African American women. Keller, from Galveston, was inspired by Booker T. Washington's belief that African Americans could achieve economic advancement through education and vocational skills. The institute's teachers were members of the Sisters of the Holy Family, an African American order founded in New Orleans (OR39). The three-story brick building has a recessed center section shaded by a two-story gallery; all three floors have segmental-arched windows. A chapel is attached to the left side of the school. Ornamentation is limited to a low parapet marked by raised brick courses and a small rose window in the chapel. In 1930, the institute became a Catholic high school, admitting both women and men. Holy Rosary closed as a high school in 1993; although other buildings on the site are used for education programs for African Americans, the institute building is unused.

LA15 University of Louisiana at Lafayette

1901, many additions. University Ave. (between Johnston and Hebrard sts.)

The University of Louisiana at Lafayette is the state's second largest university (Louisiana State University at Baton Rouge is bigger), with approximately 17,000 students. Founded as the Southwestern Louisiana Industrial Institute in 1900, the institution gained college status in 1921; in 1960, it was upgraded to a university and renamed Southwestern Louisiana University. The name was changed to its present form in 1999. Land for the institute was donated by Crow Girard, president of the Bank of Lafayette, and a multipurpose structure was designed by Charles A. Favrot. This building was demolished in 1964 when the present Martin Hall was completed. A majority of the buildings on campus are constructed of red brick, with simple classical details, and are grouped around quadrangles. The campus grew slowly until the late 1930s, when twelve PWA-funded buildings, designed by the New Orleans firm of Weiss, Dreyfous and Seiferth and completed by Favrot and Reed in 1940, were constructed. A good example of their work is the former library, Stephens Hall, a Colonial Revival design with the light touch of Art Deco in its decorative elements and a central cupola. The commemorative plaques on several of these buildings give credit to Favrot and Reed but not to Weiss, Dreyfous and Seiferth, probably because 1940 was the year that Leon Weiss was jailed for the firm's

involvement in the scandals of the 1930s, when the federal government investigated misuse of public funds in state administrations following Huey Long's death.

New buildings of the second half of the twentieth century reflect the fashionable styles of their period, most notably Fletcher Hall (LA15.2). The Baptist Collegiate Ministry (1998), designed by Ashe Broussard Weinzettle Architects, located at Johnston and Brashear streets, is a small low-scale structure with intersecting geometries. Constructed of red brick in keeping with the campus buildings, it has a sloping metal roof that blends in with neighboring residences. The university has expanded since the completion of buildings at a new site farther west (LA19 and LA20).

LA15.1 Dupré Library

1960, Perry L. Brown, Inc., and Perry Segura Associates. 1965, H. J. Lagroue, Hal Perkins, Perry L. Brown. 1999, Architects Southwest. St. Mary Blvd.

The earliest section (now visible along the sides) is a simple modernist box raised a few feet from the ground on a recessed foundation so that the building appears to float. Its lower walls are covered with masonry screens (familiarly known as "Taj Maria" blocks), and the upper walls are rendered in a more vigorous fashion with concrete *brise-soleil* fins. In 1999, the library was given a large brick and glass extension at the rear and a new central entrance composed of a series of curved brick and glass walls that push assertively into the forecourt to enclose a new lobby. The remodeled interior features a wide space comparable to a central hall that leads to a rear lounge and is open on both sides for easy access to areas for books and computer terminals.

LA15.2 Fletcher Hall, School of Art and Architecture

1976, Barras, Breaux and Champeaux. E. Lewis St. and Girard Park Cir.

Occupying a site at the southern tip of the campus, this three-story building incorporates all the fashionable elements of the 1960s and 1970s: a bold angled silhouette, fortresslike concrete walls with few exterior windows, a glass-walled interior courtyard, and a difficult-to-find entrance obscured within a breezeway. A massive exterior stairway, treated as a free-standing sculptural element, provides access to the second-floor office and studio spaces. Surrounding the central courtyard are walkways on each floor. This white-colored concrete structure strikes an independent note in contrast to the uniformly red-brick campus.

LA16 Oil Center

1952–1953, A. Hays Town. Bounded by E. St. Mary Blvd., W. Pinhook and S. College rds., and Girard Park Dr.

Oil Center was conceived in 1952 when entrepreneur and landowner Maurice Heymann (1885–1967) met with representatives of the local oil community. In response to the boom in offshore drilling, the oilmen wanted office space for their companies in one-story buildings with ample parking rather than in high-rise downtown buildings. Four months later, Heymann began construction of Oil Center on property he owned on Lafayette's southwestern border. Designed by Baton Rouge architect A. Hays Town, Oil Center identifies itself as a "city within a city." The sixteen-square-block area is composed of modern beige brick single-story buildings, several connected by galleries, and includes offices, shops, and restaurants (along Coolidge and Harding streets) as well as residences. On the perimeter of Oil Center (on S. College Road) is the Heymann Center for the Performing Arts (the Municipal Auditorium), funded by Heymann and completed in 1960. Maurice Heymann's business career began with a small store he opened in Lafayette in 1916. Other buildings he has helped fund are the Lafayette Natural History Museum (LA16.1), the University Art Gallery, and Lafayette General Hospital.

LA16.1 Lafayette Natural History Museum and Planetarium

1969, Neil Nehrbass. 637 Girard Park Dr.

This long, low, glass-walled museum nestled in a pasture epitomizes architect Nehrbass's life-long concern with a building's relationship to site and nature: "When the excavations take place for a building . . . there's a real fine sense of planting something, of planting a building in the earth." Measuring 200 feet by 32 feet, the steel-frame structure consists of two floors, one partially submerged. Natural forms were made part of the building's expression; the glass

walls, which are battered like those of some ancient monument, reflect the passing clouds and surrounding trees. The museum's origins date to 1956, when Les Deux Douzaines (two dozen), a local women's organization, began conducting science enrichment programs for local schoolchildren. In 2002, the museum opened a new facility in a renovated store in downtown Lafayette (433 Jefferson Street). The future of this building is uncertain.

LA17 The Family Tree, Our Lady of Lourdes (St. Mary's Home)

1923–1924, Emile Weil and Albert Bendernagel. 605 St. Mary Blvd.

This building, in the Mission style, was the first of three in a complex built by the Diocese of Lafayette for use as an orphanage and school run by the Sisters of Charity. This building housed administrative offices and, on the second floor, accommodations for the Sisters. Girls and boys lived separately in the other two buildings. The stuccoed brick building has a curved front gable, a red tile roof, and extended eaves. As is also characteristic of Spanish architecture, decorative pilasters and elaborate moldings emphasize the entrance. In 1956, the school was closed, and, in the 1970s, with the shift to foster parenting and adoption rather than housing children in institutions, the orphanage was closed. The building is now used for other hospital services.

LA18 House

c. 1946. 1955, remodeled. 501 Myrtle Pl.

In 1955, this two-story house was transformed by its owner, Gray Lott, from a traditional pitched-roof design of red brick into a stucco-covered, flat-roofed modernist structure. Lott told the subsequent owner that he had copied the design from a house he had seen in Miami, Florida. Framed with steel beams, the house has a flat roof with a deep overhang; the second-floor windows are covered with an outer band of green-tinted louvered glass panels extending almost the entire width of the house. Although the bold modernist facade is striking, the house is not out of place in its attractive residential neighborhood, which includes early- and mid-twentieth-century homes in a variety of styles.

LA19 Cajundome of the University of Louisiana at Lafayette

1985, Neil Nehrbass and William Mouton. Cajundome Blvd. and W. Congress St.

This huge multipurpose domed arena recalls French architect Etienne-Louis Boullée's vast domed scheme (unbuilt) for a cenotaph for Sir Isaac Newton (1784). The Cajundome dominates and is tied to its surroundings by means of a system of massive diagonal entrance ramps. Demonstrating Nehrbass's commitment to the clear expression of structure, the dome's interior is an exposed space-frame construction developed by engineer William Mouton (1931–2000), Nehrbass's cousin. In a span of 380 feet, the space frame weaves a network of lines across the ceiling like a gigantic web. When built, the dome was controversial because of its high cost (over $60 million) and size. With a seating capacity of 12,800, it was criticized by some as too big, and by others as too small, to accommodate comfortably the functions for which it was planned. Until the late 1990s, the dome stood virtually alone in this section of Lafayette, but development of the university's neighboring research park, with buildings and landscaping reminiscent of a corporate center, makes the dome seem far less overwhelming and out of scale.

LA20 University of Louisiana at Lafayette Research Park

1990s, with additions. W. Congress St. and Cajundome Blvd.

The university's 145-acre research park in southwestern Lafayette is being developed as a complex of research facilities focusing on issues specific to southern Louisiana's natural resources and habitat, as well as health care and telecommunications. A convention center is also planned for the site.

LA20.1 Estuarine Habitats and Coastal Fisheries Center

1997, Eskew Filson Architects and Guidry Beazley Ostteen Architects; landscape, Jon Emerson and Associates. Cajundome Blvd. (between W. Congress St. and Eraste Landry Rd.)

The National Oceanic and Atmospheric Administration commissioned this center for the study of freshwater wetland habitats. The two-story center housing research, administrative, and interpretive facilities frames a large pool, the heart of the project. At the client's request, the construction materials of red brick, light-colored concrete or stucco, glass, and metal paneling are the same as those used for the National Wetlands Research Center (LA20.2), completed in 1992. These materials are largely employed to differentiate the building's various functions. A two-story, glass-walled office space, its interior shaded by a screen of *brise-soleils* that form a grid pattern across the surface, overlooks the lake on one side, and the brick-walled research offices form a second side. The third is defined by a glass-walled lobby and a snout-shaped, metal-faced auditorium, which adds an amusing zoomorphic note to the composition. The building's entrance, on one of its outer short sides, is preceded by a courtyard containing a small rectangular reflecting pool. The interior has blond woodwork, buffed aluminum columns, and polished aluminum light fixtures. The center received an *Architectural Record* Honor Award in 2001.

LA20.2 National Wetlands Research Center

1992, Eskew Filson Architects and Guidry Beazley Ostteen Architects; landscape, Verser-Huh. Cajundome Blvd. (between W. Congress St. and Eraste Landry Rd.)

This research center for the U.S. Fish and Wildlife Service provides 84,000 square feet of laboratories and computer facilities for the study of endangered wetlands. The glass-walled principal entrance is shaded by a freestanding curved red brick wall with rectangular openings, a postmodernist fancy reflecting that movement's passion for evocative fragments and ruins. The most eye-catching feature is the metal roof, which curves over a clerestory window to illuminate a wide hall extending the length of the building and giving access to the office spaces and library. At the front of the building, this metal roof projects over an exposed structural steel frame, giving the impression of a sail. Such nautical elements were a popular feature of architecture in the early 1990s. Like its companion building, the Estuarine Habitats and Coastal Fisheries Center, this structure has a freshwater pool along one side.

LA21 Vermilionville

1600 Surrey St.

Located on twenty-three acres beside Bayou Vermilion, this living history museum and folklife village is composed of historic buildings from southern Louisiana, dating from the 1790s, that were threatened with demolition on their original sites. New structures copied from historic prototypes are also included at the museum. Among the historic buildings are the Buller House (c. 1805), which has a plan of three front rooms and a loggia between cabinets at the rear; the late-nineteenth-century Maison Boucvalt, a four-room Acadian house with a front porch; a two-room cabin of *colombage* and *bousillage* construction that was probably a slave cabin; and a one-room schoolhouse (1890s). The Church of the Attakapas, on the other hand, is a reconstruction combining elements of the first St. Francis Church in Pointe Coupée Parish (PC12) and St. Martin Church in St. Martinville (SM4). There are also replicas of an Acadian barn and a cemetery. Although the organization of these structures is artificial, they do convey the broad spectrum of early architecture in this region.

Broussard

Broussard was laid out shortly after the Civil War on part of Valsin Broussard's sugar plantation. It is situated in an area known as Côte

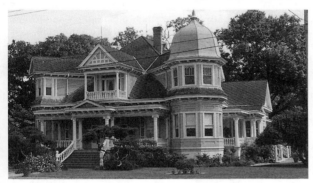

LA20.1 Estuarine Habitats and
Coastal Fisheries Center

LA22 La Grande Maison Bed and
Breakfast (Paul Billeaud House)

Gelée (frozen hills), a name acquired following the severe winter of 1784. After the railroad came through Broussard in 1879, its local industry flourished, based on Martial Billeaud's sugar mill established in 1866. Several large and elaborate houses built during this era survive along Main Street. The sugar factory closed in 1979, although some of its remains can be seen on Louisiana 82. Nearby on Louisiana 90, enormous iron gears from the mill are on display, forming a small abstract sculpture garden. Although Broussard is now a suburb of Lafayette's expanding borders, several of its old downtown structures have been preserved, capturing the character of the town's early history. The two-story Ducrest Building (1903; 101 W. Main Street), formerly a drugstore, has a facade of metal pressed to resemble stone.

LA22 La Grande Maison Bed and Breakfast (Paul Billeaud House)

1911. 302 E. Main St. (Louisiana 182)

Paul Billeaud built this huge galleried wooden house in the Queen Anne style, the most elaborate of Broussard's early-twentieth-century mansions constructed during the sugar boom. The house has a prominent octagonal domed corner tower, multiple gables, false timbering, and decorative brackets, as well as two porches with Ionic columns and pedimented centers. Nearby are three other ornate residences, also of wood construction: the Alphonse Comeaux House (208 E. Main Street), built in 1910 by Eulalie Billeaud Comeaux, daughter of Martial Billeaud; and the André Billeaud House (203 E. Main Street), built in 1903.

Acadia Parish (AC)

Crowley

Founded in January 1887, Crowley was one of four towns established by the brothers Cornelius C. Duson (1846–1910) and William W. Duson (1853–1929); the other towns were Iota, Eunice, and Mamou. The brothers, who acquired large tracts of land in the 1880s, began to promote settlement through the W. W. Duson and Bro. Real Estate Co. They next formed the Southwest Louisiana Land Company, persuaded the Southern Pacific Railroad to lay its tracks through their land, and established the town of Crowley, naming it after Patrick C. Crowley, the railroad's contractor. The Southwest Louisiana Land Company advertised the town by means of a circular, "The Prairie Region of Southwestern Louisiana," which also announced an auction sale of lots to take place in February 1887. Within three years, Crowley had 400 inhabitants, most of them from the Midwest.

Leon Fremaux laid out the town on a rectangular grid northward from the railroad tracks, placing a courthouse square at the intersection of the two principal boulevards, Parkerson and Hutchinson. Each quarter of the grid had a block-sized park at its center, a planning scheme common in midwestern towns but rare in the South. Crowley became a center for the rice industry, and again the Duson brothers played a significant role. They were instrumental in introducing a system of irrigation canals essential for successful production of the crop.

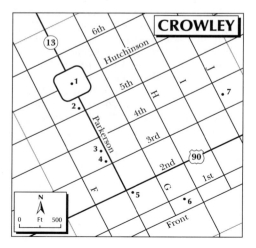

By 1904, Crowley's population numbered 6,000, and the town could boast six rice mills. Crowley's railroad tracks are still lined by tall metal-sided rice driers and concrete silos.

The principal business district, with two- or three-story brick structures, developed along Parkerson Avenue, from the railroad to the courthouse. The former post office (124 E. 3rd Street), a Beaux-Arts design of 1913 by Oscar Wenderoth, is in the vicinity of the railroad. In 1931, William Nolan designed the two-story beige brick Art Deco Municipal Building (123 W. 5th Street), which included an auditorium on the second floor. In the late twentieth century, the commercial corridor extended northward from the courthouse and was scaled for automobile traffic, not pedestrians, as was the older stretch of Parkerson Avenue. This northward shift was accelerated when the east-west Interstate 10 was built to the north of the town. Crowley is distinguished for its pleasant residential streets, planted with trees when the town was laid out, and the many attractive houses in the Queen Anne style. One example is the house (1898) at 305 E. 2nd Street, with lacy Eastlake trim, including a spindlework fan over the gallery's entrance.

AC1 Acadia Parish Courthouse

1952, Theodore L. Perrier. N. Parkerson and Hutchinson aves.

In 1886, when Acadia Parish was created, three sites were proposed for the courthouse. In a vote the following year, the selection of Crowley was undoubtedly influenced by a promise from the brothers Cornelius C. Duson and William W. Duson that they would donate $5,000 and a plot of land for the building. The present courthouse, the third on this site, was designed by New Orleans architect Theodore Perrier (1891–1971). Located at the intersection of Crowley's two principal streets, the limestone-faced courthouse responds to its site by means of a simple, rigid composition of rectangular forms that gives importance to each of the four facades. The reinforced concrete frame permits the walls to be opened up by large windows with prominent, closely spaced horizontal mullions, which create a unified linear surface pattern and constitute the building's principal ornamentation. The horizontal emphasis, geometric patterning, and overall plainness of the

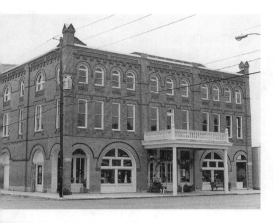

AC2 Grand Opera House

AC3 Rice Theater

tainment, including vaudeville, plays, and, after 1909, movies. Traveling road shows would stop at Crowley for one-night bookings. The auditorium could accommodate an audience of more than one thousand, an extraordinary size given that Crowley's population at the time numbered less than four thousand. Closed in 1940 and occupied for many years by a hardware store, the opera house was restored in the early twenty-first century by architect Donald A. Breaux. Shops are located on the ground floor of the three-story red brick structure, as is the staircase that leads to the second-floor auditorium. This auditorium has a balcony, box seats along the sides, and a ceiling of beaded lumber steamed and shaped into a curve. On the exterior, broad round-arched openings in the style of Louis Sullivan's designs frame the shop display windows on either side of the central entrance. (These were recently revealed when a metal facade added by the hardware store was removed in the restoration.) The windows are outlined by a darker-colored brick molding, as are the rectangular second-floor windows and the round-arched windows on the third story. Decorative brick panels enliven the walls between the second and third stories, and the building concludes with a row of dentils and a paneled cornice. Miniature gabled turrets at the building's corners provide a strong finish. The entrance is emphasized by a wooden portico with Doric columns and a balustrade.

design are reminiscent of civic architecture of the 1940s, when austerity became fashionable. Equally retardataire is the tall, thin, square central clock tower, each of its four upper corners carved in the form of an eagle in a manner similar to Art Deco reliefs of the 1930s. A wide double staircase in front of the principal facade leads to a terrace in front of the second-floor entrance, from which there is a splendid view along N. Parkerson Avenue to the rice silos at the railroad line. Despite these somewhat old-fashioned modernist elements, the courthouse achieves considerable dignity through the uncompromising severity of its design.

AC2 Grand Opera House

1901. 505 N. Parkerson Ave.

The Grand Opera House was the largest theater between New Orleans and Houston when it was built, providing a venue for all kinds of enter-

AC3 Rice Theater

1941. 323 N. Parkerson Ave.

Named in honor of Crowley's principal industry, this movie theater features a green and yellow vertical sign that rises from a V-shaped marquee to the top of the facade and then curves over the parapet. The ground floor is sheltered under a deep canopy; the upper facade is painted with a geometric design in shades of pink and rose. Built by the Southern Amusement Company, the theater was scheduled to open in 1940, but hurricane damage postponed this event until January 1941. The theater is now used for social and cultural events.

AC4 Bank of Acadia

1902, William L. Stevens. 301 N. Parkerson Ave.

The semicircular bay that marks the bank's corner entrance was originally finished with a

AC4 Bank of Acadia

AC6 Chamber of Commerce
(Colorado Southern Railroad
Depot)

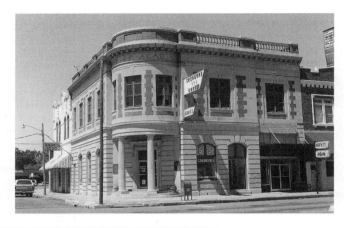

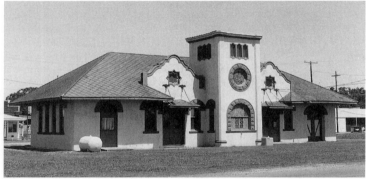

dome. Constructed of brick, the bank is liberally trimmed with limestone to highlight its curved Doric portico of partially fluted Doric columns, its rusticated ground floor with segmental-arched windows, the prominent keystones of the second story's rectangular windows, and the parapet balustrade. Architect William L. Stevens had a good eye for proportions and enjoyed creating contrasts between differently textured and colored building materials, especially brick. This effect is also evident in his design for the Commercial Building in Alexandria (RA8).

AC5 First National Bank

1920. 126 N. Parkerson Ave.

At the time it was built, this seven-story, steel-frame building was claimed to be the tallest structure between New Orleans and Houston. Still a prominent landmark, it dominates Crowley's downtown skyline. Like the Bank of Aca-

dia (AC4) diagonally opposite, this building is constructed of limestone and buff-colored brick, but, in contrast to that structure, its entrance is located at the center of the rusticated limestone ground story and is flanked by a pair of Ionic columns. The main banking hall is a double-height space supported on fluted Corinthian piers and covered with a coffered ceiling.

AC6 Chamber of Commerce (Colorado Southern Railroad Depot)

1907, C. H. Page. E. Front St. and N. Avenue G

The Colorado Southern Railroad reached Crowley in 1907, and in keeping with a style that was popular for railroad depots on this line, architect C. H. Page of Austin, Texas, produced a Mission Revival design. Symmetrical in plan and elevation, the depot has two off-center entrances with a ticket office in between, emphasized by a low square tower, which was

originally surmounted by a square cupola. The tower is pierced by three windows, arranged vertically, each a different shape: round-arched at the lowest level, circular above, and a triple-divided rectangle at the top, all with prominent voussoirs or frames. The brick walls have a pale gray stucco finish, and window frames and cornices are painted dark red; the low hipped roof was originally covered with red tiles. On both sides of the ticket office were large square waiting rooms, one for African American patrons and the other for whites. Scrolled gables on the exterior of the building, each with a star-shaped window, indicate these areas. The small, square hip-roofed structure near the depot at the corner of N. Parkerson Avenue and 1st Street was built in 1903 to house the Wells Fargo Railway Express Office.

AC7 **House**

1895. 320 N. Avenue J

This elaborate Queen Anne house, built for rice farmer John Green, is notable even among the many such houses built shortly after Crowley was founded, all testifying to the town's early economic prosperity. The asymmetrical two-and-one-half-story house of white-painted wood features an octagonal tower with a spire, a large polygonal bay, multiple gables and dormers, and a second story sheathed with scalloped shingles. A two-story wooden gallery wraps around two sides of the house and is magnificently ornamented with fluted colonnettes clustered in groups of three and supported on paneled pedestals, railings with shaped columns, spindlework, and fancy brackets.

Evangeline Parish (EV)

Ville Platte

Founded in the late eighteenth century by Marcellin Garand, a former French army officer, Ville Platte (flat town) lies in the heart of southwestern Louisiana's prairie. The cupola from the demolished Beaux-Arts courthouse, completed in 1912 to a design by Emile Weil, has been preserved in the parish square fronting the new courthouse, built in 1976. Louis Simon designed the Colonial Revival post office (1937; 240 W. Main Street), which is crowned by a small square cupola. Approximately eight miles north of Ville Platte is the 300-acre Louisiana State Arboretum (Louisiana 3042 North). Established in 1961, the first arboretum in the South and the first state-supported one in the United States, it offers among its hills, ravines, and creeks almost every type of Louisiana vegetation except that of coastal marshes.

EV1 **City Hall** (Evangeline Bank and Trust Company)

c. 1912, Favrot and Livaudais. 342 W. Main Street

This two-story former bank is the most monumental structure in Ville Platte's old commercial downtown. As in small towns throughout America, Ville Platte's original commercial heart has been superseded by shopping malls on the town's perimeter. Occupying a corner site and constructed of dark red brick with white trim, the former bank has two handsome Beaux-Arts entrance porticoes, one on each of its facades. These porticoes include gabled pediments, pilasters on each side of the door, side lights, and large rectangular transom windows. Alterations to the interior, including dropped ceilings, have been made for its present use.

EV2 **Alexis LaTour House**

1835–1837. 247 E. Main St.

The house began as a small cottage, one room wide and two rooms deep, with a front gallery. In 1837, two rooms and an American central hall were added, and the gallery was extended to shade the entire front facade. The *bousillage* construction and exterior staircase in the front gallery place the house within Creole building traditions. At a later date, probably around 1900, two large dormers were inserted into the pitched roof at both the front and rear, and a wing was attached to the rear of the house. Other minor changes include scroll brackets added to the front porch. Despite the additions and alterations, the house has a unified and coherent appearance, thus demonstrating the adaptability of the basic Creole plan to changes in use and form.

St. Landry Parish (SL)

Opelousas

Named in honor of this Native American tribe, the town of Opelousas traces its beginnings to an early-eighteenth-century trading post that was established on the route from New Orleans to Natchitoches. In 1765, it became a military post, and in 1805, the settlement was designated the parish seat. For a brief period in 1863 during the Civil War, after Union forces occupied Baton Rouge, Opelousas served as Louisiana's capital. But the town did not gain importance as a commercial center until the arrival, in 1882, of Charles Morgan's Louisiana and Texas Railroad (later part of the Southern Pacific system). One of the oldest houses in Opelousas is the Estorge house (1827; 417 N. Market Street), a two-story structure with a brick first story and brick between posts on the upper, a pedimented gallery, and a central-hall plan. Despite the town's early origins, most of its built fabric dates from the late nineteenth

century onward. Among the more flamboyant residences is the Paul Pavy House (corner of Vine and S. Market streets), a huge galleried Queen Anne house of wood construction, with a corner turret and angled bays, built in 1905. The Temple Emanuel synagogue (corner of S. Main and Franklin streets), built in 1929 when the congregation was formed, is a small, simple rectangular structure with exterior walls of variegated red brick and a small portico. Opelousas is the birthplace of the musical form known as zydeco and has been designated the zydeco capital of the world.

SL1 St. Landry Parish Courthouse

1939–1940, Theodore L. Perrier. Courthouse Sq.

Occupying the center of the town square, the site of earlier courthouse buildings, this PWA-funded Art Deco structure is typical of the rather severe designs favored in Louisiana in the 1930s. Concrete framed and faced in light gray limestone, it has a tall center section flanked by slightly lower three-story wings raised on an above-ground basement. For the upper part of the facade, New Orleans sculptor Angela Gregory designed low-relief sculptural panels illustrating Louisiana's agricultural industries. The central entrance opens to a low-ceilinged but well-proportioned hall; at its far end is a spiral staircase with aluminum railings, and the circular stairwell has beige marble wainscoting that steps up rhythmically in tune with the stairs.

SL2 Office Building (Old Federal Building and Post Office)

1893, Jeremiah O'Rourke, Supervising Architect of the Treasury. 1932, additions. 131 Court St.

This dark red brick Romanesque Revival building began as a two-story structure with a courtroom on the second floor. In 1932, it was enlarged in the same style with a three-story addition to the rear, a courtroom extension over a lower side wing, and a new hipped roof with decoratively cut rafter ends. A post office was then located on the ground floor. The building is entered through a broad, round-arched entrance outlined by a rectangular frame, similar, for example, to the entrance that

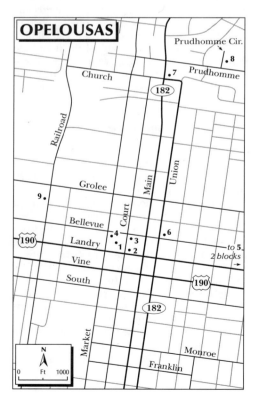

Three huge arched openings and a central pediment monumentalize the facade of this one-story former bank of stuccoed brick, giving it almost the appearance of a Roman triumphal arch. Ionic columns of glazed tile outline the central entrance arch, above which is a pediment decorated in white glazed tile with the state's emblem—a pelican framed within a circle—and rows of dentils. An identical entrance is repeated on the narrow side facade. Atop the building are an entablature and a low curved mansard roof. Although the details differ, the composition as a whole resembles the design Favrot and Livaudais produced in 1910 for the Citizens Bank of Lafourche in Thibodaux (LF4).

SL4 City Hall (Opelousas Market)

1888, 1932. Courthouse Sq.

Only the outer walls of the former market survive from its conversion into a city hall in 1932. Its plain red brick walls were dressed up with an Ionic portico, large round-arched windows were cut in the principal elevation, and a light-colored stucco was applied to the exterior. The original hipped roof and cupola were replaced by a flat roof and a high paneled brick parapet. These changes provided the Beaux-Arts features characteristic of contemporary civic buildings and, with a facade similar to that of the Union Bank and Trust Company (SL3), added a note of architectural unity to Courthouse Square. In a late 1990s renovation, the building was unfortunately given tinted windows, which look highly incongruous. The St. Landry Tourist Commission now occupies the building.

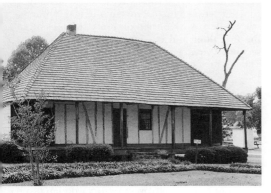

SL2 Office Building (Old Federal Building and Post Office)

SL5 Venus House–Jim Bowie Museum

Louis Sullivan designed in 1893 for the Transportation Building at the World's Columbian Exposition. Also inspired by Sullivan are the swirling foliate designs that fill the area between the arch and its frame. Centered within this sculpted foliage are terra-cotta medallions with images of the shield and the eagle from the Great Seal of the United States, identifying the building's original function. The ground-floor windows are segmental-arched; the round-arched windows on the second story are linked by brick molding. Although the upper windows are now blocked and double glazing obscures the classical window frames on the first floor, the structure is still impressive.

SL3 City Building (Union Bank and Trust Company)

c. 1910, Favrot and Livaudais. 101 Court St.

SL5 Venus House–Jim Bowie Museum

c. 1800. 828 E. Landry St. (U.S. 190)

This Creole cottage, moved ten miles to this site in 1973, forms the centerpiece of a small outdoor museum complex of vernacular buildings and a tourist information center. The house, constructed of a hand-hewn pegged timber frame and plastered *bousillage* infill, has a steeply pitched, wood-shingled hipped roof and a front gallery that is integrated with the pitch of the roof. Laid out on a typical Creole plan, it has three rooms across the front and, at the rear, a loggia set between two cabinets. The central front room is higher than those on ei-

ther side, which are attached by joists mortised into the wall posts, a typical Creole method for adding rooms. The fireplace has a wraparound French mantel. The house is named for a Creole woman of color who once owned it and also for Jim Bowie, a hero of the Alamo and the inventor of the bowie knife. However, there is no known connection between Bowie and this house; although he lived in Opelousas, his house no longer exists. Other structures on the site include a mid-nineteenth-century house, a Union Pacific freight depot, and an African American Methodist church (1948).

SL6 Opelousas Museum of Art (Wier House)

c. 1820. 310 E. Bellevue St.

This tall, narrow two-story brick house, two rooms wide and one room deep, with a low pitched roof, a central single bay, and pedimented portico, was a common type in the eastern United States beginning in the late eighteenth century but is rare in Louisiana. Its small windows seem designed to keep out cold air, but fortunately the one-room depth did allow cooling breezes to pass through to temper Louisiana's heat. The (restored) two-story pedimented portico has delicate Greek Revival decorative details, and a narrow entrance door with a round-arched fanlight opens onto a central hall. The exact date of the house and its builders are not known for certain, but it is thought to have been constructed by members of a family who came to Opelousas from Kentucky. In 1945, Harvey Wier purchased the house, and his descendants converted it into an art museum in 1997.

SL7 St. Landry Catholic Church

1908–1909, Diboll and Owen. 900 N. Union St.

This red brick church, notable for its vast size, replaced one built in 1828. Blending Romanesque and Gothic forms, as was common at that time, the three-bay facade is dominated by a massive square tower and spire with flanking turrets; the corner buttresses are also treated as turrets. The interior, which can seat 2,000 people, has a barrel vault with tie bars supported on large decorative metal brackets. Corinthian-columned arcades separate the nave from the aisles. A cemetery with raised tombs is adjacent to the church.

SL8 Ringrose (Michel Prudhomme House)

c. 1800. 1152 Prudhomme Circle

Although Michel Prudhomme acquired several Spanish land grants in this area in the 1770s, it is not known precisely when this house was built. In plan, construction techniques, and general appearance, it resembles late-eighteenth-century houses, but a date in the early nineteenth century has been proposed on the basis of the scored stucco exterior wall finish (although this could have been added later) and window treatment. Constructed of soft pink brick on the lower story and of brick between posts on the upper, the house has a Creole plan, with three rooms across the front and a loggia between two cabinets at the rear. A two-story gallery is supported on brick columns on the first floor and cypress colonnettes on the second. A square wooden *pigeonnier* and a corn-crib are next to the house.

SL9 St. Landry Lumber Company

c. 1890. 215 N. Railroad Ave.

Located beside the railroad tracks, the St. Landry Lumber Company complex consists of five lumber sheds dating from the late nineteenth to the early twentieth centuries and—the showpiece—a narrow, two-story wooden office building in the Queen Anne style constructed around 1890. The building's angled front bay, gables, bargeboards, large freestanding sunburst gable ornament, brackets, window frames, and shingles were designed to demonstrate the exciting effects that could be achieved with wood. The lumber company, originally known as J. T. Stewart's Lumberyard, is one of what were once many small industrial and commercial complexes situated along this railroad corridor.

Washington

As the head of navigation on Bayou Courtableau (formerly known as the Opelousas River), Washington was the principal shipping point in St. Landry Parish. Goods were transported by keelboat to New Orleans from the site as early as 1815; the town was laid out in 1822 on land deeded to the church by Jacques Courtableau. The first steamboat to dock at Washington was the *Opelousas,* around 1832, after which the town grew rapidly as a center for commerce and

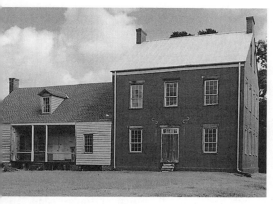

SL10 Schulze House (François Marchand House and Eagle Hotel)

transportation. Passenger boats linked there with Texas-bound stagecoaches, and overland cattle drives crossed Louisiana's western prairies to Washington, where the herds were loaded onto steamboats headed for New Orleans. By steamboat, the journey from Washington along Bayou Courtableau to the Atchafalaya River, and then via a maze of bayous to the Mississippi River and on to New Orleans, took about forty hours. After the railroad arrived in Washington in the early 1880s, river traffic declined, and the last steamboat left in 1900. Washington's steamboat history is still detectable in its buildings and in the street pattern, which dips down the bluff to Bayou Courtableau. A surviving brick and wooden warehouse (c. 1820) from the steamboat era has been converted into a restaurant, Jack Womack's Steamboat Warehouse Restaurant (118 W. Water Street). On the bluff is the Immaculate Conception Church (315 E. Moundville Street), which was built in 1852, expanded and given a steeple in 1892 and enlarged again in 1905. On the outskirts of Washington is Magnolia Ridge (1830; N. Prescott and DeJean streets), a two-and-one-half-story plantation house, with a gallery that has six two-story Tuscan columns, set in an attractive garden.

SL10 **Schulze House** (François Marchand House and Eagle Hotel)

c. 1825 (Marchand House); c. 1852 (Eagle Hotel). 117 E. Water St.

In 1826, Opelousas businessman François Marchand purchased this site on the high bluff overlooking Bayou Courtableau and opened a billiard parlor in a wooden building that he either built or moved here and remodeled. Billiards was not only a favorite pastime in Washington but also an important source of tax revenue for the town. This building has a Creole plan, with three rooms across the front and a loggia between two cabinets at the rear. After Marchand died in 1830, the house had several owners until it was purchased in 1852 by James McDaniel. He constructed an adjoining two-and-one-half-story brick structure with a pitched roof, end chimneys, and a central-hall plan. He also made some changes to the earlier wooden building, including the addition of dormer windows and relocation of its chimney from an interior wall to the end wall. An advertisement of 1855 described the brick building as the newly refurbished Eagle Hotel. With the decline of steamboat traffic at the end of the century, the hotel became a boardinghouse. The structure later became known as the Schulze House, named for the family who occupied it from 1947 to 1989. The two buildings and grounds are being restored to their 1852 appearance by James E. Fontenot of Abbeville.

SL11 **Deshotels Steamboat House** (Dominique Lalanne House and Store)

c. 1866–1868. 317 N. Bridge St.

Built by French-born Dominique Lalanne as a combined store and residence, this two-and-one-half-story brick structure has two architectural elements that are unusual in southern Louisiana: stepped gables on the end walls and a full-height cellar. The latter is possible only because the house is located on a bluff high above the bayou. The gables, characteristic of Dutch architecture, were possibly adopted here as a reference to the houses that line Dutch canals, suggesting the importance of water transportation for Washington when the house was built. A small iron balcony fronts the central second-floor window, and a two-story gallery is at the rear. When the house was built, the first floor consisted of one large storeroom and had no interior stairs. Between 1902 and 1936, new owners operated a hotel (Schmit Hotel) in the building. It is now a residence.

Grand Coteau

The small community of Grand Coteau (large hillock) occupies a site on the Coteau Ridge, a

bluff formed by the ancient Teche-Mississippi River system. Grand Coteau became an educational center for southwestern Louisiana in the early nineteenth century, when two Catholic schools were established here: the Academy of the Sacred Heart for girls and St. Charles College for boys. Almost three miles of shady oak-lined lanes link the two important educational institutions with the town.

SL12 St. Charles College Jesuit Novitiate and Spirituality Center (St. Charles College)

1909, Diboll, Owen and Goldstein; Frederick Nehrbass, associate. 313 Main St. (Louisiana 93)

In 1837, a group of Jesuits moved to Grand Coteau and opened a boarding school for young men on a site they could keep without charge, provided they attend to the spiritual needs of the parish. After their first school was destroyed by fire in 1907, a New Orleans firm was hired to design the new building. Although the initial design had a more pronounced Collegiate Gothic appearance than the final product, the three-story building, of brick painted white, does convey a suitably medieval scholastic image. The taller, four-story central section has a crenellated parapet, gable-fronted projecting end wings, and rows of tall rectangular windows across the facade. A single-story wooden gallery fronts the lower facade. In 1922, the Jesuits closed the school and established a novitiate in the building.

SL13 St. Charles Borromeo Catholic Church

1879–1880, attributed to James Freret; additions. 174 Church St. (Louisiana 760–1)

This picturesque wooden church has a pedimented gable front, above which is a square tower that rises in stages to a steeple. This tower is overwhelmed by an enormous Second Empire belfry over the sanctuary, added in 1886 to house a bell donated by one of the parishioners. Covered by a tall, dormered mansard roof, the two-story bell tower has a second story surrounded by a narrow balcony and balustrade and an open arcade for displaying the bell. The design of the church (excluding the bell tower of 1880) has been attributed to James Freret on the basis of drawings he made in 1875, although these only vaguely resemble the church as it stands. However, Freret did do work for the Jesuits, for example, at Mobile, Alabama. If this church was designed by Freret, it was not begun until 1879, and it is clear that numerous changes were made. The steeple at the front of the church is quite different from the one in the Freret drawing, which shows a spire rising uninterrupted from the roofline. The church's present spire is a replacement built in 1950 after the previous wooden one, which it replicates, was struck by lightning. Freret's scheme for the interior was not followed, for his design shows a gallery over the aisles, which was not built, and what appear to be iron brackets on slender columns supporting an arcade. The church has an arcade of slender, square paneled piers with Composite capitals, a small balcony at the rear, and a flat ceiling with stenciled decoration. Artist Erasmus Humbrecht, who also painted some frescoes at St. Louis Cathedral in New Orleans, is recorded as having executed the fourteen Mysteries of the Rosary for the niches along the aisle walls. Stained glass windows from the studio of Emil Frei date from the 1920s and 1940s. Adjacent to the church is a cemetery with tombs from the early 1800s and a grotto (1926), which is a replica of Our Lady of Lourdes grotto in France.

SL14 Academy of the Sacred Heart

1830, with additions. 1821 Academy Rd.

Founded in 1821 by the Society of the Sacred Heart as a school for girls, the academy was first accommodated in a house donated by Mrs. Charles Smith. The present school, a product of several building campaigns, is a three-story brick structure, twenty bays wide, with a pair of two-story pedimented end wings. The earliest part, constructed by William Moore, was approximately 50 feet long and two stories tall, with brick walls laid in Flemish bond. In 1834, Samuel Young, who also worked at Chrétien Point Plantation House (next entry), extended the building to the east, more than doubling its original length. In the 1840s, a three-story addition was appended to the west; another story was subsequently added to the earlier sections, giving the building a uniform height. Cast iron gallery columns and railings replaced the original wooden columns.

The Greek Revival chapel, built in 1850 on the left side of the academy, has four brick pilasters and a pediment, as does the library, added at the opposite end. Despite the many

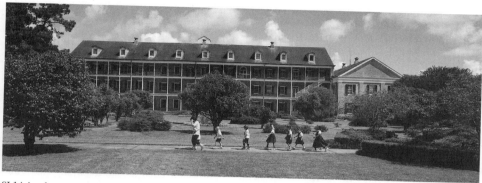

SL14 Academy of the Sacred Heart

building campaigns, the academy presents a remarkably unified appearance. Even the twentieth-century additions, which include the Greek Revival–inspired Memorare Hall (1939) by A. Hays Town, respect the original concept. Several dependency buildings, among them a large brick barn (1854), are located to the rear of the school. The extensive grounds include a formal front garden with parterres in octagons, squares, and circles, laid out in 1835 by Madame Xavier Murphy.

The academy survived the Civil War unharmed, as General Nathaniel Banks, who commanded the Union Army in this area, had a daughter attending a sister school, the Convent of the Sacred Heart, in Manhattanville, New York. The academy's secluded location, buildings, and gardens continue to offer a serene atmosphere.

tion. The building contract, signed in 1831, stipulated that the house was to have a brick foundation, four bricks thick, sunk 2 feet below the surface. The round-arched windows and doors opening onto the galleries show Federal influence and are a rare feature for a Louisiana plantation house. Some of the rooms were originally wallpapered, and three of the upstairs rooms have imported marble chimneypieces. After Hypolite died from yellow fever in 1837, his wife, Félicité Neda, managed the cotton plantation, doubled the landholdings, and became famous for the gambling parties she hosted. The house stayed in the family until the 1930s, after which it fell into disrepair. In 1975, new owners purchased and restored the house, which is now open for tours and as a bed-and-breakfast. Chrétien Point's rural location has changed little since it was built.

Sunset Vicinity

SL15 Chrétien Point Plantation House

1831–1835. 665 Chrétien Point Rd. (Parish Rd. 2–151, off Louisiana 356)

Hypolite Chrétien II built Chrétien Point on land acquired by his grandfather Joseph C. Chrétien in the eighteenth century. The two-story house has a Creole plan: three rooms wide with a loggia between cabinets at the rear, a two-story gallery on double-height plastered brick Tuscan columns across the front, and a hipped roof. Stairs are located in the loggia. Carpenter Samuel Young, who also worked on the Academy of the Sacred Heart in Grand Coteau, and bricklayer Jonathan Harris constructed the house with bricks made by slaves on the planta-

Eunice

Eunice was established in 1894 as a real estate venture by the brothers Cornelius C. and William W. Duson, who had laid out Crowley (Acadia) in 1886, and was named for C. C. Duson's wife. A street called Park Avenue was planned as the principal boulevard, but businesses were established along a route with a less exalted name, 2nd Street. The Duson brothers advertised in circulars and newspapers throughout the nation, especially the Midwest, the wonderful opportunities their new towns offered. Eunice's population grew from 316 in 1900 to 1,684 in 1910. The railroad played an important part in the town's development, enabling it to become a center for rice milling and for shipping of cotton oil and lumber. The Eunice Depot Museum (220 South C. C. Duson Drive)

is located in the former railroad depot (1894), which was converted in 1984. The Prairie Acadian Cultural Center (250 W. Park Avenue), a unit of the Jean Lafitte National Historical Park, has a wide range of exhibits on local culture.

SL16 Liberty Center for the Performing Arts (Liberty Theater)

1919–1924, Duncan and Barron. 220 W. Park Ave.

The Liberty Theater was intended to be a larger and more ornate movie house and commercial structure, but the scheme by the Alexandria-based architects was modified after the building consortium experienced financial difficulties. The brick walls are articulated simply by brick pilasters and a parapet. Shops and offices occupy the first story, and the corner entrance leads into the auditorium space. On the interior, the side walls were designed to curve inward to the proscenium. The walls were painted with marbleized Tuscan pilasters. During the late 1920s and 1930s, the theater accommodated all the town's social and public events, from theater productions to club meetings and political rallies. The theater was restored and reopened in 1987 as a center for Cajun and zydeco music, including radio and TV shows.

Southwestern Parishes

U NTIL THE TURN OF THE TWENTIETH CENTURY, SOUTHWESTERN
Louisiana was sparsely populated. Longleaf pine forests and dense cane
and underbrush discouraged settlement, as did the unstable marshlands
bordering the coastline. The territory between the Sabine and Calcasieu rivers,
which flow into the Gulf of Mexico, was claimed by both the Spanish and the
French during the 1700s, and its ownership remained unresolved under the terms
of the Louisiana Purchase of 1803. As a neutral strip, it was a haven for outlaws and
bandits until Texas was annexed to the Union in 1845 and the center of the Sabine
River became the boundary between the two states. As the Sabine River's numerous
shoals hindered navigation except during the high-water period, few settlements
were built along its banks. The Calcasieu River was navigable, enabling Lake
Charles to develop as an important port, the center of the region's lumber industry,
and the largest town in southwestern Louisiana. Cameron Parish was founded in
1870, and the rest of the southwestern region formed one parish, Calcasieu (a Na-
tive American word for crying eagle), until 1912, when it was divided into Allen,
Beauregard, and Jefferson Davis parishes.

Rapid changes after 1880 resulted in large part from the railroad, which enabled
expansion of the nascent lumber industry and, in the eastern sector of the region,
rice cultivation. New towns, such as Jennings, were laid out along the railroad on
rectangular grids, with wide main streets. Lumber barons who came south from
Michigan to make fortunes from Louisiana's forests established company towns.
Most of these are now ghost towns or, as in the case of Longville, constructed for the
Long-Bell Lumber Company, mere shadows of these once thriving communities. In
Lake Charles, the lumber barons built Colonial Revival or Queen Anne residences
for themselves; the latter constitute some of the best Shingle Style houses in the
state. Because the city had few trained architects, prestigious out-of-town firms, such

as Favrot and Livaudais from New Orleans and Joseph Finger (1887–1953) from Houston, were hired to design its early-twentieth- century civic and commercial buildings. In the third quarter of the twentieth century, the Lake Charles firm of Dunn and Quinn—George Lewis Dunn (1907–) and Gustav G. Quinn, Sr. (1905–1997)—introduced the International Style to the city.

In the eastern area of the region, particularly Jefferson Davis Parish, farmers from Iowa and other midwestern states expanded the rice industry; a community named Iowa attests to their presence. Rice silos and mills line the railroad tracks in the town of Jennings, which also gained attention for a new industry: Louisiana's first oil well was drilled just outside the town in 1901. Oil and petrochemical industries remain crucial to the region's economy, especially to Lake Charles and the

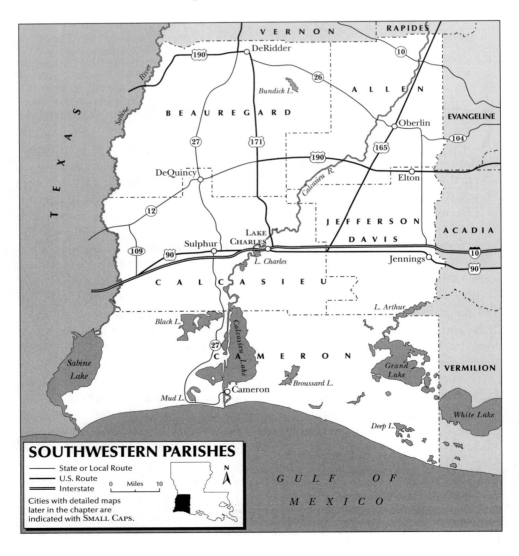

SOUTHWESTERN PARISHES

—— State or Local Route
—— U.S. Route
══ Interstate

0 Miles 10

N

Cities with detailed maps later in the chapter are indicated with Small Caps.

town of Sulphur. In the late twentieth century, when casino gambling was legalized in Louisiana, a new economic base was added; casino boats were established on Lake Charles to attract customers from Texas, where gambling is prohibited. Following the direction of many other Native American groups, the Coushatta (Koasati) operate a casino in Allen Parish three miles north of Elton, where their tribal headquarters are located.

In striking contrast to the forests and prairies of the rest of the region, Cameron Parish, bordering the Gulf of Mexico, is characterized by marshes and cheniers (from *chêne*, the French word for oak), ancient oak-covered beach ridges formed by wave action and offshore currents. Cameron is still thinly populated, but it lies on the flight path of birds crossing the Gulf of Mexico and is a primary winter refuge for waterfowl. The Sabine National Wildlife Refuge, established in 1937, covers 142,000 acres and is the largest on the Gulf Coast.

Cameron Parish (CM)

Cameron

CM1 Cameron Parish Courthouse

1937–1938, Herman J. Duncan. 119 Smith Ridge

This concrete courthouse was one of the few buildings in town to survive Hurricane Audrey in 1957 and provided temporary accommodations for local residents made homeless by the hurricane. Designed by Herman Duncan of Alexandria, Louisiana, and funded by the PWA, the courthouse is an austere, plaster-covered Art Deco structure, whose only surface articulation is zigzag ornamentation around the entrance door. Flanked by recessed lower wings, the three-bay center section is three stories tall, its verticality emphasized by piers that reach up to the flat roof. A staircase leads to the central entrance of the main floor raised above a basement level. The judge's chambers and courtroom are located on the top floor. A landscaped court in front of the courthouse adds to the building's presence.

Cameron Vicinity

CM2 Sabine Pass Lighthouse

1856, Captain Danville Leadbetter. Eastern side of Sabine Pass (accessible only by boat; visible from Sabine, Texas)

Army engineer Captain Danville Leadbetter designed and supervised construction of this rocket-shaped lighthouse at the entrance to the Sabine River. It is one of only four surviving brick lighthouses along the coast; most of them sank because they were too heavy for Louisiana's soft, marshy soil. Captain Leadbetter avoided a similar fate for this lighthouse by giving the base of the octagonal brick structure eight finlike buttresses (four of them 18 feet at the base, the other four 10 feet) in order to

CM2 Sabine Pass Lighthouse

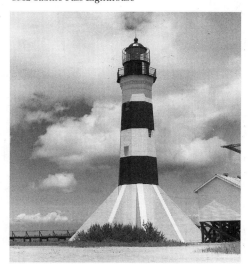

spread the weight. The lighthouse has an 18-foot radius and reaches a height of 84 feet above the water. At its top is a brick cornice ornamented with dentils and a cylindrical lantern room, originally covered by a copper dome. The lantern's beam reached out twenty-five miles, helping ships from the Gulf of Mexico to navigate Sabine Pass and enter the river. During the Civil War, the light was extinguished to prevent Union boats from finding their way up the Sabine River. Nearby, in the river, is a sunken Union gunboat. The lighthouse was decommissioned in 1952. Plans are being made to restore the lighthouse and open it to the public. Captain Leadbetter used the same plans for three other lighthouses; the two in Louisiana have been demolished, but the one, at Aransas Pass, Texas, still stands.

Calcasieu Parish (CC)

Lake Charles

Two major periods of industrial expansion have given Lake Charles some remarkable buildings. Beginning in the 1880s, the city became a center for the lumber industry, and later the oil industry. Both were made possible by the Calcasieu River and Lake Charles, which provide access to markets beyond Louisiana.

The city of Lake Charles, known as Charles-town in its early years, grew on the east shore of its eponymous lake around the lumber mills of Daniel Goos and Jacob Ryan. Ryan, who came to the area in 1817, is credited with laying out the first streets between what are now Broad and Pujo streets. Immigration to the city was encouraged by a land syndicate, headed by J. B. Watkins, who advertised in his nationwide newspaper, *The American*, describing Lake Charles as a "Garden of Eden." The population

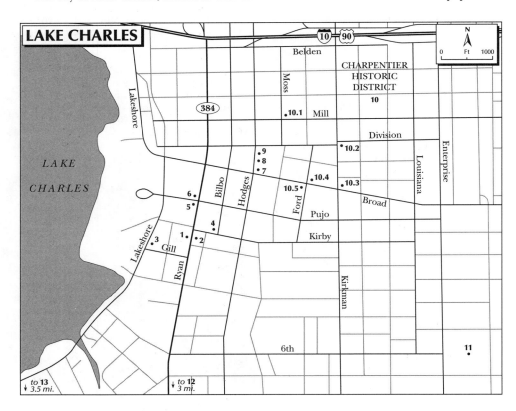

jumped from approximately 400 in 1866 to 7,500 in 1896. Lake Charles was designated the parish seat in 1852, when Calcasieu Parish embraced an area that included what are now Allen, Beauregard, and Jefferson Davis parishes.

The forests of longleaf yellow pine that covered the southwestern region provided Lake Charles's first major industry. Local lumber barons such as Goos and Ryan were joined by people from the north, known locally as the "Michigan men," who came to exploit Louisiana's forests after exhausting the timber in their native states. Logs were brought down the Calcasieu River and rafted into the lake, where many of the sawmills were located. Schooners then transported the finished product to the Gulf ports, primarily to Galveston, Texas. A railroad that reached Lake Charles in 1880 was a stimulus to growth, supplementing but not supplanting water transportation. The lumber barons created a neighborhood of grand houses, now known as the Charpentier Historic District (CC10), constructed of the local longleaf pine and cypress. Orange Grove and Graceland Cemetery (2023 Broad Street) provided the final resting place for many of the lumber barons; the monumental tombs of lumbermen Walter Goos (1865–1943) and John A. Bel (1857–1918) are particularly splendid.

A major fire in 1910 destroyed seven blocks, including the city's civic buildings and its records. Immediately following the fire, the New Orleans firm of Favrot and Livaudais was commissioned to design a new courthouse, a city hall, the Catholic church (now cathedral), a bank, and a school. Several wealthy Lake Charles families also hired the firm to design new residences for them. Favrot and Livaudais seized the opportunity to display their skills in a range of fashionable styles of the time, thus making Lake Charles a focal point for the study of this important early-twentieth-century firm.

The stock of timber was exhausted by the second decade of the twentieth century, and the sawmills and lumberyards closed. However, Lake Charles was launched as a major industrial center with the construction of a deepwater port, opened in 1926, which was linked with the Intracoastal Waterway and ship canal and was a mere thirty-four miles inland from the Gulf of Mexico. Oil and the docks brought new industries: chemical plants, refineries, and oil-related plants. Shell Beach Drive, along the eastern shore of the lake, became a fashionable address, and the south shore of Lake Charles

began to be swallowed up by new residential subdivisions. But in the oil-prosperous years from the 1950s to the 1970s, downtown Lake Charles underwent urban renewal as well as demolition of historic structures. A sixty-four-acre landfill along the lake's eastern shore provided the site for a new civic center and park and a four-lane boulevard, Lakeshore Drive, all of which attracted high-rise office buildings. Unfortunately, historic buildings were demolished to provide surface-level parking lots, and the shops that had once contributed to the area's vitality relocated to the suburbs. Beginning in the 1990s, however, restoration and adaptive reuse of surviving buildings have given the downtown a new energy, notably the former Gordon Drugstore (901 Ryan Street), a two-story brick building that is now the Pujo Street Café on the ground floor and apartments on the second. Behind it, at 310–320 Pujo Street, a row of commercial buildings (1890s), faced with buff and bottle-green glazed tiles and with a green tile balustrade, has been adapted for commercial and residential occupancy.

CC1 Calcasieu Parish Courthouse

1912, Favrot and Livaudais. 1000 Ryan St.

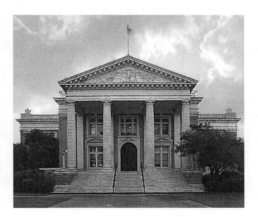

Favrot and Livaudais designed this Beaux-Arts courthouse to replace the one destroyed in the fire of 1910. Taking as its precedent the Pantheon in Rome, the courthouse has a prominent portico and shallow dome. It has two stories and is raised on a high podium, which allows an imposing flight of stairs in front of the pedimented portico. Walls are of a buff-colored brick, the portico's four fluted columns are sheathed in white terra-cotta, and the dome

is covered with copper. The courthouse has a cruciform plan with four arms of equal length; the reentrant angles are finished with convex curves, which give the building a lively silhouette. A terra-cotta entablature and openwork balustrade wrap around the courthouse to unify the composition, and large classical urns mark each corner. The pediment is decorated with a relief of an eagle with outspread wings.

The principal courtroom is beneath the central dome and has semicircular lunette windows cut into the dome's square base. The room has rounded corners corresponding to the exterior curves and a shallow dome set within the outer dome. The interior wood detailing is superb, from the original judge's bench and jury box to doors with pediments and ear moldings and windows capped by ear moldings. Two original lampposts with papyrus-leaf designs and two wall sconces on either side of the courthouse's front steps were restored in the late 1990s. One of the best

Beaux-Arts buildings in the state, the courthouse is the work of a firm that was committed to the early-twentieth-century spirit of inventive classicism in architectural forms and decoration. A modern three-story annex is attached to the rear of the building.

CC2 **Lake Charles City Court** (City Hall)

1911, Favrot and Livaudais; Ira C. Carter, associate architect. 1007 Ryan St.

Favrot and Livaudais, with Lake Charles architect Ira C. Carter (1872–1956) as associate, designed the new city hall in a style quite different from that of the courthouse. Similar to the city hall destroyed in the fire of 1910, the two-story building has a four-story clock tower in the center of the facade. Its detailing, however, differs from that of its predecessor. The dark red brick exterior is smothered with off-white terra-cotta decoration, including cartouches around the

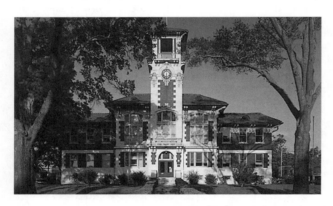

CC2 Lake Charles City Court (City Hall)

CC4 Cathedral of the Immaculate Conception

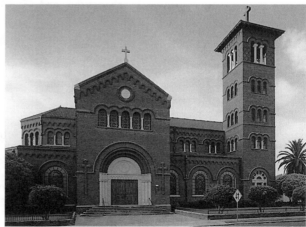

clock, a balcony over the entrance resting on oversized consoles, and massive paired wooden brackets beneath the projecting eaves of the red pantile roofs. The interior woodwork and moldings are intact, and the ceiling cornices are visible despite the more recent dropped ceilings. Originally the first floor accommodated the city court and mayor, and council chambers occupied the second floor.

CC3 Junior League Headquarters (Waters Pierce Oil Company Stable Building)

1903. 1019 Lakeshore Dr.

This small two-story brick building housed the draft horses used for transporting equipment between the oil fields, their terminal points, and storage areas. Its only ornamentation the prominent stepped gable ends, this building is one of the few not destroyed in the fire of 1910. It is also a rare survivor from the early years of the state's oil industry, for oil companies were quick to replace buildings that became outdated by new technology.

CC4 Cathedral of the Immaculate Conception

1913, Favrot and Livaudais. 1973, addition, Dunn and Quinn. 935 Bilbo St.

The fire of 1910 destroyed all the Catholic church properties on this site: the church, convent, and boys' school. Favrot and Livaudais selected the Italian Romanesque style for the new church (which became a cathedral in 1980) and gave it a cruciform plan with transepts almost as long as the nave and a polygonal apse. All the openings are round-arched, from the entry portal with its compound columns and voussoirs to the windows and their brick surrounds. Round-arched corbel tables form blind arcades along the eaves. A five-story bell tower with multiple arched openings marks one corner of the facade. The cathedral is constructed of dark red bricks joined with a rosy-colored mortar that impart a vibrant glow. The interior has a short three-bay nave that is divided into three aisles by columns with elaborately floriated capitals and covered by a shallow-curved vault. During a remodeling in the 1930s, an image of the Virgin in Majesty was painted on the apse half dome, and stenciled designs were added to the chancel walls and the intrados of the nave arches. The biblical scenes in the Vi-

ennese stained glass windows have a lavender-blue background that gives the interior its principal luminous coloration. A two-story brick rectory and garage are part of the original design, but a one-story wing and connecting arcade were added in 1973 by the Lake Charles firm of Dunn and Quinn. These later additions emulate the style of the church, but their crisp-edged bricks stand out from the weathered ones of the original buildings.

CC5 Office Building (Charleston Hotel)

1929, Joseph Finger and Livesay Williams. 902 Ryan St.

Lake Charles's first skyscraper played an important role in the city, prominent not only for its height but also as the place where social events were held in its tropical roof garden, the ballroom on the second floor, and the dining room on the ground floor. Designed by a Houston-based architecture firm, the ten-story, steel-frame building has a cement finish over the lower two stories, scored to resemble rusticated stone. The upper stories are faced with brick and ornamented with Spanish Colonial Revival details and finials of cast concrete. The decoration of the two-story lobby is a colorful blend of Spanish and Islamic influences that were popular for hotels in the 1920s, here in the form of glossy blue tiles around the doors, the stairwell arch, and the base of the walls, as well as the ogee-arched decorative niches. Balconies with ornate iron railings and chandeliers add to the Mediterranean ambience.

CC6 W. T. Burton Operations Center (Calcasieu Marine Bank)

1928, Favrot and Livaudais. 840 Ryan St.

Favrot and Livaudais selected Beaux-Arts classicism as the style for this three-story, steel-frame building faced with limestone. Tall, round-arched openings dominate the center of the facade, the central one serving as an entrance, and all are separated by colossal engaged columns with tall papyrus capitals. The columns reach almost to the roofline, as do the pilasters framing the central section of the facade. Pilasters and columns support a narrow entablature, above which is a row of four relief medallions. An eagle, wings outspread, perches on the parapet. As is typical of the work of Favrot and Livaudais, the exterior articulation

gives a hint of what lies behind; in this case, the tall arched openings are in tune with the 30-foot-high banking hall. Stairs in three corners of this hall lead to a mezzanine level that accommodates offices. The ceiling is coffered; interior furnishings and materials include terrazzo floors, marble counters, and finishes in a color scheme of pink, brown, and ocher-hued beiges. The structure was renovated by Barry D. King in 1995.

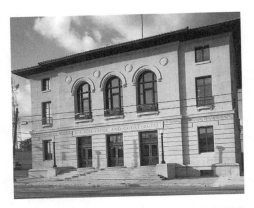

CC7 **Lundy and Davis LLP Office** (U.S. Post Office and Courthouse)

1908–1912, James Knox Taylor, Supervising Architect of the Treasury. 501 Broad St.

In the manner of an Italian Renaissance palace, the exterior of this handsome two-story limestone-faced building has a rusticated ground floor and smooth surfaces on the two upper stories. Over the centrally placed entrance are three tall round-arched windows with prominent moldings, and above them is a row of four gray granite medallions. A tiled hipped roof has deep eaves supported on wooden brackets, beneath which is a band of stylized magnolia flowers in wood. The building served as the post office and courthouse until the late 1950s, when a new structure was built. In the early 1960s, the building was gutted in a renovation for an educational institute, at which time the marble staircase was removed. After the school closed c. 1980, the building stood empty until purchased by a law firm in 1996. Moss Architects of Lake Charles undertook a complete renovation and installed a new "grand" staircase. Myriam Hutchinson Interior Design guided the interior work, which included restoration or reconstruction of such original details as the raised wall panels in the former courtroom (now used as a moot court), terrazzo floors, and plaster ceiling details.

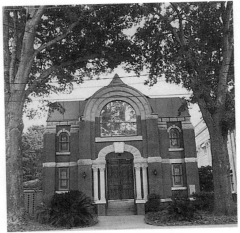

CC7 Lundy and Davis LLP Office (U.S. Post Office and Courthouse)

CC9 Temple Sinai

closely spaced segmental-arched entrance doors. A balustrade surmounts the building. Neild and Olschner were Shreveport-based architects, who, together and separately, were responsible for numerous buildings in Louisiana, mostly in the northwest.

CC8 **Masonic Temple**

1919, Edward F. Neild and Clarence Olschner. 719 Hodges St.

This two-story Beaux-Arts temple is an ornate foil to its neighboring former post office (CC7). A pattern of occasional recessed courses gives the beige brick walls a rusticated character, in contrast to the building's corners, which are smooth and curved in imitation of a column. Fluted Corinthian pilasters separate the three

CC9 **Temple Sinai**

1904, attributed to Ira C. Carter. 713 Hodges St.

Organized in 1895, the Jewish congregation of Temple Sinai met for worship in a nearby Masonic Temple until this synagogue was completed in 1904. Towers with onion domes originally stood over each end of the facade but were destroyed in the 1918 hurricane. In the building's present state, the curves of the large

central window and its three surrounding arches dominate the facade. In contrast with the dark red brick walls, architectural details, all boldly three-dimensional, are of white stone. These include the paired columns with over-sized capitals and impost blocks that flank the central entrance and the correspondingly over-sized keystone that punctuates the voussoirs of the elliptical-arched entrance. The interior, a single space with a barrel-vaulted ceiling and wood wainscoting, is decorated quite simply. The building's designer is believed to be Lake Charles architect Ira C. Carter.

CC10 Charpentier Historic District

c. 1880–c. 1920. Bounded roughly by Kirby, Hodges, and Belden sts. and Louisiana Ave.

Charpentier (carpenter in French) Historic District is a National Register district, named to acknowledge the carpenters who built its late-nineteenth- and early-twentieth-century wooden houses from designs in pattern books. Especially grandiose are Pujo, Broad, Division, and Mill streets, which feature houses in Queen Anne, Colonial Revival, and Spanish Colonial Revival styles as well as smaller galleried cottages. Many of the two-story houses tilt to the west, a consequence of the hurricane of 1918, which destroyed some residences and blew turrets and porches off others. These early wooden houses were invariably painted white with green shutters but now sport pastel shades of yellow, blue, and pink. The two-story house in the Queen Anne style at 824 S. Division Street was built in 1890 for Guy Beatty, an early Lake Charles newspaperman. A two-story East-lake porch wraps around a corner, and the gables are decorated with shingles. Despite the stylistic diversity of the Charpentier District houses, they share one distinctive feature: one- or two-story square columns, paneled and tapered, that serve as gallery supports, as seen on lumber baron Walter Goos's Colonial Revival house (624 Ford Street), designed by Favrot and Livaudais, c. 1906. Constructed of cypress with a full-height gallery, the house has paneled square columns that are perhaps the earliest example in Lake Charles. In contrast, the William Gray House at 902 S. Division Street, a symmetrical two-and-one-half-story brick residence built in 1922 by Favrot and Livaudais, has a portico supported on paired Corinthian columns. In 1912, the same firm designed the former Central School (809 Kirby Street), giv-

ing the three-story brick building pediment-shaped parapets over the central and end pavilions. It was restored in the 1990s as the Arts and Humanities Center.

CC10.1 Flanders House

1901. 605 Mill St.

Taking full advantage of its corner site, the house reveals the structural and decorative potential of wood in a lavish display of architectural styles, textures, and colors. The steep hipped roof that shelters the house is pierced by wide shingled gables on both street facades, and a sunburst motif decorates each lower corner in the gables. A curved gallery, across the front and along two sides of the house, is supported on paired fluted columns, each pair gathered under one Ionic capital. Additional colors and textures include the beveled and stained glass windows and scalloped shingles. The double-door entrance is recessed between two bow windows, leading to a central hall that runs the full depth of the house. The house was built by the Bel Lumber Company for its secretary-treasurer, William Flanders, who came to Lake Charles from New Orleans and was married to Catherine Goos, of the Goos lumber family.

CC10.2 Episcopal Church of the Good Shepherd

1897, Charles W. Bulger. 715 Kirkman St.

Claimed as the oldest stone building in southwestern Louisiana, the Gothic Revival church of light gray stone is said to be modeled after an Anglican church in England. Although the original design called for a bell tower, this remained unbuilt until 1953 because of insufficient funds. The church was badly damaged in the hurricane of 1918, leaving only its side walls and roof beams. In the reconstruction, a small rose window replaced the original arched window on the facade. To the right of the church, the parish hall, added in 1926 by architect R. S. McCook, appears to be constructed of the same material but is actually made of rock-faced concrete. Inside the church, the seven-bay single nave provides an intimate space, an ambience increased by the low hammer-beam ceiling of dark-stained beaded pinewood with pendants. The oak altar with carved panels was made by Silas McBee of New York. The stained glass win-

dows along the side walls, made by J. Wippell and Company in England, were installed in 1954. The church's original heating system is served by a stone chimney, a prominent feature of the building. Galveston-based architect Charles Bulger (1851–c. 1924) apparently liked English Gothic architecture, blocky massing, and rugged masonry, as these also appear in his design of 1905 for Holy Cross Church, Shreveport (CA31).

CC10.3 District Gardens Garden Center (Gas Station)

1920s. 803 Broad St.

This brick former gas station and garage has a steeply pitched slate roof and mock chimneys to blend with its residential neighborhood. Its cottagelike appearance, designed to minimize community opposition, became a popular solution for gas stations at the time they were proliferating. The gas pumps were sheltered within a porte-cochere constructed of wood; the gable front is ornamented with vertical strips of wood to resemble medieval timbering.

CC10.4 Nason-Corman House

Late 1880s. 705 Broad St.

English-born Robert N. Nason, with thirty years' experience in the lumber business, came to Lake Charles from Michigan in 1884. Having acquired the Goos mill in 1883, he formed the Calcasieu Lumber Company, which in 1886 was reorganized as the Bradley-Ramsay Lumber Company. The asymmetrical wooden house combines several fashionable but historically disparate architectural features of its era, including a corner tower with a pyramid roof supported on brackets in the manner of an Italian villa. Two semicircular dormers at the tower's first level, a two-lancet Gothic window under an ogee arch, decorative bargeboards, gables shingled in scallop and diamond shapes, and a green tiled roof are among the embellishments. Around 1910, the Eastlake gallery was replaced by a porch gallery supported on Ionic columns and a small pediment marking the entrance.

CC10.5 Ramsay-Curtis House (William E. Ramsay House)

c. 1885. 626 Broad St.

The houses that Michigan lumber barons built in Lake Charles are typically tall, angular, and elaborate in massing and decoration. This two-and-one-half-story house was built for William E. Ramsay, president of the Bradley-Ramsay Lumber Company, organized in 1886 and reputedly the largest of the lumber companies in Lake Charles. The house has a picturesque roofline, with gables, prominent brick chimneys on the side elevations, and a slender shingled turret on the rear elevation. Originally a circular turret stood over the semicircular bay on the front facade, now sheltered within the deep two-story gallery. William Ramsay sold the house in 1906. Around 1910, the two-story gallery was widened and its Eastlake decoration replaced with the newly fashionable paneled square columns and an entablature. Stained glass windows, along with marble and wood paneling in the former library, add to the elaborate textures. The original carriage house is at the rear of the property. The house now offers bed-and-breakfast accommodations.

CC11 Lake Charles High School

1952, Dunn and Quinn. 1509 Enterprise Blvd.

When the former high school on this site was destroyed by fire in 1951, the Lake Charles architecture firm of Dunn and Quinn designed the new school in the latest modernist style. The two-story building emphasizes horizontality; continuous bands of smooth beige brick walls, clear glass windows, and glass block windows, the last across the upper walls of the second-story classrooms, stretch like a skin over the structural steel frame. The frame is revealed on the left side of the facade as red-painted steel columns that support the second floor in its extension over the first to provide a shaded walkway. A flat canopy indicates the principal entrance. Although the original gymnasium survived the fire, it was replaced by the present one in 1956. An auditorium, cafeteria, library, and offices occupy the first floor of the main building; classrooms are located on the second floor. Rooms were decorated in shades of light green or blue with a minimum of contrast to reduce eyestrain, with walls of glazed tiles and terrazzo floors. Lake Charles High School was built when the city was undergoing industrial expansion and school enrollment was increasing. Preexisting schools were modernized, and many new schools were constructed in the 1950s and 1960s, all in contem-

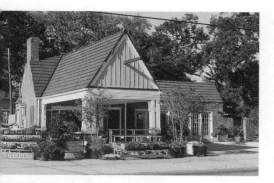

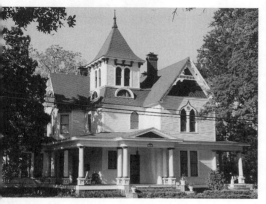

CC10.3 District Gardens Garden Center (Gas Station)

CC10.4 Nason-Corman House

CC12.1 McNeese State University Auditorium, drawing by J. de la Vergne for the architects, 1939

porary styles. One example, located adjacent to the high school at 1300 5th Street, is the Pearl Watson Elementary School (1962). Its undulating roof extends well beyond the building's glass curtain walls in a bold and dramatic canopy.

CC12 McNeese State University

1939, Weiss, Dreyfous and Seiferth; many additions. 4205 Ryan St.

McNeese State University, founded in 1939 as a division of Louisiana State University (LSU), was planned in association with the Cattlemen's Association as a complex that would include a college and a livestock pavilion. The first plans for the project show a small administration building and a huge pavilion, which would also house the classrooms. However, James Smith, president of LSU, rejected those plans in order to put greater emphasis on education and less on animals. The campus was given three buildings: a livestock pavilion smaller than originally planned, a classroom building, and an auditorium. PWA funds helped finance the buildings. McNeese was named in honor of lawyer John McNeese, Calcasieu Parish's superintendent of schools in the late nineteenth century. The university separated from LSU in 1950, advancing from a two-year to a four-year program, and has since acquired many new buildings.

CC12.1 McNeese State University Auditorium

1939–1940, Weiss, Dreyfous and Seiferth

The auditorium, a severe symmetrical structure of blond brick has a triple arched entrance divided by brick piers that extend above the openings to the roofline. The small square bricks of the piers are laid to convey the effect of fluting. Interior walls are finished in various shades of beige marble, colors typical of the era, and the curved walls give the interior a streamlined movement that the rather static exterior lacks. The adjacent three-story classroom building features bands of horizontal windows that create a nicely abstract composition in combination with the vertical window over the entrance.

CC13 Our Lady Queen of Heaven Church

1968–1971, Curtis and Davis. 3939 Lake St.

Our Lady Queen of Heaven Church was built for a new parish in a growing residential neighborhood. Its modern design was made possible in large part by the parish priest, Monsignor Irving DeBlanc, who persuaded his parishioners that a contemporary building would best serve the major changes in the liturgy made by Vati-

CC13 Our Lady Queen of Heaven Church

can Council II in 1962–1965. To confirm that the design complied with the new liturgy, the architects submitted the plans to artist and liturgical design consultant Frank Kacmarcik of Minnesota. The church as built was the third design submitted by the architects, Curtis and Davis of New Orleans, and provides a handsome and effective response to the Vatican Council's recommendations. From the construction materials of brick, wood, and glass to the square plan, flat roof, and continuous open space, the church provides, as project architect Robert Biery said, "a simple objective statement of transparency restrained so as to allow the people to see each other in celebration rather than the building elements." Set to the rear of its site, the church is screened from the street first by a grove of pine trees and then by low, white-painted brick walls that define a forecourt, mediating between secular and sacred space. The church embodies transparency. Its lower walls of clear glass allow for a view through the building to the landscaped courtyard on the other side. Landscaping, plants, and flowers provide the colorful substitutes for stained glass. The upper exterior walls of stained cedar extend beyond the boundaries of the lower glass walls to mediate entering light. Seating is arranged on three sides facing the altar, and the baptismal font is incorporated into the single interior space that encompasses all aspects of worship. The wood ceiling, low-backed pews, curtains, and carpet are in low-key tones of brown and beige, meant to serve as a background for the congregants. Both the exterior and interior offer a serene, peaceful environment.

Sulphur

As its name indicates, the town of Sulphur owes its existence to the mineral that was mined here. The town was laid out in 1878 by civil engineer Thomas Kleinpeter, but commercial mining of sulphur did not begin until 1905, after Herman Frasch, a German immigrant and chemist, developed a system whereby steam was forced into Sulphur's salt dome to melt the underground sulphur for piping to the surface. The product obtained was 99 percent pure and was put on the market unrefined. By 1924, the field was exhausted. Today Sulphur is an important center for petrochemical industries. The Brimstone Museum and Welcome Center in Frasch Park (800 Picard Road) presents exhibits and films that celebrate Frasch's achievements. It occupies the former Southern Pacific Railway Depot of c. 1915, having moved from downtown Sulphur to this site in 1976.

DeQuincy

DeQuincy was one of the towns, along with De-Ridder and Zwolle, that were established on the Kansas City Southern (KCS) Railroad line. Following the Panic of 1893, the KCS was bailed out by investors from Holland, and the railroad's president gave Dutch names to the new towns in recognition of his backers. DeQuincy is said to be named for a Baron DeQuincy, an early stockholder who was perhaps a Dutch nobleman. It became an important railroad town, contributing to southwestern Louisiana's lum-

ber boom. The Gothic Revival All Saints Episcopal Church (corner of Hall and Harrison streets), a wooden structure built in 1885, was moved to this site from Patterson (St. Mary Parish) in 1946.

CC14 DeQuincy Railroad Museum
(Kansas City Southern Depot)

1923. 400 Lake Charles Ave.

The Kansas City Southern Railroad Company, a north-south line in Louisiana, branched at DeQuincy, where the main line went to Beaumont, Texas, and a spur line went south to Lake Charles. Rail tracks passed on both sides of the station. When the company began remodeling or replacing its depots in western Louisiana in the 1920s, its preferred style was Mission Revival. Accordingly, this depot has stuccoed walls, a Spanish red tile roof, curvilinear gable parapets, and wide overhanging eaves with exposed rafters and heavy brackets. The two-story center section, housing a ticket office on the first floor and an office above, is flanked by one-story wings. The west wing provided a waiting room for African Americans and a baggage room; the east-wing waiting room and the open-air patio next to it served white patrons. A vintage caboose and a steam locomotive that date from 1913 are part of the museum's exhibits.

Beauregard Parish (BE)

DeRidder

DeRidder was founded in 1897 on the newly built Kansas City Southern Railroad line and named in honor of one of the Dutch investors who rescued the line following the Panic of 1893. DeRidder became the parish seat in 1912, when Beauregard Parish was formed. The historic commercial street is made up of one- and two-story false-fronted brick buildings typical of Louisiana's early-twentieth-century small towns. The First National Bank (131 N. Washington Street) of 1920 is one of the more detailed structures, with a recessed entry set behind fluted Ionic columns. Architect William Drago from New Orleans designed the First United Methodist Church (Pine and Port streets) in 1915, giving the red brick building a pedimented Ionic portico. In 1936, Conrad Albrizio painted the mural *Rural Free Delivery*, depicting a farmer opening his mail, for the foyer of the former post office, a red brick Colonial Revival structure (204 W. 1st Street), designed by Louis A. Simon in 1935. The former First Street School (500 W. 1st Street), a Moderne building with a dynamic butterfly-wing plan, was designed in 1940 by Max Heinberg of Alexandria; an auditorium by Barron and Heinberg was added in 1948.

BE1 Beauregard Parish Courthouse

1913–1914, Stevens and Nelson. 1st St. (corner of Stewart St.)

The parish courthouse was built on land donated to the town by the Hudson River Lumber Company. Stevens and Nelson of New Orleans designed a three-story, buff-colored brick building with a central dome raised on a tall square base, with a clock on each of the four sides. Porticoes at front and back are each fronted with four pairs of two-story Ionic columns sheathed in a thin layer of glazed terra-cotta that is scored to resemble stone. Under the dome is an octagonal lobby, but this is the only grand space; the interior is otherwise functional. A tunnel connects the courthouse to the jail, which allowed prisoners to be brought unseen and safely from one building to the other. In 1914, Stevens and Nelson repeated this design, substituting paired Doric columns for the single Ionic ones, for the Morehouse Parish Courthouse in Bastrop (MO1).

BE2 Beauregard Parish Jail

1914, Stevens and Nelson. 1st St. (between Stewart and Pine sts.)

Stevens and Nelson created an impressive and formidable jail. The cruciform-shaped reinforced concrete building piles up in tiers to a central tower, a vertical movement that is exag-

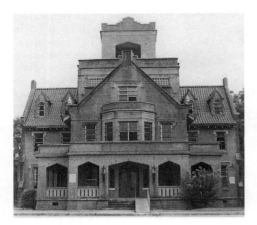

BE2 Beauregard Parish Jail

look decidedly undesirable. The building is locally known as "The Hanging Jail" because the open top story of the central tower was used for hangings, the legal method of execution in Louisiana until 1941. Gothic-styled jails were popular in small towns around 1900, but very few survive, most having either been replaced by a larger facility or moved to the uppermost floor of a new courthouse. (Many of the latter were replaced in the 1920s and 1930s.)

BE3 Beauregard Parish Museum (Kansas City Southern Railroad Passenger Depot)

1926. 120 S. Washington Ave. (corner of 2nd St.)

This one-story brick depot, now restored to house a local history museum, has a tile roof elaborated with brackets under the eaves. A centrally located cross wing with a gable roof accommodated the ticket office, flanked by waiting rooms. The freight depot was attached as an extension to the south. Across the street is the three-story brick Standard Building, constructed in 1913 as the headquarters and commissary for the Long-Bell Lumber Company.

gerated by steep gables on each facade. A red tile roof, dormer windows, and a wide projecting portico with Tudor arches give the jail a residential flavor. However, the barred windows, fortresslike appearance of the central tower, and the gray-colored, rough-surfaced exposed aggregate exterior finish make residence there

Allen Parish (AL)

Oberlin

Oberlin was founded in 1893 adjacent to the turnaround of the Watkins Railroad, which had reached this area from Lake Charles in 1885. The oldest town in Allen Parish, it was named for Oberlin, Ohio, from which its first settlers came.

AL1 Allen Parish Courthouse

1914, Favrot and Livaudais. 5th and 6th sts.

When Allen Parish was created in 1912, the New Orleans firm of Favrot and Livaudais had just completed Calcasieu Parish's new courthouse

(CC1) and the city hall (CC2) in Lake Charles and, in 1911, the De Soto Parish courthouse (DS1) in Mansfield. For Allen Parish, Favrot and Livaudais reused their De Soto design with minimal and barely detectable modifications. Allen Parish's Beaux-Arts courthouse stands on an axis with and dominates Oberlin's principal commercial street. The building is constructed of buff-colored brick with limestone trim; its second floor is emphasized by Ionic columns between the three round-arched windows and, in the center of the facade, a small balcony supported on scroll brackets. A brick parapet and stone balustrade complete the building. The courtroom, embellished with classical moldings, occupies the center of the second floor.

Jefferson Davis Parish (JD)

Jennings

Founded in 1881 as a railroad stop, Jennings was named for Jennings McComb, the contractor in southwestern Louisiana for the Southern Pacific Railroad. Sylvester L. Cary became the railroad's land and immigration agent, attracting about one hundred fellow Iowans to Jennings by 1883. The arrival of other midwesterners expanded the town's population to 1,539 by 1900. Rice cultivation and processing became the mainstay of the economy; the first rice mill was built in 1896. Silos and other rice-related buildings still line the railroad tracks. Louisiana's first oil well was drilled near Jennings in 1901, creating a new boom.

The year 1901 is also memorable for the fire that burned down most of the town's business section. Rebuilding was rapid along Main Street, a wide thoroughfare of mostly one- and two-story brick commercial structures. Housed in one of these buildings is the W. H. Tupper General Merchandise Museum (311 N. Main Street), a re-creation of an early-twentieth-century general store, with original merchandise on display. The Strand Theater (432 N. Main Street), an Art Deco structure of 1939, restored in the 1990s, is decorated with yellow, red, and lavender vertical bands on the facade above the marquee. At the end of Main Street is the flat-iron-shaped Heywood Building (203 N. Main Street), built c. 1905 as a department store and refaced on its ground story with Carrara glass at a later date. Opposite is a large two-story brick structure decorated with escutcheons (1902; Market and Main streets), which was also a store. In 1907, members of the Civic League planted 376 trees to beautify Jennings; many of these oaks still shade the town's streets. The Zigler Museum (411 Clara Street) occupies the former home of Fred and Ruth Zigler. After she donated the Colonial Revival house (1908) in the early 1960s, two gallery wings were added. The New Orleans architecture firm of Burk, Le Breton and Lamantia designed the Immaculate Conception Chapel (701 Lake Arthur Avenue) in 1954. Working with a very small budget, they produced a steel-frame modern building with light-colored, non-load-bearing brick walls that enclose a rectangular space gently illuminated by a narrow band of clerestory windows.

JD1 Jefferson Davis Parish Library (U.S. Post Office)

1914, Oscar Wenderoth, Supervising Architect of the Treasury. 118 W. Plaquemine St. (corner of Cary Ave.)

This one-and-one-half story Federal Revival structure of red brick has a pitched roof with gable-end parapets and small pedimented dormers. The ground-story openings of the five-bay facade are semicircular, and its keystones, along with the architrave and cornice, are of limestone. The building served as a post office until 1976, after which it was adapted for use as a library and its original interior altered.

JD2 Public Library

1908, Whitfield and King. 303 Cary Ave. (corner of Plaquemine St.)

In 1889, the Jennings Ladies' Library Association opened the first public library in a house they purchased on Main Street with funds they had raised. After this structure burned down in 1901, the association purchased the site of the present building and requested financial support for a new library from the Carnegie library program, which donated $10,000. The exterior design, by a New York firm, is reminiscent of Thomas Jefferson's house Poplar Forest (1805–1812) in Virginia. The library is constructed of buff-colored brick with white-painted wood trim. Its V-shaped plan fits neatly onto the corner site, and it has a prominent entrance portico supported on four Corinthian columns. This leads to an octagonal rotunda with Ionic

JD1 Jefferson Davis Parish Libraary

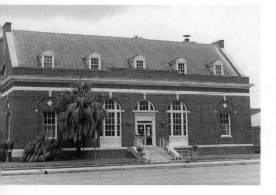

columns in each corner, illuminated by a sky-light in the octagonal dome; the rest of the interior has been remodeled. In 1952, the south wing was extended by four bays.

JD3 House

c. 1900. 314 W. Academy Ave. (between Cary Ave. and N. Lake Arthur Rd.)

In many ways this house is representative of the Queen Anne houses that transplanted midwesterners built for themselves in Jennings. In contrast to the single-story Queen Anne houses with deep galleries that are typical of Louisiana, it has two and one-half stories, vertical massing, and a small balconied porch. The Dutch-style double-pitched gable that extends through one and one-half stories carries bands of scalloped and sawtoothed patterned shingles in quantities seen most often in Louisiana railroad towns established by settlers who migrated from the Midwest and the North. Some features, however, are standard in Louisiana: wood construction, horizontal siding on the lower half of the building, shingles restricted to the upper sections, and white paint for the entire house, including shingles. The house was built for Dr. John E. Foster from Iowa, who was in the lumber business.

At one time, Jennings had many houses similar to this, as did the nearby town of Welsh.

Other fine examples in Jennings include the large house at 402 W. Nezpique Street, c. 1895, with scalloped and saw-toothed shingles and a pedimented entrance pavilion. Hotel owner T. C. Mahaffey's house (802 Cary Avenue), built c. 1895, has a single-story Eastlake gallery that wraps around a two-story polygonal bay.

JD4 Louisiana Oil and Gas Museum Park (Replica of Louisiana's First Oil Derrick)

1976 replica of 1901 derrick. 100 Rue de l'Acadie (I-10 at exit 64)

In 1901, when farmer Jules Clement observed oil bubbles after he had flooded one of his rice fields, a group of Jennings businessmen formed the S. A. Spencer Company and contracted with the Heywood brothers (Alba, O. W., Clint, Dewey, and Scott) to drill two wells. The Heywoods, who began their careers in their father's traveling theatrical troupe, had moved to Beaumont, Texas, immediately following the discovery of the Spindletop field, where they drilled some of the first wells. At Jennings, they struck oil at approximately 2,000 feet, and Louisiana's oil and gas industry was born. A replica of the Heywoods' first derrick, built of wood and 64 feet tall, commemorates the discovery of oil in the state. Adjacent to the derrick is a replica of an Acadian cottage that houses the museum.

Central Parishes

T WO DISTINCT CULTURES DEVELOPED IN CENTRAL LOUISIANA. One was plantation-based, bordering the Red and the Cane rivers and the bayous Rapides and Boeuf, and the other grew out of the lumber communities of the pine hills. The former emerged in the late eighteenth century and was dominated by French-speaking settlers in Natchitoches Parish and English-speaking settlers in Rapides Parish. The lumber industry, however, was a late-nineteenth-century development that owed its existence to the advent of railroad transportation, and it was dominated by Anglo-Americans

The Native Americans of central Louisiana were the Caddo and the Natchitoches, and their trails ultimately became the routes used by immigrants heading west into Texas and beyond. Jean-Baptiste Le Moyne, Sieur de Bienville, and Louis Antoine Juchereau de St.-Denis explored the Red River in 1700; in 1714, the latter established a trading post, Fort St. Jean Baptiste, which became the site of Natchitoches, Louisiana's oldest permanent settlement. A chain of plantations developed south of Natchitoches, and the area became a center for Creole culture and architecture. In the area known as Isle Brevelle was a unique plantation-owning community of free people of color, descendants of French settlers and African slaves. The earliest buildings were of wood and *bousillage* construction, but the local clays proved ideal for making bricks, so this building material became increasingly popular.

Away from these centrally located waterways, pine forests stretched west from Alexandria and Natchitoches to the Sabine River, which now forms Louisiana's border with Texas. But until 1826, Louisiana's western boundary was unclear, and east of the Sabine River a north-south strip of land extending to the Gulf of Mexico was disputed territory. Before the United States gained control, this neutral area became a safe haven for outlaws, murderers, and ne'er-do-wells.

Numerous shoals on the Sabine River made navigation difficult, keeping Sabine

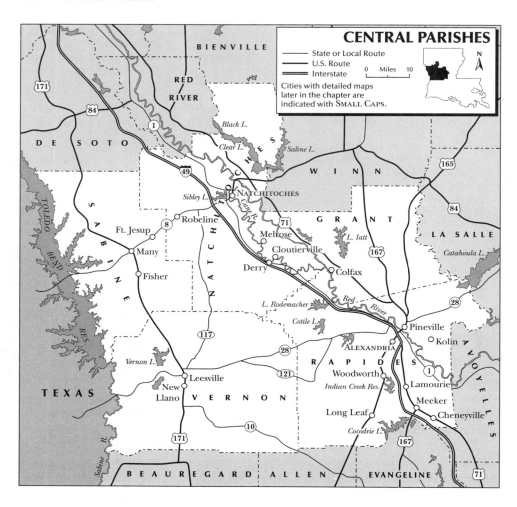

and Vernon parishes sparsely populated until the railroad era, which led to the enormous growth of the lumber industry. Lumber company towns sprang up almost overnight, but by the late 1920s, 70 percent of the pine forest had been cut done; most of the mills closed, and the company towns all but disappeared. The town of Fullerton (Vernon Parish) is typical. Established by the Gulf Lumber Company in 1907, Fullerton had a population of approximately 3,500 by 1924. It could boast the second largest mill in the South and a concrete-frame, five-story plant for the production of alcohol (grain alcohol made from chips of the longleaf pine). After 97,000 acres of longleaf pine had been cut down, the mill closed in 1927 and the town emptied. Fullerton Park now occupies the mill site, where crumbled remnants of the alcohol plant, covered by new forest growth, can be encountered along the park's nature trails. An important start in conservation and reforestation was made when the U.S. Forest Service established an office in Alexandria in 1928 and

purchased 10,000 acres in Natchitoches Parish to create the Kisatchie National Forest in 1930. Kisatchie is the only national forest in Louisiana.

Louisiana's central region has also been important as the location of many military camps, from the early French fort at Natchitoches and the Spanish fort of Los Adaes to Fort Polk (Vernon Parish), established in 1941, and the numerous facilities that made Alexandria a military training center during World War II.

Of the five parishes that make up this region, Rapides was formed in 1806, named for the rapids on the Red River just above Alexandria; Natchitoches was established in 1807 and named in honor of the local Native Americans; Sabine was carved from Natchitoches in 1843, drawing its name from the river on its western border; and Grant Parish, created in 1869, was named for Ulysses S. Grant. The origins of the name of Vernon Parish, established in 1871, have not been identified.

Rapides Parish (RA)

Alexandria

Alexandria traces its origins to a trading post established beside the Red River in the 1790s by Alexander Fulton and William Miller from Pennsylvania. In 1805, Fulton laid out the town, naming it for his daughter Alexandria; in 1807, it was made the seat of the newly created Rapides Parish. Alexandria quickly became an important steamboat shipping center for the

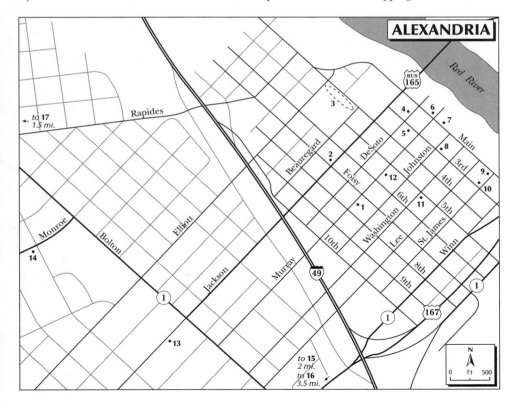

neighboring cotton plantations and prospered further after 1837, when one of the first railroads west of the Mississippi was built south of the town to the vicinity of Cheneyville. The fertile land bordering Bayou Rapides, which branches from the Red River at Alexandria, made it ideal for growing cotton. Remnants of the area's many nineteenth-century plantations survive along Bayou Rapides Road leading out of Alexandria. During the Civil War, both Alexandria and Pineville, on the opposite side of the Red River, were burned down by Union troops retreating south from the battles at Mansfield and Pleasant Hill in 1864. Recovery after the war was rapid, especially after two additional railroad lines were built. A booming pine lumber industry caused the town's population to triple between 1901 and 1907. By the early twentieth century, seventy-five sawmills existed within a fifty-mile radius of Alexandria. Catering to this economic prosperity were a splendid large hotel and new commercial buildings, such as the four-story Hemenway Building (c. 1918) at 3rd and Jackson streets. In 1939, the Kress Company built a four-story beige brick store at 1102 3rd Street, designed by Edward F. Sibbert and Charles T. Roberts. Attractive residential areas, with houses predominantly of wood construction, were developed, notably in the vicinity of Jackson Street between Bolton Avenue and Bayou Robert. New schools included the handsome limestone-faced Bolton High School (2101 Vance Street), designed by Edward Neild in 1926, which has a colonnade of eight two-story columns that gives it the grandeur of a courthouse.

During World War II, central Louisiana accommodated several training centers for troops, including Camps Beauregard, Livingston, and Claiborne and the Alexandria Air Base. The latter, renamed England Air Force Base in 1955, was closed in 1992, but its buildings and runways have found new use as a retirement community, school, and commercial airport. In the 1990s, Alexandria's downtown lost several buildings to the new Interstate 49, a process begun in the 1950s when buildings were razed for surface parking lots. However, the late twentieth century saw a rebirth of the old business district, with a new convention center, expansion of the museum, a riverfront park, and the adaptive reuse of several historic buildings. There are no historic cemeteries in Alexandria; the dead were ferried across the river to Pineville, where the land is higher.

RA1 Rapides Parish Courthouse

1939–1940, Edward F. Neild and Barron and Roberts. 701 Murray St.

This imposing PWA-funded courthouse has a tripartite composition, with a seven-story central section flanked by six-story wings. Boldly articulated by three vertical bands of windows deeply recessed between piers, the central section appears much taller than it is. The design is quite severe, relying on symmetry, the play of light and shadow, and the grids established by the window frames and the evenly coursed limestone wall surfaces. Stylized figures symbolizing Law and Justice are carved in low relief on each side of the entrance and, as the only applied ornament, have all the more impact. The building's design owes something to the Louisiana State Capitol (1932) in Baton Rouge (EB1) and to Paul Cret's Federal Reserve Building of 1937 in Washington, D.C. The courthouse interior was modernized in 1974.

RA2 Greater New Hope Missionary Baptist Church (First Methodist Church)

1907, W. E. Mathews. 630 Jackson St.

Constructed of light brown brick and covered by a red tile roof, this Romanesque Revival church is anchored to its corner site by a large square tower with a pyramid-shaped spire. The principal facade, centered between the corner tower and a similar but smaller one, has a triple-arched portico and a rose window in its gable front. The minor facade has a large round-arched stained glass window on the upper part of the wall just beneath the gable. In 1911, Mathews produced a similar design with

towers and gables for the Methodist congregation of the Noel Memorial Church in Shreveport(CA43).

RA3 St. Francis Xavier Cathedral, Rectory, and Academy Building

1894–1899, cathedral, Nicholas J. Clayton and Company. 1898, 1930, rectory. 1906, academy, Frederick B. Gaensen. 4th and Beauregard sts.

When Galveston architect N. J. Clayton designed this brick Gothic Revival church, he intended it to have a spire on the front tower. Revisions made in 1905 resulted in a 135-foot-high battlemented square clock tower constructed by African American brick mason A. J. Toussaint in 1907. Although the tower is much too wide and tall in relation to the rest of the building, it does form a prominent landmark in Alexandria's downtown. The facade on each side of the tower has a pair of tall, narrow, pointed-arched windows and a sharply pointed gable, emphasizing the vertical Gothic qualities. Inside the church, the nave is five bays in length, with a transept, and is covered by rib vaulting. The Jacobi Art Glass Company of Missouri designed the brilliantly colored stained glass. The church became a cathedral in 1910, when the Catholic diocese was transferred from Natchitoches to Alexandria.

The rectory began as a one-story building housing a school and convent. In 1903, it was moved to the other side of the site to make way for the new school building, and in 1930, the rectory acquired an upper floor. San Antonio architect Frederick Gaensen designed the two-story, buff-colored brick academy. Its elaborate facade has a curved gable faced with variously patterned shingles, and the mansard roof has huge dormers decorated with foliate capitals. The attic rooms originally housed the nuns.

RA4 Bentley Hotel

1907–1908, George R. Mann. 200 DeSoto St.

Lumber baron Joseph A. Bentley hired George Mann (1856–1939) of Little Rock, Arkansas, to design his 145-room, six-story hotel. Bedford limestone and terra-cotta detailing enrich the brick structure, and a colossal seven-bay Ionic colonnade fronts the entrance to a splendid lobby. This 100-foot-long lobby has a central dome highlighted with stained glass, a richly patterned tiled floor, pillars faced with gray marble, elaborate overblown capitals, ornamental plaster molding, and a grand staircase leading to a mezzanine floor. In 1937, Bentley added an eight-story wing to the rear of the hotel, bringing the total number of rooms to 315. Despite local skepticism about such expansion during the Depression, events vindicated Bentley's bold venture. In World War II, central Louisiana became the hub of a nine-state region for military training, with five major camps located in the area. Bentley's large hotel accommodated visiting families of military personnel, as well as important figures such as George Patton and Dwight Eisenhower. The

RA4 Bentley Hotel, exterior and interior

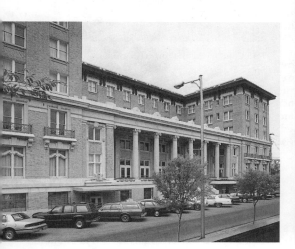
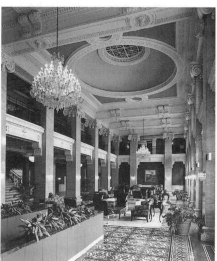

Bentley's fortunes waned in the 1960s, in part due to the closure of England Air Force Base; the hotel closed in the 1970s. A few years later, it was purchased and restored by a new owner, reopening in 1985.

RA5 Commercial Building (C. A. Schnack Jewelry Co.)

1931, Herman J. Duncan. 924 3rd St.

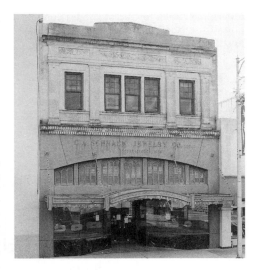

German immigrant Carl August Schnack established his jewelry company in 1865 and built this two-story shop in 1931 from a design by Herman J. Duncan of Alexandria. The lower half of the shop front is defined by a massive segmental-arched opening that was originally surrounded by polished black granite. Within this arch, the display windows are angled inward to the central entrance and decorated with brass Persian columns, elaborate marquetry, and bands of faceted etched glass panels. A curved metal canopy shades the store's display windows, its outer edge patterned with geometric forms. Directly above the canopy is a transom window with mullions shaped as a row of round arches. The cream-colored, limestone-faced upper story follows a more classical line, with large rectangular windows set between pilasters, an entablature decorated with foliate patterns, and a parapet whose center is raised in the shape of a pediment. The facade was designed with an eye to the distance from which it would be viewed: the first floor has delicate, small-scaled ornament, whereas that of the upper floor is proportionally larger. The two-story interior space is even more precious than the exterior. In a color scheme that emphasizes various shades of green, brown, and gold, paneled pilasters with gilded capitals divide the space into bays; walls are painted to resemble marble; acanthus leaf cornices are gilded; and the ceiling panels and beams have painted anthemia and various geometric shapes in designs by John Geiser. At the far end of the space, a mezzanine is fronted by an openwork metal balustrade. The shop closed in the early 1990s, and the building awaits a new use.

RA6 Alexandria Museum (Rapides Bank and Trust Company)

1898. 1914, remodeling, Favrot and Livaudais. 1998, addition, Barron, Heinberg and Brocato. 933 Main St.

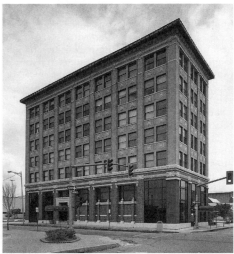

RA5 Commercial Building (C. A. Schnack Jewelry Co.)

RA8 Commercial Building

When James Wade Bolton established and built his bank, it was a simple two-story brick structure. In 1914, the fashionable New Orleans firm of Favrot and Livaudais was hired to give the building a stylish and monumental Beaux-Arts facade. The exterior was faced with limestone; four full-height Tuscan columns on plinths were applied to the facade; and a balustrade replaced the original small pediment on the roof. After the bank closed, the building was converted for use as a museum in

1977. In 1998, the museum acquired a 21,000-square-foot addition that incorporated a new entrance and lobby from DeSoto Street. This three-story extension has exterior walls of dark purplish-gray brick; on the upper part of the facade, four tall brushed aluminum columns support an enclosed curved gallery.

RA7 Alexandria Transit Center (Missouri Pacific Railroad Station)

1987, Lewis R. Brown and Associates. Main St. between Murray and Johnston sts.

When the Missouri Pacific's railroad depot (built by H. Longstaff in 1909) was dismantled, its curved Dutch-gabled entrance porticoes were reused to form the end walls of Alexandria's new bus transit center. Of orange-tinted red brick with white stone quoins and cornice, they have scrolled ornament along the gable top and obelisks on end piers. Lewis R. Brown's design refers to the original station in the low, one-story outline, hipped roof, and such Arts and Crafts detailing as bracketed eaves. The former station's ticket window was incorporated into a service building for transit employees.

RA8 Commercial Building

1915–1916, William L. Stevens. 201 Johnston St.

Alexandria's first skyscraper shows the influence of Chicago's late-nineteenth-century highrise architecture, in which the structural steel frame is expressed on the building's exterior

RA11 Alexandria Historical and Genealogical Library and Museum (Public Library)

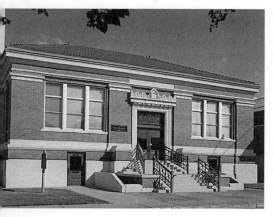

through the rhythm of piers and windows. The projecting slab roof and the repeating geometric brick and cast-concrete detailing on the facade are reminiscent of the work of Louis Sullivan. Alexandria's first Otis elevator was installed in this building.

RA9 River Oaks Square (James Wade Bolton House)

1899. 1330 Main St.

Banker James Wade Bolton built this one-story Queen Anne house of yellow pine for his family a year after his Rapides Bank and Trust Company was constructed. Gables and dormers give the thirteen-room house an irregular silhouette. A deep wooden porch with Ionic columns wraps around two sides of the house.

RA10 Arna Bontemps African-American Museum and Cultural Center (Arna Wendell Bontemps House)

c. 1900. 1327 3rd St.

Author and poet Arna Wendell Bontemps (1902–1973) lived in this house until 1906, when he moved with his family to California. The plain L-shaped frame house was relocated to this site in 1991 to avoid demolition occasioned by the construction of I-49 through Alexandria. Bontemps, who wrote twenty-five books, was a leading figure in the Harlem Renaissance of the 1920s. His autobiographical essay "Why I Returned" (published in *Harper's Magazine* in 1965) describes his childhood in Louisiana and refers specifically to this house. The museum features displays relating to the life of Bontemps and African American history of central Louisiana.

RA11 Alexandria Historical and Genealogical Library and Museum (Public Library)

1907, Crosby and Henkel. 503 Washington St.

Funded jointly by local resident Simpson Sheppard Bryan and the Carnegie library fund to replace an earlier library burned down during the Civil War, the two-story building occupies the square on the original town plat (Alexander Fulton map, 1805) reserved for the "advancement of learning and culture." The compact red brick structure, with a red tile hipped

roof, white trim over the windows and along the cornice, and terra-cotta anthemion decoration over the door, resembles an oversized casket. The New Orleans architects obviously admired the work of Frank Lloyd Wright. A central entrance leads to the main library space on the second floor, which is subdivided into study areas only by the structural piers.

RA12 U.S. Courthouse and Post Office Building

1932–1933, James A. Wetmore, Acting Supervising Architect of the Treasury, and Edward F. Neild. 515 Murray St.

Alexandria is fortunate to have two extremely fine Art Deco courthouse buildings: this one, dating from the early 1930s, and the Rapides Parish Courthouse, constructed later in that decade (RA1). Designed by Shreveport architect Edward Neild under the supervision of the Treasury Department, this federal courthouse has a white granite base, and its upper three stories are faced with a light buff limestone. The central nine bays are slightly taller than the wings, which are also quite narrow, just one bay in width. Fluted piers separate the windows, and above them are stylized cross motifs. Bronze grilles across the top of the three entrance doors depict the evolution of mail transport in designs by Arthur C. Morgan: packet boat, stagecoach, steamship, train, and airplane. Originally, the first floor accommodated postal services; the two upper floors were used for judicial functions. Although the post office section now functions only as a substation, the vestibule and the lobby retain most of their original detailing. These splendid interior spaces have marble walls, terrazzo floors, aluminum-framed light fixtures encasing opaque glass, metal mailboxes set within an oak surround, and a marble staircase. Unfortunately, the upper floors have largely been remodeled.

RA13 MRI Center

1994, Ashe Broussard Weinzettle Architects. 1751 Jackson St.

The pitched roofs and intimate scale of this outpatient magnetic resonance imaging center allow it to fit comfortably into its primarily residential neighborhood. Despite the need for screening interior functions, the design seems to deny a sense of enclosure. By raising the roofs above the circulation spine and the main public areas, the architects provided clerestory windows that give the building a luminous, airy interior and enliven the exterior of concrete painted in shades of beige. At the center of the facade a low curved wall outlines a courtyard space accessible only from the interior. Landscaping and lawns are a crucial element in relating this building to its site and area.

RA14 Cook House

1904–1905. 222 Florence Ave.

This two-and-one-half-story Queen Anne house is unusual because it is constructed of brick rather than wood, the more traditional material for houses in this style. Moreover, the house is well insulated with double walls with an airspace between. Very likely this practical system was proposed by the owner of the house, Sherman Cook, an engineer who had moved to Alexandria from Ontario, Canada, c. 1892, to work on the Kansas City, Watkins and Gulf Railway. When the house was built, it was described in the local newspaper as "one of the prettiest in Alexandria." The principal feature is a corner tower with an entablature decorated with sculpted garlands and a dome-shaped roof. On each of the principal facades are small single-story galleries supported on slender Ionic columns and finished with a balustrade. The pyramid roofs, which flare at their ends, have deep eaves with brackets; a gabled dormer features a Palladian window. Cook is said to have copied the design from a house he saw in San Francisco.

RA15 Hibernia Bank (Guaranty Bank and Trust Company)

1973, Glankler and Broadwell. 3499 Masonic Dr.

In order to cater to both walk-in and drive-in clients, this bank was located on the edge of the parking area of a large regional shopping center. The bank's fortresslike appearance and exposed concrete surfaces give it a great deal of character, but both were chosen primarily to project an image of permanence and stability, well suited for a banking facility. A walk-in entrance, located on the mall side, leads to a single-story banking hall. On either side and accessed by exterior stairs are two-story curved wings, which were made taller than the banking hall to achieve a scale compatible with the mall. Their rounded corners visually correlate

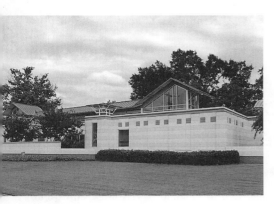

RA13 MRI Center

with the traffic pattern of the drive-in facility, which is indicated by a concrete canopy. The roughly finished exposed concrete surfaces, expressive, powerful forms, and impregnable appearance show the influence of Brutalism, a suitable style for this building's function and the character of its site.

RA16 Grand Lodge, State of Louisiana Free and Accepted Masons (Masonic Home for Indigent Children)

1924, Jones, Roessle, Olschner and Wiener. 5800 Masonic Dr.

This three-story orphanage built in the Mediterranean Revival style, of brick with cast concrete details, is a visible and handsome symbol of Masonic charitable activity in the early twentieth century. A central flight of stairs leads to a splendid entrance portico of white stone shaped in the form of a Palladian window and flanked by pairs of Ionic pilasters. Windows on the principal floor of the building are round-arched; all others are square-headed. The roof is of red tiles. The original ornamentally cut rafter ends and decorative window surrounds suffered some changes when the building was renovated in the 1990s. Additional structures were added to the complex over the years, including a small one-story brick infirmary funded by the Masonic Women's Auxiliary.

RA17 Kent Plantation House

1800. 3601 Bayou Rapides Rd. (Louisiana 496)

Although this house was moved in the 1960s from its original site farther downstream, its wide, low silhouette and enormous hipped roof do not look out of place in its new location. Peter Baillio II built the house, which is the oldest known standing building in central Louisiana. It has a Creole plan, with three rooms across the front and a loggia set between cabinets at the rear. Raised on brick piers, the house has upper walls of *bousillage* between the cypress timber frame, and the front gallery is included within the pitch of the roof. When Robert Hynson from Kent County, Maryland, purchased the cotton plantation from the Baillio family in 1842, he added the two flanking pyramid-roofed pavilions, a favored way to increase the number of rooms while maintaining the integrity and beauty of a house. Hanson named the house for his home county, Kent.

The dependency buildings are not original to the house, although the majority are historic. These include a brick-between-posts kitchen (1840s), a pegged-frame milkhouse (c. 1820), a carriage house (1820s), a log shed (1830s), two brick-between-posts slave cabins, and a replica of a sugarhouse. The house is open to the public.

Pineville

Named for the vast pine forests that once covered this area, Pineville enjoyed healthy air and an elevated site that made it a favorite place for local planters to build their summer homes. The high elevation also made it the burial ground for Alexandria, where the water table was too high for in-ground interment; by 1900, much of Pineville's land was devoted to cemeteries. The Old Rapides Cemetery (Main and Hardtner streets), with burials dating from 1792, is surrounded by a nineteenth-century cast iron fence. Next to it is the Jewish cemetery, with burials dating from 1854, and on Hardtner Street is the Methodist cemetery. The Alexandria National Cemetery (209 Shamrock Street) was established in 1867 to bury the thousands of Union and Confederate soldiers killed in the area; it also accommodates the graves of more than 5,000 veterans of recent wars. The enclosing wall and lodge were constructed in 1878.

Pineville, like Alexandria, was burned down by retreating Union forces in 1864, and in 1923, a cyclone destroyed most of the rebuilt town. Although there is little in the way of surviving evidence, Pineville was the venue of several important historic structures. In 1864,

Lieutenant Colonel Joseph Bailey devised a way to move the retreating Union gunboats trapped behind the rapids on the Red River. Two winged dams, assembled from demolished buildings and railroad stock, were built out from the banks, forcing a deeper channel through which the boats could pass. The site of Bailey's Dam is indicated by a marker near the O. K. Allen Bridge. Nearby are the remains of the Fort Buhlow earthworks, a Confederate stronghold built in 1864. The circular earthwork of Fort Randolph (1864) is located on the grounds of the Louisiana State Hospital and is inaccessible to the public. Both forts were built to prevent a new invasion of the Red River valley by Union forces, which never took place.

The light-colored brick Huey P. Long Charity Hospital (now part of the Louisiana State University Health Sciences Center), designed by Edward F. Neild and Theodore Flaxman of Shreveport in 1939, has a three-story, curved center front and seven relief panels over the entrance, sculptured by Duncan Ferguson.

RA18 Mount Olivet Church

1858. 335 Main St.

This small Carpenter's Gothic church with board-and-batten siding, a mission of St. James Episcopal Church in Alexandria, was built within the grounds of a cemetery established in 1824 and was consecrated by Bishop Leonidas Polk in 1859. In his *History of the Diocese of Louisiana* (1888), the Reverend Herman Duncan of St. James Church attributed the design to New York architect Richard Upjohn. More likely, Mount Olivet adhered to the design principles that Upjohn advocated for small rural churches. The building has a steeply pitched roof with flared eaves and large brackets, and a small porch also has a flared gable roof. One of the side windows retains its original tracery, but the original glazing in the other windows has been replaced by twentieth-century stained glass. The quatrefoil window on the facade above the porch also dates from the twentieth century. The interior has a wooden vaulted ceiling with scissors trusses and a triple-arched arcade on paneled piers, which separates the nave from the sanctuary. In 1873, a three-room structure was added at the rear of the church; additions in 1946 include a small bell tower with a conical roof and a two-story brick parish hall whose design repeats some of the church's details.

RA19 Alexandria Hall, Louisiana College

1920, R. H. Hunt and C. Scott Yeager. 1140 College Dr.

Founded by the Baptists and opened in 1906, Louisiana College was the successor to two earlier Baptist schools, Mount Lebanon University (Bienville Parish) and Keachie Female College (De Soto Parish), which had closed because of declining enrollment. Dallas architect R. H. Hunt collaborated with C. Scott Yeager of Alexandria in the design of the first buildings. Alexandria Hall, constructed after a fire destroyed the first structures, is a three-story Colonial Revival building of red brick with white trim, a central portico flanked by Corinthian columns, and a pedimented gable. The building is similar to Newcomb Hall (1917) at Tulane University in New Orleans (OR143.1), a resemblance that was stronger before the flight of stairs leading from the ground to the second-floor entrance was removed upon completion of a new entry at ground level in 1980. Women students were admitted to Louisiana College in 1909. Near the college, at 1403 College Drive, is the house built in 1907 for Dr. Claybrook Cottingham, one of Louisiana College's first three faculty members and its president from 1910 to 1941. The two-story wooden house is a blend of Queen Anne and Colonial Revival styles.

RA20 Central Louisiana State Hospital, Dairy Barn,

1923, Joseph H. Carlin. U.S. 71 (Louisiana 165/167)

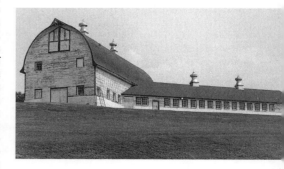

First planned to treat mentally ill African Americans, Louisiana State Hospital also had Caucasian patients when it opened in 1906. By 1940, it had expanded to sixty-five brick buildings on 2,300 acres. Most of the original buildings have been demolished. The hospital super-

intendent appointed in 1909 believed that wholesome food and work constituted the basis for restoring mental health. By the mid-1920s, the hospital owned a herd of milk cows; a dairy barn was among the structures that allowed the institution to function as a self-contained "asylum" community. Perched dramaticall on one of the highest bluffs overlooking Lake Buhlow, the two-story, Y-plan frame barn has a curved gambrel roof, flared eaves, a Palladian-shaped vent in the roof's gable end, and six elaborate, oversized vent stacks along the roof ridge. The original dairy machinery has been removed. Patients also performed other kinds of work; in a two-year period, 20,000 pounds of Spanish moss were gathered, cured, and made into 7,100 mattresses for the inmates. Joseph H. Carlin, a patient at the hospital, designed the dairy barn and at least one other building, a pathology laboratory (1917); only the barn is visible from U.S. 71.

RA21 Veterans Administration Medical Center

1928–1930, with additions. 2495 U.S. 71 North

Spread across 400 acres on both sides of U.S. 71, the medical center includes a hospital on the larger site west of the highway. The earliest buildings in the complex were placed around a quadrangle, in accordance with a scheme developed by the Veterans Administration in Washington, D.C., for all its medical centers. However, these hospitals were given architectural styles that represented their regions, and the French colonial tradition was chosen for Louisiana. The Medical Center buildings show the influence of such institutional structures as the Ursulines Convent in New Orleans, rather than that city's more widespread vernacular buildings. The medical center's cream-colored, stuccoed brick buildings feature rusticated quoins, ornate pilasters flanking the major entrances, garlanded terra-cotta panels under the windows, and hipped roofs with small dormers. The four-story main medical structure, larger than the other buildings, has a central pavilion-like unit and a central pedimented gable decorated with an enormous shell and cornucopia. When the hospital opened in 1930, it had sixteen buildings and a bed capacity of 419 (now 441). By 1968, the complex had expanded to thirty-one buildings. Excluding the utility structures, the later buildings stayed with the French colonial theme.

Kolin

RA22 Welcek Farmstead

c. 1917–c. 1926. 5174 Louisiana 107

The Welcek Farmstead is the most complete of the many such places that made up a community of Czechoslovakian immigrants. The towns of Kolin and neighboring Libuse were founded in 1913 and 1914 respectively under the auspices of *Hospodar* (Husbandman), a popular Czech agricultural periodical published in Omaha, Nebraska. Beginning in 1908, *Hospodar* championed a colonization effort aimed at bringing together Czechs scattered throughout America into new agricultural communities. In response to a fear that Czechs were being assimilated too rapidly and leaving their farms for cities, John Rosicky, founder and editor of *Hospodar*, became the first president of the Bohemian Colonization Club, established in 1908 as the magazine's colonization arm. *Hospodar* ran advertisements extolling the fertile lands of Kolin, although, in fact, the 21,000 acres purchased for the colonies were cutover pine land. However, agricultural experts were sent to work with the settlers during the early years. It is estimated that there were about fifty farms in the Kolin community during the 1920s. Francis J. Welcek's farmstead (he held title to 160 acres), built up gradually between 1917 and 1926, consists of a farmhouse and four outbuildings, all of wood. The five-room farmhouse has five half-timbered gables covered with steeply pitched roofs. Two barns, typical of early-twentieth-century midwestern dairy farms, are two stories high, have vertical board siding, and, unusually, were built without tie beams and with several windows. The farmstead also has a small shingle-walled and gabled syrup house (Welcek engaged in syrup and tung oil production) and a shed. Although some sheds and chicken houses were lost over the years, the farmstead to a large extent conveys its original appearance.

Meeker

RA23 Meeker Sugar Mill and Refinery

1911–1912. Sugar Mill Rd. (off U.S. 71, approximately 2.5 miles south of LeCompte)

The enormous brick sugar mill and its two tall chimney stacks are a striking landmark in this flat agricultural area. These structures and a

few small support buildings are all that remain of this industrial complex that once included two boardinghouses and several cottages. The mill was constructed by a group of Chicago investors who formed the Meeker Sugar Refining Company, Inc. A ledger book of 1912 records payment to brick mason L. A. Toussaint for laying 285,847 bricks for the main building, which was sufficiently completed later that year to enable the mill to grind its first cane. The mill's exterior is articulated by pilaster buttresses between windows under segmental relieving arches and a row of circular windows at clerestory level, which provided natural light for the mill workers at their machines. An elevated central section originally provided space for the gravity feed of the cane juice. The machinery, now removed, included cane crushers with giant rollers, juice clarifiers, and filters. One of the rollers, approximately 20 feet in diameter, has been moved to the grounds of the nearby Old LeCompte High School (St. Charles Street, LeCompte).

The Meeker refinery was built as a central factory, buying and processing cane from the area's sugar growers, in contrast to earlier practice, when each plantation had its own, much smaller mill. By 1938, the mill and refinery served 275 farms and employed 175 people. In 1948, it was purchased by a consortium of sugarcane farmers in Avoyelles, Rapides, and St. Landry parishes and operated as the Meeker Sugar Cooperative. Closed in 1981, the mill, which has lost its roof and part of its walls, is now a sublime ruin. Its enormous size and rural location make it a difficult candidate for adaptive reuse.

Meeker Vicinity

RA24 Loyd Hall Plantation House

c. 1850s. 292 Loyd Bridge Rd. (off Louisiana 167)

Loyd Hall was built by members of the Loyd family who came to this area from Tennessee in the 1820s. No documents survive to date the house exactly, but architectural evidence suggests it was built in the mid-nineteenth century, with some later additions. Most unusually, the two-and-one-half-story house is constructed of brick and has paired end chimneys and raised parapets—features that are associated with East Coast houses. The two-story gallery's six slender square columns are replacements of steel en-

cased in wood and are raised on tall square plinths. Late-nineteenth-century additions to the house include cast iron balustrades and large decorative brackets on the entablatures over the doors. The house has a central hall on both floors featuring ornate hand-molded plaster ceilings. In 1864, then-owner James Loyd was hanged in the house by Union troops for being a Confederate spy. Behind the house is a two-room galleried brick kitchen with stepped end gables. Loyd Hall offers bed-and-breakfast accommodations.

Cheneyville

RA25 Trinity Episcopal Church

1860, William Henry Chase. Bayou Boeuf Rd. (corner of Ave. B)

This small Gothic Revival church has an especially picturesque setting beside the placid Bayou Boeuf. The stucco-covered brick structure has a single square crenellated tower in the center of its facade, with a pointed-arched door at the base and large windows in the upper two stories. The five-bay nave includes a slave gallery and the original cypress pews, pulpit, and baptismal font. Just south of the church is Edgefield Cemetery, which contains four stuccoed brick columns that are the sole remnants of a Campbellite church built in the 1840s by followers of minister Alexander Campbell, who was born in Ireland and settled in Bethany in what became West Virginia. When these churches were built, Bayou Boeuf was a bustling waterway for shipping cotton grown in this area, but after the railroad came through to the west of Cheneyville, the town's center of focus shifted in that direction. Cheneyville was founded by William Cheney, who came from South Carolina in 1811. The Producers Mutual Cotton Gin, a complex of metal-sided structures, is located between Louisiana 71 and the railroad in Cheneyville.

Cheneyville Vicinity

RA26 Bennett Plantation Store (former)

c. 1854 and late 19th century. U.S. 71 (2.6 miles south of Cheneyville)

Ezra Bennett moved from upstate New York to Cheneyville to teach school, but he became a

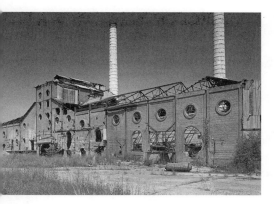

bay gallery with flattened ogee arches. The eaves decoration on the side elevation is typical of late-nineteenth-century woodwork. The store's windows and doors have shoulder molding. Bennett's house, built facing the store on the opposite side of the road, is in dilapidated condition and has lost its front gallery.

Long Leaf

RA27 Southern Forest Heritage Museum and Research Center (Crowell Long Leaf Lumber Co.)

1892 and additions. Louisiana 497

This unique museum was founded to preserve and interpret the heritage of the southern lumber industry. It occupies the surviving buildings of the sawmill town founded by Caleb T. Crowell and A. B. Spencer in 1892, which they named Long Leaf in recognition of the forests of longleaf pine that would supply their mill. In 1905, Crowell built a spur from the Red River and Gulf Railroad from Long Leaf to Le-Compte (closed in 1955) to transport the lumber. Although the first sawmill burned down in 1910, the rebuilt structure forms the core of the mill complex as it exists today. Its roof and huge metal ventilator were rebuilt in 1999 after the originals were damaged in a storm. Other structures included the roundhouse and machine shop (1920s), dry kiln (1936), and fuel house (1944). In the 1950s, following operational changes, forklifts and trucks replaced the old tramway system that relied on men and mules to move lumber around the plant, and the tramways were removed. A new dry kiln and sheds were built. Among the surviving rail and logging equipment are three steam logging machines, a skidder (for hauling newly cut logs to the rail lines for loading onto log cars), and sawmill and planing machinery. The museum also houses two McGiffert loaders (only six are known to exist in the United States), the oldest of the two manufactured in 1919 by the Clyde Iron Works of Duluth, Minnesota. A few structures survive from the company town, including a post office, the one-story Colonial Revival Allen Crowell House (1935), the altered Draughton Crowell House, and the commissary (1948). After the sawmill ceased operations in 1969, the fifty-seven-acre site was acquired by the Southern Forest Heritage Museum and Research Center, which opened in 1998.

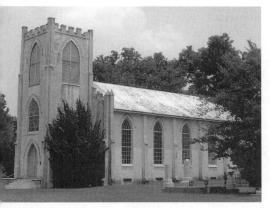

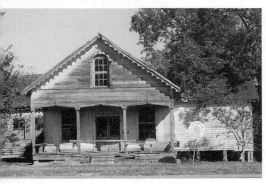

RA23 Meeker Sugar Mill and Refinery

RA25 Trinity Episcopal Church

RA26 Bennett Plantation Store

storekeeper in the 1830s and an important merchant in the local trade with New Orleans. Succeeding members of his family continued the business and were responsible for the store's present appearance, adding the three-

Woodworth Vicinity

RA28 Alexander State Forest Headquarters Building

1935. Forestry Rd. (1.1 mile on Robinson Bridge Rd. [off Louisiana 165])

In 1923, the Louisiana Division of Forestry made the first of a series of purchases in this area in order to demonstrate what could be achieved with proper timber management. A Civilian Conservation Corps (CCC) camp was located in the forest from 1933 to 1940, and the corps constructed a headquarters building and an entry gate, hand-planted pine on much of the land, and built thirty-five miles of roads still in use today. The one-story log building was constructed in 1935 as a showpiece of lumber artistry and logging skills. Cut in a wide range of lengths and thickness, the peeled and varnished logs are laid in different patterns, including a sunburst design in the gallery gable. The interior walls are composed of bevel-edged vertical boards sanded smooth. The Alexander State Forest, which now comprises almost 8,000 acres, was named for M. L. Alexander, Louisiana's first commissioner of conservation.

Vernon Parish (VE)

Leesville

Leesville was established as the seat of the newly created parish of Vernon in 1871 and named in honor of General Robert E. Lee. In 1892, the town's population was a mere one hundred people, but by 1900 had risen to 1,300, as a result of the arrival of the Kansas City Southern Railroad in 1897. The railroad enabled the town to emerge as the business and commercial center for the area's lumber industry. Brick party-wall commercial buildings, primarily two stories in height, line the commercial downtown streets. The brick Merchants and Farmers Bank (S. 3rd and E. Courthouse streets) is the most elaborate, with prominent stone quoins outlining its corner piers. The Wingate House (800 S. 8th Street) of c. 1905 is a good example of the wooden Queen Anne houses built during the boom years of the region's lumber industry. Also built of wood but mixing Queen Anne with Colonial Revival elements are the two-and-one-half-story house (c. 1900, remodeled c. 1910; 406 N. 6th Street) for G. R. Ferguson, plant manager of the Nona Mills Lumber Company, and the two-story house (c. 1905; 102 E. North Street) for the company's bookkeeper, H. T. Booker. Nona Mills, based in Beaumont, Texas, sold the Leesville plant in 1922, and, although it continued to operate for a few years under a different owner, none of the plant structures has survived.

VE1 Vernon Parish Courthouse

1908–1910. 201 S. 3rd St.

The courthouse is a large building with a tall octagonal cupola and is a prominent landmark in Leesville's low-rise downtown. The building is remarkably similar to the Tensas Parish Courthouse in St. Joseph (TN1), designed by P. H. Weathers and built in 1906. Both have a Greek cross plan, with pedimented Corinthian porticoes inserted within the reentrant angles, and a tall cupola. Despite the courthouse's complex outline, the effect is static rather than flowing and lively, but it is quite monumental, an effect that results in part from the building's uniform coating of white stucco.

VE2 Museum of West Louisiana (Kansas City Southern Railway Depot)

1916. 803 S. 3rd St.

This Mission Revival depot is a long, low structure with a large open porch at one end and sections for passengers and freight. Constructed of stucco-covered brick, the building has decorative piers at the corners; the red tile roof, which extends well beyond the walls, is articulated with decorative brackets. After passenger service was terminated in 1968, the building was restored by Farrar, Morris, Farrar and opened in 1987 as a museum devoted to regional history and culture. The museum complex also includes a dogtrot cabin (1850s) and a late-nineteenth-century railroad "section

house" like those the railroad erected at intervals along its route to house so-called section managers.

New Llano

The New Llano Cooperative colony was established by socialist and lawyer Job Harriman in 1917. He had founded the Llano del Rio Company in 1914 and attempted to build a town in southern California. By purchasing $2,000 worth of stock, people could join the socialist community and receive voting rights and a job. Forced to find a new location because of an inadequate water supply, in 1917 Harriman purchased 20,000 acres of cutover timber land in Louisiana from the Gulf Lumber Company. The new town was named New Llano. In California, Harriman had hired architect Alice Austin to design Llano del Rio, and although she did no work at New Llano, several of the individual building types featured in her scheme were constructed. (She later published her ideas in a book, *The Next Step*.) These included single-family homes, communal apartment houses, and children's dormitories. Children spent half of the day in school and the other half working, which provided their practical education. Other buildings at New Llano included a hospital, a nursery, a college, a large library, and a roof-garden dance floor. New Llano's economy was based on small industries, among which were an ice and cold-storage plant, a printing plant, an oil well, a brick kiln, a crate factory, a hotel, and three newspapers. All profits were shared equally among the cooperative's members, and jobs were rotated. Financial losses related to the Great Depression and then dissension between some members and the leadership caused the colony to close in 1937. Of its many buildings, only the former Trading Post, a galleried, false-fronted store, and some adjacent wooden buildings can be reliably identified. These are located two miles south of Leesville on Louisiana 171.

Sabine Parish (SA)

Many

Founded in 1844 as the seat of the newly created Sabine Parish, Many was selected because of its central location. The town was named for Colonel John B. Many, the commanding officer at Fort Jesup. Many and Fort Jesup remained the only towns in Sabine Parish until after the Civil War, and as late as 1880, Many's total population was a mere 147. Then in 1896, when the Kansas City Southern Railroad came through Many, the town began to grow. The brick depot (750 W. Georgia Avenue), built in 1929 and occupied by the Sabine Council on Aging since 1972, when rail service was discontinued, includes a freight and passenger waiting area; the Mission Revival detailing is typical of KCS depots. The two-story Italianate brick structure that formerly housed the McNeely Hotel (690 San Antonio Avenue) was built c. 1906 to serve the increased trade encouraged by the railroad. Hodges Gardens (12 miles south of Many on U.S. 71), the nation's largest privately operated horticultural parkland, was developed in the early 1940s by conservationists A. J. and Nona Trigg Hodges as a 4,700-acre experimental arboretum within a vast reforestation project they undertook in western Louisiana. Within the park, they used the rock formations of an abandoned stone quarry to landscape a scenic garden and, in 1954, created a 255-acre lake. The gardens were opened to the public in 1956.

SA1 St. John the Baptist Catholic Church
1925, 1964. 1130 San Antonio Ave.

After the first wooden church of 1871 burned down in 1922, it was replaced by a simple brick building with round-arched windows, a square corner tower, plain stuccoed walls, and a tile roof, all mildly suggestive of the Mediterranean Revival style. In 1964, the exterior was remodeled in what the pastor described as the Spanish Mission style. The front gable was given a curvilinear outline and two small obelisks on its edge, as well as a small circular window surrounded by a shaped molding. A freestanding statue of St. John the Baptist, with scrolled moldings on both sides of the figure, was placed above the central entrance. The tower

acquired small obelisks at each of its four corners, and the entire church was covered with a cream-colored stucco.

Fisher

Fisher is one of a handful of survivors among the many lumber towns that existed in Louisiana in the late nineteenth and early twentieth centuries and still conveys the tight-knit atmosphere of a rural early-twentieth-century company town. The Louisiana Long Leaf Lumber Company (known as 4-L) built Fisher in 1899 and continued to own and operate the town until 1966. Since then, Boise Cascade has provided employment for the town's residents. Named for the Long Leaf Company's president, Oliver Williams Fisher, the town was laid out on a grid plan. One-story frame houses were built for the employees in areas segregated by race, as was typical of company towns in the South. Although the streets originally were unpaved, they did have wooden sidewalks, and the town was supplied with electricity. By 1905, the population numbered around 1,000. The railroad tracks and the Kansas City Southern Railroad depot (now converted into a police station) separated this residential section from the company office, a commissary, an opera house, and a group of large houses for the lumber company's managers. The wooden Gothic Revival nondenominational church, since replaced by modern churches, was relocated from its original site within the town to a new spot near the commissary. The town's hospital and hotel no longer exist. A modern sawmill (1966) has replaced the original sawmill (1901) and hardwood mill (1907).

SA2 **Opera House**

c. 1914. 4-L Dr.

Constructed of longleaf pine frame and clapboards, the Classical Revival opera house has four Doric columns supporting its pedimented porch. A semi-octagonal box office is located in the center of the front facade. The auditorium, which has a raised stage with an arched proscenium, retains its original seats and can accommodate approximately four hundred people. The Fisher Opera House was the first to show movies in this area of the state.

SA3 **Commissary**

1900, 1914. 4-L Dr.

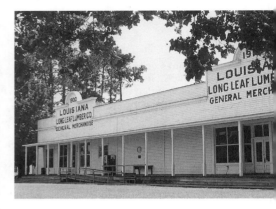

The longleaf-pine commissary, extended to its present size in 1914, has a front gallery topped with a stepped parapet. The plate glass front windows and the shelving and bins lining the interior walls are all original. A 1914 report noted, "Besides the staple supplies, the store furnishes the people with nearly every luxury which a store or market could offer."

Fort Jesup

SA4 **Fort Jesup State Historic Site**

1822. 32 Geoghagan Rd. (6 miles east of Many off Louisiana 6)

Located on the San Antonio Trace between the Red and Sabine rivers, Fort Jesup was established after the Louisiana Purchase of 1803 failed to define the western boundary of Louisiana. This resulted in a neutral corridor east of the Sabine River, known as the Sabine Strip or the Free State of Sabine, which became inhabited by adventurers, outlaws, and fugitives. The United States established Fort Jesup in 1822 to provide protection for settlers in western Louisiana and to prevent Spanish claims to the territory. The fort was named for Brigadier General Thomas Sidney Jesup. Although the Sabine River was recognized as Louisiana's western boundary in 1826, Fort Jesup remained occupied until 1845. During the 1830s, the fort was a center of social activity, including balls and parties. General (later President) Zachary Taylor was the fort's first commander.

The fort was made up of tents until the log structures were built. Of the eighty-two buildings that once covered this twenty-two-acre site, only the kitchen–mess hall survives, although the stone foundations of some of the other buildings are visible. The kitchen–mess hall (c. 1826), which served the twenty to twenty-five men housed in the adjacent barracks, is a single-story, squared-log structure raised on low stone piers and has a stone fireplace. The interior has been restored and furnished with cypress tables and benches to convey a sense of its original appearance and use. In front of the kitchen are the stone piers that originally supported the barracks. A reconstructed officers'quarters houses a museum and information center.

Natchitoches Parish (NA)

Natchitoches

Natchitoches, Louisiana's oldest permanent settlement, is located on the site of a trading post established by Louis Antoine Juchereau de St.-Denis (1676–1744) in the course of an expedition to the west in 1714. To curb Spanish claims to the area, the post was fortified in 1716 (Fort St. Jean Baptiste [NA13]) and reinforced in 1732. At that time, Natchitoches was located on the Red River, and until the river shifted its course in the 1830s, the settlement was an important shipping center for the region's cotton crop. With steamboats linking the town to New Orleans, it also served as a trading stop with the west and Mexico, as well as for westward-bound emigrants on the Camino Real. After Natchi-

NA1 Natchitoches Parish Courthouse

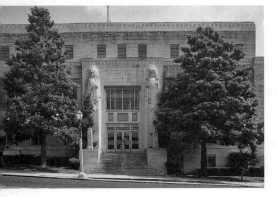

Fort Jesup Vicinity

SA5 Stoker House

1840s. Louisiana 6 (approximately 1 mile east of Fort Jesup)

The one-and-one-half-story dogtrot house (the passage is now enclosed) built for Riley Stoker by his slaves is thought to be the oldest surviving house in Sabine Parish. Riley's father was a member of the vigilantes patrolling the neutral strip of land between American and Spanish territories. In 2000, Stoker's double-pen, notched and pegged barn was moved to the Louisiana Rural Life Museum (EB37) in Baton Rouge.

toches was stranded on the remnants of the old course, named the Cane River, it had to await the arrival of the Texas and Pacific Railroad in 1885 to revive its importance as a trading center. By-products of cotton continue to be processed in Natchitoches, as evidenced at the Southern Cotton Oil Company (now ADM Company) at 322 Mill Street.

Natchitoches, a National Historic Landmark District, retains a nineteenth-century ambience, most notably along Front Street, which overlooks the Cane River. The rows of party-wall brick structures along this street's commercial section give way to galleried houses on its residential blocks. Natchitoches served as a second home for many of the downriver planters, who built houses here and came to town to enjoy "the season." Most of Natchitoches's institutional and religious buildings are constructed of brick, in colors ranging from beige to an array of reds, which give the town a particularly lively aspect. From 1921 to the early 1930s, Natchitoches was home to a summer art colony, established by a group of local women in collaboration with New Orleans artist Ellsworth Woodward, who was eager to promote southern art. Artist Will Henry Stevens was one of the tutors.

NA1 Natchitoches Parish Courthouse

1939–1940, J. W. Smith and Associates. Church St.

Of the eight courthouses Monroe architect J. W. Smith designed for Louisiana, this is the

most unusual. The PWA-funded, three-story structure features a magnificent portal highlighted by figures of Native Americans of the Natchitoches tribe carved in relief on the sides. Other ornamentation includes bands of geometric motifs along the cornice and at the first-floor level and fluted pilasters between the windows, which give the requisite classical touch. The window mullions and the two tall square lamp stands at the base of the exterior staircase are of aluminum. The courthouse was built without a courtroom. Apparently, the committee supervising the courthouse plans was composed of lawyers who were at odds with the district judge and refused to give him space in the new building. He was obliged to use the courtroom in the old courthouse (NA3). In 1959, Butler and Dobson added an annex at the rear of the building that includes a courtroom.

NA2 U.S. Post Office

1907, James Knox Taylor, Supervising Architect of the Treasury. St. Denis and 3rd sts.

This two-story post office is thought to be Louisiana's oldest in continuous use. Raised on a basement, the light-colored brick building has a recessed triple-arched entrance that is quite plain, almost severe, with square piers, abacus blocks, and keystones. A projecting cornice is underlined with dentils, and a balustrade runs along the roofline. The lobby repeats the exterior's Renaissance theme, with walls articulated by pilasters, a coffered ceiling outlined with dentils, a terrazzo floor, ornamental plasterwork, and the original mailboxes.

NA3 Old Courthouse Museum
(Natchitoches Parish Courthouse)

1896, Favrot and Livaudais. 600 2nd St.

Natchitoches's former courthouse is a weighty Romanesque Revival building of dark red brick, with round-arched openings, a single square clock tower, corbeled cornices, and gabled dormer windows. The tower was originally much taller than at present, its height having been reduced when it was repaired after a fire in 1933. A Palladian window was added at that time. The smaller staircase tower at the corner was more prominent before the building lost its mansard roof. Now the sole indication of the tower's function is provided by four narrow windows ascending the wall in tandem

with the interior staircase. The old courthouse owes its imposing presence to its size and design, for its ornamentation is minimal, consisting primarily of terra-cotta floral panels around the entrance door in the base of the tower. The building was restored in 1979 by E. P. Dobson, Jr., and opened as a museum and genealogy center in 1996.

NA4 Central Fire Station

1951. 590 2nd St.

This two-story, beige-painted brick fire station has the clean, uncluttered silhouette favored in the early 1950s. The three openings for the fire engines are united and outlined in one crisp, dark-brown frame that projects at an angle from the walls, creating a three-dimensional geometry to play off the smooth surfaces of walls and windows. The horizontal strip of metal-framed windows above the portico for the engines and the flat roof were fashionable features when this station was built.

NA5 Immaculate Conception Catholic Church

1856–1890s. 601 2nd St.

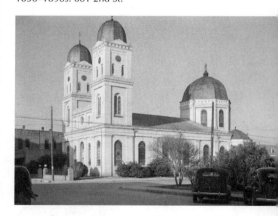

Although construction of this brick church began in the 1850s, it was not completed until the 1890s, when the sanctuary and dome, the sacristies, and the smaller domes on the facade's twin towers were finished. The interior is bright and spacious, an effect achieved through the use of slender iron Corinthian columns that separate the nave from the aisles without obstructing light from the windows. The columns are painted to represent marble, and the flat

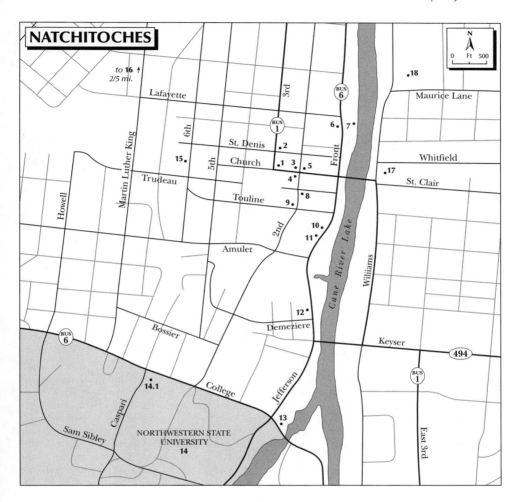

NATCHITOCHES

ceiling has stenciled decoration. Clerestory windows in the dome over the apse and multicolored stained glass side windows add to the brilliant effects. A freestanding spiral staircase leads to the choir loft; the crystal chandeliers were imported from France. Until 1910, this church was called the Cathedral of St. Francis; it was renamed after the diocesan seat was transferred to Alexandria.

NA6 **Kaffie Frederick's Hardware Store**

Late 19th century. 758 Front St.

The date of construction for this former general merchandise store is usually given as 1863, although there is no evidence to substantiate this. The business was established then by Adolph Kaffie. The two-story building is a particularly noteworthy example of the several brick commercial establishments along Front Street. A cast iron canopy shades the shop front. The window frames and the cornice are also of cast iron, as is the fan-shaped decoration in the center of the parapet.

NA7 **Roque House**

Late 18th century. Riverbank below Front St.

Roque House was moved to this location in 1967 from the nearby community of Isle Brevelle, which in the nineteenth century was heavily populated by free people of color. Built by a

freed slave named Yves, the house is constructed of *bousillage* between mortised and tenoned posts and has a steeply pitched hipped roof covered with cypress shingles that is supported on cypress gallery posts inserted directly into the ground. The double fireplace in the center of the house has been reconstructed.

NA8 Trinity Episcopal Church

1857. 533 2nd St.

The first Episcopal services in Natchitoches were held in 1839 in a converted store, with Bishop Leonidas Polk officiating. Although this church was sufficiently completed for use in 1858, its details remained unfinished until after the Civil War. Constructed of light brown brick, the Gothic Revival church has a massive square corner tower with angle buttresses and a gabled facade pierced by a small rose window. The single nave is covered by a wooden vault with supporting arches. The windows behind the altar, the church's earliest ones, have diamond panes with fleur-de-lis designs. The stained glass in the side windows dates from 1958, having replaced earlier windows that had deteriorated. Their dark blue, red, and deep yellow colors create a shadowy and serene atmosphere. It has been suggested that Frank Wills of New York designed the church, and although there is no direct evidence to support this, the building is similar to the designs Wills, as official architect for the New York Ecclesiological Society, proposed for Episcopal churches. A parish house and classroom wing were added in 1962 by A. Hays Town.

NA9 First Baptist Church

1929. 508 2nd St.

This Italian Romanesque–influenced structure is the third church for the First Baptist congregation, which was organized in 1879. It is raised over a high basement, and the entrance, which is reached by a monumental double set of stairs, is set within a projecting gabled portico that rises the full height of the facade. Within this portico, the entrance doors and the triple window above it are highlighted by panels of polychrome tile and capitals of glazed tile. The building presents a lovely contrast between the small-scale colorful tile work and the weighty quality and variegated reds of the brick walls. Corbel tables outline the roof gables on all sides of the building to provide a strong finish.

NA10 Prudhomme-Rouquier House

c. 1790, c. 1830. 436 Jefferson St.

This two-story house is believed to have been built by François Rouquier on land granted by the Spanish government. The pegged cypress frame is infilled with *bousillage* and covered with a coat of white stucco. The two-story gallery has square columns on the ground floor, and the three dormers are topped by pediments. Although a date of c. 1790 is claimed for the house, the Greek Revival elements, the central-hall plan, and the entrance door with transom and side lights indicate that the house was remodeled a few decades later. The house illustrates the wealth and elegance centered in Natchitoches during the cotton boom years of the early nineteenth century.

NA11 Tante Huppé House

Between 1827 and 1853. 424 Jefferson St.

This one-and-one-half-story house was built for Suzette Prudhomme after her third marriage in 1827. Like the Prudhomme-Rouquier House, this one employs an early construction method, in this case, brick between posts, and the exterior is covered with a coat of stucco. The house has two pedimented dormers, a central hall, and its original window glass; the gallery is supported on square piers. The house is named for a character in the writings of the nineteenth-century diarist Lestant Prudhomme.

NA12 Lemée House

c. 1837, Triscini and Soldini. 310 Jefferson St.

The Swiss-Italian immigrants known only as Triscini and Soldini settled in Natchitoches, designing and constructing a number of buildings. This one-and-one-half-story brick house is built flush with the sidewalk, giving it a much more urban aspect than the other houses along this street. Its facade is plastered and articulated with flat pilasters. The double-pitched roof has a "cradle" frame, a Mediterranean form that gives protection from high winds, and a single dormer. The house is three rooms in depth, with a rear loggia. In 1849, banker Alexis Lemée purchased the house.

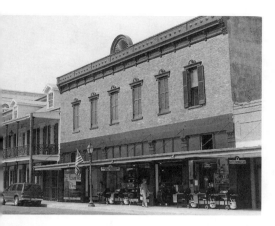

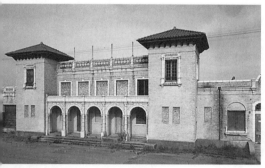

NA6 Kaffie Frederick's Hardware Store

NA15 Texas and Pacific Depot

NA13 **Fort St. Jean Baptiste State Historic Site**

130 Moreau St.

Located a few hundred yards south of the original fort site, this replica of a French colonial fort was built in 1979 under the supervision of architect Samuel Wilson, Jr. He based the reconstruction on Ignace Broutin's drawings of the reinforcement of the fort undertaken in 1732. The rectangular-shaped and bastioned fort was established in 1716 to deter Spanish claims to French territory and to safeguard trade with the Native Americans. In response, the Spanish promptly built their own fort, Los Adaes (NA29), a mere fifteen miles away. Inevitably, the French felt compelled to strengthen their fort, which they did in 1733. Materials and techniques similar to those used originally were employed for the modern reconstruction. For example, the church is of *poteaux-en-terre* construction (see NA24), with

bousillage between the posts, and is roofed in bark. Among the other buildings that have been replicated within the fort's double palisade are a barracks, a warehouse, the commandant's house, a guardhouse, and powder magazines. The original fort never saw any action, and by 1803, when the United States purchased Louisiana, the fort was already in ruins.

NA14 **Northwestern State University**

1906, with many additions. 715 College Ave.

Northwestern State University traces its origins to the Louisiana State Normal School, a two-year college founded in 1884 for the preparation of teachers. The campus's first major structure (1906) no longer exists, but its Jacobean Revival forms were echoed in the design Favrot and Livaudais produced for the former Women's Gymnasium Building of 1923. Today, only this building's red brick exterior walls with curved end gables and white stone trim are original, for the interior was gutted by a fire and remade in the late 1990s by Wayne Coco to house the National Center for Preservation Technology and Training. Several PWA-funded buildings were added to the campus between 1939 and 1940, most of them designed by Edward F. Neild, Jr., of Shreveport, and by Weiss, Dreyfous and Seiferth.

NA14.1 **Alumni Center** (President's House)

1927, Favrot and Livaudais

Favrot and Livaudais borrowed from residential rather than collegiate medieval architecture in their design for the president's house. Its brick walls, tall and elaborate chimneys, multicolored slate roof, and half timbering of artificially aged wood are a picture-book interpretation of the Middle Ages. Occupied by successive presidents of the institution until the 1960s, the house then became the home economics department. It was renovated in 1984 and converted for use as the alumni center.

NA15 **Texas and Pacific Depot**

1926. Bounded by 6th, Trudeau, and St. Denis sts.

Resembling a sixteenth-century northern Italian villa, this splendid two-story depot glorified the experience of arrival and departure by train. The station's center, which is slightly recessed between square pyramid-roofed towers, is faced by

a single-story, five-bay arcaded portico. The blond brick walls contrast with the cream-colored terra-cotta-faced spiral Corinthian columns attached to the portico and flanking the windows in the towers, the terra-cotta entablature over the portico's arches, and bands of yellow and blue glazed tiles in the shape of magnolias above the windows and along the parapet. The main waiting room, two stories in height, was said to be an enlarged replica of the master's cabin on Christopher Columbus's ship, the *Santa Maria*. No longer in use as a station, the structure is currently empty and awaiting a new use.

NA16 Caspiana Plantation Store

1906. 1300 Texas St.

Originally located on a cotton plantation in southern Caddo Parish, this store was moved here in 1991 to prevent its demolition. The plantation house had already been relocated to the Pioneer Heritage Center in Shreveport (CA66.1). It is one of the few surviving plantation stores of the hundreds that once existed in Louisiana. Two stories tall, with one-story shed wings along the sides, the store has a false front with a gable in the center of its parapet and a single-story front gallery. Measuring 90 feet by 60 feet, the two-story interior is surrounded on three sides by a mezzanine balcony suspended on iron beams tied into the roof trusses. The flooring and narrow-gauge beaded board ceiling are original, as is the shelving that lines the lower-level walls.

NA17 Tauzin-Wells House

Late 18th century. 607 Williams Ave.

Set far back on a spacious lot, the house, with its low, broad silhouette, appears long settled into its site. It was originally a two-room structure, constructed of hand-hewn notched and pegged cypress timbers and *bousillage*, and was surrounded by a gallery on all four sides. Shortly after construction, additional rooms gave the house its present size. Gabriel Buard, who built the house, reputedly used it as a way station for goods being shipped west. The house is known by the names of families who later owned it.

NA18 Rose Lawn

1903, George F. Barber. 901 Williams St.

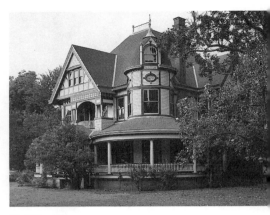

NA18 Rose Lawn

Situated on the bluff overlooking Cane River, this twenty-five-room house in the Queen Anne style built for J. H. Williams, Sr., is gaily painted in its original nine colors. The two-and-one-half-story house features a circular tower with a conical roof pierced by a tall, round-arched dormer on one corner and a smaller, more slender turret on the other corner. Gables in the steeply pitched hipped roof feature half timbering and shingles, and the walls are sheathed in a variety of wood and shingle treatments. The house has tall brick chimneys, and a gabled portico is set between single-story galleries that wrap around each of the house's front corners. The architect, George Barber (c. 1854–1915) of Nashville, Tennessee, was famous for his Queen Anne designs, which were published in his pattern books and available by mail order. It is believed that he was responsible for the design of approximately 10,000 houses throughout the nation.

Natchitoches Vicinity

Some of Louisiana's oldest plantation houses lie along the Cane River south of Natchitoches, where the landscape seems to have changed little since the early nineteenth century. As the former channel of the Red River, the Cane River provided access to New Orleans, and its banks offered the fertile soils ideal for growing cotton. Consequently, the area was settled early in Louisiana's history and constitutes a unique enclave of French culture and architecture in an otherwise Anglo northern Louisiana. Harriet Beecher Stowe memorialized this area in *Uncle Tom's Cabin* (1852). Some of the homes

are open for visitors, and all can be viewed from the road.

NA19 Oaklawn Plantation House

c. 1835. 2966 Louisiana 494

Preceded by a 680-foot-long allée of live oaks, the third longest in the state, Oaklawn evokes all the romanticism of the southern plantation. The house is of cypress frame and *bousillage* construction, with an upper floor raised a full story above the ground, with galleries on three sides. The massive hipped roof is pierced by small dormer windows. Each of the three front rooms measures 20 feet square, which makes them unusually large for a Creole house. According to tradition, Narcisse Prudhomme built this house for his son, Pierre Achille Prudhomme, between 1830 and 1835.

NA20 Maison de Marie Thérèse

c. 1786. Dirt road off Louisiana 494 (1 mile northwest of Bermuda)

This may have been the home of Marie Thérèse Coincoin (1742–c. 1816), who began life as a slave and, in 1767, became the mistress of Claude Thomas Pierre Metoyer, with whom she had several children. The house is identified on a survey plat of 1794 as the "Maison de Marie Thérèse, Négresse libre." It is believed that Metoyer, who had purchased Marie Thérèse in 1778, gave her the land in 1786, when he ended their relationship and freed her. Marie Thérèse expanded her landholdings and purchased the freedom of almost all of her children and grandchildren. Her descendants owned plantations in the area. This five-room Creole raised cottage has a hipped roof, front gallery, two large front rooms separated by a chimney, and a room at the rear flanked by two cabinets. The side and rear galleries were added later. The house is built with frame posts and *bousillage*, and the exterior is sheathed in irregularly placed beaded boards.

NA21 Cherokee Plantation

c. 1839. 3109 Louisiana 494

This house was probably built shortly after the marriage in 1837 of Charles Emile Sompayrac and Clarisse Prudhomme, daughter of Narcisse Prudhomme, who owned Beau Fort (NA22). The one-story house is raised on brick piers and has walls of *bousillage* and a steeply pitched hipped roof. The house originally had four rooms and galleries on all sides, as was typical of houses in this area, but at a later date the north gallery was enclosed to create two additional bedrooms and a kitchen. That such adaptations were common demonstrates the flexibility that allowed the galleried Creole house to absorb changes without losing its character. As no special emphasis is placed on either bilateral symmetry or the importance of the facade over the sides and rear, these house can grow, or even shrink, to suit their occupants. Cherokee has two entrances on the front, one to the principal bedroom and the other to the parlor; the latter room had double doors that opened to a dining room behind. The house is believed to be named for the Cherokee roses that grow there. It is open for tours.

NA22 Beau Fort

c. 1800. 4078 Louisiana 494

The Louis Barthélemy Rachel family was living on this property by 1790, and it is believed that the house was built around that time. The one-and-one-half-story house has a cypress frame, and the *bousillage* infill is composed of mud and deer hair, which may be an earlier type than the usual mix of mud and Spanish moss. The original floor plan consisted of four rooms across the front and two rooms at the rear, where two sets of interior stairs led to the attic. All the rooms except one opened into each other. This exception was known as the "stranger's room," which allowed the owners to offer hospitality to travelers without giving them access to the rest of the house. A gallery on ten square wooden columns extends across the front of the house; the steps leading to it are off center and lead into the living room. A short avenue of live oaks precedes the house. Originally named St. Charles Plantation, the house was known as the Old Narcisse Prudhomme Plantation from c. 1830 to 1925; it was then renamed Beau Fort on the basis of an unsupported story that it occupied the site of a French fort. Cotton is still farmed on this plantation. The house is open to the public. Opposite the house is the small frame St. Charles Catholic Church (c. 1909), closed in 1994 by the diocese.

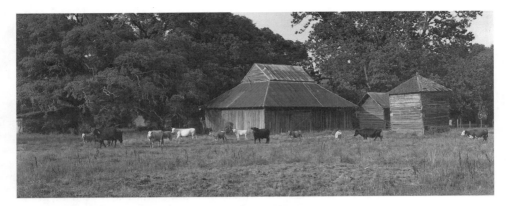

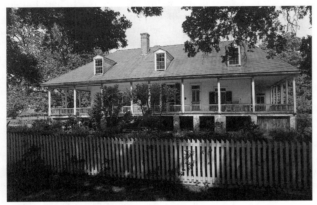

NA23 Cane River Creole National Historical Park (Oakland Plantation) house (left) and stable and *pigeonnier* (above)

NA23 **Cane River Creole National Historical Park** (Oakland Plantation)

1818, and later additions. 4386 Louisiana 119 (2.3 miles south of Natchez)

Oakland Plantation was established by Jean Pierre Emmanuel Prud'homme on land granted to him by the Spanish crown in 1789. The plantation remained in the family until the buildings and forty-two acres were sold to the National Park Service in 1997. Oakland and the nearby Magnolia Plantation (NA27) form the Cane River Creole National Historical Park; both have been designated National Historic Landmarks. Oakland's twenty-four historic structures, almost all of them dating from the nineteenth century, constitute one of the most complete collections of rural French Creole structures in the nation. Eight of the buildings are of *bousillage* construction, and while individual structures of this type can be found elsewhere in Louisiana, it is rare to find a group of them, as at Oakland.

Oakland's buildings are informally arranged parallel to the Cane River (formerly the Red River), as was typical along rivers other than the Mississippi, with the main house at the north end of the property. The two-story raised Creole house has a brick ground story, an upper floor of frame and *bousillage* construction, and a hipped roof. When the house was first built, in 1818, it was a four-room structure completely surrounded by a gallery. In the 1820s, three rooms were added on the north side, one of which was used as a plantation office; shortly afterward, the house was enlarged to the west. The surrounding gallery and hipped roof were extended to accommodate these additional rooms. After the Civil War, the southwest corner of the gallery was enclosed to form a room, as was a portion of the north gallery; the latter, with access only from the gallery, served as a "stranger's room," where travelers could stay overnight. Additionally, a narrow hallway was cut through the house and a galleried two-room kitchen wing extended to the rear.

The interior of the house includes features from the early-nineteenth-century construction, such as the elliptical archway between the front salon and the rear dining room, two wraparound mantels, and door and window surrounds in the Federal style. Changes made in the 1880s included replacing the parlor's French doors with triple-hung sash windows and installing a Gothic Revival wooden mantel. In front of the house is a short allée of live oaks and a bottle garden. Bottles are pushed upside down into the ground to outline parterres in a variety of shapes. Although such gardens were common on nineteenth-century French Creole plantations, Oakland's is believed to be one of only two surviving in the Mississippi Valley. At Oakland, the bottles range in date from the late eighteenth to the early twentieth centuries.

Among the several outbuildings are a two-room cook's house of *bousillage* construction, with a gallery along three sides. Originally situated closer to the house, the structure was moved in the twentieth century. Two similar but not identical square *pigeonniers* (c. 1830–c. 1850) are located on the south side of the house, both of which have *bousillage* walls on the lower floors. A pair of two-room slave houses survives; each structure accommodated two families. With the introduction of the sharecropping system after the Civil War, a door was opened between the rooms so that each house would accommodate a single family. In 1860, just before the Civil War, when Jean Pierre Prud'homme's son Pierre Phanor Prud'homme controlled the plantation, there were thirty slave dwellings housing 145 slaves. The one-story raised Creole house for the overseer (1861) is of *bousillage* construction and has a hipped roof. The doctor occupied a galleried cottage that probably was built in the mid-nineteenth century, then enlarged later in the century. Other structures at Oakland include a three-bay, gable-fronted carriage house, a barn that consists of a central log crib surrounded by a shed-roof gallery, storage sheds, chicken coops, a stable, a cottonseed house, and an in-ground brick cistern with a domed top protruding from the earth. The plantation store, built after the Civil War, was enlarged at the end of the nineteenth century.

NA24 Badin-Roque House

c. 1800. Louisiana 484 West (.5 mile from Louisiana 493)

This small house is thought to be Louisiana's only surviving original example of *poteaux-en-terre* construction (unbraced vertical posts sunk into the earth), a method of building prevalent in the Mississippi Valley in the late eighteenth century. The walls are of *bousillage*. The house has the typical Creole plan of two rooms with two rear cabinets flanking a loggia; the single asymmetrically placed interior chimney reveals that the rooms are of a different size. The house had a dirt floor. A free man of color named Pascale built the house. In the 1850s, the house was occupied by nuns and used as a school for Cane River free people of color.

Melrose Vicinity

NA25 St. Augustine Church

c. 1829. 2250 Louisiana 484 East (.2 mile from Louisiana 493)

After the congregation was established c. 1803, this wooden church was built by Augustin and Louis Metoyer, sons of Marie Thérèse Coincoin. The church has a square tower with a short spire in the center of the facade and round-arched windows. Inside, the nave and aisles are separated by arcades on slender piers and are covered by wooden barrel vaults. In the adjacent cemetery are above-ground tombs and wrought iron crosses with French inscriptions. The artist Clementine Hunter is buried here. The church was the site of the wedding scene in the movie *Steel Magnolias* (1989).

Melrose

NA26 Melrose Plantation

c. 1796–1833. 3533 Louisiana 119

Melrose Plantation owes its fame not only to its architecture but also to the people who have been connected with it. Marie Thérèse Coincoin established the plantation, which was then known as Yucca Plantation. Her son Louis Metoyer built the large house c. 1833. After the plantation was sold in 1847, it had a succession of white owners and was purchased in 1898 by John Hampton Henry and Cammie Garrett Henry. They renamed the plantation after novelist Sir Walter Scott's burial place, Melrose Abbey. Cammie Henry replanted and extended the plantation gardens and, by inviting

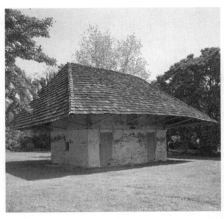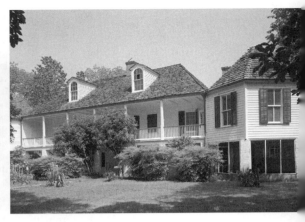

NA26 Melrose Plantation, African House (left) and main house (right)

artists and writers to stay at Melrose, made it a center for arts and literature. Among the guests were Gwen Bristow, Erskine Caldwell, Caroline Dorman, Alberta Kinsey, John Steinbeck, William Faulkner, and Lyle Saxon, whose novel *Children of Strangers* (1937) portrays the Cane River area. François Mignon, who arrived for a six-week visit, remained for thirty-two years and recorded life at Melrose in *Plantation Memo* (1972). The self-taught artist Clementine Hunter (1886–1988) also documented plantation life in hundreds of paintings, in her case, from the viewpoint of one who had worked and lived at Melrose her entire life, first in the fields as a cotton picker, then as the plantation's cook, and, finally, as an artist. Melrose was acquired by the Association for the Preservation of Historic Natchitoches in 1971, which restored the surviving eight structures and opened the complex to the public.

Begun in the 1830s for Louis Metoyer and completed by his son, the main house is a raised structure with ground-floor walls of brick and upper walls of *bousillage*. The hipped roof is covered with wooden shingles. Galleries across the front and rear have square brick piers on the lower floor and chamfered wooden columns on the upper. Stairs are set in the galleries. The house has two large rooms on each floor but is only one room in depth, which permits cooling breezes to pass through when the French doors are opened. A small room or cabinet is set at both corners of the rear gallery. After the Henrys purchased the property in 1898, they added the two-story hexagonal, pyramid-roofed structures at each end of the front gallery and a two-story kitchen wing.

The Yucca House (c. 1796) is believed to be the original main house at Melrose. Built of hand-hewn cypress timbers and *bousillage* walls, the house has galleries front and rear, two large rooms, and a smaller room at each end, which may have been formed by enclosing end galleries. The gallery columns of peeled cypress logs are probably not original. The artists and writers who stayed at Melrose during Cammie Henry's ownership were accommodated in the Yucca House.

The two-story structure known as the African House (c. 1800) was probably built as a storehouse and is said to have been used as a jail for slaves. The ground floor is of brick and the upper of hand-hewn, square timbers dovetailed at the corners. A huge hipped roof envelops the house and extends 10 feet beyond the exterior walls on all four sides, supported by round struts extending out from the brick wall, without vertical supports. At one time, wooden posts supported the roof at its edges. There continues to be debate on the precedents or sources for the building. It has long been held that it had African sources, an opinion originally accepted by historian John Michael Vlach. More recently, in his book on plantation structures, *Back of the Big House* (1993), Vlach stated that the house "needs to be understood as a building based on local practices rather than on exotic custom." According to New Orleans architect Eugene Cizek, several structures similar to this one existed on plantations in the Natchitoches area. The interior upper walls have murals painted in the 1950s by Clementine Hunter depicting the life of the African American community in the area.

Derry Vicinity

NA27 Cane River Creole National Historical Park (Magnolia Plantation)

c. 1835, with many additions. 5487 Louisiana 119

Ambrose Lecomte I and Ambrose Lecomte II established this plantation in the 1830s on land granted to Jean Baptiste Lecomte by the French colonial government in 1753. Additional land purchased in the 1820s and 1830s increased the plantation to 7,800 acres. The buildings are laid out on the west bank of the Cane River and parallel to it, forming a typical progression from main house to slave hospital to slave quarters to the area for ginning and pressing the cotton. By 1860, Lecomte was the largest producer of cotton in the parish. Today the plantation is owned and administered by the National Park Service as a unit in the Cane River Creole National Historical Park. Among its twenty-one historic structures, almost all of which were built in the nineteenth century, are the planter's house, eight slave dwellings, a slave hospital (the oldest surviving structure), a *pigeonnier*, a blacksmith shop, several barns, a stable, a plantation store, and a mule-drawn wooden cotton press.

The original main house, built in the 1830s by Ambrose Lecomte II, was burned down by Union troops during General Nathaniel Banks's retreat from the Battle of Mansfield in 1864. The present house, constructed in the late 1890s on the brick basement of the original house, has front and rear galleries, a gable roof with three dormers, a central hall, and double parlors with a chimney set between. A large rear wing contains a private chapel. Just behind the house is a two-hole frame privy with louvered openings on the side elevations and a pitched roof.

Archaeological investigations in the area of the eight surviving slave dwellings indicate that a total of twenty-four cabins were laid out in a grid pattern of four cabins across and six down. Documentary evidence reveals that five cabins were under construction in 1845. The two-room brick structures, which each housed two families, had a central chimney, iron lintels, and gable parapets. Originally, shutters covered the unglazed windows and the doorways. After the Civil War, a door was cut between the rooms in these cabins to transform them into single-family dwellings.

The slave hospital (c. 1835), a raised cottage with a hipped roof, has had various uses over the years. From 1864 until the 1890s, it was the main residence for Magnolia's owners after their original house was burned down during the Civil War. In the twentieth century, it was the home of the overseer or plantation manager. The building originally consisted of three rooms, a 12-foot-deep gallery on three sides, and, probably, two cabinets. Later alterations, which included conversion of the rear gallery to enclosed rooms and the addition of two smaller structures, have given the building an irregular outline.

Although a gin house is shown on the 1858 map in approximately the same location, the existing one is considered to be later, perhaps built shortly after the Civil War. The gin house is a massive, two-story structure that measures 85 feet by 37 feet, with a gable roof of corrugated metal that is a modern replacement. The structure houses a huge wooden screw press (c. 1840) of a type used from around 1810 until the introduction of power screw presses after the 1840s. The carved wooden screw mechanism, probably turned by mule power, propelled a wooden piston into a box filled with cleaned, seedless cotton (lint) to compress it into bales weighing from four hundred to five hundred pounds. It is the only known mule-powered gin in its original location in the United States. At the other end of the gin house, on the second floor, is a late-nineteenth-century system gin. This type of gin, largely devised by Robert Munger, was a mechanized assembly line that unified the ginning and pressing processes, requiring little human contact with the cotton. The gin was hydraulically powered by a stationary steam engine located outside the gin house on a brick base; only the base survives. Both the screw press and the system gin are extremely rare. In the early twentieth century, it became increasingly common for farmers to send their cotton to a large gin that serviced several plantations rather than maintaining their own gins. Magnolia, however, continued to gin its own cotton until 1939.

Magnolia's other structures include a frame two-story square *pigeonnier* with a low pyramidal roof. It is probably the one that is shown in a different location on an 1858 map of Magnolia, later moved farther from the house. The blacksmith shop has a central crib of *bousillage* and a surrounding skirting shed. The plantation store (c. 1880), located close to the roadway, has a gable roof, a front gallery, and a central set of front doors. The lean-to wings on each

side were added later, the one on the left incorporating a small bedroom for the clerk.

Cloutierville

NA28 Kate Chopin House and Bayou Folk Museum (Alexis Cloutier House)

c. 1810. 243 Main St. (Louisiana 495)

Novelist Kate Chopin (1851–1904) lived in this two-story galleried house from 1879 to 1883. Although she did not begin to write until 1888, when she returned to her childhood home town of St. Louis, the Cane River area and its culture served as a backdrop for her short stories in *Bayou Folk* (1894). When Chopin lived in this house, her husband, Oscar Chopin, helped manage the family plantation and general store. At his death in 1882, she continued to run the business for one year before returning to St. Louis. It is believed that the house was built by Alexis Cloutier in the early 1800s following his acquisition of the land in the late 1700s; the house is noted on a State Land Office map dated 1813. The ground floor is constructed of handmade bricks and the upper floor of cypress with dovetail joints and square wooden pegs; the front gallery is supported on brick piers below square wooden columns. The ground floor was originally used as a storage area, connected to the second-floor parlor and four bedrooms by an exterior staircase in the gallery. Changes made since the Chopins lived in the house include the enclosing of the upper rear gallery and demolition of the dependency structures. The rear yard now contains two structures that were relocated here. One is a late-nineteenth-century log barn, now known as the Blacksmith Shop; the other, called the Doctor's Office, was moved here in 1938 and served that purpose until the late 1950s.

Robeline Vicinity

NA29 Los Adaes State Historic Site

1719. 6354 Louisiana 485

Only the foundations remain of this important outpost of the Spanish empire. In 1717, Spain established the Mission San Miguel de los Adaes on this site as part of an effort to prevent the French from extending their occupation west of Natchitoches. The Spanish colonial administration maintained that the Red River was the eastern boundary of their province of Texas, while the French insisted that their province of Louisiana extended to the Brazos River. In 1721, the Spanish decided to reinforce Los Adaes, which was only fifteen miles from France's Fort St. Jean Baptiste (NA13). From 1731 to 1773, the Presidio of Los Adaes served as Spain's capital of the province of Texas. Excavations and documentary evidence have revealed that the fort was surrounded by a hexagonal stockade and included a governor's house measuring 60 feet by 20 feet, a small chapel, a powder house, three houses for the soldiers, and two wells.

Grant Parish (GR)

Colfax

Named for Schuyler Colfax, U.S. vice president during President Ulysses S. Grant's administration, both the town and Grant Parish were formed in 1869. Before the Civil War, Colfax was a village known as Calhoun's Landing, an important steamboat stop on the Red River for the products of Meredith Calhoun's four plantations, which had a combined river frontage of seven miles. After the Shreveport and Red River Valley Railroad came through to Colfax in 1900, harvesting of the parish's extensive forests began in earnest, and Colfax prospered as a commercial and transportation center. The river has swallowed much of Colfax's oldest area, but the wooden columned houses along 2nd Street give some idea of the town's late-nineteenth- and early-twentieth-century character, as does the two-story galleried McNeely House (Main Street between 3rd and 4th streets) of 1885. The two-story courthouse, designed by the Alexandria firm of Barron, Heinberg and Brocato in 1954, has an exposed aggregate exterior surface, and all the window shapes are variants on a circle.

Northwestern Parishes

I F COTTON AND LUMBER WERE THE INDUSTRIES THAT INITIALLY brought settlers to this area, oil and natural gas had a far greater impact on its economy, growth, and architectural heritage. Exploitation of these resources in the early twentieth century created the wealth that gave rise to Shreveport's splendid public and commercial buildings and its exclusive suburbs and mansions.

Dense pine forests and an immense 200-mile logjam (known as the Great Raft) that prevented navigation along the Red River had left northwestern Louisiana isolated and largely undisturbed by white settlers until the 1830s. But after the logjam was cleared under the direction of Captain Henry Miller Shreve, then Superintendent of Improvements for the Western Rivers, the region became more accessible. In 1835, the Caddo Indians ceded their territory to the U.S. government for $80,000 and migrated west to a reservation in Oklahoma. Beginning in the 1840s, slave-owning settlers from the Carolinas, Georgia, Alabama, and Mississippi populated the region. Most were Protestants, as were their slaves, and Baptist and Methodist churches took a strong hold. Shreveport, established in 1836 on the west bank of the muddy, red-tinted Red River, became the regional center for trade and commerce, with steamboats shipping cotton along the Red to the Mississippi River and on to New Orleans. Later in the nineteenth century, when the railroads came through, Shreveport became a major terminus and transfer point from one line to another. The railroad also proved a stimulus for expansion of the lumber industry.

The first oil well in the region was drilled in 1905, and a year later natural gas was discovered. The Rodessa Field, approximately thirty miles north of Shreveport, was then one of the largest in the world. In 1911, the Gulf Oil Refining Company built what is thought to be the first offshore oil well, constructing a drilling platform on a base of cypress logs driven into the bed of Caddo Lake. Using cable rigs powered by steam engines, basic underwater drilling techniques were first developed here. Oil

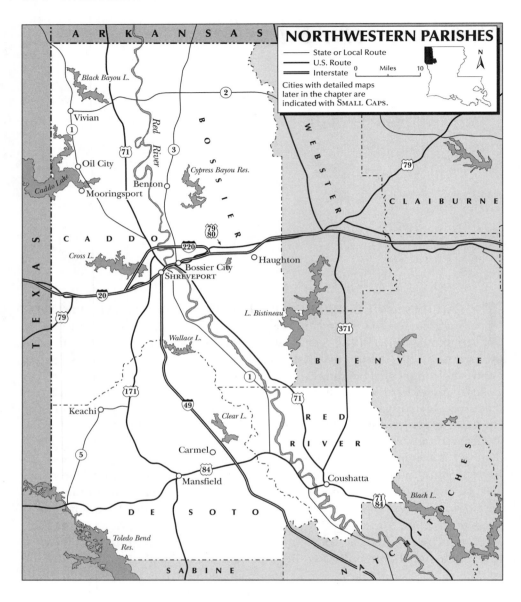

derricks dominated the landscape, and oil inflated land prices. Temporary camps and shantytowns sprang up near the drilling sites, and many existing small communities were transformed virtually overnight into rowdy boom towns. Although the region's economy is still to a large extent based on the petroleum industry, the most visible evidence of oil's impact remains in Shreveport's skyscrapers, cultural facilities, and showy houses. Caddo Lake is now used for leisure activities.

The Red River runs through three of the four parishes (Caddo, Bossier, and Red River) that make up this region, which borders Texas and Arkansas. Caddo, named

in honor of the Native Americans, was formed in 1838. Both Bossier and De Soto parishes were created in 1843, named respectively for the Louisiana congressman Pierre-Evariste Bossier and the explorer Hernando de Soto. Red River was created in 1871.

Caddo Parish (CA)

Shreveport

Although founded in 1836, Shreveport is at heart a twentieth-century city, for its great period of growth was generated by the discovery of oil in the region. The Shreve Town Company laid out the town on an eight-block-square grid on the west bank of the Red River, naming many of the streets after heroes of the struggle for Texas's independence. The town itself was named in honor of one of the company's investors, Captain Henry Miller Shreve. With navigation along the Red River opened, Shreveport quickly became a shipping and trading center

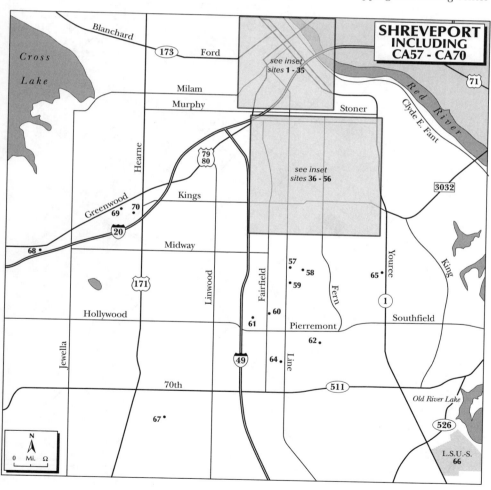

for northwestern Louisiana. Cotton factoring houses, warehouses, and stock pens were built along Commerce Street (formerly Levee Street) to serve the riverboats linking Shreveport to New Orleans. Westward-bound wagon trains set off along the ridge known as the Texas Trail, which would become Texas Street, the city's principal thoroughfare. In those years, Shreveport was a rough river town. It avoided direct conflict during the Civil War (Union troops were turned back at Mansfield about forty miles south of Shreveport) and, from 1863 to 1865, served as the last capital of the Confederacy after the government fled Opelousas.

By 1904, Shreveport's seven railroads made it the commercial center for a three-state region (Arkansas, Texas, and Louisiana) and fostered

expansion of the area's lumber industry. That same year, oil was discovered north of the city in what came to be known as the Caddo–Pine Island Field, and drilling began in Caddo Lake in 1911. People flocked to the city in search of profits, setting off a construction boom that included high-rise commercial buildings, public institutions, and exclusive suburbs. Additional oil discoveries in the 1930s lessened the impact of the Depression on Shreveport. In 1933, the area's economy was boosted by the establishment of an Army Air Corps base across the Red River in Bossier City, later renamed Barksdale Air Force Base (BO3). Post–World War II oil prosperity brought additional glass and concrete high-rise buildings to Shreveport's downtown.

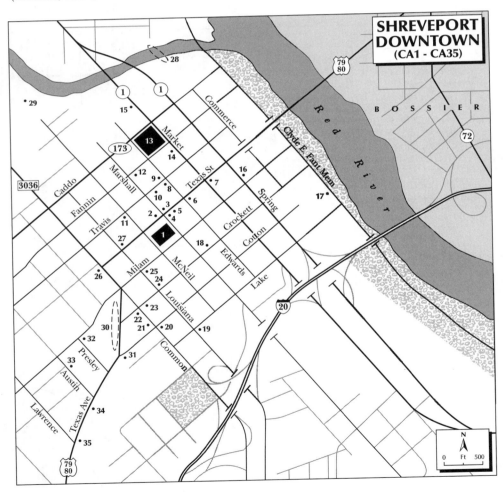

Residential subdivisions were developed southward, along the route of an electric streetcar system that began operations in 1890. Commercial and medical institutions have encroached on the formerly residential Highland neighborhood immediately south of downtown, but South Highlands, Broadmoor, and Fairfield, laid out beginning in 1911 by real estate developers A. C. Steere and Elias Goldstein, have maintained their residential character. Many new houses were of the foursquare type, uncommon elsewhere in Louisiana, and came in the variety of styles—Colonial Revival, Mediterranean, and Renaissance Revival—popular between the two world wars. Bungalows were favored as well, and South Highlands is notable for many good examples. Fairfield Avenue can boast some of Louisiana's most splendid mansions, comparable to those on the more famous St. Charles Avenue in New Orleans. Shreveport can also claim Louisiana's earliest and most extensive group of modernist houses, with characteristic flat roofs and bands of horizontal windows, designed by a group of local architects from the early 1930s through the 1950s. Whether traditional or contemporary, homes in these neighborhoods are set in large gardens along streets lined with oaks, magnolias, and pines. The Lambert Landscape Company, with offices in Shreveport, Dallas, and Houston, designed some of Shreveport's finest residential gardens in the 1920s and 1930s for numerous wealthy clients (see CA50). Residential growth also moved west, forming such neighborhoods as Lakeside, Werner Park, and Jewella. In the 1980s and 1990s, the Ellerbe Road area of south Shreveport became a prestigious address, where enormous houses in historical styles were built among the pine woods.

Some of Louisiana's most inventive twentieth-century architects lived and worked in Shreveport. Nathaniel Sykes Allen (1829–1922), who moved from Marshall, Texas, to Shreveport in 1870, produced many buildings, only a handful of which remain. Shreveport native Edward F. Neild (1884–1955) was responsible for numerous civic, parish, and federal buildings, mostly in northwestern Louisiana. In 1923, Dewey A. Somdal (1898–1973), from Chicago, began to work with Neild, a collaboration that evolved into a partnership, with Somdal contributing a modernist influence on their designs. Clarence Olschner (1888–1967) was employed in Neild's office from 1912 to 1922, then formed a partnership with Ernest W. Jones

(1888–1955), Rudolph B. Roessle (1890–1967), and Samuel G. Wiener (1896–1977) known as Jones, Roessle, Olschner and Wiener. In 1940, Wiener set up his own practice, continuing to design some of America's purest modern buildings, as did his brother William B. Wiener (1907–1981). After traveling to Europe in 1927 and 1931, where the Wiener brothers saw firsthand the work of Walter Gropius, J. J. P. Oud, and Erich Mendelsohn, they introduced the forms, materials, and aesthetics of modernism to Shreveport a decade before the International Style was adopted elsewhere in the state and at the same time it appeared in New York and Los Angeles. Perhaps it is Shreveport's absence of "old wealth" and clients who were not part of the Old South that has made it more open to outside influences than, fr example, New Orleans.

Shreveport is often described as being closer in spirit to Texas than to southern Louisiana, and, indeed, until the completion of the north-south Interstate 49 in the early 1990s, it was much easier for Shreveporters to get to Dallas than to New Orleans. After 1993, when casino gambling was legalized in Louisiana, the links with Texas took a new direction: Texans now flock to Shreveport and Bossier City to gamble. Shreveport is adding new attractions to lure tourists, notably development of the river as a leisure attraction, with a riverside walk, museums, garden center, auditorium, and nightspots.

DOWNTOWN

CA1 Caddo Parish Courthouse

1926–1928, Edward F. Neild and Dewey Somdal. 501 Texas St.

Caddo Parish's magnificent courthouse, built at the height of the region's oil boom, is a testament to civic pride. Occupying a full city block, the building is composed of three successively recessed blocks set on a high podium. The first segment rises three stories and is pierced by a two-story-high, round-arched portal and square-headed windows. Floors four through six are fronted by eight colossal Ionic columns on the building's two principal facades and are finished with a tall entablature. The upper two stories, accommodating the jail, have round-arched openings. Faced with Indiana limestone, the courthouse has carved ornament in the form of stylized magnolias and

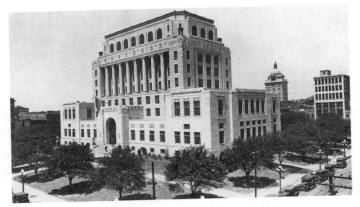

CA1 Caddo Parish Courthouse, with the Hutchinson Building (CA2) at right, photo c. 1930

CA3 Shreve Memorial Library (U.S. Post Office and Federal Building)

CA4 Slattery Building

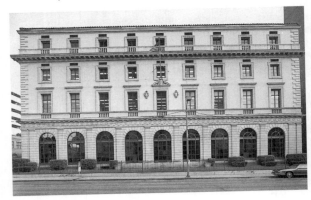

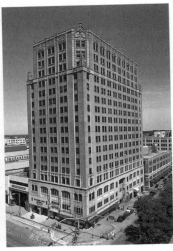

eagles that contributes to the air of grandeur. Matching wings were added to the courthouse in 1971. The lobby retains its original bronze light fixtures; its walls are lined with rosatta marble, and the floors are of pink and gray Tennessee marble with a border of Belgian black marble.

Soon after the courthouse was completed in 1928, Harry Truman, then a county judge in Kansas City, Missouri, who was in charge of a project to build a new courthouse, saw a photo of Neild's courthouse and traveled to Shreveport to inspect it. He appointed Neild as consulting architect for the Jackson County Courthouse in Kansas City (completed 1932), which is a high-rise version of Shreveport's. Truman later asked Neild to act as a consultant on the design for the Truman Library at Independence, Missouri.

CA2 Hutchinson Building

1911, John Y. Snyder. 504 Texas St.

The original plans called for a four-story building, but after the contractor failed to meet the agreed date of completion, two additional floors were added at his expense. The steel-frame construction, expressed on the facade and faced with white glazed terra-cotta, allows for large expanses of windows. A row of elliptical arches and a projecting cornice complete the structure. The Hutchinson brothers chose Texas Street, Shreveport's principal commercial thoroughfare, for their building, which originally housed a jewelry store on the ground floor. Their architect, John Snyder (1875–1939), who was also an engineer and a geologist, opened an architectural office in Shreveport in 1899.

CA3 Shreve Memorial Library (U.S. Post Office and Federal Building)

1910–1912, James Knox Taylor, Supervising Architect of the Treasury. 1931, James A. Wetmore, Acting Supervising Architect of the Treasury. 424 Texas St.

When this former post office and federal building, was completed to James Knox Taylor's design, it had three stories and was half its present size. James Wetmore's enlargement of 1931, which included extensions of both principal facades and the addition of a fourth floor, repeated the Italian Renaissance palace design so that the structure appears to belong to one building campaign. The rusticated first story has Doric pilasters separating the round-arched windows, and the smoothly finished limestone upper floors feature square-headed windows with surrounds of spiral ornamentation. Originally, the building's entrance and lobby were centered on the facade facing Texas Street, but when the post office relocated in 1974 and the building was remodeled into a library, the entrance was moved to the side on the passageway perpendicular to Texas Street. The partial reconstruction of the lobby's shallow domes and dark green marble walls inside the new entrance has diminished its original grandeur. The rest of the interior was completely modernized. Walker and Walker, Architects-Engineers, were in charge of the remodeling.

CA4 Slattery Building

1924, Mann and Stern. 509 Marshall St.

Lawyer and businessman John B. Slattery, who came to Shreveport from New York in 1874, hired the distinguished Arkansas firm of Mann and Stern to design his seventeen-story steel-frame, brick and limestone building. The Gothic Revival structure probably was inspired by Hood and Howells's famous design for the Chicago Tribune Building, then under construction. Unlike that structure, however, the Slattery Building has Gothic elements applied as decoration to the facade rather than Gothic forms, achieving contrast between solid and void through the play of light and shade. Most of these details, pointed and ogee arches, are concentrated on the first four floors and the upper four. The skyscraper, which cost $1.5 million to construct, is a splendid contribution to Shreveport's business district. John Slattery's mansion on Fairfield Avenue (CA47) had al-

ready helped make that street a fashionable residential address.

CA5 Commercial Building (Jordan and Booth Men's Store)

1949, Neild-Somdal-Associates. 421 Texas St.

Steel-frame construction allowed the architects to manipulate this shop front into a dynamic asymmetrical composition. The off-center entrance is deeply recessed between one large, curved glass display window and a smaller, angled window. Above the windows, masonry walls follow this movement, their inward curve accentuated by horizontal striations. A rectangular frame of pinkish-gray marble neatly sets off the entire two-story composition. A third-story apartment is expressed on the exterior by a narrow strip window that extends almost the entire width of the building. Inside, the store is two stories in height and features a balcony that undulates along one side and is echoed on the opposite wall by rounded display niches that resemble theater boxes. Toward the rear of the store is a curved staircase with aluminum railings and terrazzo-paved steps leading to a rear mezzanine level.

CA6 American South Building (Commercial National Bank)

1939–1940, McKim, Mead and White; Samuel G. Wiener, associate architect. 333 Texas St.

The famous New York firm of McKim, Mead and White collaborated with Shreveport architect Samuel Wiener in the design and construction of this austere Moderne building faced with limestone. Several setbacks conclude the upper sections of the front half of the seventeen-story building, which is taller than its rear section. Wiener's preliminary sketch for the bank, in the archives of Louisiana State University, Shreveport, depicts a structure with a simpler outline, but the final design incorporated pronounced setbacks. Both the sketch and the completed structure place emphasis on the expression of height. To this end, piers between the windows rise without interruption to the building's summit; fluting along the cornice, on the spandrels, and beside the principal entrance further accentuates verticality. Lobby murals painted on Belgian linen by J. Buck Winn depict the area's history. Photographs of the bank were published in contemporary ar-

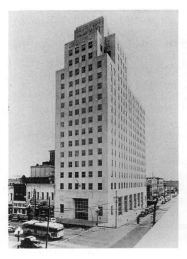

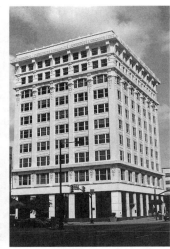

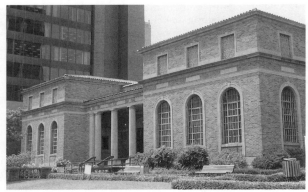

CA6 American South Building (Commercial National Bank), photo c. 1950

CA7 Commercial Building (Old Commercial National Bank)

CA8 Shreveport Chamber of Commerce (Shreve Memorial Library)

chitecture journals for advertisements promoting the building's use of cellular floors that provided 6-inch-deep spaces between floors for easy access to electrical wiring. The building was renovated in 1997.

CA7 **Commercial Building** (Old Commercial National Bank)

1911, Mann and Stern. 509 Market St.

Constructed at the dawn of Shreveport's oil and gas boom, this ten-story steel-frame building seems to celebrate the new era with a coat of brilliant white terra-cotta and thickly encrusted foliate ornament across the second and upper three stories. The tripartite facade expressing base, shaft, and capital and the conspicuous projecting cornice were inspired by Louis Sullivan's high-rise buildings. A typical Chicago School feature is the triple division of the windows. This building was Shreveport's tallest until Mann and Stern designed the nearby Slattery Building (CA4). In the 1970s, the bank's first story, with large, round-arched openings, was insensitively remodeled.

CA8 **Shreveport Chamber of Commerce** (Shreve Memorial Library)

1922–1923, Joseph P. Annan and Clarence W. King. 400 Edwards St.

Shreveport's first public library was one of the civic improvements resulting from the early-twentieth-century oil boom. Modeled on Italian villas, the reddish-brown brick library has a central portico with four limestone Tuscan columns in antis, with pilasters flanking the colonnade. The portico is recessed between

two-story projecting pavilion wings with tall, round-arched windows on the first floor and square-headed windows on the upper. Each wing has a gently sloping red tile pyramid roof. Raised over a basement floor, the building has a terraced forecourt surrounded by a balustraded wall, providing an elegant and formal oasis in Shreveport's dense city center. Joseph P. Annan (1868–1936), who moved to Shreveport from St. Louis in 1910, collaborated on this design with Shreveport's city architect, Texas-born Clarence King (1876–1946). Paul Heerwagen, from Fayetteville, Arkansas, supervised the interior decoration. When Haas and Massey renovated the interior in 1984 for the Chamber of Commerce, the lobby and its elaborate plaster ceiling were preserved, although the doors that now fill the spaces between the lobby's arcades have diluted its original grandeur.

CA9 Henry C. Beck Building

1956, Neild-Somdal-Associates. 400 Travis St.

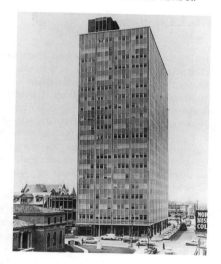

This twenty-story steel-frame building, Shreveport's tallest when it was built to house oil and gas industry offices, was viewed as a symbol of the city's progress. Its blue-tinted glass and aluminum curtain wall gave it the smooth, shimmering, weightless quality favored by architects and clients in the 1950s. The anodized aluminum spandrel panels, originally robin's-egg blue but now faded uniformly to a light gray, allowed the developers to advertise their building as the "world's first colored aluminum skyscraper." The ground floor is set in from the facade to reveal the structural frame and forms a darker band, making the building appear to float above its base in the same way as Lever House in New York (Skidmore, Owings and Merrill, 1952).

CA10 Parking Garage

1975, Evans and Evans, Architects. 419 Travis St.

Constructed to serve the neighboring high-rise bank, this concrete parking garage accommodates 300 cars on five floors. Access ramps form two sweeping curves over the sidewalk, boldly expressing their function. These one-way ramps were given generous widths and turning radii, enabling motorists to navigate regardless of an automobile's size. A projecting staircase zigzags up the building's corner, its angled form in sharp contrast with the automobile ramps. The garage included a drive-in bank and a walk-up branch, both with high security, and, separated from them, a bulk currency vault with secure armored-car parking and a tunnel to the bank building. Shreveport architect William S. Evans (1913–1999), who started his firm in 1945, and his son Jonathan M. Evans fashioned a utilitarian structure into a monument.

CA11 Young Men's Christian Association (YMCA)

1925, J. Cheshire Peyton and Clarence King. 400 McNeill St.

This four-story YMCA is typical of the handsome, commodious designs the organization commissioned in the 1920s. The multipurpose building incorporates bedrooms, meeting rooms, and two gymnasiums, all surrounding a tile-decorated courtyard, and a basement-level indoor swimming pool. Designed in the style of an Italian Renaissance palace, the structure has a triple-arched entrance, double-arched windows with central colonnettes along the first story, and square-headed windows on the upper floors. Blue and gold tiles add decorative touches around the entrance and on the two small roofline towers. The YMCA organized a subscription drive in 1923 to fund this center on donated land. J. Cheshire Peyton (1890–1962), who began his career in the office of Edward Neild, was associated with Clarence King from 1925 to 1933.

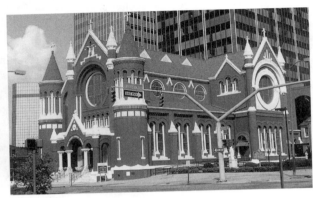

CA10 Parking Garage
CA12 Holy Trinity Catholic Church

CA12 Holy Trinity Catholic Church

1896–1899, Nicholas J. Clayton. Marshall and Fannin sts.

Holy Trinity Church was constructed by northwestern Louisiana's oldest Catholic congregation, which was established in 1856 and acquired this site in 1858. Galveston architect Nicholas J. Clayton produced two designs for this church, one in the Romanesque Revival style and the other Gothic Revival. A modified version of the Romanesque Revival scheme was built. The church has the tightly clustered composition and weighty mural qualities characteristic of Clayton's designs. The pointed gables and the circular twin towers with closely spaced attenuated columns supporting their conical roofs show the influence of Romanesque churches in the Poitiers area of west-central France, but the enormous rose windows on the facade and transept ends are Gothic forms. Clayton's choice of dark red brick with smoothly dressed white stone trim was repeated in his design of 1897 for St. Matthew's Church in Monroe (OU7), although such intense color contrasts had already become unfashionable. Holy Trinity has a short four-bay nave below ribbed plaster vaults, circular clerestory windows, and a triple apse. Most of the colorfully painted interior decoration dates from the 1940s and was retouched in 1984, when the columns were marbleized. The stained glass windows range in date from the 1890s to the 1980s. The altar and carved altar railings are of Italian marble. Edward Neild's firm designed the adjacent rectory in 1928.

CA13 U.S. Courthouse

1993, KPS Group, Inc. 300 Fannin St.

Occupying an entire city block, this four-story courthouse was a project of the KPS Group of Birmingham, Alabama, with Brasfield and Gorrie, Contractors. Shreveport architect Jonathan Evans assisted. The entrance facade, hollowed out of one of the building's corners in order to create a forecourt, has a short first story with square openings and a prominent cornice, above which is a concave colonnade with six fluted, three-story columns without capitals or bases. Behind the colonnade is a dark blue-green glass curtain wall. The courthouse's side walls are equally severe in a grid of dark-tinted glass and precast concrete walls in two colors to simulate granite and limestone. An entablature with stylized triglyphs and metopes encircles the building. The entire effect is severe and somewhat daunting.

CA14 Office Building (Wray-Dickinson Automobile Showroom and Garage)

1913, Neild and Olschner. 308 Market St.

This one-story Beaux-Arts building, a former automobile showroom, has extensive display windows framed by paired fluted Ionic pilasters

and a balustrade faced with white glazed terra-cotta. The elegant entrance portico is carried on fluted Composite columns, and fluted Composite pilasters flank the round-arched door. The building's original use is revealed above the central portico, where a high-relief lion's head grips an axle with winged wheels in its jaws. Wray-Dickinson (later Wray Ford) was founded in 1911; the building housed the car dealership until 1968, when it was sold and converted into a bank. Despite these changes, the interior showroom retains much of its original character, including the plaster ceilings and a large brass and glass chandelier. The building was renovated in the 1990s by Slack Alost Miremont and Associates to serve as their office.

CA15 Texas and Pacific Railroad Terminal

1940. 104 Market St.

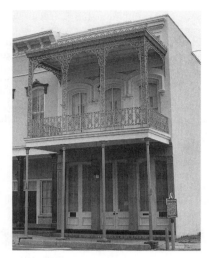

CA16 Spring Street Museum (Tally's Bank)

Formerly the terminal for the Texas and Pacific Railroad, this three-story Art Deco structure with a reinforced concrete frame was one of the first in the nation to have a completely air-conditioned interior. The building's granite masonry blocks are laid with their joints clearly visible, forming an abstract linear pattern across the wall surfaces. Fluted masonry panels between the windows and checkerboard-patterned aluminum window mullions complete the exterior embellishments. Marble facings on the interior walls gave a glamorous aura to travel by rail. The terminal, which closed in 1969, has stood empty for many years but will probably be integrated into planned developments along Shreveport's riverfront.

CA16 Spring Street Museum (Tally's Bank)

1865. 525 Spring St.

Since most of Shreveport's downtown was built or rebuilt during the oil-boom years of the early twentieth century, this nineteenth-century building is an important contribution to its streetscape. Three bays in width, the two-story brick structure is fronted by a New Orleans–style gallery supported on extremely slender fluted cast iron Composite columns and decorated with foliate-patterned wrought iron on the second story. At first-floor level, segmental-arched openings are set between cast iron piers fabricated by the Francis Lurges Foundry of New Orleans. The first floor housed the princi-

pal banking room and a walk-in vault, and the upper floor probably served as office space. Tally's Bank was established by D. L. and Martin Tally, but the uncertain economy of the immediate post–Civil War years made their ownership brief. After it had passed through several owners, mostly banks, the Colonial Dames of Louisiana acquired the building in 1978 and began a restoration for its reuse as a museum. The buildings next door (513–517 Spring Street), similar in style, date from approximately 1880.

CA17 Sci-Port Discovery Center

1998, Slack Alost Miremont and Associates. 820 Clyde Fant Memorial Pkwy.

This hands-on science discovery museum, encompassing 68,000 square feet, was designed to reflect its historic site on the city's original docks. The building's functions, including museum galleries, an IMAX theater, administrative offices, and a gift shop, are organized around an atrium lobby and can be discerned separately on the exterior. Curved to echo the shape of the river, the museum's three-story-high facade of green-tinted glass showcases the exhibits inside. A blue-colored, wavy-edged metal canopy at first-floor level shades pedestrians and window-shoppers. The circular IMAX theater is set within a giant drum and covered by a low dome. The brick drum has accents of cast stone to give texture and a base of rustic

concrete block; the dome has a structural steel frame and a sprayed concrete surface. The museum faces a new riverfront park designed by Patrick C. Moore Landscape Architects and Planners and overlooks Bossier City's high-rise casinos on the opposite side of the Red River. Near the museum, the park is straddled by the enormous ovoid stone piers and steel trusses of a railway bridge that crosses the river, offering a fascinating and different perspective on bridge architecture.

CA18　SporTran Terminal

1984, Evans and Evans, Architects. 400 Crockett St.

Encountering Shreveport's bus terminal in the midst of the downtown high-rise buildings is like finding an oasis in the desert. The tentlike, Teflon-coated fiberglass tension structure extends almost half a city block to shelter fifteen buses and passengers. It also covers a small air-conditioned building that provides spaces for ticket sales, a waiting area, restrooms, and a drivers' lounge. Although these services are necessary, the building interrupts the sweeping space outlined by the tent roofs. When this innovative design was first proposed, it aroused considerable controversy; more than a year and a half went by before the city finally agreed to build it. With their parking garage (CA10), Evans and Evans has given Shreveport two imaginative buildings that represent architectural trends of their time.

CA19　Apartment House (Jefferson Hotel)

1922, Henry E. Schwarz. 907 Louisiana Ave.

This four-story former hotel adjacent to the now-demolished Union Station provided 106 rooms for overnight guests. The building's plain brick walls and rows of identical rectangular windows are interrupted only by oversized cast concrete keystones, although the entrance received greater elaboration with pilasters and egg and dart molding. A canopy extended the entire width of the facade's ground floor to protect guests and shade the shops, café, and dining room located along the building's perimeter. Early photographs show a large freestanding billboard on the roof that served to advertise the hotel. In 1990, the hotel was renovated as a home for the elderly. The old railroad tracks survive next to the building's side elevation on Lake Street. Texas-born

architect Henry Schwarz settled in Shreveport in 1921 after graduating from Columbia University.

CA20　Scottish Rite Temple

1916–1917, Neild and Olschner. 725 Cotton St.

Neild and Olschner designed this ornate Beaux-Arts Masonic temple immediately after their similarly styled B'nai Zion Temple diagonally opposite (CA21). This building is the more complex and flamboyant of the two. Its portico, stretching almost the entire width of the facade, consists of four pairs of fluted Composite columns, a double entablature, and an oversized raised pedimented gable with prominent moldings and dentils. At each end of the uppermost entablature are high-relief sculptures of a double-headed eagle, a symbol of the Scottish Rite of Freemasonry. The multiple projections and recessions of the facade allow for a dramatic play of light across the surfaces, and the various construction materials, including beige brick and glazed terra-cotta, add to the temple's sumptuous effect. Although the building contains four interior levels, it appears from the front to have only two stories; a sub-basement is hidden by the flight of stairs leading to the entrance, and another floor is disguised by the pediment. Interior spaces match the exterior in magnificence. Freestanding columns support the coffered ceiling of the vast marble entrance hall; two sweeping staircases lead to the second-floor auditorium with its gilded proscenium arch. Elaborate cornices and moldings in various patterns enrich surfaces throughout the interior.

CA21　Knights of Columbus (B'nai Zion Temple)

1914, Neild and Olschner. 802 Cotton St.

Equally handsome but slightly more subdued than the Scottish Rite Temple, this former synagogue, constructed of brick and glazed terra-cotta, has a grand Beaux-Arts presence. Its dramatic portico, with four single Composite columns and a simple pediment outlined with dentils, is embellished in its center with a Star of David. Windows and doors are framed with elaborate surrounds that range from pediments to shields. Leading up to the temple is a tall flight of stairs. The interior, designed for a seating capacity of 500, features a partially

new fire stations were included in the plan. This two-story station, replacing an outdated structure, added a lively note to the business district with its bottle-green tile roof and green glazed bricks under the eaves and on the lower walls. Along the side, bas-relief panels ornamented with griffins, urns, and shields fill the spaces between the segmental-arched windows. Cast concrete cartouches decorate the upper walls, and freestanding sculptures of owls perch on each corner of the roof. The ground floor was altered in 1971, when one of the original five fire-engine stalls was eliminated to accommodate modern firefighting equipment. Less felicitous changes to the building include the replacement of the original mullioned windows with large panes of glass and the addition of a large sign with the building's name across the center of the facade. A five-story hose-drying tower at the rear of the station has walls that are battered like the sides of an obelisk and is finished with a denticulated cornice.

CA23 Parking Garage (Andress Motor Company)

1931, attributed to Samuel G. Wiener. 717 Crockett St.

Art Deco ornament modeled in high relief and stylized Ionic piers provided an eye-catching frame for the former Ford car dealership's display windows. Wide bands patterned with upright and inverted triangles fill the wall area between the building's two floors and the zigzag border along the parapet. The mullions of the second-story windows form a checkerboard pattern that is echoed in the grid of square brown tiles along the building's base. These decorative elements have much in common with the former Big Chain Grocery Store on Fairfield Avenue (CA37), designed by Samuel Wiener. R. T. Andress, who established his first automobile dealership in Cotton Valley in 1926, moved to Shreveport in 1931 to sell Fords and Lincolns.

CA24 Strand Theater

1923–1925, Emile Weil. 619 Louisiana Ave.

The Shreveport brothers Julian H. and A. D. Saenger formed the Saenger Amusement Company in 1911. By expanding their holdings to approximately 300 theaters, the company became one of the largest theater chains in the United States. In 1922, the Saengers, in collab-

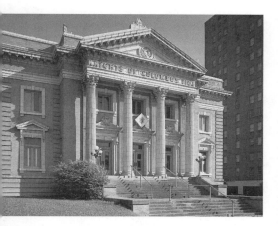

CA21 Knights of Columbus (B'nai Zion Temple)

CA23 Parking Garage (Andress Motor Company), c. 1940

vaulted ceiling and ten two-story-high stained glass windows from the workshop of John La Farge. Paul Heerwagen, who later decorated the Shreve Memorial Library (CA8) and the Strand Theater's interior (CA24), designed the interior painted decorations. Congregation B'nai Zion evolved from Shreveport's first Jewish congregation, founded in 1859. In 1956, when the congregation moved to a new site, the Knights of Columbus took over the building but then vacated it in 1993; the structure awaits a new use.

CA22 Central Fire Station

1922, Clarence King. 801 Crockett St.

In the 1920s, when Shreveport's government initiated a city improvement program, several

oration with Harry and Simon Ehrlich, who owned several theaters in the Gulf states, hired New Orleans architect Emile Weil to design this especially grand theater for their hometown. Weil designed theaters for the Saengers in locations including Cuba, Costa Rica, and Panama; several in Texas; and, in 1926, the Saenger in New Orleans (OR72).

Facing a busy commercial intersection, the Strand Theater has a corner entrance that is dramatically crowned by an openwork cast concrete dome. Reliefs of masks and lyres, niches, and pilasters decorate the brick exterior; inscribed over the large window on the building's Crockett Street facade is the slogan "Progressive Amusement for Progressive People." The theater's oval marble lobby opens into an opulent larger foyer containing a grand staircase. The 1,600-seat auditorium was adorned with depictions of the muses painted by Paul Heerwagen; the gilded ceiling was inspired by a ducal palace in Venice. The Strand featured live performances and movies. The theater was renovated in 1984.

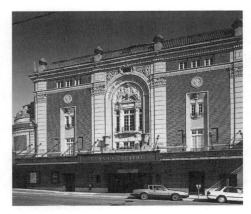

CA24 Strand Theater

visible, as is the delicate blue terra-cotta work high on the facade inside the portico. The central tower and steeple were added in 1972. The three-story education building was added at the rear of the church in the 1940s, and flanking buildings were completed in 1964.

CA25 Shepherd-Blanchard Building

1900. 631 Milam St.

This three-story red brick structure, one of several in this block, is a fine example of Shreveport's late-nineteenth- and early-twentieth-century commercial fabric. Cast iron columns define the ground floor, and the second and third floors have round-arched windows with white surrounds. The building concludes with a decorative flourish, including a corbel table and a pediment-shaped tablet in the center of its decorated brick parapet.

CA26 First United Methodist Church South

1913. 500 Common St.

Occupying a commanding site at the head of Texas Street, acquired by the church in 1882, this structure replaced an earlier church, which the congregation had outgrown. The building relies principally on the site and the simplicity of classical forms for its effect. A six-column pedimented Doric portico fronts the rectangular structure, whose bright red brick walls and contrasting white columns and trim provide the most obvious enrichment. But at close range, the classical decoration along the pediment is

CA27 Commercial Building (Feibleman Department Store)

1923–1925, Samuel G. Wiener of Jones, Roessle, Olschner and Wiener. 624 Texas St.

The size and splendor of this five-story steel-frame former department store testify to Shreveport's booming economy in the 1920s. Both facades of the corner building have rusticated surfaces on the lower two stories, windows with pedimented tops on the first floor, and huge windows (currently boarded up) between three-story-high fluted Corinthian pilasters on the upper floors. On the upper walls just below the first entablature are roundels with representations of the arts. A low attic between that entablature and the projecting cornice has panels with low-relief ornament depicting griffins set between classical vases and foliage. Along the Texas Street facade, the roofline is marked by four large freestanding urns. Sears, Roebuck and Company acquired Feibleman's in 1930 and operated its store there until relocating to one of the new shopping malls in the 1960s. After standing empty for many years, the building was acquired by the state in 2001 to be renovated for use as offices.

CA28 Kansas City Southern Railroad Bridge, Cross Bayou

1890s. 1926, John A. L. Waddell. Cross Bayou and Spring St.

Moved from its original location spanning the Arkansas River, this bridge was reassembled over Cross Bayou in 1926. It consists of a 100-foot-long steel Waddell A-frame truss between two 127-foot-long steel deck truss spans, forming a bridge with a total span of 354 feet. Concrete piers support the span. Engineer John A. L. Waddell (1854–1938) patented this short-span railroad bridge design in 1895. Using a minimum number of prefabricated parts that were pinned together on site made construction cheap, quick, and easy. The two main trusses were connected by top bracing, giving the characteristic "A" shape and solving the stress and vibration problems of short-span railroad bridges. The bridge was used by the Kansas City Southern Railroad until the late 1980s. More than 100 Waddell A-frame truss bridges were built in the United States and Japan, where Waddell had taught engineering in the 1880s, but the only other surviving example known is in Parksville, Missouri. Another Waddell bridge of a different design is a short distance north of Shreveport at Mooringsport (CA72).

CA29 McNeill Street Pumping Station (Shreveport Water Works Company)

1886–1921. Cross Bayou Rd. (off the Common St. extension, Louisiana 3036)

The McNeill Street Pumping Station began operations in 1887 after the city fathers awarded a franchise to New York contractor Samuel R. Bullock and Company. Designed by E. F. Fuller, who was responsible for water systems in other southern cities, the station's brick buildings contained steam-engine pumps that drew water from Cross Bayou directly into the water mains. A filter house was built in 1890, but human-waste contamination of Cross Bayou forced the Shreveport Water Works Company—the private company that then owned the waterworks—to construct a canal north from Cross Bayou to bring uncontaminated water from Twelve Mile Bayou. Ultimately, that also proved unsatisfactory. Shreveport's water supply problems were resolved with the conversion of Cross Lake into a reservoir with a twenty-billion-gallon capacity, completed in 1926. In the mean-

time, complaints about water quality, equipment failures, and poor water pressure for fighting fires were so numerous that the city assumed ownership in 1917.

In the 1920s, the pumping station was remodeled, buildings were enlarged, and the one-story brick High Service Engine Building was added in 1921. This handsome structure has gabled ends, a long roof vent, a curved pediment over the central entrance, and full-height mullioned windows. The 100-foot-high smokestack dates from 1901. In 1980, electric pumps replaced the steam pumps, making the 1921 Worthington Snow steam pump the last steam-powered equipment to deliver water to a major American city. Several original pumps are still at the station, which is to be converted into a museum. The McNeill Pumping Station, designated a National Historic Landmark, offers a rare physical documentation of a municipal water system.

CA30 Commercial Buildings

1907–1917. 824–864 Texas Avenue

Texas Avenue (as distinct from the downtown's Texas Street) was the staging point for the road to Texas in the nineteenth century, and by the early twentieth century, it had become an important commercial street. In its heyday from the 1920s to the 1940s, the blocks numbered from 800 to 1000 were the center of a thriving African American business and residential district. Although some buildings remain on the 900 and 1000 blocks, the 800 block's row of two-story, party-wall brick buildings has survived best. Members of various ethnic groups—African Americans, Italians, Jews, and Lebanese—operated businesses that included a grocery, confectionery, dry goods and furniture stores, restaurants, a pharmacy, and doctors' and dentists' offices. The *News Enterprise*, a weekly newspaper for African Americans, was published in offices at number 854. Although each of the buildings has a different appearance, a unifying classical framework of pilasters, arched openings, cornices with modillions, and parapets gives the street a rare cohesiveness. A scheme has been proposed to restore and adapt the buildings for use as art and music studios—a "living museum" reflecting the area's history. In the early twentieth century, a neighboring residential area known as St. Paul's Bottoms (for its proximity to St. Paul's Church and its location below the ridge

of downtown) was a notorious red-light district. It was shut down in 1917, a week after New Orleans's Storyville district was closed. The neighborhood was renamed Ledbetter Heights in 1984 in honor of Shreveport blues musician Huddie "Leadbelly" Ledbetter.

CA31 **Church of the Holy Cross** (St. Mark's Episcopal Church)

1905, Charles W. Bulger. 875 Cotton St.

The rough-surfaced, irregularly sized dark red bricks that give this church an aura of great antiquity was unintentional, for the architect had planned a stucco finish. The Gothic style in England provided the inspiration for Bulger's design, and Holy Cross is a larger version of his composition for the Episcopal Church of the Good Shepherd (1896) in Lake Charles (CC10.2). A square crenellated bell tower with massive proportions is positioned beside the gabled facade. The broad single nave features a beautiful hammer-beam roof decorated with trefoils and pendants and stained glass windows whose predominant colors are muted greens and yellows. The church originally served the parish of St. Mark, but when that congregation relocated to Fairfield and Rutherford streets in 1954, the Holy Cross congregation was established.

CA32 **Municipal Auditorium**

1928–1929, Samuel G. Wiener of Jones, Roessle, Olschner and Wiener, and Seymour Van Os. 705 Elvis Presley Pl. (formerly Grand Pl.)

Dedicated to the soldiers of World War I, the auditorium has accommodated a wide range of entertainments and public events. From 1948 to 1960, it was the studio used for the *Louisiana Hayride* radio show, known as the "Cradle of the Stars" because of the famous performing artists who got their start there. Among them, in 1954, was the nineteen-year-old Elvis Presley. Samuel Wiener was the lead designer of the auditorium; like his Kings Highway Christian Church (CA53) of 1925, this building is evidence of his fascination in the late 1920s with abstract massing and the decorative potential of brick, terra-cotta, and stone. In 1927, Wiener had visited Venice, where he observed the relationship between architecture and ornament; on his return to Shreveport, his drawings were published in a book, *Venetian Houses and Details*

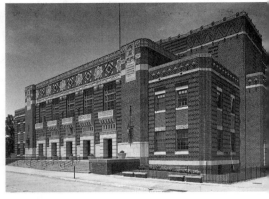

CA32 Municipal Auditorium

(1928). For both the auditorium and the church, Wiener employed simple blocky forms for the body of the building and combined brick, terra-cotta, and cast stone into intricate abstract wall patterns. Wiener demonstrated an exquisite sensitivity to the ornamental potential of brick, varying the brick size, bond, and depth of the mortar, weaving materials, color, and patterns of zigzags and circles, so that each surface is a work of art, yet the total design is unified. The auditorium seats approximately 3,300. Wiener was also responsible for the interior, designing the bronze and etched glass light fixtures, stage sets, and floor patterns. The auditorium is the finest example of Art Deco in the state and is also important because it illustrates the direction Wiener's work was taking in the late 1920s: from historicism, which dominates at the Kings Highway Church, to abstract modernism, nascent here.

CA33 **Logan Mansion**

1897, Nathaniel S. Allen. 725 Austen St.

Shreveport architect Nathaniel S. Allen designed this Queen Anne house for Lafayette R. Logan, a brewer and ice supplier, in the late nineteenth century, when this area was a fashionable and wealthy residential enclave. Although few of the neighborhood's grand turn-of-the-century houses have survived, three houses on this street convey an impression of its former character. The Logan Mansion has a deep wraparound gallery, a porte-cochere, a small upper balcony with horseshoe-shaped arches and spindles, gables with false timbering, and a steep asymmetrical roof. Of the two other Queen Anne houses on this street, the

former Ogilvie-Wiener House (728 Austen), built by Luther T. McNabb in 1896 for hardware merchant W. B. Ogilvie, was purchased by the Wiener family upon completion and was the childhood home of architects Samuel and William Wiener. It features gables, dormers, and a splendid turret but suffered some changes after it was sold and converted into a club in the 1950s. The smaller Christian-Hamel House (740 Austen), built c. 1883 and moved to this site in 1976, has splendid Eastlake details.

CA34 Calanthean Temple

1923. 1007 Texas Ave.

The temple was built by the Court of Calanthe, an African American women's organization that is the auxiliary of the fraternal order of the Knights of Pythias. The Court occupied the fourth floor, and, over the years, the lower three floors have accommodated professional offices, a Masonic lodge, a café, and the Ideal Pleasure Club. The brick and limestone building has a central entrance with a small pediment supported on scrolled brackets. The second and third floors are visually united by double-height Corinthian pilasters framing the windows. A low balustrade marks the beginning of the fourth floor, above which is a tall parapet. A rooftop garden was host to many great performers and musicians, including Cab Calloway and Louis Armstrong.

CA35 Antioch Baptist Church

1901–1903, Nathaniel S. Allen. 1057 Texas Ave.

In 1866, seventy-three newly freed African Americans formed the First Colored Baptist Church, renaming it Antioch Baptist Church in 1871. Nathaniel S. Allen was Shreveport's most prestigious architect when he was selected to design the church. The Romanesque Revival building makes a dramatic impact with its composition of gables and towers and the striking contrast between dark red brick walls and abundant white trim. A square tower incorporating an entrance anchors each corner of the facade; the larger of the two towers, a landmark in the neighborhood, has three stories and a pyramidal steeple with dormers on each face. A short, round, conical-roofed tower nestles beside the tall tower. The church's two principal facades are defined by groups of tall, round-arched windows with a central rose window. Inside is an auditorium space with a fan-shaped

seating plan and the altar on the long wall. A semicircular balcony carried on cast iron Corinthian columns faces the apse. In the late 1990s, the church was restored and its original pressed metal ceiling replicated.

HIGHLAND AND FAIRFIELD

CA36 State Office Building (United Gas Corporation)

1940 and 1952, Neild and Somdal. 1525 Fairfield Ave.

When the United Gas Corporation built this reinforced concrete, air-conditioned office building on its more than six-acre lot, it signaled the neighborhood's transition from primarily residential to commercial. The earliest part of the structure consists of an eight-story central section flanked by two sets of recessed and slightly lower wings; the first has seven stories, and the outer wings have six. Ornament is spare, consisting of piers that rise from the central entrance to the cornice and emphasize the building's height. Even rows of identically shaped rectangular windows project an appearance of efficiency. A landscaped forecourt added a softer note to the design while monumentalizing the building by providing sufficient space to view all of it. Business was so profitable for this oil and gas company that within a few years, a twelve-story addition was constructed at the rear of the original building. Houston-based Pennzoil acquired United Gas in 1965, and shortly thereafter, the building was closed. The state of Louisiana purchased it in 1975 for office space.

CA37 Kalmbach Advertising (Chez Jere)

1928–1929, Samuel G. Wiener of Jones, Roessle, Olschner and Wiener. 1530 Fairfield Ave.

Designed for a hat shop, this delightful little storefront displayed its wares in the round-ended windows on each side of the central entrance. The upper third of the facade is composed of a tall terra-cotta frieze encrusted with stylized anthemia and volutes. The shop's name originally was located just above the windows. This shop was half of a double store; the other half has a lower facade faced with blue, lavender, and green glazed tiles. These two shops were the end of a small commercial strip—only part of which survives and in altered condi-

tion—containing a supermarket, drugstore, beauty salon, laundry, and service station. The row of brick stores, developed by I. Ed Wile for his Big Chain Grocery Company, was one of the earliest in the nation to provide parking spaces in front for automobiles. The walls of the Big Chain grocery next to Kalmbach survive, but its Art Deco facade, similar to the facade Samuel Wiener designed for the Andress Motor Company building (CA23), is covered by the present occupant's metal shopfront. Wiener was not only the architect for Wile's house (CA56) but also, with his brother William, designed additional stores for Wile (CA65).

CA38 **Fairfield Building**

1949–1950, Samuel G. Wiener and Associates. 1600 Fairfield Ave.

Samuel Wiener's design for this four-story office building is a perfect expression of post-World War II aesthetics and technology. The narrow bands of windows that continue uninterrupted around the building's corners suggest that the walls are merely a skin over a steel

frame. Vertical mullions counter the windows' emphatic horizontal expression. At roof level, a metal track placed to carry the maintenance and window-washing cart forms a wide curve as it negotiates the corner. The visual impact of this curved line, repeated only in the rounded corners of the marquee over the off-center entrance, is all the more powerful in contrast to the building's angular composition. Commissioned by the Commercial National Bank, which occupied the ground floor, the Fairfield rented its upper stories as office space.

CA39 **The Fountain Community for Senior Citizens**

1964, Frey-Huddleston and Associates. 1846 Fairfield Ave.

This twelve-story circular apartment house was constructed with federal funds to provide residences for the elderly. In the early 1960s, circular and other nonrectilinear-plan buildings were in vogue, especially after several were featured at the New York World's Fair of 1964. The circular plan was ideal for odd-shaped lots, as

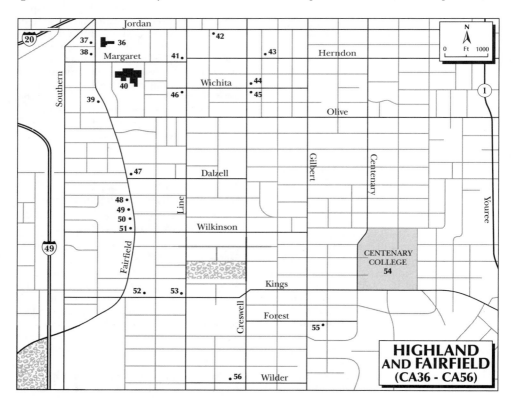

CA37 Kalmbach Advertising (Chez Jere)

CA38 Fairfield Building

here. Additionally, a circular floor plan allowed a maximum number of rooms to have exterior views and saved space by eliminating long corridors and focusing circulation around a central service core. Inevitably, the circular scheme was adopted by hotels, which probably led one architecture journal to comment that this apartment building could pass as a Miami hotel. Some of the residents apparently found the interior trapezoidal spaces a little disconcerting. The curtain-wall facade is composed of alternating rows of large windows, dark red spandrel panels, and metal-railed balconies. A canopy roof with an undulating edge adds to the building's lively exterior.

CA40 **T. E. Schumpert Memorial Medical Center**

1954–1957, Neild-Somdal-Associates. 941 Margaret Pl.

Schumpert Hospital, founded in 1894 by Dr. Thomas E. Schumpert and administered by the Sisters of Charity beginning in 1907, relocated to this site in 1911. Rebuilding and expansion of the hospital in the 1950s were funded in part by the federal government, as authorized by the Hill-Burton Act. The new, ten-story 325-bed facility, designed by project architect Howard C. Sherman for Neild and Somdal, follows a scheme developed in the 1920s and used nationwide. The cruciform plan includes a tall central section for administrative offices, slightly lower wings with regularly spaced windows for the wards, a lower portico with an entrance marquee, and a large forecourt to facilitate vehicular traffic. Exterior walls of blond brick over a reinforced concrete frame and piers faced with a light gray-blue fluted porcelain enamel led hospital journals to praise the building's "clean tailored appearance, reflecting a simple orderly interior." Interiors were designed for durability and easy maintenance, with terrazzo floors and walls covered with structural glazed tile; the lobby was faced with wood and marble. Although additions to the hospital have more than doubled its size, most are to the rear and do not visually disrupt the original scheme. In the 1990s, the hospital's facilities were expanded at a new site, Christus Schumpert, located at 1500 Line Avenue. Designed by Slack Alost Miremont and Associates, this building exhibits the late-twentieth-century preference for the frank expression of structure and materials (brick, glass, and metal) in place of traditional ornament.

CA41 **Shreveport Woman's Department Club Building**

1925, Clarence King. 802 Margaret Pl.

The Woman's Department Club was founded in 1919 (the year Congress passed the Nineteenth Amendment, which granted women the vote) to provide "a center of thought and action for the promotion of educational, literary and artistic growth of Shreveport and vicinity." Among the community activities the club undertook were a study of schools and their standards, establishing libraries, educational programs, and college scholarships, studies of city sanitation and health problems, and concerts. Colonial Revival designs in red brick were popular for buildings devoted to women's activities because of their residential qualities and emphasis on delicate details, and this one follows

the pattern. The corner location of the two-story building allows an entrance portico with paired Corinthian columns on one side and, on the longer side, a similar but larger portico, which serves as a porte-cochere. The gables are outlined as pediments. The architect's plans identify the two principal first-floor spaces as "living room" and "dining room," reinforcing the residential concept. A 441-seat auditorium with a stage fills the second floor and has plaster moldings decorated with dentils, urns, and festoons. When an addition was made to the north side of the club in 1965, the six original dormers were removed.

CA42 **Office Building** (Lewis House)

c. 1898. 675 Jordan St.

By the late nineteenth century, Jordan Street, located in the neighborhood named Highland because of its hilly location, could boast some of the largest and most fashionable houses in Shreveport. Highland is no longer a residential enclave, and today this Queen Anne house, now used as an attorney's office, borders hospitals, medical clinics, and commercial buildings. The wooden house has all the best elements of its style: tall, narrow proportions, asymmetrical angled bays, a three-story turret with hexagonal spire, an Eastlake gallery, and variously cut shingles on the gables and between the first- and second-floor windows. The house was built by a Mr. Ross, who sold it to drugstore owner Thomas Lewis soon after its construction.

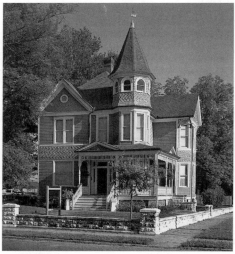

CA43 **Noel Memorial United Methodist Church**

1911–1913, Mathews and Clark. 520 Herndon St.

CA41 Shreveport Woman's Department Club Building

CA42 Office Building (Lewis House)

Founded as a mission church in 1906, this building was funded by cotton planter and oilman James S. Noel and dedicated to his deceased son. The bright red brick church occupies a corner site, with its principal entrance located on the long side of the building. On approach along the street from the corner, the structure appears as a sequence of successively lower stages: tower, gable-fronted section with three-bay entrance, a shorter tower, another gable-fronted section, and the shortest tower. Mathews and Clark employed a similar composition for Alexandria's First Methodist Church (now the Greater New Hope Missionary Baptist Church, [RA2]) in 1907. All the towers at Noel

are finished with gables and corner posts resembling miniature turrets; the corner tower's upper walls have alternating bands of red brick and white stone, a pattern repeated on the piers of the entrance portico. When completed in 1913, the sanctuary was the largest in Shreveport. The interior was reconstructed after a fire in 1925. Although the church has had numerous additions, Mathews and Clark's original composition retains its visual integrity.

CA44 **St. George Greek Orthodox Church**

1938, Nicholas Kalohorites and Joseph P. Annan. 1719 Creswell St.

Formed in 1919, Shreveport's Greek Orthodox congregation held its first services at St. Mark's Episcopal Church (Holy Cross [CA31]) and then in a private house until this church was built. It was named for St. George Church, destroyed by the Greeks in 1917, in the Anatolian city then known as New Ephesus (now Kusadasi, in Turkey). Nicholas Kalohorites of New Ephesus drew up the cruciform plan for the building, and Joseph P. Annan executed the design. The church is quite small, divided into two levels, with the upper serving as the principal space. A steep flight of stairs leads to the tall, round-arched entrance, which almost fills the facade. The brick walls incorporate projecting horizontal courses and polychrome arches, giving a highly animated effect similar to many medieval Byzantine churches. A freestanding tower to the left of the entrance has triple-arched window at its summit. In 1957, an activities center in a similar but less elaborate style was added to the rear of the church.

CA45　Masonic Temple

1937, Theodore A. Flaxman. 1805 Creswell St.

Shreveport architect Theodore Flaxman (1901–1990), a native of Texas, drew upon the sweeping forms of German architect Erich Mendelsohn's work in his design for this temple. Flaxman had toured Europe specifically to see modern architecture in 1931, the same time that his friend architect Samuel Wiener was there. A drawing in Flaxman's travel sketchbook indicates that the Empire Hall in London (1929) was another source for this temple. The facade is composed of horizontal bands of cream-colored glazed brick and glass-block windows that curve inward to a recessed central entrance. Unfortunately, the tall glass-block window over the entrance was replaced in the 1980s by an aluminum-framed plate glass window embellished with a Masonic symbol. Flaxman also provided a landscaping scheme for the temple's forecourt, but only a low concrete retaining wall survives to give any indication of the intended layout.

CA46　Northwestern State University Nursing Education Center (Line Avenue School)

1905, Nathaniel S. Allen. 1800 Line Ave.

Nathaniel S. Allen was seventy-five years old when he won the design competition for the Line Avenue School (originally called the Texarkana Annex School), and it is believed to be his last work. As in his design for the Antioch Baptist Church (CA35), Allen used dark red brick and white trim for the walls. Other than the square-headed first-floor windows, all openings are round-arched and are emphasized by white moldings and keystones that constitute the building's principal ornamentation. The structure is raised on a subbasement, which allows for an imposing flight of stairs to the triple-arched central entrance. The school closed in 1964 after this formerly residential area had become predominantly commercial and had acquired numerous medical facilities.

CA47　John B. Slattery House

1903, Nathaniel S. Allen. 2401 Fairfield Ave.

Allen designed this Queen Anne house for John B. Slattery, a lawyer, businessman, and real estate tycoon who built and owned the Slattery Building (CA4). As one of the oldest mansions on Fairfield Avenue, it helped establish the street's prestigious reputation within this developing and prosperous suburb. The design emphasizes the vertical qualities of the Queen Anne style, with tall windows, crisply angled bays, gables, pedimented dormers, and a pedimented entrance porch with Eastlake decoration. Shingles are used sparingly on the wooden house, mostly as decorative touches in the gables. Today the house is a bed-and-breakfast inn.

CA45 Masonic Temple

CA48 Barret Place

1908, John Y. Snyder. 2524 Fairfield Ave.

Lawyer Thomas C. Barret, who was the lieutenant governor of Louisiana from 1912 to 1916, built this huge Colonial Revival house on land purchased by his father in 1866. The two-story frame house and garden occupy half of a city block. A two-story pedimented portico supported on clusters of three Ionic columns stands in front of the central entrance; sheltered within the portico on the second story is a balcony supported on paired brackets. A single-story gallery on columns and piers covers the left side of the house, and a Palladian window is located on the right side of the ground floor. Although not an elegant design, the house has many features that were fashionable at the time it was built.

CA49 Woolf House

1931. 2530 Fairfield Ave.

By the late 1920s, the Colonial Revival style was no longer the most fashionable choice for a mansion; instead, clients were looking at a wide range of historical options. For some, the French château conveyed the right image, and this house for William Woolf (who was in the oil business) and his wife is a rather severe version, with a steeply pitched, flared, and dormered hipped roof that gives it additional height and presence. The two-story house, wood frame with brick-veneered walls, has a central entrance, a pavilion wing at the left, and a muted color scheme of beige walls and gray roof. In terms of its size, setback from the street, large surrounding formal garden, and distinctive but historically based style, the house is a fine example of what made the Fairfield neighborhood so prestigious in the oil-rich years of the 1920s.

CA50 Walker House

1923, Maritz and Young. 2610 Fairfield Ave.

Lawyer Henry C. Walker, Jr., hired the St. Louis firm of Maritz and Young to design his Mediterranean Revival mansion. The large two-story house, constructed of stuccoed masonry, is impressive in its simplicity and exquisite proportions. Symmetrical in outline, the house has a wide main section, flanked by narrow, slightly recessed two-story wings, one serving as a porte-cochere. Paired chimneys mark the division between the central section and the wings. The entrance to the house is round-arched, as are the porte-cochere and the window on the other wing; the remaining windows are rectangular in outline. A broad Palladian dormer and flanking flat-roofed dormers are cut into the hipped roof of green glazed tile. The roof's slight upward tilt at the eaves adds liveliness to the entire composition. The Lambert Landscape Company designed the garden. Maritz and Young also designed the enormous Tudor Revival house (1923) at 1015 St. Vincent Avenue, now owned by Willis-Knighton Medical Center and used as a meeting facility.

CA51 Files House

1921, Edward F. Neild and Clarence Olschner. 2650 Fairfield Ave.

Designed for John Bennett Files, a law partner of Thomas Barret (CA48), the house is similar to the Walker House in its proportions, size, and Mediterranean flavor; however, it shows what a few details can do to change a building's character. This house has a more countrified appearance, with a front portico of exposed rafters carried on paired Tuscan columns, more elaborate window detailing, and a red tile roof. The architects drew on traditional Louisiana architecture for the hipped roof with a slight break in its pitch and deep eaves to shade the upper walls. Another concession to Shreveport's hot summers is the walls, constructed of brick and hollow tile to provide insulation. The house has a stucco finish, wrought iron entrance doors, and, inside, marble mantels carved in Italy.

CA52 Lawyers' Offices (Roy House)

c. 1925, Edward F. Neild and Dewey Somdal. 912 Kings Hwy.

Oil magnate R. O. Roy's enormous rectangular mansion is modeled on a French Renaissance palace. The two-story brick structure is organized on a tripartite scheme, with a central section covered by a steeply pitched hipped roof. Wings at each end have their own hipped roofs, but these are perpendicular to that of the central section. Round-headed dormers are cut into all of the roofs. Rectangular brick chimneys attached to the outer ends of the facade rise uninterrupted from ground to rooftop, serving as markers of place as much as func-

tional smokestacks. A portico on the narrow side of the house is set on a small terrace enclosed by a balustrade; on the long facade, a driveway leads to a larger central portico. Cartouches, on the area between the first and second floors and along the entablature of the larger portico, decorate the walls. Neild built the house with a structural system capable of carrying two additional floors in case Roy wanted to convert his house into a tall office building.

CA53 Kings Highway Christian Church

1925, Samuel G. Wiener of Jones, Roessle, Olschner and Wiener. 1951–1952, additions to east and tower, Julian Sokoloski. 806 Kings Hwy.

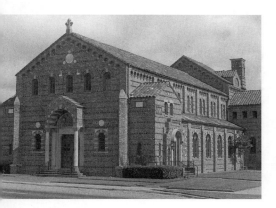

Samuel Wiener's sources for this colorful church included nineteenth-century art critic John Ruskin's writings promoting the polychromy and ornament typical of Venetian Romanesque architecture. The simple cruciform plan gave Wiener the opportunity to pattern red bricks of various shades with dark blue brick and colored marble. Raised horizontal brick bands in a sawtooth pattern, diapering, and blind arcades contribute to the rich tactile quality of the walls. A small gabled entrance portico is supported on four columns with Byzantine block capitals, and red pantiles cover the roof. Exhibiting as much character as the exterior, the interior has a powerful, almost primitive quality. The six-bay nave, with its short square piers, an alternating round-arched arcade and transverse arches of brick and stone, huge plain impost blocks substituting for capitals, and an exposed timber-frame roof, is dimly lit from small paired clerestory windows, creating an atmosphere of mystery. The tower

to the rear of the church, although part of Wiener's original scheme, was constructed in 1951. Additions to the church since 1951 are sympathetic to, but clearly distinguishable from, the original building.

CA54 Centenary College

1908, with many additions. 2911 Centenary Blvd.

Centenary was formed from a merger in 1845 of two institutions: the College of Louisiana, founded in 1825 in Jackson, Louisiana (EF9), and Centenary College, a Methodist institution established in 1839 in Brandon Springs, Mississippi. In 1908, Centenary relocated from Jackson to a rolling, wooded forty-acre tract of land then south of Shreveport's city limits. This is a pretty campus, with a ravine and arboretum at its center featuring Louisiana and southern plants. Enrollment at this liberal arts college, which first accepted women in 1895, was slow at first but picked up in the 1920s. The three-story, red brick Jackson Hall, constructed in 1908, was the first building on campus. Other notable early buildings include the Art Deco Haynes Memorial Gym, of red brick (1936), and the outdoor amphitheater and bandshell (1936). After World War II, when student enrollment increased dramatically, Centenary added several new red brick structures that drew on Colonial Revival forms, including a science building, Mickle Hall (1949), by Peyton and Bosworth and the Meadows Museum of Art (1975). Of a more contemporary style for their time are the cafeteria (Bynum Commons), with a curved glass wall, by J. Cheshire Peyton and Associates (1956), and Samuel Wiener's 325-seat Marjorie Lyons Playhouse (1956), a reinforced concrete structure with rough-textured brick walls. The Gold Dome, a geodesic dome on a brick base, was built in 1973 to accommodate athletic events. Today, Centenary enrolls almost a thousand students.

CA55 Huey P. Long House

1926. 305 Forest Ave.

Following his election to the Louisiana Railroad Commission in 1918, Huey P. Long moved to Shreveport, where he practiced law until elected governor in 1928. In Shreveport, Long and his wife, Rose, lived in a small house on Laurel Street (demolished in the early 1990s) until they commissioned Rose's brother

Gilman McConnell, a building contractor, to construct this far more substantial house. In his autobiography-manifesto, *Everyman a King* (1933), Long notes that he built "a modern home in the best residential section of the City of Shreveport at a cost of $40,000." Constructed of stucco over hollow tile, the two-story house is in the Mediterranean Revival style, which was at the height of popularity in the mid-1920s among the upwardly mobile. A small balcony over the entrance has the letters HPL shaped into the center of its iron railing. Opening onto a terrace, the ground floor's large living room was designed for entertaining. Although Long moved to the Governor's Mansion in Baton Rouge in 1928, his wife and children continued to live in this house.

CA56 Wile-Schober House

1934, Samuel G. Wiener of Jones, Roessle, Olschner and Wiener. 626 Wilder Pl.

I. Ed Wile, owner of the Big Chain Grocery Company (CA37 and CA65) and a cousin of Samuel Wiener, hired him to design this modern house. Built the year after experimental houses were displayed at the Chicago World's Fair, Wile's house was widely regarded as a prototype "house of the future," and many people felt free to walk through and inspect it. The Wile family had to hire a policeman to protect their privacy from intruders. The first floor is constructed of dark red brick, but most of the house is of wood stud construction, with wood sheathing and white-painted stucco on metal lath. To prevent cracking, the stucco was divided into comparatively small panels by strips of sheet metal secured to the sheathing to form expansion joints; this system was tried successfully the previous year by Sam's brother William for the Wiener family's weekend house on Cross Lake (demolished). The windows, stock steel casements set in a wood frame, project beyond the exterior stucco surface to give a more waterproof construction. No gutters disturb the pure lines of the flat roof; instead, a cornice flashing forms a guard around the edge of the roof, and two downspouts carry rain to the concrete driveway. This cornice originally was painted bright red, and the window sashes were black. The L-shaped plan allowed for cross ventilation, aided by the wraparound corner windows of the dining room. The living and dining rooms were painted orange and white, and the carpet was olive green.

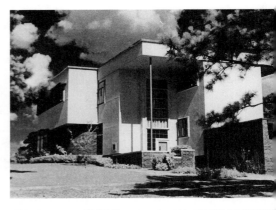

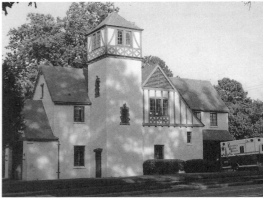

CA58 Samuel G. Wiener House

CA59 South Highlands Fire Station (Fire Station No. 10)

Note: For locations of sites CA57–CA70, see the Shreveport overview map on p. 335.

CA57 Gamm-Mitchell House

1948, Samuel G. Wiener and William B. Wiener. 1 Longleaf Ln.

This house for lawyer Sylvian Gamm was the first of several designed in the 1940s and 1950s, mostly by William Wiener, based on a modular system and what he referred to as a T-shaped plan. In an arrangement designed for the automobile age, the stem of the T forms the carport and entrance court and is integrated with the house by a roof extension. The one-story house has a north-south orientation, with service areas along the north wall and living, dining, and recreation areas on the south facade forming a window wall overlooking the garden. The

house was designed to utilize solar heat in the winter, and a deep extension of the single-pitched roof screens the wall in the summertime. According to the current owner, architect Kim Mitchell, this passive cooling system is such effective protection from sun that curtains are not essential. The exterior finish is wood siding with brick for one end wall. Opposite (2 Longleaf Lane) is the house William Wiener built for his own family in 1951, also based on a modular system with a T-shaped plan and a north-south orientation to take advantage of solar heat. Many of the Wieners' post–World-War II designs (houses, including both of these, schools, and commercial buildings) were featured in such journals as *Architectural Forum* and *Architectural Record*, as were their designs of the 1920s and 1930s.

CA58 Samuel G. Wiener House

1937, Samuel G. Wiener. 615 Longleaf Rd.

Samuel Wiener had already designed several modern houses (see CA56) before undertaking one for his own family. Consequently, his experiments with new materials and construction methods, spatial organization, and climatic concerns in relation to the aesthetics of modernism are most successfully resolved in this house. It has a structural system of reinforced concrete, steel, and wood, faced with brick on the front lower floor and white stucco panels set in metal expansion joints on the upper. At the rear of the house, the south side, the entire attic space extends 8 feet to shade the walls and windows. A two-story entry porch is supported on a single column of industrial steel pipe, painted bright red. Space is equally hollowed out diagonally opposite on the garden side of the house, where a two-story screened porch provides an open sitting room, above which is a summer sleeping porch. Interior colors and their placement emphasized the planar qualities and abstract forms of the house. The entrance hall was painted white, pale green, and bright blue as it turned the corner into the pale green and white living room; the dining room was yellow with a white ceiling; the kitchen was white with a red ceiling; the principal bedroom was a bluish green color with a white ceiling; and the children's rooms were much brighter, in red, yellow, and blue. All the furniture was custom-made. Both front and rear gardens were designed to complement the house: a formal arrangement of low curved walls and a di-

agonal path at the front, and fuller, curved planted areas creating picturesque informality at the rear.

The house remained in the family unaltered until Mrs. Wiener's death in 1987. New owners painted the entire house white, including the brick ground floor, which gives the structure a false streamlined effect. Further, it violated a fundamental principle of Wiener's work—truth to materials—for the brick walls have lost their natural color and texture. Like most of Wiener's designs, this house was featured in the leading architecture journals of the day.

Longleaf Road was laid out in the 1930s to achieve a parklike character; free of curbs and sidewalks, it was to be a pedestrian promenade, permitting limited use by cars. Like Longleaf Lane (see CA57), it became a street favored by architects for their own houses; in addition to the Wieners', these include John Walker's (number 711; 1950s), which has an informal ranchlike composition, and Richard LeBlanc's (number 737; 1970s), influenced by Sea Ranch in California in its clustered geometric composition of wood siding laid vertically and diagonally. Bill Wiener, Jr., designed the Weiss House (number 641; 1966), which shows the influence of Louis Kahn, specifically in its curved wall, a typical feature of his work.

CA59 South Highlands Fire Station (Fire Station No. 10)

1929, Henry E. Schwarz. 763 Oneonta St.

This miniature Bavarian castle was one of the new fire stations constructed during Shreveport's program of civic improvements initiated in the 1920s. The design allows the hose-drying tower to be integrated into the body of the building rather than standing separately, as was typical of most fire stations. Imitation half-timbering on the gables and around the top of the tower adds an additional picturesque note to the cream-colored, stuccoed-brick structure. The contrast between the building's medieval fairy-tale appearance and the glossy metal fire engines increases the visual delights of both.

CA60 Haddad House

1929. 985 Thora Blvd.

This unusual and beautiful house was built for George Haddad, a Lebanese immigrant and dealer in oriental rugs. Constructed entirely of

beige brick, the two-story house incorporates architectural forms that derive from his homeland. The 10-foot-deep, single-story front gallery has pointed-arched openings outlined by decorative brick patterns, and the windows opening onto the second-story bedrooms have lobed tops. Pointed-arched windows and entrances occur throughout the house, including the library door, windows to the sun porch and living room at the side of the house, and in the entrance hall. The roof is covered with red tiles. Living- and dining-room doors are of hand-carved mahogany, as is the front door, which is also inlaid with ceramic tile. The library features an arched ceiling and a 12-foot-high mahogany bookcase wall. A curved brick wall that extends from the house along the entrance drive bears the address and, in blue and white tiles, the Arabic inscription *Al Barouk*, the area of south Lebanon that was Haddad's birthplace. On the iron railing of the staircase inside the house is an inscription in Arabic that translates, "The essence of wisdom is the fear of God"—a paraphrase of Proverbs 1:7.

CA61 James O'Brien House

1950, Richard J. Neutra. 4740 Richmond Ave.

When businessman James O'Brien and his wife, Nora, decided to build a modern house, they first approached Frank Lloyd Wright and visited him at Taliesin. They chose Neutra instead after seeing a cover story on him in the August 15, 1949, issue of *Time* magazine and finding him to be more flexible in his ideas than Wright. The single-story house was built behind existing trees to seclude it from the street. The wood-frame house has exterior siding of redwood laid in contrasting vertical and horizontal patterns and a flagstone chimney. A binucleate plan, with the principal bedroom separated from the guest bedroom area by a flagstone pathway, ensured the owners' privacy while accommodating visiting married children and grandchildren. The two areas are visually united by roof overhangs. The living room, which has a redwood ceiling, white-plastered walls, and a flagstone chimney, extends onto a screened porch overlooking the garden.

CA62 Flesh-Walker-Guillot House

1936, William B. Wiener. 415 Sherwood Rd.

This modern house for geologist David Flesh is more boxy and abstract in shape than Wiener's other houses, which tend to be linear in plan. Functional and formal concerns are combined in the handling of the ventilation space between ceiling and roof, which is articulated as a deep cornice extending well beyond the walls. It protects the interior from the sun and contributes to the building's abstract qualities of plane and line. The windows project from the wall surface and wrap at the corners, making clear that the walls are weightless skins. Emphasizing that point, the structural columns are visible inside the upper windows. The single counterpoint to the horizontal emphasis of roof and windows is a narrow vertical window that indicates as well as illuminates the interior stairwell.

CA63 House

1955, Samuel G. Wiener and William B. Wiener. Not visible from the street

Widely published in major architectural journals and the recipient of an *Architectural Record* Award of Excellence, this house, including its landscaping and furnishings, was entirely designed and selected by the architects. Emphasizing privacy, the stone wall on the narrow end faces the street, and the house stretches back under a single gently pitched roof into its pine-tree-filled lot. The plan features a large combination living-dining room with a freestanding fireplace and a separate family room, both of which have glass walls overlooking the terrace and swimming pool. The bedrooms are at the far end of the house. Identical materials were used inside and out; at the owners' request for a rustic quality, the architects used Colorado stone and mahogany for the walls and gray-green slate for the floors.

CA64 Southwestern Electric Power Company (SWEPCO)

1993, Morgan, Hill, Sutton and Mitchell. 6400 Line Ave.

The curved facade of this two-story, steel-frame, beige brick and limestone office building provides space for a landscaped plaza in front. Six short columns define the entrance area, above which is a narrow horizontal band of windows. The building's other windows are square, and those on each side of the entrance are "boxed" in projecting frames. A glass pyramid illuminates the central two-story lobby. The design

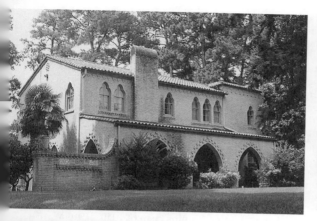

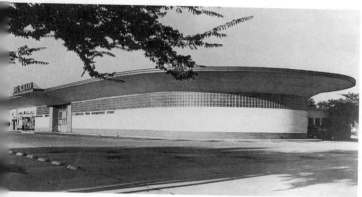

CA60 Haddad House (above, left)

CA62 Flesh-Walker-Guillot House (above, right)

CA65 Commercial Building (Big Chain Store), photo 1941 (left)

successfully blends elements from a variety of architectural sources dating from the second half of the twentieth century. Unfortunately, since the building was converted into a phone center for the power company, its attractive plaza no longer gets the public use it deserves.

CA65 **Commercial Building** (Big Chain Store)

1941, Samuel G. Wiener and William B. Wiener. 3950 Youree Dr.

Extensive display windows were considered unnecessary for this supermarket, which was set back 70 feet from the street in order to provide an ample and easily accessed parking lot. In order to capture the attention of potential shoppers from across the parking lot, the architects produced a dynamic, streamlined structure with a curved end. The store owner appreciated the solid lower wall, which could be used for interior display and self-service. Above it, a continuous band of five rows of glass blocks provided natural interior light during the day, augmented by fluorescent tubing, and at night allowed interior lights to illuminate the parking lot. The ribbon of light also provided a dramatic horizontal beacon to attract customers. Extending the entire length of the building, a 12-foot-deep steel and stucco canopy with a slight upward curve, painted red on its outer edge, shaded the walls and protected shoppers as they walked from their automobiles to the store. Altogether the 225-foot-long, 110-foot-wide store had one mile of display shelves in an air-conditioned interior without internal supports. The largest retail store in Shreveport when it was built, it included a luncheonette, a deli, a bakery, a newsstand, and five checkout counters.

I. Ed Wile founded the Big Chain Grocery Company in Shreveport in 1922 and dominated the supermarket business in the city for approximately forty years. Wile realized the importance of aesthetics as well as convenience,

so his markets were designed, many of them by the Wiener brothers, as striking visual landmarks in their neighborhoods. Convenience for motorists was also high on Wiles's agenda; his stores were among the first in the nation to provide parking space in front (CA37). When this store was built, the parking area was criticized as being unnecessarily large, but it soon proved an astute design decision. In 1957, the Wieners designed the row of small shops that was added to the Ockley Drive side of Big Chain. They are united under a single zigzag canopy; some still survive, although in poor condition. The store closed in 1970 and is now used for different commercial purposes.

CA66 Louisiana State University, Shreveport

1967, with many additions. 8515 Youree Dr. (Louisiana 1)

Louisiana State University at Shreveport opened in 1967 on a 200-acre site at what was then the outskirts of the city. The Shreveport firm of Somdal-Smitherman-Sorensen-Sherman-Associates developed the master plan, which featured vast parking lots on its perimeter for the initial enrollment of commuting students. The centerpiece of the campus is an open-ended quadrangle landscaped with a formal arrangement of terraces, paths, and plantings, to which allées of crepe myrtle trees have been added. Different architecture firms were hired to design the individual buildings, which show slight variations within a modern, flat-roofed idiom.

CA66.1 Caspiana House at the Pioneer Heritage Center

c. 1856. North corner of campus, between Youree Dr. (Louisiana 1) and E. Kings Hwy.

This small Greek Revival wooden house is one of several historic vernacular structures relocated from elsewhere in northwestern Louisiana to form the Pioneer Heritage Center. Caspiana House, which was moved here in 1977 from a flood-prone site near the Red River, is a type of house common in southern Louisiana but rare in this sector of the state. Raised on brick piers, it has a front gallery and is two rooms wide at the front, with a loggia between two cabinets at the rear and end chimneys. The site also contains a restored log dog-

trot house (c. 1860) from Bienville Parish, a small two-bay shotgun house with Eastlake trim, a small wooden store, and a log cabin.

CA67 Woodlawn High School

1959, William B. Wiener. 7340 Wyngate Blvd.

In the 1950s, almost forty new schools or additions were built by various architecture firms in Caddo Parish for the baby-boom generation. Woodlawn was the third in a series of handsomely designed schools by William Wiener employing the popular finger plan and given a north-south orientation in consideration of the southern climate. Although not the first in this group (Linwood Junior High of 1949, at 401 W. 7th Street, takes that honor), Woodlawn is the least altered or obscured by additions and thus it most authentically demonstrates Wiener's scheme. The finger plan consists of separate parallel blocks; at this school, the courtyard space between the blocks is landscaped with shade trees. The three-story classroom block has a curtain wall of glass and blue spandrel panels, and its first floor is recessed under the upper stories to provide a covered walkway. Samuel Wiener, Jr. designed the eye-catching abstract murals, mostly blue in color, on the narrow end walls facing the street. The one for the classroom block is a mosaic, the gym-auditorium wall is painted, and the bus shelter is decorated with glazed brick.

CA68 Palomar Motel (Palomar Hotel Courts)

1938. 3975 Greenwood Rd.

In the typical courtyard arrangement for early motor courts, or tourist camps, as they were called, the Palomar is composed of two rows of detached cottages that face one another across a central access area. Although the cottages vary slightly in size, they are identically fashioned in a Moderne style with smooth white stuccoed walls, three front steps between curved frames, and wraparound steel-casement corner windows. The original tile roofs have been replaced by asbestos shingles. Some of the cottages have attached enclosed garages, which, along with the steps in front of the entrance doors, add to the impression of a suburban street in miniature. The Palomar Motel was constructed in 1938 by the owner after his distressing experience in a nearby motel, where

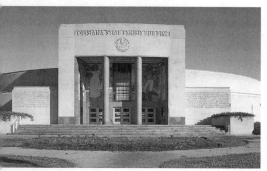

CA68 Palomar Motel (Palomar Hotel Courts)

CA69 Louisiana State Museum (Louisiana State Exhibit Building)

both the fan and radio were broken. A room cost $2.50 when the motel opened. Although there is no documentary evidence, Bill Wiener, Jr., thinks his uncle Samuel Wiener may have been the motel's architect.

CA69 **Louisiana State Museum** (Louisiana State Exhibit Building)

1937–1938, E. F. Neild, D. A. Somdal, and E. F. Neild, Jr. 3015 Greenwood Rd.

Shreveport's State Fairgrounds opened in 1906, and by the late 1930s, when this PWA-funded exhibit building was added, there were more than twenty-three buildings, including stock barns, exhibit spaces, and a football stadium. This reinforced concrete frame structure consists of a two-story, flat-roofed rotunda and rectangular one-story wings housing additional museum space and an auditorium. The rotunda's upper story is recessed and incorporates a central circular courtyard 116 feet in diameter. Since all of the windows face into the

courtyard, the exterior wall is an unbroken smooth surface of buff-colored Indiana limestone. Two elliptical dark pink granite columns, without bases or capitals, form an in-antis portico. The building's monochrome severity sets off Conrad Albrizio's colorful frescoes on the portico's upper walls. Northern and southern Louisiana are portrayed as monumental classicized figures engaged in industrial and agricultural pursuits. Inside, are a lobby faced with rose-colored marble and curved walls designed for dioramas.

Within the fairgrounds and near the State Museum is the Agriculture Building, a large shedlike structure with a handsome Beaux-Arts facade of brick, featuring a triple arch and a pedimented gable. Diagonally opposite the museum is the three-story Fair Park High School (3222 Greenwood Road), with a central square tower topped by a dome, which was designed in 1928 by Edward F. Neild and Dewey Somdal.

CA70 **Velva Street Fire Station** (Fire Station No. 8)

1925, Clarence W. King. 3406 Velva St.

Clarence King, Shreveport's city architect and designer of Central Fire Station (CA22), was responsible for this two-story stuccoed brick station in the Spanish Colonial Revival style. The fire truck enters the station through a wide projecting portico that is embellished with a curved parapet, relief decoration of garlands, and iron lamps. Exterior walls are covered with a rough-finished stucco; the roof is of red tile and has two tiny chimneys. Several small additions to the building were made over the years, and in 1953, a hose-drying tower and a large perpendicular extension were attached to the rear.

Shreveport Vicinity

CA71 **Northwood High School**

1966–1967, Bill Wiener, Jr., of W. B. Wiener, Morgan and O'Neal. 5939 Old Mooringsport Rd. (corner of Louisiana 1 and Louisiana 538)

Planned for 1,200 students drawn from a wide area north of Shreveport, the school is large in size and monumental in appearance. According to architect Bill Wiener, Jr., it reflects the influence of Le Corbusier's government buildings at Chandigarh, India (1957–1965), which

he had recently visited. United under a single roof, the three-story school is divided into three major units (academic block, auditorium, and gym) by breezeways, which provide sheltered and airy outdoor areas. The outer units, the academic block and the gym, have a rectangular form, while the auditorium, located between them, has a curved silhouette. Entrance to the school is provided on two levels: at ground level, buses drop off students, the means by which the majority of them arrive; pedestrians use a ramp and a bridge that spans the bus-loading roadway. Because the school is air conditioned, the design breaks from the popular finger plan, although the north-south orientation is retained. A separate cylinder-shaped concrete structure to the right of the main block contains the heating and cooling units. Materials used in construction include bright red brick and concrete. Some changes have been made since construction, including the insertion of an elevator in one of the breezeways and the removal of vertical *brise-soleil* fins on the gym windows.

Mooringsport

CA72 Caddo Lake Bridge

1914. J. A. L. Waddell and John L. Harrington. Louisiana 538

Designed by renowned bridge engineers and built by the Midland Bridge Company of Kansas City, this 575-foot-long, single-lane steel bridge consists of seven spans resting on concrete piers. The third span from the south was designed to lift vertically, so that oil drilling equipment, particularly Gulf Oil Company's pile drivers, could pass into Caddo Lake, the site of numerous oil rigs. A steel tower at each end of the lift span carried the pulley cables and counterweights. In the summer of 1941, just before America's entry into World War II, Generals Dwight Eisenhower and George Patton came here to direct practice maneuvers, which involved capturing the bridge and bombing it with sacks of flour. The bridge was open to vehicular traffic until 1989, when it was replaced by a nearby concrete bridge.

Oil City

At the beginning of the twentieth century, Oil City, on the banks of Caddo Lake, was just a railroad flag stop in the midst of an area of small farms. In 1904, when oil was discovered in what became known as the Caddo–Pine Island oil field, the railroad stop was transformed almost overnight into Oil City, a boom town of shacks and tents. Even the hotel was a tent.

CA73 Caddo–Pine Island Oil and Historical Society Museum (Trees City Office and Bank Building)

1910. 200 S. Land Ave.

In 1983, this three-room wooden building, formerly the headquarters and bank building for the J. C. Trees Oil Company, was moved to this site from Trees City, fifteen miles away. It is one of the few remaining buildings in the state connected with the oil industry's early years. The building is quite simple, resembling a house more than an office, with a pitched roof, gables, and an encircling gallery with slender turned columns. Trees City was founded in 1909 by wildcatters Joe C. Trees and Mike L. Benedum to house their workers and protect them from the insalubrious influence of the saloons, gambling dens, and brothels common to oil boom towns. Trees City provided a church, dance pavilion, and school to encourage families rather than single men to settle and work there. In 1911, when Standard Oil purchased the local oil leases, Trees City became its company town. Today, all that remains of Trees City is a clearing in the woods and a few houses. The former headquarters building is maintained by the Caddo–Pine Island Museum, formed in 1969, which offers exhibits on the area's oil industry.

Vivian

Vivian was laid out adjacent to the Kansas City, Pittsburgh and Gulf Railroad (later the Kansas City Southern) tracks in 1895 by the Arkansas Townsite Company. It is believed that the town was named for a railroad official's daughter. The railroad became of critical importance to the area's oil industry for shipping its products from the Caddo Lake Field, and Vivian prospered accordingly.

CA74 Kansas City Southern Depot

1921. 100 N. W. Front St.

Vivian's one-story depot of brownish-red brick shows the influence of the Arts and Crafts movement. It has a pitched red tile roof with deep eaves supported on large decorative brackets and small gables in the center of each of the long facades; on each side of the gables and at the building's corners, round-topped, stucco-decorated piers extend above the roof line. Inside were segregated waiting rooms, one on each side of the ticket office, and a freight section. The depot now houses a museum with exhibits on the railroad and oil industry.

Bossier Parish (BO)

Bossier City

Bossier City was laid out in 1883 on James and Mary Cane's Elysian Groves Plantation, located on the Red River's east bank opposite Shreveport. Known as Cane City until 1907, the town was renamed Bossier City in honor of Pierre-Evariste Bossier, a Louisiana general and congressman. Early-twentieth-century oil discoveries in the region nourished Bossier City's economy at first; then, in the 1930s, the U.S. government established a military airport in the city. In recent years, Bossier City has benefited from the gambling industry, and high-rise casinos have been constructed along the riverfront.

BO1 Bossier City High School

1938–1940, Samuel G. Wiener of Jones, Roessle, Olschner and Wiener. Coleman Ave. (between Mansfield and McCormick sts.)

Samuel Wiener used a 9-foot modular system to unify this PWA-funded school's five distinct but related units: classrooms, gymnasium, auditorium, cafeteria, and manual training shop. The clarity of the plan and the geometric simplicity of the forms show the continuing influence of Bauhaus ideals on Wiener's work. The three-story linear classroom block was sited to receive light from the north and south, considered the best illumination for classrooms and for the southern climate; on the building's southern face, 2-foot overhangs shade the horizontal bands of windows. In the postwar years, the Caddo Parish School Board adopted this orientation for schools built in Shreveport, many of which were designed by Samuel Wiener and his brother William. The auditorium's stepped outline reflects its internal spatial organization. A 104-foot-long exposed reinforced concrete entrance canopy serves as a shelter for school buses and shields children from inclement weather. The school was featured in architecture and education journals. Samuel Wiener served as advisory architect to the School Building Division of the Federal Bureau of Education.

BO2 Library and Classroom Building, Bossier Parish Community College

1986–1987, Kelly and Doughty Architects. 2719 Airline Dr. North

Bossier Parish Community College has its origins in Airline Community College, which was established in 1967. The design of the library and classroom building, with its exposed structural columns, light gray glazed brick, glass block, grid of window mullions, metal railings, and monochrome coloration, was inspired by Richard Meier's buildings, notably his High Museum in Atlanta (1983). The entrance is set between two curved forms, the larger encompassing the library and the smaller outlining a student lounge. A double-height lobby, with a balcony and an interior ramp, also echoing Meier's museum, gives an air of monumentality to this structure.

BO3 Barksdale Air Force Base

1930–1933, Captain Norfleet Bone. Barksdale Blvd.

Bossier City was chosen as the site for an Army Air Corps air squadron in 1928 on a 20,886-acre tract of land acquired for the purpose by the city of Shreveport, which presented it to the federal government as an inducement. Landscape architect Captain Norfleet Bone designed the complex, which was dedicated in 1933 and named for World War I airman Eugene H. Barksdale of Mississippi. Norfleet laid out the site with a wide, tree-lined boulevard, one-third of a mile in length, leading to the base headquarters. Residential streets curve outward in a wing-shaped pattern from both sides of the boulevard. In keeping with the military's practice of selecting styles thought to be indigenous to an area, Norfleet described his design as resembling "a little French village," despite the fact that French precedents are not characteristic of northern Louisiana's architecture. Although the base headquarters building is much larger, it resembles New Orleans's Ursuline Convent (OR30), and the officers' houses are characteristic of French and Mediterranean residential architecture, with cream-colored stuccoed exteriors, red tile hipped roofs, and round-arched entrance porticoes. Barksdale includes a chapel, a fire station, and various recreational facilities. Aircraft hangars separate the administrative and residential sections from the runways. When built, Barksdale was said to be the world's largest military airfield; its three-mile-long landing area could accommodate the simultaneous takeoff or landing of 100 airplanes.

Barksdale has continued to play a major role in the nation's defense strategy. Some of the U-2 spy planes that flew over Cuba during the Cuban missile crisis in 1962 were based at Barksdale, as were fighter and nuclear bomber wings during the Cold War. In the 1990s, Barksdale's bombers participated in raids over Iraq and Kosovo; its fleet of B-52 bombers has given Barksdale the title of "Home of the B-52." A museum on North Gate Road includes fourteen aircraft among its displays.

Benton

BO4 Hughes House

c. 1840, c. 1850. 414 Sibley St.

Moved from its original location in nearby Rocky Mount to Benton in 1995, this dogtrot house is an unusual combination of two regional traditions: the vernacular of the upland South and high-style Greek Revival. The oldest section of the house consisted of a two-room, pegged-frame office building with a four-column pedimented portico. In about 1850, the structure was converted into a residence through the addition of a four-room unit separated from the earlier section by an open dogtrot passage. The front gallery of the earlier section was extended to cover the front of the addition and neatly unite the two. Four of the gallery's nine columns are twentieth-century replacements. The interior wooden walls of the larger room in the 1840 section were left with the rough finish that indicates a wallpaper covering was planned. Walls in the newer section were sheathed in flush boards.

Haughton

BO5 Haughton High School

1940, Samuel G. Wiener. 201 E. McKinley St. (Louisiana 614)

This two-story school was built around a modular, mullion-column framing system that would allow room sizes to be changed merely by moving partitions. Characteristic of Wiener's work from this period, the school's clean-cut design includes a north-south orientation, smooth brick walls, crisp angles, a flat roof, and bands of horizontal windows shaded by overhangs. A single vertical window indicates the staircase, adding a dynamic accent to the rectangular composition. The town of Haughton was established in 1884 as a stop on the Vicksburg, Shreveport and Pacific Railroad.

Red River Parish (RR) and De Soto Parish (DS)

RED RIVER PARISH (RR)

Coushatta

Named after a local Native American group, the town of Coushatta was established in 1865 on the east bank of the Red River and was designated the parish seat in 1871. The settlement became an important riverboat stop for riverboat traffic on the Red, but the town's commercial focus gravitated to the railroad after the Louisiana and Arkansas line came through in 1898. Much of the old town adjacent to the river was lost to the riverbank by a shift in its course and by devastating fires in 1874, 1898, and 1918.

RR1 Red River Parish Courthouse

1928, William T. Nolan. 615 E. Carrol St. (U.S. 84)

This large, Beaux-Arts courthouse with a rectangular plan is constructed of buff-colored brick. The columns, pediment, entablature, and balustrade of the three-story building are covered with a yellowish-cream glazed terracotta. A shallow portico of four Corinthian columns supports a pediment with ornament representing the scales of Justice between festoons; terra-cotta decoration over every window adds to the courthouse's rather festive appearance. A red tile roof and a small dome topped by an urn complete the building.

DE SOTO PARISH (DS)

Mansfield

To a visitor from New Orleans writing in 1860, Mansfield's high elevation (331 feet) offered the advantage of healthful air as well as "blessed exemption from the plague of mosquitoes and good spring and well water." Founded in 1843 as the parish seat for the newly created De Soto Parish, Mansfield at first depended economically on the processing and shipping of cotton. The town profited from rapid expansion of the region's lumber industry after the railroad arrived in the 1880s and from oil after the discovery of the De Soto pool in 1913. A surviving railroad depot, the former Kansas City Southern (1927), now houses parish offices (Polk Street at the railroad tracks).

Mansfield's reputedly healthy location made it the choice of the Methodists in 1854, when they established Mansfield Female College, a pioneer in the education of women. The college closed in 1930, but one of its brick buildings (1856) has been remodeled as a private home. The De Soto Historical Society is housed in the log structure built in 1844 by William Crosby and Jesse Pugh as the parish's first courthouse (Madison and Polk streets). The prominence of the Baptist Church in northern Louisiana is reflected in the size of the domed and pedimented former First Baptist Church (Polk and Jefferson streets), built in 1911 and now converted into apartments for the elderly.

Four miles south of Mansfield is the 177-acre Mansfield State Historic Site (15149 Louisiana 175), which commemorates the important Civil War battles of Mansfield and Pleasant Hill. In 1864, Confederate troops turned back Union forces under the command of General Nathaniel Banks, who sought to take Louisiana and Texas by advancing up the Red River. A museum and interpretive trails record the historic event.

DS1 De Soto Parish Courthouse

1911, Favrot and Livaudais. Bounded by E. Texas, Adams, N. Washington, and E. Franklin sts.

The New Orleans firm of Favrot and Livaudais designed several Beaux-Arts courthouses for Louisiana parishes in the early twentieth century. Some look remarkably alike, and De Soto's obviously served as the model for the Allen Parish Courthouse (1914) in Oberlin (AL1). The design of De Soto's courthouse is based on a theme of three: it is three stories high, and the central section and the recessed wings are each three bays wide. The ground floor is rusticated, and the central portion of the upper part of the facade has large arched windows separated by pairs of Ionic columns. Beaux-Arts details include a small balcony over the central entrance supported on paired consoles, prominent keystones, and a balustrade along the roofline. The courthouse is built of beige brick with details in white stone.

DS2 Post Office

1931, James A. Wetmore, Acting Supervising Architect of the Treasury. 110 N. Jefferson St. (between Texas and Polk sts.)

Built over a subbasement, this Colonial Revival post office has an imposing double flight of stairs leading to its central entrance. Although only one story in height, the post office is a tall building, and thus the proportions of the portico's four Corinthian columns, for example, which extend the full height of the facade, appear too tall for their width and spacing. Also, the pediment is on too small a scale in relation to the composition as a whole. Despite this awkwardness, the post office achieves a certain monumentality by virtue of its isolation from surrounding buildings. A balustrade and a low mansard roof with three large dormer windows complete the composition.

DS3 Mundy-McFarland House

1862. 200 Welsh St. (corner of Water St.)

John Mundy built this house on land purchased by his wife, Ann, in 1862, and their family retained ownership until 1901, when it was sold to Josephus McFarland. Located in an early residential neighborhood close to Mansfield's center, the raised wooden house has a front gallery supported on eight square columns and an entablature decorated with tiny, closely spaced dentils. A wide, low belvedere with scalloped eaves crowns the low-pitched hipped roof, adding a picturesque note to the classical features. A wide central entrance with side lights separated by pilasters opens to rooms in a central-hall plan.

Carmel

DS4 Rock Chapel

1891. Off Smithport Lake Rd. (Louisiana 509, .7 mile south of Carmel)

This tiny chapel on a forested bluff beside Bayou Loupe was constructed by Carmelite friars under the direction of Father Anastasius Peters, pastor of the church at Carmel, for their ministry to the African American population. The friars used the chapel as a religious training place and devotional center and as a school for children during the week. Many local white citizens were opposed to the friars' educational

mission, and in 1897, the Carmelites left the area. The Gothic Revival chapel, which is constructed entirely of roughly hewn native stone held together with mud plaster, has one window on each side and a curved apse. The interior was decorated with frescoes of saints. Although it was abandoned, the chapel survived and was restored twice in the second half of the twentieth century. A few graves line the narrow pathway to the chapel's entrance.

Keachi

Keachi (also known as Keatchie) is a small crossroads community at the junction of Louisiana 5, 172, and 789. The town was settled before the Civil War, when the Greek Revival style was at the height of popularity, and it continued to be favored in Keachi for many more decades. At Keachi's crossroads are a former store (c. 1850) and the Liberty Lodge Masonic Hall (c. 1880), both with Greek Revival porticoes. The town's three churches also employ elements of this style. All of Keachi's buildings are constructed of wood and are painted white.

DS5 Keachi Presbyterian Church

1858. Louisiana 5

The church's Doric pedimented portico was enclosed in the 1890s, and the new facade was given a central entrance with flanking windows, all three with triangular openings at the top. The pedimented belfry was probably added at

DS5 Keachi Presbyterian Church

the same time. The classical theme is carried through to the interior, where the paired pilasters and entablature are attached to the sanctuary wall behind the raised altar.

DS6 United Methodist Church

1879. Louisiana 5

The United Methodist Church has a simpler and more austere design than that of the Keachi Presbyterian Church. Its front facade has two separate but identical pointed-arched entrances, one for men and the other for women, and is outlined with gable end returns that give the impression of a pediment. A belfry at the peak of the gable has a small pointed steeple.

DS7 Keachi Baptist Church

c. 1880. Louisiana 172 West

Greek Revival and Gothic Revival features are combined in this church. The gabled front, small projecting portico, and belfry all have molded profiles and gable end returns. The facade has Greek Revival elements (the portico's gable is expressed as a pediment; narrow pi-

DS6 United Methodist Church

lasters define the corners of the portico and the main body of the church), while Gothic influence is evident in the pointed-arched windows of the side walls. Opposite the church is the site of the Keachi Female College, founded by the Baptists in 1856 and closed in 1912.

North Central Parishes

BAYOUS DORCHEAT AND D'ARBONNE AND THE DUGDEMONA RIVER, flowing into the Red River, drain the gently rolling hills of this region. Bienville Parish boasts Louisiana's highest point, the 535-foot Mount Driskill. The state of Arkansas borders the northern limits of the region. Areas with limestone and ironstone among the red clays and sandy loams provided building material, and the salt domes of Webster and Winn parishes and salt springs in Bienville Parish yielded an important early commodity.

Indian mounds dating from A.D. 300–500 survive in northern Claiborne Parish, and when Europeans arrived in the early nineteenth century, Caddo tribes inhabited much of this region. The newcomers also encountered forests of shortleaf pine, oak, hickory, and maple, made almost impenetrable by a thick mat of underbrush and vines and inhabited by wolves, bears, panthers, and deer. Since waterways were navigable for only part of the year, when water levels were sufficiently high, settlement was slow and widely scattered. Most of the settlers were of Scots-Irish descent, having migrated from the Carolinas and Georgia and from Kentucky, Tennessee, and Alabama. Although some were wealthy slaveholders who brought their slaves with them, others were small farmers. Establishing cotton plantations and farmsteads, they built houses and farm buildings of logs; dogtrot houses were common.

The region first consisted of a single parish, Claiborne, established in 1828 and named for Louisiana's first governor, William C. C. Claiborne. As the population grew, Claiborne was subdivided to create Union Parish in 1839, Jackson in 1845, Bienville in 1848, Winn in 1852, and, after the Civil War, Webster and Lincoln parishes in 1871 and 1873 respectively.

Around 1825, a stage line connecting Monroe with El Paso, Texas, to the west, fostered a number of settlements along its route, catering to traders and migrant

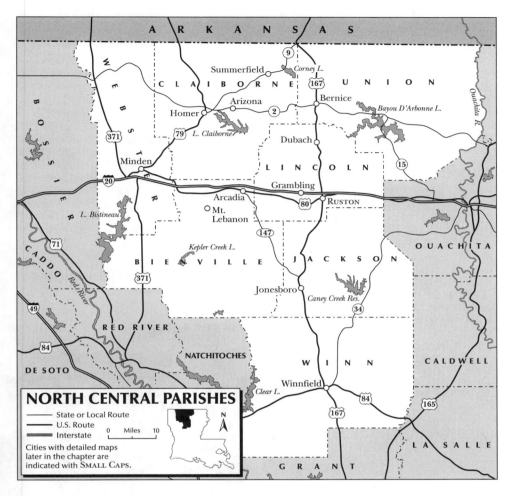

NORTH CENTRAL PARISHES

— State or Local Route
—— U.S. Route
══ Interstate

0 Miles 10

Cities with detailed maps
later in the chapter are
indicated with SMALL CAPS.

families. But in the 1880s, after completion of the east-west Vicksburg, Shreveport and Pacific Railroad (now the Illinois Central), new towns grew along the railroad line, supplanting established ones. Ruston displaced Vienna as the parish seat, and Arcadia supplanted Sparta. Construction of north-south railroad lines further determined new settlements. More recently, Interstate 20 has occasioned another shift; commercial establishments formerly along the railroad corridor now cluster around the freeway interchanges.

Until the arrival of the railroad, the region's economy was based primarily on cotton and cotton processing, but rail transportation enabled the lumber industry to flourish. Sawmills and company towns were set up throughout the forests, and although most of these have ceased to exist, reforestation allows lumber to remain a major industry. Most of the fast-growing timber is manufactured into paper products, as at the vast mill in Hodge (Jackson Parish). Railroad transportation also encouraged expansion in cattle and dairy farming, as well as in vegetable and fruit

farms, notably peaches and pecans; these crops remain important to the local economy. In the 1930s, oil and natural gas drilling boosted the economies of the parishes bordering Arkansas.

Webster Parish (WE) *and Bienville Parish* (BI)

WEBSTER PARISH (WE)

Minden

Founded in 1836, Minden is one of northern Louisiana's oldest towns. It was laid out beside Bayou Dorcheat by Charles Veeder, who named it for his parents' birthplace in Germany. Minden became the parish seat when Webster Parish was created in 1871, and its importance as a regional commercial center followed the arrival of the north-south Louisiana and Northwest Railroad (later the Louisiana and Arkansas) in 1898. The present courthouse (410 Main Street), designed in 1951 by Shreveport architects Peyton and Bosworth, is a four-story, buff-colored brick structure with an unusual concave-shaped entrance preceded by a convex one-story colonnaded portico. Within the portico is a low-relief frieze of stylized figures representing highlights of Louisiana's history.

Minden's commercial district along Main Street consists of two- and three-story party-wall brick buildings dating from the late nineteenth and early twentieth centuries. In the same period, an upscale residential district developed north of downtown along Broadway and its adjacent streets. Handsome turreted Queen Anne houses include the McDonald House of c. 1900 (328 Lewisville Road) and the Fuller House (220 W. Union Street) of 1905, both built of wood. The wooden Fitzgerald-Slaid House (304 McDonald Street), built for lumberman Edward Fitzgerald in 1902, mixes Queen Anne asymmetry and projecting bays with a Colonial Revival porch and pedimented entrance. An Arts and Crafts–inspired house, (c. 1925; 625 Elm Street), combines brick and wood in an expansive composition with low-pitched gables, projecting eaves supported on brackets, and a deep, shady gallery with extended eaves. The house of stuccoed brick in the Mediterranean Villa style, built in the early 1920s for lumberman Joe Ferguson, now rather crisply restored and occupied by the Webster Parish Library

(521 East-West Street), exemplifies the eclectic and picturesque qualities of the neighborhood. The former gas station (306 Broadway) follows the prototype porcelain-enameled, metal-clad rectangular box developed by Walter Dorwin Teague for Texaco in the late 1930s. It has two service bays and a flat projecting canopy that originally sheltered the pumps on an island in front of the structure.

WE1 Holland-Crawford Insurance (Bank of Minden)

1901. 605 Main St.

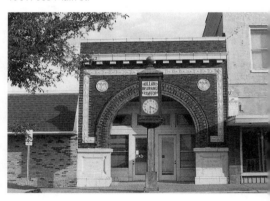

This jewel of a building has a glistening bottle-green tiled facade composed of a single huge round arch framed by a rectangular white terra-cotta frieze. The design was inspired by Louis Sullivan's arched entrances of the 1890s, such as that for the Chicago Stock Exchange, and precedes the small banks Sullivan designed in the Midwest (for example, the National Farmers Bank in Owatonna, Minnesota, of 1907–1908). The voussoirs are made up of interlocked green glazed tiles; for contrast, white terra-cotta is used along the cornice and parapet border and for the pelican-motif roundels in the spandrels. The entrance doors, sheltered deep within the arch, are framed with egg and

dart moldings, while geometric-patterned tiles line the lower sides of this entrance vestibule. Unfortunately, the interior of the bank has been altered, but the original freestanding clock in front of the building still functions. Nearby is the Bank of Webster (704 Main Street), of 1910, a more traditional Beaux-Arts design, with double-height Ionic columns set within the recessed central portico.

WE2 Miller House

c. 1840. 1917, Clarence King. 416 Broadway

At the core of this house is a two-story, five-bay structure, one room deep, with a central-hall plan, built in approximately 1840. In 1905, when J. R. Miller owned the house, it was moved farther back on the lot, and the gallery's original square posts were replaced with columns. In 1917, Miller hired Shreveport architect Clarence King to enlarge the house and upgrade its classical appearance. King added rear rooms to double the depth of the house, enlarged an existing rear wing, and attached a rear sun room. He also replaced the simple gallery columns with correctly proportioned Tuscan columns and entablatures. Inside, King designed a curved staircase for the central hall and added paneled dadoes to the downstairs rooms.

WE3 Minden Presbyterian Church

1923. 1001 Broadway

Built to replace an earlier structure of 1889, this red brick Gothic Revival church has a square corner tower decorated with a blind arcade along its eaves and a short spire. Its steeply pitched gables are ornamented with half timbering, which allows the church to fit harmoniously in its mostly residential neighborhood. Later additions to the side and rear of the church have somewhat obscured the clarity of its original silhouette. The congregation was formed in 1853.

Minden Vicinity

WE4 Germantown Colony

1835. Webster Parish Road 114 (7 miles northeast of Minden, off Louisiana 534)

The communal colony near Minden was established by German immigrant Elisa Mueller (the

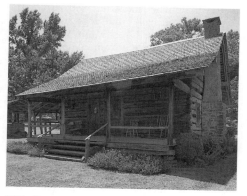

WE4 Germantown Colony, Countess von Leon's house

Countess von Leon), widow of Bernhard Mueller, the self-styled Count von Leon (named for the Lion of Judah). Emigrating from Germany in 1830, where their unorthodox religious views had provoked the government to place them under house arrest, the Muellers and a group of followers made their way to the Harmonist colony founded by George Rapp at Economy, Pennsylvania. They stayed for a couple of years, but after ideological disagreements with Economy's leaders, the Muellers and about forty followers moved to Louisiana, settling first at Grand Ecore on the Red River in Natchitoches Parish. After the count died from yellow fever in 1834, his widow and the approximately thirty-five surviving colony members moved to the Minden area for its healthier climate. They must also have found the landscape of hills and deciduous trees reassuringly like that of their European homeland. The colonists employed local log construction methods for their buildings—a bachelors' hall, a communal kitchen–dining hall, a general store, a school, and several barns, workshops, and sheds. Although the commune disbanded in 1871, a few members occupied the buildings until the last colonist died in 1907.

Two of the colony's original buildings survive: the countess's residence and the communal kitchen–dining hall. The countess's two-room log house has a gallery across the front and a double-pitched gable roof; the larger of the two rooms was wallpapered. Religious services were held in the members' homes in winter and in a grove of oaks in summer. Replicas of the smokehouse and blacksmith shop have been constructed on their original sites. In the

1980s, the O'Bier House (c. 1850), a dogtrot constructed of half-round logs with square notching, was moved from within Webster Parish to this site to save it from demolition. The settlers' cemetery is on a small hilltop nearby, overlooking the colony.

BIENVILLE PARISH (BI)

Arcadia

In 1882, when the east-west Vicksburg, Shreveport and Pacific rail line came through Bienville Parish, it bypassed by about twenty miles the parish seat at Sparta but edged the small community of Arcadia. Consequently, in 1893, parish citizens voted to move their courthouse closer to the railroad, after which the new town rapidly thrived as a center for shipment of the area's cotton and lumber. The extensive freight area within the depot built in 1910 on Railroad Avenue testifies to the size of this former trade. The depot now houses a museum featuring exhibits on the parish's history. Although Arcadia's commercial district has suffered the fate of many small towns in America, where business has moved to the periphery, the town's early-twentieth-century vitality is still evident in Railroad Avenue's two blocks of brick commercial structures, the former hotel opposite the train depot, and the substantial three-story brick Masonic Lodge of 1927 (corner of Myrtle and 1st streets). Louis Simon designed the unornamented, yellow brick post office (1979 N. Railroad Avenue) of 1937, which contains a WPA-funded mural of a cotton-harvesting scene, painted in 1942 by Allison B. Curry. Arcadia's name reflects the popular interest in Greek archaeology and culture at the time it was founded in the early nineteenth century, as holds true for the nearby towns of Athens, Homer, and Sparta. But as in much of northern

Louisiana, the forests, hills, and relatively sparse population made the area attractive to ne'er-do-wells. It was in the hills south of Arcadia that the outlaws Clyde Barrow and Bonnie Parker established their hideout before they were gunned down and killed by six law enforcement officers from Louisiana and Texas rangers in 1934.

Mount Lebanon

First known as the Carolina Colony because of the settlers from South Carolina who established farms here beginning in 1847, the town was incorporated as Mount Lebanon in 1854. It became a major center for Baptist activity following the formation of the Louisiana Baptist Convention at a statewide meeting here in 1848. Five years later, the convention established Mount Lebanon University and an associated college for women. During the Civil War, the university buildings were used as a hospital. Although the university did not successfully recover after the war, it reopened in Pineville (Rapides Parish) as Louisiana College (RA19) in 1906. The first Women's Missionary Society in Louisiana was organized in Mount Lebanon in 1874.

Mount Lebanon's Baptist church (Louisiana 154), built in 1857 and altered by a small early-twentieth-century tower, is typical of the plain, white-painted frame churches in the Greek Revival style built in rural areas of northern Louisiana. Its original pews have a divider bar down the center to create separate seating for women and men. Greek Revival details are also displayed on the town's houses, which are spread out along approximately three miles of Louisiana 154 and 517. Opposite the church is a one-and-one-half-story dogtrot house of c. 1850; later additions include an enclosed central hall above the dogtrot passage, which terminates on the front facade in a balcony set beneath a massive pedimented roof dormer.

Claiborne Parish (CL) and Union Parish (UN)

CLAIBORNE PARISH (CL)

Homer

Homer was founded in 1848 as the site for a new parish courthouse after the one in the town of Athens burned to the ground. The

town's name, like those of other communities in the area, reflects the American fascination with Greek culture in the first half of the nineteenth century, as does the title of its newspaper from 1859 to 1877, the *Homer Iliad*. The town's regional importance as a center for cotton production was boosted when the railroad

came through in 1887. Oil was discovered in the parish in 1919, and by 1940, there were 338 wells in production on the Homer field. The majority of the brick one- and two-story commercial buildings surrounding the courthouse were built after fires in 1876 and 1889, and many date from the 1920s following the oil boom.

CL1 Claiborne Parish Courthouse

1860. Courthouse Sq.

Appropriately for a town named after a Greek poet, the parish courthouse is an almost square two-story peripteral Greek Revival temple—northern Louisiana's only example of this southern Louisiana type. Constructed entirely of brick and covered with white stucco, the courthouse carries an octagonal cupola in the center of its low-pitched pyramidal roof. The walls and all the columns rest on square bases placed directly on the ground, without a basement or podium. The entablature is unadorned; the courthouse achieves its presence through size and simplicity rather than ornamentation. A 1964 renovation altered the original interior.

CL2 Ford Museum (Hotel Claiborne)

1890. 519–521 S. Main St. (corner of W. Main St.)

The second floor of this former hotel is faced with colorfully painted metal pressed into designs of double pilasters between windows and geometric-patterned bands on a prominent cornice. The hotel's name is inscribed on a

CL2 Ford Museum (Hotel Claiborne)

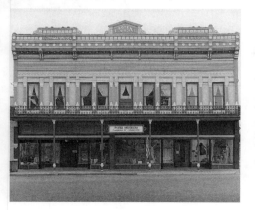

pedimented tablet. A gallery supported on attenuated cast iron columns shades the large windows of the ground floor. Planter and nursery proprietor A. K. Clingman from Arkansas built the hotel. Restored in 1982, the building gives this small town a lively, cosmopolitan air.

CL3 Homer National Bank

c. 1921. W. Main St. (between S. and N. Main sts.)

Flanked by lower side wings, the bank's central section takes the form of a single triumphal arch—a popular formula for small-town banks at the time. The entrance is tucked under a large arch that is carried on slender fluted columns. A prominent entablature is finished with a row of anthemia, and the building concludes with a blind balustrade. Low-relief sculptures of eagles serve as capitals for the shallow pilasters that frame each end of the facade. The bank makes a sophisticated Beaux-Arts foil to the sturdy Greek Revival courthouse that it faces.

Arizona

Arizona was a thriving cotton community in the years before the Civil War, and at its conclusion, local farmers cooperated to build a cotton mill. The venture soon failed, however, because of the lack of transportation such as a railroad for shipping the mill's product. A square single brick chimney, approximately 50 feet tall, survives to mark its existence.

CL4 Arizona Methodist Church

c. 1880. Louisiana 806

The white-painted frame church, one of the few remaining buildings of this once much larger community, has a simple rectangular shape. Its classical ornament is equally restrained, consisting of friezes and gable returns on both facades and pilaster corner boards on all four elevations. A small pyramidal bell tower was added to the roof at a later date. Constructed by builder Doss Pennington, the church is a good example of the rural type that was once widespread in northern Louisiana hill country.

Summerfield Vicinity

CL5 Alberry-Wasson Homeplace

c. 1860. Off Louisiana 9 (1.5 miles south of Summerfield)

One of Louisiana's few surviving log dogtrots, this structure is remarkable for its fully developed second story with its own dogtrot passage. The second story is not readily apparent, as it is obscured by a massive pitched roof that extends to encompass the front gallery. Originally the second floor was accessed by a double staircase from the front gallery. Constructed of half-round logs, the interior walls are sheathed in random-width horizontal boards. The front windows were unglazed and covered solely by board-and-batten shutters. In its isolated wooded setting, the house still seems to belong to the time of its construction.

UNION PARISH (UN)

Bernice

Bernice was founded when Captain C. C. Henderson extended his Arkansas Southern Railroad southward from El Dorado in 1899, auctioning lots on the land bordering the tracks. Rail service terminated in 1984, and in 1992, the small wooden depot (4th and Holly streets) of c. 1899 reopened as the Bernice Depot Museum. Bernice's houses reflect the turn-of-the-century styles popular when the town was founded. The Reeder-Garland House (701 Cherry Street), built in the Queen Anne style in 1902 for the town's doctor, features a spired octagonal turret and Eastlake gallery. In the Colonial Revival style, the J. W. Heard House (605 Cherry Street) of 1904 has its gallery columns grouped in twos and threes. Both of these houses, along with others in Bernice, were constructed by builder Jacob T. Crews.

UN1 Lindsey Bonded Cotton Warehouses

c. 1915–c. 1925. Holly, 1st, and 2nd sts.

These six wood-frame cotton warehouses, varying in size from 10,000 to 17,000 square feet, are a rare historic vernacular building type. Privately owned, the warehouses stored cotton purchased by the United States government from growers throughout the South to await more favorable market conditions. Cotton prices were notoriously unstable, as was evidenced in 1920, for example, when the price of cotton per pound fluctuated between 42 cents and 13.5 cents. Originally there were seven structures, but one was demolished in the 1990s because it had deteriorated so badly. Located near the railroad line, the rectangular warehouses have low-pitched monitor roofs; under the present tar-paper covering, their walls consist of rough flushboards. Double doors on the structures' narrow sides open to interiors marked only by simple wooden support posts and exposed truss systems. Floors are of concrete. The warehouses were in use until the 1950s, when fifty new, metal-sided warehouses were built to the east of the historic structures. At that time, the stored commodity was surplus grain. One of the historic warehouses is now used for community activities, and adaptive reuse possibilities are being investigated for the others.

UN2 Bernice Civic Clubhouse

1938. 700 E. 4th St. (Louisiana 2)

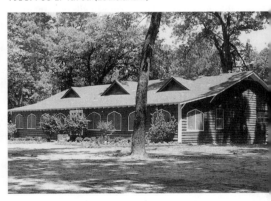

Located in Oakhurst Park and sponsored by the Bernice women's organization, the Civic Clubhouse is a one-story frame building sheathed in rough circular-sawn boards. Ogee-arched windows illuminate the enclosed front gallery; an ironstone chimney is located at the center of the rear elevation, and three wide, gabled dormers articulate the roof. The interior is equally rustic in appearance, its wooden ceiling and wallboards left unpainted in the large meeting room and ancillary spaces. In plan, the clubhouse is similar to drawings by the Monroe firm of J. W. Smith and Associates, titled "A Civic Clubhouse for Bernice, Louisi-

ana." The principal difference between the existing clubhouse and the one shown in Smith's drawings is the latter's Colonial Revival exterior elevation with a pedimented portico. A rustic aspect was popular at this time for small-town clubhouses; moreover, the clubhouse as built was less costly to construct than the proposed version would have been and suits the rural nature of its surroundings. In addition to Civic Club activities, the building was used for many of Bernice's social events because the town lacked other facilities.

Bernice Vicinity

UN3 Alabama Methodist Church

1895. Louisiana Alternate 2 (approximately 5 miles west of Bernice)

In its simple rectangular plan, pitched roof, and white-painted wooden exterior, this church is typical of the rural churches constructed throughout northern Louisiana. But here the play of contrasts between the vertically emphasized architectural forms and the horizontal wooden siding and square-headed side windows is particularly attractive. A square tower centered on the facade has an open belfry and a steeple; at its base, the entrance is emphasized by a steeply pitched gable molding. On the opposite wall, a pair of doors flank the altar. The interior is quite simple, although the diagonal placement of the boards on the side walls and behind the altar provides a dynamic quality that similar churches lack. The plain box pews are probably original. The church's founders came from Shelby County, Alabama. Gravestones and markers in the cemetery at the rear of the church date from the 1850s.

Lincoln Parish (LI)

Ruston

Ruston owes its existence to landowner Robert E. Russ, who, in 1883, donated 640 acres of land to the Vicksburg, Shreveport and Pacific Railroad on the condition that its engineers survey and plat a town and build a station. Russ began to sell town lots, setting aside space for a courthouse, a school, two churches, and a cemetery. Seeing better opportunities for profit in the new railroad town, merchants immediately transferred their businesses from the parish seat of Vienna, five miles to the north of Ruston, and in 1884, Ruston was proclaimed the new seat of justice.

Ruston experienced a second boom in 1901, when the north-south Arkansas Southern rail line (later the Chicago, Rock Island and Pacific) made the town an important railroad junction and commercial center. Only one east-west line operates today, but the path of the former tracks is visible in Railroad Park. Two depots survive, although both have been put to different uses. From the VS&P line is a large rectangular frame structure with a pitched roof, built c. 1900 (N. Vienna Street at the railroad), and from the north-south route is a gable-ended brick depot (corner of N. Monroe and Mississippi streets) dating from the early twentieth century, now renovated for use as a bank.

Ruston's commercial downtown, adjacent to the railroads, maintains its early-twentieth-century character, with two-and three-story brick buildings and restored brick street paving. An upscale residential district developed immediately north of the downtown has large houses that inventively mix Queen Anne and Colonial Revival elements, as seen on Trenton, Vienna, and Bonner streets. A prominent example is the two-story T. L. James House (504 N. Vienna Street), built in 1884, which acquired its colos-

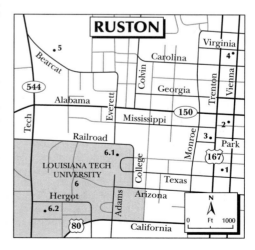

sal Tuscan pedimented portico in a remodeling of 1926. From 1892 to 1905, an annual Chautauqua was held at Chautauqua Springs, two miles north of Ruston, but none of the buildings—including the hotel and 2,000-seat auditorium—survive. Louisiana Tech University, opened in 1895, now provides the educational and cultural resources for the region. The Dixie Theater (210 N. Vienna Street), built in 1928 as the New Astor, has been renovated for shows and community events. The brick building has a stuccoed facade and a V-shaped marquee crowned by a neon star.

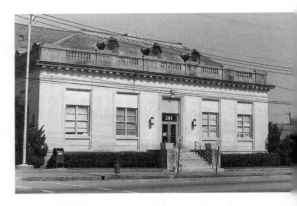

LI1 Lincoln Parish Courthouse

1949–1950, Neild and Somdal. Bounded by Trenton, Texas, Louisiana, and Vienna sts.

The courthouse's bright salmon-pink brick walls and lively asymmetrical composition of boxlike units exude postwar optimism. A four-story central section with a recessed, asymmetrically located entrance is flanked by lower, differently sized wings. In true postwar style, the building rejects all but essential ornamentation; only its name is spelled out in raised letters above the entrance doors. The building's aesthetic lies in its uncompromising functionalism, the abstract geometry of its forms, its color, and the rhythmic composition of plain rectangular windows across its surfaces. The lobby is a disappointingly bland rectangular space.

LI2 Old Post Office

1909, James Knox Taylor, Supervising Architect of the Treasury. 201 N. Vienna St.

Despite some alterations, the Old Post Office remains the most sophisticated design in Ruston. The reinforced concrete structure is faced with limestone and capped by a shallow cornice with a row of modillions and a balustrade. Bull's-eye windows ventilate the low mansard roof. Although the original casement windows of this one-story building have been replaced by smaller metal windows and their transoms filled with masonry, the shallow moldings that surrounded them survive to convey the fine proportions of the original design. The lobby was totally remodeled in 1963 when the building was converted into a multipurpose federal building; it is now used for parish business.

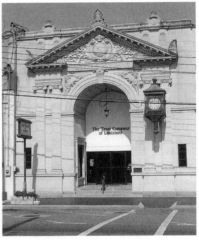

LI2 Old Post Office

LI3 The Trust Company of Louisiana (Ruston State Bank)

LI3 The Trust Company of Louisiana (Ruston State Bank)

1910. 107 N. Trenton St.

The bank's facade is designed in the form of a monumental triumphal arch, with paired pilasters on each side and topped by a broken pediment filled with swirling foliate ornament and cartouches. Anthemions mark each angle of the pediment, and half shells highlight the roofline. The entrance door, deeply recessed within the arch, and the bank's interior date from a 1955 remodeling. Established in 1890, the Ruston State Bank was the first banking company between Monroe and Shreveport.

LI4 Lincoln Parish Museum (Kidd-Davis House)

1886, with additions. 609 N. Vienna St.

Captain Milton B. Kidd purchased this house in 1886, probably while it was still under construction, and his family occupied it until 1921. As his family grew, so did the house; the only visual details of the 1886 construction are the shallow-arched windows and the front door with its transom and side lights. Additional changes occurred when Robert W. Davis, a founder of the Davis Brothers Lumber Company, acquired the house and engaged Monroe architect William King Stubbs (1909–1986), who undertook the last major remodeling in 1938, replacing the gallery's Doric columns and adding the Chippendale railing along the roofline, which reinforced the Colonial Revival appearance of this central-hall residence. The house, said to be the first in Ruston to have indoor plumbing, was donated to the city in 1975 and is now a museum.

LI5 Ruston High School

1939, J. W. Smith and Associates. 1968, library, Smith and Padget. 900 Bearcat Dr.

Set on a high ridge of land and accessed by way of several flights of stairs, this Art Deco structure of beige brick commands attention. Its siting and deep U-shaped entrance forecourt create a spatial tension that reinforces its dramatic effect. The forecourt, however, was not formed until 1968, when the projecting library wing on the right was added to the original L-shaped building. Because the addition echoes the original in design and materials, the school appears to date from one building campaign. An auditorium occupies the projecting wing on the left side of the forecourt. The central classroom block has a taller square tower at its center, and above the entrance doors are narrow panels with figural reliefs representing the arts and industries. Large zigzag reliefs set in vertical panels decorate the tower's upper walls. The entire effect is almost formidable, suggesting an abstract interpretation of a medieval college. Such a severe interpretation of Art Deco was a trademark of J. W. Smith's designs in the 1930s, as seen in his numerous courthouses in Louisiana. Smith's earlier (1931) design for the University of Louisiana at Monroe (OU18) is perhaps a precedent for the Ruston school.

LI6 Louisiana Tech University

1894, with many additions. College St. and Louisiana Ave.

Founded in 1894 as the Louisiana Industrial Institute and College, Louisiana Tech was located on land donated by Francis P. Stubbs, a lawyer, planter, and state senator from 1876 to 1879. During the 1930s, an almost 60 percent increase in the college's enrollment prompted a wave of new building. These structures are among the oldest on campus, as none of the original buildings survive. Keeny Hall (originally named for Governor Richard Leche but renamed in 1939 after he resigned and was imprisoned) was designed in 1936 by Weiss, Dreyfous and Seiferth and Neild, Somdal and Neild. Its red brick Colonial Revival style was popular for college buildings during the 1920s and was already present on this campus in the former library (LI6.1). Six PWA-funded buildings were added in 1940; of these, Howard Auditorium (now the Performing Arts Center) was designed by Neild, Somdal and Neild. The university continued to add buildings during the second half of the twentieth century.

LI6.1 Visual Arts Building (Prescott Memorial Library)

1926, Neild, Somdal and Neild. Keeny Circle

The former library is one of only two remaining structures that predate the 1930s building campaigns. Constructed of red brick, it consists of a central block with pavilions at each end that are placed at right angles. All three units have gabled parapets. The central block has almost identical front and rear facades, with large round-arched windows with small panes and scrolled pediments over the entrance doors. A cupola originally crowned the center of the building but was removed in the 1940s, as was a balustrade along the roof ridge. The library was named for Colonel A. T. Prescott, who made the original donation of books.

LI6.2 Institute for Micromanufacturing Research

1996, Morgan, Hill, Sutton and Mitchell. Tech Dr. and Hergot Ave.

This two-story research and teaching facility posed unusual design challenges for the

Shreveport architects. The building needed to accommodate laboratories for newly developed scientific processes, a lecture hall–media center, areas where the science faculty could interact on a more informal basis, faculty offices, and work stations for graduate students. The kinds of research activities taking place, in such fields as lithography, metrology, and micromanufacturing, required the building to be vibration-free and to have climate controls that limited variation in temperature to two degrees plus or minus and in humidity to 5 percent. The architects describe their solution as a "clean box." But with its curved red brick and glass walls, it is a lively box in a late-twentieth-century version of modernism. To the right of the glass-faced entrance, a curved wall outlines the lecture hall; the smaller, rounded unit on the left encloses administrative spaces illuminated by a horizontal window band. A two-story wing houses faculty offices, as its regular rows of windows suggest, and stretching behind these are the laboratories. With its pitched roof and red brick, the design also pays heed to the stylistic character of the campus, although the bricks for this building range from dark to light shades of red in order to animate the wall surfaces.

Ruston Vicinity

LI7 James Residence

1978, E. Fay Jones. 286 Woodvale Dr. (1 mile north of Louisiana 146 and 167)

Located on a private road and nestled in a wooded vale, the house stretches horizontally into its surroundings, emphasizing shelter and privacy. Characteristic of Arkansas architect Fay Jones's work is his insistence on the expressive and contrasting qualities of natural materials: a wood-shingled roof and a combination of wood and stone for the walls. Jones acknowledges the influence on his work of Frank Lloyd Wright's ideas about the interchange between nature and architecture. These are readily apparent in the relationship of this house to its site, as well as in its composition and details, such as the geometric light fixture marking the driveway entrance. The interior reflects Wright's preference for horizontally flowing spaces and the reiteration of exterior construction materials.

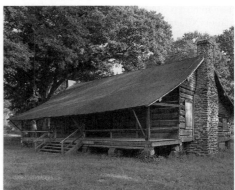

LI6.2 Louisiana Tech University, Institute for Micro-manufacturing Research

LI8 Autrey House

Dubach Vicinity

LI8 Autrey House

1849. Louisiana 152 (1 mile west of Dubach at intersection of Louisiana 151)

Absalom Autrey built this large four-room dogtrot after arriving by wagon train from Selma, Alabama, in 1848. The house measures almost 46 feet in width and is constructed of square-notched, half-round logs with hewn joists; the interior walls are planked. Each of the end walls has an exterior chimney, one constructed of irregularly sized pieces of local ironstone and the other of brick. Two rooms on one side of the dogtrot passage were a bedroom and a bed–living room, and on the other side were a kitchen and a bedroom. In the end walls are windows covered with wood shutters.

Around 1900, the gallery roof was lowered and the rear gallery enclosed with board-and-batten siding. The roof, originally wood-shingled, is now metal. A ladder on the back gallery gave access to the sleeping loft and was later replaced by stairs. In addition to housing Autrey's family of fifteen children, the structure was also used for boarding teachers from the nearby Autrey school and as a meetinghouse for the local Primitive Baptist church. Restored in 1992, the house is open to the public. To the rear is a small cemetery containing the graves of Autrey and his two wives.

Grambling

LI9 Grambling State University

1905. College Ave.

Charles Philip Adams (1873–1961) founded the university, which began as the North Louisiana Agricultural and Industrial School in 1905. Born in Brusly (West Baton Rouge Parish) in 1873, Adams studied at Booker T. Washington's Tuskegee Institute. Under Adams's leadership, the school opened in the small community of Grambling with seven faculty members and 152 African American students in grades one through ten. In 1919, the school began to offer teacher training and was renamed the Lincoln Parish Training School. It was funded largely through private sources until 1932, four years after it was accepted as a state institution. In 1940, the school became a four-year college and finally, in 1974, achieved university status. Although most of the Grambling campus consists of late-twentieth-century structures, it in-

cludes five PWA-funded buildings designed by J. W. Smith and Associates in 1939, including a two-story red brick classroom-administration structure with a central cupola and an auditorium-gym.

LI9.1 Charles P. Adams House

1936. 549 Main St.

Located just south of the university campus, the Adams House was originally constructed as a one-and-one-half-story frame building, with the upper half story formed from a large pent dormer. Sometime after 1950, the upper story was cosmetically altered on its end walls, so that the house now appears to be a two-story structure. A gallery extends across the first floor of the front facade, and there are two end-wall brick chimneys. Adams retired as president in 1936 and lived in this house until his death in 1961. The house he occupied while president was destroyed by fire.

Grambling Vicinity

LI10 Camp Ruston Prisoner-of-War Buildings

1942. 2776 Louisiana 150 (1.6 miles west of Grambling)

Only two structures remain of the more than 200 that formerly made up this 770-acre internment camp, the Ruston Alien Internment Facility, or Camp Ruston, as it was generally known. Since most World War II military facilities were designed for short-term occupancy, to be de-

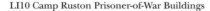
LI10 Camp Ruston Prisoner-of-War Buildings

molished after the war, these two buildings are rare survivors of an important historic type, even though it is believed that they housed U.S. Army personnel rather than war prisoners. Placed about 50 feet apart, the rectangular one-story wooden structures are located toward the rear of the Ruston Developmental Center, which now occupies the site. Both structures have undergone minor alterations, including the enclosure of end-wall doors and some windows. Built by the T. L. James Company of Ruston, the camp was completed in December 1942, but because there were not enough prisoners to put it to its intended use, the first occupants were trainee recruits for the Women's

Army Corps (WAC). The first prisoners, from German Field Marshal Erwin Rommel's Afrika Korps, arrived in August 1943. At its peak in October 1943, Camp Ruston accommodated 4,315 men. When these internees were moved to other camps, Camp Ruston housed Italian prisoners and non-German nationals who had joined or been impressed into the German army. Many POW camps were located in the southern states because the climate precluded the need for heating the buildings. Camp Ruston closed in June 1946. An archaeological survey of the camp in 1994 revealed its dimensions and noted that the prisoners had made attempts at landscaping around their barracks.

Jackson Parish (JA) and Winn Parish (WI)

JACKSON PARISH (JA)

Jonesboro

First known as Macedonia, Jonesboro was renamed in 1900 for its founder, Joseph Jones, who settled in the area around 1860. It is a small town dominated by the courthouse, constructed with PWA funds in 1939 to a design by J. W. Smith and Associates in collaboration with H. H. Land, Sr., both of Monroe. Similar to Smith's courthouses in Concordia, Caldwell, and East Carroll parishes, it is a four-story blocklike Moderne structure, with a few bands of sawtooth and cross-patterned ornament. The courthouse is surrounded by one- and two-story brick commercial structures, most of which were built after fires in the mid-twentieth century. Jonesboro's economy is closely tied to the lumber industry and the nearby town of Hodge, which was founded c. 1899 as a sawmill town by D. E. Hodge and J. S. Hunt. In 1927, the Southern Advance Bag and Paper Company acquired the mill and constructed company housing. Today known as Stone Container Corporation, it is one of the world's largest paper mills, supplied by the region's trees.

WINN PARISH (WI)

Winnfield

Winnfield proudly boasts that it is the "birthplace of three governors." And these were no or-

dinary governors, for two of them (the brothers Huey and Earl Long) were among the most significant, powerful, and colorful in Louisiana's history. All three, Huey P. Long (governor 1928–1932), Oscar K. Allen (1932–1936), and Earl K. Long (1939–1940, 1948–1952, 1956–1960), were born and raised in this small town. The Louisiana Political Museum and Hall of Fame (499 E. Main Street), housed in Winnfield's former Louisiana and Arkansas Railroad depot, displays memorabilia connected with these political figures. A life-size bronze statue of Huey Long stands in Courthouse Square. A bronze statue (1961) of Earl Long (1895–1960) stands over his grave in the Earl K. Long Memorial Park (Maple Street between Valley and Pineville streets).

The parish's political singularity was demonstrated early in its history when, at the outbreak of the Civil War, it refused at first to join the rest of Louisiana in seceding from the Union and briefly claimed itself to be the "Free State of Winn." In the early twentieth century, three railroads made Winnfield an important center for the lumber industry and truck farming. Winnfield was designated the parish seat when Winn Parish was formed in 1852. Both the town and the parish were named for Walter O. Winn, attorney and state legislator in the early 1800s.

WI1 Winnfield Post Office

1935, Louis Simon, Supervising Architect of the Treasury. 201 Bevill St. (corner of E. Court St.)

This red brick Art Deco post office has a three-bay center section and slightly recessed wings. It is unusually well-detailed, with the red brick patterned as fluted pilasters beside the central entrance and the windows, and a light-colored stone used for stylized foliate capitals and a decorative cornice. Other than the glazed brown tiles on the lower sections of the walls, the interior has been modernized.

WI2 Winnfield Elementary School
(Westside Elementary School)

1939, Samuel G. Wiener. S. St. John St. (corner of W. Lafayette St.)

The school's fine proportions, clean lines, flat roof, asymmetrically located entry, and a boldly projecting reinforced concrete entrance canopy eloquently represent Shreveport architect Samuel Wiener's modernist principles. Although the continuous horizontal bands of steel-sash windows, which wrap around the corners of the building, have been covered with metal louvered screens, the single vertical window and the clock over the entrance remain as

they were built. An auditorium attached to the building's rear was provided with a separate entrance for nonschool use. The school has a reinforced concrete frame and light beige brick walls; the cornice is a narrow band of metal flashing. The twenty-six classrooms were originally painted different colors to enliven the interior. Opposite this school is the two-story Colonial Revival Winnfield Intermediate School, designed by Herman J. Duncan in 1928.

WI3 George P. Long House

1908. 1401 Maple St. (corner of Payne St.)

Banker, merchant, and property owner George Long was an important force in Winnfield. Of the several houses he built as real estate investments, his own was the most pretentious. An ample Tuscan-columned gallery curves around the one-and-one-half-story structure with a central-hall plan, and the steeply pitched roof is pierced by a small arched balcony set between two dormers with angled bay windows. George Long was an uncle of governors Huey Long and Earl Long.

Northeastern Parishes

LOUISIANA'S EARLIEST INHABITANTS AND OLDEST CONSTRUC-
tions belong to this region. The Poverty Point complex, dating from c. 1500
B.C. (WC2), is famous. Less well known is Watson Brake, the site of eleven
earthen mounds, reaching a height of 30 feet and arranged in an oval formation,
which date from c. 3000 B.C. The town of Jonesville in Catahoula Parish now occu-
pies the site of the former Troyville Mounds. The region's many rivers and water-
ways provided a means of communication for these early inhabitants, especially the
Ouachita River, which divides the delta land to the east from the pine-covered west-
ern hills.

It is thought that the Spanish explorer Hernando de Soto descended the Oua-
chita River as early as 1542. The first land concessions to European immigrants,
given in 1719, were along the Ouachita River, but the majority of the region's popu-
lation arrived after the Louisiana Purchase. Most were of Anglo-Saxon stock, from
Tennessee, Kentucky, the Carolinas, and Georgia. A few of these immigrants estab-
lished cotton plantations east of the Ouachita, but the majority owned small farms,
raising corn and dairy farming. The isolation of these early settlers also made the
region a haven for outlaws; the notorious James brothers were known to have fre-
quented Delhi (Richland Parish).

Most of the parishes have names that relate to their early history: Ouachita
(formed in 1804), an Indian tribe in the region; Catahoula (1808), an Indian term
for "clear water" or "big lake"; Caldwell (1838), the name of a local family; Franklin
(1843), in honor of Benjamin Franklin; Morehouse (1844), named for Abram
Morehouse, an early settler; Richland (1868), for the fertility of its soil; West Carroll
(1877), after Charles Carroll, a signer of the Declaration of Independence; and La
Salle Parish (1908), after the French explorer Robert Cavelier, Sieur de La Salle.

Railroads had a big impact on the region. In 1861, the Vicksburg, Shreveport

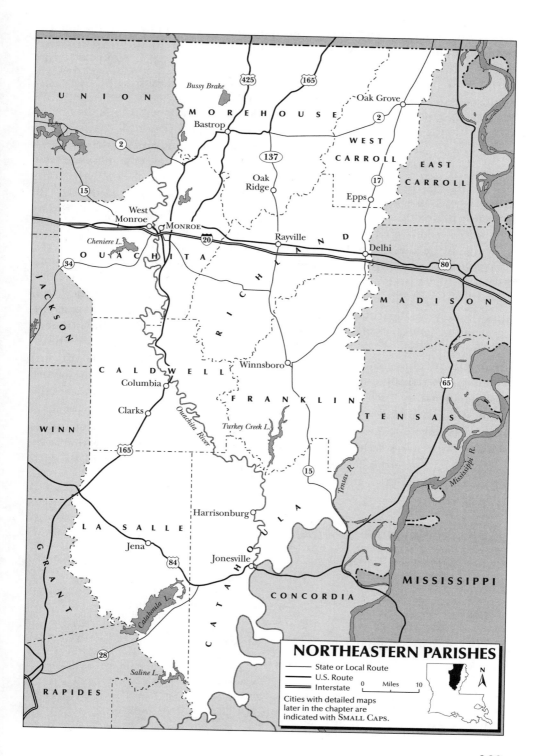

NORTHEASTERN PARISHES

State or Local Route
U.S. Route
Interstate

0 Miles 10

Cities with detailed maps later in the chapter are indicated with SMALL CAPS.

N

and Pacific connected Vicksburg, Mississippi, to Monroe, and by 1884, the line extended to Shreveport and west to Texas. In the 1890s, south-north routes were opened (later becoming the Missouri Pacific). New towns such as Delhi sprang up along the railroads, and others, most notably Monroe, expanded in commercial importance and population. The railroad enabled the lumber industry to flourish. A description of the pine forests by Timothy Flint, who traveled through the region in 1835, makes clear what tempted lumber baron into the region: "I have seen the pine woods of New England, and many others, but this grand and impressive forest is unique and alone in my remembrance. . . . Millions of straight and magnificent stems, from seventy to a hundred feet clear shaft, terminate in umbrella tops, whose deep and somber verdure contrasts strikingly with the azure of the sky." By the early twentieth century, the hardwoods were all clear-cut, but Henry E. Hardtner, who owned lumber mills in La Salle Parish, pioneered reforestation, and pines now supply the many sawmills and paper mills in northeastern Louisiana.

The discovery in 1916 of the Monroe Gas Field, which extended across Union, Ouachita, and Morehouse parishes, set off a wave of new construction in the 1920s and 1930s, especially in Monroe and Bastrop (Morehouse Parish). In the main, these are still rural parishes, composed of small communities that have similar cultural and social backgrounds. The various Protestant faiths dominate the northern parishes of Louisiana, and their rural churches tend to be plain, simple structures, frequently of white-painted wood, with little elaboration. Wood is the principal building material, although commercial buildings in the small towns invariably are one- and two-story brick structures. The largest community, Monroe, possesses the greatest number of structures in recognizable architectural styles, many of them built of imported stone. Several Monroe-based firms played a significant role in shaping the region's architecture, notably J. W. Smith and Associates, who were responsible for numerous civic and institutional buildings, and H. H. Land, Sr., Merl Padgett, William Drago, and William King Stubbs.

La Salle Parish (LS) and Caldwell Parish (CD)

LA SALLE PARISH (LS)

Jena

LS1 La Salle Parish Courthouse

1969, Barron, Heinberg, and Brocato. Courthouse St. (between 2nd and 1st sts.)

With its low height and horizontal emphasis, the courthouse is in harmony with the architecture of this small town. Raised on a sub-basement to accommodate parking and stor-age, the one-story building is surrounded by a colonnade of umbrella-shaped piers of reinforced concrete that support a flat projecting roof. It is a modern version of a classical temple. Openwork ceramic screens protect the glass walls from sun and glare. The courthouse has a terraced and landscaped forecourt, and its central entrance opens onto a spacious lobby with a concrete coffered ceiling. This is a successful design, conveying an appropriate civic monumentality while also reinvigorating the state's strong tradition of classical forms.

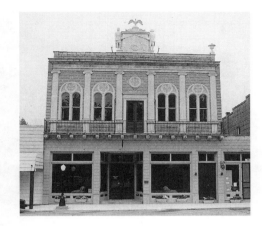

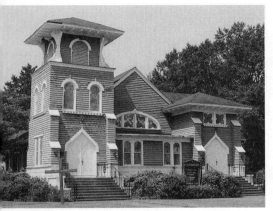

CD1 Schepis Museum (Schepis Building)

CD2 First United Methodist Church

CALDWELL PARISH (CD)

Columbia

One of northern Louisiana's oldest communities, Columbia became a busy steamboat port and trading center on the Ouachita River in the 1820s. River traffic remained important until the 1920s. New building in the downtown followed fires in 1876, 1900, and 1909; most of the one- and two-story brick commercial structures date from the early twentieth century. J. W. Smith and Associates designed the PWA-funded Art Deco courthouse (1938), a three-story building of yellow brick on Main Street, which has a glass and brick addition of 1971 designed by Prentis M. Seymour. Although the river is now hidden from view behind a high levee,

Main Street's party-wall buildings and daytime bustle still communicate a sense of Columbia's earlier history.

CD1 **Schepis Museum** (Schepis Building)
c. 1916. 107 Main St.

It is believed that Italian immigrant John Schepis wished to herald his Italian roots as well as his newly acquired American identity. Centered on the parapet of his former store are nearly life-size concrete statues of Christopher Columbus and George Washington flanking a square tablet embellished in relief with representations of Italian and American flags. Between the flags is a low-relief profile head set in a circular frame, resembling a Roman coin. On top of the tablet is a freestanding sculpture of an American eagle. The two-story building, constructed of cast concrete blocks imitating rusticated stone, resembles a small-scale version of an Italian Renaissance palace. The upper story has a central doorway and double-arched windows decorated with quatrefoils that are evenly spaced between six Ionic pilasters. Small single-story wings flank the storefront. Local legend maintains that Schepis was an architect in Sicily before immigrating to the United States. The building, restored in the 1990s, is now a museum and community cultural center.

CD2 **First United Methodist Church**
1911. Louisiana 165 and Church St.

This attractive wooden church has a square tower on each side of its gabled front, and although they are of different heights, both towers have gently pitched pyramidal roofs with deep eaves supported on brackets. Windows and doors are a catalogue of shapes and sizes, from flat-headed to round, pointed, ogee, and quatrefoils. Trim and moldings are all painted white, creating a lively contrast to the dark green-painted walls. It is believed that the church was modeled on plans brought from Europe by a member of the congregation. While the plans may be European, the expansive lines and decoration of this Arts and Crafts structure are purely American. The interior is a simple hall-like space with a pitched roof. The contractor was Frank Masselin and Son from Monroe. An education annex was added in 1939.

Clarks

CD3 The Oasis

c. 1905. Main St. (Louisiana 845)

This two-story wooden structure was built by
the Louisiana Central Lumber Company for its
newly established sawmill town of Clarks. It
housed a post office, barber shop, and confec-
tionery-drugstore on the first floor and a lodge
hall on the second floor. Refreshments sold by
the confectionery gave the building its name.
Today the Oasis accommodates a post office,
town hall, and library on the first floor and a
lodge hall on the upper floor. The front
gallery, which originally continued along the
building's sides but is now enclosed, provides a
narrow balcony for the second floor. Large
round-headed French windows on the upper
story extend above the cornice in the form of
gabled dormers. The Louisiana Central Lum-
ber Company was founded in 1902 by Missouri
Lumber and Mining Company, which had pur-
chased a sawmill at this site originally owned by

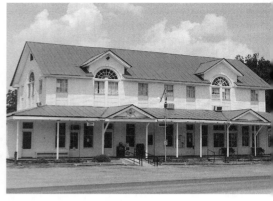

CD3 The Oasis

the Clark family. Louisiana Central became
one of the largest lumber companies in the
state, acquiring one-third of the total acreage
of Caldwell Parish as well as forest lands in ad-
jacent parishes. The mill closed in 1953 and,
other than the Oasis, little survives to tell the
community's story.

Ouachita Parish (OU)

Monroe

By the late eighteenth century, the site of pres-
ent-day Monroe was a well-established ren-
dezvous point for Native Americans and fur
traders. In 1785, Don Juan Filhiol, born in
France but serving in the Spanish army, was
given land grants and a commission by the
Spanish governor, Estevan Miro, to establish a
post in northeastern Louisiana. Filhiol located
it on the east bank of the Ouachita River, which
was named Fort Miro in honor of the governor.
The community's name was changed in 1819 to
commemorate the *James Monroe*, the first steam-
boat to ascend the Ouachita River. With a fast
connection to New Orleans by river now pos-
sible during the eight months of the year when
the river was high enough, Monroe grew as a
processing and shipping center for cotton. The
railroad increased this trade and enabled the
lumber industry to expand. The Vicksburg,
Shreveport and Pacific Railroad, the first line in
northern Louisiana, reached Monroe in 1861
from Vicksburg, Mississippi, and by 1884, the
line extended to Shreveport. Thus, in the late

nineteenth century, Louisiana's northern hard-
wood forests began to be felled, and Monroe
gained numerous lumberyards. The city's early-
twentieth-century Coca-Cola bottling plant was
also located next to the rail line until shipment
by truck replaced rail; the company moved to a
new and much larger facility (1300 Martin
Luther King Boulevard) designed in 1966 by
William King Stubbs.

Along with the lumber industry, the discovery
in 1916 and exploitation of the Monroe Oil and
Gas Field, north of the city, account for Mon-
roe's handsome downtown commercial build-
ings dating from the 1920s and 1930s. Local ar-
chitects as well as prominent practitioners from
elsewhere, such as Walter Burley Griffin of Chi-
cago and Nicholas J. Clayton and Wyatt C. Hed-
rick, both of Texas, also left their mark on Mon-
roe. In the post–World War II era, downtown
Monroe suffered the fate of many American
cities where too many buildings were demol-
ished for surface parking lots. Nevertheless, the
center-city structures that do survive are imagi-
natively designed, and Monroe is an important
center for Art Deco architecture in the state.

OU1 Ouachita Parish Courthouse

1924–1926, J. W. Smith and H. H. Land, Sr. 1967, addition, H. H. Land, Jr. 301 S. Grand St.

The Ouachita Parish Courthouse is the fifth courthouse located on this site, which was donated to the city by Don Juan Filhiol in the early nineteenth century. It has four stories and is constructed of concrete faced with limestone, which is rusticated on the first floor. The Beaux-Arts design features a recessed colonnade with eight fluted Ionic columns across the second and third floors of the two principal facades. An openwork balustrade along the roofline screens the fourth floor, which formerly housed the jail. Extensions in 1966 at both ends of the courthouse blend stylistically with the original building and add to its imposing effect. The entrance lobby retains its original pink-hued buff marble wainscoting, pilasters, and stair balustrades, although such modernizations as dropped ceilings dilute its former monumental qualities. This was Smith's first courthouse commission, and he used a modified version of this design for the Catahoula Parish Courthouse of 1930 (CT1).

On the courthouse grounds is a small cypress structure that may have been built in 1816 as an office for the clerk of the court for the first courthouse, although there is no documentary evidence to confirm this date. The exterior stucco covering was added in the twentieth century. The building currently serves as a chapter house for the Daughters of the American Revolution.

OU2 Commercial Building (J. S. Bloch Building)

1893. 101 N. Grand St.

Situated in Monroe's oldest commercial section, this building is one of the few survivors of the city's late-nineteenth-century economic boom. J. S. Bloch operated a wine, liquor, and cigar business on the ground floor, and a cotton exchange occupied the second floor. Constructed primarily of brick, the store has large display windows set between cast iron piers; the recessed corner entrance is marked by a slender iron column. Pullis Brothers Iron Works of St. Louis, Missouri, manufactured the iron. The row of small-paned windows above the shop windows is not original to the building. Pressed metal pediments adorn the second-

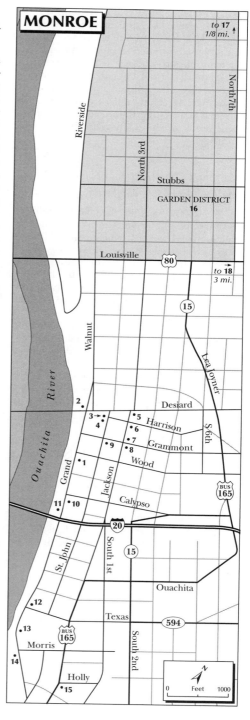

floor windows, and atop the building is a tall paneled cornice. Across Desiard Street, on the 100 block of S. Grand Street, are several similarly designed commercial buildings employing cast iron supports and pressed metal cornices, which also date from the late nineteenth century. However, the colored upper windows of the former Merchants and Farmers Bank (Desiard and Grand streets) were added by a subsequent owner of the building in the twentieth century.

OU3 **Bank One** (Ouachita National Bank)

1920. 130 Desiard St.

This Beaux-Arts bank was the tallest building in northeastern Louisiana until the nearby Frances Hotel was constructed in 1930. The lower three stories of the twelve-story, steel-frame structure are faced with limestone, and the upper walls are clad with brick. Floor heights and pilasters on the lower stories are scaled to align with the columns and entablature of the bank's earlier home, located next to it on St. John Street (OU4). A narrow molding sets off the top three stories and the prominent cornice. The two-story main banking hall inside has a handsome coffered ceiling, as was customary for banks in the early twentieth century. Ouachita Bank's expansion was one result of the economic boom generated by the recently developed Monroe Gas Field.

OU4 **Bank One** (Old Ouachita National Bank)

1906, Drago and Smith. 106 St. John St.

Ouachita National Bank's earlier home is designed in the manner of a Roman temple, featuring a shallow portico with four fluted Composite columns that rise the full height of the two-story building. Anthemia decorate the pediment at its crest and outer corners. Fluted pilasters are set between the round-arched entrance door and flanking windows. The bank's finely detailed facade is one of the highlights of Monroe's business district. The interior has been altered.

OU5 **Bank One** (Central Savings Bank and Trust Company)

1923, H. H. Land, Sr. 300 Desiard St.

This corner building offers unexpected delights, as its two facades present quite different versions of Beaux-Arts classicism. On the narrower entrance front, the portico, which extends just a few inches from the wall behind it, has four two-story columns with papyrus capitals and a heavy entablature. The entablature continues beyond the columns, transforming itself into a foliated frieze that wraps around the corner onto the Jackson Street facade of the building, where it meets an undecorated entablature. In contrast to the entablature on the Desiard Street side, this one barely projects from the wall. Below it, the large windows are divided by equally shallow pilasters. The smooth planar surfaces, on which architectural and decorative features are barely raised, thus appear to be appliquéd rather than modeled. This effect, which is characteristic of Monroe's buildings of the 1920s and 1930s, gives the downtown a unique and coherent unity despite differences in architectural styles.

OU6 **Housing Authority of the City of Monroe** (Frances Hotel)

1930, Wyatt C. Hedrick. 117 Jackson St.

Texas-based architect Wyatt Hedrick designed this eleven-story, concrete-frame hotel for lawyer Carl McHenry, who named it for his wife, Frances. The lower three floors and top floor have brick facing decorated with terracotta shafts, stylized Ionic capitals, and rows of zigzags suggestive of lightning bolts. At the building's summit, the terra-cotta shafts extend beyond the roofline to give additional vertical emphasis. A two-story water tower and beacon on the roof are a Monroe landmark. The ballroom on the top floor was a fashionable gathering place for many years. Like many early-twentieth-century downtown hotels, this one became redundant in the post–World War II period. Fortunately, it was purchased by the city of Monroe and in the 1970s was converted into an apartment building for the elderly. The spacious lobby has terrazzo floors, friezes with stylized foliate decoration, and Art Deco chandeliers. Wyatt Hedrick (1888–1964) was a prominent architect in the South; his firm was at one time believed to be the third largest in the nation. Hotel design was one of his firm's specialties. McHenry was one of the founders of Delta Air Service, the predecessor of Delta Airlines.

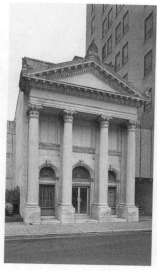
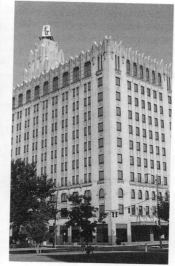
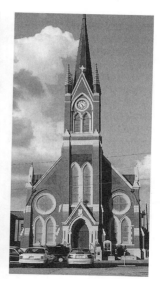

OU4 Bank One (Old Ouachita National Bank)

OU6 Housing Authority of the City of Monroe (Frances Hotel)

OU7 St. Matthew's Catholic Church

OU7 St. Matthew's Catholic Church

1898–1905, N. J. Clayton and Company. Jackson and Grammont sts.

The bold forms, vertiginous surfaces, and contrasting colors and materials of this Gothic Revival church are typical features of Galveston architect Nicholas Clayton's work. He designed this building shortly after completing Holy Trinity Catholic Church (1896–1899) in Shreveport (CA12), with which it has much in common. Constructed of dark red brick with white trim, the church has a sharply angular silhouette that emphasizes the vertical. A tower in the center of the facade is surmounted by a steeple surrounded by four tall pinnacles. Clayton often marked the entrances of his churches with a single projecting portico covered by a sharply pointed gable. Here the gable form is repeated around the base of the steeple. The brick is arranged in textured patterns in the wall areas between the strongly projecting stepped buttresses and the unusually large round- and pointed-arched windows of the facade. In contrast to the dramatic exterior, the interior is visually restful. Painted a cream color, it is filled with light from the enormous windows on the facade and side walls.

OU8 U.S. Courthouse and Post Office

1932, James A. Wetmore, Acting Supervising Architect of the Treasury, and J. W. Smith and Associates. 201 Jackson St.

From a distance, this Art Deco structure, a three-story rectangular building of light-colored stone, appears monolithic, severe, and intimidating. Its ornamentation is barely visible, carved in shallow relief and only lightly interrupting the wall surfaces. Close up, however, the fine decorative details are revealed as vertically fluted, pilaster-like bands between the evenly spaced windows, with zigzag capitals, horizontal bands of geometric ornament, and a row of stylized eagles of cast stone standing along the cornice. Each of the aluminum spandrels separating the floors has a different geometric design. Beside the three entrance doors are fluted metal columns topped by metal eagles, and over the doors are aluminum panels with reliefs by Albert Rieker depicting the history of mail transportation, ranging from a man on horseback to a train and an airplane. Lamp standards at the base of the entrance stairs are shaped as columns. The lobby retains much of its original decoration, although modern mailboxes fill the former counter windows.

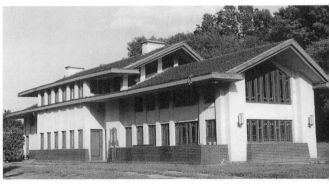

OU8 U.S. Courthouse and Post Office (detail)

OU12 G. B. Cooley House

The coffered ceiling has a border decoration of zigzags, and the light fixtures are ornamented with sugarcane motifs.

OU9　First Baptist Church (First Christian Church)

1911–1913, Smith and Bartel. 201 St. John St.

This beige brick church occupying a corner site has two identically modeled principal facades. In the center of each, suggesting a portico, are four tall Ionic columns and a pediment. Entrance to the church, which is on the St. John Street side, is through smaller-scale doors on each side of the imitation portico. These doors are emphasized by pediments, and similar pedimented forms are on the Grammont Street facade, although it has no entrance doors. The church has an auditorium seating plan covered by a low dome.

OU10　Ouachita Grand Plaza (Ouachita Parish High School)

1924–1930, H. H. Land, Sr. 501 S. Grand St.

The Jacobean Revival style was popular for school buildings throughout the United States when Ouachita's high school was built, and this is a particularly grand example. Occupying a splendid site overlooking the Ouachita River, the three-story red brick building has limestone trim around its large mullioned windows, and limestone pilasters, cartouches, and urns frame the entrances. The curved parapet is punctu-

ated by pointed and ball-shaped finials. Because much of the ornamentation is of shallow projection, the walls have a planar, almost streamlined, quality that gives the historical style a more modern look. The building sits on land originally deeded by Don Juan Filhiol for a school. The school was made redundant when another was built in 1963, and in the 1990s, it was restored and converted into housing for the elderly.

OU11　Colonial Dames Museum (Isaiah Garrett Law Office)

1840. 520 S. Grand St.

Built by Samuel Kirby as his residence, this one-story building of soft red brick with a pitched roof consists of two rooms, each with its own entrance, a gallery in the center of the facade, end chimneys, and a kitchen in the rear wing. In 1842, Kirby sold the house to lawyer Isaiah Garrett, who had recently moved to Monroe from Missouri, and he used the building as his office. The Little Red Brick House, as the building is known locally, is situated about 200 yards from the original site of Fort Miro and is one of the earliest buildings in Ouachita Parish.

OU12　G. B. Cooley House

1926, Walter Burley Griffin. 1011 S. Grand St.

Walter Burley Griffin designed this house for Gilbert B. Cooley in 1908, but Cooley lacked the funds to build it until the 1920s. Although

Cooley was often described as a riverboat captain (as were his father and brother), he, in fact, owned a steam-laundry plant. It is believed that Cooley's older brother, who lived in Chicago, brought Griffin to his attention. Griffin, who had worked with Frank Lloyd Wright from 1901 to 1906, was one of several Chicago-based architects intent on producing a modern American architecture not based on historical styles. By the time Cooley's house was constructed, Griffin was in Australia, where he had relocated after winning the competition to design that country's new capital in Canberra. On a return visit to Chicago, Griffin took a trip to Monroe, made some minor revisions to the original scheme, and appointed one of his previous employees to oversee construction. One of the most original and unusual houses in the state as well as the entire South, it shows that Cooley had a mind of his own, willing to step beyond southern conventions.

The cement-covered brick house has a linear plan, with a living room at one end and, behind it, a slightly higher two-story block, with a dining room and study downstairs and bedrooms above. A mezzanine gallery extends along two sides of the double-height living room to connect the bedrooms with the sun porch, which overlooks a small rectangular reflecting pool. The living room has a "tent" ceiling that echoes the shape of the roof above it. Windows at the narrow gable end of the house are wider than they are tall and, typical of the Prairie Style, all have mullions in a pattern of grids and zigzags. A garage designed in the same style stands separately at the rear of the house.

Although known familiarly as the Steamboat House because of its shape, its location near the river, and the supposed occupation of its owner, the structure has many characteristics of Griffin's Prairie Style houses in Illinois, including its rectangular shape, horizontal emphasis, and low-pitched roofs that extend and shade the walls at the gable end and along the sides. The rectangular outline was also conditioned by the long, narrow shape of the traditional Louisiana lot. Cooley lived in the house until his death in 1952. It is now owned by G. B. Cooley Community Services.

Drawings for the house by Marion Mahony Griffin (1871–1961), architect and wife of Walter Griffin, are at Northwestern University in Chicago. Griffin also designed (1913) the Monroe Riverside Country Club in Monroe, which was demolished in the 1930s as part of a flood-control development.

OU13 Layton Castle (Mulberry Grove Plantation)

1814, 1910. 1133 S. Grand St.

This sixty-room, turreted brick mansion began as a two-story, raised wooden cottage built by Judge Henry Bry, a Swiss-born entrepreneur, planter, essayist, and politician. He named the house for the mulberry trees he had planted for his silkworm business, an enterprise that he and numerous other Americans in the early nineteenth century thought would prove viable. The house was enlarged twice in the nineteenth century, achieving its present form beginning in 1910 under the direction of Eugenia Stubbs Layton, who had married Bry's grandson. Her extensive additions included the round tower, the arcaded gallery, and a reworking of the roof to cover the added rooms. The two-story porte-cochere is a magnificent space, formed by two-story-high tapered brick columns supporting round arches. Eugenia Layton remodeled the interior to relocate the living spaces on the second floor and incorporated a winding staircase and a ballroom. She may have acquired some of her grand ideas from the mansions and estates she saw in Europe, where she lived for several years following her husband's early death in 1892. Surrounded by an extensive garden, the house occupies an entire block.

OU14 Masur Museum of Art (Slagle House)

1929, H. H. Land, Sr. 1400 S. Grand St.

Lumberman Elmer C. Slagle hired Monroe architect H. H. Land to design this grand stone house. The asymmetrical composition, sharply angled gables and dormers, and hood-molded casement windows are typical of medieval architecture. Yet despite these historicizing features, the house has a thoroughly modern character, owing to its crisp outline, the gridlike pattern of walls formed from smoothly finished blocks of Indiana limestone, the taut, skinlike quality of the blue-gray slate roof, and the precise way the roof meets the walls without any extension. Sigmund and Beatrice Masur acquired the house in the early 1930s, and their heirs donated the building to the city in 1963. Some alterations were made to the interior when it was converted into an art museum, which opened in 1964. The several more modest versions of the Slagle House in Monroe's Garden District were probably influenced by Land's design.

OU15 YWCA (Governor Luther Hall House)

c. 1906, William Drago. 1515 Jackson St.

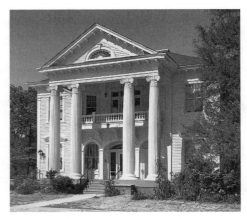

OU15 YWCA (Governor Luther Hall House)

When lawyer and politician Luther E. Hall moved to Monroe from Alexandria, he commissioned William Drago to design his house on what was then a fashionable street. Late-twentieth-century commercial encroachment has changed Jackson Street's character, and many of the surviving mansions, including this one, have been converted for other uses. It is fronted by a massive, pedimented two-story Ionic portico, its entablature weighted with dentils and modillions. Similar details are repeated on a heavy cornice that wraps around the house. The facade is unusually elaborate, with an entrance door flanked by concave windows and recessed behind a screen of three arches on square fluted piers. Above the arches is a second-floor balcony supported on enormous fan-shaped brackets. In plan, the house has a central hall flanked by four large rooms with windows placed to allow for cross breezes. Luther Hall moved out of the house in 1912 when he was elected governor of Louisiana. The building was converted for use as a YWCA in 1946. Also representing this street's earlier residential heyday is a handsome Queen Anne house, now converted ino law offices, at 918 Jackson Street. Built around 1890, the house has vertical proportions and a mansardlike pyramid roof that are more typical of East Coast versions of the Queen Anne style than of Louisiana's preference for a broad, expansive composition.

OU16 Garden District

1890s–present. Bounded approximately by Riverside Dr., Hudson Ln., and McKinley and 7th sts.

Designated a National Register Historic District in 1996, the Garden District is a residential neighborhood northwest of downtown, distinguished by attractive houses and abundant greenery. The area was subdivided in stages, beginning in the 1890s. A streetcar line (now covered under the levee of 1935) laid along Riverside Drive to Forsythe Park (originally known as City Park) in 1906 encouraged further development. Houses, bungalows, and two-story apartment buildings reflect prevailing styles of the early twentieth century. Some of the earliest and largest houses line Riverside Drive, including the Causey House (1206 River-side Drive) of 1902, known locally as "riverboat style" for its two-story, wraparound gallery. The Biedenharn House (2006 Riverside Drive) was built in 1914 by Joseph A. Biedenharn following his move to Monroe after purchasing the city's Coca-Cola bottling plant. Biedenharn was the first person in the nation to bottle Coca-Cola, which he did in 1894 at his family's soda fountain in Vicksburg, Mississippi, in order to deliver the soft drink directly to his customers' homes. His eclectically styled house is now the Emy-Lou Biedenharn Museum and ELsong Garden.

The frame and stucco Masur House (901 N. Third Street) of 1914 has Arts and Crafts details, including deep porches with thick octagonal columns and half-timbered gables. The Spanish Colonial Revival style is exceptionally well done at 1401 and 1405 N. Third Street, the latter designed by William Drago, who may also be responsible for 1401. Both are of stuccoed brick, with red tile roofs and arched openings. J. W. Smith and Associates designed the Georgia Tucker Elementary School at 401 Stubbs Avenue in 1920. Its twin towers, red brick walls with terra-cotta detailing, arcaded entrance, curved gable, red tile roof, and twisted columns give it the Mediterranean look fashionable throughout the country for elementary schools in the 1920s. With its tall proportions and huge arched windows, the rectangular brick Entergy power plant (1920s; 800 Park Avenue) possesses a Roman monumentality.

OU17 Neville High School

1931, Merl L. Padgett. 600 Forsythe Ave.

The focal point of this Art Deco building of buff-colored brick is a five-story central entrance pavilion, which is embellished with foliate-decorated cast concrete spandrels, geometric-patterned ventilation grilles at the fifth floor, and a pyramidal roof. The central pavilion has identical front and rear facades and entrance doors that open to a wide central hall, which serves as a breezeway. It is handsomely decorated with marble-faced piers. Three-story classroom wings on each side of the pavilion are boldly articulated with buttresslike pilasters that extend beyond the roofline to give a castellated effect. The wings terminate in pavilions, both smaller than the central pavilion, with windowless walls of brick organized in rectangular and diamond-shaped patterns. To the right of the school is a recessed extension housing an auditorium. Its decoration repeats that of the facade, with the addition of three grotesque heads set in medallions, representing the dramatic and literary arts. A gymnasium was added to the rear of the school in the 1950s.

OU18 University of Louisiana at Monroe (Northeast Louisiana University)

1928, J. W. Smith and Associates; many additions. Desiard St. and University Ave.

J. W. Smith's first design, of 1926, was in the red brick Jacobean Revival mode, a typical solution for academic buildings in that decade. His revised scheme, from two years later, is in the Art Deco style, which gave the college a much more progressive image. Opening in 1931 as Ouachita Parish Junior College, it was later upgraded to university status and renamed Northeast Louisiana University (NLU).

The name was changed in 1999 to the University of Louisiana at Monroe. The three buff-colored brick buildings that compose the original campus are Brown Hall (1931), which is flanked by two similarly styled but more decorative smaller buildings, Biedenharn Hall (1939) and Bry Hall (1939). All three buildings are more elaborately ornamented than Smith's similar Art Deco design of 1939 for Ruston High School in Lincoln Parish (LI5). Biedenharn and Bry halls were constructed with PWA funds. Renovations in 1972 have altered the original interiors. The campus acquired many new buildings in the second half of the twentieth century, including a colorful Art Deco–influenced, seven-story library (1998) by Blitch/Knevel Architects, which features a monumental clock and bell tower.

West Monroe

Situated on the west bank of the Ouachita River, West Monroe evolved from two small steamboat towns, Cottonport and Trenton. The town was chartered in 1889, and its commercial center developed along Trenton and Cotton streets, both running parallel to the river. Their two-story brick structures, which formerly accommodated shops, a Masonic temple, and a theater, have been revitalized as antique shops. In the heart of this neighborhood are the early-twentieth-century brick structures that formerly housed the Union Oil Mill (N. Trenton and Pine streets), a cottonseed processing plant. The First United Methodist Church (1920; 101 N. 2nd Street) is designed in the Colonial Revival style and has a pedimented portico with six Corinthian columns.

Morehouse Parish (MO) *and West Carroll Parish* (WC)

MOREHOUSE PARISH (MO)

Bastrop

Bastrop was named for a Dutch immigrant, the self-styled Baron de Bastrop (born Philip H. N. Bögel), who was granted a 36-square-mile tract of land by Spanish governor Francisco de Carondelet in 1796, with the proviso that he settle 500 families, but no "Americans." The so-

called baron attracted only ninety-nine people and finally left the area, ending up in Texas. In 1844, Bastrop was made the parish seat because of its location, at the intersection of the area's two main roads. Its growth came in the twentieth century, following the discovery in 1916 of the Monroe Gas Field and the construction of paper mills in 1920 and 1924, both acquired by the International Paper Company later in that decade. Among Bastrop's more historic struc-

tures are the brick-fronted Rose Theater, in a mild version of the Arts and Crafts style (102 E. Jefferson Street), of 1927; the Gothic Revival Christ Episcopal Church (216 S. Locust Street), of 1897, a white-painted wooden structure whose interior walls are composed of dark walnut-stained narrow boards nailed at different angles; and the one-story beige and brown brick Snyder Memorial Museum and Creative Arts Center, formerly the Snyder House (1924; 1620 E. Madison Avenue), designed by H. H. Land, Sr., an eclectic cottage with an enormous Palladian window on its gabled front.

MO1 Morehouse Parish Courthouse

1914–1915, Stevens and Nelson. 1935, additions, J. W. Smith and Associates. 1966–1967, alterations and additions, Jacka and Mattison Architects. W. Madison St. (between S. Washington and S. Franklin sts.)

Occupying an elevated position and an entire city block, this massive Beaux-Arts courthouse is the product of several building campaigns yet conveys the impression of a single unified scheme. As first built, the courthouse consisted of the four-story central section, crowned by an octagonal drum and a cone-shaped dome, and two-story wings three bays wide. The two-story in antis portico with its paired Doric columns also dates from this period. Narrow one-story wings funded by the PWA were added on each side of the courthouse in 1935. These were incorporated into the much larger two-story wings of 1966 that brought the courthouse to the perimeter of its site. The additions replicated the building's original style and used bricks of similar age, color, and texture, salvaged from the demolished city hall in Monroe. The only flaw in this carefully crafted expansion is the relationship of the dome to the body of the building, for it unfortunately now looks quite small and out of scale. Stevens and Nelson designed this courthouse in the same year they produced a similar version for Beauregard Parish (BE1), although in that variation they employed Ionic rather than Doric columns for the portico.

Oak Ridge

MO2 Oak Ridge Baptist Church

1905, Drago and Smith; with additions. 306 S. Oak St. (Louisiana 133 and 134)

Drago and Smith created an interesting asymmetrical design for this wooden church, which replaced an earlier structure. Two square towers, one taller than the other, flank the pedimented center; each tower has a pyramid-shaped steeple and pedimented entrance at its base. An oversized Palladian window fills the center of the facade and is repeated on the side wall. The single-nave interior is simple and intimate, with pews, hand-crafted in the 1840s, that were transferred from the earlier church, and two figural stained glass windows on the side walls. Several annexes were added to the church in the second half of the twentieth century. Next to the church is the small Oak Ridge United Methodist Church, a white-painted wooden building with a Doric portico that was added in 1955 to its late-nineteenth-century nave.

MO3 Episcopal Church of The Redeemer

1858. Corner of Louisiana 133 and 134

Incorporating an earlier structure of 1848, this simple white-painted wooden church is the oldest Episcopal church in the parish. The gabled porch, vestibule, and square tower with pointed steeple were added to the rectangular nave a few years after it was built, and the side annex for Sunday school rooms at a later date. The windows have pointed tops, which in combination with the gabled front and exposed wooden trusses in the nave give the building a Gothic appearance. Church records indicate that slaves were seated in pews at the rear of the nave. Between 1861 and 1865, both Union and Confederate troops attended the church, and soldiers from both sides are buried in its cemetery.

WEST CARROLL PARISH (WC)

Oak Grove

After a branch of the St. Louis, Iron Mountain, and Southern Railroad (later the Missouri-Pacific) was built through Oak Grove in 1908, the town quickly became the parish's commercial hub. In a referendum of 1915, Oak Grove was voted the parish seat, replacing Floyd, which the railroad had bypassed. W. L. Stevens designed the courthouse (305 E. Main Street) in 1916, a two-story brick structure with a prominent surrounding cornice and a portico with four Doric columns. The log cabin in City

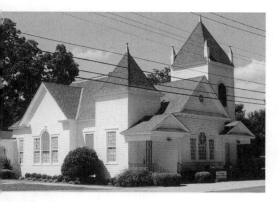

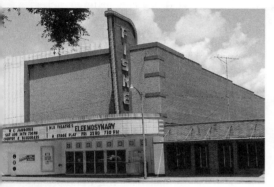

MO2 Oak Ridge Baptist Church

WC1 Donald B. Fiske Memorial Theater

Park, built by the Civilian Conservation Corps in the 1930s, has shingled gables and a brick chimney.

WC1 Donald B. Fiske Memorial Theater

1951. 306 E. Main St. (between S. Horner and S. Briggs sts.)

The most eye-catching and colorful facade on Main Street is that of the Fiske Theater, whose two-story expanse is a play of asymmetrical angles, curves, and textures. Glass entrance doors at the right side of the ground floor and a curved wall on the left, which originally contained the ticket booth, are sheltered under a marquee that sweeps at an angle over the sidewalk. Faced with buff-colored brick, the upper half of the facade is intersected at one end by a vertical sign that curves over the cornice and displays the theater's name in giant neon letters on a ruby red background. At the opposite end, the wall is stuccoed and fluted to imitate a pi-

laster. This design is repeated as a frieze across the top of the building. D. B. Fiske built his first theater in Oak Grove in 1928; this theater replaced it. The theater was renovated for community events and concerts in the early 1990s.

Epps Vicinity

WC2 Poverty Point State Commemorative Area

c. 1500 B.C. Louisiana 577 (6 miles northeast of Epps)

Located about thirty miles west of the Mississippi River, Poverty Point is one of the largest prehistoric native constructions in eastern North America and the oldest of any earthworks of its size in the Western Hemisphere. The 400-acre site, occupying the Macon Ridge approximately 30 feet above the floodplain, consists of six concentric artificial earth ridges arranged in a C-shape facing Bayou Macon. Approximately 70 feet in height, the ridges are spaced 140 to 200 feet apart. The diameter of the outermost ridge is three-quarters of a mile. At the center point of the outer ridge is a bird-shaped mound. Measuring 710 feet from head to tail, 640 feet from wing tip to wing tip, and more than 70 feet high, it is the largest surviving mound in the state. It is believed to be a memorial or shrine rather than a base for a tomb or temple. Two small rectangular mounds are within the enclosure, and a 20-foot-high conical mound located outside and to the north of the enclosure was constructed over a bed of ash and burnt bone fragments.

Millions of artifacts were retrieved from the ridges in the course of excavations, including arrowheads, cooking implements, small tools, fishing weights, beads, pendants, and bird effigies. Some archaeologists believe that several thousand people lived on the ridges, although little evidence of structures has been found. Others think it was a campground, occupied temporarily during ceremonies and trade gatherings. Whatever its purpose, the objects show that Poverty Point was extremely important for trade relations in the lower Mississippi Valley. Items from as far away as the Great Lakes were found at the site, and there is some evidence to suggest that Native Americans at Poverty Point may have had contact with the Olmec culture of Mexico. The culture collapsed sometime around 750 B.C. for unknown reasons. The organization and physical labor required to con-

struct these huge mounds, as well as the purpose for which they were built, make Poverty Point a site that elicits curiosity and awe. Included on the United Nations list of World Heritage Archaeological Sites, it is open to the public.

Richland Parish (RI), Franklin Parish (FR), and Catahoula Parish (CT)

RICHLAND PARISH (RI)

Rayville

Named for planter John Ray, who donated land for the town, Rayville developed after the Civil War as a junction for the Vicksburg, Shreveport and Pacific Railroad and the New Orleans and Northwestern lines. In 1951, Smith, Padgett and Stubbs of Monroe designed the six-story parish courthouse (Julia and Madeline streets), a severe concrete structure with regularly spaced windows separated by plain pilasters. Many of Rayville's large fashionable residences were built along Julia Street, notably a Spanish Colonial Revival house of c. 1935 (1104 Julia Street). The former Rayville High School (411 Madeline Street), a three-story structure of red brick with white trim with a short central tower, designed by Edward Neild in 1930, has been renovated to provide housing for the elderly.

RI1 Nonnie Roark Rhymes Memorial Library

1928. 815 Louisa St.

Richland was the first parish to receive funds from the Louisiana Library Commission (later to become the State Library) to build a public library. The program was aimed at rural areas and supported in part by a Carnegie grant. Rayville was selected because its Women's Club had already established a membership library. It now became free to all parish residents. Local planter R. Rhymes donated $5,000 for the new building, which was named for his deceased wife, Nonnie, a former member of the library's board of directors. The small Colonial Revival building is constructed of dark red brick with white trim and has large round-arched windows.

RI2 St. David's Episcopal Church

1911. 834 Louisa St.

St. David's is a diminutive Gothic Revival church constructed of richly textured russet-colored bricks. All the traditional Gothic elements, such as pinnacles and buttresses, and the gabled portico are miniaturized to match the scale of the church. Similarly small in scale is the Presbyterian church diagonally opposite, although it lacks the tactile refinements and careful attention to details of St. David's.

Delhi

After the Vicksburg, Shreveport and Pacific Railroad came through Delhi in 1859, the town was transformed from a scattering of houses to a shipping center for the area's cotton farmers. One- and two-story brick commercial structures were built alongside the rail tracks. Of Delhi's wooden houses, one of the most elaborate is the single-story Miles-Hanna House, in the Queen Anne style (1892; 206 Charter Street),

FR1 Northeast Louisiana Power Cooperative Inc.

which the town has restored as a local history museum. Delhi's Municipal Baseball Park (Chicago and Louisiana streets) has a covered wooden grandstand built in 1948 and funded from stocks sold to Delhi's citizens.

FRANKLIN PARISH (FR)

Winnsboro

Founded in 1843 for the new parish of Franklin, Winnsboro became an important commercial center after the arrival of the Missouri-Pacific Railroad in 1890. The business district, originally focused around the courthouse, then shifted west along the rail line. Now that the railroad has closed, the path of its former tracks has been landscaped into a linear park. In 1951, Winnsboro's courthouse was replaced by a three-story rectangular building of salmon-pink brick, designed by John W. Baker and Neild-Somdal and Associates. On the northeast corner of Courthouse Square is one of Winnsboro's oldest structures, the Belle Fann House, of 1891, a one-story wooden cottage in the Greek Revival style, with five galleried bays. The simple Colonial Revival brick post office (513 Prairie Street), designed by Louis Simon in 1936, is decorated with a WPA-funded mural, *Logging in the Louisiana Swamps*, painted in 1939 by Datus Myers.

FR1 Northeast Louisiana Power Cooperative Inc.

1948, Smith, Padgett and Stubbs. 1411 Landis St.

Form clearly symbolizes function in this unusual design, which features a tall concrete parapet shaped like an electrical connector. The small structure, with its horizontal emphasis, asymmetrical facade, smooth beige brick walls, glass-block windows, and wraparound corner window, is an excellent example of postwar modernism. This is an amusing and imaginative design from the Monroe-based architects.

CATAHOULA PARISH (CT)

Harrisonburg

Situated on a bluff of the Ouachita River's west bank, Harrisonburg was laid out on a tract of land owned by John Harrison. Selected as the parish seat in 1808, the town was also important for steamboat trade and as a river crossing for wagons traveling west from Natchez.

CT1 Catahoula Parish Courthouse

1930, J. W. Smith and Associates. Louisiana 124 and 1018–1.

The Catahoula Parish Courthouse is the second of several Louisiana courthouses for which the Monroe firm of J. W. Smith was responsible. It follows the Ouachita Parish Courthouse in Monroe (OU1) in date and in its Beaux-Arts design, although it is smaller in size. Smith's other courthouses were built in the 1930s, most of them in the Art Deco style. Identical front and rear elevations have a rusticated stone first floor, and brick is used for the upper three floors. Six stone Ionic columns form a colonnade across the center of the second and third stories. The fourth floor, which originally housed the jail, is recessed and screened by a balustrade. In a modernization of the 1970s, metal-framed windows with tinted glass replaced the originals, and interior ceilings were lowered. At the same time, a large annex, lower in height than the original structure, was added to the south elevation. Designed by Barron, Heinberg and Brocato, it is a stripped-down, boxy interpretation of the courthouse.

Upper River Parishes

THE MISSISSIPPI RIVER HAS CONTROLLED LIFE IN THESE PARISHES, for in its passage to the Gulf of Mexico, it has laid down the alluvial soils that are among the most fertile in the nation. But the river can also bring tragedy, especially for the low-lying parishes on its west bank—Pointe Coupée, Concordia, Tensas, Madison, and East Carroll—which have always had an infinitely more precarious relationship with the river than does the higher land of West Feliciana on the east bank. On its western side, the Mississippi has succeeded in changing its course and makes continued attempts to do so. False River, Lake Concordia, Lake St. Joseph, Lake Bruin, and Lake Providence are all former beds of the Mississippi River. And the Mississippi is at its widest, 7,600 feet, at East Carroll Parish.

Native Americans were the first inhabitants of the lands along the river, constructing villages and burial and ceremonial mounds. The river subsequently drew European explorers: Hernando de Soto in 1542; Robert Cavelier, Sieur de La Salle, who claimed the land for Louis XIV, king of France, in 1682; and Pierre Le Moyne, Sieur d'Iberville, and his brother Jean-Baptiste, Sieur de Bienville, who, in 1699, went up the Mississippi as far as present-day Pointe Coupée Parish.

There are seven parishes in this region: West Feliciana, created in 1804 from a division of Feliciana; Pointe Coupée, formed in 1805 and named for the shortcut shown to Iberville and Bienville in 1699 by the chief of the Bayou Goulas; Avoyelles, 1807, named for the Avoyels Indians; Concordia, created in 1804; Tensas, cut from Concordia in 1843 and named for the Taensa Indians; Madison, also carved from Concordia, in 1838; and East Carroll, formed in 1877 by a division of Carroll Parish. Although West Feliciana is east of the Mississippi and composed of bluff and upland formation rather than flat alluvial land, it shares a plantation economy with the parishes of this region.

By the 1760s, French and Spanish settlers had established indigo and tobacco

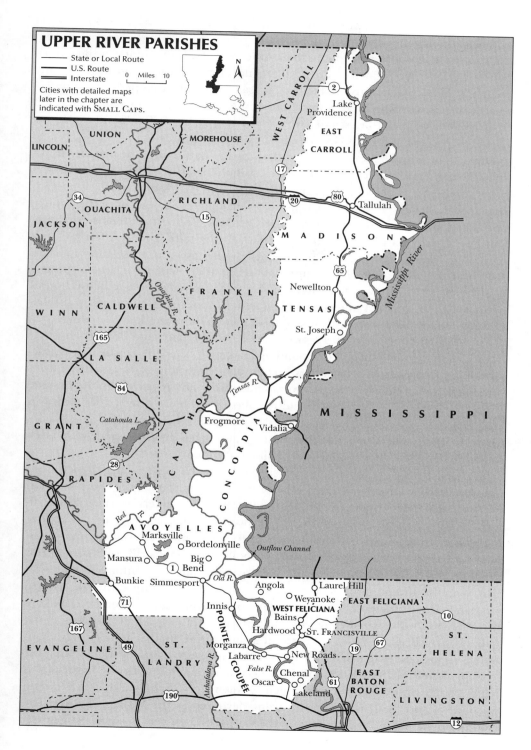

plantations in the areas of present-day Avoyelles and Pointe Coupée parishes. At the end of the eighteenth century, generous land grants enticed Anglo-Americans from the eastern seaboard, who brought their African slaves. In the nineteenth century, cotton became the principal crop in the northern parishes and sugar in the southerly. Many plantations in Madison, Tensas, and Concordia parishes belonged to absentee owners who lived in townhouses in Natchez, Mississippi, and delegated management of their slaves and crops to overseers. In 1860, absentee planters owned 81 percent of the land in Concordia and Tensas parishes.

Other figures give a fuller picture of the size and nature of these plantations. In 1860, Tensas Parish contained 118 large slaveholdings (fifty or more slaves), and slaves composed 91 percent of the parish's population. Madison Parish's figures are similar, with 99 large slaveholdings and slaves making up 88 percent of the population. For more than ten years before the Civil War, Concordia, Tensas, Madison, and East Carroll parishes were the wealthiest in the state. Even so, few architecturally significant pre–Civil War plantation houses survive in these four parishes. Moreover, absentee ownership meant that there was no need for a large or permanent house in which to raise a family, and thus the number of plantation houses never matched the total number of plantations. More recently, increased mechanization in farming has seen the loss of most plantation dependency buildings.

The early architecture of this region exhibits both French and British characteristics, sometimes combined in one building, making it decidedly regional in character. Raised Louisiana houses, with a French plan consisting of two or three front rooms and a rear gallery between two cabinets, are found mostly in Pointe Coupée and Avoyelles parishes. British or eastern seaboard influence is seen most clearly in West Feliciana, which was settled primarily by English-speaking Americans. As elsewhere in Louisiana, wood was the most common building material, with brick sometimes employed for ground-story walls and columns.

Most structures were not architect-designed; those that were used architects from Monroe or New Orleans or from Mississippi. Slaves built many of the plantation houses and the dependency buildings, and contractor-builders, working from pattern books and ordering prefabricated decorative details, constructed the appealing Queen Anne houses that proliferated in the new railroad towns. Forming a distinct rural type is the small, white-painted wooden church, usually with a single low tower centered over the facade; many of these early-twentieth-century churches survive. With the advent of the railway in the late nineteenth century, the river ceased to be the primary means of communication and transportation. Commercial life in the old river towns turned away from the river to form new centers focused on the railroad. Railroad transportation proved a spur to the lumber industry, although little architectural evidence of the industry remains. Agriculture is still dominant.

Major floods in 1882, 1912, and 1927 devastated communities and farms in this region. Some towns were relocated, such as Waterproof (Tensas), which was moved twice (1876 and 1880) to prevent its being devoured by the Mississippi River. The Flood Control Act of 1928 authorized the Corps of Engineers to construct new lev-

ees, spillways, and control gates to hold the river on its present course. These are some of the most monumental structures in this area of the state. Although the Mississippi is now screened from view behind a continuous high earth levee, it continues to assert its presence, as the levee is the only interruption in an otherwise unbroken flat landscape of cotton or sugarcane fields. Much of the time, the only movement is from cattle browsing on the levee's grassy slope. The landscape and its architecture seem to have changed little since the nineteenth century.

East Carroll Parish (EC) and Madison Parish (MA)

EAST CARROLL PARISH (EC)

Lake Providence

The town of Lake Providence lies between a lake with the same name and the Mississippi River. The oxbow-shaped lake is an ancient former course of the Mississippi. When laid out in 1833, the town was known simply as Providence (it was renamed in 1923), because, as legend maintains, it was considered providential if a traveler could evade river pirates along this stretch of the Mississippi. The town was a shipping center for this rich cotton-growing region and an important trading post between New Orleans and Memphis. During the Civil War, in January 1863, Union Army General Ulysses S. Grant directed the construction of a canal between the Mississippi River and the lake, which, by connecting via a bayou with the Tensas, Black, and Red rivers, would allow the Union forces to bypass the guns of Vicksburg stationed on the Mississippi. This imaginative scheme never materialized because in the summer there was no current on the waterway to carry the troops south. The canal was filled in 1953, when it was realized that the standing water had become a health menace.

Lake Providence, badly damaged during the war, was rebuilt and became East Carroll's parish seat when Carroll Parish was divided in 1877. Some of the town's most substantial houses line the lake's shores; the oldest is the two-story Arlington Plantation House (214 Schneider Street), built in 1841 and purchased by Irish-born planter and Confederate politician Edward Sparrow in 1852. The central-hall galleried house has a lower story of brick and an upper story of wood; the rooftop balustrade was a later addition. Lake Providence is home to a small Mennonite community. Three miles

north of Lake Providence (U.S. 65) is the Louisiana State Cotton Museum, which includes seven acres of cotton farmland, a late-nineteenth-century farmhouse, a tenant house, a plantation church, and a modern barn housing cotton-farming equipment and the first all-electric gin built in Louisiana.

EC1 Old East Carroll Parish Courthouse

1901, William and W. A. Stanton. 308 Hood St. (between 1st and 2nd sts.)

This two-story former courthouse of red brick is a plainly styled Romanesque Revival building with a square four-story corner tower covered by a pyramid roof. Ornamentation consists principally of white stone lintels over the first floor's rectangular windows and narrow bands of brick molding around the upper round-arched windows. A small classical portico on four wooden columns is topped by a balustrade. Next to the courthouse is its PWA-funded three-story replacement (1938), designed by J. W. Smith and Associates. Characteristic of the firm's courthouse designs in the late 1930s, it is a crisply angled rectangular structure of buff-colored brick, with large metal-framed, square-headed windows and simple Art Deco–ornamented limestone trim featuring fluting and horizontal lines. The courthouse is now used for parish government business.

EC2 Byerley House

1902. 600 Lake St. (corner Ingram St.)

This single-story wooden Queen Anne house was moved two blocks to this site in 1991 and restored as a visitor and community center. Its asymmetrical plan incorporates an angled bay

window on one corner and an Eastlake gallery that curves around the opposite corner. Large curved brackets support the gable over the bay window, and fish-scale and diamond-shaped shingles fill several of the gables. Although an interior wall between two rooms was removed during the restoration to create a space large enough for social functions, other rooms have been restored almost to their original appearance. Frank Byerley, Jr., the son of the builder of the house, was a well-known aviator, in whose honor Lake Providence's airport was named.

EC3　House

c. 1859. 702 Lake St. (between Ingram St. and Blackburn Ave.)

Facing Lake Providence on its south shore, this handsome two-story house with a central-hall plan was built for Francis M. Hays, mayor of Lake Providence in 1859. The house has a distinctly urban appearance owing to its red brick walls, compact symmetrical plan, angled bay windows flanking the two-story portico, windows that are round-arched on the ground floor and segmental-arched on the second, and a tall cornice with prominent brackets. The entrance door has side lights and a curved transom, as does the door above it, which opens onto a balcony formed by the upper story of the portico. In the early twentieth century, the house was owned by John C. Bass, sheriff of East Carroll Parish.

MADISON PARISH (MA)

Tallulah

Tallulah was founded in 1857 beside Brushy Bayou, and in 1885, after two railroads were brought through the town, it supplanted the town of Delta as the parish seat. D. Curtis Smith designed the PWA-funded Madison Parish Courthouse in the Colonial Revival style (1939; 100 Cedar Street), giving it a four-columned, pedimented Ionic portico and small cupola. The Madison Historical Society (307 N. Mulberry Street) occupies the former Hermione Plantation House, which was moved here in 1997 from its original site east of Tallulah after it was donated to the society. Built of wood in 1856, the single-story house with a central-hall plan has a Greek Revival front gallery. The two-story former Coca-Cola bottling plant (c. 1928;

E. Green and N. Beech streets) is typical of the company's structures in its location on the edge of the business district and construction of red brick with a low-relief cast concrete paneled sign giving the company's name, flanked by Coca-Cola bottles.

MA1　Bloom's Arcade

1930–1931, N. W. Overstreet. 102 Snyder St. (bounded by E. Green and N. Poplar sts.)

This shopping arcade, Louisiana's only surviving historic example, was designed for Abe and Mertie M. Bloom by Mississippi architect N. W. Overstreet, who was known for his modernist designs. The interior arcade, 300 feet long and 18 feet wide, is paved with terrazzo and illuminated by a continuous skylight of translucent glass supported on steel trusses. The exterior of buff-colored brick is embellished with Art Deco geometric and floral motifs in cast concrete. Among the shops that formerly lined each side of the arcade were two soda fountains, a post office, a jewelry store, a barbershop, a poolroom, and Bloom's Drug Store. The arcade was well positioned to attract shoppers, as the Missouri Pacific Railroad Depot originally stood opposite it, and a filling station was located on the building's corner at E. Green and N. Poplar streets. On the Green Street side of the arcade was Bailey's Theater, one of the movie theaters in the B and C chain, founded by Robert Lee Bailey, Sr., of Bunkie (Avoyelles Parish). Bailey owned several theaters in central and northeastern Louisiana, as well as the Bailey Hotel in his hometown (AV11). Now that edge-of-town shopping malls have drawn businesses from downtown, the arcade houses only a few local organizations and commercial ventures.

MA2　LeBlanc Research Corporation (Tallulah Book Club Building)

1930, William Stanton. 513 Johnson St. (between Mulberry and Cedar sts.)

In 1902, a group of local women founded the Tallulah Literary Club, operating a lending library from the home of one of the members. By the late 1920s, the club's membership had grown to one hundred women, who were also active in various civic causes. Requiring a larger space to hold their meetings, the women commissioned this new building, which included a large library room and a

EC3 House

MA1 Bloom's Arcade

who was manager of the Bailey Theater in Tallulah (see MA1). The club's meeting hall was used for many of Tallulah's social and cultural events. It closed in the 1980s.

Tallulah Vicinity

MA3 Standard Oil Terminal at Scott Field

1928. Scott Airport Rd. (.1 mile east of the junction of U.S. 80 and Louisiana 602)

The Standard Oil Company of Louisiana built this administrative and service facility for the crop-dusting companies based at Scott Airfield on William B. Scott's Shirley Plantation. In 1909, the U.S. Department of Agriculture (USDA) established the Delta Laboratory in Tallulah to research ways to combat the boll weevil, which was destroying cotton crops. A variety of ground-level methods of applying the poison, calcium arsenate, proved ineffective, and in 1922, aerial crop dusting using World War I airplanes was tried at Shirley Plantation. Although aerial application had been tested previously (1921) to combat worms on catalpa trees in Ohio, this was its first use on cotton plants. One of the commercial crop-dusting companies (Huff-Daland Dusters) at Scott Field was purchased in 1928 by a group of investors (including Carl McHenry, owner of the Frances Hotel in Monroe [OU6]). The new company, renamed Delta Air Service, began carrying passengers from Dallas to Jackson, Mississippi, and ultimately became Delta Airlines, with headquarters in Atlanta. At Scott Field, Standard Oil built a handsome Mediterranean Revival terminal (now abandoned) with a two-story square tower, large round-arched windows, and low-pitched red pantile roofs with deep eaves. Scott Field, which also has a hangar dating from the 1920s and two hangars built in the 1950s, is still used by the yellow crop-dusting planes.

meeting hall with a stage, both available for use by nonmembers. The simple Spanish Colonial Revival structure has an exterior of brick covered with textured stucco, a curved parapet, a scroll-shaped buttress marking the entrance, and blue tiles inset over the entrance vestibule. The Book Club remained the area's only library until the Madison Parish Library opened in 1945. One of its presidents was Cora Pearce Bailey, wife of Robert Lee Bailey, Jr.,

Tensas Parish (TN)

St. Joseph

St. Joseph was already significant as a shipping center for the area's cotton when it was made the seat of the new parish of Tensas in 1843. In contrast to most Louisiana towns, commerce and government are physically separate in St.

Joseph. Plank Road, the principal commercial street (named for its former surface of wooden planks), is located several blocks from the courthouse. The courthouse is nestled in a pleasant residential neighborhood of nineteenth- and early-twentieth-century wooden galleried houses set along tree-lined streets.

Among the most attractive are the Bondurant House (313 2nd Street), a five-bay, central-hall structure with a Greek Revival gallery, built c. 1852 and moved to this site in 1881 for use as the Episcopal church rectory; the Garrett-Drake House (209 Washington Street), built c. 1878, a five-bay raised house with a central-hall plan, slender gallery piers, and Eastlake railings; and the Davidson House (115 Front Street), said to have started out as a log cabin, which was enlarged c. 1860 with galleries and dormers to form an attractive asymmetrical composition. The former Presbyterian church (Hancock and 4th streets), a wooden structure built in 1905, has a picturesque silhouette, with a large square corner tower surmounted by a pyramid roof and variously sized gables.

TN1 Tensas Parish Courthouse

1906, P. H. Weathers. Courthouse Square (between Washington and Hancock sts.)

The Tensas Parish Courthouse achieves a particular grandeur at the head of a large rectangular park that extends to the levee, where the river landing was originally located. The Greek-cross plan, with two-story Corinthian porticoes nestled within the reentrant angles, gives the structure a lively silhouette. An octagonal cupola raised on a tall drum is positioned over the center of the courthouse. Pressed metal covers the cupola and sheaths the tall entablature and the pediments of the porticoes. Inside

the building, the paneled judge's bench, witness stand, and jury box in the second-story courtroom are part of the original construction. In plan and elevation, the courthouse resembles that of Vernon Parish in Leesville (VE1), which was begun in 1908. The Tensas courthouse was repaired in 1934 by J. W. Smith and Associates with PWA funding. At the river end of the park and on an axis with the courthouse is a two-story wooden Masonic hall (1875), which has a pedimented facade and segmental-arched windows.

TN2 Christ Episcopal Church

1872. 212 Hancock St. (between Front and 2nd sts.)

Episcopal services were held as early as 1856 in St. Joseph, but it was only after the Civil War, under the leadership of Carrie Hardemann Tullis, that a contractor, a Mr. Hennessey, was engaged to build this Carpenter's Gothic church. It is believed that Hennessey based the design on his recollection of English churches. Constructed of cypress and pine, the church has a square tower in the center of the facade and a tall octagonal spire. All the detailing emphasizes verticality, from the slender pinnacled buttresses framing the facade, the vertical wooden siding, and the pointed-arched windows and doors with their hood molds to the scalloped bargeboards. The stained glass windows were designed by F. W. Cole for Payne Studios of Paterson, New Jersey. Immediately be-

TN1 Tensas Parish Courthouse

TN2 Christ Episcopal Church

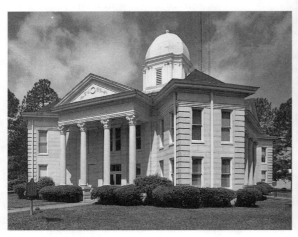

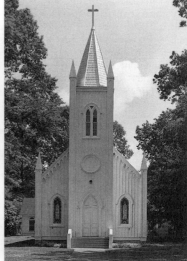

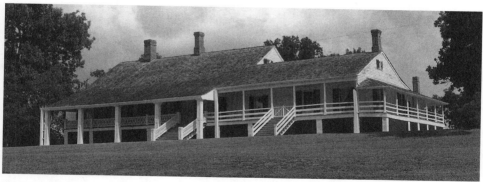

TN4 Winter Quarters

hind the church is the Parish House (1953), which faithfully imitates the Carpenter's Gothic lines of the church.

TN3 Tensas Parish Library and Museum (Snyder House)

c. 1855. 205 Plank Rd. (between Front and 2nd sts.)

Now accommodating the town's library and a museum, this five-bay raised house was built for lawyer Robert Snyder. In its plan, construction materials, and exterior appearance, the house represents the kind of dwelling favored in mid-nineteenth-century Louisiana, suiting both the climate and fashionable taste. It has a brick ground floor and wooden second story, and the front gallery is delicately ornamented with slender hexagonal wooden piers, paired brackets, and a row of dentils along the cornice. The three dormer windows have pedimented tops, and other Greek Revival details include side lights and a rectangular transom window over the door. A wide central hall has two rooms on each side; the double parlor to the right features a fireplace with a mirrored overmantel outlined by full-height fluted Ionic columns, which dates from 1890. The house had become a hotel just before the Civil War, and afterward it had a succession of owners until acquired by the parish c. 1960; the lower floor was enclosed for use as a library.

Newellton Vicinity

TN4 Winter Quarters

Louisiana 608 (south shore of Lake Joseph, 6 miles east of Newellton)

This large, rambling house began as a raised three-room hunting lodge built by Job Routh in 1803 on his 800-acre Spanish land grant. Routh apparently used the lodge only in winter, hence its name. *De Bow's Review* of 1853 identified Routh as the first permanent settler of Tensas Parish and the person who named Lake St. Joseph. Ann Ogden, Routh's daughter, was responsible for the second phase of construction in 1830, adding three rooms across the front of the dwelling along with front and side galleries. Around 1850, Dr. Haller Nutt purchased the house and added a large raised one-and-one-half-story wing to its east side. This consisted of a broad hall extending from the front to the rear of the house, four rooms, and front and rear galleries supported on piers reaching from ground level to the eaves of the double-pitched roof. Nutt installed a billiard room and two bedrooms in the half story above this new section. Shortly afterward, he attached a semi-octagonal bay to the northeast corner of the house. Inevitably, the building ended up with a complex floor plan, a broad, spreading outline, and miscellaneous architectural styles, although it is largely classical in inspiration.

Dr. Haller Nutt (1816–1864), a wealthy planter, scholar, and inventor, lived with his family at Winter Quarters for much of the 1850s and early 1860s. During these years, his famous octagonal house, Longwood, in Natchez, Mississippi, was under construction. Nutt continued the experiments on cotton hybrids and seed breeding initiated by his father, Dr. Rush Nutt, and in 1841 produced a successful strain known as Egypto-Mexican cotton. He owned two cotton plantations in Tensas Parish: Winter Quarters and, adjacent to it, Evergreen, now demolished. Nutt prospered in the years immediately preceding the Civil War; in 1860,

he owned 800 slaves and 42,947 acres on twenty-one plantations in Mississippi and Louisiana. At Winter Quarters, he possessed over 2,000 acres, more than 300 slaves, several cotton gins, a sawmill, and boat docks. During the Civil War, Nutt, who was said to be a Union sympathizer, vacated the area; he died in 1864. His wife, Julia, left in charge of Winter Quarters, met with General Ulysses S. Grant and offered to feed and quarter his troops in exchange for sparing her home. Later that year,

however, Union stragglers burned the other buildings and drove off the livestock. The war had a devastating effect on the family's holdings. Losses on the Louisiana plantations alone were estimated at over a million dollars, and the family was forced to sell Winter Quarters and Evergreen. Mrs. Nutt did finally receive some compensation for damage caused by both Union and Confederate troops. Winter Quarters now belongs to the Louisiana State Park system and is open to the public.

Concordia Parish (CO)

Vidalia

Vidalia has its origins in the Post of Concord (also recorded as the Post of Concordia), which was established by Spanish Governor Antonio de Ulloa in the 1780s to counter American influence in the area. The settlement was renamed Vidalia in 1811 in honor of Don José Vidal, one of the post's commanders. Vidalia quickly became one of the shipping centers for Texas longhorn herds; with its saloons and gambling houses, it was reputed to be "one of the toughest little towns in the world." Located on the low west bank of the Mississippi, Vidalia was continually subject to floods. In the 1930s, in anticipation of a westward shift of the river, the U.S. Army Corps of Engineers constructed a new levee through the town, six blocks behind the existing levee. The Corps relocated some of Vidalia's downtown buildings farther inland, among them the former city hall, a rectangular two-story structure of red brick, built c. 1920 (409 Texas Street). Architecturally, Vidalia remains in the shadow of its more famous neighbor, Natchez, Mississippi, across the river on a high bluff. Natchez became a fashionable home for wealthy plantation owners, many of whom were absentee landholders of plantations in the Louisiana parishes of Concordia and Tensas.

CO1 Concordia Parish Library (Concordia Parish Courthouse)

1939, J. W. Smith and Associates. 405 Carter St. (between Spruce and Oak sts.)

This former courthouse, a four-story building of beige brick, has the severe Art Deco form

typical of Monroe architect J. W. Smith's civic designs of the late 1930s. Shallow fluted pilasters articulate the second and third floors, and a geometrically patterned cornice provides a horizontal decorative touch. Although the central entrance is small in scale and subdued in ornamentation, the building's simplicity and its position behind a landscaped forecourt provide the necessary civic presence. The fourth floor originally housed the jail. In 1976, Vidalia acquired a new concrete and glass courthouse, designed by Barron, Heinberg and Brocato of Alexandria, which is located on U.S. 84 on the western edge of the town.

Frogmore

CO2 Frogmore Plantation

c. 1843. 11054 U.S. 84

Daniel Morris acquired the land for this plantation in 1815 and built a small house, probably enlarged at some point between his marriage in 1832 and his death in 1839. The house as it stands today is raised a full story above the ground; constructed of hand-hewn timbers pegged together with interior walls of *bousillage*, the house is three rooms wide and has a five-bay gallery and a double-pitched roof. The center hall does not extend all the way through the house, indicating that the loggia and cabinets were added later. It is possible that the house was originally a dogtrot; the chimneys are on the end walls rather than inside between rooms, as was typical of Creole houses. The house has a modern extension to one side.

The plantation includes a group of buildings,

all of which, with the exception of one slave cabin, were moved here from other sites to save them from demolition and were arranged as a plantation "village." There are several two-room slave cabins, a cypress dogtrot cottage (1810), a kitchen reconstructed in 1997, a barn, and a plantation store. A rare steam-powered cotton gin (1884), moved here from Rodney, Mississippi, in 1997, is housed in a narrow two-story wooden structure with gable ends (c. 1880). Typical of its era, the second, taller story contained the machinery for ginning (removing the seeds from the cotton) and pressing the cotton into bales; the power plant, a single piston steam engine, occupied the ground floor. A modern gin (1991) now serves this 1,800-acre working cotton plantation. A few hundred yards west of the house is an Indian mound, one of several in the area; although the mound is covered with trees, its profile is clear.

Pointe Coupée Parish Line Vicinity

CO3 Old River Control

1955–1963, U.S. Army Corps of Engineers. Louisiana 15

Old River Control is a network of structures that regulates the flow of water between the

Mississippi, Atchafalaya, and Red rivers. Completed in 1963 at a cost of $67 million, the entire complex includes a navigation lock, a closure dam, and the Low Sill and Overbank control structures.

Old River is a former channel of the Mississippi River, formed in 1831 when the river shifted its course. However, fluctuating alluvial flows began to divert most of its flow back to the old course (Old River) and then down the Atchafalaya instead of the Mississippi, which offered a shorter route to the Gulf of Mexico by almost 200 miles. By 1951, it became clear that unless something was done, the Mississippi would take the course of the Atchafalaya, thereby creating an economic and social catastrophe for the towns and industries along the lower Mississippi. In 1953, the Mississippi River Commission decided to build Old River Control. The plan was to dam the natural stream of Old River and build two control structures, the Overbank, which operates at all times, and the Low Sill, which operates only during floods. To preserve navigation between the Mississippi and the Atchafalaya–Red River systems, a lock and canal were also included.

The reinforced concrete control structures permit a determined amount of water to flow from or into the Mississippi and from or into the Red and Atchafalaya rivers. The Overbank structure has 73 bays, each 44 feet wide, reaching a total length of 3,356 feet, with a crest ele-

CO3 Old River Control

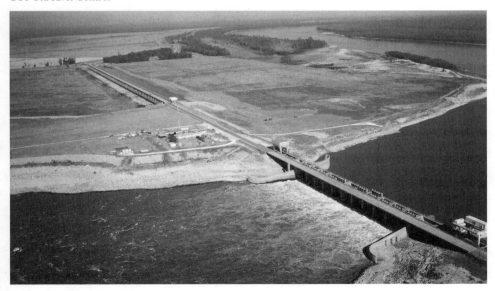

vation of 52 feet above sea level. The Low Sill is made up of eleven gates, each 44 feet wide, with a total length of 566 feet. The maximum water elevation in the forebay can reach 69 feet 8 inches above sea level. The Low Sill was designed to withstand changes in water levels of up to 37 feet between the higher Mississippi and the lower Atchafalaya River. The limit was lowered to 22 feet after the disastrous flood of 1973, when extraordinarily heavy winter and spring rains in the Mississippi and Ohio valleys caused such an increase in the volume and pressure of water downriver that a 67-foot-high concrete wing wall was destroyed. Only emergency repairs prevented the south end of the Low Sill structure from collapse.

After closing Old River, the corps constructed locks to allow access from the Mississippi to the Red, Ouachita, and Atchafalaya rivers. Eleven miles downstream from the control structures, the locks are situated on the navigation canal that runs parallel to and essentially replaced Old River. It is 75 feet wide and 1,185 feet long, with a floor 11 feet below sea level.

Additional constructions are continually being made to prevent future problems, as the river's course is constantly fluctuating. In the 1980s, the Army Corps of Engineers completed the auxiliary structure to reinforce the flow and containment of water. A hydroelectric power station, located immediately above the Low Sill structure, was constructed in the late 1980s. A road that crosses the complex of structures provides views of the entire project.

CO4　Auxiliary Structure

1981–1986, U.S. Army Corps of Engineers. Louisiana 15

The reinforced concrete Auxiliary Structure operates with the Low Sill structure to provide protection during emergencies. Built at a cost of $206 million, it is composed of six gates, each 62 feet wide, for a total length of 442 feet; its maximum discharge capacity is approximately 300 million gallons per minute. When opened, the gates lift up into a concrete superstructure composed of six huge, boxlike containers, which form a spectacular sight in this vast, flat, watery landscape. As at the Low Sill and Overbank, Highway 15 crosses the length of the Auxiliary Structure.

Avoyelles Parish (AV)

Marksville

Human habitation in the Marksville area goes back at least 2,000 years, when the spectacular Marksville Mounds were built. Much more recently—the late eighteenth century—French and Acadian settlers came to this area, making Marksville the unofficial northern border of Louisiana's "French belt." The town itself dates from the early nineteenth century, when Italian trader Marc Eliche donated a portion of his land for a courthouse. In 1821, Eliche's widow subdivided their land and sold lots. Marksville was voted the parish seat in 1842, but its real growth began after the railroad was brought through in 1896. By the early twentieth century, the town was a center for local cotton plantations, boasting four electric cotton gins. Marksville's downtown consists of one- and two-story early-twentieth-century brick commercial structures surrounding the three-story Beaux-Arts brick courthouse, which was built in 1927 to a design by Herman J. Duncan of Alexandria. Just south of Marksville on Louisiana 1, the Tunica-Biloxi Indians have established a casino on the site of the town's former stock auction yard.

AV1　Union Bank

1918. 300 N. Main St. (corner of Mark St.)

Marksville's most elaborate commercial structure is this two-story bank with a facade shaped like a triumphal arch. The arch is formed by a tall lunette window above the central entrance and is set between two-story-high Tuscan columns supporting a plain entablature. The entablature is continued as a cornice around the sides of the building, and the parapet above has a pediment-shaped center. The bank is constructed of buff-colored brick with limestone trim. The interior has been modernized. The nearby community of Hessmer has a similarly designed structure, the former Central Bank and Trust (1917; 2472 Main

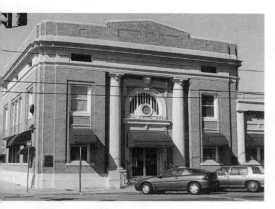

AV1 Union Bank

Street), and People's Bank in Houma (in Terrebone Parish) (TR3), also built in 1917, follows the same pattern, although with paired columns.

AV2 Belle Oak

c. 1872. 511 N. Washington St. (corner of Laurel St.)

Alfred H. Bordelon built this one-and-one-half-story raised house, which blends a traditional French plan with more contemporary fashions in decoration. Constructed of wood, the galleried house has a central room rather than a central hall; locating the staircase in this space rather than in a rear room was a more modern feature. Typical of the late nineteenth century are the ornamental bargeboards outlining the roof's gable ends and the shaped gallery railings, both of which show Eastlake influence.

AV3 Joffrion House

1908, Favrot and Livaudais. 605 N. Monroe St. (between Joffrion and Tarleton sts.)

Favrot and Livaudais of New Orleans designed this large central-hall house in the Colonial Revival style for lawyer and businessman J. W. Joffrion. Much admired for their Colonial Revival designs, the architects monumentalized this simple rectangular wooden house by adding an enormous two-story pedimented Ionic portico. The pediment is decorated with a heavy modillion cornice and a fan window. Although small in scale compared with the massive portico, the central entrance is emphasized by a pediment; above it, a small balcony marks the second-floor central hall.

AV4 Hypolite Bordelon House

c. 1820. 242 Tunica Dr. West. (Louisiana 1; corner of Cottage St.)

Built by Hypolite Bordelon, a descendant of one of the pioneer families of Avoyelles, this Creole cottage was restored and moved to this site in 1978 after being donated to the city. The house has two large rooms with a central chimney, a front gallery, one rear cabinet room and gallery, and a double-pitched cypress shingle roof. It is built of *bousillage* set between hand-dressed posts; the front and rear exterior walls, as well as the interior walls, are plastered. Windows are covered with board shutters. Furnishings representative of the early nineteenth century evoke the period when the house was built. Along with some smaller buildings on the grounds, it is open as a museum and tourist center.

AV5 Marksville State Historic Site

A.D. 1–400. 700 Martin Luther King Dr. (1 mile north of Marksville off Louisiana 452)

The Marksville culture (named for this important site) of the lower Mississippi Valley shows connections with the Hopewell culture of the Ohio River valley. Located on a bluff overlooking Old River, the 42-acre site is surrounded by a semicircular earthwork, 3,300 feet long and ranging from 3 to 7 feet high. Within the enclosure are five mounds. Three conical mounds near the center of the site vary in height from 3.5 feet to 20 feet and from 60 to 100 feet in diameter. The other two mounds, 13 and 14 feet high respectively, are flat-topped; one of them seems to have been rectangular in shape. One of the conical mounds was used for burial. Additional mounds exist outside the enclosure. Openings in the earthwork, one on the western side and two at the southern end, suggest that the site had a ceremonial rather than a defensive purpose. The first scientific investigation of the area took place in 1926, and additional excavations followed in 1933 and 1938; further work needs to be done before this site is fully understood. Among the objects uncovered are clay pots, pipes, and spear points. The site was opened to the public in 1950 and has a visitor center that houses a small museum.

Bordelonville Vicinity

AV6 **Bordelonville Floodgate**

1931. Louisiana 451 (2 miles east of Bordelonville)

The Bordelonville Floodgate on Bayou des Glaises was one of the first of the water control gates constructed after Congress passed the Flood Control Act of 1928. Floods in 1908, 1912, and 1927 had caused extensive damage in this area of Louisiana. The plan was to create spillways to drain excess water when the rising Mississippi River threatened to overflow or break the levees. The Bordelonville Floodgate was the focus of a system of levees designed to protect over 40,000 acres and several communities around Bayou des Glaises by channeling backwater from the Mississippi along a diversion canal into the Atchafalaya Floodway. The floodgate is constructed of reinforced concrete with steel gates that were raised, when necessary, by chains on pulleys mounted on the platform above. A concrete framework of piers and beams forms the upper part of the structure; the floodgate originally included a single-lane traffic bridge. The floodgate was built as a joint venture of the state of Louisiana and the Red River, Atchafalaya, and Bayou Boeuf Levee Board in cooperation with the U.S. Army Corps of Engineers. In 1979, the floodgate became redundant when it was incorporated into a levee as part of a new flood control scheme.

Big Bend

AV7 **Sarto Bridge** (Old Iron Bridge)

1916. Louisiana 451

Prior to the construction of this bridge, floodwaters from the Mississippi, Atchafalaya, and Red rivers frequently forced the evacuation of people, livestock, and property in the Big Bend area. This elevated steel-truss swing bridge, a rare survivor of its type, was constructed across Bayou des Glaises to provide a safe route. The three-part central span was mounted on a pivoting gear and ratchet mechanism that was rotated manually and supported on a concrete cylinder embedded in the center of the bayou. The span is made up of two modified quern post truss sections that extend to a concrete trestle near each bank, which carried the load when the bridge was closed. When open, the

two truss sections were supported by cables held by four vertical posts over the central pivoting cylinder. After 1930, when flood control projects lowered the water level, the bayou ceased to be navigable, and the bridge is now rusted and unused.

Simmesport

Located on the banks of the Atchafalaya River, Simmesport was an important stop for steamboats and barge traffic between the inland port of Washington and New Orleans before the Civil War. The town was named for Bennett B. Simmes, who constructed docks and a warehouse on the river's west bank before 1837. On the opposite side of the river is Simmes's plantation house, White Hall (Louisiana 418 between Louisiana 1 and 15 in Pointe Coupée Parish), built c. 1849, which he purchased in 1852. The two-story wooden structure has a two-story front gallery with octagonal columns and a bracketed cornice. The older bridge that crosses the Atchafalaya at Simmesport was constructed by William Edenborn in 1928; the modern bridge was built in 1971.

Mansura

AV8 **Commission des Avoyelles** (Dr. Jules Charles Desfossé House)

c. 1854. 1800 block of L'Église St.

It is believed that this house was built by Jules Charles Desfossé, a French-born dentist, after he acquired the property in 1850. The one-and-one-half-story house is raised on hand-hewn cypress blocks and constructed of *bousillage* between posts, covered with stucco on the front facade and beaded cypress boarding over the side walls. The gable roof, originally covered with cedar shingles, now has metal sheathing. Although the central entrance and symmetrical facade suggest that the house has a central-hall plan, the off-center chimney indicates the traditional Creole scheme of three large rooms across the front of the house. At the rear of the house, a loggia separates two smaller rooms, and upstairs are two bedrooms; the front gallery is supported on eight slender hand-worked octagonal columns. Acquired by the Commission des Avoyelles in 1975, the house was restored in 1980 with period furnishings and is now open to the public. It is believed

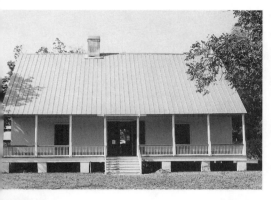

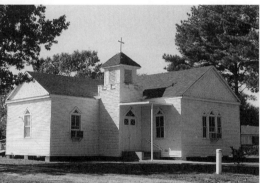

eighth-grade class was added. At its peak, the school had an enrollment of eighty students. The Lutheran Mission Board sent teachers, who were usually also pastors. The church has a square tower surmounted by a pyramid-shaped roof set between the angle of the two wings. Triangular moldings over doors and windows provide adornment that is simple, yet successfully gives the church a Gothic feeling. The front gable is elaborated with shingles.

Bunkie

Bunkie came into existence with the arrival of the Texas and Pacific Railroad in 1882 and served as a cotton shipping center until the mid-twentieth century, when truck transportation took over. The commercial center of the town was laid out parallel to the rail tracks. A sufficient number of Bunkie's early-twentieth-century brick-fronted commercial buildings survive to give a sense of the town's heyday during the railroad era. Most notable is the two-story former Merchants and Planters Bank, built in 1911 (122 S.W. Main Street), with a white glazed-tile facade and a pressed metal ceiling over the banking hall.

AV8 Commission des Avoyelles (Dr. Jules Charles Desfossé House)

AV9 St. Paul Lutheran Church

that the town of Mansura was established by refugees from Napoleon's defeated army, who named the town after Mansura, Egypt, because the local prairie reminded them of their posting in Egypt.

Mansura Vicinity

AV9 St. Paul Lutheran Church

1916. Louisiana 107 (1.3 miles north from junction with Louisiana 1)

This small, L-shaped frame church also served as the school for local African American children from 1916 to the 1930s. After Reconstruction, when schools were segregated by race, parochial schools such as this were essential for providing African Americans in rural areas with a formal education. Grades one through seven were offered until the late 1920s, when an

AV10 Bunkie Chamber of Commerce (Texas and Pacific Railroad Passenger Depot)

1911. U.S. 71 (corner of S.W. Main and Oak sts.)

Although many of the cotton-related industrial buildings and warehouses that once lined the rail tracks in Bunkie have gone, this two-story brick and reinforced concrete passenger station attests to the railroad's former importance to the town's economy. Bunkie had a second depot just for freight. The station's linear composition, red brick with a cream-colored base, stringcourses, and cornice and a low-pitched hipped roof with deep eaves all reveal how much the architect admired the work of Frank Lloyd Wright. The second story extends only across the center of the ground story. Originally, the ground floor included waiting rooms for African American and white passengers, separated by a bay-windowed ticket office and storage area. Of the three rooms on the second floor, the central room with the bay window was the dispatcher's office. When architect Wayne Lawrence Coco renovated the depot in 2000 for its new use, the rooms were restored to their

original state, although they are now put to different uses. The pine beaded wood wainscot and chair rail were replaced, the plaster walls repaired, and the stairs refinished. On the exterior, replicas of the original ornamental brackets (removed during an earlier renovation) were added under the eaves. The building now serves the Chamber of Commerce and includes a local museum.

AV11 Bailey Hotel

1907. 200 W. Magnolia St. (corner of Walnut St.)

The Bailey Hotel was known as the Hotel Ernest when it was built by Josephine Ernest, who sold it to Robert Lee Bailey, Sr., in 1918. Constructed of dark red brick, the two-story building has segmental-arched windows with concrete hood moldings and a curved corner entrance. The entrance porch, which originally had a single story, was heightened to two stories in 1941 when the hotel received its second enlargement. Although it is not a particularly well-proportioned or refined design, the size and scale of the hotel emphasize Bunkie's commercial significance to the region. Conveniently situated only one block from the railroad passenger depot, the hotel also served as a center for the town's social activities. A dining room occupied a rear wing. Bailey, who was active in real estate and the lumber industry, also ventured into the theater business. He built the Bailey Theater in Bunkie (now demolished) in 1925 and twelve more theaters in the region, including the one in Tallulah (MA1). The hotel

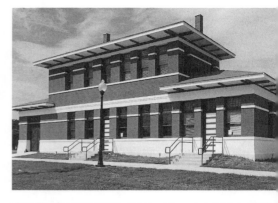

AV10 Bunkie Chamber of Commerce (Texas and Pacific Railroad Passenger Depot)

AV11 Bailey Hotel

closed in 1970, and after standing empty for several years, it was renovated and reopened in 2001.

Pointe Coupée Parish (PC)

New Roads

Records indicate settlement in the vicinity of New Roads at an early date. By 1739, a French garrison existed, and in his account, published in 1770, Captain Philip Pittman of the British army wrote, "The fort, which is a quadrangle with four bastions, is built with stockades, and contains a very handsome house for the commanding officer, good barracks for the soldiers, store-houses, and a prison." He also stated, "The settlements at Point Coupée . . . extend twenty miles on the west side of the Mississippi. . . . They cultivate tobacco and indigo,

raise vast quantities of poultry, which they send to the market of New Orleans." During his exploratory trip along the Mississippi River in 1699, Pierre Le Moyne, Sieur d'Iberville, coined the name Pointe Coupée (cut point) to describe a shortcut he took to avoid a 22-mile-long oxbow curve. Around 1722, the river itself took the shortcut, leaving a crescent-shaped lake that the French called *la fausse rivière*, or False River. Today the area between False River and the Mississippi is known locally as The Island. Its rich fertile soil proved ideal for sugarcane, which replaced indigo as the crop of choice. In the nineteenth century, New Roads

became the commercial and social center for the area. First known as St. Mary's, New Roads derived its name from the new road that was built in 1847 from the town to the ferry on the Mississippi River. New Roads also became a popular lake resort, with weekend and summer homes reaching outward from the town along the lake's edge.

New Roads retains the ambience of its earlier days, evident in Main Street's late-nineteenth- and early-twentieth-century brick commercial buildings and its attractive residential neighborhoods of Greek Revival and Queen Anne houses, notably along Poydras Street and Pennsylvania and North Carolina avenues. Large shed-roofed dormer windows must have become a fashionable addition for New Roads home owners in the early twentieth century, judging from the unusually large number to be seen. The small wooden First United Methodist Church (206 Pennsylvania Avenue), built in 1904 in the Gothic Revival style, with an openwork scroll-bracketed bell tower over the center of the facade, fits comfortably into this neighborhood. More elaborate is St. Augustine Catholic Church (812 New Roads Street), built in 1923 for an African American congregation, which features a square bell tower and a pedimented and columned central entrance.

PC1 Pointe Coupée Parish Courthouse

1902, A. J. Bryan and Co. 1939, W. T. Nolan, U. M. Nolan, and A. W. Norman. E. Main St. (between Court and Alamo sts.)

This building's square entrance tower flanked by two squat round towers with conical roofs is reminiscent of a French château. Although it is

tempting to think the design reflects Pointe Coupée Parish's French heritage, the courthouse is almost identical to Bryan's design for the Coffee County Courthouse in Elba, Alabama, which was built in 1903 by the same contractor, M. T. Lewman and Co. Nevertheless, the courthouse is unique among those Bryan designed in Louisiana, such as those for West Feliciana (WF1) and Iberville parishes, which are Beaux-Arts classical structures. The building is constructed of an orange-red brick, and the first-floor walls have been given a weighty, rusticated aspect through the alternation of smooth surfaces with occasional projecting courses. Windows on the ground floor are flat-headed, while those on the second floor and entrances are round-arched. A decorative brick cornice surrounds the building. The wide arched entrance at the base of the tower opens to a central hall; the interiors have been modernized with dropped ceilings and new partitions. Originally, the courthouse had a landscaped forecourt enclosed by an iron fence, but this area is now used as a parking lot.

In 1939, a PWA-funded two-story rear annex was added on the Court Street side of the courthouse; this beige brick structure in the Moderne style asserts its own identity and the design tastes of the era. Entrances at each end of the facade are minimally decorated with linear incisions, and over each are freestanding cast concrete eagles.

PC2 LeJeune House

c. 1820, c. 1856; additions. 507 E. Main St. (between LeJeune and North Carolina sts.)

In the early nineteenth century, François Samson built a two-story house, of brick-between-posts construction, with two rooms on each floor and galleries on all four sides. About the middle of the century, the second-floor side and rear galleries were enclosed to form rooms. The present pitched roof may have been added at that time. François Avernant, a builder from Bordeaux, is believed to have effected the changes. In the early twentieth century, the first-floor side and rear galleries were converted to rooms, and a single shed-roofed dormer replaced the original pair of dormer windows. Despite so many changes, the house retains its aesthetic coherence and still reflects the simplicity of its Creole origins. Interior detailing includes wraparound mantels with full entablatures resting upon pilasters. The house

later became the home of François LeJeune, a descendant of one of Pointe Coupée's earliest families.

PC3　St. Mary Catholic Church

1904–1907, Theodore Brune. 348 W. Main St. (corner St. Mary St.)

When New Orleans architect German-born Theodore Brune (1854–1930) designed this red brick and white stone-trimmed Gothic Revival church, he was already admired for the monumental above-ground tombs based on historical styles that he had produced for Metairie Cemetery in New Orleans. The church's enormous square tower in the center of the facade was intended to have a steeple, but insufficient funds necessitated its completion in 1929 with a high balustrade of pointed arches and four tall crocketed pinnacles. The tower is elaborated with a large pointed-arched stained glass window, blind arcades, and a gabled entrance. Crocketed pinnacles conclude the church's corner buttresses, and the side walls are strengthened by prominent stepped buttresses. Bricks for the church were manufactured at the New Roads Brick Yard, which was established c. 1900 and is said to have been one of Pointe Coupée Parish's foremost industries at that time. Inside, the pointed-arched barrel vault over the central nave is decorated with moldings to imitate rib vaults. Emil Frei designed the stained glass windows; the facade windows were made in 1992. The inscription on the church's cornerstone is in French as a tribute to the settlers who established the Catholic faith in the parish. To the right of the church is the rectory, a two-story wooden structure in the Colonial Revival style, dating from c. 1900. St. Mary Cemetery (New Roads and 5th streets) includes above-ground tombs and graves from the late eighteenth century, moved here from the original St. Francis Cemetery (PC12) when its site was incorporated in a flood-control project.

PC4　Julien Poydras Museum and Art Center (Poydras High School)

1924, William R. Burk. 500 W. Main St.

Poydras High School is a three-story structure with the five-part composition typical of school designs. It is constructed of brick in warm shades of beige, brown, and gold; on the end pavilions, the bricks are organized in patterns

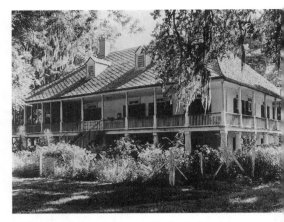

PC6 Parlange, photo by Frances Benjamin Johnston, c. 1938

of repeating diamonds, which appear to resemble textiles rather than solid walls. A single-story columned portico indicates the central entrance. Detailing in white cast concrete includes representations of two owls, symbols of wisdom, set within niches on the parapet.

The school is on the site of Poydras College, founded in 1829 by the French-born merchant and planter Julien Poydras (1746–1824). Arriving in Pointe Coupée in 1769, he started out as a peddler and later accumulated a fortune sufficient to acquire extensive landholdings in the parish, including Alma Plantation (PC9). In 1804, Poydras was appointed president of the first legislative council of the Territory of New Orleans. At his death, Poydras, who never married, bequeathed money to various institutions and causes, among them Charity Hospital in New Orleans, dowries for needy girls in Pointe Coupée and West Baton Rouge parishes, and funds to establish an academy in Pointe Coupée. A monument composed of a marble block topped by an urn marks Poydras's grave in front of the school. His remains were moved here in 1891 from the St. Francis Church cemetery (PC12), where he was originally interred.

New Roads Vicinity

PC5　Pointe Coupée Parish Museum and Tourist Center

1815, 1840. 8348 Louisiana 1 (6 miles southwest of New Roads)

This small structure is a rare example of log construction used for a Creole house. Hand-sawn cypress timbers, 3.5 inches by 10 inches, are laid horizontally, dovetailed at the four corners, and secured vertically by large wooden pegs. This type of notched log construction, known as *pièce sur pièce*, was common in French Canada. A mixture of mud and moss fills the cracks between the timbers. Floors and ceilings are of wide cypress boards. When built in 1815, the house consisted of two rooms, a front gallery, and a single central chimney. Around 1840, a third room, made of *bousillage*, was added to the south side of the house, along with the present double-pitched wood-shingle roof and front and rear galleries, and the house was painted white. It is now furnished with objects either made or used in eighteenth- and early-nineteenth-century Louisiana. The house was moved from Olivia Plantation when it was donated by the Wurtele family in memory of Allan Ramsey Wurtele, the plantation's former owner, who was the inventor of a sugarcane harvester.

PC6 Parlange

c. 1820. 8211 Louisiana 1 (near junction with Louisiana 78)

Parlange occupies land granted to the Marquis Vincent de Ternant by the French Crown just after the mid-1700s. At the marquis's death in 1757, the property passed to his son Claude and, after his death in 1818, to his widow, Virginie. She married French-born Charles Parlange, and the property has remained in this family ever since. Although family tradition

maintains that the house was built c. 1750, its attic structure, of smaller dimensions and constructed of lighter-weight wood beams than those of earlier buildings, indicates an early-nineteenth-century date, and the trim and moldings appear to date from around 1835. However, the house's weighty structural skeleton suggests the possibility that there was an older house, which was enlarged and remodeled to accommodate changing needs.

The raised house has a ground floor of brick-between-posts construction, wood upper floors, and walls plastered inside and out with a mix of mud, sand, Spanish moss, and animal hair, then whitewashed. The family's slaves manufactured the building materials and constructed the house. Parlange is beautifully proportioned, its strong horizontal outline balanced by the verticals of heavy brick columns supporting the gallery at ground level and slender, turned cypress colonnettes on the upper level. A gallery encircles the entire house. Each floor contains seven rooms, with the main living quarters on the upper level and service rooms on the lower floor. There is no hall, and all of the rooms open onto the gallery through French doors with fan-shaped transoms in rectangular frames. The high, hipped, dormered roof is covered with cypress shingles. The front steps now leading to the second floor were added later. The census of 1860 records 35 slave dwellings (and 129 slaves) at Parlange, but none of these survive.

An allée of cedars originally lined the entrance drive, although some live oaks are now interspersed among the surviving cedars. The garden, remade in the 1950s by landscape designer Steele Burden, features two octagonal two-story brick *pigeonniers* from the nineteenth century. In the eighteenth century, the plantation's principal crop was indigo, which was replaced by sugarcane, as at other plantations, in the early 1800s. The house is open for tours.

Oscar Vicinity

PC7 Austerlitz Plantation House

c. 1832, with additions. 7559 Louisiana 1

Austerlitz, which was named for Napoleon's victory of 1805, was probably constructed by Antoine DeCuir in the 1830s on land his father, Joseph DeCuir, acquired in 1783. The two-story

PC7 Austerlitz Plantation House, photo 1930s

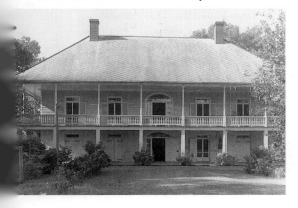

house incorporates both Creole and Anglo-American features. Typical of Creole building traditions are the structure's low, wide silhouette, the use of plastered brick for the first story, a heavy timber frame with *bousillage* infill for the second story, a Norman truss supporting the hipped umbrella roof, galleries that shade the house on all sides, French doors, fan-shaped transoms over the entrances, and wraparound mantels. Anglo-American influence is seen in the symmetrical plan and the central entrance opening onto a central hall. But, maintaining the Creole tradition, the four rooms on each side of the hall are grouped in pairs, with a chimney between them, and French doors provide direct access to the gallery.

After Joseph Aubin Rougon purchased the plantation in 1885 at a sheriff's sale, he added a two-story rear wing. Other changes made during that period included removal of the staircase in the front gallery, the addition of an interior staircase, and the substitution of piers for all but two of the lower gallery columns.

Near Austerlitz are two galleried plantation houses that also acquired additions and alterations. Pleasant View (7091 Louisiana 1), built c. 1825, is a raised house, three rooms wide with a chimney between two of the rooms, a two-story front gallery, and a rear gallery added at a later date. North Bend (6847 Louisiana 1), when constructed in c. 1835, was four rooms wide and one room deep, with front and rear galleries. An additional room was added to both floors at the west end of the house around 1850, and in the late nineteenth century, the upper rear gallery was converted to a cabinet and loggia arrangement. These houses reveal how the basic plan of the Creole house, with its interconnecting rooms and galleries, can easily incorporate additions or modifications without diminishing the character or the aesthetic of this Louisiana house type.

PC8 Riverlake Plantation House

c. 1840, with additions. 6323 Louisiana 1

Riverlake, like Parlange (PC6), has a disputed construction date. What does seem clear is that the building as it now stands dates from between 1840 and 1845. When construction began—c. 1795, according to some sources, or, more likely, about 1820, according to others—the house consisted of a brick lower story and *bousillage* upper story; it was three rooms wide

and one room deep, with a gallery on all sides. In about 1840, the present front and rear galleries were added and given enclosed sides and cabinets to make the house five rooms wide and two deep. At the same time, the steep hipped roof was rebuilt to incorporate two small dormer windows for ventilation. Finally, in the late nineteenth century, a two-story kitchen wing was added to the rear of the house, and new columns and balustrades in the then-fashionable Eastlake style replaced the Greek Revival columns on the upper front gallery. Only one of the two original *pigeonniers* survives; it is square in shape, with a brick lower story and frame upper story, and has a pyramid roof and finial.

Until 2001, two of Riverlake's slave cabins (c. 1840) survived on Major Lane (.5 mile west of the intersection with Louisiana 1). Four cabins (one intact and three in pieces) had previously been moved to Magnolia Mound Plantation in Baton Rouge (EB29), where the intact cabin can be visited. It is not known how many cabins existed originally, but former residents recall a double row of about thirty in the 1930s, and one remained occupied until 1994. After emancipation, the cabins housed sharecroppers or tenant farmers. Novelist Ernest Gaines provided a vivid picture of the quarters in *The Autobiography of Miss Jane Pittman* (1971) and *A Lesson Before Dying* (1994). Gaines spent the first fifteen years of his life in one of the cabins. They were also known as Cherie Quarters Cabins, named for planter Purvis Cherie Major, who purchased Riverlake in 1892.

Lakeland Vicinity

PC9 Alma Plantation Ltd. (Alma)

1890s, with additions. Louisiana 416 (.3 mile from junction with Louisiana 413)

Julien Poydras purchased the land for this plantation in 1789. After his death in 1824, the plantation was sold, and by the 1850s, it was owned by David Barrow of Afton Villa (WF20), a member of the powerful Barrow family in West Feliciana Parish, and his partner, English-born George Pitcher, who became sole owner in 1859. The plantation was named for Barrow's daughter, Alma, who died of yellow fever. It is still a working sugar plantation, whose layout and extant structures provide revealing de-

tails about a historic Louisiana vernacular complex, few of which have survived. The modern raised galleried house now standing near the entrance to the plantation is believed to have incorporated part of Poydras's house, specifically the sections of brick-between-posts wall. Just beyond the house are several wooden structures, among them the company office, a small store, some sheds, and two barns. The wide, low barn with a double-pitched roof and partially open side aisle was built c. 1897, and the tall rectangular barn with two roof ventilators dates from c. 1890. Farther along the plantation road is a double row of post–Civil War tenant houses with board-and-batten siding, including two-room cabins and small shotgun houses. Beyond them is the working sugar mill, now composed of tall, metal-sided structures and smokestacks. In the twentieth century, metal largely replaced brick as the construction material for mills.

Poydras was one of the wealthiest planters in Louisiana in the early nineteenth century, acquiring four plantations in Pointe Coupée Parish and two in West Baton Rouge Parish. Alma Plantation was the site of the slave uprising of 1795 known as the Black Rebellion. Inspired by the success of the St.-Domingue Revolution, the slaves planned an insurrection but were betrayed, and twenty-five of them were killed.

Chenal Vicinity

PC10 Maison Chenal
c. 1820. 13967 Chenal Rd. (Louisiana 414)

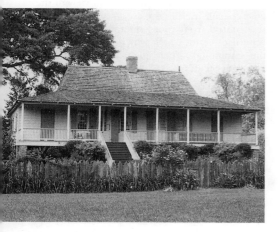

The house known as Maison Chenal is one of a collection of Louisiana vernacular buildings saved from demolition, moved to this site, and restored by Pat and Jack Holden. Almost all the structures are easily visible from the road. The first structure the Holdens acquired, in 1975, was a raised Creole cottage, which was restored to serve as their residence; it was originally located beside False River eleven miles from its present site. Construction techniques and nail analysis indicate a date before 1790 for the core of the house, but its exterior appearance suggests a date of c. 1820, and the restoration has adhered to that era. A characteristic of Creole cottages is their asymmetry in room layout and façade elevation. The off-center chimney indicates the division of the two front rooms, with the larger, the parlor, on the left. Other deviations from symmetry are the unequal spacing of the gallery posts and the off-center staircase rising to a six-bay gallery. These irregularities give the facade a special animation. The house has a double-pitched hipped roof over a Norman truss. The ground-level floor, possibly lower when first built, has been remodeled for family use; a staircase was added in one of the cabinets flanking the rear loggia. The windows are the original single large casements. Exterior and interior colors have been restored to the colors found under later layers of paint.

Several outbuildings have been added over the years, some from Cedar Bend Plantation in the Natchitoches area, whose culture was similar to that of Pointe Coupée. These structures include a square wooden *pigeonnier,* with a *bousillage* first-floor exterior sheathed in wood, a frame upper floor, and door jambs and lintel of beaded wood. Behind the main house are two dependencies, placed here in the same relationship to the house as they had at Cedar Bend. One was a kitchen and laundry room, the other probably a *garconnière;* both have brick floors and open ceilings. Smaller structures include a privy, a chicken house, pens and coops for chickens and geese, and a barn, which dates from c. 1829. To the right of Maison Chenal is a small cottage transferred from nearby Labatut Plantation.

Gardens have been re-created from extensive written and graphic evidence of nineteenth-century gardens. The front entry garden has been laid out in the French manner, with a parterre of lozenge-shaped beds divided by walkways, designed to be viewed from above.

The rear garden includes vegetables as well as regional flowers and bushes, such as Cherokee roses and native azaleas. *Pieux* (upright post) fences enclose both the front and rear gardens.

Opposite Maison Chenal on the other side of the road are two other buildings the Holdens have acquired. The smaller is a cottage of *bousillage* construction, with cabinets and a loggia behind the front rooms and a double-pitched gable-end roof. More intriguing is the enormous frame and *bousillage* structure known as the LaCour House, moved from its original site a few miles away. It resembles drawings (now in the National Archives, Paris) made in the 1720s of the earliest buildings constructed in French Louisiana, such as the barracks. This structure has wide openings with segmental arches, which are similar to those at Madame John's Legacy and the Ursuline Convent in New Orleans. The building's date and purpose are unknown, although among the speculations is that it was a large house or a structure connected with the Pointe Coupée fort.

PC11 LeBeau House

c. 1840. 14199 Chenal Rd. (Louisiana 414)

Sugarcane planter St. Ville LeBeau built this Creole raised cottage, which has a brick first floor, *bousillage* second story, and a gable roof that incorporates the front gallery within its pitch. The six slender columns supporting the gallery are typically not aligned with door and window openings. The ground floor was originally used for storage; the upper floor, the principal living space, consists of two large front rooms with a double fireplace between them, and, behind them, instead of the usual open loggia, is a large room flanked by corner cabinet rooms. Access to the third, or attic, level was provided by a narrow set of stairs on the front gallery; these still exist, but interior stairs were added in the twentieth century. The outside kitchen is constructed of wide cypress boards and was probably built at the same time as the house.

The LeBeau House occupies one of the narrow lots typical of The Island, the area between the Mississippi and False rivers. Both the lots and the houses were much larger on the western side of False River along Louisiana 416 and Louisiana 1. Two other galleried homes on The Island that are similar to the LeBeau House and representative of this type of smaller plantation house (both c. 1840) are the Jean Bap-

tiste Bergeron House (13769 Chenal Road) and the Valmont Bergeron House (13861 Chenal Road), although the latter differs from the type in being only slightly raised from the ground.

Labarre Vicinity

PC12 St. Francis of Pointe Coupée

1895. 10364 Louisiana 420

One of the first parish churches in the state, St. Francis of Pointe Coupée was founded in 1728. The present church, however, is the third, the others having been lost to shifts in the Mississippi River. Although this building was relocated from its original site in the 1930s for construction of a new levee, it is still just a few yards from the river. A simple rectangular building with pointed-arched windows, it has a small bell tower with a miniature spire at the peak of the facade gable and a trefoil-patterned bargeboard along the front gable. Above the entrance door is a small niche containing a statue of St. Francis of Assisi. Inside, a truss roof covers the hall-like single space, and a small balcony is set against the entrance wall. The church contains an eighteenth-century confessional. A cemetery with simple grave markers is behind the church.

A few hundred yards to the east of St. Francis is Labatut (10466 Louisiana 420), a two-story galleried plantation house that, according to family tradition, dates from c. 1800, although it has also been given dates of 1810 and 1830. The latter date is most probable in view of the kind of nails used in the construction, the narrow central front room resembling an Anglo-American central hall, which is not found in the traditional Creole plan, and the interior decorative features.

Morganza

PC13 Morganza Spillway and Control Gate

Spillway, 1939–1956; control gate, 1949–1954. U.S. Army Corps of Engineers. Louisiana 1

The Morganza Spillway is another component of the flood control system mandated by the Flood Control Act of 1928 for the lower Missis-

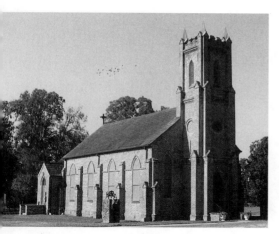

PC14 St. Stephen's Episcopal Church

Innis Vicinity

PC14 St. Stephen's Episcopal Church

1850–1859, attributed to Frank K. Wills. Louisiana 418 (.1 mile north of junction with Louisiana 971)

St. Stephen's originally served the village of Williamsport, which was devastated by a flood after a Mississippi River levee collapsed in 1912. The church was constructed according to drawings by New York architect Frank Wills, who was the architectural expert for the New York Ecclesiological Society and favored English-inspired designs. Since most of the members of St. Stephen's congregation were of British descent, the design was very appropriate. St. Stephen's features a large square tower in the center of the facade that rises in three stages, each of which is marked by angle buttresses with pointed tops, a crenellated parapet, and pinnacles at the corners. A narrow vestibule within the base of the tower precedes the aisle-less nave, which is separated from the raised sanctuary by a pointed arch. The flattened pointed-arched vault is a recent modification. During services, slaves occupied the rear balcony, where the organ is now located. The tall, narrow pointed-arched windows have stained glass that was made in England and brought by steamboat via New York to New Orleans and then up the Mississippi River to the Williamsport steamboat landing. Slaves manufactured the bricks, made the entrance door and pews, and built the church, but construction was slow because of high waters in 1850 and 1851. In 1872, when St. Stephen's lacked a rector, Bishop Leonidas Polk appointed Mrs. Sarah Archer as lay reader, the first woman in the diocese to hold that position. The cemetery predates the church and includes some attractive cast iron–fenced family plots and a Confederate monument (1904).

sippi River (see Old River Control, CO3). It was designed to channel floodwaters from the Red and Mississippi rivers into the Atchafalaya Basin. Extending southward for twenty miles from the town of Morganza, the spillway joins the Atchafalaya Basin Spillway, which runs south to Morgan City, where excess water can be discharged into the Gulf of Mexico. With an average width of 5.3 miles, the Morganza Spillway can move 600,000 cubic feet of Mississippi River floodwaters per second, and its guide levees protect more than 100 square miles of farmland in upper Pointe Coupée Parish. The control gate at Morganza rises 30 feet above the spillway and is almost 4,000 feet in length. It consists of 125 bays, each 21 feet wide, in a concrete structure supported on piles; the bays are equipped with steel vertical-lift gates operated by gantry cranes. A highway-railroad bridge crosses the control structure. The U.S. Army Corps of Engineers is responsible for operation and maintenance of the spillway and the control gate.

West Feliciana Parish (WF)

St. Francisville

St. Francisville was laid out in approximately 1807 on a narrow bluff of land owned by John H. Johnson on the east bank of the Mississippi River. Below at the river's edge was the town of Bayou Sara, laid out in 1808, the shipping center for local cotton planters. St. Francisville was named for the monastery of St. Francis, which was established nearby in the 1730s by Spanish Capuchin monks. In September 1810, St. Francisville was designated the capital of the republic of West Florida, serving the short-lived independent state until Louisiana's Florida parishes were incorporated into the United States seventy-four days later. St. Francisville then served

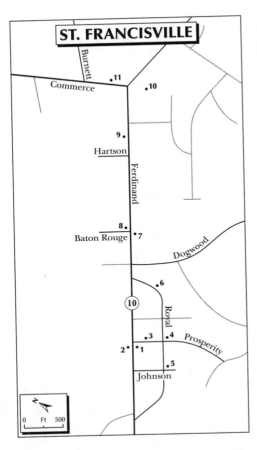

ST. FRANCISVILLE

Burnett

Commerce •11 •10

9•

Hartson

Ferdinand

8• •7

Baton Rouge

Dogwood

•6

(10)

Royal

•3 •4 Prosperity

2• •1

•5

Johnson

N

0 Ft 500

the railroad had replaced river traffic, eliminating Bayou Sara's economic significance, although repeated fires, floods, and erosion had already hastened the town's demise. A red caboose located at the river end of Ferdinand Street marks the site of the former railroad tracks, abandoned in 1978.

St. Francisville's principal thoroughfare, Ferdinand Street, contains an interesting mix of nineteenth- and early-twentieth-century small-scale commercial and residential buildings, the majority of which are constructed of wood. Two attractive late-nineteenth-century wooden structures are the single-story galleried Brasseaux House (11833 Ferdinand Street), which has fine gingerbread details, and Our Lady of Mount Carmel Catholic Church (number 11485), completed in 1893 from plans drawn in 1871 by General P. G. T. Beauregard. The church has a small belfry, a classical doorway, and vivid blue and yellow-colored glass windows illuminating the simple interior.

Royal Street has some of St. Francisville's grandest houses. Among them is the Barrow House Inn (number 9779), built in 1810, a wooden house with two rooms on each floor and cast iron gallery railings (added in 1858), which has an attached one-story cottage relocated here in the nineteenth century for use as a law office. Also noteworthy on Royal Street are Virginia (number 9838), which began as a one-room store in 1817 and was expanded in 1826 and again in 1855 with the addition of the two-story section, and Hillcroft (number 9732), built in 1905, a large-scale Colonial Revival residence with an Ionic portico and a widow's walk. Also on Royal Street at 9856 is the United Methodist Church, a wooden structure built in 1899, which has a bell tower over the entry that was saved from the Methodist church of 1844 in Bayou Sara. The wooden structure at 4740 Prosperity Street has an interesting history. It was built in 1902 for Temple Sinai, but dwindling membership caused the congregation to dissolve in 1905, and the synagogue was acquired by the Presbyterian church in the 1920s. The building has pointed-arched windows and a pedimented gable over the two-story portico; within the portico, exterior stairs lead to the upper gallery.

WF1 West Feliciana Parish Courthouse

1903, A. J. Bryan and Co. Ferdinand St. (corner of Prosperity St.)

as the seat of Feliciana Parish, and in 1824, when the parish was split in two, it became the seat of West Feliciana Parish.

In 1842, the West Feliciana Railroad, the first standard-gauge railroad in the United States, was completed from St. Francisville to Woodville, Mississippi, making it easier for inland planters to transport their cotton to the steamboats at Bayou Sara on the Mississippi River. Landscape architect Frederick Law Olmsted described his impressions of the area in his book *The Cotton Kingdom* (1861): "For some miles about St. Francisville the landscape has an open, suburban character, with residences indicative of rapidly accumulating wealth. . . . For twenty miles to the north of the town, there is on both sides a succession of large sugar and cotton plantations. Much land still remains uncultivated, however. The roadside fences are generally hedges of roses—Cherokee and sweet brier." By the close of the nineteenth century,

This courthouse was built to replace its mid-nineteenth-century predecessor, which had been damaged in the Civil War. It is said that St. Francisville's citizens were so enraged about the demolition of the old courthouse that the architects and contractors for the new building refused to have their names inscribed on the cornerstone. This Beaux-Arts courthouse is more typical of the many courthouses Bryan's firm designed in the southern states than is the French château–inspired structure he produced the previous year for neighboring Pointe Coupée Parish (PC1). Each facade of the West Feliciana courthouse has a shallow four-columned Corinthian portico (an addition in 1963 by Perry L. Brown is now attached to the rear facade), with a massive entablature and pediment; the columns, dainty in proportion to the other architectural elements, are raised on tall brick pedestals. The courthouse's finest feature is a tall cupola that rises from an octagonal base to a small circular lantern at the top; in between are broken pediments, a dome, and four clocks, each set within a bull's-eye frame facing in four directions. Construction materials for the courthouse include rusty red-colored brick for the walls, light-colored stone trim, wood for the cupola, and cast iron capitals. The interior has marble floors and a wooden dado; the courtroom on the second floor is a simple large space, also with a wooden dado. An octagonal covered well house (1842) stands on the courthouse grounds.

WF2 Grace Episcopal Church

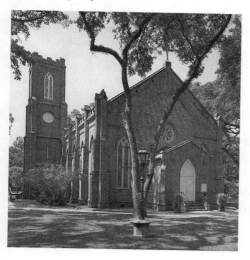

WF2 Grace Episcopal Church

1858–1860, Charles N. Gibbons. 11621 Ferdinand St.

Grace Church serves Louisiana's second oldest Episcopal parish, organized in 1827. The red brick church, which replaced the first, smaller structure, has a square apse, short transepts, a single square battlemented tower, narrow stepped buttresses, lancet windows, and a small projecting portico—features typical of the ideal Gothic Revival parish church advocated in popular writings by architects Frank Wills and Richard Upjohn in the 1850s. The design of the facade, with its portico, flanking windows, and decorative brick moldings, suggests an interior arrangement of central nave and side aisles, so it is a surprise upon entering to find a single, wide, hall-like space. Tall, narrow stained glass side windows illuminate the interior; the flat ceiling is ornamented with rococo medallions, which are rather incompatible with the church's Gothic appearance, and an arcade of three pointed arches separates the apse from the nave. The two-manual tracker-action pipe organ (1860) was manufactured by Pilcher Brothers of St. Louis.

It is believed that the live oak trees on the church grounds were planted in 1855, when installation of the wrought and cast iron fence surrounding the cemetery was begun. The earliest surviving grave dates from 1858; several graves are surrounded by their own elaborate cast iron fences, which combine with the ancient oaks and feathery Spanish moss to create a most charming effect. Grace Church was damaged in 1864 during the Civil War, when its tower was used as a target for the shelling of St. Francisville. The church was restored in 1893.

WF3 Kilbourne and Dart Lawyers' Office

1842. 4780 Prosperity St.

New York lawyer Uriah B. Phillips built this small wooden office building after he came to Louisiana to help codify its laws. After Phillips died, Robert C. Wickliffe, a former Kentuckian who served as governor of Louisiana from 1856 to 1860, acquired the building. In 1873, James H. Kilbourne purchased the structure, where he practiced law for sixty years. The front gallery is supported on four fluted piers and has a pedimented gable with a small fan window. In size, style, and date, this law office is similar to those in Clinton (EF2) and repre-

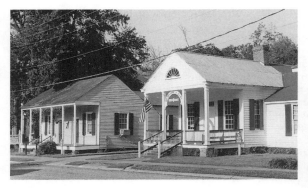

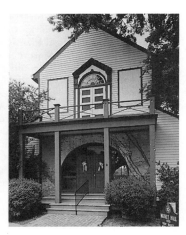

WF3 Kilbourne and Dart Lawyers' Office

WF6 Audubon Hall (Market Hall)

sents a type that once was widespread in Louisiana's courthouse towns.

WF4 **Grandmother's Buttons** (Bank of Commerce and Trust)

1905. 9814 Royal St.

Resembling a small sturdy fortress, this red brick former bank has large round-arched windows on the first floor and identical but smaller windows on the upper floor. The windows on each floor are linked by a continuous brick stringcourse, and a tall battlemented parapet surmounts the building. Marking the corner entrance is a thick white column, whose elaborate floriated capital adds to the general impression that the bank's design was influenced by the architecture of H. H. Richardson. The original walk-in safe was retained when the bank was converted into an antique shop.

WF5 **Propinquity**

c. 1812. 9780 Royal St.

John H. Mills, who had established a trading post at Bayou Sara in 1799, purchased this lot in 1809 and shortly afterward began construction of this brick two-story building combining a store and house. The brick structure has a two-story wooden gallery on its rear facade and when built probably had three rooms on each of its two floors. The west chimney serves only the second floor, as it does not reach to the ground floor. After Mills died in 1812, his widow completed the house and sold it in 1816. Some work was done on the house in 1826 by

James Coulter, architect-builder of Greenwood Plantation House (WF16). Under successive owners, the structure served as a store, a bank, and apartments. Propinquity was restored in 1966, when it acquired its current name and a two-story brick wing on the south elevation. The house now offers bed-and-breakfast accommodations.

WF6 **Audubon Hall** (Market Hall)

1819. 9896 Royal St.

This long, narrow structure had only one story when it was built by the town trustees as a public market. Open-air stalls occupied the brick-fronted building, and wagons could enter through the huge round-arched opening. In 1852, a wooden second story was added to house the magistrate's office. Traces of former stairs to the upper-floor gallery are visible on the exterior facade. A central entrance, flanked by delicate pilasters and topped by a fanlight set in a pediment-shaped molding, would have provided access from the upper gallery to the second floor. Since the late nineteenth century, the market hall has accommodated a theater, a Masonic lodge, a library, and, from 1947 to 1978, the town hall. In the 1980s, the hall was restored for use by the West Feliciana Historical Society.

WF7 **Old Benevolent Society Lodge**

1883. 11740 Ferdinand St.

This small, single-story frame building is a surviving example of a rare building type. It was

the first burial society lodge organized by the African American community within the parish. The narrow structure has a front gallery and large wooden double doors in the center of the facade.

WF8 West Feliciana Historical Society (Hardware Store)

1896. 11757 Ferdinand St.

A. T. Gastrell established his hardware business in this two-story wooden structure, which was acquired by Charles Weydert in 1912 after Gastrell retired. The three-bay-wide structure has a front gallery with slender turned columns and a gable front. The interior, 90 feet by 36 feet, has a row of wooden supports down the center and stairs at the rear. The building was restored in 1970 and now houses a museum and tourist center.

WF9 Evergreenzine

1885. 11875 Ferdinand St.

In contrast to Ferdinand Street's commercial buildings, this attractive house is set deep into its lot behind a large garden. Built by merchant Adolph Teutsch, who was instrumental in establishing Temple Sinai, the house shows the eclectic styling typical of its time. Doric piers supporting the front gallery are classical, but the paired brackets above the columns and the tall round-arched windows are Italianate. The house has a pyramid-shaped roof and a side gallery. Charles Weydert, who then owned the nearby hardware store (WF8), purchased the house in 1916, and his family occupied it until 1974.

WF10 3-V Tourist Court

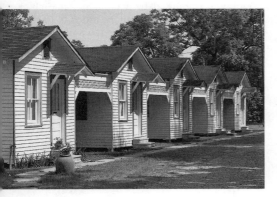

WF10 3-V Tourist Court

c. 1928. 5689 E. Commerce St.

The motel court originally consisted of three rows of freestanding cabins positioned in a U shape around an open court—a typical arrangement for early motels. One row of six small frame cabins survives almost intact, its separate units connected by carports with latticework trim. A few other surviving cabins were altered to create larger units. A manager's house stands near the front of the complex. All the units were originally identical to those of the surviving row, with a gable roof, a gable-shaped hood over the door, and a window on the facade. Inside, the cabins had one room, an enclosed bath, and an open kitchenette installed on the wall opposite the door. The court was built by Santos (Sam) Vinci, one of three brothers (hence the court's name, 3-V) who emigrated from Cefalu, Sicily, in the 1890s, when many Italian immigrants settled in southern Louisiana. The brothers also operated a gas station, combination café–dance hall, and a store in St. Francisville.

WF11 St. Francisville Inn (Wolf-Schlesinger House)

c. 1880. 5720 N. Commerce St.

Merchant Morris Wolf built this one-and-one-half-story wooden house opposite his general store and his cotton gin. With its three steeply pitched, Gothic-decorated dormer gables, the outer two as tall as the roof, the house offers a picturesque and romantic spectacle, especially because of its setting behind a grove of live oak trees draped with Spanish moss. The gables incorporate pointed-arched windows and elaborate scroll-decorated bargeboards. The house has semi-octagonal bays on its side elevations and a one-story wing at the rear. Restored in 1984, the building now accommodates a restaurant and bed-and-breakfast inn.

St. Francisville Vicinity

WF12 Audubon State Commemorative Area (Oakley Plantation)

c. 1806. Louisiana 965 (4.8 miles southeast of St. Francisville)

During John James Audubon's four-month tenure at Oakley in 1821 as tutor to Eliza Pirrie,

daughter of James and Lucretia (Lucy) Pirrie, he produced thirty-two of his bird paintings. Audubon's contract provided board and lodging and allowed him time to devote to studying the flora and fauna of the area and to painting. In his journal, Audubon described his arrival in June 1821 at Bayou Sara and the journey to Oakley: "We arrived at the landing at the mouth of the bayou on a hot sultry day, bid adieu to our fellow-passengers, climbed the hill at St. Francisville. . . . The aspect of the country was entirely new to me . . . and surrounded once more by numberless warblers and thrushes, I enjoyed the scene. The five miles we walked appeared short, and we arrived and met Mr. Perrie [*sic*] at his house" (*The Life of John James Audubon, the Naturalist* [1883]). Apparently Eliza was not a model student—or daughter, for she eloped with her cousin Robert Hilliard Barrow in 1823. Unfortunately, he died six weeks later. In 1828, she chose a more orthodox path by marrying the Reverend William Bowman, first rector of St. Francisville's Grace Episcopal Church.

Oakley was begun by Ruffin Gray of Natchez and his wife, Lucy, on land granted to him by the Spanish government in 1796. After Ruffin Gray died, Lucy married Scottish immigrant James Pirrie. Family tradition dates the house to 1799, but records indicate it was built in 1806, and a recent Historic American Buildings Survey study gives 1815. Oakley is unusually tall, with two stories and an attic raised on brick piers above a basement. It has a double-pitched roof, gable ends, external chimneys, and galleries front and back. The back room on the first floor was originally a gallery, but it was enclosed at a later date and another gallery added. The jalousies enclosing the south gallery's upper level, which allow breezes to pass but exclude sun and glare, are typical of houses in the West Indies. The wooden bars of the jalousies absorb some of the moisture in the air, thereby lowering the humidity level of the breezes passing through them. Another cooling feature is the upper gallery's curved ceiling, which speeds the movement of air over its surface, thus making breezes more effective.

On the grounds of the plantation are two slave cabins, a three-bay barn on brick piers (its side sheds were added and enclosed later), and a kitchen reconstructed on the old foundations. Both the formal and kitchen gardens as reconstructed are conjectural, although in the spirit of nineteenth-century gardens; the parterre to the left of the house was laid out in

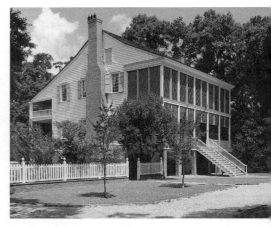

WF12 Audubon State Commemorative Area (Oakley Plantation)

the 1930s. Oakley was acquired by the state of Louisiana in 1947, restored, and opened to the public.

WF13 Rosedown Plantation State Historic Site (Rosedown)

1834–1835. 1844–1845, side wings. 12501 Louisiana 10 (near the intersection with U.S. 61) (Not visible from the road)

Six years after returning from their honeymoon in Europe, Scottish-born cotton planter Daniel Turnbull and his wife, Martha Barrow Turnbull, commissioned Wendell Wright, contractor for the West Feliciana Railroad, to build their house in the "most modern style." Constructed of cypress and cedar, some of which was processed at the plantation's sawmill, the two-story house features a two-story gallery with Doric columns and entablature and a central doorway, surmounted by a fanlight, on each floor. One-story brick side wings, added in 1845 and designed as miniature Greek temples with end porticoes, complete a balanced and well-proportioned ensemble. In plan, the house blends the traditional Louisiana rear gallery set between cabinet rooms with an Anglo-American central hall containing a wooden spiral staircase. Some of the furniture was purchased in Europe while the Turnbulls were on their honeymoon.

Several mid-nineteenth-century dependency buildings survive, among them the kitchen, a *pigeonnier*, a doctor's office with a Greek Revival gallery, a two-story barn with a central open pas-

sage, a milk shed covered by a pyramidal shake roof and enveloped by galleries to shade the walls of hewn logs, and a square clapboard privy.

Rosedown's gardens are justly famous. The house is approached by way of a 660-foot-long allée of oaks planted as acorns by Martha Turnbull. She planned and developed the 28-acre garden, which included peach, fig, apple, and quince orchards, a kitchen garden, a cold pit, a large conservatory, and the pleasure garden. The last included both formal parterres with boxwood hedges and winding pathways among flowering bushes and roses; the azaleas and camellias, some of which survive in the garden, were among the first to be introduced into the United States. Three wooden latticework gazebos with onion-shaped roofs add focal points. The garden originally included imported Carrara marble statues, but these were sold in 2000 by the then-owner, along with furniture from the house. Rosedown is now owned by the state of Louisiana, which has replaced the original statues with copies in order to restore the gardens to their former glory. From 1837 until the year before her death in 1896, Martha Turnbull kept a meticulous record of her work on this garden, which was utilized in a restoration by Houston landscape architect Ralph Ellis Gunn in the 1960s.

The Turnbulls were a family of enormous wealth. In 1850, they owned 347 slaves to work on their land and in the house. They spent the summer months in the East and had their portraits painted by Thomas Sully. When in residence at Rosedown, the Turnbulls made it one of the great social centers of the plantation-owning families in West Feliciana. After the Civil War and the death of her husband and son, Martha Turnbull managed Rosedown Plantation. The house and gardens are now open for tours.

Rosedown's house appears to have influenced Weyanoke Plantation House near Bains (not visible from the road), which began as a log cabin and was remodeled between 1838 and 1856 by John Turnbull Towles, a relative of the Rosedown Turnbulls.

Hardwood

WF14 The Myrtles

1796, c. 1840. 7747 U.S. 61 (1.3 miles north of junction with Louisiana 10) (Not visible from the road)

This unusually wide house began as a one-and-one-half-story, six-bay structure, built by Pennsylvanian General David Bradford, a judge and businessman and a leader in the Whiskey Rebellion of 1794. The collapse of the rebellion caused Bradford to flee to Louisiana, where he obtained a Spanish land grant of 650 acres in 1797 and built a house, which he named Richland. By 1834, Ruffin G. and Mary Stirling owned the house and renamed it The Myrtles. To accommodate their six children, they expanded the house to ten bays in width, for a total of 107 feet. Their new 16-foot-wide entrance—very accommodating for the hoopskirts women wore at that time—opens onto a hall that extends through the house's two-room depth to the rear loggia. The elaborate plaster frieze work is thought to have been done by the craftsman who decorated Afton Villa's ballroom (WF20). The Myrtles' most unusual feature, which adds a pleasingly delicate touch, is the grapevine-patterned cast iron gallery. This was a common feature for urban dwellings, particularly in New Orleans, but rare for a plantation house. Ruffin Stirling owned several plantations, as well as a townhouse in Natchez. The Myrtles is said to be haunted. The house is open for tours.

Hardwood Vicinity

WF15 Butler Greenwood

c. 1810, 1850s. 8345 U.S. 61 (2 miles north of St. Francisville) (Not visible from the road)

In 1786, physician Samuel Flower received a 2,200-acre land grant from the Spanish government, and in the early nineteenth century he began to build this one-and-one-half-story galleried house with six rooms. In 1816, Flower's daughter, Harriet Mathews, inherited the house, and with her son, Charles Mathews, undertook its remodeling in the 1850s. This included enclosing the rear gallery to provide additional rooms, adding a massive front gable with a Palladian window, remodeling the front gallery with square posts and jigsaw decoration, and, for the interior, marble mantels. In height and appearance the front gable matches the end wall gables; together they form the focal points of the facade rather than the gallery, as is usual with the Louisiana galleried house. These pointed gables also add a Gothic touch. No doubt stimulated by the precedent of Afton

Villa (WF20), the Gothic Revival style was popular in the St. Francisville area, perhaps more so than elsewhere in the state. An octagonal wooden gazebo ornaments the surviving portions of the formal gardens, which were laid out beginning in the late 1840s; a grove of magnificent live oaks draped with Spanish moss stands in front of the house. A nineteenth-century three-room brick kitchen, which originally contained a dairy and smokehouse, is now used for bed-and-breakfast accommodations. The house is open for tours.

Bains Vicinity

WF16　Greenwood Plantation House

1830, attributed to James Hammon Coulter. 1984, reconstruction. 6838 Highland Rd. (off Louisiana 66)

This massive Greek Revival plantation house is a modern replica of the original building. Struck by lightning in 1960, the house burned to the ground, leaving only the twenty-eight brick columns of its gallery and four chimneys. Since no plans of the house existed, the owners based its reconstruction on the surviving foundations, photographs, an inventory of furnishings, and oral descriptions. Almost 100 feet square, the rebuilt house is surrounded by two-story-tall Doric columns; it has a 70-foot-long central hall and a third-floor attic surmounted by a rooftop belvedere. It is believed that builder James H. Coulter, who came to West Feliciana in the 1820s from Delaware, supervised construction of the original house, using contemporary pattern books and African American carpenters.

The original house was built for William Ruffin Barrow and his wife, Olivia Ruffin Barrow (she was his first cousin and a sister of Martha Turnbull of Rosedown [WF13]). Like other plantation-owning members of the Barrow family, William Barrow amassed an enormous fortune. In 1840, the Barrows owned 275 slaves on this 12,000-acre sugarcane plantation.

Greenwood is similar in size and design to nearby Ellerslie Plantation (5811 Louisiana 968; partially visible from the road). Ellerslie was built in 1832, perhaps by James Coulter, for Judge William C. Wade from North Carolina and Olivia Ruffin Wade; reputedly, it was mostly her money that financed construction. Neither Greenwood nor Ellerslie are imaginative designs, but their sheer size makes them impressive. They are prime examples of the commit-

ment to the Greek Revival style for plantation houses in Louisiana in the 1830s and 1840s because it represented power, wealth, and cultured taste rather than because of its associations with the Greek ideals of democracy. Greenwood is open for tours and offers bed-and-breakfast accommodations.

WF17　Highland

1805. Highland Road (Louisiana 66) (Not visible from the road)

William Barrow, Jr., and his wife, Pheraby Hilliard, along with family members and slaves, moved to West Feliciana from North Carolina around 1800. The Barrow family emerged as one of the largest landholding families in the antebellum South as well as in West Feliciana, dominating its economic and social life. William Barrow prospered quickly: in 1808, he owned 150 slaves; at his death in 1823, he owned six plantations, 348 slaves, and an extensive library. He also played a major role in the West Florida rebellion of 1810, serving as one of the five members of the provisional government.

Highland (known as Locust Grove until the 1840s) was the first house built by members of the Barrow family. Similar to houses in North Carolina rather than Louisiana, Highland was significant for introducing Anglo building traditions to West Feliciana. The two-story wooden house has a central hall, with one room on each side on both floors, a rear extension of three rooms, end chimneys, and a two-story gallery. The front gallery was originally only one story in height but was replaced in the 1870s by a two-story gallery, and the roof was extended to cover it. The finely detailed woodwork includes Greek motifs around the entrance door and mantels. In the 1830s, Barrow's son, Bennett Hilliard Barrow, who had inherited the property in 1823, enclosed the back gallery and added an allée of oaks, a racetrack, a sugarhouse, a dance hall for the slaves, a hospital, and a jail. He also converted the crop from cotton to sugarcane. Near the house is the family cemetery with a tomb dating from 1803.

Weyanoke

WF18　St. Mary's Episcopal Church

1857, attributed to Frank K. Wills. Louisiana 66 (.5 mile north of Weyanoke post office)

According to tradition, this small brick church is based on plans by Frank Wills of New York. Certainly it exhibits the design characteristics Wills recommended in his book *Ancient English Ecclesiastical Architecture and Its Principles, Applied to the Wants of the Church at the Present Day* (1850), written to guide communities unable to afford or to find a suitable architect. Wills's designs were simple in plan and elevation to allow nonspecialists to copy them easily. This English Gothic Revival church features a square crenellated tower over the entry portico, a single three-bay-long nave, a narrower and lower chancel, and a small room attached to the chancel's south side. It is similar to the larger St. Stephen's Episcopal Church, Innis (PC14), also built in the 1850s to a design by Wills. St. Mary's, one of the mission churches established by St. Francisville's Grace Church, was built on land donated in 1854 by Sarah Mulford of Retreat Plantation in Weyanoke. The church was deconsecrated in 1947.

Angola

WF19 Louisiana State Penitentiary at Angola

1952–1956, Curtis and Davis. Louisiana 66

Angola, as this prison is commonly known, was built to replace an earlier set of buildings after an investigation in 1951 revealed appalling conditions within the compound. The first penitentiary on this site was a prison farm established in 1917 and named for the plantation it

WF19 Louisiana State Penitentiary at Angola, dining hall, photo c. 1956

replaced. The name refers to the Angola kingdom of the Mbundu people in southern Africa, from which thousands of slaves were exported, including those purchased by a local slave trader. Surrounded on three sides by the Tunica Hills and bounded on the other by the Mississippi River, the isolated 18,500-acre site was considered an ideal location for a penitentiary. Curtis and Davis developed their scheme for Angola based on the latest ideas on penal reform, including placing prisoners in groups based on age and the type of crime committed. The design incorporated minimum-, medium-, and maximum-security compounds, as well as a number of shared areas, such as a central dining hall and educational and training facilities. The overall plan was laid out in a pinwheel pattern, a scheme with origins in a much earlier era of prison reform, that of the first decades of the nineteenth century. Although Angola was planned for 2,500 inmates, by 1958, just two years after it opened, the prison housed 3,700.

The building project was time- and cost-effective as a result of using such advanced methods as lift-slab construction for the concrete walls, which eliminated the need for the carpentry form work required for poured concrete, and placement of floor slabs 3 feet above ground level, so that all pipes and wires could be hung underneath rather than in trenches. In addition, the use of inmates to do the construction is said to have cut labor costs by 70 percent. The dining hall (now used as a recreation center) is a 76,000-square-foot area spanned by a 200-foot soaring double-curved roof of prestressed concrete hinged at the center. Architect Sidney Folse of Curtis and Davis led the design team for Angola, and civil engineer Walter Blessey was consultant for the dining hall.

Angola received accolades both nationally and internationally. Describing the new Angola, James V. Bennett, then-director of the Bureau of Prisons under the U.S. Department of Justice, stated: "Its [Angola's] unique design, low per capita cost and the diversity of its facilities have no counterpart elsewhere in this country, and none to my knowledge in the world." Architects were dazzled by the design of the dining hall. In 1995, Angola again gained public attention through the film *Dead Man Walking* and the documentary *The Farm*.

Immediately after its completion, Angola became a model for prison architecture around the nation, making the firm of Curtis and Davis one of the leaders in prison design. They designed more than thirty jails and detention

centers in over twenty states, including those in Moberly, Missouri; Shelton, Washington; Sumter County, Florida; Fox Lake, Wisconsin; Cheshire, Connecticut; and Vienna, Illinois. Angola's Louisiana State Penitentiary Museum offers what is described as "the history of crime and punishment in the deep South."

Angola, and the plantation it supplanted, occupied the site of an abandoned Tunica Indian village. Archaeological investigations have revealed that the village, which was occupied from approximately 1731 to 1764, included dwellings, a temple, and a burial ground.

Bains Vicinity

WF20 Afton Villa Gardens

c. 1849. U.S. 61 (4 miles north of St. Francisville)

Only the gardens and fragments of foundations survive from the fire that destroyed Afton Villa in 1963. David Barrow and his second wife, Susan Woolfolk Barrow, from Kentucky, created the exotic mansion around a smaller two-story house, and Susan planned the twenty-acre gardens. The gardens were restored twice in the second half of the twentieth century, first in 1952 by landscape architect Theodore Landry and then, in 1972, a few years after the fire, when the new owners, Morrell and Genevieve Trimble, hired landscape architect Neil Odenwald to restore them and create new plantings within the ruins of the house.

The gardens are approached along a half-mile-long serpentine allée of oak trees, which suddenly opens out to lawns and terraces, and would once have included the spectacular house. A row of four classical statues now marks the spot where the facade of the house once stood. They add a poignant note to the enjoyment of the gardens, making the absence of the house palpable. To the left is a low boxwood maze, remade in the restoration of 1952, and beyond are the broad grass terraces that lead toward the ravine below. Odenwald created a naturalistic arrangement of flower plantings within the few remaining fragments of walls and entrance steps from the house, and he added a pond to one side of the terraces.

Barrow, possibly the wealthiest planter in West Feliciana, had a net worth in 1860 of almost $1.4 million. In addition to Afton Villa, he owned two plantations in Pointe Coupée Parish, including Alma (PC9), and property in North Carolina and Florida. He is buried in the family cemetery beside the house, which also contains raised marble tombs and an obelisk marking the graves of his first wife and other family members. The gardens are open to the public in early summer and fall. The Gothic Revival gatehouse and the iron gates date from the 1940s.

WF21 Catalpa

1885. 9508 Cottage Ln. (off U.S. 61, 5 miles north of St. Francisville) (Not visible from the road)

In common with many of West Feliciana's plantation houses, Catalpa is reached by way of an impressive double row of moss-draped oak trees, although here it forms a sweeping semicircle. In its size, plan, and delicate details, Catalpa is a typical late-nineteenth-century planter's house. Built to replace an earlier structure destroyed by fire, Catalpa is a one-and-one-half-story galleried house with East-lake brackets and a central gabled dormer in the hipped roof. Five bays wide, it has a central hall with two rooms on each side and a large rear wing. A dependency and cistern are adjacent to the house. Catalpa is open for tours.

WF22 Cottage Plantation

1795–1859. 10528 Cottage Ln. (off U.S. 61, 5 miles north of St. Francisville) (Not visible from the road)

This plantation house is situated at the end of a half-mile-long driveway sheltered by oaks and deciduous trees and across a bridge that spans a creek. The house was constructed in three stages. It began as a one-and-one-half-story house, 42 feet in length, and was extended in the early 1800s to a length of 85 feet and a total of twelve rooms. The two sections are visually integrated by a gallery that extends the full width of the house and by four symmetrically placed dormer windows. A four-room rear wing was added in the 1850s. The entire house is constructed of cypress, with sills of blue poplar. Its earliest section was built on land granted to John Allen and Patrick Holland by the Spanish government in 1795. Lawyer Thomas Butler from Pennsylvania purchased Cottage Plantation in 1811 and the following year was appointed a parish judge. From 1818 to 1821, he represented Louisiana in the U.S. Congress. During Butler's ownership of Cottage, he entertained Andrew Jackson when he was en

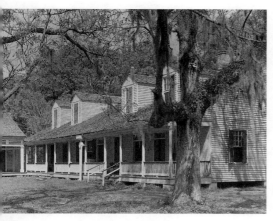

WF22 Cottage Plantation, photo 1930s

route to Natchez after the Battle of New Orleans.

Several of the original dependencies survive in an irregular arrangement behind the main house. These structures include two two-room slave cabins, a two-room building with a central chimney that served as an office and schoolhouse, a milk house for processing cream and butter, a two-room kitchen, a carriage barn, a horse barn, a well house, and two cold frames. At the entrance to the grounds are remnants of the West Feliciana Railroad tracks, on which the cotton from this and other plantations was transported to St. Francisville and the Mississippi River port of Bayou Sara. Cottage Plantation now offers bed-and-breakfast accommodations.

Laurel Hill

WF23 St. John's Episcopal Church
1873. Old Laurel Hill Rd. (West Feliciana 9)

Along with St. Mary's at Weyanoke (WF18), this diminutive Carpenter's Gothic structure is one of the mission churches established by Grace Episcopal Church in St. Francisville. Constructed by contractor William Goddard, the church is sheathed with narrow clapboards; its gable roof is trimmed with pointed-arched bargeboards, as is the roof over the tiny front vestibule. A small room that extends from the chancel was built at the same time as the church. Above the three-bay-long nave and the chancel are pointed barrel vaults; the pointed-arched windows have their original stenciled and stained glass. A small cemetery next to the church is enclosed by a cast iron fence.

Florida Parishes

WEDGED BETWEEN LAKE PONTCHARTRAIN AND THE MISSISSIPPI state line, this area of Louisiana, known as the Florida Parishes, has lived under French (1717–1763), British (1763–1779), and Spanish rule (1779–1810). In 1810, the region was annexed by the United States, but not before a brief existence (seventy-four days) as the independent Republic of West Florida. The political boundaries of the republic also included West Feliciana and East Baton Rouge parishes, but because the economy, culture, and architecture of these two parishes have been so strongly influenced by the presence of the Mississippi River, they are included with the Lower River parishes in this book.

The region encompasses six parishes: St. Helena (1810), named for St. Helen, the mother of Emperor Constantine the Great; St. Tammany (1810), named for a Delaware Indian chief who became a symbol of American resistance to the British; Washington (1819), named for the nation's first president; East Feliciana (1824); Livingston (1832); and Tangipahoa (1869), named for the Tangipahoa Indians. The eastern boundary is formed by the Pearl River, so named because of some low-grade pearls found there, and the southern boundaries are Lake Pontchartrain and Lake Maurepas. It was the narrow waterway between the two lakes, now known as Pass Manchac, which provided the shortcut that the Indians showed to Pierre Le Moyne, Sieur d'Iberville, and Jean-Baptiste Le Moyne, Sieur de Bienville, in 1699. The region's terrain is hilly in its northernmost parts. Before the big lumber companies arrived in the late nineteenth century, most of this area was densely covered with longleaf yellow pine, the trees reaching heights of 100 feet. Cypress swamps lie to the southwest

Native Americans, notably the Choctaw, inhabited the region before settlers of European ancestry began to arrive, many of them from the East Coast. Some carved small farms out of the forests, raising cattle and growing mixed crops. The wealthier

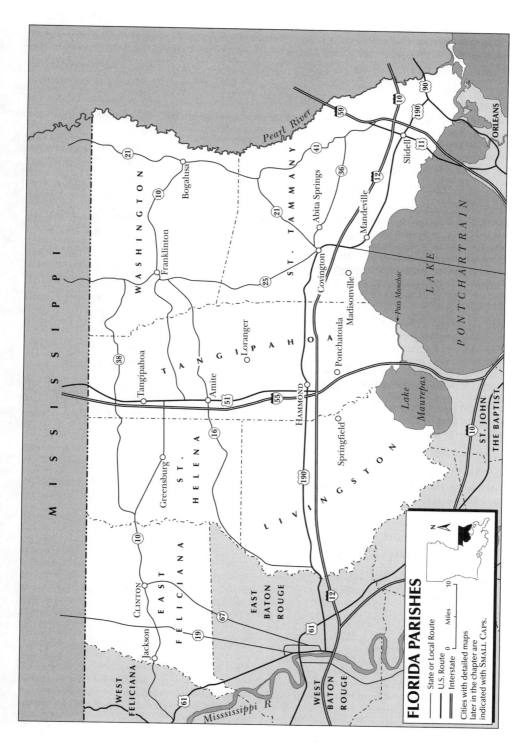

FLORIDA PARISHES

Cities with detailed maps
later in the chapter are
indicated with SMALL CAPS.

State or Local Route
U.S. Route
Interstate

0 10
Miles

settlers came with their slaves and established cotton plantations. In the northern and eastern sections, log cabins, including dogtrot houses, were common, and in the western areas, Greek Revival forms were adopted with enthusiasm. The towns of Clinton and Jackson in East Feliciana Parish are showcases of Greek Revival architecture. In the mid-nineteenth century, New Orleanians discovered the pure pine-scented air and natural springs along the north shore of Lake Pontchartrain and traveled by boat to this "ozone belt" across the lake. Health resorts and hotels quickly sprang up. But in general the area remained thinly settled until the railroads arrived. The Illinois Central Railroad, for example, encouraged settlement by issuing such pamphlets as *The Farmer's Road to Wealth, Tangipahoa Parish, Louisiana*; such promotion encouraged hundreds of immigrants from Iowa, Michigan, and Illinois to relocate to this area. Hungarians formed a large rural colony at Arpadhon in Livingston Parish. Italian immigrants also utilized the railroads, cultivating cutover pine lands for strawberry production and shipping the fruit to Chicago in refrigerated freight cars. Among the new towns that grew up at the railroad stops, which were placed at ten-mile intervals alongside the tracks, are Ponchatoula, Amite, Tangipahoa, and Albany. Also, lumber companies established mills and towns. By the early 1900s, there were thirty pine sawmills in Washington Parish alone, including, at Bogalusa, what was said to be the largest pine mill in the world. In addition to pine, cypress was harvested from the swamps beside Lake Maurepas.

Today, crop and dairy farming and lumber remain important to the economy. The southern sectors of the Florida parishes, particularly St. Tammany Parish, have experienced extraordinary population growth. In 1956, the 24-mile-long causeway linking New Orleans to Lake Pontchartrain's north shore was completed—the longest highway bridge in the world at that time. With completion of the second span in 1969, New Orleanians began relocating across the lake in greater numbers. The formerly small towns of Covington and Mandeville have become bedroom communities for New Orleans and have expanded outward with many new subdivisions. By the early 1990s, suburban sprawl and traffic congestion had become irreversible problems.

St. Tammany Parish (ST)

Covington

In 1813, Covington was laid out on the west bank of the Bogue Falaya River on land donated by merchant John Wharton Collins. First known as Wharton, the town was renamed in 1816 for General Leonard Covington, who died in the War of 1812. Each of Covington's original twenty-seven square blocks had a small open square at its center, which connected to the street grid by narrow alleys. These squares were set aside for common use and were known as ox lots, probably because they were used for animals and livestock. Several of the alleys and squares have survived, some of the latter now used as parking lots. A navigable river, the Bogue Falaya, and easy access to Lake Pontchartrain accounted for Covington's initial growth as a port for shipment of local produce to New Orleans. By the late nineteenth century, Covington was a popular health resort, appreciated for the purity of its air and water.

Summer visitors and tourists came by steamer across Lake Pontchartrain from New Orleans and, after 1887, via the East Louisiana Railroad.

Covington's historic center was rebuilt beginning in the 1880s following two fires and has retained its small-town atmosphere, although many of the one- and two-story brick and wooden commercial buildings are now occupied by antique stores and coffee shops. The former railroad freight and passenger depot, a simple rectangular wooden structure (501 N. New Hampshire Street) of c. 1890, has been adapted for commercial use. Nearby, the former pumping station (N. Theard and E. 25th streets) is a small rectangular structure with curved Dutch gables, built in 1928 by Kramer Engineering Company of Magnolia, Mississippi. Next to it is an early-twentieth-century metal conical-roofed water tank on a steel tower. Sam Stone, Jr.'s, design for the gable-fronted, two-story rectangular Masonic Lodge (1924; 130 Columbia Street) has walls of variously tinted red brick to create a tapestrylike effect. The three-story modernist St. Tammany Parish Courthouse (E. Boston and N. New Hampshire streets) has a revealed reinforced concrete frame with exterior wall finishes that include patterned brick, mosaic, and limestone. It was built in 1959 to a design by August Perez and Associates.

ST1 St. Tammany Parish Administrative Complex (Southern Hotel)

1907. 608 E. Boston St. (corner of N. New Hampshire St.)

Popular with vacationers, this former hotel conveys the impression of intimate comfort, with a low horizontal outline, round-arched openings, and low-pitched roofs with wide eaves and large scrolled brackets. The building has a U-shaped plan, with a relatively narrow front and end wings that extend deep into the lot. Shops fronted by a wooden gallery originally lined the New Hampshire Street side. The central section of the facade is recessed between the end wings to provide space for a front arcade and a small landscaped forecourt. As an attraction, domestic and wild animals were kept in cages in the lobby. Constructed of stucco-covered brick, the hotel has small wooden balconies in front of the second-floor end wing windows that add to its slightly Mediterranean appearance. The hotel closed in 1960 and was pur-

chased by the parish in 1980. In 1982, the interior was remodeled by Arthur Middleton for use as a government building; another use will be found when the new St. Tammany Parish Judicial Complex opens (E. 26th and N. Theard streets).

ST2 Christ Episcopal Chapel

1847, Jonathan Arthur. 120 S. New Hampshire St.

English-born Jonathan Arthur, a member of the congregation, provided the design for this three-bay, gable-fronted wooden chapel. Its present appearance is the result of several later additions, starting in the 1880s with an octagonal bell tower on the left side of the facade. A few years later, six pointed-arched windows replaced the square-headed windows, and the chapel acquired a chancel, a cove-molded wooden plank interior ceiling, three stained glass windows in the apse, and a stained glass lunette on the facade. The present octagonal spire was added after the original was destroyed in the hurricane of 1915, and the entrance porch was then extended across the entire facade. In the 1960s, a Gothic Revival brick church with a square corner tower was built adjacent to the chapel to accommodate the much-enlarged congregation.

Covington Vicinity

ST3 St. Joseph Abbey and Seminary College

1902. 1931, St. Joseph Church, Theodore Brune. 1960, Corpus Christi Chapel, Lawrence and Saunders. 75376 River Rd. (off Louisiana 25, 1.9 miles north of junction with Louisiana 190)

In 1889, a small group of Benedictine monks from St. Meinrad Abbey in Indiana established St. Joseph Priory and Preparatory College near Ponchatoula and moved to this site in 1902. The following year, the priory was elevated to the status of abbey. In addition to training priests, the abbey offers retreats, a youth program, and cultural events; many of the new buildings added during the twentieth century to serve these programs were designed in contemporary forms. The red brick abbey church, however, takes its cue from Italian Romanesque designs, with its gabled front, four-columned portico, and a single bell tower,

which in this case is located beside the semicircular apse. Inside, the nave is separated from the aisles by a round-arched arcade on Corinthian columns and has an open timber ceiling. The most striking feature is the series of vividly colored murals by Dom Gregory de Wit (1892–1978), who also decorated the abbey's refectory. In a style that blends Pre-Raphaelite color and emotionalism with Romanesque linearity, images of saints and apostles adorn the areas between the clerestory windows and the aisle walls; musical angels in flight envelop the dome over the crossing of nave and transept; and Christ in Majesty, Adam and Eve, angels, and scenes of hell fill the apse.

In 1961, a rectangular two-story modern administrative and academic structure, designed by the New Orleans firm of Lawrence and Saunders, was added to the college. This building's interior courtyard, covered by a folded-plate roof, contains a small, freestanding prayer chapel, circular in plan. Thirty feet in diameter, the modernist chapel is constructed of plaster-finished panels over a steel frame that zigzags around the space. Narrow vertical bands of abstractly patterned colored glass separate the panels, providing the only touch of color and decoration in the white interior. The parasol-shaped ceiling is suspended below a flat roof; lamps recessed behind the ceiling shed light on the walls, making the ceiling appear to hover like a many-pointed star. The interior evokes a dual sense of enclosure and dematerialization, suiting the structure's purpose and role.

Abita Springs

In addition to its fresh pine-scented air, Abita Springs gained a reputation as a health resort because its artesian water was valued for its curative powers. By the early twentieth century, the town had several hotels, none of which have survived. Today Abita Springs is characterized by galleried wooden single-family houses set among the pine trees. In Abita Springs Tourist Park (Main Street at its conclusion) is a raised octagonal wooden pavilion, similar to a bandstand, that was constructed in 1888 over the site of a former spring. Trinity Evangelical Lutheran Church (corner of Level and Hickory streets), built in the Gothic Revival style in 1905, has an attractive square tower with a steeple sheathed with wood shingles in three different patterns. Just west of

ST3 St. Joseph Abbey and Seminary College, interior courtyard and chapel

Abita Springs (Louisiana 36) is the Abita Springs Brewery, a microbrewery established in 1986 that uses spring water for its variously flavored beers.

Madisonville

Madisonville was one of the nineteenth-century resort communities on Lake Pontchartrain's north shore favored by New Orleanians as a weekend retreat as well as during the summer months when yellow fever was a threat. Because of its location beside the Tchefuncte River, just two miles above its entrance into Lake Pontchartrain, Madisonville also became an important shipbuilding center, boasting four shipyards by the late nineteenth century. During World War I, the Jahncke Shipyard employed more than 2,000 workers. But after World War II, the shipbuilding industry declined, and today Madisonville is a tranquil small town, catering mostly to leisure boating. One remnant of the shipbuilding days is a former boardinghouse (703 Main Street), built of wood c. 1880, which was originally a private residence before being converted for lodgers in the 1920s. Madisonville's former town hall, now a museum (203 Cedar Street), is a small two-story brick structure, built in 1911, that accommodated a jail on the ground floor; an exterior double staircase rises to the second-floor central entrance. The wooden house at 206 Covington Highway, constructed in 1911 for Theodore Dendinger, who was prominent in lumber and transportation, mixes Queen Anne and Colonial Revival features, as was popular in Louisiana at that time.

ST4 Madisonville Branch Library
(Madisonville Bank)

1900. 1919, facade. 400 Cedar St. (corner of E. St. John St.)

This two-story frame building was constructed in 1900 and given a showy classical facade in 1919. Corinthian pilasters outline three bays; molded-relief garlands and cartouches decorate the spandrels between the second and third floors; a projecting cornice and entablature complete the facade. The recessed entrance is set at an angle to the street corner, and fluted pilasters outline the door. The interior has been modernized.

Madisonville Vicinity

ST5 Tchefuncte River Range Rear Lighthouse

1910. Visible from the southern termination of Louisiana 21 (2 miles from Madisonville)

The white-painted tapered brick cylinder, 34 feet high, marks the spot where the Tchefuncte River flows into Lake Pontchartrain. Although a lighthouse has occupied this site at the mouth of the river since 1838, the present structure dates from 1910. A black vertical stripe on the exterior increases its visibility as a daytime marker.

ST6 Otis House (Jay House)

c. 1890. Fairview-Riverside State Park, Louisiana 22

Now part of a ninety-nine-acre state park, this Queen Anne house facing the Tchefuncte River was built by William T. Jay shortly after he purchased the site in 1885 and opened a sawmill. The two-story frame house has an asymmetrical floor plan organized around a central hall, a two-story gallery enclosing two sides of the house, a hipped roof, and two gables. Jay's lumber came from an area west of Lake Maurepas and was brought by boat through Pass Manchac and Lake Pontchartrain to the dock in front of his house. By 1906, Jay employed almost one hundred workers, who lived in the company town, Jayville, that had grown up next to his house. Jay sold his company and house in 1906 to the Houlton Lumber Company, which renamed the town Houltonville, and the following year Jay purchased a home in New Orleans

(OR145). In 1930, Frank Otis, who owned a company in New Orleans manufacturing mahogany furniture, purchased the house and made some minor alterations. Otis renamed the house Fairview, after one of his plantations in Honduras, the source of his mahogany, and used it as a summer home and for entertaining. At his death in 1961, Otis donated the house and the surrounding land to the state of Louisiana for use as a recreational site. Only the house survives from the company town.

Mandeville

Mandeville was founded in 1834, occupying part of what was formerly the sugar plantation of Bernard de Marigny de Mandeville. By 1806, Marigny had subdivided his plantation and successfully sold lots to buyers in New Orleans. Mandeville, on Lake Pontchartrain's shore, soon became a favorite resort for New Orleanians, who would cross the lake by ferry. Some built summer homes with broad galleries from which they could catch the lake breezes. Many of these early houses survive along Lakeshore Drive. The Greek Revival raised wooden house with a central hall at number 1717 was built c. 1840. At number 1721 is a stucco-covered house of brick-between-posts construction, built c. 1837, with a Creole plan, including a front gallery and a rear loggia, under a double-pitched gable roof. Later in the century, the side galleries and their pitched roofs were added to create this picturesque dwelling. At number 2407 is a raised and galleried wooden house (c. 1885) with a steeply pitched gabled dormer and spindlework decoration. At number 2423, a pretty Eastlake gallery ornaments the raised wooden house with a central hall (c. 1885).

Other buildings reflecting Mandeville's early history can be seen on streets perpendicular to the lake. The Dew Drop Social and Benevolent Hall (432 Lamarque Street), a small, gable-fronted frame structure, was built in 1895 by an African American benevolent society and was a popular jazz venue in the early twentieth century. The Holy Family Hall (395 Lafitte Street) of Our Lady of the Lake Catholic Church formerly housed a Catholic school for African Americans. The two-story wooden building is surrounded by galleries and has ogee-arched windows on the second floor.

Mandeville had declined as a resort by the 1940s, when the automobile could take New

Orleanians farther afield, but after the causeway across the lake was completed in 1956, the town became popular again as a bedroom suburb of New Orleans.

ST7 **Fontainebleau State Park**

1938, plan, William W. Wells. 1938, buildings, Theodore L. Perrier. 67825 U.S. 190

The main section of Fontainebleau State Park, consisting of 2,000 acres on the lakeside of the highway and bounded by Lake Pontchartrain and Cane Bayou, was developed between 1938 and 1942 and built by 215 young men from the Civilian Conservation Corps (CCC). The park bears the name of Bernard de Marigny's sugar plantation, which formerly occupied this site and was itself named after the estate of the French king François I. By the time the Louisiana Department of Conservation purchased the site in 1938, it was owned by the Great Southern Lumber Company, which had established the mill town of Bogalusa in Washington Parish. The development of Fontainebleau Park was carried out by the State Parks Commission in consultation with the National Park Service; landscape architect William W. Wells designed the plan to emphasize recreational activities. Although some components such as a boating lagoon and a lodge were never built, the park, as a whole, reflects his scheme.

New Orleans architect Theodore Perrier designed several of the park's structures. Wells wrote in his report of 1939, "All of the buildings are being kept in the early Louisiana style of architecture." The main entrance is marked by brick piers and flanking low walls and by an octagonal brick *pigeonnier* to one side. Just inside the entrance is a small one-story galleried cottage, formerly a ranger's dwelling. Other structures include a brick bathhouse (1939) with a Doric portico and cupola, a colonnaded shelter (1940) with open pavilions at each end, and a hip-roofed brick restroom fronted by a Doric porch (1940). The ruins of Marigny's sugar mill (1829), including two brick chimneys, were incorporated into Wells's landscape design, as was the plantation's oak allée. Structures built subsequent to the CCC work include a hip-roofed picnic shelter (1946) and, on the park's western perimeter, four concrete tepee-shaped buildings constructed when the Boy Scouts owned this area of the park. A small group camp, with separate access from U.S. 190 on

the park's eastern perimeter (1947–1948), consists of two dormitory buildings and a dining hall. Other small structures were added to the park in subsequent years.

Slidell

Surveyed and platted in 1883 for the New Orleans and Northeastern Railroad, Slidell was named for John Slidell (1793–1871), Confederate ambassador to France and U.S. congressman. His son-in-law was a principal investor in the railroad. The town of Slidell began to grow after Fritz Salmen established a brickworks in 1886. With his brothers, Jacob and Albert, Fritz formed the Salmen Brick and Lumber Company, which operated until the 1920s. Among Slidell's historic buildings are the railroad depot (1913; 1809 Front Street), a long brick structure covered by a hipped roof, with eaves carried on large decorative brackets, and the Arcade Theater (1927; 2247–2251 Carey Street), a stucco-covered brick structure with a pantile roof that gives a light Mediterranean touch.

ST8 **Salmen-Fritchie House** (Fritz Salmen House)

c. 1900, with additions. 127 Cleveland Ave. (corner of Front St.)

Swiss immigrant Fritz Salmen built this one-and-one-half-story house with a central-hall plan across the street from his brickyard, and he is said to have observed activities at the yard from the parlor's bay window. Combining Queen Anne and Colonial Revival elements, the house has a deep gallery with paneled piers raised on brick pedestals and a hipped roof with prominent shed dormers decorated with shingles. By 1906, a kitchen ell was added to the rear, and in a further expansion of 1917, the east gallery was transformed into a sun room and a porte-cochere added to it. After Salmen died in 1934, his home was purchased by Homer G. Fritchie, Sr., a relative by marriage and mayor of Slidell from 1930 to 1962. The house now accommodates a restaurant. Another house belonging to the Salmen family (2854 Front Street), perhaps begun by Fritz's wife, Rosa, who died in 1897, is a Swiss chalet with broad overhanging eaves and elaborate woodwork.

Tangipahoa Parish (TA)

Amite

Amite was laid out in 1860 beside the New Orleans to Mississippi route of the New Orleans, Jackson and Great Northern Railroad (now the Illinois Central), and in 1869, the town was selected as the seat of the newly formed Tangipahoa Parish. That year the Gullet Gin Manufacturing Company established a plant one mile south of Amite, operating until 1963. Its brick and metal structures are now abandoned. Amite also became a center for shipping lumber and strawberries, but now that trucks carry the region's produce, the one-story brick railroad depot (c. 1920; E. Oak Street at the railroad) has been converted for use as police headquarters. The Amite City Museum occupies the early-twentieth-century two-story brick building that was formerly a bank (E. Oak Street and S.E. Central Avenue). The Gothic Revival Episcopal Church of the Incarnation (111 E. Olive Street) was rebuilt in 1908 after the structure of 1872 was blown down in a tornado. This small wooden cruciform church has a square front tower with a flared spire and bracketed eaves. Among Amite's older houses, Greenlawn (200 E. Chestnut Street) is a particularly attractive example with its galleries, patterned shingles, and Eastlake trim reflecting popular taste when it was built in the 1890s.

TA1 **Tangipahoa Parish Courthouse**

1967, Desmond-Miremont and Associates. 100 N. Bay St. (corner of E. Mulberry St.)

A characteristic of this architecture firm's work was to express a building's structure and its in-

TA2 Commercial Building (Hotel Ponder)

terior spatial organization as directly as possible. Thus the reinforced concrete frame of this modernist courthouse is exposed on the exterior walls, rendering floor levels and heights of the building's three stories easy to read. The geometry of the frame and the contrasts between the various construction materials of concrete, limestone, and glass enrich the exterior. Second-floor windows are shaded by concrete vertical *brise-soleils.* A jail originally occupied the third floor. Paired staircases in the two-story-high lobby are visible through its glass facade. Designed during the Cold War, the courthouse was required to provide rooms that could double as fallout shelters. The two principal courtrooms at the core of the second floor were designed to be radiation-proof, and the interior spaces of the lower floor are surrounded by concrete walls. Yet through careful proportions and lighting, the oak-paneled courtrooms convey an aura of calm order rather than entombment. Bold and robust forms allied with meticulous attention to materials and details give this courthouse a monumentality rarely seen in Louisiana's late-twentieth-century civic buildings.

TA2 **Commercial Building** (Hotel Ponder)

1947. 121 S.E. Central Ave. (corner E. Chestnut St.)

Lawyer Leslie B. Ponder, Jr., built this former three-story hotel adjacent to the railroad tracks at a time when Amite was a busy shipping center. The influence of Le Corbusier's work of the 1930s is evident in the hotel's streamlined forms, smooth surfaces, rounded corners, encircling ground-floor canopy, flat roof, and rooftop steel railings. Occasional rows of darker bricks, a checkerboard-patterned cornice of cream-colored glazed tiles, and horizontal mullions in the second- and third-floor windows further emphasize the building's horizontal elements. Along with the rooftop railings, a prominent rectangular elevator tower, which reads from a distance as a smokestack, adds a nautical flavor. When the hotel was new, its roof was a popular venue for dances, and an annual dance still takes place there.

TA3 **Blythewood**

c. 1905. Corner of Elm and Daniel sts.

Planter, banker, and merchant Daniel H. Sanders built this large two-story Colonial Revival wooden house, set in spacious grounds on the edge of town. The house depends for its effect on its size and the two-story-high central portico of paired slender Doric columns supporting a pediment with a diminutive Palladian window in its center. The house has a wide central hall on both floors; a small balcony in front of the second-story hall is sheltered within the portico. Ground-floor galleries wrap the front and sides of the house. The hipped roof originally included a widow's walk in its center.

cludes approximately 450 acres. Camp Moore was a tent city with a few permanent buildings, none of which survive. More than 400 soldiers died during training here, the majority of them from various diseases, including a measles epidemic in 1862. The 150 gravestones were added at a later date and do not necessarily mark the exact grave sites. Two Union raids in 1864 destroyed the camp. A statue of a Confederate soldier, carved from Italian white marble, was placed here in 1907. The Camp Moore Confederate Museum, built in 1965 to resemble a Creole antebellum residence, houses a collection of Civil War artifacts. Also on the site is the log cabin that served as the initial meeting place of the local chapter of the United Daughters of the Confederacy.

Tangipahoa

TA4 **Camp Moore**

1861. U.S. 51 (1 mile north of Tangipahoa)

Camp Moore, named for Louisiana governor Thomas Overton Moore, served as the training camp for more than 20,000 Confederate soldiers during the Civil War. The pine-tree-covered site near the New Orleans, Jackson and Great Northern Railroad line was in use by May 1861. Although the precise boundaries of the original camp are not known, the site today in-

Loranger Vicinity

TA5 **Zemurray Lodge and Gardens**

1829. 1920s, additions, Moise H. Goldstein; interiors, George Gallup. 1950s, addition, John Desmond. 23115 Zemurray Garden Dr. (2 miles northwest of Hammond, off Louisiana 40)

This large, rambling house began as a one-and-one-half-story frame structure built as a retreat by lawyer, planter, and entrepreneur Alfred Hennen. It had a central-hall plan, brick exterior chimneys at each end, and a pitched roof.

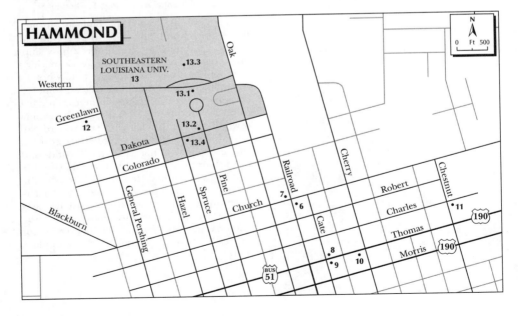

When Hennen's daughter and son-in-law, Cora and John Morris, inherited the property, it became known as the Morris Retreat and later Mount Hennen. In 1918, lumber magnates Charles H. and William L. Houlton purchased the property, renaming it Houltonwood. They already owned the former William Jay House and lumber company near Madisonville (ST6). In 1928, the Houltons sold Houltonwood to Samuel Zemurray, a Russian Jewish immigrant who had made his fortune importing bananas from Central America. Zemurray also had previously purchased a house from William Jay: the mansion on prestigious Audubon Place in New Orleans (OR145).

The Houltons had begun a major renovation and expansion of the house, which was continued by the Zemurrays. New Orleans architect Moise Goldstein and interior designer George Gallup were responsible for this work. The changes included covering the exterior with stucco, adding concrete Doric columns that wrap around most of the house, enlarging the upper half story with pent dormers, and adding a porte-cochere and a sleeping porch. The attached rustic log den, used for recreations that included gambling, was also renovated. Gallup's superb Arts and Crafts interiors included a paneled staircase with four landings, high paneled wainscoting, oak beams in the central hall, and painted foliate designs on the dining room's upper walls and ceiling. It is probable that the two cottages and the stables were built at the same time. One further addition to the house is a small modernist annex designed by John Desmond in the 1950s.

Zemurray's wife, Sarah, expanded the gardens to 171 acres; created the two-acre Mirror Lake, with its small island and bridge; installed copies of classical statues; and, with horticulturist Howard Schilling, developed azalea-lined trails that create a flamboyant blaze of color in the spring. Although the house is not open to the public, the gardens may be visited in the spring.

Hammond

Hammond was laid out beside the New Orleans to Chicago railroad line at the end of the Civil War by entrepreneur Charles Emery Cate. The town was named for an early settler, Swedish immigrant Peter Hammond. Cate owned a brickyard, sawmill, and shoe factory and was a principal manufacturer of shoes for the Confederate army. In the 1880s, midwesterners and Italian immigrants, the latter barred from nearby towns, settled in Hammond. The population jumped from 277 in 1880 to 1,500 in 1900. Strawberry cultivation became a major industry, especially with the development of the Klondyke, a hardy variety that could survive shipment by rail over long distances.

Hammond's historic commercial district along Thomas Street, which is bisected by the railroad corridor, is remarkably intact and vital, consisting mostly of early-twentieth-century two-story brick structures. The former Saik Hotel (1896; 120 E. Thomas Street) is a good example. More eye-catching is the former Fagan Drutstore at 207 E. Thomas Street, built in 1903, whose second story is faced with metal that has been pressed into designs of paired columns, shells, vine scrolls, garlands, and urns. The former Greyhound Bus Station, now Mannino's Pharmacy (113 W. Charles Street), was built in 1939, employing the company's characteristic curved streamlined forms. Nolan and Torre designed the three-story brick former high school (1915; 500 E. Thomas Street), which was converted into apartments in the late 1990s.

Hammond's early growth coincided with the popularity of the Queen Anne style, as is handsomely evident in houses at 113 S. Pine Street, built in 1888 and moved to this site from W. Thomas Street, and at 111 N. Magnolia Street (c. 1900). Both show the influence of northern versions of the style, with an emphasis on verticality and angularity, multiple gables and dormers, and shingles on the gables. Hammond has more Arts and Crafts–influenced houses than most other Louisiana towns. Two impressive and quite different versions are on W. Thomas Street, where lumber barons built their homes. At number 708 is a broad-spreading one-and-one-half-story wooden house with Dutch gables; the house at number 711 has two stories and features some particularly fine wood trim. In contrast to these houses, and occupying an entire block at 802 W. Thomas Street, is a two-story Colonial Revival mansion, constructed of wood, with a giant Ionic portico. Since the mid-twentieth century, Southeastern Louisiana University has played an increasingly important role in the town's economy. In the 1960s, two interstate highways (I-12 and I-55), built adjacent to Hammond, generated urban sprawl, along with strip and mall development.

TA6 Illinois Central Railroad Depot

1911–1912, J. A. Taggart. N.W. Railroad Ave. at W. Church St.

Designed by an employee of the railroad company, this red brick station consists of three separate units connected by breezeways. All three units have hipped roofs with extended eaves, and the central unit, the largest, has a squat octagonal tower with a conical roof on the platform side. The ticket office and segregated waiting rooms occupied the central unit; an express office was located in the unit to the north; and a baggage room and restaurant were in the other unit. The station now houses offices for city government and for Amtrak.

TA7 Grace Memorial Episcopal Church

1875, church. 1966, education building, Desmond-Miremont and Associates. 104 W. Church St.

The congregation, organized in the 1860s, held its services in the home of Charles and Mertie Cate until the church was built on land donated by the Cates. The wooden Gothic Revival building, painted white, has an asymmetrical facade with a square tower and an octagonal spire on one side of its gabled front. The lower half of the walls are of board-and-batten construction; the battens are connected at their tops to form a pointed-arched blind arcade. Horizontal siding covers the upper walls. The nave is covered by a lath and plaster ceiling embellished with a nonstructural wooden rib vault. The nineteenth-century stained glass window above the principal altar was originally in Old Christ Church, New Orleans.

To the left of the church is an early-twentieth-century wooden parish hall (formerly the Sunday school). To the right is the two-story wooden education building, designed by John Desmond and Andrew Gasaway. This structure repeats the vertical and linear qualities of the church and its gabled massing, demonstrating, as the architects intended, that the modern and the historic can coexist and complement each other. Two projecting glass-walled staircase towers on the building's long side further emphasize its contemporary image. The cemetery at the rear of the church includes the stuccoed brick raised tomb of the Cate family.

TA8 Commercial Building (Boos Building)

1898. 101 E. Thomas St.

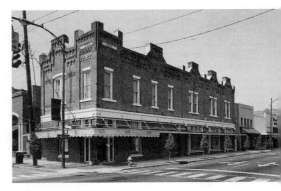

TA8 Commercial Building (Boos Building)

With its castellated parapet, this two-story red brick commercial structure takes full advantage of its corner location to attract attention. The tall parapet is set off from the lower walls by two rows of corbeling, with a row of bricks laid in a checkerboard design between them. A canopy shades the ground-floor windows. Eva Boos purchased the lot in 1897, and her husband, William Boos, established his barbershop in the building. It is said that they hired a German architect. By the early 1900s, the Boos Building also accommodated a soda stand and a jewelry store.

TA9 Commercial Building (First Guaranty Bank)

c. 1905, 1927. 100 E. Thomas St.

Appropriately for a bank, this two-story brick building is visually far more conservative than the Boos Building. Drawing its forms and details from Italian Renaissance palace architecture, the building has round-arched openings on the first floor and rectangular ones on the second, all with prominent keystones. In 1927, the first story was refaced with glazed brick in a stippled pattern that resembles veined marble; the corner entrance was closed and one bay added to the south side. The second story is of red brick, and the pressed metal cornice is marked by a row of modillions.

TA10 Columbia Theater for the Performing Arts

1928, William T. Nolan. 218 E. Thomas St.

The Columbia was designed for both vaudeville and movie shows. Constructed of brick with

cast stone decoration, the three-story building has a tall facade adorned with a double-height blind arch on each side of a central section. A vertical sequence of panels on the central section, surmounted by a shaped parapet, is embellished with the theater's name, urns, and a lyre in relief. The theater was renovated in the late 1990s by Holly and Smith Architects.

TA11 Preston House

1907. 706 E. Charles St.

Eli V. Preston, superintendent of the cypress lumber mill at Ruddock, hired New Orleans builder G. W. O'Malley to construct his one-and-one-half-story house on the section of East Charles Street known as Bankers Row. Sheltered under a pyramid-shaped roof with deep eaves supported on huge brackets, the house nestles comfortably in its spacious lot. A round-arched gallery encompasses two sides, although the west gallery is now enclosed; paired piers and a wider low arch with a prominent keystone indicate the central entrance. Centered on each side of the house are huge dormers with double-curved gables and miniature balconies. The present wooden fence around the property replicates the original.

TA12 House (Desmond House)

1960, John Desmond. 905 Greenlawn St.

John Desmond designed this modernist house for his family of four (his wife and their two sons) in a newly developed residential neighborhood. The house is made up of four steel-frame, glass-walled pavilions, each accommodating a separate function. Organized in a linear scheme around garden courtyards and sheltered under gently pitched roofs with deep extensions, the pavilions are also shaded by pine trees. Low (7 feet high) glass-walled hallways link the pavilions. On the street side, the pavilions have brick walls and clerestory windows. The house was featured in *Architectural Record* as a Record House of 1960.

TA13 Southeastern Louisiana University

1927, with many additions. W. Dakota St. between N. General Pershing Dr. and N. Oak St.

Southeastern Louisiana University (SLU), founded in 1925 as Hammond Junior College, was brought into the state system of higher edu-

cation in 1928 and renamed Southeastern Louisiana College. In 1927, fifteen acres of land in the northwest section of Hammond were purchased as the site for the new campus. The site included the Hunter Leake House, which the school used as its building until new ones were constructed. Several buildings added in 1940, which were funded by the PWA, were designed by Weiss, Dreyfous and Seiferth. Rapidly increasing student enrollment beginning in the 1950s set off a new wave of construction. Notable is the cafeteria building (1958) by Desmond-Davis Architects (John Desmond and William Burks, designers), whose forms were inspired by the acclaimed glass-walled, pavilion-like academic buildings designed by Mies van der Rohe for the Illinois Institute of Technology, Chicago, in the 1940s.

TA13.1 Lucius McGehee Hall

1934, Weiss, Dreyfous and Seiferth. N. Pine St. (off W. Dakota St.)

McGehee Hall, the first permanent building constructed at SLU, is set at the head of a landscaped avenue that forms the principal entrance to the university. The symmetrical two-story brick building has a central entrance outlined by Doric pilasters and a pediment. Metal-sash factory windows are placed in even rows. The interior has suffered alterations, including lowered ceilings. Named in honor of physician Lucius McGehee, one of the founders of Hammond Junior College, the building originally housed administration and classroom spaces. Preceding and flanking McGehee Hall are two PWA-funded red brick academic buildings designed by Weiss, Dreyfous and Seiferth: on the right is the angular Moderne Science Building (1939), and on the left is the more streamlined Moderne former library (1940), now Clark Hall, which houses an art gallery.

TA13.2 University President's House

1940, Weiss, Dreyfous and Seiferth. 408 W. Dakota St. (corner of N. Pine St.)

With its flat roof and metal-frame windows that wrap around the corners of the house, this is the most boldly modernistic design of all Weiss, Dreyfous and Seiferth's contributions to the campus. Interior ceiling heights are expressed on the exterior by horizontal projecting eaves, and a single vertical note is struck by the crisp-

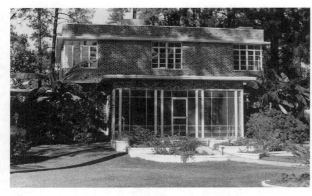

TA13.2 Southeastern Louisiana University, President's House

TA13.3 Southeastern Louisiana University, Ralph R. Pottle Music Building (Liberal Arts Building)

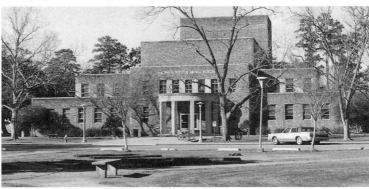

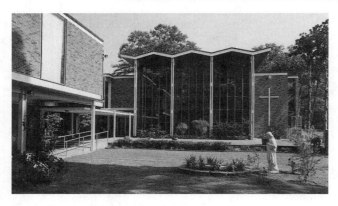

TA13.4 St. Albert's Catholic Student Center

edged chimney stack on one side of the house. Although the design attempts to negate a sense of weight and mass, the coziness of the red brick walls keeps the house firmly grounded.

TA13.3 **Ralph R. Pottle Music Building** (Liberal Arts Building)

1940, Weiss, Dreyfous and Seiferth. Friendship Circle (behind McGehee Hall)

Although designed by Weiss, Dreyfous and Seiferth, this PWA-funded building was completed under the supervision of Favrot and Reed, with Frederick J. Nehrbass as associate architect. The plaque on the building omits the name of the firm responsible for the design, presumably because Leon Weiss was indicted for mail fraud in 1940 in connection with Louisiana's political scandals of the late 1930s. (The firm's name is also omitted at the University of

Louisiana at Lafayette; see LA15.) The building is a handsome Moderne design with a semicircular portico of fluted concrete piers. The corners are smoothly rounded; set-back wings and a set-back upper section have fluted concrete panels between the windows.

TA13.4 St. Albert's Catholic Student Center

1960, Desmond-Davis Architects. W. Dakota and N. Spruce sts.

Designed by John Desmond and William Burks, this complex consists of a two-story chapel and a pair of two-story buildings organized around a small courtyard. All three buildings are of steel-frame construction, with the frame exposed on the exterior to reveal the logic of each structure. The chapel's side walls of glass emphasize the clarity of the structural frame and allow natural light to flood the interior—hallmarks of Desmond's work at that time. The single-space interior is covered by a transverse folded-plate roof, and the apse wall is constructed of brick. The glass walls of the two support buildings are shaded by *brise-soleils* made of thin strips of wood and attached to the steel-frame exoskeleton.

Ponchatoula

Ponchatoula (Choctaw for "hanging hair," referring to Spanish moss) was laid out in 1854 by James B. Clark, surveyor and engineer for the New Orleans, Jackson and Great Northern Railroad. Pine lumber, first, and strawberry production, second, fueled the town's economy. The latter is still important, and strawberry-packing sheds stand along the railroad corridor. Since the late twentieth century, Ponchatoula has also benefited from the antiques trade, which has revitalized its historic downtown. Shop windows of Pine Street's late-nineteenth-century one- and two-story brick commercial structures now display regional antiques. Several shops retain their single-story galleries on cast iron supports, which add to the historic ambience. The former railroad depot (Railroad Avenue at Pine Street), built in 1894 and remodeled in the 1920s, also serves the antiques trade. The one-story frame Collinswood School (101 E. Pine Street) was moved here from the Collins estate west of Ponchatoula, where it had served as a one-room school from 1876 to 1908, and has been restored as a museum. Desmond-

Miremont-Burks, Architects, designed the award-winning D. W. Reeves Elementary School (1968; Sisters Road) as a series of one-story pavilions radiating from a central pavilion and linked by covered walkways.

Ponchatoula Vicinity

TA14 Mount's Villa

1915, Favrot and Livaudais. Mount Villa Estates Rd. (off Louisiana 22, 2.5 miles west of Ponchatoula)

Lumber magnate and banker W. E. Mount hired the prestigious New Orleans firm of Favrot and Livaudais to design his villa, which is set in an extensive, informally planted garden. The one-and-one-half-story Arts and Crafts house is a rambling structure with projecting bays, French doors, and large, mullioned casement windows under a gently sloped tile roof with exposed rafter ends and wide pent dormers. Doubled rafter ends of the entrance loggia and a porte-cochere at the rear further emphasize the building's horizontal lines. Exterior finishes of brick, stucco, and half-timbering add to the villa's richly textured appearance. The interior is equally luxuriant, with wood paneling in the dining room, beamed ceilings in the dining and living rooms, brick mantels, and stained glass. A billiard hall occupies half of the attic space. The double garage and the former servants' cottage have been converted, respectively, into an antiques shop and a bed-and-breakfast.

Nearby and slightly closer to Ponchatoula, at 14625 Louisiana 22, is the raised board-and-batten plantation house (c. 1880) built by Edwin Nichols. Preceded by an oak allée, the single-story house has a 90-foot-wide front gallery, four large front rooms, and a rear gallery between two cabinet rooms.

Pass Manchac

TA15 Pass Manchac Lighthouse

1867. North side of Pass Manchac (not visible from land)

In 1699, the Native Americans who inhabited this area told French explorers Pierre Le Moyne, Sieur d'Iberville, and Jean-Baptiste Le Moyne, Sieur de Bienville, about the shortcut through Bayou Manchac (from the Choctaw

imashaka, meaning rear entrance) from Lake Maurepas to Lake Pontchartrain and thence to the Mississippi Sound. The first lighthouse marking Pass Manchac at the western end of Lake Pontchartrain to help guide ships into the pass was built in 1837. This, the fourth, was constructed after the one built in 1857 was severely damaged in the Civil War (the first two disintegrated). It is a 40-foot-high cylindrical brick structure, painted white. In 1952, the light was automated and the keeper's house demolished. Pass Manchac remained an important transportation passage connecting the lakes until the railroads replaced travel by boat.

Livingston Parish (LV) *and East Feliciana Parish* (EF)

LIVINGSTON PARISH (LV)

Springfield

LV1 House (Old Livingston Parish Courthouse)

1835. Corner of 2nd and Mulberry sts.

Named for the many springs in the area, Springfield was the second of Livingston Parish's five successive seats, serving this function from 1835 to 1872. It was chosen because of its location on a navigable river, the Natalbany. The courthouse first occupied a different building in Springfield. In 1843, the parish acquired this two-story brick structure built in 1835 for the New Orleans Gas Light and Banking Company, which had just failed. The one-room-deep building has gable-end parapets

with lunette windows, four sets of French windows on the ground floor, and a two-story wooden gallery supported on plain wooden posts. An exterior staircase set within the gallery connects the building's two floors. The structure originally had a rear gallery. After it ceased to function as a courthouse, the building had a succession of owners and uses and has now been converted into a house. Since 1941, the parish seat has been located in the town of Livingston, founded in the early twentieth century as an extension of the Lyon Cypress Lumber Company of Garyville (St. John the Baptist Parish).

EAST FELICIANA PARISH (EF)

Clinton

Clinton was founded in 1824 as the seat of the newly created East Feliciana Parish. Inauguration of the Clinton and Port Hudson Railroad in 1840 gave Clinton direct access to the Mississippi River, allowing it to develop as a commercial center. Clinton's location among the pine-covered hills was regarded as providing a particularly healthy climate, and, along with nearby Jackson, it quickly became a center for schools and academies. The Clinton Female Academy was founded as early as 1832, and by 1860, there were three schools for girls and two for boys. Clinton's churches are in the Gothic Revival style, as seen in the stuccoed brick First Baptist Church (1870s; 12329 Jackson Street), which has a square corner tower. However, the town is noteworthy for its Greek Revival civic and residential architecture.

EF1 East Feliciana Parish Courthouse

1840, J. L. Savage. Bounded by Woodville, Liberty, St. Helena, and Bank sts.

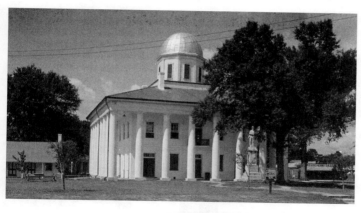

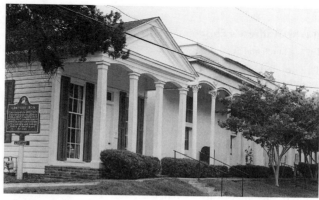

EF1 East Feliciana Parish Court-
house

EF2 Lawyers' Row

Built at the height of the passion for Greek Re-
vival architecture in Louisiana, this white stuc-
coed brick courthouse is surrounded by a
massive two-story Tuscan colonnade similar
to those that became popular for plantation
houses in southern Louisiana around the
1840s. The domed octagonal cupola in the
center of the hipped roof, however, indicates
the building's civic function. Lawyer Lafayette
Saunders resigned as a member of the East Fe-
liciana Parish Police Jury when his construction
bid of $23,000 was accepted. Restored in 1963
by A. Hays Town, the courthouse has been des-
ignated a National Historic Landmark.

EF2 **Lawyers' Row**

c. 1840–c. 1860. Woodville St. between Liberty and
Bank sts.

Built to accommodate lawyers' offices, hence
the name, these five small galleried Greek Re-
vival buildings look all the more delicate and
exquisite in contrast to the massive courthouse

opposite them. Each varies in the use of Greek
forms and details. The two brick offices on the
right, with simple columns and pediments, and
the pedimented frame building at the left are
the oldest. The other two, larger structures were
built later; the one on the right has narrow piers
supporting a prominent entablature, and the
office to its left, the latest (1860) of the group,
has a gallery of slender cast iron Corinthian
columns linked by segmental arches. Although
each building is unique, together they form a vi-
sually harmonious grouping. Some of the build-
ings still house law offices, and one is now occu-
pied by a library.

EF3 **Brame-Bennett House** (Davis House)

1839–1842. 11120 Plank Rd.

Although built by Dr. D. Davis, the house is
more commonly known by the names of the
two subsequent owners, Judge Franklin Brame
and William H. Bennett, both of whom were ac-
tive in parish politics in the late nineteenth

century. The one-and-one-half-story Greek Revival house of stucco-covered brick has a pedimented portico with six Doric columns; a frieze of triglyphs and metopes with guttae above and below, which runs along the front and sides of the house; shoulder moldings around the door and windows; and rosettes on the moldings and around the fanlight window in the pedimented wooden front gable. The central-hall plan has two rooms on each side, which are embellished with moldings carved in Greek-inspired acanthus, bead-and-reel, and egg-and-dart patterns. Behind the house is an underground cistern sheltered under a circular pavilion-like structure supported on posts and decorated with Greek triglyphs.

EF4 St. Andrew's Episcopal Church

1871. Church and St. Andrew's sts.

The wooded hilltop site emphasizes the vertical qualities of this board-and-batten Carpenter's Gothic church. Pointed arches over the windows and doors and the small gabled tower add to the verticality that was considered appropriate for rural wooden churches beginning in the mid-nineteenth century. The bargeboards are cut in an arcade pattern with elongated forms that hang down like Spanish moss or icicles from the steeply pitched roofs and the gabled portico. The interior five-bay-long space is covered by a pointed vault accented with wooden ribs, and the windows have rose-colored glass. Two rear additions date from 1955.

EF5 Marston House

c. 1837. 11022 Bank St.

In 1837, the Union Bank of New Orleans opened a branch on the ground floor of this building, thus giving the street its name. In 1851, following financial setbacks, the bank sold the still unfinished building to Boston-born cashier Henry Marston, who completed the structure and used the upper floor as his residence. Marston later became the bank's president and owner. Of brick construction with exterior walls plastered and scored to resemble stone, the house has a huge pedimented portico with six two-story Ionic columns. Two front doors indicate the building's former dual use; the larger pedimented door gave access to the bank. To the right of this building is the wooden former Clinton High School (1905).

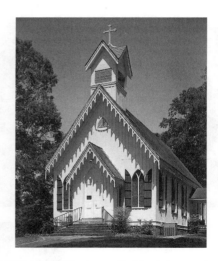

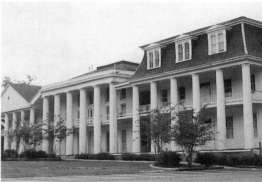

EF4 St. Andrew's Episcopal Church

EF6 Silliman Institute (Silliman Female Collegiate Institute)

EF6 Silliman Institute (Silliman Female Collegiate Institute)

c. 1850, c. 1860, c. 1894; additions. 10830 Bank St.

This former women's college consists of three large temple-fronted brick buildings with monumental white-stuccoed Doric columns. Each building, however, is slightly different, most noticeably at roof level. The oldest building, at the left, has two stories and a pediment above its Greek Revival facade. In the center is a three-story structure with a hipped roof that originally supported a cupola and balustrade. This building is believed to have replaced an earlier one destroyed by fire in 1858. The two-story building at the right has a concave mansard roof with three dormers. Interiors of the three buildings,

all of which originally contained classrooms and dormitories, have been altered over the years. Named for William Silliman, a member of the original board of trustees, the school was chartered in 1852 as the Silliman Female Collegiate Institute and operated until 1932. In the nineteenth century, Silliman Institute attracted students from around the state. Its catalogue advertised such benefits as its "hill country" location, which was considered "healthful." Silliman's curriculum included mathematics, natural sciences, foreign languages, fine arts, government, and history, and, by 1899, typing. During the Civil War, Silliman served as a field hospital, receiving wounded soldiers from the Port Hudson siege. The school reopened in 1966 and teaches students from kindergarten through twelfth grade.

Jackson

Founded as the seat of Feliciana Parish in 1815, Jackson lost this status when the parish was divided in two, at which time Clinton was named East Feliciana's seat. Consequently, Jackson, named for Andrew Jackson, never grew sufficiently to fill the grid of streets originally laid out. The three-bay brick building (1816; corner of High and College streets) was the courthouse when the Felicianas were one parish; the structure originally had two stories but was reduced to one after a fire in 1876. In common with Clinton, Jackson became an important center for education in antebellum Louisiana, and it retains a significant number of Greek Revival buildings. Millbank (3053 Bank Street), built c. 1836 as the banking house for the Clinton and Port Hudson Railroad Company and later converted into a residence, has a portico with six two-story Doric columns of stuccoed brick. Such double-height porticoes were a popular architectural feature for important buildings in East Feliciana.

EF7 Jackson Town Hall (Second Bank of Jackson)

1906. 1610 Charter St.

Surmounting this former bank's circular corner tower is an onion-shaped dome, its metal surface silver in color. In this area where the Greek Revival style predominates, it is an odd sight. The bank is constructed of pink-tinted bricks, and on the tower these have been laid with occasional recessed courses to convey a rusticated effect. At the base of the tower, the building's round-arched entrance is surrounded by oversized voussoirs and flanked by two columns. The second-floor windows have segmental arches, and corbeling outlines the top of the building.

EF8 Roseneath

c. 1832. 1662 Erin St.

The Greek Revival details on this two-story wooden house are particularly fine. A pedimented portico with four fluted Doric columns marks the center of the five-bay-wide house; like the Brame-Bennett House (EF3), it has a Greek-inspired frieze with guttae at both the top and bottom of the metopes, which extends across the entire facade and around the sides of the house. Slender Doric colonnettes and moldings frame the side-lighted front door, which opens to a central hall. The portico incorporates a second-floor balcony with curved corners.

EF9 Centenary State Historic Site (Centenary College of Louisiana)

1837. 3522 College St.

Centenary College was founded by the Methodists in 1839, the centenary year of Methodism. In 1845, the college relocated from Brandon Springs, Mississippi, to Jackson, acquiring the property of the College of Louisiana. The latter, founded in 1825, had closed because of declining enrollment after occupying this site since 1830. Centenary flourished in its new location, adding a three-story academic building in 1857 to the two existing dormitories, one built in 1832 and the other in 1837 to house its 300 students. The college closed during the Civil War, when its buildings were used by both Confederate and Union forces: as a convalescent hospital (Confederate) and for housing troops and supplies (Union). Although Centenary reopened afterward, it never regained its earlier enrollment and, in 1908, relocated to Shreveport (CA54). The academic building and one of the dormitory structures were demolished in the 1930s. When the state of Louisiana acquired the property, the surviving dormitory and a professor's house, a wooden galleried structure of c. 1840, were restored and reopened with exhibits on education in Louisiana.

EF9.1 West Wing Dormitory

1837

The West Wing dormitory was built in 1837 by contractor Alexander Smith from Mississippi. Two stories high and one room deep, the brick structure has a two-story Tuscan gallery across the long south front and its end walls. Exterior stairs at each end of the front gallery give access to the second floor. Both floors contain twelve rooms, with chimneys set between each pair of rooms, and each room has a door, a front window, and two rear windows. After the college closed, the dormitorywas adapted for different purposes, including a tuberculosis sanatarium, and, later, as low-income housing. Several rooms in the building, now restored and opened to the public, have been furnished as they were in the nineteenth century.

Jackson Vicinity

EF10 East Louisiana State Hospital (Insane Asylum of the State of Louisiana)

1847–1854, C. N. Gibbons; many additions. Louisiana 10 (1 mile east of Jackson)

In 1847, a "Mr. Gibbens"—probably Charles Gibbons, who built Grace Episcopal Church in St. Francisville (WF2)—was appointed architect for the Insane Asylum of the State of Louisiana, the state's first major permanent facility for care of the mentally ill. Robert Perry was the brickmason. The hilly 250-acre site just east of Jackson was chosen because it was considered a healthful location. Asked to design a building that would not look like a prison, Gibbons produced a Greek Revival temple flanked by two Tuscan-galleried wings set perpendicular to the central building. The "temple" has a pedimented portico with six three-story-high brick columns with cast iron Ionic capitals. The fourth story is screened by the entablature and topped by a central cupola. The pediment originally carried elaborate ornamentation. This impressive masonry structure—the largest Greek Revival building in Louisiana—was stuccoed and painted white. The central building has a central hall preceding the wide staircase; it housed offices, a reception hall, a chapel, and private apartments for paying patients. Nonpaying patients were accommodated in the wings, women in one and men in the other; each wing contained dormitories, bedrooms, parlors, and dayrooms. One of the wings

opened in 1848 to accommodate patients from the Insane Department of the Charity Hospital in New Orleans; the central building opened in 1854. By 1898, more than one thousand patients were in residence. Many additional buildings have been added to the complex over the succeeding years. The central building is now occupied by administrative offices.

EF11 Glencoe (Thompson House; Westerfields)

1897. 9510 Louisiana 68 (1.2 miles north of junction with Louisiana 963)

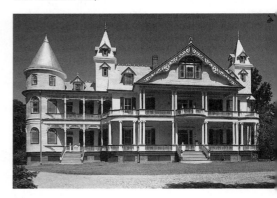

Robert Thompson, Sr., and Millie Scott Thompson built this house on land she owned to replace an earlier home that had burned down. The architect is said to have been a Mr. Kennedy. The house is unusually elaborate, even for this time period when eclecticism was favored. The facade presents a sequence of gables, dormers, and towers, among which are a squat circular tower with a spire and two tall, narrow square towers with dormered spires. The effect is of an illustration from a child's fairy-tale book. From the front, the wide facade gives the impression that the house is enormous. In fact, it is for the most part only one room in depth, making it easier for breezes to cool the interior. Much of the house is fronted by a two-story gallery on paired columns; the left side of the house with the circular tower has a two-story gallery on shaped single columns and delicate Eastlake ornament. Windows are variously shaped and sized. The building is just as rich in textures as it is in silhouette, with scalloped and diamond-shaped shingles, clapboards, slate roofs, filigree bargeboards, and stained glass. The interior features a large entry-living hall, which also is richly elaborated with

scroll-sawn filigree ornament, paneling, and a wide staircase.

EF12 Oakland

1827. 6165 Louisiana 963 (1.2 miles east of Louisiana 68)

Oakland is one of several cotton plantation houses in the area around Jackson and Clinton that represent the impact of East Coast planters and their architectural preferences during the early part of the nineteenth century. Thomas W. Scott from South Carolina built this two-story wooden house, which is three bays wide, including the central hall, and one room in depth. The house has front and rear one-story galleries, and chimneys are placed on the exterior side walls. The interior has elaborate Federal woodwork, including carved wooden mantels. To the left of the house is the separate brick kitchen. A similar house is Fairview (8338 Louisiana 963), built c. 1830.

EF13 Linwood

c. 1848. Junction of Louisiana 964 and 955 (.6 mile east of Louisiana 68)

Planter and politician Albert G. Carter built Linwood on the Spanish land grant he inherited from his family. A gallery with four colossal Tuscan columns of stuccoed brick monumentalizes the two-story frame house. The present gable roof was added in 1905; in the center of the facade is a fake pediment, which heightens the classical appearance of the structure. The central hall extends halfway through the house to meet a ballroom that stretches across the rear. In 1860, Carter owned ninety-five slaves, and the plantation included nineteen slave dwellings, none of which survive. Sarah Morgan Dawson recorded life at Linwood during the Civil War in *A Confederate Girl's Diary*, after finding refuge there from September 1862 to April 1863. She and her family had fled Baton Rouge when their house was sacked by the Union army. In her diary, Dawson describes in some detail sugarcane processing on the plantation, whose sugarhouse no longer exists. When the Union army bombarded Port Hudson, only three miles from Linwood, Sarah and her family were forced to seek safety elsewhere. The sugarhouse was subsequently used by the Union army as a hospital.

St. Helena Parish (SH)

Greensburg

SH1 St. Helena Parish Courthouse

1938, Jones, Roessle, Olschner and Wiener. N. Main St. (Louisiana 10) and Hamberlin St.

Funded by the Work Projects Administration and designed by a Shreveport firm known for its modernist designs, this Moderne courthouse was constructed under the supervision of parish architect C. E. McAnally. The reinforced concrete building has a three-story central section and symmetrical two-story wings. The entrance portico and first-floor central window are hollowed out of the massive walls, reinforcing the building's aura of solidity and permanence and, at the same time, creating a play of light and shade between the smooth wall surfaces and cavernous openings. The low-relief images of Justice, Vigilance, and Mercy over the entrance doors, designed by New Orleans sculptor Angela Gregory, are unusual in depicting only the heads and shoulders of the stylized figures. Justice and Vigilance display exceptionally severe expressions.

St. Helena Parish's first jail (c. 1855), opposite the courthouse on Hamberlin Street, is a two-story brick structure with a cell on the upper floor that was accessed via a trapdoor from the jailer's office below.

SH2 Greensburg Land Office

c. 1820s. N. Main St. (Louisiana 10) and Hamberlin St.

This land office originally served all of the Florida parishes until 1843, when its function was transferred to Baton Rouge. Here residents of the Florida parishes applied for American patents to their lands. The one-room brick building has a portico with two massive Doric columns of stuccoed brick supporting a small wooden pediment. The interior formerly featured a large paneled mantel in the Federal style.

Washington Parish (WA)

Franklinton

Although founded in 1821 as the proposed parish seat (ratified in 1826), Franklinton is essentially a twentieth-century town, as its real growth did not occur until after the New Orleans and Great Northern Railroad was brought through in 1906. The railroad enabled the town to benefit from the large-scale lumber industry then beginning in the parish's forests. Typical of the one- and two-story brick commercial buildings that define the downtown is the former C. A. Varnado and Son dry goods store (1900; remodeled c. 1925; 936 Pearl Street), which has segmental-arched windows on the second story and, inside, the original display cases.

WA1 Moore and Jenkins Insurance
(Farmers and Merchants Bank)

1906. 1018 Main St. (corner of Pearl St.)

This small two-story brick building with an elaborately articulated facade is a good example of small-town banks in early-twentieth-century America. The huge round arch of the central entrance is supported on squat columns and has a foliate-patterned keystone. Between the arch and the three upper windows is a decorative band on which the bank's name is inscribed. The building is now painted a dark green color with a light green trim.

WA2 Franklinton Junior High School
(Franklinton High School)

1939, Herman J. Duncan. 617 Main St. (between Alford and Howard sts.)

The English royal palace of Hampton Court inspired the design of this red brick castellated building with narrow twin towers flanking the central entrance, a battlemented parapet, and square windows with hood moldings. Outlining the central entrance is a Tudor arch, above which the school's name is inscribed in Gothic lettering. This structure housed classrooms and administrative offices; behind it is a separate auditorium-gymnasium building. Both structures were funded by the Public Works Administration.

WA3 Robert H. Babington House

1906, P. H. Weathers. 608 Main St. (between Alford and Howard sts.)

New Orleans architect P. H. Weathers designed this splendid house for Robert Babington, who was prominent in local real estate, banking, and the lumber industry. Realizing that rail transportation was essential for Franklinton's economic well-being, Babington, with his brothers, was instrumental in persuading the railroad company to run tracks through the town. The house has many of the hallmarks of the Queen Anne style, including a picturesque roofline, numerous gables, dormer windows, octagonal bays, a two-story entrance pavilion with large round-arched openings, and scalloped shingles. However, the Colonial Revival style is evi-

WA4.1 Mile Branch Settlement, King House

WA4.2 Mile Branch Settlement, Knight Cabin

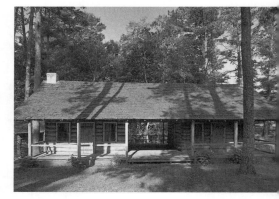

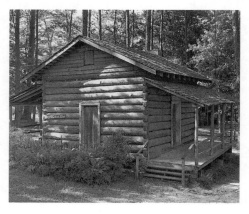

dent in the gallery's simple square columns and plain balustrade, the second-story Palladian window within the entrance pavilion, and the central-hall plan. The house is set on three acres in the residential section of the town, which was laid out with larger lots following the arrival of the railroad.

WA4 Mile Branch Settlement at the Washington Parish Fairgrounds

Mid- to late nineteenth century. Junction of Bene Rd. (Louisiana 25) and Main St. (Louisiana 430)

The first official parish fair in Franklinton was held in 1911, and this site has been used for the annual event since 1913. The colorful wooden stands that display the produce remain year round. In 1976, structures typical of the parish's early homesteads were added to the site, moved here from other locations in the parish to save them from demolition. Illustrating different aspects of rural life and economy, the buildings include dogtrot houses, log cabins, barns, a shop, and a school.

One of the dogtrot houses is the King House (WA4.1), probably built by Thomas King from Georgia in the 1830s, when he married Lucy Bickham. Constructed of half-round logs with square notching, the two-room house has attic rooms and front and rear galleries. The dogtrot passage is uncommonly wide, at 12 feet; also unusual is the sophisticated interior finish of planed lumber ceilings and wooden mantels carved in a simple Federal style and displaying the initials of the builder, TIK.

Pioneer farmers George and Martha Knight constructed their cabin (WA4.2; c. 1857) of split half-round logs that are square-notched at the corners. Measuring 18 feet by 22 feet, the structure consists of one large room with a sleeping loft in part of the attic. Galleries at front and rear replicate the originals, and the chimney at one end of the house is a replacement for a mud chimney. The windows have much of the original glass. The census of 1880 records that the Knights and their seven children lived here, and that the Knights owned 250 acres of land, of which 25 acres were under cultivation and the rest was used for livestock.

Nehemiah Sylvest's dogtrot house (c. 1880) is constructed of small and medium-sized round logs, saddle-notched at the corners. Brick chimneys stand at each end of the house. Other interesting buildings at this site include the Pigott log cabin (c. 1868), one room of the

former three-room frame Mount Hermon School (1885), the frame Bankston Store (late 1890s), the one-room log Burrel Jones House (c. 1885), the Bankston Blacksmith Shop (early 1890s), and the log Fleming Barn (c. 1890). The Half-Moon Bluff Baptist Church is a replica (1978) of the early-nineteenth-century structure.

Bogalusa

Bogalusa was built as, and remains, a single-industry mill town. The Great Southern Lumber Company selected the townsite in 1906 after acquiring vast tracts of longleaf yellow pine timberland in and around Washington Parish. Planned for a population of 25,000, Bogalusa was begun in 1907; the mill (1908) was said to be the largest pine mill in the world and the first built of steel. In addition to employee housing, the company built the town's entire infrastructure—water supply, sewerage, telephone systems, and an electricity plant. Space was set aside for a park, churches, schools, and a depot for the new railroad line, the New Orleans Great Northern. In 1907, Bogalusa's population numbered 1,500 and had expanded to 10,000 by 1914, but the town never reached the 25,000 envisioned by its planners. The driving force behind the entire scheme was Canadian-born William Henry Sullivan (1864–1929), the vice president and general manager of the Great Southern Lumber Company and the town's first mayor. He also gave Bogalusa its name, from the Bogue Lusa Creek (Indian for Black Creek) that flowed through the town. Sullivan also had an eye on the future. To ensure the town's survival, he launched a reforestation project in 1920 to provide pulpwood for a paper company that would replace the sawmill; seedlings can grow sufficiently for use as pulpwood within fifteen years. The sawmill was dismantled after the last log was cut in 1938. The Gaylord Container Company, the lumber company's successor, is now the basis of Bogalusa's economy. A strong reminder of that fact is the spectacular sight of steam belching from its chimneys (along with the odor).

Bogalusa's railroad depot (400 Austin Street), built in 1907 by the New Orleans and Great Northern Railroad, is a large brick building with nine bays; its cupola is a replacement. James Lamantia, for Burk, Le Breton and Lamantia, designed the small modernist South Columbia Street Elementary School (now the

Columbia Street Magnet School) (1954; 1028 S. Columbia Street). Constructed of reinforced concrete, the building has a binucleate plan, with classrooms and library in one unit linked by a crosswalk to a unit housing the assembly hall and cafeteria. The same architects were responsible for the Bogalusa High School (Sycamore and Plaza streets) of 1955–1958; its classrooms are organized around a central court, their windows shaded by porcelain enamel louvers, and separate buildings house the gymnasium and auditorium. Recent additions to this school have obscured the clarity of its original composition.

WA5 Bogalusa City Hall

1917, Rathbone Debuys. 214 Arkansas Ave.

New Orleans architect Rathbone Debuys designed this impressive Beaux-Arts city hall, which, appropriately for a lumber town, is constructed entirely of wood. The structure has a central portico with four Tuscan columns, and centered on the hipped roof is a large circular lantern with a conical roof. Exterior pinewood sheathing conveys the effect of rusticated masonry. Large paired brackets and a row of tiny dentils are tucked under the extended eaves, and above them is a continuous band of miniature modillions. The entrance door is topped by a pediment, as are the doors in the splendid wood-paneled lobby. The building is now painted entirely white, but early photographs reveal that the exterior was dark in color, with the columns and other details in white.

WA6 Sullivan House

1907. 223 S. Border Dr. (between Sycamore and W. 3rd sts.)

As general manager of the Great Southern Lumber Company, William Henry Sullivan lived in a mansion constructed of longleaf yellow pine. It is thought that he and his builder

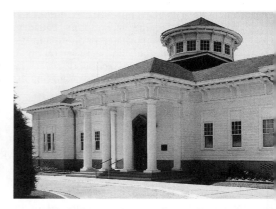

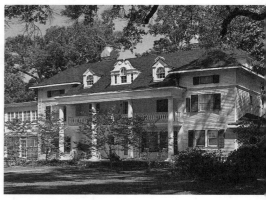

WA5 Bogalusa City Hall
WA6 Sullivan House

designed the house, which may explain the idiosyncratic design and proportions. Sullivan was known for his flamboyant personality. The central section of the house has a wide two-story portico with four double-height Tuscan columns, and its own pitched roof is pierced by three dormers. The central dormer, much larger than the other two, has a Palladian window surmounted by a scrolled pediment; the other two dormers have pediment tops. Each of the three-story wings has a hipped roof.

Suggested Readings

Publications on Louisiana architecture have tended to focus on specific places, such as New Orleans; on building types, such as plantation houses; and on the eighteenth and nineteenth centuries. Relatively little has been published on the state's twentieth-century buildings; information on these can be found in architecture magazines. Samuel Wilson, Jr.,'s many publications are essential to understanding Louisiana's early architecture. Those most relevant to this volume are listed below; additional essays he authored are collected in *The Architecture of Colonial Louisiana: Collected Essays of Samuel Wilson, Jr., F.A.I.A.* The files of the Division of Historic Preservation at the Louisiana Department of Culture, Recreation and Tourism in Baton Rouge, which include nominations for the National Register of Historic Places, are invaluable in identifying and researching buildings. Important archaeological and prehistoric sites are featured in a series of publications by the department's Division of Archaeology. The U. S. Army Corps of Engineers, New Orleans District, produces booklets about various river control projects within Louisiana. Information on many aspects of Louisiana's history and culture can be found in the Louisiana Purchase Bicentennial Series in Louisiana History. This multiple-volume series is made up of essays drawn from different journals. *Preservation in Print,* published every month by the Preservation Resource Center, gives information on recent National Register listings, short histories on Louisiana's historic buildings, and preservation issues. *Cultural Vistas,* a quarterly published by the Louisiana Endowment for the Humanities, covers many aspects of the state's culture, including architecture.

For New Orleans, the ongoing series *New Orleans Architecture,* begun in 1971, devotes each of its volumes to a single neighborhood. Written by many authors (listed under the authorship of Friends of the Cabildo), these carefully researched illustrated books provide a street by street guide to the city's buildings. Other valuable resources include the plan book drawings in the city's Notarial Archives, which feature more than 5,000 watercolor depictions of the city's buildings, dating mostly from the nineteenth century. The Historic New Orleans Collection possesses an enormous collection of historical documents and photographs, and the New Orleans Public Library contains the city's records and a wide variety of other materials relating to the city's history. An essential resource is the Southeastern Architectural Archive at Tulane University, which has a collection of plans, documents, and photographs designed by architects throughout Louisiana.

The bibliography is divided thematically into sections on general and regional sources, architects, plantations, and New Orleans. Many communities throughout Louisiana are covered by walking-tour booklets, which range widely in format and detail, and local historical societies and public libraries can provide additional information.

GENERAL WORKS

Audubon, John James. *The Life of John James Audubon, the naturalist.* Edited by his widow. Introduction by Jas. Grant Wilson. New York: G. P. Putnam & Son, 1869.

Bacot, H. Parrott, Barbara S. Bacot, Sally K. Reeves, John Magill, and John Lawrence. *Marie Adrien Persac: Louisiana Artist.* Baton Rouge: Louisiana State University Press, 2000.

Baudier, Roger. *The Catholic Church in Louisiana.* New Orleans: A. W. Hyatt, 1939.

Brasseaux, Carl A. *A Comparative View of French Louisiana, 1699 to 1762: The Journals of Pierre Le Moyne d'Iberville and Jean-Jacques Blaise d'Abbadie.* Lafayette, La.: Center for Louisiana Studies, University of Southwestern Louisiana, 1979.

———, Glenn R. Conrad, and R. Warren Robison. *The Courthouses of Louisiana.* Rev. ed. Lafayette, La.: Center for Louisiana Studies, University of Southwestern Louisiana, 1997.

Casey, Powell A. *Encyclopedia of Forts, Posts, Named Camps, and Other Military Installations in Louisiana, 1700–1981.* Baton Rouge: Claitor's Publishing Division, 1983.

Christian, Marcus. *Negro Ironworkers of Louisiana, 1718–1900.* Gretna, La.: Pelican Publishing Company, 1972.

Conrad, Glenn, gen. ed.. *Louisiana Purchase Bicentennial Series in Louisiana History.* Multiple volumes. Lafayette, La.: Center for Louisiana Studies, University of Southwestern Louisiana, 1995–.

Cullison, William R. III. *Architecture in Louisiana, a documentary history.* Exhibition catalogue. New Orleans: Tulane University, 1983.

Daspit, Fred. *Louisiana Architecture, 1714–1830.* Lafayette, La.: Center for Louisiana Studies, University of Southwestern Louisiana, 1996.

Dawson, Sarah Morgan. *A Confederate Girl's Diary.* Bloomington: Indiana University Press, 1960.

Edwards, Jay. *Louisiana's Remarkable French Vernacular Architecture, 1700–1900.* Baton Rouge: Department of Geography and Anthropology, Louisiana State University, 1988.

————. "The Origins of Creole Architecture." *Winterthur Portfolio* 29: 2–3 (1994): 155–189.

Farnsworth, Jean M., and Ann M. Masson, eds. *The Architecture of Colonial Louisiana: Collected Essays of Samuel Wilson, Jr., F.A.I.A.* Lafayette, La.: Center for Louisiana Studies, University of Southwestern Louisiana, 1987.

Flint, Timothy. *Journal . . . from the Red River to the Ouachita or Washita, in Louisiana in 1835* [s.n. n.d.]

Franks, Kenny A., and Paul F. Lambert. *Early Louisiana and Arkansas Oil: A Photographic History, 1901–1946.* College Station: Texas A & M University Press, 1982.

Fricker, Jonathan, Donna Fricker, and Patricia L. Duncan. *Louisiana Architecture: A Handbook on Styles.* Lafayette, La.: Center for Louisiana Studies, University of Southwestern Louisiana, 1998.

Goins, Charles R., and John M. Caldwell. *Historical Atlas of Louisiana.* Norman: University of Oklahoma Press, 1995.

Hennick, Louis C., and E. Harper Charlton. *Louisiana: Its Street and Interurban Railways.* Shreveport: Journal Printing Company, 1962.

Huber, Leonard V. *Louisiana: A Pictorial History.* New York: Charles Scribner's Sons, 1975.

Jakle, John J., Keith A. Sculle, and Jefferson S. Rogers. *The Motel in America.* Baltimore: Johns Hopkins University Press, 1996.

Kidder, Tristram R. "Mississippi Period Mound Groups and Communities in the Lower Mississippi Valley." In *Mississippian Towns and Sacred Spaces: Searching for an Architectural Grammar,* ed. R. Barry Lewis and Charles Stout. Tuscaloosa: University of Alabama Press, 1998.

Kimball, Fiske. "Recent Architecture in the South." *Architectural Record* 55:3 (March 1924): 209–271.

Kingsley, Karen. *Modernism in Louisiana: A Decade of Progress, 1930–1940.* Exhibition catalog. New Orleans: School of Architecture, Tulane University, 1984.

Kniffen, Fred B. "Louisiana House Types." *Annals of the Association of American Geographers* 26:4 (December 1936): 179–193.

————. *Louisiana: Its Land and People.* Baton Rouge: Louisiana State University Press, 1968.

Lane, Mills. *Architecture of the Old South: Louisiana.* New York: Beehive Press, 1997.

Latrobe, John H. B. *Southern Travels: Journal of John H. B. Latrobe.* Edited by Samuel Wilson, Jr. New Orleans: Historic New Orleans Collection, 1986.

Laussat, Pierre Clément de. *Memoirs of My Life to My Son During the Years 1803 and After. . . .* Translated with an introduction by Sister Agnes-Josephine Pastwa. Edited by Robert D. Bush. Baton Rouge: Louisiana State University Press, 1978.

Lee, Antoinette J. *Architects to the Nation: The Rise and Decline of the Supervising Architect's Office.* New York: Oxford University Press, 2000.

Lemann, Bernard, Malcolm Heard Jr., and John P. Klingman, eds. *Talk About Architecture: A Century of Architectural Education at Tulane.* New Orleans: School of Architecture, Tulane University, 1993.

Le Page du Pratz. *The History of Louisiana.* London: T. Becket, 1774. Reprint. Edited by Joseph G. Tregle, Jr. Baton Rouge: Louisiana State University Press, 1975.

Liebs, Chester. *Main Street to Miracle Mile: American Roadside Architecture.* Boston: Little Brown, 1985.

Lockett, Samuel H. *Louisiana As It Is, a Geographical and Topographical Description of the State.* Edited with an introduction by Lauren C. Post. Baton Rouge: Louisiana State University Press, 1970.

Myers, Denys P. "The Architectural Development of the Western Floating Palace." *Journal of the Society of Architectural Historians* 11:4 (December 1952): 25–31.

Neuman, Robert W., and Nancy W. Hawkins. *Louisiana Prehistory.* 2nd ed. Baton Rouge: Department of Culture, Recreation and Tourism, Division of Archaeology, 1993.

Newton, Milton B. *Louisiana House Types.* Baton Rouge: Museum of Geoscience, Louisiana State University, 1971.

Olmsted, Frederick Law. *The Cotton Kingdom: A Traveller's Observations on Cotton and Slavery 1861.* Edited with an introduction by Arthur M. Schlesinger. New York: Modern Library, 1969.

————. *A Journey in the Seaboard Slave States, with Remarks on Their Economy.* New York: Dix and Edwards, 1856.

Pittman, Philip. *The Present State of the European Settlements on the Mississippi.* A facsimile reproduction of the 1770 edition. Introduction by Robert R. Rea. Gainesville: University of Florida Press, 1973.

Poesch, Jessie. *The Art of the Old South: Painting, Sculpture, Architecture and the Products of Craftsmen, 1560–1860.* New York: Knopf, 1983.

———— and Barbara SoRelle Bacot, eds. *Louisiana Buildings: 1720–1940.* Baton Rouge: Louisiana State University Press, 1997.

Prichard, Walter, ed. "A Forgotten Louisiana Engineer: G. W. R. Bayley and His 'History of the Railroads of Louisiana.'" *Louisiana Historical Quarterly* 30:4 (October 1947): 1065–1325.

Reps, John W. *Cities of the Mississippi: Nineteenth-Century Images of Urban Development.* Columbia, Mo.: University of Missouri Press, 1994.

Robin, C. C. *Voyage to Louisiana, 1803–1805.* Abridged and translated by Stuart O Landry, Jr. New Orleans: Pelican Publishing Company, 1966.

Turner, Suzanne. *Gardens of Louisiana: Places of Work and Wonder.* Baton Rouge: Louisiana State University Press, 1997.

Twain, Mark. *Life on the Mississippi.* London: Chatto and Windus, 1883.

Vlach, John Michael. "The Shotgun House: An African Architectural Legacy." In *Common Places:*

Readings in American Vernacular Architecture, edited by Dell Upton and John Michael Vlach. Athens, Ga.: University of Georgia Press, 1986.

Whitehead, Russell F. "The Old South and the New South." *Architectural Record* 30:1 (July 1911): 1–56.

Wilds, John, Charles Dufour, and Walter G. Cowan. *Louisiana Yesterday and Today; A Historical Guide to the State.* Baton Rouge: Louisiana State University Press, 1996.

Williams, T. Harry. *Huey Long.* New York: Knopf, 1969.

Wilson, Charles R., and William Ferris, eds. *Encyclopedia of Southern Culture.* Charlotte: University of North Carolina Press, 1989.

Workers of the Writers' Program of the WPA in the State of Louisiana. *Louisiana: A Guide to the State.* New York: Hastings House, 1941.

ARCHITECTS AND BUILDERS

"The Architect and His Community: Curtis and Davis, New Orleans." *Progressive Architecture* 41:4 (April 1960): 141–155.

Banks, William Nathaniel. "The Galliers, New Orleans Architects." *Antiques* 151 (April 1997): 600–611.

"Bodman and Murrell, Architects, Baton Rouge, La." *Architecture and Design* 6:15 (September 1942). Reprint, New York: Architectural Catalog Co., 1942.

Brady, Patricia. "Florville Foy, F. M. C.: Master Marble Cutter and Tomb Builder." *The Southern Quarterly* 31:2 (winter 1993): 8–20.

"Design Firm Case Study: Curtis and Davis." *Interiors* 126 (February 1967): 100–148.

Dufour, Charles L. "Henry Howard: Forgotten Architect." *Journal of the Society of Architectural Historians* 11:4 (December 1952): 21–24.

"The Equal Arts of James Lamantia." *Architectural Forum* 109 (November 1958): 134–139.

Gallier, James. *Autobiography of James Gallier, Architect.* Introduction by Samuel Wilson, Jr. New York: Da Capo Press, 1973.

Irvin, Hilary Somerville. "The Impact of German Immigration on New Orleans Architecture." *Louisiana History* 27:4 (fall 1986): 375–406.

Koehler, Robert. "Practice Profile: Desmond-Miremont-Burks." *AIA Journal* 54 (August 1970): 37–48.

Latrobe, Benjamin H. *The Journals of Benjamin Henry Latrobe, 1799–1820: From Philadelphia to New Orleans.* Edited by Edward C. Carter II et al. New Haven: Yale University Press, 1980.

Martin, F. Lestar. *The Louisiana Architecture of William King Stubbs.* Lafayette, La.: Center for Louisiana Studies, University of Southwestern Louisiana, 1994.

Masson, Ann M. "Mortuary Architecture of Jacques Nicolas Bussière de Pouilly." Master's thesis, Tulane University, 1992.

"Peristylar Precast Structures by SOM." *Progressive Architecture* 44:9 (September 1963): 126–135.

Scully, Arthur, Jr. *James Dakin, Architect: His Career in New York and the South.* Baton Rouge: Louisiana State University Press, 1973.

Town, A. Hays. *The Architectural Style of A. Hays Town.* Baton Rouge: Amdulaine Publications, 1985.

Weil, Emile. *Illustrations of Selected Work of Emile Weil, Architect, New Orleans, La., 1900–1928.* New York: Architectural Catalog Co., 1928.

Wilson, Samuel Jr., Patricia Brady, and Lynn Adams, eds. *Queen of the South, New Orleans: 1853–1862: The Journal of Thomas K. Wharton.* New York and New Orleans: The Historic New Orleans Collection and The New York Public Library, 1999.

PLANTATIONS

Bacot, H. Parrott. "Magnolia Mound Plantation House in Baton Rouge, Louisiana." *Antiques* 123 (May 1983): 1054–1061.

Banks, William Nathaniel. "The River Road plantations of Louisiana." *Antiques* 111 (June 1977): 1170–1183.

Bonner, James C. "Plantation Architecture of the Lower South on the Eve of the Civil War." *Journal of Southern History* 11:3 (August 1945): 370–388.

Fricker, Jonathan. "The Origins of the Creole Raised Plantation House." *Louisiana History* 25:2 (spring 1984): 137–153.

Krotzer, Henry W., Jr. "The Restoration of San Francisco (St. Frusquin), Reserve, La." *Antiques* 111 (June 1977): 1194–1203.

Menn, Joseph Karl. *The Large Slaveholders of Louisiana—1860.* New Orleans: Pelican Publishing Company, 1964.

Overdyke, W. Darrell. *Louisiana Plantation Homes: Colonial and Ante Bellum.* New York: Architectural Book Publishing Company, 1965.

Poesch, Jessie J. "Furniture of the River Road Plantations in Louisiana." *Antiques* 111 (June 1977): 1184–1193.

Reeves, William D. "A Transitional Plantation House in Louisiana Architecture." *Arris* 8 (1997): 24–33.

Rehder, John B. *Delta Sugar: Louisiana's Vanishing Plantation Landscape.* Baltimore and London: Johns Hopkins University Press, 1999.

Smith, J. Frazer. *White Pillars: Early Life and Architecture of the Lower Mississippi Valley Country.* New York: W. Helburn, 1941.

Stahls, Paul F., Jr. *Plantation Homes of the Lafourche Country.* Gretna, La.: Pelican Publishing Company, 1976.

———. *Plantation Homes of the Teche Country.* Gretna, La.: Pelican Publishing Company, 1979.

Vlach, John Michael. *Back of the Big House: The Architecture of Plantation Slavery.* Chapel Hill: University of North Carolina Press, 1993.

———. "Plantation Landscapes of the Antebellum South." In *Before Freedom Came: African-American Life in the Antebellum South,* edited by Edward D.

C. Campbell, Jr., and Kym S. Rice. Charlottesville: University Press of Virginia, 1991.

Wilson, Samuel, Jr. "Architecture of the Early Sugar Plantations." In *Green Fields: Two Hundred Years of Louisiana Sugar*. Lafayette, La.: Center for Louisiana Studies, University of Southwestern Louisiana, 1980.

——. "The Building Contract for Evergreen Plantation, 1832." *Louisiana History* 21:4 (winter 1990): 399–404.

SPECIFIC REGIONS AND PLACES

Barras, Lloyd. *Early Homes of Lake Charles*. Baton Rouge: Claitor's Publishing Division, 1975.

Baughman, James P. "A Southern Spa: Antebellum Lake Pontchartrain." *Louisiana History* 3:1 (winter 1962): 5–32.

Carleton, Mark. *River Capital: An Illustrated History of Baton Rouge*. Woodland Hills, Calif.: Windsor Publications, 1981.

Comeaux, Malcolm L. "Cajuns in Louisiana." In *To Build in a New Land: Ethnic Landscapes in North America*, edited by Allen G. Noble. Baltimore: Johns Hopkins University Press, 1992.

Forbes, Gerald. "A History of the Caddo Oil and Gas Field." *Louisiana Historical Quarterly* 29:1 (January 1946): 59–72.

Kramer, Thomas F., M.D. *Grandeur on the Bayou: The Antebellum Homes of the Franklin, Louisiana, Area*. Franklin, La: [s.n.] 1997.

Kruty, Paul. "The Gilbert Cooley House: A Prairie Style Masterpiece in Monroe." *Preservation in Print* (June 1994): 10–12.

Kubly, Vincent F. *The Louisiana Capitol: Its Art and Architecture*. Gretna, La.: Pelican Publishing Company, 1977.

Mamalakis, Mario. *If They Could Talk!: Acadiana's Buildings and Their Biographies*. Lafayette, La.: Lafayette Centennial Commission, 1983.

Martin, F. Lestar. *Folk and Styled Architecture in North Louisiana*. Lafayette, La.: Center for Louisiana Studies, University of Southwestern Louisiana, 1988.

Millet, Donald J. "Town Development in Southwest Louisiana, 1865–1900." *Louisiana History* 13:2 (spring 1972): 139–168.

Quick, Amy. "The History of Bogalusa, The 'Magic City' of Louisiana." *Louisiana Historical Quarterly* 29:1 (January 1946): 73–201.

Ruffin, Thomas F. *Under Stately Oaks: A Pictorial History of Louisiana State University*. Baton Rouge: Louisiana State University Press, 2002.

Sternberg, Mary Ann. *Along the River Road: Past and Present on Louisiana's Historic Byway*. Baton Rouge: Louisiana State University Press, 2001.

Swanson, Betsy. *Historic Jefferson Parish from Shore to Shore*. Gretna, La.: Pelican Publishing Company, 1975.

Thomson, Bailey, ed. *Historic Shreveport: A Guide*. Shreveport: Shreveport Publishing Corporation, 1980.

Wells, Carolyn McConnell. "Domestic Architecture of Colonial Natchitoches." Master's thesis, Northwestern State University, Natchitoches, 1973.

NEW ORLEANS

Cable, Mary. *Lost New Orleans*. Boston: Houghton Mifflin Company, 1980.

Campanella, Richard. *Time and Place in New Orleans: Past Geographies in the Present Day*. Gretna, La.: Pelican Publishing Company, 2002.

Cantwell, Robert. "The New New Orleans." *Architectural Forum* 107 (December 1957): 96–105, 186, 188, 190.

Curtis, Nathaniel Cortlandt. *New Orleans: Its Old Houses, Shops and Public Buildings*. Philadelphia: J. B. Lippincott Company, 1933.

Douglas, Lake, and Jeannette Hardy. *Gardens of New Orleans: Exquisite Excess*. San Francisco: Chronicle Books, 2001.

Durrell, Edward H. *New Orleans As I Found It. By H. Didimus* [pseud.] New York: Harper & Brothers, 1845.

Earl, Geo G. "Drainage and Sewerage." *Architectural Art and Its Allies* 2:5 (November 1906): 1–4.

Federal Writers' Project of the WPA for the City of New Orleans. *New Orleans City Guide*. Boston: Houghton Mifflin Company, 1938. Rev. ed. New York: Pantheon Books, 1983.

Ferguson, John. "The Architecture of Education: The Public School Buildings of New Orleans." In *Crescent City Schools, Public Education in New Orleans, 1841–1991*, edited by Donald E. DeVore and Joseph Logsdon. Lafayette, La.: Center for Louisiana Studies, University of Southwestern Louisiana, 1991.

Filipich, Judy, and Lee Taylor. *Lakefront New Orleans, Planning and Development 1926–1971*. New Orleans: Urban Studies Institute, Louisiana State University in New Orleans, 1971.

Forman, L. Ronald, Joseph Logsdon, and John Wilds. *Audubon Park: An Urban Eden*. New Orleans: Friends of the Zoo, 1985.

Friends of the Cabildo. *New Orleans Architecture*. Multiple volumes. Gretna, La., Pelican Publishing Company, 1971–.

Gandolfo, Henry. *Metairie Cemetery: An Historical Memoir*. New Orleans: Stewart Enterprises, Inc., 1981.

Guilbeau, Charles. *The St. Charles Streetcar or the History of the New Orleans and Carrollton Rail Road*. New Orleans: Louisiana Landmarks Society, 1992.

Heard, Malcolm. *French Quarter Manual: An Architectural Guide to New Orleans' Vieux Carré*. Oxford, Miss.: University of Mississippi Press, 1997.

Huber, Leonard V. *Landmarks of New Orleans*. Rev. ed. New Orleans: Louisiana Landmarks Society, 1991.

——, and Samuel Wilson, Jr. *Baroness Pontalba's*

Buildings, Their Site and the Remarkable Woman Who Built Them. New Orleans: Louisiana Landmarks Society, 1966.

———. *The Basilica on Jackson Square: The History of St. Louis Cathedral and Its Predecessors, 1727–1965.* New Orleans: St.. Louis Cathedral, 1972.

———. *Jackson Square through the Years.* New Orleans: Friends of the Cabildo, 1982.

Janssen, James S. *Building New Orleans: The Engineer's Role.* New Orleans: Waldemar S. Nelson and Company, 1987.

Jewell, Edwin L., ed. *Crescent City Illustrated: The Commercial, Social, Political and General History of New Orleans.* New Orleans: [s.n.], 1873.

Johnson, Jerah. *Congo Square in New Orleans.* New Orleans: Louisiana Landmarks Society. 1995.

Kemp, John R. *New Orleans.* Woodland Hills, Calif.: Windsor Publications, 1981.

Kingsley, Karen. "Designing for Women: The Architecture of Newcomb College." *Louisiana History* 35:2 (spring 1994): 183–200.

Latrobe, Benjamin H. *Impressions Respecting New Orleans: Diary and Sketches, 1818–1820.* Edited by Samuel Wilson, Jr. New York: Columbia University Press, 1951.

Lewis, Peirce F. *New Orleans: The Making of an Urban Landscape.* Cambridge, Mass.: Ballinger Publishing Company, 1976.

Mahé, John A. II, and Rosanne McCaffrey. *Encyclopedia of New Orleans Artists, 1718–1918.* New Orleans: The Historic New Orleans Collection, 1987.

Masson, Ann M., and Lydia H. Schmalz. *Cast Iron and the Crescent City.* New Orleans: Louisiana Landmarks Society, 1995.

McDowell, Peggy. "New Orleans Cemeteries: Architectural Styles and Influences." *The Southern Quarterly* 20:2 (winter 1982): 9–27.

Mitchell, William R., Jr. *Classic New Orleans.* New Orleans: Martin–St. Martin Publishing Company, 1993.

Norman, Benjamin Moore. *Norman's New Orleans and Environs.* New Orleans: B. M. Norman, 1845. Reprint. Baton Rouge: Louisiana State University Press, 1976.

Parkerson, Codman. *New Orleans, America's Most Fortified City.* New Orleans: The Quest, 1990.

Reeves, Sally K. "The Plan Book Drawings of the New Orleans Notarial Archives: Legal Background and Artistic Development." *Proceedings of the American Antiquarian Society* 105:1 (1995): 105–125.

———, and William Reeves. *Historic City Park, New Orleans.* New Orleans: Friends of City Park, 1982.

Rivet, Hilton L. *The History of the Immaculate Conception Church in New Orleans.* New Orleans: Immaculate Conception Church, 1978.

Starr, S. Frederick. *Southern Comfort: The Garden District of New Orleans, 1800–1900.* Rev. ed. New York: Princeton University Press, 1998.

———. "St.. Charles Avenue, New Orleans, Louisiana." In *The Grand American Avenue, 1850–1920,* edited by Jan Cigliano and Sarah Bradford Landau. San Francisco: Pomegranate Artbooks, 1994.

Toledano, Roulhac. *The National Trust Guide to New Orleans.* New York, John Wiley, 1996.

Upton, Dell. "The Master Street in the World: the Levee." In *Streets: Critical Perspectives on Public Space,* edited by Zeynep Çelik et al. Berkeley: University of California Press, 1994.

Wilson, Samuel, Jr. *The Beauregard-Keyes House.* New Orleans: Keyes Foundation, 1993.

———. *The Church of St. Alphonsus.* New Orleans: Friends of St. Alphonsus, 1996.

———. *A Guide to the Architecture of New Orleans— 1699–1959.* New York: Reinhold Publishing Corporation, 1959.

———. "The Howard Memorial Library and Memorial Hall." *Louisiana History* 28:3 (summer 1987): 229–244.

———. *The Pitot House on Bayou St. John.* New Orleans: Louisiana Landmarks Society, 1992.

———. *The Presbytère on Jackson Square.* New Orleans: Friends of the Cabildo, 1981.

———. *St.. Patrick's Church, 1883–1992: A National Historic Landmark, Its History and Its Pastors.* New Orleans: The Church, 1992.

———. *The Vieux Carré: Its Plan, Its Growth, Its Architecture.* New Orleans: Vieux Carré Historic District Commission, 1968.

———, and Leonard V. Huber. *The Cabildo on Jackson Square.* New Orleans: Friends of the Cabildo, 1970

———. *The St. Louis Cemeteries of New Orleans.* New Orleans: St. Louis Cathedral, 1963.

Glossary

AIA See American Institute of Architects.

abacus The top member of a column capital. In the Doric order, it is a flat block, square in plan, between the echinus of the capital and the architrave of the entablature above.

abat-vent A roof overhang or roof extension of wood or metal to protect the walls of a house from rain or sun.

Academic Gothic See COLLEGIATE GOTHIC.

acroterium, acroterion (plural: acroteria) **1** A pedestal for a statue or similar decorative feature at the apex or at the lower corners of a pediment. **2** Any ornamental feature at these locations.

aedicule, aedicular An exterior niche, door, or window, framed by columns or pilasters and topped by an entablature and pediment. Meaning has been extended to a smaller-scale representation of a temple front on an interior wall. Distinguished from a tabernacle (definition 1), which usually occurs on an interior wall. See also the related term NICHE.

Aesthetic movement A late nineteenth-century movement in interior design and the decorative arts, emphasizing the application of artistic principles in the production of objects and the creation of interior ensembles. Aesthetic movement works are characterized by a broad eclecticism of materials and styles (especially the exotic) and by a preference for "conventionalized" (i.e., stylized) ornament, rather than naturalistic. The movement flourished in Britain from the 1850s through the 1870s and in the United States from the 1870s through the 1880s. Designers associated with the movement include William Morris (1834–1896) in England and Herter Brothers (1865–1905) in America. The Aesthetic movement evolved into and overlapped with the Art Nouveau and Arts and Crafts movements. See also the related term QUEEN ANNE (definition 4).

allée A double row of trees or a tree-lined walk.

ambulatory A passageway around the apse of a church, allowing for circulation behind the sanctuary.

American Adam Style See FEDERAL.

American bond See COMMON BOND.

American Foursquare See FOURSQUARE HOUSE.

American Institute of Architects (AIA) The national professional organization of architects, established in New York in 1857. The first national convention was held in New York in 1867, and at that meeting, provision was made for the creation of local chapters. In 1889, the American Institute of Architects absorbed the inde-

pendent Chicago-based Western Association of Architects (established 1884). The headquarters of the national organization moved from New York to Washington in 1898.

American Renaissance Ambiguous term. See instead BEAUX-ARTS CLASSICISM, COLONIAL REVIVAL, FEDERAL REVIVAL.

Anglo-Palladianism, Anglo-Palladian An architectural movement in England motivated by a reaction against the English Baroque and by a rediscovery of the work of the English Renaissance architect Inigo Jones (1573–1652) and the Italian Renaissance architect Andrea Palladio (1508–1580). Anglo-Palladianism flourished in England (c. 1710s–1760s) and in the British North American colonies (c. 1740s–1790s). Key figures in the Anglo-Palladian movement were Colen Campbell (1676–1729) and Richard Boyle, Lord Burlington (1694–1753). Sometimes called Burlingtonian, Palladian Revival. See also the more general term PALLADIANISM and the related terms GEORGIAN PERIOD, JEFFERSONIAN.

antefix. In classical architecture, a small upright decoration at the eaves of a roof, originally devised to hide the ends of the roof tiles. Also, a similar ornament along the ridge of the roof.

anthemion (plural: anthemions) A Greek ornamental motif based upon the honeysuckle or palmette. It may appear as a single element on an antefix or as a running ornament on a frieze or other banded feature.

antiquity The broad epoch of Western history preceding the Middle Ages and including such ancient civilizations as Egyptian, Greek, and Roman.

apse, apsidal A semicircular or polygonal feature projecting as a major element from an important interior space, especially at the chancel end of a church. Distinguished from an exedra, which is a semicircular or polygonal space, usually containing a bench, in the wall of a garden or nonreligious building. A substantial apse in a church, containing an ambulatory and radiating chapels, is called a chevet. The terms apse and chevet are used to describe the *form* of the end of the church containing the altar, while the terms chancel, choir, and sanctuary are used to describe the liturgical *function* of this end of the church and the spaces within it. Less substantial projections in nonreligious buildings are called bays if polygonal or bowfronts if curved.

arbor 1 An openwork structure covered with climbing plants. Distinguished from a trellis, which is generally a simpler, more two-dimen-

sional structure, often attached to a wall. Distinguished from a pergola, which is an openwork structure supported by a colonnade, creating a shaded walk. **2** A grouping of closely planted trees or shrubs, trained together and self-supporting.

arcade **1** A series of arches, carried on columns or piers or other supports. **2** A covered walkway, one side of which is part of a building, while the other is open, as a series of arches, to the exterior. **3** In the nineteenth and early twentieth centuries, an interior street or other extensive space lined with shops and stores.

arch A curved construction that spans an opening. (Some arches may be flat or triangular, and many have a complex or compound curvature.) A masonry arch consists of a series of wedge-shaped parts (voussoirs) that press together toward the center while being restrained from spreading outward by the surrounding wall or the adjacent arch.

architrave **1** The lowest member of a classical entablature. **2** The moldings on the face of a wall around a doorway or other opening. Sometimes called the casing. Distinguished from the jambs, which are the vertical linings perpendicular to the wall planes at the sides of an opening. Distinguished from surround, a term usually applied to the entire door or window frame considered as a unit.

archivolt The group of moldings following the shape of an arched opening.

arcuation, arcuated Construction using arches.

Art Deco A decorative style stimulated by the 1925 Exposition Internationale des Arts Décoratifs et Industriels Modernes, held in Paris. As the first phase of the Moderne, Art Deco is characterized by sharp angular and curvilinear forms, by a richness of materials (including polished metal, stone, and exotic woods), and by an overall sleekness of design. The style was often used in the commercial and residential architecture of the 1930s (e.g., skyscrapers, hotels, apartment buildings). Sometimes called Art Deco Moderne, Deco, Jazz Moderne, Zigzag Moderne, Zigzag Modernistic. See also the more general term MODERNE and the related terms MAYAN REVIVAL, PWA MODERNE, STREAMLINE MODERNE.

Art Moderne See MODERNE.

Art Nouveau A style in architecture, interior design, and the decorative arts that flourished principally in France and Belgium in the 1890s. The Art Nouveau is characterized by undulating and whiplash lines and by sensuous organic forms. The Art Nouveau in Britain and the United States evolved from and overlapped with the Aesthetic movement.

Arts and Crafts A late-nineteenth- and early-twentieth-century movement in interior design and the decorative arts, emphasizing the importance of hand crafting for everyday objects. Arts and Crafts works are characterized by rectilinear geometries and high contrasts between figure and ground, and the furniture often features expressed construction. The term originated with the Arts and Crafts Exhibition Society, founded in England in 1888. Designers associated with the movement include C. F. A. Voysey (1857–1941) in England and the brothers Charles S. Greene (1868–1957) and Henry M. Greene (1870–1954) in America. The Arts and Crafts movement evolved from and overlapped with the Aesthetic movement. For a more specific term, used in the United States after 1900, see also CRAFTSMAN.

ashlar Squared blocks of stone that fit tightly against one another.

atelier **1** A studio where the fine arts, including architecture, are taught. Applied particularly to the offices of prominent architects in Paris who provided design training to students enrolled in or informally attached to the Ecole des Beaux-Arts. By extension, any working office where some organized teaching is done. **2** A place where artworks or handicrafts are produced by skilled workers. **3** An artist's studio or workshop.

attic **1** The area beneath the roof and above the main stories (or story) of a building. Sometimes called a garret. **2** A low story above the entablature, often a blocklike mass that caps the building.

axis An imaginary center line to which are referred the parts of a building or the relations of a number of buildings to one another.

axonometric drawing A pictorial drawing using axonometric projection, in which horizontal lines that are perpendicular in an object, building, or space are drawn as perpendicular (usually at two 45-degree angles from the vertical, or at complementary angles of 30 and 60 degrees). Consequently, all angular and dimensional relationships in plan remain the same in the drawing as in the thing depicted. Sometimes called an axon or an axonometric. See also the related terms ISOMETRIC DRAWING, PERSPECTIVE DRAWING.

balloon-frame construction A system of light frame construction in which single studs extend the full height of the frame (commonly two stories), from the foundation to the roof. Floor joists are fastened to the sides of the studs. Structural members are usually sawn lumber, ranging from two-by-fours to two-by-tens, and are fastened with nails. Sometimes called balloon framing. The technique, developed in Chicago and other boomtowns of the 1830s, has been largely replaced in the twentieth century by platform frame construction.

baluster One of a series of short vertical members, often vase-shaped in profile, used to support a handrail for a stair or a railing. Balusters that are thinner and simpler in profile are sometimes called banisters.

balustrade A series of balusters or posts supporting a rail or coping across the top (and sometimes resting on a lower rail). Balustrades are often found on stairs, balconies, parapets, and terraces.

band course Ambiguous term. See instead BAND MOLDING or STRINGCOURSE.

band molding In masonry or frame construction, any horizontal flat member or molding or group of moldings projecting slightly from a wall and marking a division in the wall. Not properly a synonym for band course. Simpler horizontal bands in masonry are generally called stringcourses.

bandstand A small pavilion, usually polygonal or circular in plan, designed to shelter bands during public concerts in a garden, park, green, or square. See also the related terms GAZEBO, KIOSK.

banister 1 Corrupted spelling of baluster, in use since about the seventeenth century. Now occasionally used for balusters that are thinner and simpler in profile than classical vase-shaped balusters. 2 Improperly used to mean the handrail of a stair.

bargeboard An ornate fascia board that is attached to the sloping edges (verges) of a roof, covering the ends of the horizontal roof timbers (purlins). Bargeboards are usually ornamented with carved, turned, or jigsawn forms. Sometimes called gableboards, vergeboards. Less ornate boards along the verges of a roof are simply called fascia boards.

Baroque A style of art and architecture that flourished in Europe and colonial North America during the seventeenth and eighteenth centuries. Although based on the architecture of the Renaissance, Baroque architecture was more dynamic, with circles frequently giving way to ovals, flat walls to curved or undulating ones, and separate elements to interlocking forms. It was a monumental and richly three-dimensional style with elaborate systems of ornamental and figural sculpture. See also the related terms RENAISSANCE, ROCOCO.

Baroque Revival See NEO-BAROQUE.

barrel vault A vaulted roof or ceiling of semicircular or semielliptical cross section, forming a tunnel-like enclosure over an apartment, corridor, or similar space.

basement 1 The lowest story of a building, either partly or entirely below grade. 2 The lower part of the walls of any building, usually articulated distinctly from the upper part of the walls.

batten 1 A narrow strip of wood applied to cover a joint along the edges of two parallel boards in the same plane. 2 A strip of wood fastened across two or more parallel boards to hold them together. Sometimes called a cross batten. See also the related term BOARD-AND-BATTEN SIDING.

battered (adjective). Inclined from the vertical. A wall is said to be battered or to have a batter when it recedes as it rises.

battlement, battlemented See CRENELLATION.

Bauhaus 1 Work in any of the visual arts by the faculty and students of the Bauhaus, the innovative design school founded by Walter Gropius (1883–1969) and an active force in German modernism from 1919 until 1933. 2 Work in any of the visual arts by the former faculty and students of the Bauhaus, or by individuals influenced by them. See also the related terms INTERNATIONAL STYLE, MIESIAN.

bay 1 The interval between two recurring members. A facade is frequently measured by window bays, a skeletal frame by structural bays. 2 A polygonal or curved unit of one or more stories, projecting from the wall and usually containing grouped windows (bay windows) on each story. See also the more specific term BOWFRONT.

bay window The horizontally grouped windows in a projecting bay (definition 2), or the projecting bay itself, if it is not more than one story. Distinguished from an oriel, which does not rise from the foundation and has a suspended rather than rooted appearance. A semicircular or semielliptical bay window is called a bow window. A bay window with a central section of plate glass in a late-nineteenth-century commercial building is called a Chicago window.

beam A structural spanning member of stone, wood, iron, steel, or reinforced concrete. See also the more specific terms GIRDER, I-BEAM, JOIST.

bearing wall A wall that is fully structural, carrying the load of the floors and roof all the way to the foundation. Sometimes called a supporting wall. Distinguished from curtain wall. See also the related term LOAD-BEARING.

Beaux-Arts Historicist design on a monumental scale, as taught at the Ecole des Beaux-Arts in Paris throughout the nineteenth century and early twentieth century. The term Beaux-Arts is generally applied to an eclectic Roman-Renaissance-Baroque architecture of the 1850s through the 1920s, disseminated internationally by students and followers of the Ecole des Beaux-Arts. As a general style term Beaux-Arts connotes an academically grounded discipline for historical eclecticism, rather than one single style, as well as the disciplined development of a *parti* into a fully visualized design. More specific style terms include Néo-Grec (1840s–1870s) and Beaux-Arts classicism (1870s–1930s). See also the related terms NEOCLASSICISM, for describing Ecole-related work from the 1790s to the 1840s, and SECOND EMPIRE, for describing the work from the 1850s to the 1880s.

Beaux-Arts classicism, Beaux-Arts classical Term applied to eclectic Roman-Renaissance-Baroque architecture and urbanism after the Néo-Grec and Second Empire phases, i.e., from the 1870s through the 1930s. Sometimes called Classic Re-

vival, Classical Revival, McKim classicism, Neo-classical Revival. See also the more general term BEAUX-ARTS and the related terms CITY BEAUTIFUL MOVEMENT, PWA MODERNE.

belfry A cupola, turret, or room in a tower where a bell is housed.

bell cote A small gabled structure astride the ridge of a roof, which shelters a bell. It is usually close to the front wall plane of the building.

belt course See STRINGCOURSE.

belvedere **1** Any building, especially a pavilion or shelter, that is located to take advantage of a view. See also the related term GAZEBO. **2** See CUPOLA (definition 2).

blind (adjective) Term applied to the surface use of elements that would otherwise articulate an opening but where no opening exists. Used in such combinations as blind arcade, blind arch, blind door, blind window.

board-and-batten siding A type of siding for wood-frame buildings, consisting of wide vertical boards with narrow strips of wood (battens) covering the joints. (In rare instances, the battens may be fastened behind the joints. If the gaps between boards are wide and the back battens approach the width of the outer boards, the siding is called board-on-board.) See also the related term BATTEN.

board-on-board siding A type of siding for wood-frame buildings, consisting of two layers of vertical boards, with the outer layer of boards covering the wide gaps between the boards of the inner layer.

bousillage Mixture of mud, moss or animal hair, and lime, sometimes in the form of ground shells, used as filling between the posts of a timber-frame structure.

bowfront A semicircular or semielliptical bay (definition 2).

bow window A semicircular or semielliptical bay window.

brace A single wooden or metal member placed diagonally within a framework or truss or beneath an overhang. Distinguished from a bracket, which is a more substantial triangular feature, and from a strut, which is essentially a post set in a diagonal position.

braced-frame construction A combination of heavy and light timber-frame construction, in which the principal vertical and horizontal framing members (posts and girts) are fastened by mortise and tenon joints, while the one-story-high studs are nailed to the heavy timber frame. The overall frame is made more rigid by diagonal braces. Sometimes called braced framing.

bracket Any solid, pierced, or built-up triangular feature projecting from the face of a wall to support a projecting element, like the top member of a cornice or the verges or eaves of a roof. Brackets are frequently used for ornamental as well as structural purposes. Distinguished from

a brace, which is a simple barlike structural member. Distinguished from the more specific term console, which has a height greater than its projection from the wall. See also the related term CORBEL.

Bracketed Style A nineteenth-century term for Italianate.

brick bonds, brickwork See the more specific terms COMMON BOND, ENGLISH BOND, FLEMISH BOND, RUNNING BOND.

brique-entre-poteaux In French colonial and post-colonial architecture, a form of half-timber construction in which bricks are used as filler between the vertical posts and the horizontal framing members. Also called *briquette-entre-poteaux.*

brise-soleil Sunbreak; device such as a set of horizontal or vertical fins or louvers used to shade a window.

British colonial A term applied to buildings, towns, landscapes, and other artifacts from the period of actual British colonial occupation of large parts of eastern North America (c. 1607–1781 for the United States; c. 1750s–1867 for much of Canada). The British colonial period saw the introduction into the New World of various regional strains of English and Scots-Irish folk culture, as well as high-style Anglo-European Renaissance, Baroque, and Neoclassical design. Sometimes called English colonial. Loosely called colonial or Early American. See also the related term GEORGIAN PERIOD.

Brutalism An architectural style of the 1950s through 1970s, characterized by complex massing and by a frank expression of structural members, elements of building systems, and materials (especially concrete). Some of the work of Paul Rudolph (born 1918) is associated with this style. Sometimes called New Brutalism.

bungalow A low one- or one-and-one-half-story house of modest pretensions with a low-pitched gable or hipped roof, a conspicuous porch, and projecting eaves. This house type was a popular builders' type from around 1900 to 1930. The term bungalow was also loosely applied to any vernacular building of a semirustic nature, including vacation cottages and lodges.

buttress An exterior mass of masonry bonded into a wall that it strengthens or supports. Buttresses often absorb lateral thrusts from roofs or vaults.

Byzantine Term applied to the art and architecture of the Eastern Roman Empire centered at Byzantium (i.e., Constantinople, Istanbul) from the early 500s to the mid-1400s. Byzantine architecture is characterized by massive domes, round arches, richly carved capitals, and the extensive use of mosaic.

Byzantine Revival See NEO-BYZANTINE.

cabinet A small private room in a house. A typical Creole house plan incorporates a cabinet at

each of the rear corners of the house with a loggia between them.

campanile In Italian, a bell tower. While usually freestanding in medieval and Renaissance architecture, it was often incorporated as a prominent unit in the massing of picturesque nineteenth-century buildings.

cantilever A beam, girder, slab, truss, or other structural member that projects beyond its supporting wall or column.

cap A canopy, ledge, molding, or pediment over a window. Sometimes called a window cap. Distinguished from a hood, which is a similar feature over a door. See also the related term HEAD MOLDING.

capital The moldings and carved enrichment at the top of a column, pilaster, pier, or pedestal.

Carpenter's Gothic Term applied to a version of the Gothic Revival (c. 1840s–1870s), in which Gothic motifs are adapted to the kind of wooden details that can be produced by lathes, jigsaws, and molding machines. Sometimes called Carpenter Gothic, Gingerbread Style, Steamboat Gothic. See also the more general term GOTHIC REVIVAL.

carriage porch SEE PORTE-COCHERE.

casement window A window that opens from the side on hinges, like a door, out from the plane of the wall. Distinguished from a double-hung window.

casing See ARCHITRAVE (definition 2).

cast iron Iron shaped by a molding process, generally strong in compression but brittle in tension. Distinguished from wrought iron, which has been forged to increase its tensile properties.

cast iron front An architectural facade made of prefabricated molded iron parts, often markedly skeletal in appearance with extensive glass infilling. Prevalent from the late 1840s to the early 1870s.

castellated Having the elements of a medieval castle, such as crenellation and turrets.

cavetto cornice See COVED CORNICE.

cement A mixture of burnt lime and clay with water, which hardens permanently when dry. When a fine aggregate of sand is added, the cement may be used as a mortar for masonry construction or as a plaster or stucco coating. When a coarser aggregate of gravel or crushed stone is added, along with sand, the mixture is called concrete.

chamfer The oblique surface formed by cutting off a square edge at an equal angle to each face.

chancel 1 The end of a Roman Catholic or High Episcopal church containing the altar and set apart for the clergy and choir by a screen, rail, or steps. Usually the entire east end of a church beyond the crossing. In churches that have a long chancel space, the part of the chancel between the crossing and the apse, where the singers participate in the service, is called the choir. The innermost part of the chancel, containing the principal altar, is called the sanctuary. 2 In less extensive Catholic and Episcopal churches, the terms chancel and choir are often used interchangeably to mean the entire eastern arm of the church.

Chateauesque A term applied to masonry buildings from the 1870s through the 1920s in which stylistic references are derived from early French Renaissance chateaux, from the reign of Francis I (1515–1547) or even earlier. Sometimes called Chateau Style, Chateauesque Revival, Francis I Style, François Premier.

chevet In large churches, particularly those based upon French Gothic precedents, a substantial apse surrounded by an ambulatory and often containing radiating chapels.

Chicago School A diverse group of architects associated with the development of the tall (i.e., six- to twenty-story), usually metal-frame commercial building in Chicago during the 1880s and 1890s. William Le Baron Jenney, Burnham and Root, and Adler and Sullivan are identified with this group. Sometimes called Chicago Commercial Style, Commercial Style. See also the related term PRAIRIE SCHOOL.

Chicago window A tripartite oblong window in which a large fixed center pane is placed between two narrow sash windows. Popularized in Chicago commercial buildings of the 1880s–1890s. See also BAY WINDOW.

chimney girt In timber-frame construction, a major wooden beam that passes across the breast of the central chimney. It is supported at its ends by the longitudinal girts of the building and sometimes carries one end of the summer beam.

choir 1 The part of a Roman Catholic or High Episcopal church where the singers participate in the service. Usually the space within the chancel arm of the church, situated between the crossing to the west and the sanctuary to the east. 2 In less extensive Catholic and Episcopal churches, the terms choir and chancel are often used interchangeably to mean the entire eastern arm of the church.

Churrigueresque Term applied to Spanish and Spanish colonial Baroque architecture resembling the work of the Spanish architect José Benito de Churriguera (1665–1725) and his brothers. The style is characterized by a freely interpreted assemblage of such elements as twisted columns, broken pediments, and scroll brackets. See also the related term SPANISH COLONIAL.

cinquefoil A type of Gothic tracery having five parts (lobes or foils) separated by pointed elements (cusps).

City Beautiful movement A movement in architecture, landscape architecture, and planning in the United States from the 1890s through the 1920s, advocating the beautification of cities in the image of some of the most urbane places of

the time: the world's fairs. City Beautiful schemes emphasized civic centers, boulevards, and waterfront improvements, and sometimes included comprehensive metropolitan plans for parks, parkways, and transportation facilities. See also the related term BEAUX-ARTS CLASSICISM.

clapboard A tapered board that is thinner along the top edge and thicker along the bottom edge, applied horizontally with edges overlapping to provide weathertight siding on a building of wood construction. Early clapboards were split (rived, riven) and were used for barrel staves and for wainscoting. The term now applies to any beveled siding board, whether split or sawn, rabbeted or not, regardless of length or width. (The term is sometimes applied only to a form of bevel siding used in New England, about four feet long and quarter-sawn.) Sometimes called weatherboards.

classical orders See ORDER.

classical rectangle See GOLDEN SECTION.

Classical Revival Ambiguous term, suggesting (1) Neoclassical design of the late eighteenth and early nineteenth centuries, including the Greek Revival; or (2) Beaux-Arts classical design of the late nineteenth and early twentieth centuries. Sometimes called Classic Revival. See instead BEAUX-ARTS CLASSICISM, GREEK REVIVAL, NEOCLASSICISM.

classicism, classical, classicizing Terms describing the application of principles or elements derived from the visual arts of the Greco-Roman era (seventh century B.C. through fourth century A.D.) at any subsequent period of Western civilization, but particularly since the Renaissance. More a descriptive term for an approach to design and for a general cultural sensibility than for any particular style. See also the related term NEOCLASSICISM.

clerestory A part of a building that rises above the roof of another part and has windows in its walls.

clipped gable roof See JERKINHEAD ROOF.

coffer A recessed panel, usually square or octagonal, in a ceiling. Such panels are also found on the inner surfaces of domes and vaults.

collar beam A horizontal tension member in a pitched roof connecting opposite rafters, generally halfway up or higher. Its function is to tie the angular members together and prevent them from spreading.

Collegiate Gothic 1 Originally, a secular version of English Gothic architecture, characteristic of the older colleges of Oxford and Cambridge. 2 A secular version of Late Gothic Revival architecture, which became a popular style for North American colleges and universities from the 1890s through the 1920s. Sometimes called Academic Gothic.

colombage In French colonial and post-colonial architecture, the term for half-timber construction. Distinguished from *poteaux-en-terre* and *poteaux-sur-sol* contruction, in which the vertical posts are unbraced and more closely spaced. Sometimes called *colombage-sur-sol*. Also spelled *columbage*.

colonial 1 Not strictly a style term, but a term for the entire period during which a particular European country held political dominion over a part of the Western Hemisphere, Africa, Asia, Australia, or Oceania. See also the more specific terms BRITISH COLONIAL, DUTCH COLONIAL, FRENCH COLONIAL, SPANISH COLONIAL. 2 Loosely used to mean the British colonial period in North America (c. 1607–1781 for the United States; c. 1750s–1867 for much of Canada).

Colonial Revival Generally understood to mean the revival of forms from British colonial design. The Colonial Revival began in New England in the 1860s and continues nationwide into the present. Sometimes called Neo-Colonial. See also the more specific term GEORGIAN REVIVAL and the related terms FEDERAL REVIVAL, SHINGLE STYLE.

colonnade A series of freestanding or engaged columns supporting an entablature or simple beam.

colonnette A diminutive, often attenuated, column.

colossal order See GIANT ORDER.

column 1 A vertical supporting element, usually cylindrical and slightly tapering, consisting of a base (except in the Greek Doric order), shaft, and capital. See also the related terms ENTABLATURE, ENTASIS, ORDER. 2 Any vertical supporting element in a skeletal frame.

Commercial Style See CHICAGO SCHOOL.

common bond A pattern of brickwork in which every fifth or sixth course consists of all headers, the other courses being all stretchers. Sometimes called American bond. Distinguished from running bond, in which no headers appear.

Composite order An ensemble of classical column and entablature elements, particularly characterized by large Ionic volutes and Corinthian acanthus leaves in the capital of the column. See also the more general term ORDER.

concrete An artificial stone made by mixing cement, water, sand, and a coarse aggregate (such as gravel or crushed stone) in specified proportions. The mix is shaped in molds called forms. Distinguished from cement, which is the binder without the aggregate.

console A type of bracket with a scroll-shaped or s-curve profile and a height greater than its projection from the wall. Distinguished from the more general term bracket, which is usually applied to supports whose projection and height are nearly equal. Distinguished from a modillion, which usually is smaller, has a projection greater than its height (or thick-

ness), and appears in a series, as in a classical cornice.

coping The cap or top course of a wall, parapet, balustrade, or chimney, usually designed to shed water.

corbel A projecting stone that supports a super-incumbent weight. In medieval architecture and its derivatives, a support for such major features as vaulting shafts, vaulting ribs, or oriels. See also the related term BRACKET.

corbeled construction Masonry that is built outward beyond the vertical by letting successive courses project beyond those below. Sometimes called corbeling.

corbeled cornice A cornice made up of courses of projecting masonry, each of which extends farther outward than the one below.

Corinthian order An ensemble of classical column and entablature elements, particularly characterized by acanthus leaves and small volutes in the capital of the column. See also the more general term ORDER.

cornice The crowning member of a wall or entablature.

Corporate International Style A term, not widely used, for curtain wall commercial, institutional, and governmental buildings since the Second World War, which represent a widespread adoption of selected International Style ideas from the 1920s. See also the more general term INTERNATIONAL STYLE.

Corporate Style An architectural style developed in the early industrial communities of New England during the first half of the nineteenth century. This austere but graceful mode of construction was derived from the red-brick Federal architecture of the early nineteenth century and is characterized by the same elegant proportions, cleanly cut openings, and simple refined detailing. The term was coined by William Pierson in the 1970s. Not to be confused with Corporate International Style.

cottage 1 A relatively modest rural or suburban dwelling. Distinguished from a villa, which is a more substantial and often more elaborate dwelling. 2 A seasonal dwelling, regardless of size, especially one located in a resort community.

cottage orné A rustic building in the romantic, picturesque tradition, noted for such features as bay windows, oriels, ornamented gables, and clustered chimneys.

course A layer of building blocks, such as bricks or stones, extending the full length and thickness of a wall.

coved ceiling A ceiling in which the transition between wall and ceiling is formed by a large concave panel or molding. Sometimes called a cove ceiling.

coved cornice A cornice with a concave profile. Sometimes called a cavetto cornice.

Craftsman A style of furniture and interior design belonging to the Arts and Crafts movement in

the United States, and specifically related to *The Craftsman* magazine (1901–1916), published by Gustav Stickley (1858–1942). Some entire houses known to be derived from this publication can be called Craftsman houses. See also the more general term ARTS AND CRAFTS.

crenellation, crenellated A form of embellishment on a parapet consisting of indentations (crenels or embrasures) alternating with solid blocks of wall (merlons). Virtually synonymous with battlement, battlemented; embattlement, embattled.

Creole In reference to house types, a house or cottage with two or more interconnected rooms, without hallways, and often with two cabinets, or small rooms, at the rear, joined by a loggia.

cresting An ornamental strip or fencelike feature, usually of metal or tile, along the ridgeline or summit of a roof.

crocket In Gothic architecture, a small ornament resembling bunched foliage, placed at intervals on the sloping edges of gables, pinnacles, or spires.

crossing In a church with a cruciform plan, the area where the arms of the cross intersect; specifically, the space where the transept crosses the nave and chancel.

cross rib See LIERNE.

cross section See SECTION.

crown The central, or highest, part of an arch or vault.

crown molding The highest in a series of moldings.

crowstep Any one of the progressions in a gable that ascends in steps rather than in a continuous slope.

cruciform In the shape of a cross. Usually used to describe the ground plans of buildings. See also the more specific terms GREEK CROSS, LATIN CROSS.

cupola 1 A small domed structure on top of a belfry, steeple, or tower. 2 A lantern, square or polygonal in plan, with windows or vents, which is located at the summit of a roof. Sometimes called a belvedere. Distinguished from a skylight, which is a lesser feature located on the slope of a roof. 3 In historic English usage, synonymous with dome. A dome is now understood to be a more substantial feature.

curtain wall In skeleton frame or reinforced concrete construction, a thin nonstructural cladding of stone, brick, terra-cotta, glass, or metal veneer. Distinguished from bearing wall. See also the related term LOAD-BEARING.

cusp. The pointed, roughly triangular intersection of the arcs of lobes or foils in the tracery of windows, screens, or panels.

dado A broad decorative band around the lower portion of an interior wall, between the baseboard and dado rail or cap molding. (The term is often applied to this entire zone, including baseboard and dado rail.) The dado may be

painted, papered, or covered with some other material, so as to have a different treatment from the upper zone of the wall. Dado connotes any continuous lower zone in a room, equivalent to a pedestal. A wood-paneled dado is called a wainscot.

Deco. See ART DECO.

dentil, denticulated A small ornamental block forming one of a series set in a row. A dentil molding is composed of such a series.

dependency A building, wing, or room, subordinate to or serving as an adjunct to a main building. A dependency may be attached to or detached from a main building. Distinguished from an outbuilding, which is always detached.

diaper An overall repetitive pattern on a flat surface, especially a pattern of geometric or representational forms arranged in a diamond-shaped or checkerboard grid. Sometimes called diaper work.

discharging arch See RELIEVING ARCH.

dogtrot An open breezeway between two main rooms of a log or frame house; also, a house so constructed.

dome A major hemispherical or curved roof feature rising from a circular, polygonal, or square base. Distinguished from a cupola, which is a smaller, usually subordinate, domical element.

Doric order An ensemble of classical column and entablature elements, particularly characterized by the use of triglyphs and metopes in the frieze of the entablature. See also the more general term ORDER.

dormer A roof-sheltered window (or vent), usually with vertical sides and front, set into a sloping roof. Sometimes called a dormer window.

dosseret See IMPOST BLOCK.

double-hung window A window consisting of a pair of frames, or sashes, one above the other, arranged to slide up and down. Their movement is sometimes stabilized by a system of cords and counterbalancing weights contained in narrow boxing at each side of the window frame. Sometimes called guillotine sash.

double-pen In vernacular architecture, particularly houses, a term applied to a plan consisting of two rooms side by side or separated by a hallway.

double-pile In vernacular architecture, particularly houses, a term applied to a plan that is two rooms deep and any number of rooms wide.

double-pitched roof A roof with two different slopes, one covering the house and the other the porch or gallery.

drip molding See HEAD MOLDING.

drum 1 A cylindrical or polygonal wall zone upon which a dome rests. **2** One of the cylinders of stone that form the shaft of a column.

Dutch colonial A term applied to buildings, towns, landscapes, and other artifacts from the period of actual Dutch colonial occupation of the Hudson River valley and adjacent areas (c.

1614–1664). Meaning has been extended to apply to the artifacts of Dutch ethnic groups and their descendants, even into the early nineteenth century.

Dutch Colonial Revival The revival of forms from design in the Dutch tradition.

ear A slight projection just below the upper corners of a door or window architrave or casing. Sometimes called a shouldered architrave.

Early American See BRITISH COLONIAL.

Early Christian A style of art and architecture in the Mediterranean world that was developed by the early Christians before the fall of the Western Roman Empire, derived from late Roman art and architecture and leading to the Romanesque (early fourth to early sixth century).

Early Georgian period Not strictly a style term, but a term for a period in British and British colonial history approximately coinciding with the reigns of George I (1714–1727) and George II (1727–1760). See also the related term LATE GEORGIAN PERIOD.

Early Gothic Revival A term for the Gothic Revival work of the late eighteenth to the mid-nineteenth century. See also the related term LATE GOTHIC REVIVAL.

Eastlake A decorative arts and interior design term of the 1860s and 1880s sometimes applied to architecture. Named after Charles Locke Eastlake (1836–1906), an English advocate of the application of Gothic principles of construction and design, rather than mere Gothic elements. Characterized by simplicity and solidity of forms, which are sometimes embellished with chamfered, turned, or incised details. Sometimes called Eastlake Gothic, Modern Gothic. See also the related term QUEEN ANNE.

eaves The horizontal lower edges of a roof plane, usually projecting beyond the wall below. Distinguished from verges, which are the sloping edges of a roof plane.

echinus A heavy molding with a curved profile placed immediately below the abacus, or top member, of a classical capital. Particularly prominent in the Doric and Tuscan orders.

eclecticism, eclectic A sensibility in design, prevalent since the eighteenth century, involving the selection of elements from a variety of sources, including historical periods of high-style design (Western and non-Western), vernacular design (Western and non-Western), and (in the twentieth century) contemporary industrial design. Distinguished from historicism and revivalism by drawing upon a wider range of sources than the historical periods of high-style design.

Ecole, Ecole des Beaux-Arts See BEAUX-ARTS.

Egyptian Revival Term applied to eclectic works or elements of those works that emulate forms in the visual arts of ancient Egyptian civilization.

elevation A drawing (in orthographic projection) of an upright, planar aspect of an object or

building. The vertical complement of a plan. Sometimes loosely used in the sense of a facade view or any frontal representation of a wall, whether photograph or drawing, whether measured to scale or not.

Elizabethan Manor Style See NEO-TUDOR.

embattlement, embattled See CRENELLATION.

en suite An arrangement of rooms opening into one another rather than into a hall; rooms and doors in a cluster or a line.

encaustic tile A tile decorated by a polychrome glazed or ceramic inlay pattern.

enfilade Rooms and doors in a line.

engaged column A half-round column attached to a wall. Distinguished from a free-standing column by seeming to be built into the wall. Distinguished from a pilaster, which is a flattened column. Distinguished from a recessed column, which is a fully round column set into a niche-like space.

English bond A pattern of brickwork in which the bricks are set in alternating courses of stretchers and headers.

English colonial See BRITISH COLONIAL.

English Half-timber Style See NEO-TUDOR.

entablature In a classical order, a richly detailed horizontal member resting on columns or pilasters. It is divided horizontally into three main parts. The lowest is the architrave (definition 1), the structural part, and is generally an unornamented continuous beam or series of beams. The middle part is the frieze (definition 1), which is generally the most freely ornamented part. The uppermost is the cornice. Composed of a sequence of moldings, the cornice overhangs the frieze and architrave and serves as a crown to the whole. Each part has the moldings and decorative treatment that are characteristic of the particular order, but modern adaptations often alter canonical details. See also the related terms COLUMN, ORDER.

entablature block A block bearing the canonical elements of a classical entablature on three or all four sides, placed between a column capital and a feature above, such as a balcony or ceiling. Distinguished from an impost block, which has the form of an inverted truncated pyramid and detailing typical of medieval architecture.

entasis The slight convex curving of the vertical profile of a tapered column.

entresol A low-ceilinged or balconylike story between two stories. In New Orleans, used to refer to a space between the first and second floors of a combined commercial-residential structure, typically used for storing goods.

exedra A semicircular or polygonal space usually containing a bench, in the wall of a garden or a building other than a church. Distinguished from a niche, which is usually a smaller feature higher in a wall, and from an apse, which is usually identified with churches.

exotic revivals A term occasionally used to suggest a distinction between revivals of European styles (e.g., Greek, Gothic Revivals) and non-European styles (e.g., Egyptian, Moorish Revivals). See also the more specific terms EGYPTIAN REVIVAL, MAYAN REVIVAL, MOORISH REVIVAL.

extrados The outer curve or outside surface of an arch. See also the related term INTRADOS.

eyebrow dormer A low dormer with a small segmental window or vent but no sides. The roofing warps or bows over the window or vent in a wavy line.

facade An exterior face of a building, especially the principal or entrance front. Distinguished from an elevation, which is an orthographic drawing of a building face.

Fachwerk A form of half-timber construction introduced by German-speaking immigrants.

false half-timbering A surface treatment that simulates half-timber construction, consisting of a lattice of broad boards and stucco applied as an exterior veneer on a building of masonry or wood-frame construction. Most commonly seen in domestic architecture from the late nineteenth century onward.

fanlight A semicircular or semielliptical window over a door, with radiating mullions in the form of an open fan. Sometimes called a sunburst light. See also the more general term TRANSOM (definition 1) and the related term SIDE LIGHT.

fan vault A type of Gothic vault in which the primary ribs all have the same curvature and radiate in a half circle around the springing point.

fascia **1** A plain, molded, or ornamented board that covers the horizontal edges (eaves) or sloping edges (verges) of a roof. Distinguished from the more specific term bargeboards, which are ornate fascia boards attached to the sloping edges of a roof. Distinguished from a frieze (definition 2), which is located at the top of a wall. **2** One of the broad continuous bands that make up the architrave of the Ionic, Corinthian, or Composite order.

Federal A version of Neoclassical architecture in the United States popular from New England to Virginia, and in other regions influenced by the Northeast. It flourished from the 1790s through the 1820s and is found in some regions as late as the 1840s. Sometimes called American Adam Style. Not to be confused with Federalist. See also the related terms JEFFERSONIAN, ROMAN REVIVAL.

Federal Revival Term applied to eclectic works (c. 1890s–1930s) or elements of those works that emulate forms in the visual arts of the Federal period. Sometimes called Neo-Federal. See also the related terms COLONIAL REVIVAL, GEORGIAN REVIVAL.

Federalist Name of an American political party and the era it dominated (c. 1787–1820). Not to be confused with Federal.

fenestration Window treatment: arrangement and proportioning.

festoon A motif representing entwined leaves, flowers, or fruits, hung in a catenary curve from two points. Distinguished from a swag, which is a motif representing a fold of drapery hung in a similar curve. See also the more general term GARLAND.

fillet 1 A relatively narrow flat molding. 2 Any thin band.

finial A vertical ornament placed upon the apex of an architectural feature, such as a gable, turret, or canopy. Distinguished from a pinnacle, which is a larger feature, usually associated with Gothic architecture.

fireproofing In metal skeletal framing, the wrapping of structural members in terra-cotta tile or other fire-resistant material.

flashing A strip of metal, plastic, or various flexible compositional materials used at roof valleys and ridges and at chimney corners to keep water out. Any similar material used to protect door and window heads and sills.

Flemish bond A pattern of brickwork in which the stretchers and headers alternate in the same row and are staggered from one row to the next. Because this creates a more animated texture than English bond, Flemish bond was favored for front facades and more elegant buildings.

Flemish gable A gable whose upper slopes ascend in steps rather than in a straight line. These steps may be rectilinear or curved, or a combination of both.

fluting, fluted A series of parallel grooves or channels (flutes), usually semicircular or semi-elliptical in plan, that accentuate the verticality of the shaft of a column or pilaster.

flying buttress In Gothic architecture a spanning member, usually in the form of an arch, that reaches across the open space from an exterior buttress pier to that point on the wall of the building where the thrusts of the interior vaults are concentrated. Because of its arched construction, a flying buttress exerts a counterthrust against the pressure of the vaults contained by the vertical strength of the buttress pier.

foliated (adjective). In the form of leaves or leaflike shapes.

folk Not a style term in itself, but a descriptive term, applicable to all the visual arts and all styles and periods. Applied to (1) a regional, often ethnic, tradition in which continuities through the years in the overall appearance of artifacts (including buildings) are more important than changes in stylistic embellishment; (2) the work of individual artists and artisans unexposed to or uninterested in prevailing or avant-garde ideals of form and technique. Approximate synonyms include anonymous, naive, primitive, traditional. For architecture, see also the more general term VERNACULAR and the related term POPULAR.

four-part vault See QUADRIPARTITE VAULT.

foursquare house A hip-roofed, two-story house with four principal rooms on each floor and a symmetrical facade. It usually has a front porch across the full width of the house and one or more large dormers on the roof. A common suburban house type from the 1890s to the 1920s. Sometimes called American Foursquare, Prairie Box.

frame construction, frame Ambiguous terms. See instead BRACED FRAME CONSTRUCTION, LIGHT FRAME CONSTRUCTION (BALLOON FRAME CONSTRUCTION, PLATFORM FRAME CONSTRUCTION), SKELETON CONSTRUCTION, TIMBER-FRAME CONSTRUCTION. Not properly synonymous with wood construction, wood-clad, or wooden.

Francis I Style See CHATEAUESQUE.

François Premier See CHATEAUESQUE.

French colonial A term applied to buildings, towns, landscapes, and other artifacts from the period of actual French colonial occupation of large parts of eastern North America (c. 1605–1763). The term is extended to apply to the artifacts of French ethnic groups and their descendants well into the nineteenth century.

French Norman A style associated since the 1920s with residential architecture based on rural houses of the French provinces of Normandy and Brittany. While not a major revival style, it is characterized by asymmetrical plans, round stair towers with conical roofs, stucco walls, and steep hipped roofs. Sometimes called Norman French.

fret An ornament, usually in series, as a band or field, consisting of a latticelike interlocking of right-angled linear elements.

frieze 1 The broad horizontal band that forms the central part of a classical entablature. 2 Any long horizontal band or zone, especially one that has a chiefly decorative purpose, located at the top of a wall. Distinguished from a fascia, which is attached to the horizontal edge of a roof.

front gabled Term applied to a building whose principal gable end faces the front of the lot or some feature like a street or open space. Sometimes called gable front. Distinguished from side gabled.

gable The wall area immediately below the end of a gable, gambrel, or jerkinhead roof.

gableboard See BARGEBOARD.

gable front See FRONT GABLED.

gable roof A roof in which the two planes slope equally toward each other to a common ridge. Sometimes called a pitched roof.

galerie In French colonial domestic architecture, a porch or veranda, usually sheltered by an extension of the hipped roof of the house.

gallery A roofed corridor, passage, or promenade. In the southern United States, a porch or veranda, one or more stories in height, usually functioning as an outdoor living space.

gambrel roof A roof that has a single ridgepole but a double pitch. The lower plane, which rises

from the eaves, is rather steep. The upper plane, which extends from the lower plane to the ridgeline, has a flatter pitch.

garçonnière On Louisiana plantations, a separate structure, usually near the main house, for the young unmarried men of the household.

garland A motif representing a rope of entwined leaves, flowers, ribbons, or drapery, regardless of its shape or position. It may be formed into a wreath, festoon, or swag, or follow the outline of a rectilinear architectural element.

garret See ATTIC (definition 1).

gauged brick A brick that has been cut or rubbed to a uniform size and shape.

gazebo A small pavilion, usually polygonal or circular in plan and serving as a garden or park shelter. Distinguished from a kiosk, which generally has some commercial or public function. See also the related terms BANDSTAND, BELVEDERE (definition 1).

Georgian period A term for a period in British and British colonial history, and not, in architecture or the other visual arts, a sufficiently specific style term. The Georgian period begins with the coronation of George I in 1714 and extends until about 1781 in the area that became the United States (and in Britain, until the death of George IV in 1830). See also the related terms ANGLO-PALLADIANISM, BRITISH COLONIAL.

Georgian plan See DOUBLE-PILE plus DOUBLE-PEN (i.e., a four-room plan with central hallway).

Georgian Revival A revival of Georgian period forms—in England, from the 1860s to the present, and in the United States, from the 1880s to the present. Sometimes called Neo-Georgian. See also the more general term COLONIAL REVIVAL and the related term FEDERAL REVIVAL.

giant order A composition involving any one of the five principal classical orders, in which the columns or pilasters are nearly as tall as the height of the entire building. Sometimes called a colossal order. See also the more general term ORDER.

Gingerbread Style See CARPENTER'S GOTHIC.

girder A major horizontal spanning member, comparable in function to a beam, but larger and often built up of a number of parts. It usually runs at right angles to the beams and serves as their principal means of support.

girt In timber-frame construction, a horizontal beam at intermediate (e.g., second-floor) level, spanning between posts.

glazing bar See MUNTIN.

golden section Any line divided into two parts so that the ratio of the longer part to the shorter part equals the ratio of the length of the whole line to the longer part: a/b - $(a+b)/a$. This ratio is approximately 1.618:1. A golden rectangle, or classical rectangle, is a rectangle whose long side is related to the short side in the same ratio as the golden section. It is proportioned so that neither the long nor the short side

seems to dominate. In a Fibonacci series (i.e., 1, 2, 3, 5, 8, 13, . . .), the sum of the two preceding terms gives the next. The higher one goes in such a series, the closer the ratio of two sequential terms approaches the golden section.

Gothic An architectural style prevalent in Europe from the twelfth century into the fifteenth in Italy (and into the sixteenth century in the rest of Europe). It is characterized by pointed arches and ribbed vaults and by the dominance of openings over masonry mass in the wall. The Gothic was preceded by the Romanesque and followed by the Renaissance.

Gothic Revival A movement in Europe and North America devoted to reviving the forms and the spirit of Gothic architecture and the allied arts. It originated in the mid-eighteenth century. Sometimes called the Pointed Style in the nineteenth century, and sometimes called Neo-Gothic. See also the more specific terms CARPENTER'S GOTHIC, EARLY GOTHIC REVIVAL, HIGH VICTORIAN GOTHIC, LATE GOTHIC REVIVAL.

Grecian A nineteenth-century term for Greek Revival.

Greek cross A cross with four equal arms. Usually used to describe the ground plan of a building. See also the more general term CRUCIFORM.

Greek Revival A movement in Europe and North America devoted to reviving the forms and the spirit of classical Greek architecture, sculpture, and decorative arts. It originated in the mid-eighteenth century, culminated in the 1830s, and continued into the 1850s. Sometimes called Grecian in the nineteenth century. See also the more general term NEOCLASSICAL.

groin The curved edge formed by the intersection of two vaults.

guillotine sash See DOUBLE-HUNG WINDOW.

HABS See HISTORIC AMERICAN BUILDINGS SURVEY.

HAER See HISTORIC AMERICAN ENGINEERING RECORD.

half-timber construction A variety of timber-frame construction in which the framing members are exposed on the exterior of the wall, with the spaces between timbers being filled with wattle-and-daub (i.e., woven lath and plaster) or masonry materials, such as brick or stone. These masonry materials may also be covered with stucco. Sometimes called half-timbered construction.

hall-and-parlor house, hall-and-parlor plan A double-pen house (i.e., a house that is one room deep and two rooms wide). Usually applied to houses without a central through-passage, to distinguish from hall-passage-parlor houses.

hall-passage-parlor house, hall-passage-parlor plan A two-room house with a central through-passage or hallway.

hammer beam A short horizontal beam projecting inward from the foot of the principal rafter and supported below by a diagonal brace tied into a vertical wall post. The hammer beams carry much of the load of the roof trussing above. Hammer beam trusses, which could be assembled using a series of smaller timbers, were often used in late medieval England instead of conventional trusses, which required long horizontal tie beams extending across an entire interior space.

haunch The part of the arch between the crown or keystone and the springing.

header A brick laid across the thickness of a wall, so that the short end of the brick shows on the exterior.

head molding A molding or set of moldings designed to shelter and embellish the top of a door or window. Sometimes called a drip molding. See the related terms CAP (for windows) and HOOD (for doors).

heavy timber construction See TIMBER-FRAME CONSTRUCTION.

high style or high-style (adjective) Not a style term in itself, but a descriptive term, applicable to all the visual arts and all styles and periods. Applied to the works of the masters and their schools and disciples, usually reflecting a cosmopolitan awareness of traditions beyond a particular place or time. Usually contrasted with vernacular (including the folk and popular traditions).

high tech Term applied to architecture in which building materials and elements of building systems are used to celebrate contemporary technology. Elemental geometric forms, primary colors, and metallic finishes are used to heighten the technological imagery.

High Victorian Gothic A version of the Gothic Revival that originated in England in the 1850s and spread to North America in the 1860s. Characterized by polychromatic exteriors inspired by the medieval Gothic architecture of northern Italy. Sometimes called Ruskin Gothic, Ruskinian Gothic, Venetian Gothic, Victorian Gothic. See also the more general term GOTHIC REVIVAL.

hipped gable roof See JERKINHEAD ROOF.

hipped roof A roof that pitches inward from all four sides. The edge where any two planes meet is called the hip.

Historic American Buildings Survey (HABS) A branch of the National Park Service of the United States Department of the Interior, established in 1933 to produce detailed documentation of American architecture. HABS documentation typically includes historical and architectural data, photographs, and measured drawings, and is deposited in the Prints and Photographs Division of the Library of Congress. See also the related term HISTORIC AMERICAN ENGINEERING RECORD.

Historic American Engineering Record (HAER) A branch of the National Park Service of the United States Department of the Interior, established in 1969 to produce detailed documentation of sites and structures associated with industry, transportation, and other areas of technology. See also the related term HISTORIC AMERICAN BUILDINGS SURVEY.

historicism, historicist, historicizing A type of eclecticism prevalent since the eighteenth century, involving the use of forms from historical periods of high-style design (usually in the Western tradition) and, occasionally, from favored traditions of vernacular design (such as the various colonial traditions in the United States). Historicist influences are designated by the use of the prefix Neo- with a previous historical style (e.g., Neo-Baroque). Distinguished from the more general term eclecticism, which draws upon a wider range of sources in addition to the historical. See also the more specific term REVIVALISM.

hollow building tile A hollow terra-cotta building block used for constructing exterior bearing walls of buildings up to about three stories, as well as interior walls and partitions.

hood A canopy, ledge, molding, or pediment over a door. Distinguished from a cap, which is a similar feature over a window. Sometimes called a hood molding. See also the related term HEAD MOLDING.

horizontal plank frame construction A system of wood construction in which horizontal planks are set or nailed into the corner posts of a timber-frame building. There are, however, no studs or intermediate posts connecting the sill and the plate. See also the related term VERTICAL PLANK FRAME CONSTRUCTION.

hung ceiling See SUSPENDED CEILING.

hyphen A subsidiary building unit, often one story, connecting the central block and the wings or dependencies.

I-beam The most common profile in steel structural shapes (although it also appears in cast iron and in reinforced concrete). Used especially for spanning elements, it is shaped like the capital letter I to make the most efficient use of the material consistent with a shape that permits easy assemblage. The vertical face of the I is the web. The horizontal faces are the flanges. Other standard shapes for steel framing elements are Is, Ts, Zs, Ls (known as angles), and square-cornered Us (channels).

I-house A two-story house, one room deep and two rooms wide, usually with a central hallway. The I-house is a nineteenth-century descendant of the hall-and-parlor houses of the colonial period. The term is commonly applied to the end-chimney houses of the southern and mid-Atlantic traditions. The term most likely derives from the resemblance between the tall, narrow end walls of these houses and the capital letter I.

impost The top part of a pier or wall, upon which rests the springer or lowest voussoir of an arch.

impost block A block, often in the form of an inverted truncated pyramid, placed between a column capital and the lowest voussoirs of an arch above. Distinguished from an entablature block, which has the details found in a classical entablature. Sometimes called a dosseret or supercapital.

in antis Columns in antis are placed between two projecting sections of wall, in an imaginary plane connecting the ends of the two wall elements.

intermediate rib See TIERCERON.

International Style A style that originated in the 1920s and flourished into the 1970s, characterized by the expression of volume and surface and by the suppression of historicist ornament and axial symmetry. The term was originally applied by Henry-Russell Hitchcock and Philip Johnson to the new, nontraditional, mostly European, architecture of the 1920s in their 1932 exhibition at the Museum of Modern Art and in their accompanying book, *The International Style.* Also called International, International Modern. See also the more specific term CORPORATE INTERNATIONAL STYLE and the related terms BAUHAUS, MIESIAN, SECOND CHICAGO SCHOOL.

intrados The inner curve or underside (soffit) of an arch. See also the related term EXTRADOS.

Ionic order An ensemble of classical column and entablature elements, particularly characterized by the use of large volutes in the capital of the column. See also the more general term ORDER.

isometric drawing A pictorial drawing using isometric projection, in which all horizontal lines that are perpendicular in an object, building, or space are drawn at 60-degree angles from the vertical. Consequently, a single scale can be used for all three dimensions. Sometimes called an isometric. See also the related terms AXONOMETRIC DRAWING, PERSPECTIVE DRAWING.

Italianate 1 A general term for an eclectic Neo-Renaissance and Neo-Romanesque style, originating in England and Germany in the early nineteenth century and prevalent in the United States between the 1840s and 1880s, not only in houses but also in Main Street commercial buildings. The Italianate is characterized by prominent window heads and bracketed cornices. Called the Bracketed Style in the nineteenth century. See also the more specific term ITALIAN VILLA STYLE and the related terms RENAISSANCE REVIVAL, ROUND ARCH MODE, SECOND EMPIRE. 2 A specific term for Italianate buildings that are predominantly symmetrical in plan and elevation.

Italian Villa Style A subtype of the Italianate style (definition 1), originating in England and Germany in the early nineteenth century and prevalent in the United States between the 1840s and 1870s, mostly in houses, but also churches and other public buildings. The style is characterized by asymmetrical plans and elevations, irregular blocklike massing, round arch arcades and openings, and northern Italian Romanesque detailing. Larger Italian Villa buildings often had a campanile-like tower. Distinguished from the more symmetrical Italianate style (definition 2) by having the northern Italian rural vernacular villa as prototype.

Jacobean period A term for a period in British history coinciding with the rule of James I (1603–1625). See also the related term ELIZABETHAN for the immediately preceding period, which itself is part of the Tudor period.

Jacobethan Revival See NEO-TUDOR.

jamb The vertical side face of a door or window opening, amounting to the full thickness of the wall, and usually enriched with paneling, moldings, or jamb shafts (which are engaged columns set into a splayed, or angled, jamb). In an opening containing a door or window, the jamb is distinguished from the reveal, which is the portion of wall thickness between the door or window frame and the outer surface of the wall. (In an opening without a door or window, the terms jamb and reveal are used interchangeably.) Also distinguished from an architrave (definition 2), which consists of the moldings on the face of a wall around the opening.

Jazz Moderne See ART DECO.

Jeffersonian A personal style of Neoclassicism identified with the architecture of Thomas Jefferson (1743–1826), derived in part from Palladian ideas and in part from Imperial Roman prototypes. The style had a limited influence in the Piedmont of Virginia and across the Appalachians into the Ohio River valley. Sometimes called Jeffersonian Classicism. See also the related terms ANGLO-PALLADIANISM, FEDERAL, ROMAN REVIVAL.

jerkinhead roof A gable roof in which the upper portion of the gable end is hipped, or inclined inward along the ridgeline, forming a small triangle of roof surface. Sometimes called a clipped gable roof or hipped gable roof.

joist One of a series of small horizontal beams that support a floor or ceiling.

keystone The central wedge-shaped stone at the crown of an arch.

king post In a truss, the vertical suspension member that connects the tie beam with the apex of opposing principal rafters.

kiosk Originally, a Turkish summer palace. Since the nineteenth century, the term has been applied to any small pavilion or stand, usually found in public gardens, parks, streets, and malls, where it serves some commercial or public function. Distinguished from a gazebo, which may be found in public or private gardens or parks, but which usually serves as a sheltered resting place. See also the related term BANDSTAND.

label 1 A drip molding, over a square-headed door or window, which extends for a short distance down each side of the opening. 2 A similar vertical downward extension of a drip molding over an arch of any form. Sometimes called a label molding.

label stop 1 An L-shaped termination at the lower ends of a label. 2 Any decorative boss or other termination of a label.

lancet arch An arch generally tall and sharply pointed, whose centers are farther apart than the width or span of the arch.

lantern 1 The uppermost stage of a dome, containing windows or arcaded openings. 2 Any feature, square or polygonal in plan and usually containing windows, rising above the roof of a building. The square structures that serve as skylights on the roofs of nineteenth-century buildings—particularly houses—were also called lantern lights, and, in Italianate and Second Empire buildings, came to be called cupolas.

Late Georgian period Not strictly a style term, but a term for a period in British and British colonial history approximately coinciding with the reigns of George III (1760–1820) and George IV (1820–1830). In the United States, the Late Georgian period is now understood to end sometime during the Revolutionary War (1775–1781) and to be followed by the Federal period (c. 1787–1820). In Britain, the Late Georgian period includes the Regency period (1811–1820s). See also the related term EARLY GEORGIAN PERIOD.

Late Gothic Revival A term for the Gothic Revival work of the late nineteenth and early twentieth centuries. See also the more specific term COLLEGIATE GOTHIC (definition 2) and the related term EARLY GOTHIC REVIVAL.

lath A latticelike, continuous surface of small wooden strips or metal mesh nailed to walls or partitions to hold plaster.

Latin cross A cross with one long and three short arms. Usually used to describe the ground plans of Roman Catholic and Protestant churches. See also the more general term CRUCIFORM.

leaded glass Panes of glass held in place by lead strips, or cames. The panes, clear or stained, may be of any shape.

lean-to roof. See SHED ROOF.

levee An embankment built along a waterway to prevent flooding.

lierne In a Gothic vault, a short ornamental rib connecting the major transverse ribs and the secondary tiercerons. Sometimes called a cross rib or tertiary rib.

light frame construction A type of wood-frame construction in which relatively light structural members (usually sawn lumber, ranging from two-by-fours to two-by-tens) are fastened with nails. Distinguished from timber-frame construction, in which relatively heavy structural members (hewn or sawn timbers, measuring six by six and larger) are fastened with mortise-and-tenon joints. See the more specific terms BALLOON-FRAME CONSTRUCTION, PLATFORM FRAME CONSTRUCTION.

lintel A horizontal structural member that supports the wall over an opening or spans between two adjacent piers or columns.

living hall In Queen Anne, Shingle Style, and Colonial Revival houses, an extensive room, often containing the entry, the main staircase, a fireplace, and an inglenook.

load-bearing Term applied to a wall, column, pier, or any vertical supporting member, constructed so that all loads are carried to the ground through the wall, column, or pier. See also the related terms BEARING WALL, CURTAIN WALL.

loggia 1 A porch or open-air room, particularly one set within the body of a building. 2 An arcaded or colonnaded structure, open on one or more sides, sometimes with an upper story. 3 An eighteenth- and nineteenth-century term for a porch or veranda.

Lombard A style term applied in the United States in the mid-nineteenth century to buildings derived from the Romanesque architecture of northern Italy (especially Lombardy) and the earlier nineteenth-century architecture of southern Germany. Characterized by the use of brick for both structural and ornamental purposes. Also called Lombardic. See also the related term ROUND ARCH MODE.

lunette 1 A semicircular area, especially one that contains some decorative treatment or a mural painting. 2 A semicircular window in such an area.

Mannerism, Mannerist 1 A phase of Renaissance art and architecture in the mid-sixteenth century, characterized by distortions, contortions, inversions, odd juxtapositions, and other departures from High Renaissance canons of design. 2 (Not capitalized) A sensibility in design, regardless of style or period, characterized by a knowledgeable violation of rules and intended as a comment on the very nature of convention.

mansard roof A hipped roof with double pitch. The upper slope may approach flatness, while the lower slope has a very steep pitch, sometimes flaring in a concave curve (or swelling in a convex curve) as it comes to the eaves. This lower slope usually has windows, and the area under the roof often amounts to a full story. The name is a corruption of that of François Mansart (1598–1666), who designed roofs of this type, which was revived in Paris during the Second Empire period.

Mansard Style, Mansardic See SECOND EMPIRE.

masonry Construction using stone, brick, block, or some other hard and durable material laid up in units and usually bonded by mortar.

massing The grouping or arrangement of the primary volumetric components of a building.

Mayan Revival Term applied to eclectic works or elements of those works that emulate forms in the visual arts of the Maya civilization of Central America. See also the related term ART DECO.

McKim classicism, McKim classical Architecture of, or in the manner of, the firm of McKim, Mead and White, 1890s–1920s. See BEAUX-ARTS CLASSICISM.

medieval Term applied to the Middle Ages in European civilization between the age of antiquity and the age of the Renaissance (i.e., mid-400s to mid-1400s in Italy; mid-400s to late 1500s in England). In architecture and the other visual arts, the medieval period included the end of the Early Christian period, then the Byzantine, the Romanesque, and the Gothic styles or periods.

Mediterranean Revival A style generally associated since the early twentieth century with residential architecture based on Italian villas of the sixteenth century. While not a major revival style, it is characterized by symmetrical arrangements, stucco walls, and low-pitch tile roofs. Sometimes called Mediterranean Villa, Neo-Mediterranean. See also the related term SPANISH COLONIAL REVIVAL.

metope In a Doric entablature, that part of the frieze which falls between two triglyphs. In the Greek Doric order the metopes often contain small sculptural reliefs.

Middle Ages See MEDIEVAL.

Miesian Term applied to work showing the influence of the German-American architect Ludwig Mies van der Rohe (1886–1969). See also the related terms BAUHAUS, INTERNATIONAL STYLE, SECOND CHICAGO SCHOOL.

Mission Revival A style originating in the 1890s, and making use of forms and materials from the Spanish and Mexican mission architecture of the eighteenth and early nineteenth centuries. Not to be confused with Mission furniture of the Arts and Crafts movement. See also the more general term SPANISH COLONIAL REVIVAL.

modern Ambiguous term, applied in various ways during the past century to the history of the visual arts and world history generally: (1) from the 1910s to the present (see also the more specific terms BAUHAUS, INTERNATIONAL STYLE; (2) from the 1860s, 1870s, 1880s, or 1890s to the present; (3) from the Enlightenment or the advent of Neoclassicism or the industrial revolution, c. 1750, to the present; (4) from the Renaissance in Italy, c. 1450, to the present.

Modern Gothic See EASTLAKE.

Moderne A term applied to a wide range of design work from the 1920s through the 1940s, in which aspects of traditionalism and modernism coexist and in which eclecticism (from a historical, exotic, or machine aesthetic) is inseparable from the urge for stylization. Sometimes called Art Moderne, Modernistic. See also the more specific terms ART DECO, PWA MODERNE, STREAMLINE MODERNE.

modillion One of a series of small, thin scroll brackets under the projecting crown molding of a classical cornice. It is found in the Corinthian and Composite orders. Distinguished from a console, which usually is larger and has a height greater than its projection from the wall.

molding A running surface composed of parallel and continuous sections of simple or compound curves and flat areas.

monitor An extensive shed-roofed feature on a roof, containing a band of windows or vents. It may be located along one of the roof slopes (a trap-door monitor) or along the ridgeline (a clerestory monitor), and it usually runs the entire length of the roof. Distinguished from a skylight, which is a low-profile or flush-mounted feature in the plane of the roof.

Moorish Revival Term applied to eclectic works or elements of those works that emulate forms in the visual arts of those parts of North Africa and Spain under Muslim domination from the seventh through the fifteenth century. See also the related term ORIENTAL REVIVAL.

mortar A mixture of cement or lime with water and a fine aggregate of sand used to secure bricks or stones in masonry construction.

mortise-and-tenon joint A timber framing joint that is made by one member having its end shaped into a projecting piece (tenon) that fits exactly into a hole (mortise) in the other member. Once joined, the pieces are held together by a peg that passes through the tenon.

mullion 1 A post or similiar vertical member dividing a window into two or more units, or lights, each of which may be further subdivided (by muntins) into panes. 2 A post or similar vertical member dividing a wall opening into two or more contiguous windows.

muntin One of the small vertical or horizontal members that hold panes of glass within a window or glazed door. Distinguished from a mullion, which is a heavier vertical member separating paired or grouped windows. Sometimes called a glazing bar, sash bar, or window bar.

mushroom column A reinforced concrete column that flares at the top in order to counteract shear stresses in the vicinity of the column.

National Register of Historic Places A branch of the National Park Service of the United States Department of the Interior, established by the National Historic Preservation Act of 1966, to maintain files of documentation on districts, sites, buildings, structures, and objects of national, state, or local significance. Properties listed on the National Register are afforded administrative—and, ultimately, judicial—review in instances where projects funded or assisted by federal agencies might have an impact on the historic property. Properties listed on the register may also be eligible for certain tax benefits.

nave 1 The entire body of a church between the entrance and the crossing. 2 The central space

of a church, between the side aisles, extending from the entrance end to the crossing.

Neo-Baroque Term applied to eclectic works or elements of those works that emulate forms in the visual arts of the Baroque style or period. Sometimes called Baroque Revival.

Neo-Byzantine Term applied to eclectic works or elements of those works that emulate forms in the visual arts of the Byzantine style or period. Sometimes called Byzantine Revival.

Neoclassical Revival See BEAUX-ARTS CLASSICISM.

neoclassicism, neoclassical A broad movement in the visual arts which drew its inspiration from ancient Greece and Rome. It began in the mid-eighteenth century with the advent of the science of archaeology and extended into the mid-nineteenth century (in some Beaux-Arts work, into the 1930s; in some postmodern work, even into the present). See also the related terms BEAUX-ARTS, BEAUX-ARTS CLASSICISM, CLASSICISM, AND THE MORE SPECIFIC TERMS GREEK REVIVAL, ROMAN REVIVAL.

Neo-Colonial See COLONIAL REVIVAL.

Neo-Federal See FEDERAL REVIVAL.

Neo-Georgian See GEORGIAN REVIVAL.

Neo-Gothic Term applied to eclectic works or elements of those works that emulate forms in the visual arts of the Gothic style or period. The cultural movement that produced so many such works in the eighteenth, nineteenth, and twentieth centuries is called the Gothic Revival, though that term covers a wide range of work.

Néo-Grec An architectural style developed in connection with the Ecole des Beaux-Arts in Paris during the 1840s and characterized by the use of stylized Greek elements, often in conjunction with cast iron or brick construction. See also the more general term BEAUX-ARTS.

Neo-Hispanic See SPANISH COLONIAL REVIVAL.

Neo-Mediterranean See MEDITERRANEAN REVIVAL.

Neo-Norman Term applied to eclectic works or elements of those works that emulate forms in the visual arts of the eleventh- and twelfth-century Romanesque of Norman France and Britain.

Neo-Palladian See PALLADIANISM.

Neo-Renaissance Term applied to eclectic works or elements of those works that emulate forms in the visual arts of the Renaissance style or period. The mid- to late-nineteenth-century cultural movement that produced so many such works is called the Renaissance Revival, though that term covers a wide range of work.

Neo-Romanesque Term applied to eclectic works or elements of those works that emulate forms in the visual arts of the Romanesque style or period. The mid-nineteenth-century cultural movement that produced so many such works is called the Romanesque Revival, though that term covers a wide range of work.

Neo-Tudor Term applied to eclectic works or elements of those works that emulate forms in the visual arts of the Tudor period. Sometimes loosely called Elizabethan Manor Style, English Half-timber Style, Jacobethan Revival, Tudor Revival.

New Brutalism See BRUTALISM.

New Formalism A style prevalent since the 1960s, characterized by symmetrical arrangements, rich materials (marble cladding, metal grillework), and stylized classical (even Gothic) detailing. Architects associated with this style include Philip Johnson (born 1906), Edward Durell Stone (1902–1978), and Minoru Yamasaki (born 1912).

newel post A post at the head or foot of a flight of stairs, to which the handrail is fastened. Newel posts occur in a variety of shapes, in profile and cross section, and are generally more substantial elements than the individual balusters that support the handrail.

niche A recess in a wall, usually designed to contain sculpture or an urn. A niche is often semicircular in plan and surmounted by a half dome or shell form. See also the related terms AEDICULE, TABERNACLE (definition 1).

nogging Brickwork that fills the spaces between members of a timber-frame wall or partition.

Norman French See FRENCH NORMAN.

Norman truss A form of timber roof construction employing mortise-and-tenon joints and associated with building traditions of Normandy.

octagon house A rare house type of the 1850s, based on the ideas of Orson Squire Fowler (1809–1887), who argued for the efficiencies of an octagonal floor plan. Sometimes called octagon mode.

oculus A circular opening in a ceiling or wall or at the top of a dome.

ogee arch A pointed arch formed by a pair of opposing s-shaped curves.

order The most important constituents of classical architecture are the orders, first developed as a structural-aesthetic system by the ancient Greeks. An order has two major components. A column with its capital is the main vertical supporting member. The principal horizontal member is the entablature. The Greeks developed three different types of order, the Doric, Ionic, and Corinthian, each distinguishable by its own decorative system and proportions. All three were taken over and modified by the Romans, who added two orders of their own, the Tuscan, which is a simplified form of the Doric, and the Composite, which is made up of elements of both the Ionic and the Corinthian. The Romans often used the orders as a structural system in the same manner as the Greeks. Unlike the Greeks, however, they also applied them as decoration to the surfaces of walls that were supported by other means. Sometimes called classical orders. See also the related terms COLUMN, ENTABLATURE, GIANT ORDER, SUPERPOSITION (definition 1).

oriel A projecting polygonal or curved window unit of one or more stories, supported on brackets or corbels. Sometimes called an oriel window. Distinguished from a bay window, which rises from the foundation and has a rooted rather than a suspended appearance. However, a multistory projection in a tall building, whether cantilevered out or built from the foundation, is called a projecting bay or a unit of bay windows.

Oriental Revival Ambiguous term, suggesting eclectic influences from any period in any culture in the "Orient," or Asia, including Turkish, Persian, Indian, Chinese, and Japanese, as well as Arabic (even the Moorish of North Africa and Spain). Sometimes called Oriental style. See also the related term MOORISH REVIVAL.

orthographic projection A system of visual representation in which all details on or near some principal plane, object, building, or space are projected, to scale, onto the parallel plane of the drawing. Orthographic projection thus flattens all forms into a single two-dimensional picture plane and allows for an exact scaling of every feature in that plane. Distinguished from pictorial projection, which creates the illusion of three-dimensional depth. See also the more specific terms ELEVATION, PLAN, SECTION.

outbuilding A building subsidiary to and completely detached from another building. Distinguished from a dependency, which may be attached or detached.

overhang The projection of part of a structure beyond the portion below.

pigeonnier Pigeon house, dovecote; on Louisiana plantations, a large square or octagonal structure of brick or wood with nesting space in the upper section.

PWA Moderne A synthesis of the Moderne (i.e., Art Deco or Streamline Moderne) with an austere late type of Beaux-Arts classicism, often associated with federal government buildings of the 1930s and 1940s funded by the Public Works Administration. See also the more general term MODERNE and the related terms ART DECO, BEAUX-ARTS CLASSICISM, STREAMLINE MODERNE.

Palladianism, Palladian Work influenced by the Italian Renaissance architect Andrea Palladio (1508–1580), particularly by means of his treatise, *I Quattro Libri dell'Architettura* (*The Four Books of Architecture*, originally published in 1570 and disseminated throughout Europe in numerous translations and editions until the mid-eighteenth century). The most significant flourishing of Palladianism was in England, from the 1710s to the 1760s, and in the British North American colonies, from the 1740s to the 1790s. Sometimes called Neo-Palladian, Palladian classical. See also the more specific term ANGLO-PALLADIANISM.

Palladian motif A three-part composition for a door or window, in which a round-headed opening is flanked by lower flat-headed openings and separated from them by columns, pilasters, or mullions. The flanking sections, and sometimes the entire unit, may be blind (i.e., not open).

Palladian Revival See ANGLO-PALLADIANISM.

Palladian window A window subdivided as in the Palladian motif.

parapet A low wall at the edge of a roof, balcony, or terrace, sometimes formed by the upward extension of the wall below.

pargeting Elaborate stucco or plasterwork, especially an ornamental finish for exterior plaster walls, sometimes decorated with figures in low relief or indented. Found in late medieval, Queen Anne, and period revival buildings. Sometimes called parging, pargework. See also the more general term STUCCO.

parquet Inlaid wood flooring, usually set in simple geometric patterns.

parti The essential solution to an architectural program or problem; the basic concept for the arrangement of spaces, before the development and elaboration of the design.

patera (plural: paterae) A circular or oval panel or plaque decorated with stylized flower petals or radiating linear motifs. Distinguished from a roundel, which is always circular.

pavilion 1 A central or corner unit that projects from a larger architectural mass and is usually accented by a special treatment of the wall or roof. 2 A detached or semidetached structure used for specialized activities, as at a hospital. 3 In a garden or fairground, a temporary structure or tent, usually ornamented.

pediment 1 In classical architecture, the low triangular gable end of the roof, framed by raking cornices along the inclined edges of the roof and by a horizontal cornice below. 2 In Renaissance and Baroque and later classically derived architecture, the triangular or curvilinear culmination of a prominent part of a facade. 3 A similar but smaller-scale feature over a door or window. It may be triangular or curvilinear.

pendentive A concave surface in the form of a spherical triangle that forms the structural transition from the square plan of a crossing to the circular plan of a dome.

pergola A structure with an open wood-framed roof, often latticed, and supported by a colonnade. It is usually covered by climbing plants, such as vines or roses, and provides shade for a garden walk or a passageway to a building. Distinguished from arbors or trellises, which are less extensive accessory structures lacking the colonnade.

period house Term applied to suburban and country houses in which period revival styles are dominant.

period revival Term applied to eclectic works—particularly suburban and country houses—of the first three decades of the twentieth century, in which a particular historical or regional style is dominant. See also the more specific terms COLONIAL REVIVAL, DUTCH COLONIAL REVIVAL, GEORGIAN COLONIAL REVIVAL, NEO-TUDOR, SPANISH COLONIAL REVIVAL.

peripteral (adjective) Surrounded by a single row of columns.

peristyle A range of columns surrounding a building or an open court.

perspective drawing A pictorial drawing representing an object, building, or space, as if seen from a single vantage point. The illusion of three dimensions is created by using a system based on the optical laws of converging lines and vanishing points. See also the related terms AXONOMETRIC DRAWING, ISOMETRIC DRAWING.

piano nobile (plural: piani nobili) In Renaissance and later architecture, a floor with formal reception, living, and dining rooms. The principal and often tallest story in a building, usually one level above the ground level.

piazza 1 A plaza or square. 2 An eighteenth- and nineteenth-century term for a porch or veranda.

pictorial projection A system of visual representation in which an object, building, or space is projected onto the picture plane in such a way that the illusion of three-dimensional depth is created. Distinguished from orthographic projection, in which the dimension of depth is excluded. See also the more specific terms AXONOMETRIC DRAWING, ISOMETRIC DRAWING, PERSPECTIVE DRAWING.

picturesque An aesthetic category in architecture and landscape architecture in the late eighteenth and early nineteenth centuries. It is characterized by relationships among buildings and landscape features that evoke the qualities of landscape paintings, in which the eye is led past a variety of forms and spaces into the distance and the mind is led to contemplate a sense of age (by means of ruins, fallen trees, weathered rocks, and mossy surfaces on all of these). In actual settings, asymmetrical and eclectic buildings, indirect approaches, and contrasting clusters of plantings heighten the experience of the picturesque.

pièce-sur-pièce In French colonial and post-colonial architecture, a method of stacked log construction utilizing heavy timber corner posts and intermediate posts with slots or mortises into which the tapered or tenoned ends of horizontal logs are fastened. This technique requires no log-to-log corner notching and allows for the use of shorter logs between posts.

pier 1 A freestanding mass, supporting a concentrated load from an arch, a beam, a truss, or a girder. While generally rectilinear in plan, piers in buildings based upon medieval precedents are often curvilinear in plan. 2 An upright portion of a wall that performs a columnar function. The pier may be continuous with the plane of the wall, or it may be distinguished from the plane of the wall to give it a columnlike independence.

pier and spandrel A type of skeletal wall organization in which the vertical metal columns (and their square-cornered cladding) project in front of the plane of windows and their spandrel panels. The spandrel panels may be exposed structural spanning members. More often they provide decorative covering for the structure.

pieux-en-terre In French colonial and postcolonial architecture, a construction technique in which closely spaced vertical stakes or poles are set deep in the ground to form the structure of a wall. Distinguished from *poteaux-en-terre*, in which the wood members are heavier square-hewn posts. Sometimes called *pièces-en-terre*.

pilaster 1 A flattened column, with or without fluting, that is attached to a wall. It is usually finished with the same capital and base as a freestanding column. 2 Any narrow, vertical strip attached to a wall. Distinguished from an engaged column, which has a convex curvature.

pillar Ambiguous term, often used interchangeably with column, pier, or post. See instead one of those terms. (Although the term pillar is sometimes applied to columns that are square in plan, the term pier is preferable.)

pinnacle In Gothic architecture, a small spirelike element providing an ornamental finish to the highest part of a buttress or roof. It has a slender pyramidal or conical form and is often articulated with crockets or ribs and is topped by a finial. Distinguished from a finial, which is a smaller feature appearing by itself.

pitched roof See GABLE ROOF.

plan A drawing (in orthographic projection) representing all or part of an object, building, or space, as if viewed from directly above. A floor plan is a drawing of a horizontal cut through a building, usually at the level of the windows, showing the configuration of walls and openings. Other types of plans may illustrate ceilings, roofs, structural elements, and mechanical systems.

plank construction General term. See instead the more specific terms HORIZONTAL PLANK FRAME CONSTRUCTION, VERTICAL PLANK CONSTRUCTION.

plate 1 In timber-frame construction, the topmost horizontal structural member of a wall, to which the roof rafters are fastened. 2 In platform and balloon-frame construction, the horizontal members to which the tops and bottoms of studs are nailed. The bottom plate is sometimes called the sill plate or sole plate.

Plateresque Term applied to Spanish and Spanish colonial Renaissance architecture from the early sixteenth century onward, in which the

delicate, finely sculptured detail resembles the work of a silversmith (*platero*). See also the related term SPANISH COLONIAL.

platform frame construction A system of light frame construction in which each story is built as an independent unit and the studs are only one story high. The floor joists of each story rest on the top plates of the story below, and the bearing walls or partitions rest on the subfloor of each floor unit or platform. Platform framing is easier to construct and more rigid than balloon framing and has become the common framing method in the twentieth century. Structural members are usually sawn lumber, ranging from two-by-fours to two-by-tens, and are fastened with nails. Sometimes called platform framing, western frame, western framing.

plinth The base block of a column, pilaster, pedestal, dado, or door architrave.

Pointed Style A nineteenth-century term for Gothic Revival.

polychromy, polychromatic, polychrome A many-colored treatment, especially the combination of materials in various colors or the application of surface color, to articulate wall and roof planes and to highlight structure.

popular A term applied to vernacular architecture influenced by such publications as books of the orders, builders' guides, style books, pattern books, mail-order catalogs, architectural periodicals, and household magazines. Architecture in the popular tradition may be built according to commercially available plans or from widely distributed components; or it may be built by local practitioners (architects, builders, contractors) emulating buildings that are represented in publications. The distinction between popular architecture and high-style architecture by lesser-known architects depends on one's point of view with regard to the division between vernacular and high-style. See also the more general term VERNACULAR and the related term FOLK.

porch A structure attached to a building to shelter an entrance or to serve as a semienclosed sitting, working, or sleeping space. Distinguished from a portico, which is either a pedimented feature at least one story in height supported by classical columns or a more extensive colonnaded feature.

porte-cochere A porch projecting over a driveway and providing shelter to people leaving a vehicle and entering a building, or vice versa. Also called a carriage porch.

portico 1 A porch at least one story in height consisting of a low-pitched roof supported on classical columns and finished in front with an entablature and pediment. 2 An extensive porch supported by a colonnade.

post A vertical supporting element, either square or circular in plan. Posts are the integral vertical members of a frame or truss, whether of wood or metal. Posts may also carry fences or gates, or

may serve as freestanding markers (e.g., mileposts).

post-and-beam construction A structural system in which the main support is provided by vertical members (posts) carrying horizontal members (beams or lintels). Sometimes called post-and-girt construction, post-and-lintel construction, trabeation, trabeated construction.

postmodernism, postmodern A term applied to work that involves a reaction against the ideas and works of various twentieth-century modern movements, particularly the Bauhaus and the International Style. Postmodern work makes use of historicism, yet the traditional elements are often merely applied to buildings that, in every other respect, are products of modern movement design. The term is also applied to works that are attempting to demonstrate an extension of the principles of various modern movements.

poteaux-en-terre In French colonial and postcolonial architecture, a construction technique in which closely spaced vertical timbers, hewn flat on two or four faces, are set deep in the ground to form the structure of a wall. The spaces between timbers are filled with brick, clay, or other soft materials. Literally translated, the term means "posts in the earth." Distinguished from *poteaux-sur-sol*, in which the vertical timbers rest on horizontal wooden sills. Distinguished from *colombage*, which consists of a complete braced framework of more widely spaced vertical timbers.

poteaux-sur-sol In French colonial and postcolonial architecture, a construction technique in which closely spaced vertical timbers, hewn flat on two or four faces, rest on a horizontal timber sill to form the structure of a wall. The sill, in turn, rests on a stone foundation. The spaces between the vertical timbers are filled with brick, clay, or other soft materials. Literally translated, the terms means "posts upon a sill." Distinguished from *poteaux-en-terre*, in which the vertical timbers are set in the earth. Distinguished from *colombage*, which consists of a complete braced framework of more widely spaced vertical timbers.

Prairie Box See FOURSQUARE HOUSE.

Prairie School, Prairie Style A diverse group of architects working in Chicago and throughout the Midwest from the 1890s to the 1920s, strongly influenced by Frank Lloyd Wright and to a lesser degree by Louis Sullivan. The term is applied mainly to domestic architecture. An architect is said to belong to the Prairie School; a work of architecture is said to be in the Prairie Style. Sometimes called Prairie, for short. See also the related terms CHICAGO SCHOOL, WRIGHTIAN.

pre-Columbian Term applied to the major cultures of Latin America (e.g., Aztec, Maya, Inca) that flourished prior to the discovery of the New

World by Columbus in 1492 and the Spanish conquests of the sixteenth century. Distinguished from North American Indian, which is generally applied to indigenous cultures within the area that would become the United States and Canada.

pressed metal Thin sheets of metal (usually galvanized or tin-plated iron) stamped into patterned panels for covering ceilings and exterior and interior walls or into molding profiles and other details for assembly into exterior and interior cornices. Loosely called pressed tin or stamped metal. Prevalent from the 1870s through the 1920s.

program The list of functional, spatial, and other requirements that guides an architect in developing a design.

proscenium In a recessed stage, the area between the orchestra and the curtain.

proscenium arch In a recessed stage, the enframement of the opening.

prostyle Having a columnar portico in front, but not on the sides and rear.

provincialism, provincial Term applied to work in an isolated area (such as a province of a cosmopolitan center or a colony of a mother country), where traditional practices persist, with some awareness of what is being done in the cosmopolitan center or the homeland.

purlin In roof construction, a structural member laid across the principal rafters and parallel to the wall plate and the ridge beam. The light common rafters to which the roofing surface is attached are fastened across the purlins. See also the related term RAFTER.

pylon 1 Originally, the gateway facade of an Egyptian temple complex, consisting of a truncated broad pyramidal form with battered (inclined) wall surfaces on all four sides, or two truncated pyramidal towers flanking an entrance portal. 2 Any towerlike structure from which bridge cables or utility lines are suspended.

quadripartite vault A vault divided into four triangular sections by a pair of diagonal ribs. Sometimes called a four-part vault.

quarry-faced See ROCK-FACED.

quatrefoil A type of Gothic tracery having four parts (lobes or foils) separated by pointed elements (cusps).

Queen Anne Ambiguous but widely used term. 1 In architecture, the Queen Anne Style is an eclectic style of the 1860s through 1910s in England and the United States, characterized by the incorporation of forms from postmedieval vernacular architecture and the architecture of the Georgian period. Sometimes called Queen Anne Revival. See also the more specific term SHINGLE STYLE and the related terms EASTLAKE, STICK STYLE. 2 In architecture, the original Queen Anne period extends from the late seventeenth into the early eighteenth century. 3 In the decorative arts, the Queen Anne Style and period properly refer to work of the early eighteenth century during the reign of Queen Anne (1702–1714, i.e., after William and Mary and before Georgian). 4 In the decorative arts, eclectic work of the 1860s to 1880s is properly referred to as Queen Anne Revival. See also the related term AESTHETIC MOVEMENT.

quoin One of the bricks or stones laid in alternating directions, which bond and form the exterior corner of a building. Sometimes simulated in wood or stucco.

rafter One of the inclined structural members of a roof. Principal rafters are primary supporting elements spanning between the walls and the apex of the roof and carrying the longitudinal purlins. Common rafters are secondary supporting elements fastened onto purlins to carry the roof surfacing. See also the related term PURLIN.

raking cornice A cornice that finishes the sloping edges of a gable roof, such as the inclined sides of a triangular pediment.

random ashlar A type of masonry in which squared and dressed blocks are laid in a random pattern rather than in straight horizontal courses.

recessed column A fully round column set into a nichelike space only slightly larger than the column. Distinguished from an engaged column, which appears to be built into the wall.

reentrant angle An acute angle created by the juncture of two planes, such as walls.

refectory A dining hall, especially in medieval architecture.

regionalism 1 The sum of cultural characteristics (including material culture, language) that define a geographic region, usually extending beyond a single state or province and coinciding with one or more large physiographic areas. 2 The conscious use, within a region, of forms and materials identified with that region, creating an architecture that is in keeping with the historical architecture of the region, and even a distinctive new regional style.

register A horizontal zone of a wall, altarpiece, or other vertical feature. Usually synonymous with story, but more inclusive, allowing for the description of zones with no corresponding interior spaces.

relieving arch An arch, usually of masonry, built over the lintel of an opening to carry the load of the wall above and relieve the lintel of carrying such load. Sometimes called a discharging arch or safety arch.

Renaissance The period in European civilzation identified with a rediscovery or rebirth (*rinascimento*) of classical Roman (and to a lesser extent, Greek) learning, art, and architecture. Renaissance architecture began in Italy in the mid-1400s (Early Renaissance) and reached a peak in the early to mid-1500s (High Renaissance). In England, Renaissance architecture did not begin until the late 1500s or early 1600s.

The Renaissance in art and architecture was preceded by the Gothic and followed by the Baroque.

Renaissance Revival **1** In architecture, an ambiguous term, applied to *(a)* Italianate work of the 1840s through 1880s and *(b)* Beaux-Arts classical work of the 1880s through 1920s. **2** In the decorative arts, an eclectic furniture style incorporating a variety of Renaissance, Baroque, and Néo-Grec architectural motifs and utilizing wood marquetry, incised lines (often gilded), and ormolu and porcelain ornaments. Sometimes called Neo-Renaissance.

rendering Any drawing, whether orthographic (plan, elevation, section) or pictorial (perspective), in which shades and shadows are represented.

reredos A screen or wall at the back of an altar, usually with architectural and figural decoration.

return The continuation of a molding, cornice, or other projecting member, in a different direction, as in the horizontal cornice returns at the base of the raking cornices of a triangular pediment.

reveal **1** The portion of wall thickness between a door or window frame and the outer face of the wall. **2** Same as jamb, but only in an opening without a door or window.

revival, revivalism A type of historicism prevalent since the eighteenth century, involving the adaptation of historical forms to contemporary functions. Distinguished from a more pervasive historicism by an ideological conviction that sought to rationalize the choice of a historical style according to the values of the historical period that produced it. (The Gothic Revival, for instance, was associated with the Christianity of the Middle Ages.) Revival works, therefore, tend to invoke a single historical style. More hybrid works are manifestations of a less dogmatic historicism or eclecticism. See also the more general terms HISTORICISM, ECLECTICISM.

rib The projecting linear element that separates the curved planar cells (or webs) of vaulting. Originally these were the supporting members for the vaulting, but they may also be purely decorative.

Richardsonian Term applied to any work showing the influence of the American architect Henry Hobson Richardson (1838–1886). See the note under the more limiting term RICHARDSONIAN ROMANESQUE.

Richardsonian Romanesque Term applied to Neo-Romanesque work showing the influence of the American architect Henry Hobson Richardson (1838–1886). While many of Richardson's works make eclectic use of round arches and Romanesque details, many of his works show a creative eclecticism that transcends any particular historical style. The term Richardsonian, there-

fore, is a more inclusive term for the work of his followers than Richardsonian Romanesque—a term that continues to be widely used. Sometimes called Richardson Romanesque, Richardsonian Romanesque Revival.

ridgepole The horizontal beam or board at the apex of a roof, to which the upper ends of the rafters are fastened. Sometimes called a ridge beam, ridgeboard, ridge piece.

rinceau An ornamental device consisting of a sinuous and branching scroll elaborated with leaves and other natural forms.

rock-faced Term applied to the rough, unfinished face of a stone used in building. Sometimes called quarry-faced.

Rococo. A late phase of the Baroque, marked by elegant reverse-curve ornament, light scale, and delicate color. See also the related term BAROQUE.

Romanesque A medieval architectural style which reached its height in the eleventh and twelfth centuries. It is characterized by round arched construction and massive masonry walls. The Romanesque was preceded by the Early Christian and Byzantine periods in the eastern Mediterranean world and by a variety of localized styles and periods in northern and western Europe; it was followed throughout Europe by the Gothic.

Romanesque Revival Ambiguous term, applied to (1) Rundbogenstil and Round Arch work in the United States as early as the 1840s and (2) Richardsonian Romanesque work into the 1890s. Sometimes called Neo-Romanesque.

Roman Revival A term, not widely accepted, for a version of Neoclassicism involving the use of forms from the visual arts of the Imperial Roman period. Applied to various works in Italy, England, and the United States, where it is most clearly visible in the architecture of Thomas Jefferson. See also the related terms FEDERAL, JEFFERSONIAN, NEOCLASSICISM.

rood screen An ornamental screen that serves as a partition between the crossing and the chancel or choir of a church.

rosette A circular floral ornament similar to an open rose.

rotunda **1** A circular hall in a large building, especially an area beneath a dome or cupola. **2** A building round both inside and outside, usually domed.

Round Arch mode The American counterpart of the German Rundbogenstil, characterized by the predominance of round arches, whether these are accentuated by Romanesque or Renaissance detailing or left as simple unadorned openings. See also the related terms ITALIANATE, LOMBARD, RUNDBOGENSTIL.

roundel. A circular panel or plaque. Distinguished from a patera, which is oval shaped.

rubble masonry A type of masonry utilizing uncut

or roughly shaped stone, such as fieldstone or boulders.

Rundbogenstil Literally, "round arch style," a historicist style originating in Germany in the 1820s and spreading to Britain and the United States from the 1840s through the 1860s. It is characterized by an eclectic combination of Romanesque and Renaissance elements. See also the related term ROUND ARCH MODE.

running bond A pattern of brickwork in which only stretchers appear, with the vertical joints of one course falling halfway between the vertical joints of adjacent courses. Sometimes called stretcher bond. Distinguished from common bond, in which every fifth or sixth course consists of all headers.

Ruskin Gothic, Ruskinian Gothic. See HIGH VICTORIAN GOTHIC.

rustication, rusticated Masonry in which the joints are emphasized by narrow recessed channels or grooves outlining each block. Sometimes simulated in wood or stucco.

sacristy A room in a church where liturgical vessels and vestments are kept.

safety arch See RELIEVING ARCH.

sanctuary 1 The part of a church that contains the principal altar. Usually the innermost space within the chancel arm of the church, situated to the east of the choir. 2 Loosely used to mean a place of worship, a sacred place.

sash Any framework of a window. It may be movable or fixed. It may slide in a vertical plane (as in a double-hung window) or may be pivoted (as in a casement window).

sash bar See MUNTIN.

Secession movement The refined classicist Austrian (Viennese) version of the Art Nouveau style, so named beause the artists and architects involved seceded from the official Academy in 1897. Josef Hoffmann (1870–1956) is the architect most frequently mentioned in association with this movement.

Second Chicago School A term sometimes applied to the International Style in Chicago from the 1940s to the 1970s, particularly the work of Mies van der Rohe. See also the related terms INTERNATIONAL STYLE, MIESIAN.

Second Empire Not strictly a style term but a term for a period in French history coinciding with the rule of Napoleon III (1852–1870). Generally applied in the United States, however, to a phase of Beaux-Arts governmental and institutional architecture (1850s–1880s) as well as to countless hybrids of Beaux-Arts and Italianate forms in residential, commercial, and industrial architecture (1850s–1880s). Sometimes called General Grant Style, Mansard Style, Mansardic. See also the related terms BEAUX-ARTS, ITALIANATE (definition 1).

section A drawing (in orthographic projection) representing a vertical cut through an object, building, or space. An architectural section shows interior relationships of space and structure and may also include mechanical systems. Sometimes called a cross section.

segmental arch An arch formed on a segmental curve. Its center lies below the springing line.

segmental curve A curve that is a segment (i.e., less than half the circumference) of a circle or an ellipse. The baseline of the curve is a chord measuring less than the diameter of the larger circle from which the segment is taken.

segmental pediment A pediment whose top is a segmental curve.

segmental vault A vault whose cross section is a segmental curve. A dome built on segmental curves is called a saucer dome.

setback 1 In architecture, particularly in the design of tall buildings, a series of upper stories that are stepped back to allow more sunlight to reach the streets. 2 In planning, the amount of space between the lot line and the perimeter of a building.

shaft The tall part of a column between the base and the capital.

shed roof A roof having only one sloping plane. Sometimes called a lean-to roof.

Shingle Style A term applied primarily to American domestic architecture of the 1870s through the 1890s, in which broad expanses of wood shingles dominate the exterior roof and wall planes. Rooms open widely into one another and to the outdoors, and the ample living hall or stair hall is often the dominant feature of the interior. The term was coined in the 1940s by Vincent Scully for a series of seaside and suburban houses of the northeastern United States. The Shingle Style is a version of the Anglo-American Queen Anne Style. See also the related terms COLONIAL REVIVAL, STICK STYLE.

shotgun house A narrow, deep house, one room wide and two or more rooms deep, perhaps so called because the rooms open into each other in such a way that a shot fired through the front door could pass through open doors and exit at the rear without damaging the house. A double shotgun is a pair of shotguns with a party wall; a camelback shotgun has a second-story addition on the rear half of the house.

shouldered architrave See EAR.

side gabled Term applied to a building whose gable ends face the sides of a lot. Distinguished from front gabled.

side light A framed area of fixed glass alongside a door or window. See also the related term FANLIGHT.

sill course In masonry, a stringcourse set at windowsill level, usually differentiated from the wall by its greater projection, its finish, or its thickness. Not applicable to frame construction.

sill plate See PLATE (definition 2).

skeleton construction, skeleton frame A system of construction in which all loads are carried to the ground through a rigid framework of iron, steel, or reinforced concrete. The exterior walls are curtain walls (i.e., not load-bearing).

skylight A window in a roof, specifically one that is flush with the roof plane or only slightly protruding. Distinguished from a cupola (definition 2), which is a major centralized feature at the summit of a roof. Distinguished from a monitor, which is an extensive roof feature containing a band of windows or vents.

soffit The exposed underside of any overhead component, such as an arch, beam, cornice, or lintel. See also the related term INTRADOS.

sole plate See PLATE (definition 2).

space frame A series of trusses placed side by side and joined to one another by triangulated rods, tubes, or beams, so that the individual planar trusses are united into a three-dimensional structural framework. Often used in roof structures requiring long spans.

spandrel 1 The quasi-triangular space between two adjoining arches and a line connecting their crowns, or between an arch and the columns and entablature that frame it. 2 In skeletal construction, the wall area between the top of a window and the sill of the window in the story above. Sometimes called a spandrel panel.

Spanish colonial A term applied to buildings, towns, landscapes, and other artifacts from the various periods of actual Spanish colonial occupation in North America (c. 1565–1821 in Florida; c. 1763–1800 in Louisiana and the Lower Mississippi valley; c. 1590s–1821 in Texas and the southwestern United States; c. 1769–1821 in California). The term is extended to apply to the artifacts of Hispanic ethnic groups (e.g., Mexicans, Puerto Ricans, Cubans) and their descendants, even into the early twentieth century. See also the related terms CHURRIGUERESQUE, PLATERESQUE.

Spanish Colonial Revival The revival of forms from Spanish colonial and provincial Mexican design. The Spanish Colonial Revival began in Florida and California in the 1880s and continues nationwide into the present. Sometimes called Neo-Hispanic, Spanish Eclectic, Spanish Revival. See also the more specific term MISSION REVIVAL and the related term MEDITERRANEAN REVIVAL.

spindle A turned wooden element, thicker toward the middle and thinner at either end, found in arch screens, porch trim, and other ornamental assemblages. Banisters (i.e., thin, simple balusters) may be spindle-shaped, but the term spindle, when used alone, usually connotes shorter elements.

spire A slender pointed element surmounting a building. A tall, attenuated pyramidal form with any number of thin triangular faces that are un-

broken or articulated only with crockets, pinnacles, or small dormers. Distinguished from a steeple, which is divided into stages and which may be topped with a spire.

splay The slanting surface formed by cutting off a right-angle corner at an oblique angle to one face. A reveal at an oblique angle to the exterior face of the wall.

springing, springing line, springing point The line or point where an arch or vault rises from its supports and begins to curve. Usually the juncture between the impost of the support below and the springer, or first voussoir, of the arch above.

squinch An arch, lintel, or corbeling, built across the interior corner of two walls to form one side of an octagonal base for a dome. This octagonal base serves as the structural transition from a square interior crossing space to an octagonal or round dome.

stair A series of steps, or flights of steps connected by landings, which connects two or more levels or floors.

staircase The ensemble of a stair and its enclosing walls. Sometimes called a stairway.

stair tower A projecting tower or other building block that contains a stair.

stamped metal See PRESSED METAL.

Steamboat Gothic See CARPENTER'S GOTHIC.

steeple 1 A tall structure rising from a tower, consisting of a series of superimposed stages diminishing in plan, and usually topped by a spire or small cupola. Distinguished from a spire, which is not divided into stages. 2 Less commonly used to mean the whole of the tower, from the ground to the top of the spire or cupola.

stepped gable A gable in which the wall rises in a series of steps above the planes of the roof.

stereotomy The science of cutting three-dimensional shapes from stone, such as the units that make up a carefully fitted masonry vault.

Stick Style A term applied primarily to American domestic architecture of the 1850s through the 1870s, in which exterior wall planes are subdivided into bays and stories outlined by narrow boards called "stickwork." The term was coined by Vincent Scully in the 1940s for a series of houses with clearly articulated wall panels and sticklike porch supports and eaves brackets. Sources include the English and German picturesque traditions, as well as the French rationalist tradition. See also the related terms QUEEN ANNE, SHINGLE STYLE.

story (plural: stories). The space in a building between floor levels. British spelling is storey, storeys. Sometimes called a register, a more inclusive term applied to horizontal on a vertical plane zones that do not correspond to actual floor levels.

Streamline Moderne A later phase of the Moderne, popular in the 1930s and 1940s and characterized by stucco surfaces with rounded cor-

ners, by horizontal banding, overhangs, and window groupings, and by other details suggestive of modern Machine Age aerodynamic forms. Sometimes called Streamline Modern, Streamline Modernistic. See also the more general term MODERNE and the related terms ART DECO and PWA MODERNE.

stretcher A brick laid the length of a wall, so that the long side of the brick shows on the exterior.

stretcher bond See running bond.

string In a stair, an inclined board that supports the ends of the steps. Sometimes called a stringer.

stringcourse In masonry, a horizontal band, generally narrower than other courses, extending across the facade of a building and in some instances encircling such features as pillars or columns. It may be flush or projecting; of identical or contrasting material; flat, molded, or richly carved. Not applicable to frame construction. Sometimes called a band course or belt course. More elaborate horizontal bands in masonry or frame construction are generally called band moldings.

strut A column, post, or pole that is set in a diagonal position and thus serves as a stiffener by triangulation. Distinguished from a brace, which is usually a shorter bracketlike member.

stucco 1 An exterior plaster finish, usually textured, composed of portland cement, lime, and sand, which are mixed with water. 2 A fine plaster used for decorative work or moldings. See also the more specific term PARGETING.

stud One of the vertical supporting elements in a wall, especially in balloon- and platform frame construction. Studs are relatively lightweight members (usually two-by-fours).

Sullivanesque Term applied to work showing the influence of the American architect Louis Henry Sullivan (1856–1924).

sunburst light See FANLIGHT.

supercapital See IMPOST BLOCK.

supercolumniation See SUPERPOSITION (definition 1).

superimposition, superimposed See SUPERPOSITION.

superposition, superposed 1 The use of an ensemble of the classical orders, one above the other, as the major elements articulating a facade. When this is done, the Doric, considered the simplest order, is used on or near the ground story. The Ionic, considered more complex, comes next; and the Corinthian, considered the most complex, is used at the top. Sometimes the Tuscan order or rusticated masonry may be used for the ground story beneath the Doric order, and the Composite order may be used above the Corinthian order. Sometimes called supercolumniation, superimposition. See also the related term ORDER. 2 Less commonly, any vertical relationship of architectural elements (e.g., windows, piers, colonnettes) in any style or period.

superstructure A structure raised upon another structure, as a building upon a foundation, basement, or substructure.

Supervising Architect The Supervising Architect of the United States Treasury Department, whose office was responsible for the design and construction of all major federal government buildings (such as courthouses, customhouses, and post offices) from the 1850s through the 1930s. The Office of the Supervising Architect was formally established by Congress in 1864 and lasted until 1939, when its functions were absorbed into the Public Buildings Administration (and in 1949, into the General Services Administration).

supporting wall See BEARING WALL.

surround An encircling border or decorative frame around a door or window. Distinguished from architrave (definition 2), a term usually applied to the frame around an opening when considered as a series of relatively flat face moldings.

suspended ceiling A ceiling suspended from rodlike hangers below the level of the floor above. The interval between the floor slab above and the suspended ceiling often serves as a space for ducts, utilities, and air circulation. Sometimes called a hung ceiling.

swag A motif representing a suspended fold of drapery hanging in a catenary curve from two points. Distinguished from a festoon, which is a motif representing entwined leaves, flowers, or fruits, hung in a similar curve. See also the more general term GARLAND.

tabernacle 1 A niche or recess, usually on an interior wall, framed by columns or pilasters and topped by an entablature and pediment. Distinguished from an aedicule, which more often occurs on an exterior wall. See also the related term NICHE. 2 In the Jewish religion, a portable sanctuary. 3 In Protestant denominations, a large auditorium church.

terra-cotta A hard ceramic material used for (1) fireproofing, especially as a fitted cladding around metal skeletal construction; or (2) an exterior or interior wall cladding, which is often glazed and multicolored.

tertiary rib See LIERNE.

thermal window A large lunette window similar to those found in ancient Roman baths (*thermae*). The window is subdivided into three to five parts by vertical mullions. Sometimes called a *thermae* window.

three-hinged arch An arch in two major segments anchored with cylindrical "hinge" pins at either end and at the crown. Movement within the arch, caused by temperature changes, the torsion of wind movements, or other forces, can be absorbed by the movement of the arch around the pins, thereby avoiding stresses that would occur in the structural frame if the arches were fixed.

tie beam A horizontal tension member that ties together the opposing angular members of a truss and prevents them from spreading.

tier A group of stories or any zone of architectural elements arranged horizontally.

tierceron In a Gothic vault, a secondary rib that rises from the springing to an intermediate position on either side of the diagonal ribs. Sometimes called an intermediate rib.

tie rod A metal rod that spans the distance between two structural members and, by its tensile strength, restrains them against tendencies to collapse outward.

timber-frame construction, timber framing A type of wood-frame construction in which heavy timber posts and beams (six-by-sixes and larger) are fastened using mortise-and-tenon joints. Sometimes called heavy timber construction. Distinguished from light frame construction, in which relatively light structural members (two-by-fours to two-by-tens) are fastened with nails.

trabeation, trabeated construction. See POST-AND-BEAM CONSTRUCTION.

tracery Decoration within an arch or other opening, made up of narrow curvilinear bands or more elaborately molded strips. In Gothic architecture, the curved interlocking stone bars that contain the leaded stained glass.

transept The lateral arm of a cross-shaped church, usually between the nave (the area for the congregation) and the chancel (the area for the altar, clergy, and choir).

transom 1 A narrow horizontal window unit, either fixed or movable, over a door. Sometimes called a transom light. See also the more specific term fanlight. 2 A horizontal bar, as distinguished from a vertical mullion, especially one crossing a door or window opening near the top.

transverse rib In a Gothic vault, a rib at right angles to the ridge rib.

trefoil A type of Gothic tracery having three parts (lobes or foils) separated by pointed elements (cusps).

trellis Any open latticework made of strips of wood or metal crossing one another, usually supporting climbing plants. Distinguished from an arbor, which is generally a more substantial yet compact three-dimensional structure, and from a pergola, which is a more extensive colonnaded structure.

triforium In a Gothic church, an arcade in the wall above the arches of the nave, choir, or transept and below the clerestory window.

triglyph One of the slightly raised blocks in a Doric frieze. It consists of three narrow vertical bands separated by two V-shaped grooves.

triumphal arch 1 A freestanding arch erected for a victory procession. It usually consists of a broad central arched opening, flanked by two smaller bays (usually with open or blind arches). The bays are usually articulated by classical columns supporting an entablature and a high attic. 2 A similar configuration applied to a facade to denote a monumental entryway.

truss A rigid triangular framework made up of beams, posts, braces, struts, and ties and used for the spanning of large spaces. The major horizontal or inclined members are called chords. The connecting vertical and diagonal elements are called the web members.

Tudor arch A low-profile arch characterized by two pairs of arcs, one pair of tight arcs at the springing, another pair of broad (nearly flat) arcs at the apex or crown.

Tudor period A term for a period in English history coinciding with the rule of monarchs of the house of Tudor (1485–1603). Tudor period architecture is Late Gothic, with only hints of the Renaissance. See also the more specific term ELIZABETHAN PERIOD for the end of this period, and the related term JACOBEAN PERIOD for the succeeding period.

Tudor Revival See NEO-TUDOR.

turret A small towerlike structure, often circular in plan, built against the side or at an exterior or interior corner of a building.

Tuscan order An ensemble of classical column and entablature elements, similar to the Roman Doric order, but without triglyphs in the frieze and without mutules (domino-like blocks) in the cornice of the entablature. See also the more general term ORDER.

tympanum (plural: tympana) 1 The triangular or segmental area enclosed by the cornice moldings of a pediment, frequently ornamented with sculpture. 2 Any space similarly delineated or bounded, as between the lintel of a door or window and the arch above.

umbrage A term used by Alexander Jackson Davis (1803–1892) as a synonym for veranda, the implication being a shadowed area.

vault An arched roof or ceiling, usually constructed in brick or stone, but also in tile, metal, or concrete. A nonstructural plaster ceiling that simulates a masonry vault.

Venetian Gothic See HIGH VICTORIAN GOTHIC.

veranda A nineteenth-century term for porch. Sometimes spelled verandah.

vergeboard See BARGEBOARD.

verges The sloping edges of a gable, gambrel, or lean-to roof, usually projecting beyond the wall below. Distinguished from eaves, which are the horizontal lower edges of a roof plane.

vernacular Not a style in itself, but a descriptive term, applicable primarily to architecture covering the vast range of ordinary buildings that are produced outside the high-style tradition of well-known architects. The vernacular tradition includes the folk tradition of regional and ethnic buildings whose forms (plan and massing) remain relatively constant through the years in spite of stylistic embellishments. The term vernacular architecture is often used as if it meant only folk architecture. However, the vernacular

tradition in architecture also includes the popular tradition of buildings whose design was influenced by such publications as books of the orders, builders' guides, style books, pattern books, mail-order catalogs, architectural periodicals, and household magazines. Usually contrasted with high-style. See also the more specific terms FOLK, POPULAR.

vertical plank construction A system of wood construction in which vertical planks are set or nailed into heavy timber horizontal sills and plates. A building so constructed has no corner posts and no studs. Two-story vertical plank buildings have planks extending the full height of the building, with no girt between the two stories. Second-floor joists are merely mortised into the planks. Distinguished from the more specific term vertical plank frame construction, in which there are corner posts.

vertical plank frame construction A type of vertical plank construction, in which heavy timber corner posts are introduced to provide support for the plate, to which the tops of the planks are fastened. See also the related term HORIZONTAL PLANK FRAME CONSTRUCTION.

vestibule A small entry hall between the outer door and the main hallway of a building.

Victorian Gothic See HIGH VICTORIAN GOTHIC.

Victorian period A term for a period in British, British colonial, and Anglo-American history, and not, in architecture or the other visual arts, a sufficiently specific style term. The Victorian period extended across eight decades, from the coronation of Queen Victoria in 1837 to her death in 1901. See instead EASTLAKE, GOTHIC REVIVAL, GREEK REVIVAL, QUEEN ANNE, SHINGLE STYLE, STICK STYLE, and other specific style terms.

Victorian Romanesque Ambiguous term. See instead RICHARDSONIAN ROMANESQUE, ROMANESQUE REVIVAL, ROUND ARCH MODE.

villa. 1 In the Roman and Renaissance periods, a suburban or rural residential complex, often quite elaborate, consisting of a house, dependencies, and gardens. 2 Since the eighteenth century, any detached suburban or rural house of picturesque character and some pretension. Distinguished from the more modest house form known as a cottage.

volute 1 A spiral scroll, especially the one that is a distinctive feature of the Ionic capital. 2 A large scroll-shaped buttress on a facade or dome.

voussoir A wedge-shaped stone or brick used in the construction of an arch. Its tapering sides coincide with radii of the arch.

wainscot A decorative or protective facing, usually of wood paneling, applied to the lower portion of an interior partition or wall. Distinguished from a dado, which is the zone at the base of a wall, regardless of the material used to cover it. Wainscot properly connotes woodwork. Sometimes called wainscoting.

water table 1 In masonry, a course of molded bricks or stones set forward several inches near the base of a wall and serving as the cap of the basement courses. 2 In frame construction, a ledge or projecting molding just above the foundation to protect it from rainwater. 3 In masonry or frame construction, any horizontal exterior ledge on a wall, pier, or buttress. Often sloped and provided with a drip molding to prevent water from running down the face of the wall below.

weatherboard See CLAPBOARD.

weathering The inclination given to the upper surface of any element so that it will shed water.

web 1 The relatively thin shell of masonry between the ribs of a ribbed vault. 2 The portion of a truss between the chords, or the portion of a girder or I-beam between the flanges.

western frame, western framing See PLATFORM FRAME CONSTRUCTION.

winder A step, more or less wedge-shaped, with its tread wider at one end than the other.

window bar See MUNTIN.

window cap See CAP.

window head A head molding or pedimented feature over a window.

Wrightian Term applied to work showing the influence of the American architect Frank Lloyd Wright (1867–1959). See also the related term PRAIRIE SCHOOL.

wrought iron Iron shaped by a hammering process to improve the tensile properties of the metal. Distinguished from cast iron, a brittle material, which is formed in molds.

Zigzag Moderne, Zigzag Modernistic See ART DECO.

Illustration Credits

HABS Historic American Buildings Survey, Prints and Photographs Division, Library of Congress
HNOC The Historic New Orleans Collection
LSUS Louisiana State University in Shreveport, Noel Memorial Library Archives
SEAA Southeastern Architectural Archive, Tulane University Library
TU Louisiana Collection, Tulane University Library

Photographs not otherwise credited are by the author.

Introduction
Page 7, Peabody Museum, Harvard University, photo by Hillel Burger; **p. 11,** TU; **p. 12,** HNOC; **p. 13,** TU; **p. 20,** Robert S. Brantley; **p. 22,** HABS; **p. 25,** Betsy Swanson (top), Jim Zietz (bottom); **p. 28,** Louisiana State Museum, lithograph by B. W. Thayer and Co., 1845; **p. 29,** HABS; **p. 31,** HNOC; **p. 34,** SEAA, photo by Richard Koch; **p. 35,** Jim Zietz; **p. 38,** HNOC; **p. 40, p. 41,** SEAA; **p. 43,** HNOC; **p. 45, p. 46,** Caddo–Pine Island Oil and Historical Society Museum; **p. 48,** LSUS; **p. 50,** SEAA, photo by Frank Lotz Miller

Orleans Parish
Page 58, HNOC; **p. 60,** TU; **OR1** HNOC; **OR9, OR10** Jim Zietz; **OR12** HABS; **OR14** Robert S. Brantley and Jan White Brantley; **OR17** HABS; **OR21** SEAA; **OR22** Robert S. Brantley (photo); HABS (drawing); **OR23, OR28** R. West Freeman III; **OR30** SEAA; **OR31, OR36** Robert S. Brantley; **OR37** SEAA; **OR38.1** R. West Freeman III; **OR49** HNOC; **OR50** Betsy Swanson; **OR51** Library of Congress, Prints and Photographs Division; **OR52** SEAA; **OR54** R. West Freeman III; **OR55** Jim Zietz; **OR62** Robert S. Brantley and Jan White Brantley; **OR63** Betsy Swanson; **OR63.1** R. West Freeman III; **OR64, OR65** Vicky Stanwycks; **OR66** R. West Freeman III (interior), Robert S. Brantley (exterior); **OR67, OR71** R. West Freeman III; **OR73** HNOC; **OR74, OR76.2** SEAA, photo by Frank Lotz Miller; **OR79** HNOC; **OR80, OR83** SEAA; **OR90** Robert S. Brantley; **OR91** R. West Freeman III; **OR93** Jim Zietz; **OR95, OR96, OR99, OR101** Jim Zietz; **OR102, OR103** R. West Freeman III; **OR106** Jan White Brantley and Robert S. Brantley; **OR107** HNOC; **OR110, OR113** Betsy Swanson; **OR114** Jim Zietz; **OR116** R. West Freeman III; **OR117** Jim Zietz; **OR119** SEAA, photo by Frank Lotz Miller; **OR119**

SEAA; **OR120** Betsy Swanson; **OR127, OR130** R. West Freeman III; **OR131** Betsy Swanson; **OR139, OR140** Jim Zietz; **OR143** Tulane University Publications, photo by Paula Burch; **OR143.1** TU; **OR145** Jim Zietz; **OR147** Betsy Swanson; **OR150** Jim Zietz; **OR153, OR158** R. West Freeman III; **OR160** Betsy Swanson; **OR163** HNOC; **OR164** SEAA, photo by Frank Lotz Miller; **OR171** Betsy Swanson

Delta Parishes
JE9.3, JE10 Betsy Swanson; **JE12** SEAA, photo by Frank Lotz Miller; **JE18** Betsy Swanson; **PL2** SEAA, photo by Richard Koch; **SB4.2** Betsy Swanson; **SB5** HNOC

Lower River Parishes
Page 172, CH1 U.S. Army Corps of Engineers; **CH2, CH3** Robert S. Brantley; **JO3** HNOC, photo by Clarence John Laughlin, 1941; **JO4** Jim Zietz; **JM2.1** HABS; **JM3** SEAA (top), Jan White Brantley (bottom); **AN1, AN2** Betsy Swanson; **AN4** SEAA; **EB1, EB2** Jim Zietz; **EB9** SEAA; **EB13, EB15** HABS; **EB16** Jim Zietz; **p. 200,** Louisiana State University, Baton Rouge, Hill Memorial Library; **EB19, EB20, EB21, EB27** Jim Zietz; **EB29** HABS; **EB30.1, EB30.2, EB30.3, EB40.1** Jim Zietz; **WB4, WB7** Jim Zietz; **IB5, IB6** Jim Zietz; **IB10** Jim Zietz (top), Robert S. Brantley (bottom); **AN6** SEAA; **AN8, AN11, AN15.2** Jim Zietz; **JM6** Robert S. Brantley; **JO7** R. West Freeman III (top and bottom right), Betsy Swanson (bottom left)

Bayou and Gulf Parishes
LF3 Jim Zietz; **LF7** HNOC; **LF11** SEAA; **TR7** Jim Zietz; **AM2** Jim Zietz; **AM3** HNOC; **MY6** Grevemberg House Museum/Miguez Photography; **MY8** Office of The First Lady/Miguez Photography; **IA5** HNOC; **IA12** HNOC, photo by Judy Tarantino

Acadian Parishes
LA9, LA20.1 Jim Zietz; **SL2, SL10, SL14** Jim Zietz

Southwestern Parishes
CM2 U.S. Coast Guard; **CC1, CC2, CC4** Jim Zietz; **CC7** Lundy & Davis L.L.P./Monsour's Photography; **CC9** McNeese State University, Archives and Special Collections, photo by Rod Rodriguez; **CC12.1** SEAA; **CC13** SEAA, photo by Frank Lotz Miller; **BE2** Christine L. Smith, 1986

Central Parishes
RA1, RA4, RA5, RA8, RA11, RA13, RA23 Jim Zietz; **SA3** Jim Zietz; **NA1** Jim Zietz; **NA5** HABS; **NA15, NA18, NA23** Jim Zietz; **NA26** HABS

Northwestern Parishes
CA1 LSUS; **CA3, CA4** Jim Zietz; **CA6** LSUS; **CA9** LSUS; **CA16, CA21** Jim Zietz; **CA23** LSUS; **CA24, CA32** Jim Zietz; **CA38** LSUS; **CA42** Jim Zietz; **CA58** LSUS; **CA62** Jim Zietz; **CA65, CA68** LSUS; **CA69** Jim Zietz; **BO1** LSUS

North Central Parishes
WE4 Jim Zietz; **CL2** Donny J. Crowe; **LI8** Jim Zietz

Northeastern Parishes
CD1 Jim Zietz; **OU4, OU15** Jim Zietz

Upper River Parishes
TN1, TN2 Jim Zietz; **CO3** U. S. Army Corps of Engineers; **PC6** HNOC, photo by Frances Benjamin Johnston, c. 1938; **PC7** SEAA, photo by Richard Koch; **WF2, WF6, WF10, WF12** Jim Zietz; **WF19** SEAA, photo by Frank Lotz Miller; **WF22** SEAA, photo by Richard Koch

Florida Parishes
ST3 SEAA, photo by Frank Lotz Miller; **TA8, TA13.4** Jim Zietz; **EF1** HABS; **EF2, EF4, EF11** Jim Zietz; **WA4, WA5, WA6** Jim Zietz

Index

Page numbers in **boldface** refer to illustrations.